THE SCULPTURE OF JACOPO SANSOVINO

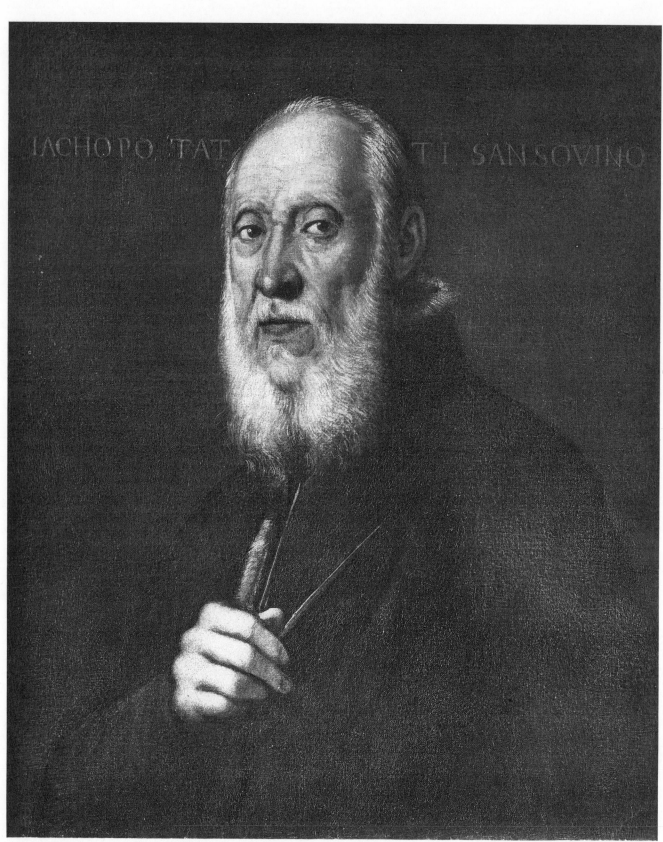

Jacopo Tintoretto: Portrait of Jacopo Sansovino, Galleria degli Uffizi, Florence

THE SCULPTURE OF JACOPO
SANSOVINO

Bruce Boucher

I

YALE UNIVERSITY PRESS
NEW HAVEN AND LONDON · 1991

For my Mother and in Memory of my Father

Designed by Faith Brabenec Hart
Set in Linotron Bembo by Excel Typesetters Company, Hong Kong
Printed in Great Britain by The Bath Press Ltd, Bath, Avon

Library of Congress Cataloging-in-Publication Data

Boucher, Bruce.
 The sculpture of Jacopo Sansovino/Bruce Boucher.
 p. cm.
 Includes bibliographical references and index.
 ISBN 0-300-04769-2
 1. Sansovino, Iacopo, 1488–1570—Criticism and interpretation.
2. Sculpture, Renaissance—Italy. I. Sansovino, Iacopo,
1486–1570. II. Title.
NB623.S3514B6 1991
730'.92—dc20
 91-50244
 CIP

Preface

I HAVE ALWAYS sympathized with Sir Walter Raleigh's attempt to write a history of the world, and at times the present work seemed cast in that mould. Any line of inquiry will lead into areas beyond its original confines, producing unexpected conclusions—if the author is lucky. My involvement with Jacopo Sansovino's sculpture began while a student at the Courtauld Institute in the early 1970s and was limited at first to his Venetian career. I soon came to appreciate that it was impossible to consider Sansovino's later sculptures without studying his early works and the Central Italian tradition from which he emerged. This led to extended periods of research in Florence and Rome, extending over more than a decade. After I began teaching at University College, London, the pace of my research inevitably slowed, but although this delayed the conclusion of my work, it did allow me to live with my material, to reconsider it periodically, and to discuss it with colleagues and students. Coleridge once wrote that 'the *heart* should have *fed* upon *truth*, as insects on a leaf, till it be tinged with the colour, and show its food in every . . . minutest fibre'. This observation remained with me as I tried to reconstruct the world in which Sansovino lived.

At various stages in my work I have enjoyed financial support from a number of institutions. My initial research into Sansovino's Venetian sculpture was conducted while a Chester Dale fellow of the National Gallery of Art in Washington, D.C., in 1975–76, and subsequent periods of research have been underwritten by the British Academy, the Central Research Fund of the University of London, and the Dean's Travel Fund of University College, London. In addition, generous grants from the British Academy and the Gladys Krieble Delmas Foundation enabled me to commission new photographs of several sculptures by Sansovino. The Harvard University Center for Renaissance Studies at Villa I Tatti provided the congenial atmosphere in which further research in Sansovino's early career was conducted in 1984–85, and the bulk of the catalogue was completed during two memorable periods as an Alexander von Humboldt research fellow in Bonn and Berlin during 1989–90.

In the course of writing any book, an author incurs numerous debts, and acknowledging them evokes a mixture of pleasure and humility. Michael Hirst and Howard Burns first interested me in Sansovino and encouraged my initial studies; although this may not be the kind of book that either of them would write on the subject, its appearance will, I hope, repay some of the scholarly support they have given me over the years. I was also fortunate in being welcomed to the study of Sansovino by Deborah Howard and Mary Garrard, whose earlier studies of his architecture and sculpture constituted a *sine qua non* for my own research. I should also record the generosity and stimulus given me by the late Ulrich Middeldorf, who, in an act both typical and magnanimous, shared with me his notes on Sansovino and his incomparable knowledge of Renaissance art.

Among friends and colleagues who have helped me over the years, I must single out Anthony Radcliffe who has taught me more about sculpture than I can ever hope to

acknowledge. John Pope-Hennessy has always been ready to discuss and criticize my ideas on Sansovino and has offered invaluable advice on a number of points. I was also extremely fortunate to be able to exchange opinions about Sansovino's early career with Giancarlo Gentilini on various occasions. Wolfgang Wolters and Michael Bury had the unenviable task of reading an earlier form of this work as a Ph.D. thesis; their comments and criticisms have influenced the recasting of that material in its present form. To Wolfgang Wolters I owe a particular debt of gratitude for that special *calcio nel sedere* which pushed me towards finishing the book. I should also like to thank: Elisa Avagnina, Charles Avery, Malcolm Baker, Giorgio Bonsanti, Kathleen Weil-Garris Brandt, Bodo Buczynski, Salvatore Camporeale, Enrico Comastri, Gigi Corazzol, Alan Phipps Darr, Charles Davis, James David Draper, Caroline Elam, Chris Fischer, John Fleming, Jean-René Gaborit, Margaret Haines, Rupert Hodge, James Holderbaum, Hugh Honour, Charles Hope, Michael Knuth, Manfred Leithe-Jasper, John Larson, Douglas Lewis, Ralph Lieberman, Bernd Lindemann, Elizabeth McGrath, Thomas Martin, Stefania Mason Rinaldi, Jennifer Montagu, Enrica Neri, Alessandro Nova, Alessandro Parronchi, Nicholas Penny, Nicolai Rubinstein, Ruth Rubinstein, Ursula Schlegel, Salvatore Settis, Wendy Steadman Sheard, John Shearman, Deborah Stott, Christian Theuerkauff, Sarah Wilk, Robert Williams, and Christoph Zindel. Gino Corti and Lina Frizzero helped with the transcription of documents. For help with photography, I am particularly indebted to Geoffrey Fisher and Philip Ward-Jackson of the Courtauld Institute's Conway Library and to the staffs of Cameraphoto and Osvaldo Böhm in Venice.

John Nicoll encouraged the development of this book and offered practical advice at every stage in its publication. Faith Hart's meticulous attention to the manuscript has spared the reader much vexation and puzzlement.

Finally, I must acknowledge the moral support of my wife and family, in the extended sense of that word. They have endured this project and tolerated its demands good humouredly; for their help, especially that of my parents, I cannot thank them enough.

Contents

ILLUSTRATIONS

Introduction

ITALIAN SCULPTURE of the High Renaissance has long been dominated by the figure of Michelangelo, to the extent that other sculptors and regional schools are often measured by his achievements. Giorgio Vasari imposed this bias upon the study of Italian sculpture, and his views have inevitably coloured later interpretations of the period. Anyone who studies Renaissance sculpture will quickly see that the situation was far more complex: Michelangelo's contemporaries and his followers faced a variety of models upon which they based their work; their response to the antique, to fifteenth-century 'classics', and to each other reflects a sophistication and an awareness of styles that often go unrecognized. Nowhere is this complexity of approach more apparent than in the work of Michelangelo's most gifted rival, Jacopo Sansovino.

Sansovino's sculpture is perennially fascinating. It demonstrates a dazzling virtuosity and at the same time explores a sentiment and style far removed from Michelangelo. As a Florentine active first in Rome and then Venice, Sansovino traced an unusual trajectory with his career, one which drew together Central Italian and Venetian elements to create a distinctive contribution to High Renaissance sculpture.

This is the first book-length study of Sansovino's sculpture since Hans Weihrauch's *Studien zum bildnerischen Werke des Jacopo Sansovino* appeared in 1935. The dearth of studies on Sansovino's sculpture, both before and after Weihrauch, stems from the general neglect of Italian Renaissance sculpture and from a preoccupation with Michelangelo. Little interest was shown in Sansovino between Vasari's biography of 1568 and that published by Temanza in 1752. Vasari's account, especially in the amended version published by the sculptor's son Francesco in 1571, remains a fundamental document in appreciating Sansovino's place in Renaissance art. Temanza's pamphlet was a painstaking attempt to reconstruct Sansovino's career, though it inevitably gave more attention to the architecture than the sculpture. During the nineteenth century, writers like Cicognara and Selvatico paid tribute to Sansovino's role as the founder of a school of Venetian sculpture, though the artistic aims of that school were out of sympathy with the Neoclassical standpoint of both men. More important were the studies based upon archival research by figures like Cicogna, Gonzati, Lorenzi, Cecchetti, and Campori; their work fleshed out many aspects of Sansovino's career and the milieu in which he moved. Only the great Jacob Burckhardt attempted to take the measure of Sansovino's sculptural achievement, in his guidebook *Der Cicerone*.

In our own century, Giulio Lorenzetti's articles and annotated edition of Vasari's life combined a sure sense of the artist's development with an encyclopaedic familiarity with primary sources. Unhappily, he never produced an extended account of Sansovino's career, and those by Pittoni and Planiscig suffer from an indiscriminate inclusion of works at best generically connected with Sansovino's. Their approach was typical of a tendency in early

twentieth-century scholarship that lumbered Sansovino and similar artists with a host of implausible attributions, chiefly in the realm of small bronzes. Weihrauch's short monograph of 1935 was of a different order. Taking his readers through Sansovino's career decade by decade, he sought to project a stylistic development grounded in Hegelian art theory. Weihrauch's book is at its best in its discussion of individual works but neglects the context in which they were created.

More recently, interest in Sansovino has revived, notably through the studies of Lotz, Tafuri, Howard, and Foscari on his Venetian architecture. The one major contribution to an understanding of Sansovino as a sculptor has been the Ph.D. thesis by Garrard, which focused on the Florentine and Roman works. My own interest in Sansovino's sculpture originated with an M.A. thesis at the Courtauld Institute of Art on the bronzes in San Marco. Subsequently, I embarked upon a Ph.D. thesis on Sansovino's Venetian sculpture, which forms the basis of the present study.

The text begins with an account of Sansovino's early training in terms of the Florentine tradition from which he emerged and examines his first works against the unfolding of the High Renaissance in Florence and Rome. Inevitably, the majority of the chapters deal with Sansovino's Venetian career, which was longer and more productive. They survey his sculpture in terms of media and subject matter, including such topics as bronze and marble reliefs, the Virgin and Child compositions, the Loggetta in Piazza San Marco, tombs, and colossal sculpture. In addition, I have tried to bring into play the personalities around Sansovino, the tightly knit circle of patrons that propelled him into prominence, and the pupils, followers, and assistants who became his extra hands as his commissions multiplied. The text concludes with an account of Sansovino's workshop and of his artistic legacy.

The text is buttressed by a corpus of documents on Sansovino's career as a sculptor. Some of these have previously been published in obscure places, and others are here in print for the first time. Though they are not all the documents touching on Sansovino, they have been chosen to illustrate his working procedure and the conditions under which he operated. They should be of interest, not only to art historians, but also to social historians and to anyone interested in learning more about the state of sculptors in sixteenth-century Italy. The final section of the book consists of a *catalogue raisonné*, the first such for Sansovino's sculptures. It deals with the varying degrees of autograph works, works after designs by the artist, lost works, and rejected sculptures; it also includes a handful of autograph drawings and a brief account of the many sheets incorrectly ascribed to Sansovino. Together, text and images provide the most comprehensive account of Jacopo Sansovino's sculpture published to date.

I. Sansovino and the Florentine Tradition

FEW ITALIAN RENAISSANCE artists enjoyed as productive a career as Jacopo Sansovino, and few played such a crucial role in Central Italian and Venetian art of the sixteenth century. Born in Florence in 1486, Sansovino was eleven years Michelangelo's junior and of the same generation as Raphael, Sebastiano del Piombo, and Andrea del Sarto. He received his training from a master deeply rooted in the Quattrocento traditions of Ghiberti and Donatello; yet he was also the first sculptor of his generation to appreciate the innovations of Michelangelo, helping to give them wider currency in his own works. Following his successes in Florence and subsequently in Rome, Sansovino transplanted himself to Venice in 1527 and began there a second career as sculptor and architect until his death in 1570. He arrived in Venice during an artistic interregnum and effectively transformed Venetian sculpture and architecture by synthesizing complementary elements from his Central Italian background with others drawn from Venice itself.

That is the broad outline of Sansovino's life, but there is something paradoxical about his career as a sculptor: while his Central Italian period witnessed some of his greatest individual masterpieces, it was Sansovino's Venetian years, years in which he employed a large number of collaborators, that proved the more influential. Compounding the paradox is the fact that there also occurred a definite stylistic break between the earlier and later careers. Indeed, so pointed is the difference between the Central Italian and Venetian Sansovinos that it would be virtually impossible to reconstruct either half of his career from the evidence of the other. Nor was it, for that matter, a break which can simply be attributable to a shift from individual works to collaborative effort. What makes Sansovino such a fascinating and, at times, elusive artist is his deliberate manipulation of various styles, for like many of his contemporaries Sansovino employed style as a sign of artistic allegiance and with an acute awareness of the context in which he worked. To understand the pattern of his career, it is necessary to consider the ambience from which he emerged and in which he created his first works.

Jacopo de' Tatti, later called Sansovino, was born in Florence on or about 2 July 1486, the son of a mattress-maker named Antonio and his wife Francesca.[1] He was the eldest of five children in a family of modest means, originally from Poggibonsi though possibly of Lucchese stock, as Vasari records.[2] Antonio's father, Jacopo di Giovanni, had been a cabinet-maker, and in the fluid world of the Florentine guilds, both Jacopo and Antonio de' Tatti would have been involved with architects, carpenters, and stonemasons. Antonio probably worked alongside carpenter-architects like Baccio d'Agnolo when furnishing beds for his clients, and he erected three baldachins in the Florentine cathedral during the period of his son's work on the statue of *St James* (fig. 45).[3] If the young Jacopo did show an early inclination for art, then his family connections with builders and architects may have determined his apprenticeship to the sculptor Andrea Sansovino in the first years of the sixteenth century.

At that time, Florence would have been the natural haven for anyone wishing to become a sculptor. It was a city with a tradition of statuary and relief sculpture extending back to the late Middle Ages.[4] Proximity to Carrara and the Apuan Alps both stimulated and satisfied a demand for marble, but Florence was also girded by its own quarries: *macigno*, a grayish-brown sandstone from the Oltr'arno, and *pietra serena* from Settignano. Michelangelo jokingly said that he absorbed his love of sculpture from his wet-nurse, the wife of a mason at Settignano, and certainly Settignano and Fiesole were areas that produced generations of sculptors, from the Rossellino brothers and Desiderio to the Maiano and Ferrucci families.[5] In addition, generations of Florentines like the Sangallo and del Tasso oscillated between the worlds of artists and artisans in a manner parallel to the de' Tatti.

Next to nothing is known of Jacopo de' Tatti's first years, though Vasari sets the scene with a vignette. According to his biography, the child Jacopo showed a precocious interest in art and was encouraged in this by his mother. She felt inspired by the early career of Michelangelo and by the coincidence of the elder sculptor's having been born on the same street as Jacopo.[6] This 'coincidence' is a typical example of Vasarian embroidery, but it must contain an approximation of the truth in that Jacopo's talents did lead to an apprenticeship unconnected with his father's business. His mother Francesca may have been instrumental in drawing out her son's gifts, and in this context it is not surprising that Jacopo's only son would be named Francesco.[7]

Incontrovertible, however, is Jacopo's apprenticeship under Andrea Sansovino, the single most important fact of his early life. Vasari places the apprenticeship about the time of Andrea's contract for the *Baptism of Christ* (fig. 1); that would mean April 1502, but the date is only an approximate one. As Andrea is documented in Florence from 1501, Jacopo could have entered his master's studio that same year when he turned fifteen.[8] It was a propitious moment for them both.

Andrea di Niccolò de Menco de' Mucci was born around 1470 in the town of Monte San Savino, near Arezzo.[9] Vasari says he studied under Pollaiuolo, but he also worked briefly under Giuliano de Sangallo in carving two capitals for the sacristy of Santo Spirito in Florence. Andrea's earliest works had been in terracotta, though he acquired a virtuoso grasp of marble carving, possibly in the Ferrucci workshop, as Pope-Hennessy has suggested. He first proved his considerable ability in this field with the Corbinelli altar in Santo Spirito, executed around 1490 (figs. 2–4). His first mature work, the altar reveals an allegiance to the traditional values of Florentine sculpture, with reminiscences of Orcagna interspersed with others from Desiderio and Donatello. Its roundels of the Annunciation show an extraordinary facility, 'more the work of a brush than a chisel,' as Vasari observed, but Andrea's gifts were not simply technical. The two statuettes of Sts Matthew and James have a weight and character that belie their small scale; they also show an understanding of classical *contrapposto* not demonstrated by any Florentine sculptor since Donatello's time. With this work, Andrea proved his worth, and it is not surprising that he was a contender for the marble block which became the *David* or that he should have been chosen to carve the statues of Christ and the Baptist for the east door of the Baptistry.

The *Baptism of Christ* reveals something of Andrea's strengths and weaknesses on a larger scale while indicating what Jacopo could have learned from him. Above all, this group displays a well-calculated exploitation of its medium in the elegant sweep of the Baptist's right arm and hanging folds of drapery.[10] The extended right arm was a piece of technical daring that may have come to Jacopo's mind when he carved his *Bacchus* (fig. 35). The serenity of Christ suggests an awareness of Leonardo's study of the *affetti* and invites comparison with Michelangelo's slightly earlier *Pietà* in St Peter's. Andrea's success in conveying the more delicate shades of emotions here anticipates Jacopo's much praised gifts in this field. As a whole, Andrea's composition betrays an indebtedness to Verrocchio's painting of the Baptism, now in the Uffizi.[11] This is not surprising, given the interest shown in

Verrocchio's work by contemporaries like Michelangelo, but Andrea's group also demonstrates a study of Ghiberti, particularly evident in the profile of the Baptist and in the residual Gothic curve of his body.[12]

These elements are even more pronounced in another pair of statues Jacopo would have had ample opportunity to study, the *Virgin* and *St John the Baptist* in Genoa Cathedral. Despatched in 1504, the figures stand on the threshold of the High Renaissance, though making only superficial concessions to the new style.[13] The novel element comes in the strikingly classical treatment of the Virgin (fig. 5), whose face and hair are obviously based upon an antique Venus or Juno while her pose and wealth of drapery remain within the Gothic idiom of the early fifteenth century. It is, none the less, a work that deeply impressed Andrea's apprentice, for echoes of it would reappear in his later work. By contrast, the *Baptist* could almost be mistaken for a work of the early Quattrocento with its broad, lateral movement and minimal interest in expression; it is a work that could easily have come from the orbit of Ghiberti and points in quite a different direction from the one taken by Andrea with the *Virgin*. Together, these statues highlight a duality in Andrea Sansovino's art, stemming from an incomplete assimilation of Quattrocentesque and more modern elements in his vocabulary. These elements will also appear in the sculpture of Jacopo Sansovino, though much more fully integrated than in the work of his master.

In 1505 Andrea was called to Rome for the tomb of Cardinal Ascanio Sforza and subsequently for that of Cardinal Girolamo Basso della Rovere, a nephew of Pope Julius II.[14] Andrea's removal to Rome marked the end of his Florentine career as well as the end of the first phase of Jacopo's training as a sculptor. What did he learn in those early years?

The turn of the sixteenth century had been as momentous in Florence as the first decades of the fifteenth. The Medici had been driven out of the city in 1494, and a new republic instituted. A generation of artists, including Verrocchio, Pollaiuolo, Bertoldo, and Filippino Lippi, died in the last years of the old century or in the first of the new, while the constellation of talent gathering in Florence strove to emulate or surpass the achievements of Donatello and Masaccio a century before. The corporate patronage of the city and its government embarked upon an ambitious series of commissions which drew artists of the calibre of Leonardo, Michelangelo, and Andrea Sansovino into competition. After his return to Florence from Milan in 1500, Leonardo began recasting the theme of the Virgin and Child in more monumental and naturalistic forms. This was the subject of a now lost cartoon, exhibited at Santissima Annunziata in 1501 and returned to in subsequent studies (fig. 6).[15] It marked a decisive break with earlier Renaissance art.

Vasari records that Leonardo's cartoon had a profound impact upon artists and the general public alike, and clearly his synthesis of substantial figures, geometrical formulae, and a strong emotional core gave a lead to artists as diverse as Michelangelo, Raphael, and the two Sansovinos (figs. 68, 72). At the same time, Michelangelo's career entered a new phase with the execution of the *David* between 1501 and 1504. Then in 1502 Andrea Sansovino received two notable commissions: the *Baptism of Christ* for the Baptistry and a statue of the Saviour for the hall of the Great Council of Florence.[16] The following year saw Leonardo accept the task of painting in fresco for the same hall the commemoration of a Florentine victory over Milan, the *Battle of Anghiari*, and Michelangelo began work on a companion piece, the *Battle of Cascina* (fig. 7), in 1504. Though none of these works for the Great Council was ever finished, the cartoons and drawings by Leonardo and Michelangelo again had a strong effect upon younger artists like Jacopo, Sarto, and Bandinelli, serving as their figural 'school'.[17]

Jacopo's apprenticeship to Andrea Sansovino meant that he could observe the unfolding of the High Renaissance from a central vantage point. Through Andrea, he may have had the opportunity to observe Leonardo and Michelangelo at work; certainly his handling of chalk in an early drawing like the sketch of the *Laocoon* (fig. 26) suggests long practice with this medium favoured by Michelangelo. More fundamentally, his training under Andrea would

have equipped him with the comprehensive knowledge of sculptural practice that stood him in good stead when he set up his own shop.[18] Like all apprentices, Jacopo would have begun with the humblest of jobs, from sweeping up the marble chips in the studio to mixing clay and stucco for Andrea's models. He would have received some instruction in drawing and probably a great deal in modelling, but the principal lessons Andrea could have taught him were in the art of carving marble. Andrea's understanding of stone was second only to Michelangelo's and his mastery of drapery, unrivalled. The benefit of observing Andrea at work also paid dividends to Jacopo when faced with the cascading drapery of his first *St James* (fig. 46) or the virtuoso pose of the *Bacchus* (fig. 35).

Beyond his personal tuition from Andrea, the young Jacopo would have looked at earlier Florentine sculpture through his master's eyes, studying and perhaps copying those works that had most influenced him. This would have meant primarily the great series of over-life-sized statues for the cathedral and the shrine of Or San Michele; they served as a textbook of Renaissance art in which the names of Ghiberti and Donatello stood out. At Or San Michele, the statues stood in niches a little above eye level and were an ideal learning tool for any young artist. Here Jacopo learned basic lessons in *contrapposto* from Donatello's *St Mark* (fig. 51) and Ghiberti's *St Matthew*, while Donatello's *St George* would become his beau ideal of a martial figure (fig. 211).[19] But he was also taken with less 'progressive' statues, such as Ghiberti's *St Stephen* (fig. 344), which may have appealed through its peculiar combination of Gothic and Renaissance elements. It, too, would reappear in Jacopo's later works.[20] For narrative, Ghiberti's reliefs on the Baptistry doors offered an incomparable thesaurus, and Jacopo studied them as did most of his contemporaries, drawing on them extensively in his relief sculpture.[21]

Andrea Sansovino may also have directed his apprentice's attention to one other sculptor, Lucca della Robbia. This is not as surprising as it might first seem because the work of the della Robbia family had an obvious importance for Andrea's early career when he worked predominantly in terracotta. Indeed, Vasari records that one of Andrea's earliest works, the altar of the Virgin and saints now in Santa Chiara, Monte San Savino, was glazed by the della Robbias.[22] The simple, direct quality of this early work reads like a provincial essay in the della Robbia style, and Jacopo absorbed such lessons in his own work. In particular, his conception of the Virgin and Child, both in relief and in the round, would have been inconceivable without the example of Lucca and of Donatello.[23]

Some of Jacopo's earliest work may even survive in the medium of terracotta. This medium had been favoured by Florentine artists throughout the fifteenth century and found a notable development through the work of Verrocchio and Leonardo.[24] While there is no clear concensus on autograph works by Leonardo, there are a number of small terracotta figures from the turn of the sixteenth century that reflect his preoccupation with capturing movement and distilling the emotions. Variously given to the Master of the David and St John Statuettes and the Master of the Unruly Children (fig. 8), they mark a change in Florentine sculpture towards a more intense and vivid characterization.[25] Collectively, they form a bridge between later Quattrocento and early Cinquecento sculpture in Florence, employing motifs that recall the world of Verrocchio while widening the sculptural vocabulary to include pensive saints and active children. This is very much the world in which the young Jacopo Sansovino emerged, and it is worthwhile focusing upon two of these terracottas as examples of early sixteenth-century sculpture that have greater claims than any others to being associated with Jacopo himself.

One of the most popular models in the group under review is of the youthful Baptist, seated on a rock in the wilderness. It exists in numerous versions, some in glazed terracotta, but the finest example is in the Bargello (fig. 11). The Baptist appears like a latter-day Daphnis with a radiant expression on his upturned face, while his body is draped in an elaborately

hanging tunic of camel's hair. It is a work of great sophistication, which Venturi attributed to Gianfrancesco Rustici because of its Leonardesque quality.[26] Certainly the figure transcends earlier sculptural presentations of the Baptist by conveying such a strong sense of inspiration, but its anticipation of the style of Jacopo Sansovino suggests a closer connection with this artist than with the more enigmatic Rustici. The association of the Bargello figure with Sansovino was made by Bode at the beginning of the century and recently reintroduced into discussion by Gentilini.[27] Indeed, the connections are so striking as to establish an attribution beyond doubt.

The most conspicuous comparison between the *Baptist* and an autograph sculpture by Sansovino is with the *Bacchus* of 1511–12 (figs. 35–38). In both, the focal point is the figure's radiant expression, with raised eyes and parted lips; in both, the broad, squarish face is framed by a cap of richly modelled curls and set off by a columnar neck. These similarities are reinforced by details such as the lightly incised eyes or the glimpse of teeth beneath the upper lip. Both figures demonstrate a tendency to define the extremities of their composition by the placement of their legs; their fingers are conceived as long and tubular. The *Bacchus* is, furthermore, not the only work by Sansovino with which the youthful *Baptist* invites comparison. Its relationship with one of Jacopo's most celebrated Venetian pieces, the *Baptist* in the Frari (figs. 93–95), is also arresting. Here it is more a question of basic compositional similarities and the lingering mannerism of the upturned face and parted lips. Then, too, there is the repetition of the motif of the camel's hair hanging about the figure's waist, an idiosyncratic touch. Despite the differences of media and of three decades between the two sculptures, there is a communality of approach that argues for a common author. This, together with the resemblances to the *Bacchus*, establishes a strong case for placing the terracotta *Baptist* among the earliest of Jacopo's works.

The second terracotta, now in the Musée Jacquemart-André in Paris, has a less strong claim to being an autograph Sansovino (figs. 9–10).[28] It is a copy of the famous bronze *Spinario* from the Capitoline Museum in Rome and has been variously given to the Master of the San Giovannino and to another Tuscan sculptor, Baccio da Montelupo. While it is of the same current as works generally ascribed to the Master of the David and St John Statuettes, it is of a better hand and closer in quality to the Bargello *St John the Baptist*. It is also unlike any known works by Baccio da Montelupo. Among the known copies of the *Spinario*, the one in question is distinguished by the pronounced elongation of the torso and accentuated gracefulness of its pose. The figure has suffered greatly through repairs and a brutal stripping of its surface; yet it possesses an expressive quality about the face that is uncommon among early sixteenth-century terracottas but is strikingly close to the ethereal expression of Jacopo's *Bacchus*. It represents the kind of creative re-creation of an antique work of art that Jacopo must have made during his early years as a means of understanding and mastering them. In the absence of comparable works of this kind, one cannot insist too much upon Jacopo's authorship of the figure, but, working backwards from the *Bacchus*, one can see in the Jacquemart-André *Spinario* what an early sculpture by Jacopo Sansovino would have looked like. Together with the Bargello *Baptist*, it demonstrates the twin aspects of Jacopo's early tuition, the Florentine tradition and classical art.

The *Spinario* could have been modelled in Florence, after a copy, or in Rome, after the original. Vasari reports that Giuliano da Sangallo invited Jacopo to Rome shortly after Andrea Sansovino's departure for the papal court.[29] This could have occurred in 1506 or possibly the following year when Sangallo passed through Florence. The short interval between Andrea's and Jacopo's removal to Rome may not have been coincidental, given Sangallo's role at the court of Julius II. As an ambitious young man, Jacopo would have been attracted by the opportunity of lodging in Rome with the distinguished architect and antiquarian and of resuming his studies under Andrea. Given Michelangelo's and Leonardo's departures,

Florence would have seemed a less inspiring place as the centre of artistic attention shifted to Rome. There Jacopo would have been able to widen his knowledge of classical art and possibly to work in the choir of Santa Maria del Popolo.

Designed by Bramante, the choir of Santa Maria del Popolo had become a focal point of papal patronage.[30] It was planned and executed between 1505 and 1509 and contained a vault frescoed by Pinturicchio, stained glass by Guillaume de Marcillat, and lateral monuments by Andrea Sansovino (fig. 13). For a sculptor, the tombs were the only significant project under way in Rome, and it would be surprising if Jacopo had nothing to do with them, especially since Vasari tells us that Bramante and Pinturicchio were well disposed towards the young sculptor.[31] Circumstantial evidence and the speed with which the tombs were finished make the participation of Jacopo highly plausible, and this is borne out by the strong resemblance between later works by Jacopo, such as the *Bacchus* or the Virgin of the Martelli altar in Sant'Agostino, and the more classical figures on the Sforza and della Rovere tombs.

Probably Jacopo began his professional career in Rome by carving decorative elements on the two monuments, perhaps graduating to work on the statues of the virtues. When viewed together, the tombs reflect several hands of varying talent. One figure, however, distinguishes itself from the rest, the *Temperance* on the della Rovere monument (fig. 14). It is the work of an artist thoroughly saturated in the study of the antique and conversant with the nude in a manner quite unlike that of any other sculpture on either tomb or any known by Andrea Sansovino. The *Temperance* is also the only sculpture of its decade that anticipates the easy familiarity with classical statuary so characteristic of Jacopo's *Bacchus*, and it is tempting to see it as one of Jacopo's early efforts under the direction of his master. The authority and ease of movement of *Temperance* places it in a class by itself, but there are other elements on the tombs that foreshadow Jacopo's later work. For example, the crisp, elaborately carved drapery of *Justice* on the Sforza monument (fig. 16) calls to mind the impressive folds of Jacopo's *St James* in Florence (fig. 45) and again points to the kind of training that prepared Jacopo for his later work. The expressive figure of *Hope* on the same tomb (fig. 15) displays that strong sense of characterization and sweetness of demeanour found in so many of Jacopo's major works. In its attempt to reconcile classical and Quattrocento elements, *Hope* typifies the work of Andrea and Jacopo Sansovino.[32]

Jacopo would not have spent all his time with his master, as there was much for a young artist to study in Rome. Chiefly, this meant a prolonged exposure to the antique, but of the drawings and models that Jacopo must have made, virtually nothing survives. The only architectural drawing that can be confidently ascribed to him is a handsome study of a Corinthian capital in the church of San Lorenzo fuori le Mura (fig. 405).[33] Though it does confirm Vasari's remarks about Jacopo's study of the antique, the sheet reveals little of his artistic gifts, other than displaying a high degree of competence. It is probably the only such sheet by Jacopo extant and it represents a form of artistic stock-in-trade which the sculptor took back to Florence and ultimately to Venice, where it disappeared.[34] It seems fair to speculate, however, that Jacopo was neither as compulsive nor as prolific a draughtsman as his contemporary Peruzzi, and his architectural drawings may have been more along the methodical lines of his sometime associate Antonio Sangallo the Younger.[35]

Such information as Jacopo gained would have been hard won. Many classical buildings were virtually inaccessible through their state of excavation, and artists had to wait for sporadic digs and restoration campaigns to study them at first hand.[36] However Jacopo mastered Roman architecture, his familiarity with its forms is manifest in his own buildings. The same can be said of his knowledge of classical sculpture. Vasari records that Jacopo studied the papal collection in the Belvedere courtyard, and he probably frequented the great private galleries as well.[37] Judging from his own sculpture, one can see that Jacopo's taste in the antique ran along conventional lines. The *Apollo Belvedere* (fig. 17), that most extravagantly admired of classical statues, was his 'oracle', as Bernini would have said, and it remained in

I. *Descent from the Cross*, Victoria and Albert Museum, London (cat. no. 5)

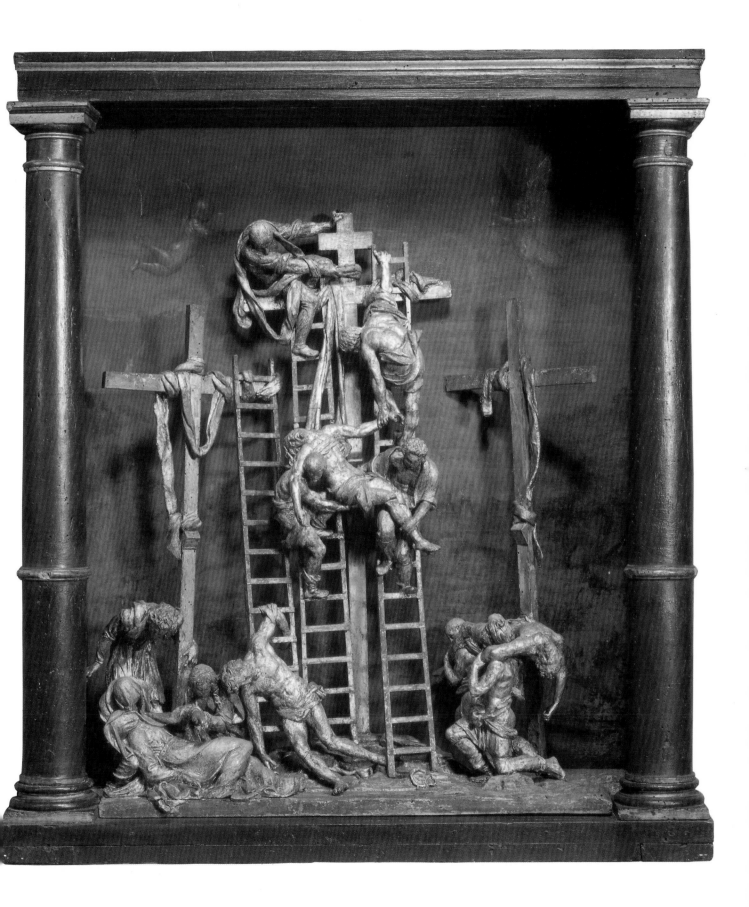

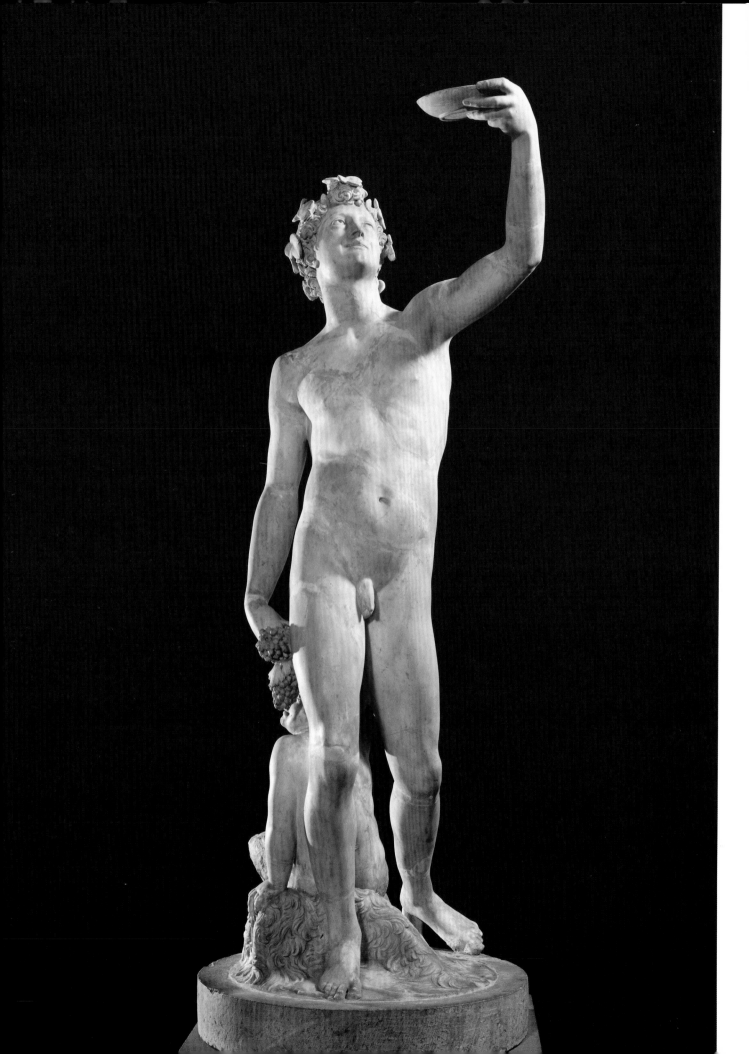

various guises a touchstone for his youthful male figures.[38] That he knew the *Spinario* seems beyond doubt, and the seated *Daphnis*, then in the Della Valle collection, may lie behind his *St John the Baptist* in the Frari (fig. 94).[39] The *Juno Cesi* (fig. 18) taught him a distinctive pattern of drapery which he employed in his female figures, and the *Juno Ludovisi* or something like it informed his conception of a classical female face.[40] Copying was, of course, one way of mastering the technique of ancient sculptors, and it is not surprising that two of Jacopo's earliest surviving statues, the *Bacchus* (fig. 35) and the Martelli *Virgin and Child* (fig. 68), closely followed classical prototypes.[41] Jacopo must have acquired a large collection of copies after the antique and used them for reference later in his career before bequeathing them to his disciple Danese Cattaneo.[42] Thus he turned to an episode from Trajan's Column (fig. 137) to provide a note of authenticity for costume and staging in his scene of St Mark's martyrdom in Alexandria (fig. 138) and may have had recourse to a cameo for the face of his *Hercules* for Ercole d'Este (fig. 301).[43] Although never an antiquarian, Jacopo did acquire enough knowledge of ancient sculpture to be consulted by Isabella d'Este on the purchase of some bronzes.[44]

There is one classical sculpture with which Jacopo's name is strongly linked, the *Laocoon* (fig. 21). It was in connection with the recently unearthed group that Jacopo first distinguished himself at the papal court. Vasari writes that Bramante admired the young man's drawings of the sculpture in the Belvedere and a clay model of a recumbent nude. He encouraged Jacopo to make a wax model of the *Laocoon*, and this formed the background to a contest, judged by Raphael, in which Jacopo competed against Domenico Aimo il Varignana, Zaccheria Zacchi, and the Spaniard Alonso Berruguete.[45] The whole affair may have been engineered by Bramante to advance the career of Jacopo, and his victory signalled his emergence as a master of classical forms. Though the competition has been generally assigned to 1510, Shearman has demonstrated that the latter half of 1507 or the first months of 1508 may be a more plausible date because that would have been the only time in which all the participants could have been in Rome together.[46] Vasari further states that a bronze version was cast at the request of Cardinal Domenico Grimani, who later bequeathed it and his collection of antique sculpture to the Venetian Republic.[47] The connection with Cardinal Grimani seems to have been the initial link between Jacopo and Venice, one which may have had a bearing upon his settling in that city after the Sack of Rome.

Neither the wax nor the bronze copy made for Cardinal Grimani survives, but some facts about the latter can be ascertained. According to an inventory of the cardinal's estate, the bronze group was cast in three pieces and stood approximately 29 cm high.[48] The Grimani cast may well have resembled a version by Jacopo recorded in the possession of Cosimo I de' Medici in 1553.[49] It was half a *braccio* (29 cm) high and thus on the same scale as the Grimani bronze. There are three versions of this subject in the Bargello today, and one of them (fig. 21) is probably Jacopo's, as Fabriczy noted long ago.[50] It is 27.2 cm high and shows the group without Laocoon's right arm and before the restorations by Montorsoli. The figure of Laocoon himself is robust and impressively modelled, though the sons are more summarily sketched in. The face of Laocoon stands out for the concentrated pathos the sculptor has captured in its expression, and this is just the kind of detail one would expect from the young Jacopo. The weight of evidence points to Jacopo de' Tatti as the probable author of the Bargello group in question; it can be seen as indicative of a type of early work which helped him to establish a reputation as a sculptor of promise.

The handling of the bronze Laocoon finds a parallel in the one figural drawing that can be assigned to Jacopo with a degree of certainty. It is a handsome red and black chalk study in the Uffizi of Laocoon from the recently discovered antique group, but with the figure's right arm conjecturally restored (fig. 26).[51] Although it bears the later inscription 'Sansovino', Middeldorf was the first to take the attribution seriously, and he placed the study in the ambit of Andrea del Sarto and of Raphael in his *Disputà* period. Undoubtedly, of all the figural

II. *Bacchus*, Museo Nazionale del Bargello, Florence (cat. no. 6)

drawings at one time or another ascribed to Jacopo, this remains the only one with strong claims for acceptance or against which any further attributions must be based. Middeldorf's comparison of it with Sarto was acute, though his allusion to Raphael was less precise. The drawing can be placed in the early years of the sixteenth century and invites comparison with chalk studies by Sarto and Michelangelo. The handling of the chalk to establish contours and hatching is very close to Sarto's early chalk studies for the San Filippo Benizzi frescoes, and the head of Laocoon shows that idiosyncratic blurring of the eyes which is a hallmark of Florentine drawings of the early sixteenth century. The comparison with Sarto's drawings for the San Filippo cycle is all the more arresting, as the painter's drawings date from 1509 while Jacopo's would have been a year or so earlier, at the time of the competition.[52] Both artists were probably friends before Jacopo's departure for Rome and they may have sketched together Michelangelo's *Battle of Cascina* cartoon. Certainly, one can detect the clear influence of Michelangelo in the study of Laocoon; the broad, parallel hatching and highlighting in Jacopo's sketch appear to have their source in Michelangelo's black chalk studies of the *Cascina* period (fig. 24).[53] These similarities lend credence to Vasari's statement that the young sculptor studied Michelangelo's drawings from an early age.

There are two other sheets of drawings which reproduce the mannerisms of the Uffizi study and are probably by the same hand. Both are in the Louvre; one contains a single study, the other three sketches after a male nude (figs. 19–20, 25).[54] The single study, a sketch of Laocoon's younger son, is a companion to the Uffizi sheet. It, too, is in chalk and shows the boy unobscured by his father's projecting knee or by the lower coil of the serpent which binds them. As in the Uffizi drawing, the figure has been given a conjectural restoration, with the right arm bending back towards the head, and in both sheets the figure has been defined by an assured sequence of parallel strokes. This is complemented by a similar use of broken, curving lines to establish contours and by the broad characterization of the face with its blurred indication of the eyes. The study of the younger son of Laocoon approximates the style of the Uffizi drawing so closely as to exclude the suggestion that it is by a different hand. The second sheet, containing three studies after a male nude, invites the same comparisons. Filed among the Fra Bartolommeo drawings, it was first given to Sansovino by Garrard, following indications by Middeldorf. The studies are not in Fra Bartolommeo's hand but are very close in style to the Uffizi drawing just considered: they have the same hook-like outlines, similar parallel hatching on the arms and legs, and the same idiosyncratic rendering of the chest and pectoral muscles. The figure on the left of the recto has been patterned after the fictive statue of Apollo in Raphael's *School of Athens* (fig. 212), which tells us something about this kind of idealized, heroic nude that Jacopo must have drawn in his first Roman period and which reappears in his statuary of the next decade.[55]

In addition to these ephemeral studies, one substantial work does survive from Jacopo's early years. This is the ambitious *Descent from the Cross* now in the Victoria and Albert Museum in London, a work that marks Jacopo's artistic maturity and his painstaking study of the antique (col. pl. I, figs. 27–29).[56] It is one of the best documented of Renaissance *modelli* and conveys vividly the *movenza* and *fierezza* that Vasari praised in Jacopo's models. The circumstances of its creation are noteworthy in that it was not made by the sculptor for himself but rather for the painter Perugino. According to Vasari, Bramante had found lodgings for Jacopo in the palace built by Cardinal Domenico della Rovere where Perugino was then staying. This was in 1508, at the time of Perugino's frescoes for the ceiling of the Stanza dell'Incendio, and he was so impressed by Jacopo's models that he requested some for use in his own works.[57] Perugino's commission may have been prompted by criticisms of his repetitive figural style and by a corresponding wish to widen his repertoire. Perugino himself never made exact use of the model, although there are several Peruginesque frescoes and paintings (fig. 34) after Sansovino's design.[58]

The *Descent from the Cross* is a *rilievo*, conceived as an *aide-mémoire* for a painter rather than as

a work of art in its own right.[59] In fashioning it, Jacopo took cognizance of a painting of the same subject begun by Filippino Lippi in 1503 and completed after his death by Perugino in 1507 (fig. 32).[60] Commissioned for the high altar of Santissima Annunziata, the painting would have been a major statement of its theme, and, given the participation of Perugino, it is not surprising that Jacopo drew upon it, especially in the grouping of figures about the dead Christ. But Jacopo also went back to an image probably behind the Lippi–Perugino altarpiece, an engraving of the same subject by a follower of Mantegna (fig. 33).[61] This was an influential rendering of the Descent in the late fifteenth century, with its lattice-work effect of the ladders and the emphasis given the swooning figure of the Virgin; it was also one of the most sculptural treatments of the subject, one which would have recommended itself to an artist like Jacopo de' Tatti. Jacopo followed the print in his presentation of the group around the supine Mary, and, like it, his version prunes away extraneous figures to focus upon the drama of the scene. Where he differs from the earlier works is in the introduction of a third, independent motif of the removal of the dead thief's body and in the prominence given to the powerfully muscular bodies of the three dead men. Jacopo amplifies the scene with this tertiary motif but without losing overall clarity. At the same time, he advertises his skill as a sculptor through the three nude figures, which, as Middeldorf noted, would have been unthinkable without the study of the antique.[62]

The medium of the composition is wax, and it is modelled with extreme subtlety so that the musculature is heightened and the figures move credibly. The figures also possess a monumental quality reminiscent of classical sculpture, particularly the Christ. His bound body recalls that of Laocoon in pathos and general disposition, while the angle of the head and right arm suggest the famous relief in which the body of Meleager is being carried, a work which Jacopo undoubtedly studied in Rome.[63]

The *Descent from the Cross* strikes a wonderful balance between the dramatic urgency inherent in its theme and the more academic preoccupations common to its subject. Like Raphael in his Borghese *Entombment*, Jacopo strove to convey the effect of a dead body being carried, one of the most difficult things to represent, as Alberti observed.[64] Where some artists might have reduced this to a formula, Jacopo employed the concept of dead weight in a highly original manner. The careful lowering of Christ's body is echoed in the groups supporting the Virgin and carrying the unrepentant thief, and the pose of Christ's body is repeated by the swooning Virgin and repentant thief (figs. 28–30). The effort is accentuated by those struggling to remove the unrepentant thief and by those supporting Christ; yet none of these elements calls overt attention to itself or compromises the principal subject. Instead, the *Descent* reveals an artist, not only full of ideas, but also capable of marshalling them to great effect.

Jacopo quit Rome for Florence around 1510. The cause may have been illness, as Vasari hints, or a calculated decision on the sculptor's part.[65] The tombs in Santa Maria del Popolo were finished by then, and there may not have been an immediate prospect of work in Rome. Florence, on the other hand, was familiar terrain where his growing reputation and contacts would have augured well for a future career.

The Florence to which Jacopo returned must have seemed retrograde by comparison with Rome; even five years later, when the city put on its best aspect for the entry of Leo X, the papal master of ceremonies dubbed it 'miserrima cïvitas'.[66] The republican government, which seemed so promising a decade before, was now running out of steam and would crumble away in the latter part of 1512. Beyond that, the artistic milieu in which Jacopo found himself was a far cry from the one he had left. The chief protagonists—Leonardo, Michelangelo, Raphael—were all elsewhere. Rome had become the focal point of artistic activity, while in Florence a Quattrocentesque style lingered on in the work of painters like Lorenzo di Credi and Piero di Cosimo and of sculptors like Benedetto da Rovezzano and Andrea Ferrucci. But, if Jacopo took a calculated risk in returning to his native city, he was amply

rewarded for it. He was soon involved in two commissions that produced his first, in some ways his greatest, masterpieces in marble. At the same time, his friend Andrea del Sarto and Fra Bartolommeo were about to experience a transformation in their own work, a transformation in which Jacopo served as a catalyst.

So many works are clustered round Jacopo's return to Florence that it is difficult to separate them into a neat chronological order. Then, too, that diversity of manner which would distinguish his later career is already apparent in the inventive exploration of various styles from this time onwards. One of the first works produced by Jacopo may have been a model for a Virgin and Child for the façade of the Mercato Nuovo. A competition was arranged by Piero Pitti and could have taken place late in 1510 or early the following year, as Vasari sets it immediately before the award of the *St James* for Florence Cathedral, which occurred in June 1511.[67] The other contestants were a mixed lot: Baccio da Montelupo, Zaccheria Zacchi, and Baccio Bandinelli. The first two were older and less talented artists and Bandinelli was slightly younger and definitely gifted. According to Vasari, Jacopo's model was judged best by the painter Lorenzo di Credi and public opinion, but the commission was given to Bandinelli through the machinations of Averardo da Filicaia, who bore Jacopo a grudge. The model by Jacopo disappeared from sight until it was identified by Balogh as a work in the Szépmüvészeti Múzeum, Budapest (figs. 58–59). Balogh noted a resemblance between the work and Andrea del Sarto's fresco of *Charity* in the Chiostro dello Scalzo (fig. 62) and used this to support her connection between the model and Jacopo's lost sculpture. Her thesis was accepted by Shearman, who proposed a dating for it prior to Sarto's fresco of 1513.[68]

Like the *Descent from the Cross*, the Budapest *Virgin and Child* was conceived as a working model. It is carved from a soft, possibly fruit, wood and draped with linen dipped in plaster. The figure is a singular instance of what must have been a common feature of artists' studios, namely, a wooden model made for the study of pose and drapery. Jacopo probably acquired some knowledge of carving in wood from his friend Nanni Unghero, whom he assisted on at least one wooden statue, and he is known to have carved crucifixes.[69] Here, as in the *Descent*, one is aware of the sculptor's dexterity, but the Roman idiom has been scaled down in favour of something more overtly Florentine. The Virgin's pose is reminiscent of one of the most famous of lost Renaissance works, Leonardo's *Leda*, in which the figure's *contrapposto* assumed a serpentine curve by placing the arm across the torso.[70] But Jacopo may also have been influenced in his presentation of the Virgin by one of the most significant new altarpieces he could have seen on his return to Florence. This was the *Annunciation* by Mariotto Albertinelli (fig. 60), sometime collaborator of Fra Bartolommeo.[71] Less inventive than Jacopo's figure, Albertinelli's Virgin stands with her right foot resting on a block and her body turned backwards towards the angelic messenger; Vasari tells us of the effort put into this work by the painter, and it does represent Florentine art on the eve of the new decade. Jacopo's interest in it may have been prompted by a desire to harmonize his own style with prevailing Florentine taste, and his model displays a similar alignment of the right leg and left shoulder, transmuted into a natural and flowing gesture of support for the Child.

The Budapest *Virgin and Child* is the earliest such work by Jacopo and fits comfortably into the series of devotional images that he fashioned in the course of his long career. Her tapering neck and ovoid head reappear in the Martelli *Virgin and Child* (fig. 68), and her features and drapery bear a family resemblance to the *St James* for Florence Cathedral (fig. 46). The connection with Sarto's *Charity* has often been observed (fig. 62), and clearly the more substantial form of Jacopo's figure anticipates Sarto's development across the next few years. The work also foreshadows Jacopo's own use of a modified serpentine curve in many of his later works, from the Florentine *St James* to the Loggetta bronzes and elsewhere.

Despite the setback of this lost commission, Jacopo was soon involved in two important commissions, one for a major private patron and the other for the cathedral. In both instances, he may have been helped by his friendship with one of the most influential members of the

Florentine art world of the day, Baccio d'Agnolo.[72] Jacopo probably knew him through Andrea Sansovino, who frequented Baccio's circle prior to his departure for Rome. In the course of his long career, Baccio had risen from being a simple carpenter to the status of a builder-architect. Already in the 1490s, he had been involved in the renovation of Palazzo Vecchio for the new government and was architect of Florence Cathedral from 1507 to 1515. This last position meant that Baccio had a say in the distribution of commissions such as the statues of the apostles and the decorations for the entry of Leo X in 1515, both projects involving Jacopo. He also worked for private patrons, and it was probably not coincidental that, while he was at work on the Bartolini palace at Gualfonda, Jacopo was carving the famous *Bacchus* for its gardens.

The *Bacchus* established Jacopo's credentials as a master sculptor (col. pl. II, figs. 35–37). It was commissioned by the Florentine nobleman Giovanni Battista Bartolini for the garden of the suburban palace he was constructing at Gualfonda, north-east of the convent of Santa Maria Novella (fig. 42).[73] The statue may have been ordered as early as March 1510 and is recorded as finished by 1512; in 1519 it was placed on a plinth of red and white marble designed by Benedetto da Rovezzano and remained there until the patron's death in 1544 when his brother gave the statue to Cosimo I de' Medici.

The *Bacchus* was, thus, the first significant work by the young Jacopo de' Tatti to go on public display and has always been admired as one of the major achievements of High Renaissance sculpture. Despite its present, insensitive placement in the Bargello, anyone looking at Jacopo's figure can appreciate its grace and *brio*. It requires more effort, however, to understand what the *Bacchus* meant to a contemporary audience; its chief virtues would have lain in its close approximation to classical sculpture and its technical daring beyond the gifts of anyone save Michelangelo and Andrea Sansovino.

Michelangelo had carved a *Bacchus* for Cardinal Riario in Rome more than a decade before (fig. 44).[74] It was his first large-scale nude figure and, as such, was of crucial importance to the development of Florentine sculpture. While Jacopo would undoubtedly have known and studied Michelangelo's *Bacchus*, the direct relationship between the two statues is very tenuous. Jacopo's *Bacchus* is much more diminutive and conceived in different terms. It establishes a serpentine curve that invites the spectator to walk around it, admiring its multiple views.[75] Michelangelo's figure seems, by contrast, introverted, its movement more rooted to the confines of the block, and its effect more of a visual pun on drunkenness. Where Michelangelo's *Bacchus* remains fixed in the world of Quattrocento sculpture with its rigid left flank and Donatellesque *contrapposto*, Jacopo's moves with a freedom hitherto unknown in Renaissance sculpture. This is confirmed by the extraordinary gesture of the extended left arm and by the subtle shifting of weight from left leg to right, features that were praised by contemporaries like Benedetto Varchi and Giorgio Vasari.[76] The sculptor's virtuosity is confirmed by such minor details as the perforation between the fingers of the left hand and the cup it holds or the vine leaves on the god's hair.

Beyond its technical virtuosity, the *Bacchus*'s rivalry of antique sculpture insured its approval by antiquarians and connoisseurs alike. Here Jacopo's years in Rome, studying and perhaps repairing ancient sculpture, paid dividends. Although various statues have been proposed as Jacopo's model, none is entirely convincing. Obviously there were a number of antique sculptures which were at that time believed to be Bacchuses, and Jacopo would have known them. One in particular merits attention since it displays the same concept of raised arm with opposing leg brought forward (fig. 39).[77] Now known in the Uffizi as *Satyr holding up Grapes, with Panther*, the statue was in the Maffei collection in Rome around 1500 and then passed into the della Valle collection before being purchased for the Villa Medici in 1584. In its restored state, the figure contemplates grapes held in its raised, right hand and has its left leg brought forward. The head and neck are Renaissance additions, and the right arm has been restored from fragments, although the earliest drawing of it in the Maffei collection

suggests the raised position of the arm. It belongs to a group of satyrs extant as statues and reliefs in museums across Europe, all corresponding in pose and perhaps derivative from a lost Hellenistic bronze.[78] A figure like the Maffei–della Valle *Satyr* could not have escaped Jacopo's attention and he drew upon it or another version of the type when creating his *Bacchus*.[79]

While classical sculpture clearly guided Jacopo in fashioning his work, one must also acknowledge the non-antique components in his *Bacchus*. He apparently wanted to create something inspired by the antique but not a slavish copy of an ancient statue. In this sense, his work comes close in spirit to Michelangelo's, and it may also explain why his statue's pose is the reverse of the classical *Satyr* just mentioned, with the left arm raised and the right leg forward. Jacopo's joyful figure represents a synthesis of the antique that was probably beyond the capabilities of any other contemporary sculptor, but it was also conditioned by his experience of modern-day art. Like Donatello or Michelangelo, Jacopo was content to use the antique as a point of departure in creating new works. Thus he endowed his *Bacchus* with a more expressive face than is commonly found in antique sculpture, one that is reminiscent of the kind of *dolcezza* found in figures by Andrea del Sarto (fig. 62). Likewise, Jacopo imparted to the figure a more fluid, feline curve which moves through the torso and concludes in the outward-turning hand. Despite severe damage in the Uffizi fire of 1762, the *Bacchus* still possesses the power to entrance through its graceful resolution of a complex pose and its ecstatic expression. These features distinguish Jacopo's work from classical sculpture and place it within the tradition of inspired Renaissance re-creations of antiquity. It is not surprising to learn that the *Bacchus* enjoyed the status of a classical work down to the nineteenth century and was displayed alongside pieces of ancient sculpture.[80] The *Bacchus* became Jacopo's most widely copied piece, in terms of statues, small bronzes, and even paintings. For Bandinelli, Giambologna, and a host of later sculptors, it endured as the touchstone for a Bacchus *all'antica* (fig. 40).[81]

If competition with Michelangelo did not figure in the *Bacchus*, it did play a role in Jacopo's other major work of the period, the *St James the Greater* for Florence Cathedral (col. pl. III, figs. 45–46, 48–49).[82] Though the contract for the statue came in June 1511, the project began some eight years earlier when Michelangelo agreed to carve a series of twelve marble statues of the apostles for the cathedral.[83] The commission was prompted by the success of the *David* but was interrupted by the *Battle of Cascina* which was in turn abandoned in favour of Rome and the tomb of Pope Julius II. By 1506 Michelangelo had begun the *St Matthew* (fig. 52) but left it unfinished when he was summoned to Rome in 1508. In the meantime, the consuls of the Arte della Lana, the Florentine guild entrusted with the maintenance and decoration of the cathedral, concentrated their expenditure on paving the church, and the project for the statues lapsed until 1511.[84] From that year until 1515, a series of new contracts was drawn up with five sculptors; significantly, Jacopo obtained the first of these, predating the second contract by one year. This may have been public recognition of his pre-eminence among the sculptors then in Florence, and it provided a splendid opportunity for Jacopo to prove himself.

The documents are silent on this and other aspects of the commission, but they do allow us to reconstruct some elements in the statue's history.[85] Jacopo's first payment came in December 1511, by which time a model for the figure would have been established. Work proceeded smoothly until August 1512, after which there was a hiatus in Jacopo's payments until May 1513. This interruption can be explained against the background of the political convulsions Florence experienced during the months of August and September 1512 when the republican government gave way and the Medici were reinstated.[86] Jacopo may have stopped work on the statue during this confused period, but the three payments to him in 1513 indicate that a degree of normality had returned to the project. In May 1514 it was decided to move Jacopo's statue from the hospital of Sant'Onofrio to the Opera del Duomo where a new

site was to be prepared for it. Then nothing more is heard of it until April 1515 when Jacopo was given approval to finish it. This decision may have been connected with the intervention of Giuliano de' Medici, who secured the commission of a statue for Baccio Bandinelli in January of that year; as de facto rulers of Florence, the Medici were interested in the resumption of the apostles project, and it is probably not coincidental that Jacopo's second serious phase of work on the *St James* began in 1515.[87] The statue must have been relatively complete by 1516, as Andrea del Sarto incorporated a side view of it in his Puccini *Pietà*.[88] The last working payment came in September 1517, and the statue was valued at 125 florins the following January.

In carving a statue like the *St James*, Jacopo faced a situation unlike that of the *Bacchus*. There the challenge had been to create a credibly antique figure for a garden setting; contemporary sculpture would have been less pertinent than what Jacopo had learned from his years in Rome. Here the task was to carve the image of a saint, something for which the antique was not suited. Jacopo and his contemporaries returned to the early Quattrocento tradition of sculpture on the Or San Michele for their chief source of inspiration. As Burckhardt observed, the Or San Michele became a school for all later sculptors faced with the challenge of large-scale statuary, for it contained a number of celebrated statues in niches close enough to the ground for easy inspection.[89] There is, perhaps, an element of archaism, of the world of Ghiberti, about Jacopo's *St James*. Its basic pose and wealth of drapery call attention to this, but it is part of the brilliance of Jacopo's work that it reflects a mastery not only of this mode, but also of the challenge posed by the example of Michelangelo's unfinished *St Matthew* (fig. 52).

Michelangelo's *St Matthew* marked the beginning of a revolution in the conception of human form, which was further developed in works like the *Slaves* and the *Victory*. As religious sculpture, however, it was highly eccentric. Its extremity of statement proved a negative example for Michelangelo's immediate successors, and none of the apostles now standing in the cathedral's tribune is remotely like it. In his *De re aedificatoria*, Alberti advocated marble statues as the best decoration for a church, stressing that they 'should exude a grace and majesty worthy of divine nature'; other kinds of statuary would be more suitable for theatres and profane buildings.[90] His observation sheds light on the difference between the apostles as a group and Michelangelo's *St Matthew*: Jacopo and his fellow-artists probably drew back from Michelangelo's example because it violated decorum and was too personal a statement for imitation here.

This is not to say that Jacopo ignored the *St Matthew*; rather, he offered a corrective to it. Michelangelo overturned the classic formulation of *contrapposto* by thrusting forward the right shoulder as well as the left leg; he also emphasized the confines of the block, thereby intensifying the figure's potential energy. While Jacopo adopted a similarly serpentine *contrapposto* with the raised left leg and the diagonal recession of the shoulders from right to left, he made this movement less tormented and more natural. By the same token, the saint's expression is dignified but accessible, unlike the withdrawn nature of the *St Matthew*. This blend of strength and sweetness in the *St James* and its 'domestication' of the *figura serpentinata* proved important as a medium through which Michelangelo's innovations were rendered more palatable to the Florentine public.

The novel balancing of Early and High Renaissance qualities in the *St James* can be appreciated more clearly when compared with the statues produced by Jacopo's competitors. Benedetto da Rovezzano's *St John the Evangelist* (fig. 55), Andrea Ferrucci's *St Andrew* (fig. 56), and Baccio Bandinelli's *St Peter* (fig. 57) seem much more firmly embedded in the Quattrocento style, almost as if they were contemporaries of Nanni di Banco and Donatello. This is less surprising for Ferrucci and Rovezzano, who were a generation older than Jacopo and Bandinelli and that much closer to the masters of the early fifteenth century. Moreover, Ferrucci and Rovezzano were essentially decorative sculptors and happiest when working on

a smaller scale. Their statues bespeak a conservatism, not to say timidity, with conventional, lateral movements and basic poses adapted from Nanni's prophets for the cathedral or Donatello's *St Mark* on Or San Michele (fig. 51). In the case of Bandinelli, reference to early fifteenth-century sculpture was probably, as with Jacopo, a conscious choice. Vasari states that Rustici advised the young Bandinelli to study the works of Donatello and probably told Jacopo much the same thing.[91] Bandinelli's *St Peter* bears witness to an early saturation in the sculpture of Donatello and seems to have been stimulated by a desire to explore alternatives to the model of Michelangelo. Together these statues give an index of Florentine sculpture in the second decade of the sixteenth century, reflecting an artistic current far removed from Michelangelo or Roman classicism.

Jacopo carved the *St James* over six years, and the unusual length of time is apparent in the care expended on the marble. Jacopo's dexterity as a sculptor is manifest not in terms of extended limbs or a complex pose, but rather in the extraordinary treatment of the drapery, which recalls his master, Andrea Sansovino (fig. 4). This is the most insistent feature of the statue, calling attention to itself through the great folds gathered under the right arm and before the right foot or fanning out from the left hand (figs. 46, 49). Jacopo's mimicry of fabric attains a degree of subtlety that verges on the miraculous and makes one realize what a loss the abandoned model for the Mercato Nuovo is; the illusion of cloth is complemented by the verisimilitude of the bare arms and the slightly exaggerated pose of the left hand on the gospel.[92] As with the *Bacchus*, the sculptor expended great care and energy on the statue and, more than any of his competitors, reconciled purely technical and artistic considerations. Jacopo may even have put more of himself into the *St James* than was previously thought. Its face (fig. 48) stands out among the blander features of the other apostles and bears a striking resemblance to Tintoretto's portrait of Jacopo in old age (frontispiece, Vol. I).[93] Both share the same ovoid face, high brow, aquiline nose, and—most importantly—the same prominent, heavily lidded eyes. As the statue is dedicated to Jacopo's name saint, it would not be surprising if he conceived the figure in personal terms. With the *St James*, Jacopo proved himself capable of creating figures on a scale larger than life and able to restate the traditional *contrapposto* of early fifteenth-century sculpture in terms recognizably 'modern'. As such, the statue mediated between the innovations of Michelangelo and the more conservative milieu of other Florentine sculptors. When Giovanni Bandini was entrusted with continuing the apostles in the 1570s (fig. 54), it is not surprising that the model he followed was Jacopo's.[94]

Two models and a wooden statue overlapped with the early stages of Sansovino's apostle, and they exhibit a variety of solutions to the problem of figural sculpture. Diverse as a group, they none the less have a common bond in Jacopo's interest in his Quattrocento predecessors. Possibly the closest in date to the *St James* is a terracotta statuette now in the Musée Jacquemart-André in Paris (fig. 63).[95] Weihrauch first recognized it as an autograph work by Jacopo, suggesting it might have been a model for one of the figures on the temporary façade of Florence Cathedral in 1515; Middeldorf later identified the figure as a St Paul and connected it with a pair of wooden statues of Sts Peter and Paul in the abbey church of Passignano, south of Florence (figs. 64–65).[96] Together, the terracotta *St Paul* and its wooden counterparts widen our knowledge of Jacopo's style around 1511. They show him grappling with the Quattrocento tradition of religious statuary and reworking it in light of his own experience. Middeldorf suggested that the *St Paul* predated the marble *St James*, but there is no evidence to support this. The *St Paul* may appear to be more archaic than the *St James*; yet both are sophisticated figures, the terracotta being virtually a mirror image of the marble in terms of *contrapposto*. Like the *St James*, it displays a modified serpentine curve, and the drapery is virtually identical, especially the tubular folds between the legs and the patterns around the right arm and across the chest. The *St Paul* is a forcefully modelled figure, in keeping with the movement and vivacity that Vasari praised in Jacopo's small-scale works. It also presents us

with a rare example of the kind of model at which he excelled and through which he mastered his native tradition.

The wooden statues at Passignano present a more opaque form of evidence about Jacopo's style. A comparison with the terracotta in Paris indicates that they are freer versions of the sculptor's handiwork, diluted by the executant and drenched in thick white paint. They were conceived as a pair for the abbey, but when they were made and to what extent Jacopo collaborated on them is more problematic.[97] They strike complementary poses, with the *St Paul* being closer to the marble *St James*, and the *St Peter* more straightforwardly a tribute to Donatello's *St Mark* (fig. 51). It is plausible that they were planned around 1511–13, during the latter stages of a major building project at the *badia*. Benedetto da Rovezzano had a major part in the work at Passignano; he may have recommended Jacopo for the two statues, although they were executed much later.[98]

This process of learning through copying can be seen in another work which must fall in approximately the same period. The work in question is the wooden figure of *St Nicholas of Tolentino* in the church of Santo Spirito (fig. 346). Vasari explains that Jacopo made a model of the saint and some cherubs for his friend the wood-carver Nanni Unghero, who was also a member of Baccio d'Agnolo's circle.[99] The figures formed part of an altar dedicated to the saint, and the altar was completed by panels of angels and of the Annunciation by the painter Franciabigio. Only the lateral panels of the angels and the statue of the saint remain *in situ*, as the altar suffered a major renovation in the seventeenth century. Vasari placed the *St Nicholas* prior to Jacopo's first Roman period, or around 1506, but this now appears to be unlikely, as Parronchi has shown that the patron, Fra Niccolao di Giovanni di Lapo Bicchielli, obtained rights to the altar in 1513 and died in 1518.[100] Other evidence points in the same direction. For one thing, Vasari dates the participation of Franciabigio (fig. 345) to a decade after the putative date of Jacopo's model; in addition, if Nanni Unghero was born around 1490, then a date of 1506 for the *St Nicholas* would be less likely than one between 1513 and 1518.[101]

This still leaves one to account for the appearance of the *St Nicholas* in comparison with Jacopo's other works in the decade following 1511. Indeed, the relative primitivism of the wooden figure has caused some scholars to exclude it from his *oeuvre*. Here, two factors should be kept in mind: the medium of wood imposed restrictions on Jacopo's normal stylistic range, and the obscure setting of the statue makes a positive appreciation of it difficult. If these factors are recalled, the *St Nicholas* can be seen as an attractive if conservative work by a sculptor with a feeling for early fifteenth-century models. It is very much a copy of Ghiberti's *St Stephen* on Or San Michele, even down to the diagonal sweep of drapery from the right arm to the left foot, with the book being shifted from one hand to the other (fig. 344). This early homage to Ghiberti is all the more remarkable because Jacopo chose one of the more 'Gothic' as opposed to 'Renaissance' works by his famous predecessor.[102] The choice tells us much about what Jacopo admired in Quattrocento sculpture: an elegant, refined, slightly feminine style, one with which much of his later work conforms. The *St Nicholas* is difficult to assess, especially in its cramped setting. Even so, it is not as mediocre a work as photographs imply, but one must project back beyond the pedestrian execution by Nanni Unghero to imagine Jacopo's original model. It must have been a rather suave and elegant figure, closer in spirit to the *St James* and the Ghibertian prototype. Only an examination of it in a modern conservation laboratory will allow us to understand more about its quality and Sansovino's putative role in its execution.

Jacopo showed himself open to a variety of influences during this second Florentine period, and, more than most of his sculptor colleagues, he was sensitive to painting. Mention has already been made of his collaboration with Perugino and of his adaptation of Albertinelli's *Annunciation* for the Budapest *Virgin and Child*. From his return to Florence until 1517, Jacopo shared a studio with his friend the painter Andrea del Sarto. Their studio was located in a group of buildings called the Sapienza situated between the convents of San Marco and

Santissima Annunziata. Originally intended as a student hostel, the Sapienza had been adapted to other purposes, and in the second decade of the sixteenth century it was something of an artist's colony until the arrival of the Medici stables in 1516 made the area distinctly less congenial.[103] Much of the activity there centred on Rustici, whose workshop was a lively place frequented by other artists. Well connected and a bit of a dilettante, Rustici was a founder of two contemporary social clubs, the Compagnia del Paiolo and the Cazzuola, where artists could mix with more aristocratic figures like the Medici or Giovanni Gaddi, who later became a notable patron of Jacopo.[104] There was much give and take among the artists of the Sapienza as well as a breaking down of barriers between disciplines. Solosmeo da Settignano studied with Sarto and Jacopo; Tribolo gravitated to Jacopo from an earlier apprenticeship with Nanni Unghero, and the young Bandinelli alternated between sculpture and painting in those same years.[106] Sarto and Jacopo collaborated on a production of the play *Tantalus* in the Gaddi palace in Piazza Madonna degli Aldobrandini, and the artists of the Sapienza would dominate the decorations for Leo X's entry in 1515.

These years in Florence were especially productive for Jacopo as he threw off any number of designs and minor compositions. Vasari recorded what can only be a portion of them in his biography of Jacopo, but they are worth mentioning for the light they shed both on his activities and on his clientele. Notable among these compositions was a fireplace that Jacopo designed for Bindo Altoviti, a connoisseur and banker who would later appraise Jacopo's *Virgin and Child* for Sant'Agostino in Rome.[106] The fireplace was carved by Benedetto da Rovezzano in *macigno*, the gray-brown sandstone commonly used in Florentine buildings, and some idea of its appearance can be gleaned from a drawing in the Albertina (fig. 365).[107] It was flanked by paired, Doric semi-columns, separated by a niche; across the centre, decorative panels framed a rectangular relief, presumably the scene of Vulcan and other gods that Vasari mentioned as designed by Jacopo. Ball finials terminated the corners of the fireplace, while its central motif included two marble putti supporting the Altoviti arms. This last feature we know from Vasari, though it does not appear in the drawing. The marble figures were subsequently removed by Don Luigi di Toledo, who placed them on a fountain in his garden behind Santissima Annunziata.[108]

Neither these putti nor a similar pair made for the palace of Giovan Francesco Ridolfi in Via Maggio have survived, but they must have been a speciality of Jacopo's because he had previously modelled such figures for his friend Nanni Unghero (fig. 59) and for his pupil Tribolo, the latter having also been set to copy putti by Jacopo for the house of Giovanni Gaddi.[109] They derived from the traditional appeal of vivacious children in Florentine art, and many small models of this kind have generically been ascribed to the Master of the Unruly Children; as Vasari tells us in the conclusion of his biography of Jacopo, such figures constituted one of the sculptor's greatest strengths.[110]

Both Shearman and Garrard have drawn attention to such Sansovinesque models in Sarto's work, and one in particular deserves mention here. It is the fireplace depicted in the fresco of the *Nativity of the Virgin*, completed by the painter in 1514 (fig. 366).[111] In general terms it resembles the Albertina drawing and also shows two ebullient children resting on the mantelpiece and holding Medici and Servite arms in their outstretched hands. The Altoviti fireplace must have looked like this in its original state and may have created a demand for such decorations, because Jacopo and Tribolo were involved in making similar works during this decade. It is also worth noting that Tribolo's experience of such figures in Jacopo's shop obviously coloured his later work as a designer of fountains in which putti play a prominent role.[112]

For Giovanni Bartolini, patron of the *Bacchus*, Jacopo also carved a crucifix, which remained in the family collection after Giovanni's death.[113] Jacopo obviously had familiarity with the medium of wood, as the *modello* in Budapest (fig. 58) and the *St Nicholas of Tolentino* confirm (fig. 346). He later returned to this medium when he carved a second crucifix for the

church of San Marcello in Rome.[114] Despite attempts to recognize it in works now at Budapest and Scarperia (figs. 368–69), the Bartolini crucifix is yet untraced. Attributions of crucifixes are extremely difficult because most Renaissance examples depend upon prototypes reaching back into the early Quattrocento, and, although the one in Budapest is an especially fine example of the genre, there is little in it to commend an ascription to Jacopo Sansovino.[115]

Much the largest collection of minor works by Jacopo was assembled by Giovanni Gaddi. In addition to the *Deposition* now in the Victoria and Albert Museum, he owned a marble Venus on a shell, a boy of tow, and a marble swan, items among those enumerated by Vasari.[116] As Vasari does not comment on their size, they may well have been small-scale works, and it is tempting to imagine the Venus as another experiment in the classicizing vein of the Bartolini *Bacchus*. The *Venus*'s model was also a collector's item, though it was lost when the house of Francesco Montevarchi was flooded in 1558.[117] The most notable feature of the figure of a boy was its medium, *stoppa* or tow. This suggests it would have been a piece of ephemera, possibly made for one of the theatrical productions in which Jacopo and Gaddi were involved, and kept as an example of Jacopo's bravura. With the demands placed upon him by occasions like the entry of Leo X in 1515, Jacopo would have had ample opportunity for mastering any number of temporary media, and this may have been one of them. The marble swan, by contrast, would indicate a different kind of virtuosity, given the distinctive physiognomy of such a bird; it may, too, have been an exercise in copying an antique marble swan of the type now in the Sala degli Animali of the Vatican.[118]

Ironically, much of what is known about Jacopo's sculpture in these years is preserved in copies or reflections in other artists' work. Still, it is enough to document his development prior to his return to Rome. Only recently have copies of two reliefs by Jacopo come to light, and they confirm the closeness of his artistic style to that of his friend Sarto and their circle around 1512–13. The reliefs of the *Presentation* and *Marriage of the Virgin* are in the Gaddi chapel of Santa Maria Novella and were carved in the latter part of the century by Giovanni Bandini (figs. 348–49). Middeldorf saw them as reminiscent of Jacopo's style, and in fact a manuscript guide by a contemporary of Bandini mentions the reliefs as copies of terracottas by Jacopo in the Gaddi family collection.[119] As the chapel was decorated by a nephew of Giovanni Gaddi, the observation must be taken seriously, and the appearance of the two reliefs lends colour to it.

In detail the reliefs are entirely Bandini's, but their compositions and many individual features call to mind Jacopo's first series of reliefs for San Marco (figs. 130, 133) and the large terracotta panel in Berlin (fig. 128).[120] Above all, they illustrate that interest in perspective which distinguishes the San Marco reliefs as well as that concern for the complementary pairing of men and women, young and old, so conspicuously employed by Jacopo in his marble relief of the *Miracle of the Maiden Carilla* (fig. 260).[121] The types of most of the protagonists, especially in the *Marriage of the Virgin*, find parallels in Jacopo's Venetian reliefs. On aggregate, the visual evidence does point to Jacopo as the creator of the Gaddi chapel reliefs.

The connections between the reliefs and contemporary Florentine painting are best seen in the *Presentation of the Virgin*. It is cast in the mould of Andrea del Sarto's recently completed San Filippo Benizzi frescoes in the atrium of Santissima Annunziata or the San Gallo *Annunciation* of 1512 (fig. 61).[122] They share a common interest in varied groups set against imposing architectural backdrops reminiscent of Ghiberti and Donatello; the sculptural forms of the main figures in the San Gallo *Annunciation* suggest the early impact of Jacopo's work, particularly the monumental *Virgin and Child* in Budapest (fig. 58), on Sarto. If anything, there is even greater similarity between Jacopo's *Presentation* and the ambitious fresco of the *Marriage of the Virgin* which Franciabigio painted for the atrium of Santissima Annunziata in 1513–14 (fig. 347).[123] In this work, Franciabigio strove to combine elements of the new

Roman style with his native Florentine and exploited the same contrasts between a frieze of monumental figures in the foreground and smaller ones scattered behind. He used many of the same tricks as Jacopo, for example, the device of semi-nude figures in the front plane or others entering the scene, climbing the steps, and being framed by the distant architecture. It would be difficult to establish the precedent among these works, but it is true to say that Jacopo would have found little in the way of recent relief sculpture for guidance along these lines; consequently, he would have studied the same models as did Sarto and Franciabigio and may here have been following their lead. Certainly, a date around 1513 for the originals of the Gaddi chapel reliefs would not be inconsistent with their style.

Vasari characterized the rapport between Sarto and Jacopo as one of close artistic affinity, and their surviving works endorse his observation. A fecundity of invention and prolonged exposure to Roman art made Jacopo an invaluable ally to Sarto, just as their artistic collaboration was the catalyst that brought out the best in both men during the years to 1517. Jacopo made models for his friend and would have learned much from Sarto's prowess as a draughtsman. The symbiotic nature of their relationship was distinctive in Florence, though resembling, in some respects, the more unequal partnership between Michelangelo and Sebastiano del Piombo in Rome.[124] Through their work together, Jacopo and Sarto were able to accommodate the power of the new Roman style then emerging without, however, sacrificing their ties to an earlier Florentine mode.

This development is best seen in Sarto's paintings. The impact of Jacopo's *Virgin and Child* in Budapest has been mentioned in terms of Sarto's San Gallo *Annunciation*, a work which marked the beginnings of his *rapprochement* with the language of contemporary Roman art. Though similar to Albertinelli's earlier *Annunciation* (fig. 60), the main protagonists of Sarto's panel are more monumental and more dynamic in pose; they indicate a study on the artist's part of the *St James* as well as the Budapest *modello*. This interest continues in a slightly later altarpiece by Sarto, the *Madonna di Sant'Ambrogio*, which is now known only in copies (fig. 353).[125] Shearman has drawn attention to the Sansovinesque nature of the St John the Baptist, proposing that it may reflect a lost model by the sculptor; beyond that, he has argued that the same model was employed by the Milanese sculptor Ambrogio Buonvicinio for a marble statuette of the Baptist in Santa Maria sopra Minerva (fig. 354). Both observations seem highly plausible, and even in a mediocre copy Sarto's Baptist demonstrates a sculptural poise, his drapery a tangible weight, which hint at the plastic model behind it. The figure in the *Madonna di Sant'Ambrogio* anticipates his more fully developed counterpart in the *Preaching of the Baptist* in the Chiostro dello Scalzo (fig. 355). Here the Baptist is intensely Sansovinesque in drapery and features, even to the arrangement of the locks of hair to either side of the forehead. It is more dynamic than the *St James* in Florence Cathedral but less monumental than the second version of this subject, which Jacopo carved at the end of the decade in Rome. As a work of 1515, the painted Baptist stands midway between the two *St Jameses*, both chronologically and stylistically.

Comparisons like these gain substance from the testimony of Vasari, who identified a figure in Sarto's *Madonna of the Harpies* as based on a lost work by Jacopo.[126] The figure in question is the St John the Evangelist (fig. 357), which was based upon Jacopo's losing submission in a competition for Or San Michele. The competition was organized by the guild of silkweavers and goldsmiths to create a statue of the Evangelist for their niche on Or San Michele, and Baccio da Montelupo's model was preferred to Jacopo's; his statue was installed on 28 October 1515 (fig. 358), the same year as Sarto's painting was ordered.[127] This means that the competition must have occurred around 1512–13, although Jacopo's model *could* have been developed independently of a specific context. A comparison of the saint in Sarto's painting with Baccio's statue makes the result of the competition all the more surprising, but it may indicate the kind of taste then prevalent in Florence. Baccio's statue is little more than a copy in bronze of Benedetto da Rovezzano's figure for the cathedral (fig. 55) and is, like its

prototype, bland and *retardataire*. In contrast, Jacopo's figure departed from such conventional formulas and presents us with his most evolved design prior to the Roman works of the latter part of the decade. The *St John* took a step closer to Michelangelo's *St Matthew* in its more strongly curving, serpentine pose which brings the left arm and right leg into more acute confrontation. The forms, too, are more substantial, the drapery more simplified. The dramatic nature of Michelangelo's invention has been domesticated, so to speak, and the *St John* can be seen as a bridge between the earlier *St James* and the more heroic image of the same saint that Jacopo would carve in Rome (fig. 80). That Jacopo's model blends in so perfectly with Sarto's composition indicates the shared language of both artists around 1515. Even if the avant-garde qualities of the *St John* were not appreciated by contemporary Florence, they were understood by Sarto and other members of Jacopo's circle. The losses of the model and of the statue that would have been made after it are two of the keenest in Sansovino's *oeuvre*, for the model shows the sculptor in a state of equilibrium between his native Florentine sensibility and the Roman *gravitas* of subsequent works.

Jacopo's relationship with Sarto has overshadowed the interest shown in his sculpture by the other main protagonist of Florentine painting in those years, Fra Bartolommeo.[128] Born in 1472, the frate found himself unexpectedly *caposcuola* of Florentine painting after 1509, and, like Andrea del Sarto, his own work underwent a transformation about this time. This was in part a response to the foundations of the new style laid down earlier by Leonardo and Michelangelo, and also a response to the example of Raphael, who was intermittently in Florence during 1507–08. But he also studied Jacopo and found in him a conduit of new ideas. Some years ago Cox Rearick noted that Fra Bartolommeo employed Jacopo's *Bacchus* for the unorthodox pose of his *St Sebastian*, a work painted after his return from an ignominious visit to Rome in 1514 (fig. 41).[129] The *St Sebastian* has been interpreted as an example of the frate's response to criticism of his limitations as a painter, especially in light of his apparent failure to come to terms with what he found in Rome. His awareness of Jacopo, however, began some time before this and may be related to his experimentation with a more sculptural figural style shortly after Jacopo's return to Florence. This can be seen most clearly in his drawings of 1511–13 and is most conspicuous in his studies for the St Bartholomew in the *Mystic Marriage of St Catherine*, now in the Accademia (figs. 359–60).[130] Finished early in 1513, the altarpiece was the painter's most ambitious work to date. The St Bartholomew in particular has the quality of a citation, and, although Venturi termed it a 'statutone michelangiolesca', the true source for the figure would seem to be Sansovino's lost *St John* (see fig. 357). Both figures employ the same motif of the raised right leg and counterpoised left arm. Sansovino's model would have been known through the competition for Or San Michele, which must have taken place about the time Fra Bartolommeo was planning his *Mystic Marriage*. While it might be argued that the influence could as easily have come from Fra Bartolommeo to Jacopo, that seems less likely, given the nature of both artists' work. The St Bartholomew does not evolve from the frate's figural canon whereas it does flow from Jacopo's experiments with the *figura serpentinata* in the *St James*; the St Bartholomew remained an isolated figure in Fra Bartolommeo's *oeuvre* while Jacopo's *St John* foreshadowed later works.

These two are not the only examples of a convergence between the work of the painter and the sculptor. A similar case occurred with the large panel of *St Peter* (fig. 53) which the frate painted together with a companion piece of *St Paul* while in Rome in late 1513 or early 1514.[131] Vasari implies that Fra Bartolommeo grew disheartened with these paintings when he saw contemporary Roman art and left the *St Peter* for Raphael to complete. While the surface finish and the face of Peter bear the imprint of Raphael's brush, the figure is unquestionably by Fra Bartolommeo and points to an awareness of Jacopo's *St James* (fig. 45). A model for the statue must have existed as early as 1511, and the statue itself was well under way by 1514; so it would not have been difficult for the frate to have had access to it. He has adapted its modified serpentine curve and raised shoulder, though in reverse. Why he should

have looked to Jacopo when commissioned to paint a fictive statue for a Roman church is not difficult to answer. Jacopo's statue would have been one of the most notable recent works in Florence, one that incorporated new developments from Michelangelo's art.

Fra Bartolommeo's interest in Jacopo was more limited than Sarto's, but his awareness testifies to the importance of Jacopo for contemporary Florentine painters. By the same token, Jacopo's figural style was inevitably coloured by association with painters like Sarto, Fra Bartolommeo, and Franciabigio. His saints share a common morphology with theirs, his approach to relief sculpture drew elements from theirs, and his Virgin and Child compositions would always bear the imprint of his Florentine background. Much of this is discernible only in later works by Jacopo, but some idea of his development across these years can be gained from Sarto's fresco cycle in the Chiostro dello Scalzo.[132] Thus the *Baptism of Christ* of 1511 reveals a figural and narrative style more in the mode of Andrea Sansovino's analogous sculpture for the Baptistry than in keeping with the more assertive manner of Jacopo. As the years went by, Sarto's frescoes registered an impact of his shared studio with Jacopo, and the *Preaching of the Baptist* of 1515 bears an unmistakable resemblance to the *St James* for Florence Cathedral and to the terracotta *St Paul* in Paris (fig. 63).[133] Here Sarto probably copied a model by Jacopo, one that anticipates the weightier, more imposing form of his Roman statue of *St James* (fig. 80). Two further examples of what could be termed the common style of Jacopo and Sarto at mid-decade can be seen in the ancillary images of *Justice* and *Charity*. Where the former combines reminiscences of figures by Andrea Sansovino and of Jacopo's lost *St John the Evangelist*, the latter (fig. 62) anticipates by two decades similar compositions in the sculptor's Venetian career (fig. 121). Finally, in Sarto's *Baptism of the Multitude* of 1517 (fig. 356), one sees the painter essaying the same Michelangelesque vein as Jacopo would do in his subsequent Roman sculptures.

We should examine these reflected glimpses of Jacopo's development during this decade because our firsthand knowledge of his works is so random. Indeed, the great concluding work of the first phase of his career is known only from verbal accounts. This was the temporary façade for the cathedral erected in honour of Pope Leo X's triumphal entry into his native city on 30 November 1515.[134] It was an important event, both politically and artistically. When Leo passed into Florence, it was as a ruler taking possession of his kingdom: the Medici were now firmly in control, and Florence became a satellite of Rome. For the artists who collaborated on the decorations, it meant an opportunity to shine, and it is not surprising that Jacopo's great success here led him, eventually, back to the papal court.

Various accounts give some idea of the outpouring of display. Throughout the city, arches were erected along the papal route, each dedicated to a different virtue; there was an obelisk at the north end of Ponte Santa Trinita, a storiated column in the Mercato Nuovo, a *teatro* at the junction of Via Tornabuoni and Via Porta Rossa, a colossal equestrian group before Santa Maria Novella, a similarly outsized Hercules in the Loggia de' Lanzi, and the principal ornament, a temporary façade for the cathedral. To one observer, at least, these structures seemed to transform Florence into another Rome.[135] The artists who collaborated on this effort were largely drawn from the Sapienza group: Sarto, Jacopo Sansovino, Rustici, Granacci, Bandinelli, Rosso, Pontormo, and Bugiardini, as well as the architects Aristotile and Antonio Sangallo the Elder.[136] Sarto and Jacopo were paid jointly for the equestrian group at Santa Maria Novella and for the cathedral façade, which was exected after their designs by Baccio d'Agnolo.

We know little about the equestrian group, except that it stood on a high base and depicted a rearing horse of clay with a prostrate *gigante* beneath. The figure was nine *braccia* or 5.3 m long, and the whole group may have reached 11 m in height.[137] Spectators likened it to colossal equestrian groups like the *Dioscuri* or the *Marcus Aurelius*, though the comparison would have been meant more in terms of scale than subject matter. If anything, it may have resembled Leonardo's ideas for the Trivulzio monument (fig. 362), which had been abandoned

in 1508 but may have been known to Jacopo through Rustici.[138] Like Bandinelli's *Hercules* in the Piazza della Signoria, the equestrian group would have been conspicuous by its scale alone, and it would have drawn attention to its creator's technical skill as well as to his familiarity with ancient and modern precedents for this type of work.

The equestrian group was probably the work of the sculptor more than his painter colleague, but their roles may have been more balanced on the cathedral façade. Vasari reports that the division of labour ran according to each artist's respective competence, with Jacopo responsible for the architectural and sculptural elements and Sarto for the painted ones. The distinction between their spheres may not have been rigidly observed, and Rustici is known to have made some statues for it, having been subcontracted by Sarto.[139] What it looked like can be pieced together from several sources.

Made of wood and canvas, the façade rose to the level of the oculi on the unfinished front, just below the awning that ran between the cathedral and baptistry during feast days. It was painted to simulate marble and consisted of a high base surmounted by twelve, paired Corinthian half-columns with entablature and pediments. Triumphal arches framed the portals. Into this structure were set paintings of figures and grotesques, panels of relief imitating bronze and, perhaps, marble; there were also statues identified as the apostles. Lotz observed that the overall scheme was reminiscent of designs by Giuliano da Sangallo (fig. 361) and foreshadowed the integration of sculpture and architecture so notable in Jacopo's Venetian career.

Unfortunately, we know nothing of the appearance of Jacopo's statues for the façade.[140] The pressure of such an undertaking would obviously have forced him to conserve his energies by limiting his participation to drawings for architectural elevations and mouldings and to sketches and small models for the reliefs and statues. One can speculate that the latter would have resembled earlier essays in statuary, like the *St James* and the terracotta *St Paul* or even the wooden *St Nicholas of Tolentino*. Some may have been openly fashioned in the mould of famous Quattrocento statues, as were those in Giuliano da Sangallo's drawings for church façades.[141] Some, too, may have been even more monumental and imposing, if the lost *St John* and figures like Sarto's *Justice* and *Charity* at the Scalzo are anything to go by. But, until firmer evidence comes to light, any conclusions about the façade's sculpture must remain conjectural.[142]

Jacopo de' Tatti would have had every right to feel pleased with himself by the end of 1515. In less than a decade, he had risen from the *garzone* of Andrea Sansovino to a position of eminence among Florentine sculptors. At the same time, he assumed his old master's name as a nickname, which gradually eclipsed his own.[143] He had proven himself a master of the antique in Rome; in Florence he had created a definitive version of the *Bacchus* and a complementary example of religious statuary with the *St James*. He gained a band of discerning patrons, and, with his façade for the Florentine cathedral, he demonstrated a potential for architecture on the grand scale. His temporary façade may well have encouraged him to shift his sights to Rome again, and in this he would be abetted by the closer links between Florence and Rome under the Medici. It was in Rome that he came to terms with the influence of Michelangelo, and there his career began to take a different direction.

II. Sansovino in Rome

JACOPO SANSOVINO'S SUCCESS with the temporary façade of Florence Cathedral obviously encouraged him to think again of Rome as a venue for his career. By the end of 1515 he had created in the *Bacchus* and the *St James* two works that consolidated his reputation as the most promising of the younger Florentine sculptors. His models and unexecuted designs served as a bridge between the latest developments in Rome and the artistic milieu in Florence, and his conspicuous role in the festivities for Leo's entry had led to an introduction to the pope and expectations of greater things.

Any thoughts of Rome would have been enhanced by the political realities in Central Italy. From late 1512 Florence had effectively become a province of Rome, and Leo's promotion of his fellow countrymen had caused a virtual siphoning of talent from Tuscany to the papal court.[1] Under Leo, Rome developed rapidly, and projects were started in all directions. This, together with his recent success in Florence, must have spurred Sansovino to raise his sights.

Already by 1516 Sansovino was enlarging his sphere of operation. The contract for the Martelli altar in the Roman church of Sant'Agostino was dated 20 May of that year; at the same time, the sculptor attempted to win a share of an even larger commission, the façade of the Florentine church of San Lorenzo.[2] The early history of this project remains unclear, though Vasari states that Sansovino competed against Michelangelo in designing a façade for what had become the Medicean church. Whatever Sansovino's initial manoeuvres may have been, Michelangelo obtained a dominant control over the project by the autumn of 1516. What is known of Sansovino's putative role comes through a series of letters written to Michelangelo in the first half of 1517, but this is only Sansovino's version of events and must be treated with some caution.[3]

As Sansovino saw it, he had been promised relief sculpture and perhaps other elements in Michelangelo's façade. This may have been mooted in Medici circles as a consolation for Sansovino's own project not having been favoured. In any case, he also believed that Michelangelo was prepared to consider collaboration, and to this end Sansovino could count upon the support of the pope, his cousin Cardinal Giulio de' Medici, and another Florentine patron, Jacopo Salviati.[4] Towards the end of June 1517 Sansovino learned that he had been excluded from the enterprise in favour of Baccio Bandinelli. He vented his anger in a bitter letter of denunciation to Michelangelo on the 30th of that month.[5]

The whole, sad episode does not reflect much credit on either man. To Michelangelo, Sansovino must have appeared intolerably pushy and capable of going behind other people's backs to ensure preferment, while Sansovino must have sensed that his elder rival may not have wanted as collaborator someone who posed a threat to his total control at San Lorenzo. If not edifying, the story is none the less illuminating as it shows Sansovino employing the Florentine network in Rome for self-advancement. In light of the earlier collaboration on the cathedral façade, the incident also reveals a shift in Sansovino's career, one which subsequent

III. *St James the Greater*, Florence Cathedral (cat. no. 7)

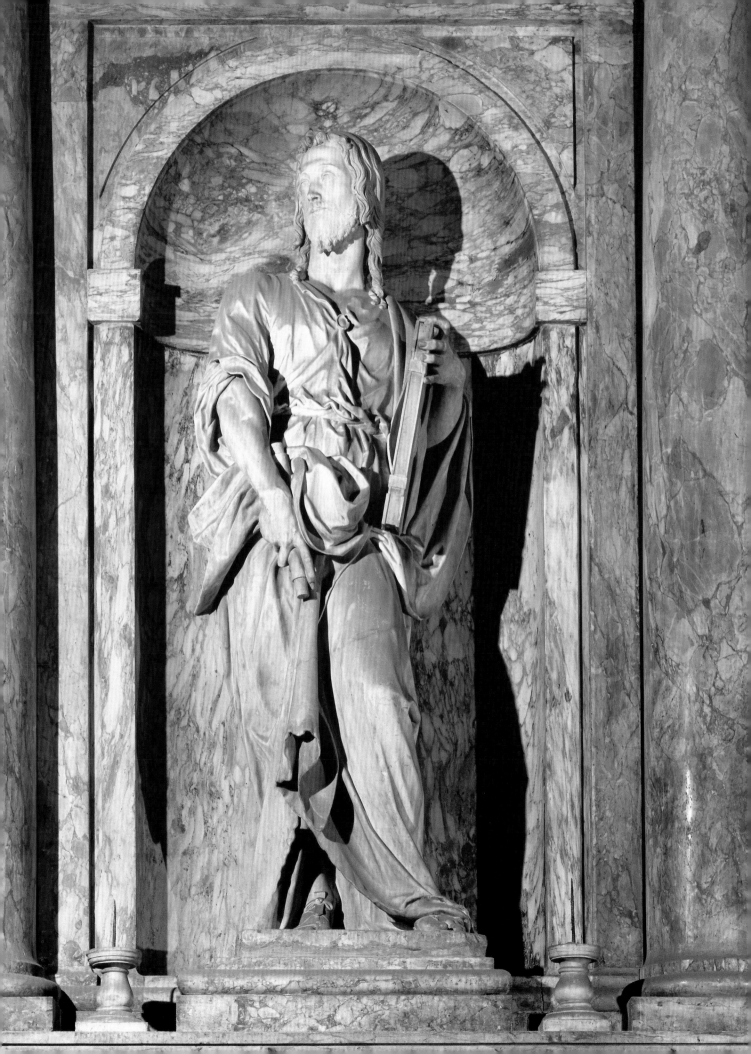

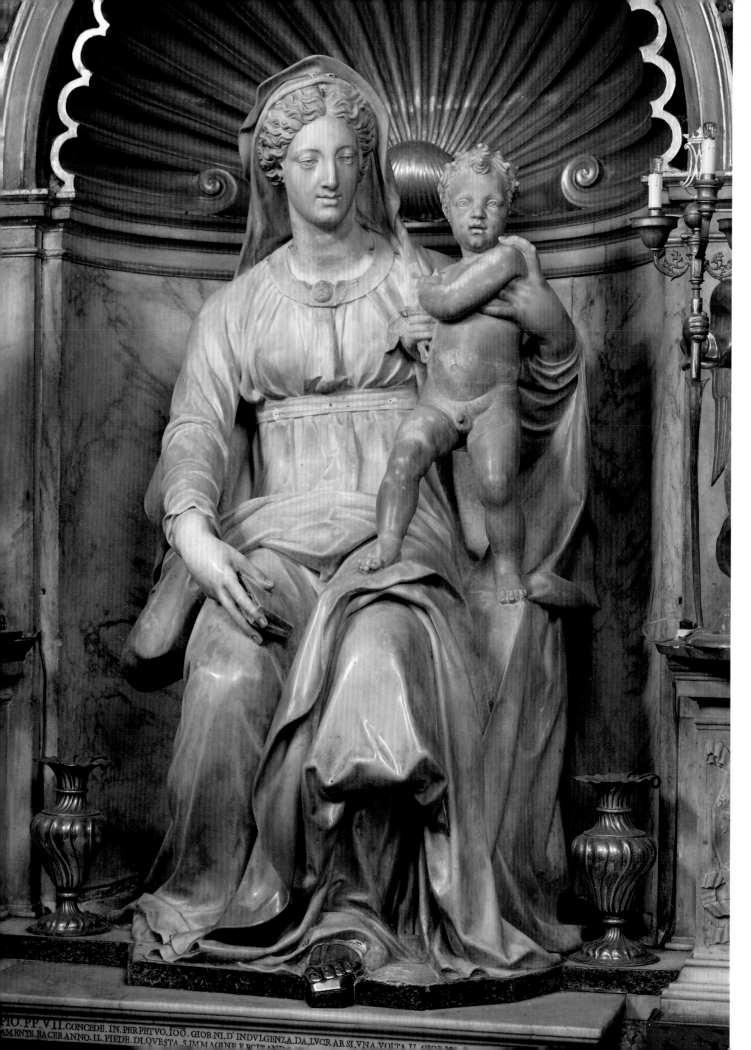

years would confirm. This was a movement away from pure sculpture towards architecture, though almost invariably architecture with a sculptural component. It was, after all, a well-established tradition, as the careers of Francesco di Giorgio, Giuliano da Sangallo, Tullio Lombardo, and Michelangelo testify. In Sansovino's case, the change of direction would have been conditioned in part by the climate of patronage he found in Medicean Rome.

Sansovino's second lengthy period of residence in Rome may have been prompted by the need to complete the Martelli altar, but also by the psychological necessity of putting as much space between himself and Michelangelo as possible. Other commissions soon accumulated, and Sansovino found himself involved with Giovanni Gaddi on the design of his family palace in Via de' Banchi. Then there was the construction of the chapel of Cardinal Serra with the statue of *St James* in San Giacomo degli Spagnoli, and the competition for the Florentine church of San Giovanni, which Sansovino won over Raphael, Peruzzi, and Antonio Sangallo the Younger. At the same time, he became involved with the rebuilding of the church of San Marcello al Corso after the old building was destroyed by fire in May 1519. The evidence, then, points to a prolonged stay, one which does not appear to have been interrupted much before the death of Leo X in December 1521.

Although his break with Michelangelo was only healed in the mid-1520s, Sansovino's awareness of Michelangelo's work around 1517 affected his own style markedly in the following years. This can be seen most clearly in his two major sculptures executed in the aftermath of the San Lorenzo *débâcle*, the *Virgin and Child* for the Martelli altar in Sant'Agostino (fig. 68) and the *St James* for the chapel of Cardinal Serra in San Giacomo degli Spagnoli (fig. 80). The *Virgin and Child* was the first commissioned, though both may have been executed concurrently. The contract of 1516 throws much light on the commission and on Sansovino's Florentine connections.[6] It explains that the statue and its tabernacle were erected by the heirs of the wealthy Florentine banker Giovanni Francesco Martelli; the site chosen was the one it still occupies, the inside wall of Sant'Agostino's façade, on the right of the main doorway. This was directly in front of the Martelli family vault, and it is obvious that the altar was intended to serve as their chapel. The contract refers to a drawing for the project, which had been shown to Ludovico Capponi, acting on behalf of the heirs, and states that the sum agreed for the whole work was to be around 250 papal ducats. The price included the cost of the marble and Sansovino's expenses, except for accommodation, which was to be provided by the Martelli in one of their Roman houses. The work was to be finished within two years, and, at its conclusion, the Florentine banker Bindo Altoviti would appraise the work, assigning it a value not exceeding 300 ducats.

The presence of Ludovico Capponi and Bindo Altoviti in this document deserves further comment. Capponi was the son-in-law and former banking partner of Giovanni Francesco Martelli; so his role in creating the Martelli altar was that of a family executor. If not in 1516, he would definitely become an ally of Sansovino a few years later, for he supervised the initial building of San Giovanni dei Fiorentini in his capacity as consul of the Florentine community. Capponi also took Sansovino's side when the latter was accused of taking money from the building fund of San Giovanni in 1521.[7] Altoviti was an even more interesting figure in Medicean Rome. Like Capponi and Giovanni Gaddi, he was a Florentine banker who transferred to Rome and there became prominent in artistic circles.[8] He sat to Raphael for his portrait and also commissioned the *Madonna dell'Impannata* from that artist; Michelangelo gave him one of the cartoons for the ceiling of the Sistine Chapel. It was to him that Sansovino gave the model for his Florentine *St James*. Thus, already in his first major Roman commission, Sansovino was involved in those overlapping circles of Florentine patronage which would propel him forward in the coming years. Like many another artist, he owed his success to a mixture of native ability and Tuscan origin.[9]

The drawing referred to in the contract for the Martelli altar presumably would have been sketched between April 1516, when the site in Sant'Agostino was ceded to the Martelli, and

IV. Martelli *Virgin and Child* (*Madonna del Parto*), Sant'Agostino, Rome (cat. no. 10)

the following month when the contract was drawn up. The contract enjoined Sansovino to work there, but the move was deferred. He did not finish the *St James* for Florence until the latter part of 1517, and his letters to Michelangelo also document his residence there for much of that year. So it is unlikely that Sansovino made much progress on the commission before 1518, the year in which he seems to have transferred his practice to Rome. That would make the most plausible period of execution from 1518 to 1521, as Garrard and Hirst have suggested.[10] Unfortunately, though the surviving copy of the contract bears Altoviti's valuation of 300 ducats, the date of the appraisal is not given.

The group of the *Virgin and Child* in Sant'Agostino, commonly known as the *Madonna del Parto*, ranks among Sansovino's most popular sculptures and is a rare example of a Renaissance work of art that has become a devotional image (col. pl. IV, figs. 66, 68).[11] It also marks a significant stage in the High Renaissance de-mythologizing of the Virgin and Child, something set in motion by Leonardo in his domestic treatment of the subject, continued by Michelangelo in his *tondi*, and perfected by Raphael through a succession of devotional paintings in the first decade of the sixteenth century. The Martelli *Virgin and Child* builds upon this tradition as well as demonstrates its creator's ability to reconcile divergent strains in his artistic makeup. It has an amplitude of form derived from Michelangelo's sibyls on the Sistine Chapel ceiling, a strong sense of human content, which was Jacopo's particular gift, and that easy assimilation of a classical manner which he had previously shown with the *Bacchus*. It is not surprising that in this, his first mature Roman work, Sansovino pulled out all the stops and fashioned an image that still remains the best endorsement of his artistic gifts.

Perhaps the first thing that strikes a spectator in Sant'Agostino is the classical aura with which the statue is embued. The seated pose of the Virgin is reminiscent of many classical figures, and it is a tribute to Sansovino's intentions here that the group long bore the nickname of 'Agrippina with the infant Nero'.[12] Sansovino's primary model was, however, a large, seated porphyry figure then in the Sassi collection in Rome (fig. 70).[13] As Garrard has shown, this statue was believed to have been a female figure in the Renaissance and, as such, was drawn upon by artists like Raphael and Amico Aspertini. The androgynous nature of the *Apollo Sassi* obviously lent itself to the kind of figure Sansovino had in mind, and from it he adapted the basic pose of the Virgin and her morphology with large torso, high waist, and small head. The pose of the Christ Child, likewise, depends upon a famous classical model, the *Boy with a Goose*, which Sansovino would have known from an example in Rome.[14] Here Sansovino has reversed the pose to create the image of the Child clasping the goldfinch, a sign of the Passion, and staring deliberately towards the high altar (fig. 69).[15]

The classical overtones of the Martelli *Virgin and Child* are unmistakable and were intended to be so. Sansovino clearly wanted to demonstrate his mastery of the classical idiom with this sculpture, but he was also concerned to show his command of the contemporary Roman style. A preoccupation with classical art was one of the hallmarks of the Roman High Renaissance and can be seen as early as the tombs by Andrea Sansovino in Santa Maria del Popolo (fig. 13). Jacopo could hardly have ignored his former master's more recent statement of this theme in his *Virgin and Child with St Anne* in Sant'Agostino (fig. 72), but other than a residual similarity in the faces of the two Virgins, the two works have little in common.[16] Andrea's group exhibits a classical idiom little developed beyond his earlier tombs and grounded, rather, in Leonardo's exploitation of the same theme around the turn of the century (fig. 6). Andrea's group marks the end of one phase of High Renaissance classicism, having little to do with the currents that informed the Martelli *Virgin and Child*. Instead, Jacopo's sculpture must be understood in terms of the growing interest in a monumental, antique figural style, bound up with new developments in the art of Michelangelo and Raphael.

Jacopo's *Virgin and Child* reflects more clearly the watershed in Renaissance art achieved by Michelangelo with the completion of the Sistine ceiling in 1512. Indeed, Sansovino's work

gives the impression of a sculpture in which classical and contemporary influences coexist. The heroic proportions of the Martelli *Virgin* can be compared in general terms with a figure like the *Delphic Sibyl*, though in other ways it is closer to one of Michelangelo's subsequent sculptures, the *Moses* (fig. 76). Both the *Moses* and the *Virgin* share the emphatic gesture of an arm complemented by the movement of the opposite leg, something more reminiscent of Donatello's *St John the Evangelist* than of classical sources.[17] Similarly, the drapery over the Virgin's legs turns into a veritable cascade in a manner recalling the swathe falling over the right leg of Moses.

This change in Sansovino's style in Rome should be considered in the context of a general shift in artistic ideals inaugurated by the Sistine Chapel ceiling. One can find an earlier parallel in Raphael's fresco of *Isaiah* of 1512 (fig. 75), designed to accompany Andrea Sansovino's marble group in Sant'Agostino.[18] Raphael's fresco and Jacopo's sculpture pay tribute to Michelangelo in terms of movement and monumentality, indicating in both cases a new departure for their creators. By the date of Sansovino's commission, Raphael's art had evolved in quite a different direction, and this later transformation in Raphael's work may also have exercised a subtle influence on Sansovino as he planned the Martelli altar.[19]

From the Chigi chapel and New St Peter's to the Farnesina frescoes and the Villa Madama, Raphael's search for variety in ancient art and architecture inevitably coloured the work of his school and of contemporaries like Peruzzi, Sebastiano, and Jacopo Sansovino. As Buddensieg observed, the tendency towards simplified, monumental forms, illustrated in a late work by Raphael like the *Madonna della Quercia* (fig. 74), remained a potent image for artists as diverse as Peruzzi and Parmigianino.[20] In Sansovino's case, the *Madonna della Quercia* would have been exactly contemporaneous with the Martelli *Virgin and Child*, and their similarities could not be merely coincidental. Both share a monumental torso in a seated, serpentine pose with tapering arms and a small head resting on a columnar neck. Sansovino may well have frequented Raphael's studio on his return to Rome, especially given his earlier contacts with Bramante and his recent break with Michelangelo. The peculiar achievement of his Martelli *Virgin and Child* lies in synthesizing elements from the Roman avant-garde without sacrificing completely the warmth and immediacy of his Florentine training. The rapport between mother and child is palpable and communicates itself to the spectator, despite the sculpture's more sophisticated features. It is this quality in the Martelli *Virgin and Child* that has commended it to subsequent generations of connoisseurs as well as believers.

Sansovino's success with this sculpture had an apparent impact upon his contemporaries, as can be seen in the work of Sebastiano and Andrea del Sarto. Sansovino and Sebastiano became friends by the early 1520s, and the painter arranged the reconciliation between Michelangelo and Sansovino in 1525. As Hirst observed, Sebastiano's *Virgin and Child* in Burgos Cathedral drew upon the same classical source as did Sansovino for his group in Sant'Agostino.[21] Sebastiano based the pose of his Virgin on the *Apollo Sassi*, though his Christ Child is more directly indebted to Sansovino's work, which would have been one of the most significant new compositions in Rome around 1520. Through it, Sebastiano may have been led back to Sansovino's primary source.

Sebastiano's painting is an isolated example of a borrowing from Sansovino, although his monumental Virgin and Child conforms to the same trend in contemporary art as the Martelli group. With Sarto, the artistic relationship went deeper and was more complex. Sarto and Sansovino evolved a common vocabulary of forms during their years at the Sapienza, a fact confirmed by the *Madonna of the Harpies* (fig. 68) and the frescoes at the Chiostro dello Scalzo (fig. 357). In this context, two paintings, the Borghese *Madonna* of 1516 (fig. 71) and the Porta Pinti *Madonna* of 1522, are worth considering. The Borghese *Madonna* is a product of the period in which Sansovino and Sarto still shared a studio and during which the sculptor would have been planning the Martelli altarpiece.[22] Sarto's painting has certain similarities with the Martelli group, particularly the morphology of the two Virgins and the presence of a

large, vivacious Christ Child. By comparison with the marble, Sarto's group seems more spontaneous, and it is tempting to see in it a reflection of Sansovino's early ideas for his first major Roman commission. In the interval between the contract of 1516 and its final form, the Martelli *Virgin and Child* evolved along different lines, and it is interesting to see that this change was not lost on Sarto but appeared in his Porta Pinti *Madonna* of approximately 1522.

The Porta Pinti *Madonna* is one of the most important of Sarto's lost works and was a large-scale fresco painted in one of the Florentine city gates (fig. 73). Shearman drew attention to its 'sumptuous cascades of drapery . . . sculpted with elaborate care and disposed in swathes of unusual amplitude . . . that play a vital part in the construction of the whole dramatic image'.[23] The central group of the Virgin and Child as preserved in copies suggests that the original bore a strong likeness to Sansovino's sculpture in Sant'Agostino. This would imply knowledge of the sculpture in its formative and probably definitive stages. The placement of the two figures with the Child standing by his mother's side and supported by her is similar, and both Virgins reiterate the same type of large torso and tapering extremities. The lapidary treatment of the drapery across the Virgin's lap in Sarto's fresco is virtually a quotation from Sansovino, while the Baptist at the Virgin's left may again reflect the phrase in the 1516 contract that left the number of *puttini* to the sculptor's discretion.[24] Sarto would undoubtedly have known Sansovino's first ideas for the altar, and his memory of the group would have been refreshed if he did visit Rome around 1520 as Vasari implies.[25] It is not surprising, then, to find the painter turning to a work by his former colleague when he was charged with creating figures on a monumental scale.

Discussions of the Martelli *Virgin and Child* rarely mention the work's setting, but it does merit attention. The relationship between the two figures and their niche is peculiarly Florentine in that the setting is so well calculated that one head or the other seems at the centre of the rays of the shell, thus creating a halo-like effect.[26] The figures are framed by a small aedicule of the Corinthian order with victories in the spandrels, reminiscent of those on the arch of Titus, and follow a pattern for chapel decoration already articulated by Andrea Sansovino in Sant'Agostino and Raphael in the Chigi chapel of Santa Maria del Popolo (fig. 77).[27] The Martelli altar has lost two elements which would have conditioned its overall effect: an attic fresco by Polidoro da Caravaggio and the original *mensa*. The former was destroyed when an organ was installed above the altar, but an idea of Polidoro's painting survives in a later drawing (fig. 67)[28] Vasari describes it as contemporaneous with Sansovino's altar, and the design bears definite traces of Sansovino's style. In particular, the motif of putti holding a cloth of honour above the Virgin and Child is the kind of Sartesque motif which Sansovino would later redeploy in his sacramental tabernacle, now in the Bargello museum (fig. 165).

The loss of the original *mensa* is equally regrettable. The whole of the lower portion of the altar was extensively reworked, probably in the wake of Vanvitelli's restoration of Sant'Agostino between 1756 and 1763.[29] The previous *mensa* would have projected several feet in front of the statue and it obviously impeded the veneration of the Virgin when the statue became a cult figure in the later eighteenth century.

When complete, the Martelli altar constituted an impressive combination of architecture, sculpture, and painting, in line with contemporary Roman tastes. Its classical aedicule contained a Virgin and Child metamorphosed into a Junoesque matron with her divine offspring, while the fictive putti raised above their heads a cloth of honour, suggestive of a baldachin.[30] As the centrepiece, the *Virgin and Child* reflect Sansovino's artistic development away from his earlier Florentine manner towards a more imposing idiom, one in keeping with the changes in Roman art since his departure around 1510. This development found its culmination in Sansovino's other major sculpture of this period, the *St James* for the mortuary chapel of Cardinal Jacopo Serra in the church of San Giacomo degli Spagnoli (fig. 80).

Spanish by birth, Jacopo Serra had been made a cardinal by his fellow countryman

Alexander VI in 1500.[31] He was later canvassed as a possible pontif in the conclave that elected Leo X. He died in Rome, rich and of great age on 15 March 1517; one year later Pope Leo appointed Cardinal Antonio de' Monte to supervise the execution of the cardinal's testimentary request for the construction of a chapel in the Spanish church in Rome.[32]

Cardinal Antonio Ciocchi de' Monte was an interesting choice for executor of Serra's intentions.[33] He had been a protégé of Julius II and became a cardinal in 1511. He would be a contender for the tiara in the conclave that would elect Clement VII and would occupy important administrative offices under Clement. His family came from Monte San Savino near Arezzo, which was also the birthplace of Jacopo's master and namesake, Andrea Sansovino, and he may have known of Jacopo through this connection. However, his choice of Jacopo Sansovino and Antonio da Sangallo the Younger as executants of the chapel and its altarpiece is noteworthy because it reflects the continuing association of Sansovino with the Sangallo family; though this association foreshadows the uneasy relationship the two men would later have at San Giovanni de' Fiorentini and San Marcello.[34] De' Monte's choice also suggests a shrewd judgement of the best available talent for what would have been a significant commission in 1518: with Michelangelo and Andrea Sansovino occupied elsewhere and with Raphael enmeshed at St Peter's, Jacopo Sansovino and Antonio Sangallo were the best men to be had for their respective contributions. The choice of Sansovino prefaced further links with the de' Monte family in the coming years. At some point in 1519 or shortly afterwards, Sansovino designed a villa for Cardinal Antonio on the site of what eventually became the Villa Giulia, and the cardinal, in his role as protector of the Servite order, may have been influential in obtaining for Sansovino the task of rebuilding San Marcello.[35] In 1521 Giovanni Maria de' Monte, the cardinal's nephew and the future Pope Julius III, stood godfather for Jacopo's son Francesco.[36]

Work must have proceeded fairly swiftly on the chapel and statue. Cardinal de' Monte's duties to the Serra estate were discharged by early 1520; construction of the chapel must have been complete by 1519. As Davidson noted, the chapel's frescoes by Pellegrino da Modena were finished before the death of Raphael in April 1520, which argues for the structure's completion the previous year.[37] Essentially, the chapel is a rectangular box with a barrel vault and thermal window above the altar wall. The lateral walls are divided into bays by Composite pilasters and frescoed with scenes from the legends of St James, while the altar wall contains an aedicule with Sansovino's statue of the saint flanked by frescoes of Sts Peter and Paul (fig. 78). Sangallo's design recalls elements of his uncle Giuliano's solution for the Cappella Gondi in Santa Maria Novella as well as features like the Composite order, barrel vault, and thermal window which became staple parts of his own vocabulary.[38] The muscular classicism of the chapel even received the compliment of being adapted by Poussin as the backdrop for the first version of *Confirmation*, painted in the late 1630s.[39]

The paintings by Pellegrino da Modena mark a rare example of Raphaelesque frescoes around 1520, but even more than these, the statue by Sansovino fulfilled the expectations of Sangallo's setting (figs. 78, 80–81).[40] Evidence for its completion is furnished in a letter from Leonardo Sellaio in Rome to Michelangelo in Florence at the end of January 1520. Sellaio cryptically mentions that Sansovino has finished 'the figure' which is said to be one of Michelangelo's, though he himself had not yet seen it. Hirst clarified the sense of these remarks by drawing attention to a chalk sketch by Michelangelo for one of the statue bays on the façade of San Lorenzo (fig. 79).[41] It is an early study for the façade, probably from the first part of 1517 and, hence, prior to the rupture between Sansovino and Michelangelo in June of that year. The drawing shows a figure standing within a tabernacle and striking a pose reminiscent in reverse of that adopted by Sansovino's *St James*. Whether Sansovino knew this kind of study through Michelangelo or subsequently through friends at the papal court, it is not surprising that he would have elaborated it for the Serra chapel. During this decade Michelangelo became a touchstone for Sansovino's development, and he wanted to

demonstrate his mastery of this new sculptural style here even more than in the Martelli *Virgin and Child*. There may, as well, have been an element of revenge prompting Sansovino's use of so explicit a 'quotation' from his rival, as if he wanted to beat Michelangelo at his own game.

The sequence of events indicates that Sansovino saw one of Michelangelo's sketches and proposed it for the altarpiece of the Serra chapel. He had employed a similar solution for the Martelli altar, but in this case the design has been refined by Sangallo, who gave the tabernacle a stronger, simplified profile, more in keeping with his own tastes.[42] The aedicule with its Composite order blends in with the articulation of the walls, and its severity makes an appropriate setting for Sansovino's figure.

The Roman *St James* marks the culmination of a progression first evident in its Florentine namesake, evolved through lost models like the *St John the Evangelist*, and mirrored in Sarto's frescoes at the Scalzo. The differences between the Florentine *St James*, which opened the decade, and the Roman one, which effectively closed it, are instructive. Where the earlier figure seemed more in rivalry with the fifteenth-century Florentine tradition of statuary, the later version shows more sense of competition with Michelangelo and the antique. Gone is the lyrical, Ghibertian grace of the earlier work with its virtuoso handling of material; in its place stands a sturdier figure whose trunk-like legs and arms stand out against shorter drapery, hanging in smaller, vertical folds. The sense of serpentine movement and the bare limbs recall Michelangelo's unfinished *St Matthew* (fig. 52) as well as the figure study for San Lorenzo (fig. 79). As with the Florentine *St James*, Sansovino favours here an arrested form of serpentine pose, but one mitigated by a strong, classicizing influence. The resolute pose, with left leg drawn back and head turned in profile to the figure's left, recalls the *Apollo Belvedere* (fig. 17). Such a borrowing may have suggested itself to Sansovino when he was considering an appropriate image of heroic resolve, but he was probably guided in this direction by Michelangelo's exploration of a strongly classicizing style in his *Risen Christ* for Santa Maria sopra Minerva (fig. 83).[43] With this sculpture, Michelangelo recast the medieval type of the Man of Sorrows as an Apollonian god, planning it for a tabernacle in the Minerva. As Michelangelo's only finished statue of the period, it is inconceivable that Sansovino would not have paid it close attention. Sansovino's figure resembles the *Risen Christ* in its adherence to the antique, though it is an adherence that does not penetrate beyond superficialities of dress and pose. The difference can be best appreciated by a comparison of the heads of the two statues (figs. 81, 83). Where Michelangelo endowed his *Christ* with an intrinsically antique profile and blank eyes, Sansovino's *St James* remains more Florentine and expressive. The brow has been exaggeratedly built up, the eyes are deeply set and expressive, the nose juts out in an unclassical fashion, and the treatment of the hair and cleaving of the beard recall Andrea Sansovino and earlier Quattrocento masters. It was as if Jacopo could not quite erase from his mind the strong impression that Donatello's *St Mark* had made on him long ago, for there, too, one finds the prominent brow, large eyes, and Gothic arrangement of the beard (fig. 82), features that remained Sansovino's pattern. So, even in one of his most forceful and 'Roman' works, Sansovino drew back from surrendering totally to the influence of Michelangelo.

Though the *St James* may lack the Florentine *dolcezza* of his earlier statues, the combination of classical and modern elements invests it with an authority found in few other works by Sansovino. It is a wonderfully calibrated work by an artist of great technical and imaginative capacity, a work in which the noble and resolute found expression not only in the forthright pose of the figure, but also in the sensitive cast of the features. Had Sansovino carved no other statuary after 1520, the Roman *St James* would have earned him a fundamental position in the history of High Renaissance sculpture. A century later, when Ippolito Buzio was charged with carving a *St James* for San Giacomo degli Incurabili in Rome (fig. 84) he could do little better than repeat Sansovino's model.[44]

The *St James* and the Martelli *Virgin and Child* were not the only preoccupations of

Sansovino in his second Roman period. Gradually he was drawn into the field of architecture, which later became his primary concern in Venice. This was not unexpected, as the careers of Michelangelo and Raphael followed a similar pattern. In Sansovino's case, his introduction to this field probably came through his Tuscan patrons. His first commission may also have been his most significant, the designing of the church for the Florentine community, San Giovanni de' Fiorentini.[45] It marked an advance in his career and was rendered all the more distinctive because Sansovino won against competition from Raphael, Peruzzi, and Antonio da Sangallo. The new church was a focal point of Medicean interest, and the commission may have been given to Sansovino in part as a compensation for his loss of face over the San Lorenzo débâcle. Awarding such a commission to anyone other than a Florentine artist would have been unthinkable around 1518, as Tafuri has suggested. The project was to be another example of the strengthening ties between Florence and Rome under Leo X.

According to Vasari, Sansovino's project called for a central, domed space complemented by four corner ones; it was of obvious Bramantesque derivation and probably resembled the centralized plan printed in the second book of Serlio's treaties.[46] If ambitious in design, the church proved equally demanding for its site between the Via Giulia and the Tiber, projecting into the river-bed almost forty-five metres.[47] The foundation stone was laid in the presence of Cardinal Giulio de' Medici in 1519, and work proceeded under Sansovino through 1520. Much of this early effort would have been directed towards the foundations, but Sansovino soon ran into problems with his patrons. His role was terminated in January 1521, following a row over finances; although Sansovino may have lacked the capacity to deal with the structural problems of San Giovanni, the pretext for his dismissal was a charge of embezzlement.[48] Ludovico Capponi and two others sided with Sansovino, but he had lost the confidence of his masters. Sangallo replaced him and scaled down the project to more manageable, albeit conventional, dimensions.

A similar pattern emerged with San Marcello. A fire destroyed the old basilica in May 1519, and reconstruction was encouraged by Leo X, who issued a bull, promising indulgences and calling on the Servite order to furnish 2,200 scudi towards rebuilding.[49] For Leo and his court, this seemed another opportunity to embellish Rome with a new church for what was, in effect, a Florentine order. Again Sansovino was selected as architect. In this case his chances were undoubtedly enhanced by Cardinal de' Monte, who was protector of the Servites and would have taken an obvious interest in their Roman church. Here, too, Sansovino directed the initial stages of construction but gave up his role, perhaps as early as 1521, in circumstances that remain unclear.[50] Two aspects of Sansovino's design are noteworthy. One is that Sansovino reoriented the church by placing the apse towards Santi Apostoli and the nave towards the Via Lata; in this way he capitalized on a new relationship between the church and the principal thoroughfare of ancient Rome. The second, as Tafuri observed, is that Sansovino's project drew upon another Servite church, the Santissima Annunziata in Florence, as a touchstone.[51] Both his sensitivity to the urban context and his Florentine frame of reference would remain conspicuous features of Sansovino's Venetian architecture, but in this case they dovetailed with Medicean aspirations for Rome.

Sansovino was more fortunate with his third major building project of these years, Palazzo Gaddi (fig. 192).[52] It lies in that area around the Via Giulia which was so conspicuously developed during the first decades of the century and can be interpreted as another example of the colonization of Rome by Tuscans attached to the court of Leo X. The patrons were Giovanni Gaddi and his brothers, especially Luigi, who ran the family bank in Rome. Giovanni Gaddi had been a close friend and collector of Sansovino's works in Florence, and he figures in an arbitration by Sansovino in a dispute over the boundary of Gaddi and Ruccellai property on this site. The dispute was settled in October 1518, and the house was probably designed around that date. Occupying a narrow strip of land on the Via del Banco, Palazzo Gaddi shows a compact and competent plan for an awkward space. The façade's sobriety is

relieved by a play of rustication and mouldings which may owe more to Raphael's Palazzo Pandolfini in Florence than Palazzo Branconio dell'Aquila in Rome.[53] Sansovino could have seen Palazzo Pandolfini under construction, and it is probably not coincidental that he drew upon Raphael's distinctly 'Florentine' façade for what was effectively a Florentine palace in Rome. With Palazzo Gaddi, Sansovino displayed his distinctive style as an architect and also showed how quickly his talents were maturing.

After the completion of the Martelli and Serra altarpieces, Sansovino may have withdrawn from Rome for some of the period between the death of Leo X in December 1521 and the election of Clement VII in November 1523. The sudden and unexpected death of Leo, followed by the election of an unknown foreigner to the papacy, provoked dismay in Rome; this was compounded by the contrast between the new pope Hadrian VI and his predecessor.[54] Hadrian was ascetic, devoid of courtly graces, and uninterested in the arts. Vasari would write about his brief reign as a catastrophe for the arts, one that made the return of Medicean rule under Clement all the more welcome.[55] In fact, the shortness of Hadrian's tenure and the penury of the papal treasury left little scope for patronage, and it would not be surprising if Sansovino, like many of his fellow artists, had begun to explore alternative possibilities of employment. If Vasari is to be believed, Sansovino travelled to Venice at this time and met Doge Andrea Gritti through the intervention of Cardinal Domenico Grimani.[56] This alleged sortie would pay handsome dividends a few years later when Sansovino was persuaded by the doge and other influential Venetians to settle in their city and assume the role of *proto-magister* or chief architect of San Marco in April 1529. He may also have cast his net wider, since his son mentions a figure of Christ sent to the sister of the emperor, possibly Eleonore, who was briefly the wife of Manuel I of Portugal from 1519 to 1521.[57] This gift may not be unrelated to another project that may have come around this time, a model for the tomb of a king of Portugal (cat. no. 77), on which Tribolo assisted Sansovino.[58]

Wherever Sansovino spent the years 1522–23, he would have been drawn back to Rome by the election of Cardinal Giulio de' Medici as Clement VII in November 1523. Clement's accession was greeted with notable enthusiasm, and it must have been seen as the harbinger of a return to better times.[59] An indication of Sansovino's growing reputation can be found in the correspondence of Michelangelo. In March 1524 a correspondent in Rome asked Michelangelo if he wished to relinquish the tomb of Julius II to Sansovino 'or others'.[60] This suggestion may have rubbed salt in an old wound, but the two sculptors did settle their differences by the beginning of 1525 when another Michelangelesque project came Sansovino's way. This was the tomb of Luis Ferrández di Cordoba, Duke of Sessa and ambassador of Charles V in Rome. The duke wanted Michelangelo to design a double monument for himself and his wife and turned to Sebastiano del Piombo as an intermediary. Surviving correspondence indicates that Bandinelli and the 'giovani di Rafaello' were intriguing to gain the commission, but Sebastiano favoured Sansovino, promising to supervise him in the execution of Michelangelo's design. Michelangelo agreed to this and received a letter of thanks from Sansovino in late February 1525.[61] Although the death of the duke in 1526 terminated the project, the incident is significant for three reasons: it signals the end of the feud over San Lorenzo; it shows that Michelangelo and his allies did not regard Sansovino, by that date, as part of the Raphael faction in Rome; and it highlights the friendship between Sansovino and Sebastiano, something confirmed by other sources.[62]

Vasari also mentions two tombs that Sansovino began prior to the Sack of Rome in 1527. They were the tombs of the Cardinal of Aragon and of Cardinal Aginense, and in both cases Vasari tells us that Sansovino had begun to carve marble for the ornaments and had made models for the figures before work was interrupted by the Sack.[63] Cardinal Luigi of Aragon, who died in 1519, was a grandson of Ferrante I of Naples and a brilliant member of the court of Leo X, serving as the papal master of the hunt. The commission was later described by Francesco Sansovino as 'di somma importanza' and must have been a conspicuous one in

what was not a brilliant period for sculpture.[64] It is difficult to say how far Sansovino proceeded with it before he abandoned Rome. Nothing survives of his project (cat. no 75), and the memorial tablet erected by Cardinal Franciotto Orsini in 1533 is a belated burial marker with which Sansovino had nothing to do.

The second memorial, to Cardinal Aginense, is more problematic. Pittoni first connected it with the double monument to Giovanni Michiel, Cardinal Sant'Angelo, and his nephew Antonio Orso, Bishop Agiense, in the church of San Marcello (fig. 383).[65] She reasoned that Vasari meant to write *vescovo Agiense*, and her interpretation has met with acceptance in varying degrees by later writers. Only recently has the identification been called into question by Foscari and Tafuri, who argued that Vasari was referring to Leonardo Grosso della Rovere, Cardinal Aginense, and consequently not to the bishop buried in San Marcello.[66] The similarity between the titular names Aginensis from Agen in France and Agiensis (Canea) in Crete led Pittoni to assume a slip on Vasari's part.[67] Furthermore, while there is no evidence to connect Sansovino with Cardinal Sant'Angelo or his nephew, Sansovino did know Cardinal Aginensis.

Leonardo Grosso della Rovere was a nephew of Sixtus IV and held the see of Agen from 1487 until shortly before his death in 1520.[68] As an executor of his kinsman Pope Julius II, he was deeply involved in the early stages of what became the débâcle of Julius's tomb, and in Michelangelo's correspondence he is almost invariably referred to as Cardinal Aginensis.[69] Indeed, it is through Michelangelo's Roman informants that we know of at least one encounter between Sansovino and the cardinal. This came in December 1518 when Sansovino, fresh from Florence and still smarting from his rebuff over San Lorenzo, slandered Michelangelo before Cardinal della Rovere by saying that his rival would never finish the pope's tomb.[70] Whether irritation with Michelangelo led the cardinal or his heirs to commission his own tomb from Sansovino cannot be said, but there is one further piece of evidence to corroborate the project. When Sansovino arrived in Venice in August 1527, Lorenzo Lotto noted that the sculptor left two important projects in Rome, 'la sepultura del nipote di papa Julio etiam quella del cardinale Grimano'; though wrong about the degree of kinship, Lotto could only have been referring to the Cardinal Aginensis.[71] Thus it seems likely that Sansovino had been entrusted with the creation of a memorial for Leonardo Grosso della Rovere and that it, too, fell victim to the Sack of Rome.[72]

If there is no documentary evidence to support the ascription of the San Marcello tomb to Sansovino, the visual evidence is also negative. In appearance, the tomb reflects those by Andrea Sansovino in Santa Maria del Popolo and would be more convincingly dated to about 1511, that is, around the time of Antonio Orso's death.[73] At that date Sansovino was based in Florence, as the payments for the *St James* bear witness. If, on the other hand, the double monument is placed in the 1520s, then it is difficult to reconcile such a *retardataire* work with Sansovino's surviving Roman sculpture.

It is true to say that the monument's appearance reflects the styles of Andrea and Jacopo Sansovino in general terms, but the reflection is a dim one. Its heterogeneous nature becomes even clearer when individual elements are examined. The principal figures, the *St Peter* and *St Paul*, not only fit uneasily into their niches, but are also ill-assorted with each other (figs. 384–85); the former harks back to the Quattrocéntesque Florentine tradition while the latter statue comes closer to the style of Jacopo's *St Paul* in Paris (fig. 63). They are, moreover, grossly executed and lack the crispness associated with Jacopo Sansovino's own work. The statues of the upper register, *St Michael* and *St John the Baptist*, similarly do not accord well with one another, and it is difficult to see either as dependent upon a Sansovinesque model, much less an autograph work. The most successfully executed elements in the ensemble are the effigy of Cardinal Michiel and the relief of the Virgin and Child; yet neither finds specific correspondence in the work of Sansovino nor would it justify, *per se*, a partial intervention by the sculptor.

When analysed, the double monument can be seen as less a work of great originality than a simple pastiche concocted by a sculptor of Tuscan background who was familiar with recent work by Andrea Sansovino and, to a more limited extent, with that of Jacopo Sansovino. It can be compared to a similar work, the drawing for an ecclesiastic's tomb, formerly in Vasari's possession and ascribed by him to Andrea Sansovino (fig. 408).[74] In both cases, the hand is not recognizable, though motifs from the works of both Sansovinos are. In particular, the architectural elements are not competently drawn, and it is unlikely that they reflect the hand of as talented an architect as Jacopo would have been by the early 1520s. It seems more plausible to place both the San Marcello tomb and the drawing in question within the ambit of Andrea Sansovino's Roman followers as opposed to the *oeuvre* of Jacopo Sansovino.

One final work of the 1520s brings to a close the pre-Venetian phase of Sansovino's career. It is the marble *St Anthony of Padua* in the Saraceni chapel of San Petronio in Bologna (figs. 320–21). The chapel bore a dedication to the Franciscan saint from 1455, but its present appearance dates from the 1520s when the then patron, Giovanni Antonio Saraceni, provided a new altar and frescoes.[75] The walls of the chapel are divided into bays by Composite pilasters with mouldings identical with the Composite columns employed on the altar aedicule; as the wall and altar articulation must have been conceived simultaneously, both would have predated the frescoes painted by Girolamo da Treviso in 1525–26. No contract survives for the architectural or sculptural decoration of the chapel, but Sansovino's name has been connected with the statue since Masini's *Bologna perlustrata* of 1666.[76] Sansovino was again named as the author of the statue in a letter from the chapel's patron, Ferdinando Cospi, to Cardinal Leopoldo de' Medici in 1670.[77]

The attribution to Sansovino was never seriously challenged until its rejection by Weihrauch. His reasons for disclaiming both the *St Anthony* and the *St Nicholas of Tolentino* (fig. 346) were that the latter was too primitive for an early work by Sansovino and the former proved too simple and unpretentious to square with Sansovino's early or later career.[78] On the other hand, Sansovino's stylistic development was more complex and certainly less linear than Weihrauch believed. Early works and Quattrocentesque elements reappear later in Sansovino's career, and Lorenzetti's observation that the *St Anthony* is like a more mature version of the *St Nicholas* seems closer to the mark.[79] Both derive from Ghiberti's *St Stephen* (fig. 344) and underscore the pronounced empathy that Sansovino had with earlier Florentine sculpture. In the *St Nicholas*, Sansovino's interest lay in adapting a compact model for the exigencies of wood sculpture. With the *St Anthony*, Sansovino apparently strove for something of the graceful, slightly detached demeanour of the *St Stephen*, although modifying features like the drapery and the way in which the book is held. In addition, the architectural design of the altar also bears the imprint of Sansovino's style and can be compared to the type found in the Nichesola altar of Verona Cathedral, executed only a few years after this one (fig. 90).[80] Consequently, the weight of evidence does point to an intervention by Sansovino in the design of the Saraceni chapel and of its principal decorative feature, probably prior to the frescoes by Girolamo da Treviso of 1525–26.

Having said that, one must also admit that signs of Jacopo's own hand in the carving of the statue are virtually non-existent. Obviously, the *St Anthony* was not a major commission and did not greatly exercise Sansovino and his role may have ceased with furnishing a model, as Garrard proposed.[81] In this context, the activity of Sansovino's former pupils Tribolo and Solosmeo may not be unrelated here; both were in Bologna during the years 1525–27 and at work in San Petronio.[82] While the style of Tribolo's known works do not correspond with the *St Anthony*, Solosmeo the sculptor also remains an unknown quantity. It could be that he was responsible for executing the figure after a model by Sansovino, but whether or not that is so, the bland nature of the finished product indicates a growing use of assistants and delegation of authority in Sansovino's workshop. This will become even more conspicuous in the sculptor's Venetian career.

Both Vasari and Francesco Sansovino confirm that Jacopo's base in the years prior to the Sack was Rome. In addition to the commissions previously mentioned, Vasari also records a palace for Luigi Leoni and a villa for Marco Coscia, but neither survives.[83] Though he may have been active, Sansovino continued to look elsewhere for patronage, as his gift of a figure of Christ to the emperor's sister would imply. During these same years he acquired familial responsibilities with the birth of a son named Francesco, who later also used Sansovino instead of de' Tatti as his surname.[84] It seems likely that Francesco was born out of wedlock, and the name of his mother is not known. In a letter written in 1579, Francesco Sansovino records that after the Sack his father first departed for Florence where he left his young son with relations before travelling to Venice, *en route* to France and the service of Francis I.[85] The French king already enjoyed a reputation as a distinguished patron of artists such as Leonardo and Andrea del Sarto; he benefitted from the disruption in Central Italy by the addition of Rosso, Primaticcio, and, intermittently, of Cellini to his *équipe*.[86] Sansovino may have been inspired by the example of his friend Sarto and had evidently been negotiating with Francis for some time before the spring of 1527.

Returning to Rome in 1518, Sansovino may have entertained high hopes of major projects. He would have been encouraged to do so in the heady atmosphere at the court of Leo and, again, in the early days of Clement's reign.

However, Sansovino obtained no sculptural commissions from the Medici, and his only public commission, the church of San Giovanni de' Fiorentini, foundered on its own grandiosity and on the question of his honesty. Sansovino executed only two major pieces of sculpture during this Roman period, and both were private projects, obtained through the Florentine community and his connections with the curia. What Sansovino could not have appreciated at the time was that Medici interests focused primarily upon Florence. The chief— at times the only—purpose of Medici policy lay in consolidating their personal rule there, and this is reflected in the most conspicuous projects sponsored by them during this period, the façade and, subsequently, the New Sacristy of San Lorenzo.[87] As these projects were entrusted to Michelangelo, other sculptors of note were effectively excluded from participation. In Rome, the demand for sculpture was obviously not great enough to employ Sansovino or any other sculptor full time; moreover, as the 1520s passed, the political climate militated against such projects, as proved by the abortive commission from the Duke of Sessa. The only other major project then under way, the Casa Santa at Loreto, was hardly an attractive alternative, and Andrea Sansovino and his collaborators there regarded their situation as little better than a form of internal exile.[88]

Rome in this period may have proved a disappointment to Sansovino, but the experience was, on balance, far from negative. His reputation as a major sculptor was firmly established by the Martelli and Serra altars, and he acquired a new versatility through his study of architecture. The third strand in the fabric of these years was the interlocking friendships that Sansovino made. The painter Sebastiano and Cardinal Domenico Grimani have previously been mentioned in this context. Through one or the other of these men Sansovino may have met one of his great friends and strongest supporters in Venice, the writer Pietro Aretino. Sansovino and Aretino were already friends by 1525 when the writer commissioned a stucco version of the *Laocoon* for the Marquis of Mantua. In a letter to the Marquis, Aretino described the work as approximately one *braccio* high and made by Sansovino, adding 'maestro Julio [i.e., Romano], your painter, can tell you who he is'.[89] When Aretino and Sansovino found themselves in Venice late in 1527, Aretino tried to help his friend by gaining a commission from Mantua, although nothing came of it.[90] He may also have introduced Sansovino to Titian, and the three men developed a lifelong mutual friendship. Consequently, one can see that Sansovino's last years in Central Italy were highly significant, not only for his artistic formation but also for his future success in Venice.

In reviewing Sansovino's career prior to Venice, three things stand out: his endowment

of native talent coupled with precocity and versatility. He had an obvious flair for marble carving which benefitted from training under another virtuoso in that field, Andrea Sansovino. From Andrea, Jacopo also imbibed a preference for sculptural models from the early fifteenth century, a taste reinforced by acquaintance with other sculptors like Rustici, Bandinelli, and even Michelangelo himself. But his artistic substratum was, so to speak, overlaid with an extensive exposure to classical sculpture and to the development of Michelangelo's and Raphael's art down to 1520. These were the principal sources for the directions in which Sansovino moved in his major sculptures from the Florentine *St James* to its Roman counterpart. Sansovino managed to evolve over these years without succumbing totally to the style of Michelangelo or abandoning completely his training under Andrea Sansovino. It was his ability to reconcile these elements, sometimes within a single work, that made his achievement so distinctive among sculptors of the early sixteenth century. It also recommended him to other artists, from Perugino to Andrea del Sarto and Fra Bartolommeo, both as a source of new ideas and as a means of bridging old and new in their own art. His inventiveness and his ability to modify his style according to the work in hand were similar to those qualities that Vasari noted in an older contemporary, Piero di Cosimo.[91] These talents, allied to a shrewdness in manipulating the mechanism of patronage, formed the background of the mature artist who confronted Venice in the summer of 1527.

III. Sansovino in Venice

On 5 August 1527 Lorenzo Lotto wrote one of his frequent letters to the Confraternity of the Misericordia in Bergamo. He reported among other things the recent arrival in Venice of two sculptors, one identified simply as young and 'the only disciple' of Michelangelo, the other named as Jacopo Sansovino, 'who in Rome and Florence is held in high esteem after Michelangelo'.[1] According to Lotto, the two men's intention was to rest briefly before returning to work, and in Sansovino's case this may have meant travel to France and service to Francis I.[2] Lotto does not mention this but does give an interesting picture of Sansovino's first weeks in Venice through subsequent letters to Bergamo. He refers to the two principal tombs that Sansovino left unfinished in Rome, namely, that of Cardinal Leonardo Grosso della Rovere and another for Cardinal Domenico Grimani.[3] Beyond that, he also describes three other notable projects: a commission for the King of England worth 75,000 ducats, which had been arranged by Sansovino's patron and fellow Florentine Giovanni Gaddi; a figure of Venus which the sculptor was making for casting; and the design of a palace 'for a wealthy man', reckoned to cost 20,000 ducats.[4]

Lotto may have been indulging in a bit of exaggeration in his valuation of the projects, especially as he was simultaneously trying to arrange a much humbler commission from Bergamo for his friend; yet there is some evidence to lend colour to two of the claims. The English commission may have been related to the tomb originally awarded to Baccio Bandinelli in 1521 and then valued at 40,000 ducats.[5] It is plausible that a similar offer may have come Jacopo's way via the Roman curia and Giovanni Gaddi's influence there, or it could be construed as an attempt by Henry VIII to lure Sansovino away from Francis I. The model for the Venus is mentioned by Lotto and crops up in an often cited letter by Aretino of October 1527, in which he dangles before Federico Gonzaga the prospect of a work by Sansovino 'so life-like as to inspire lustful thoughts in anyone who gazes upon it'.[6] Neither the English commission nor the Venus for the Marquis of Mantua reached fruition: Sansovino did not take up the former and the latter seems never to have been cast, much less dispatched.[7] More interesting is the notice of another work which was made but is now lost. According to Francesco Sansovino's notes on his father's life, Jacopo was asked by Francis I for a work and sent a marble head of Alexander the Great which so pleased the king that he sent Sansovino his portrait to be copied in marble.[8] The episode is unrecorded in any other source.

Such commissions indicate that Sansovino was an artist in demand from his first days in Venice, something borne out by the steady flow of sculptural and architectural projects that came his way over the next four decades. They also indicate that Sansovino had no fixed intentions in the confused aftermath of the Sack of Rome and was casting about for work; yet it would be wrong to see him as languishing in his first years in Venice. As we have seen, he was initially housed and protected by the influential Giovanni Gaddi, and his acquaintance

with figures like Doge Andrea Gritti, Marc'antonio Giustinian, and Marco and Vettor Grimani would have given him an entrée into the highest Venetian circles.

Sansovino's contact with Venetian patrons began long before his arrival there in 1527. Vasari states that his model of the *Laocoon* was admired by Cardinal Domenico Grimani, who had a copy of it cast in bronze.[9] An important bibliophile and connoisseur, the cardinal evidently took an interest in the young sculptor and fostered his career. Again from Vasari we have it that Cardinal Grimani commended Sansovino to Doge Gritti as the best person to restore the cupolas of San Marco. While this may be true, Francesco Sansovino records an interesting variation in the notes he sent Vasari.[10] According to these, Doge Gritti learned that Sansovino was in Venice in 1527 and offered him the commission to restore the church of San Marco; as a reward for his services, Sansovino was made architect of the Venetian fortresses, an office he could have held only briefly before receiving his appointment as *proto* or chief architect of San Marco.[11] Both accounts place Gritti in a pivotal role, while Vasari's emphasis on Cardinal Grimani receives indirect support from the correspondence of Lotto, who credited Sansovino with a project for the cardinal's tomb, as noted earlier. This suggests that Sansovino may have enjoyed the patronage of the Grimani family even before he was established in Venice. Indeed, Foscari and Tafuri have recently proposed that Cardinal Grimani had Sansovino design the tomb of his father, Doge Antonio, in 1523, although the surviving documents are silent on this point.[12] Sansovino moved in the same circles as the Grimani in Rome, and he was well acquainted with one of their set, Marc'antonio Giustinian.[13] Giustinian was a wealthy young Venetian noble who came to Rome in pursuit of an ecclesiastical career in 1523. Just before the Sack he attempted to purchase a cardinal's cap for 40,000 ducats and later had to ransom himself for a substantial sum from the Imperial soldiers. Also in Rome just prior to the Sack was Marco Grimani, whose brother Vettor married Giustinian's sister in 1521. It was Vettor Grimani who became one of Sansovino's greatest promoters in Venice; Giustinian would eventually serve as one of Sansovino's executors.[14]

Such contacts may have encouraged Sansovino to turn to Venice when the Sack disrupted life in Rome, and this venture was rewarded when he became *proto-magister* of the Procuratia di San Marco de Supra on 1 April 1529. It was an office Sansovino would hold for forty-one years.[15] His appointment as *proto* came less than two years after his arrival in Venice and can be seen as the great turning point of his career. The office furnished him with steady employment as architect and artistic adviser to one of the premier corporations of the state, apartments on Piazza San Marco, and a substantial income.[16] Within the procuracy he found a discerning and sympathetic group of patrons who shared his tastes and supported his projects for remodelling the centre of Venice. Wealthy and well travelled, they wanted to introduce to Venice the latest artistic and architectural styles from Central Italy; Sansovino was their means to that end. It is also significant that among Sansovino's chief Venetian supporters as listed by Vasari—Andrea Gritti, Vettor Grimani, Cavaliere Zuane da Lezze, and Marc'antonio Giustinian—all but the last were connected with the procuracy *de supra*.[17] It was Sansovino's official recognition by the procurators that signalled his arrival in Venetian society and led to the succession of commissions associated with his Venetian career.

In what sort of society did Sansovino find himself? Venice was just emerging from the harrowing experience of the War of the League of Cambrai (1509–16) when she found herself pitted against the great powers of continental Europe and temporarily bereft of her *terraferma* empire.[18] Though Venice did regain her colonies, further war and famine brought economic disruption throughout the 1520s. Sansovino was fortunate in arriving on the eve of a period of relative buoyancy in Venetian life; he was also lucky to be taken up by a small, interlocking group of patrons at the centre of Venetian power.

Venice regarded itself as a republic but of a mixed character.[19] Power was nominally invested in a hereditary aristocracy but actually delegated to small executive bodies such as the Council of Ten and the Senate, with the prince or doge serving as a constitutional head of

state. Though more democratic than many another state, Venice was essentially run by an oligarchy of the richest families.[20] Few would have dissented from the sentiments expressed by the Sienese writer Claudio Tolomei in a letter of 1531: 'In every republic, however large, in every state, however broadly based, it is rare that more than fifty citizens attain power at the same time. Neither in Athens or Rome of ancient times, nor at present in Venice or Lucca do many citizens govern the state although they rule these lands under the name of republic.'[21] The great wealth of a few families enabled them to manipulate men and offices to their own end, particularly as Venice passed through acute financial crises in the first decades of the century. Nor was this phenomenon confined to secular office; in 1534 the papal nuncio observed that 'three clans—Cornaro, Grimani, and Pisani—wish to monopolize all the ecclesiastical offices in their dominion', and it was among these families that Sansovino commanded support.

Venice's republican character worked in favour of artists like Sansovino because there was no central court or single fountain of patronage and, as in the Rome of Leo X, artists could mingle with the aristocracy in terms of respect.[22] In addition, patronage was pluralistic, being both corporate and private, and many bodies as well as wealthy individuals felt a responsibility to commission buildings and works of art as a reflection of their status. In the sixteenth century no corporate body in Venice outshone the procurators *de supra* in terms of magnificence and of conspicuous projects. This state of affairs was, however, the fruit of changes within the Venetian constitution in the decade or so before Sansovino's arrival.

The office of procurator of San Marco was one of the most ancient within the Venetian Republic, traceable to the twelfth century but possibly in existence from the ninth or tenth century (fig. 186).[23] Originally conceived as the deputy of the doge in the affairs of his chapel of San Marco, the office of procurator gradually acquired other responsibilities, such as acting as fiduciary for wills and trusts, supervising the guardianship of minors, and serving as banker to the state. These secondary activities demanded so much attention that the number of procurators rose until three divisions, *de supra, de citra,* and *de ultra,* were formed by 1319. They corresponded to the administration of estates whose testators lived on the San Marco side of the Grand Canal (*de citra*) or the Rialto side (*de ultra*), or who maintained the initial responsibility for the fabric of San Marco, its finances and property, including the Piazza San Marco itself (*de supra*). By the middle of the fifteenth century, the number of procurators grew to nine, three for each division.

Before the sixteenth century, procurators were invariably elected from the most distinguished elder statesmen. The office was highly coveted, not because of its financial rewards, which were negligible, but because of its prestige. Procurators held office for life, the only members of government to do so other than the doge himself; they belonged, *ex officio,* to the Senate and exercised considerable influence through the large sums of money they administered. In addition, it was widely recognized that future doges would be chosen from among their number.[24] Of the three, the procuracy *de supra* was the most illustrious. It did not administer many estates but controlled large amounts of capital through the revenue of San Marco. It also exercised charitable functions through giving alms and doweries to poor girls, providing housing for the poor, and supervising hospitals.

Procurators were required to attend their office on four days of the week and to inspect San Marco at least once each week. They appointed the canons and priests, a master of ceremonies, the choir, sacristans, and other members of the doge's chapel; they also supervised an office staff with an advocate, two castellans entrusted with the day-to-day functions, notaries, paymasters, and the *proto-magister.*

A decisive change occurred in all three procuracies early in the sixteenth century. The War of the League of Cambrai imposed heavy financial burdens on the Venetian state, while revenues declined with the temporary loss of its *terraferma* possessions. A variety of new taxes were levied to cope with the shortfall in income, and offices were sold.[25] In 1510 the Council

of Ten and its *zonta* approved the admission of ten men over thirty to the Senate for a loan of 2,000 ducats and with the approval of at least half of the Ten and *zonta*. From July 1514 patricians under the age of twenty-five could be admitted to the Great Council on payment of 100 ducats, and some three hundred young men thus began their political careers over the next few years. Straightforward loans were also raised from the patriciate, though many of the *primi* or most notable did not respond generously. Finally, an acute financial crisis in the summer of 1515 precipitated the sale of offices on a grand scale, with the office of procurator first being sold in April 1516, following the death of Luca Zen of the procuracy *de ultra*. The procedure could be likened to a competition among several candidates who offered money in the form of a long-term loan and a partial gift. In effect, this gave the wealthy and ambitious a tremendous advantage over their poorer rivals, and during the next few months seven new procurators were so elected, thereby gaining 75,000 ducats for the state.[26] Of course, not everyone approved of the new practice. Antonio Tron, one of the most respected patricians, announced his intention of resigning as procurator because the sale of the office diminished its honour.[27]

The Republic had recourse to the same stratagems during the war against the Ottoman Empire in the 1520s. Eighteen-year-old patricians were allowed to buy their way into the Great Council in 1521, and various other offices were sold for large loans. The office of procurator was again offered several times, and by the end of 1523 there were twenty procurators where a decade before there had been only nine.[28] Again, there were ructions within the ruling class. Two of the elder procurators, Pollo Capello and Alvise Trevisan, protested in July 1522 that the creation of more procurators would damage the office, which, as they put it, 'is the first dignity of this state'.[29] In that same month, Marino Sanudo confided in his diary that several men made no secret of their aspiration to the office of procurator, and he named Andrea Gussoni, Francesco Priuli, Vettor Grimani, and Zuane da Lezze di Michiel, all of whom Sanudo felt were too young.[30] Within a year, all four had been made procurators.

The creation of so many new procurators changed the nature of the corporations by introducing young, wealthy noblemen eager to exploit the potential of the office. This phenomenon had a definite bearing upon the procuracy *de supra* and upon Sansovino's career as its *proto*, for he drew his support mainly from these younger men. Certainly it is unlikely that the procuracy *de supra* would have adopted such a boldly expansionist building policy in the 1530s if their ranks had not been swelled by wealthy and cosmopolitan procurators who sought to transform the Piazza San Marco with an appropriately modern architectural style.

Who were Sansovino's chief backers within the procuracy *de supra*? The surviving evidence tends to support the names given by Vasari. From the start, Jacopo could count upon the backing of Doge Andrea Gritti (1523–38) and two of the most forceful among the younger procurators, Vettor Grimani and Antonio Capello (figs. 187–89). Their cumulative influence upon Sansovino's Venetian career was arguably greater than that of any other individual and will merit particular attention.

Though never a popular doge, Andrea Gritti was an astute and decisive one. Already as a procurator *de supra*, he took an active interest in the building of the Procuratie Vecchie on the north side of the Piazza, but his scope for action became greater after his election as doge.[31] He had an eye for talent and succeeded in drawing a variety of gifted men to Venice and encouraging their employment. In 1537 Serlio listed Gritti among the chief architectural patrons of the day, one who had brought Sansovino and Sanmicheli into the service of the Republic.[32] Vasari confirms this and implies that Gritti's influence was crucial in the appointment of Sansovino as *proto* to the procuracy and for the eventual approval of his plans for the rehabilitation of Piazza San Marco.[33] Gritti's concern for the running of his chapel is attested in the records of the procurators *de supra*, and he is credited with securing the election of the Flemish composer Adrian Willaert as choirmaster two years before Sansovino became *proto*.[34] His support for Sansovino's remodelling of the choir of San Marco would have been

as invaluable as his presence at the meetings of the Council of Ten was for the selection of Sansovino as architect of the new public mint.[35] Gritti may also have played a significant role in the new decorations for the Doge's Palace in the 1530s, particularly the *finestrone* facing the Piazzetta, which was carried out by followers of Sansovino (fig. 429). Gritti is also known to have wanted to enlarge the ducal palace with the creation of gardens and new apartments on the other side of the Ponte della Paglia.[36] But the most conspicuous act of patronage connected with Gritti's name is the church of San Francesco della Vigna. In recent years the role of Gritti in rebuilding the Franciscan church has been exaggerated or diminished, but Foscari and Tafuri have shown that Gritti's role was crucial if not decisive in the early stages of the project, lending his support to the enterprise and bringing pressure to bear for the selection of Sansovino's model.[37] Gritti laid the foundation-stone of the new church in 1534 and purchased burial rights in the presbytery. After his death, the impetus for continuing San Francesco remained very much within Sansovino's circle of patronage and in the hands of Vettor Grimani.

Francesco Sansovino attributed to Vettor Grimani and Antonio Capello specific responsibility for fostering two important projects by his father, the Library of San Marco (fig. 190) and the Loggetta (fig. 195). In the same context, he added a more personal tribute to Grimani by saying: 'io non potrei dirvi tanto che fosse abastanza s'io volessi dimostrarvi qual sia la grandezza dell'animo suo, qual la sublimità dell'ingegno, qual la copiosa e bella maniera del dire, e qual la sua liberal natura e la sua amorevole conversazione'.[38] Born around 1495, Grimani came from one of the wealthiest of Venetian families; he was the son of Hieronimo, nephew of Cardinal Domenico, and grandson of Doge Antonio Grimani (1521–23).[39] He and his brother Marco first attracted attention during the brief reign of their grandfather when Marco was the first of the *zoveni* or younger generation to be elected procurator. He was elected procurator *de citra* in March 1522 with a loan of 20,000 ducats, 16,000 of which he produced in cash.[40] The traditional bar against the election of sons and grandsons of the reigning doge was set aside, as had been done for Lorenzo Loredan in 1516.[41] When it became known that Marco's brother Vettor also aspired to become a procurator, there was some resistance, and he failed to win election to *de ultra* in June 1522. He eventually obtained election in January 1523 when he defeated another *zovene*, Antonio Capello, with an offer of 8,000 ducats.[42] As there was now a large number of procurators, Vettor became procurator 'per expetativa', unable to take office until there was a vacancy. Sanudo observed that between them the Grimani brothers had spent 28,000 ducats to become procurators and that Vettor was not even old enough to take his seat in the Senate because he was under thirty, adding: 'sichè la Procuratia è venute sì abasso'.[43]

Vettor's arrival in the procuracy *de supra* came almost by accident in January 1524. A vacancy occurred in the procuracy *de citra* with the death of Antonio Tron, but Vettor was not eligible because his brother Marco already held office there, brothers not being permitted to share office in the same corporation. At the same time, Hieronimo Giustinian, who had himself purchased a position in *de ultra* in 1516, raised similar objections against Vettor's possible placement there since Vettor was his son-in-law and theoretically barred. Eventually it was decided that Vettor Grimani should be co-opted into *de supra*, despite the presence of a first cousin, Francesco Priuli, there.[44] Whether the objections of his father-in-law were guileless or not, they helped to place Grimani in the most distinguished of the *procuratie* and the one which offered the greatest scope for his interest in building.

Vettor made further appearances in Sanudo's diaries, generally in an unfavourable light. In April 1523 Marco and Vettor supposedly blocked the possible abdication of their octagenarian grandfather because they did not want to give up the income or lodgings in the Doge's Palace that came with their grandfather's office.[45] A few months later Sanudo alleges that the brothers rode post-haste to Rome in order to secure the valuables of their dying uncle Cardinal Domenico, who had ignored them in his will.[46] They earned further black marks

from Sanudo in February 1528 when they gave a series of lavish banquets to celebrate their brother Marino's elevation to the cardinalate, while the poor were dying of plague and famine in the streets.[47] The following year Sanudo recorded in astonishment that Marco Grimani went from procurator of San Marco to patriarch of Aquileia in one day, acquiring the ecclesiastical office from his brother Marino.[48]

The picture of Vettor Grimani and his family that emerges from Sanudo's *Diarii* is of a hard-nosed and ambitious clan who manipulated the contemporary financial crises in Venice and Rome to promote their own interests.[49] Antonio Capello, Sansovino's other great supporter in the procuracy *de supra*, was apparently cut of similar cloth. He was born the son of Gianbattista di Marino and Paola, daughter of Marino Garzoni, around 1494.[50] His rise to high office, though less rapid than Vettor's, was nevertheless swift. Taking advantage of the barter in offices for money, he became *provveditore* at Legnago in 1516 and member of the Senate from 1521, this last for a loan of 400 ducats. In March 1523 he too became a procurator 'per expetativa', disbursing 8,000 ducats in cash when elected.[51] His initial unpopularity within the procuracy *de supra* was underscored at the official presentation to the Collegio in 1525 when none of the older procurators accompanied him.[52]

In the years that followed their elections, Grimani and Capello channelled their energies into the procuracy, gradually wearing down whatever internal hostilities there were. Capello was responsible for the restoration of the Treasury of San Marco, completed by 1530, but is perhaps best known for his supervision of the construction of the Library of San Marco, which he directed until 1553.[53] Capello was the chief promoter of the Loggetta and took a strong interest in the new tapestries for the choir of San Marco.[54] Outside his role as procurator, Capello was frequently in a position to bring state commissions Sansovino's way. As one of the Provveditori sopra il Ponte e la Fabbrica di Rialto in the 1550s, he was instrumental in arranging a competition for a new Rialto Bridge and for the erection of the Fabbriche Nuove, which was actually built after a design by Sansovino.[55] As a Provveditore sopra le Fabbriche di Palazzo in 1553–54, Capello helped to secure the commission of the two *giganti* (fig. 306) for Sansovino and again helped him secure the commission to build the Scala d'Oro in 1557–59 (fig. 432).[56] His acquaintance with Francesco Venier may also have been significant for the eventual assignment to Sansovino of that doge's monument (fig. 284).[57] More generally, the esteem that Capello enjoyed within Venice lent weight to his pronouncements in public matters and, inevitably, to his support for Sansovino.[58]

Grimani was, if anything, even more assiduous in his support for Sansovino. His awareness of Sansovino may have dated from the days of his uncle Cardinal Domenico or through the offices of his brother-in-law Marc'antonio Giustinian or even his brother Marco, who was also in Rome before the Sack.[59] The connection would have been maintained through the supervision of Doge Antonio's monument, which fell to Sansovino. Though never finished, it did provide an entrée into the Grimani circle during the sculptor's first years in Venice.[60] Vettor's interest in building may have been stimulated by the example of his grandfather, Doge Antonio, who as procurator *de supra* had been the prime mover in the reconstruction of the Procuratie Vecchie.[61] During the 1530s and afterwards, Vettor and his brother Giovanni turned their family palace at Santa Maria Formosa into a showcase of contemporary Roman art with works by Francesco Salviati and Giovanni da Udine.[62] His advocacy, from within the procuracy *de supra*, of the Library of San Marco must rank as Vettor Grimani's greatest single contribution to Sansovino's career. The history of the project has been examined by Deborah Howard, who stressed Grimani's role in the early stages of the building's gestation.[63] Grimani also took Sansovino's side in the one crisis in his relationship with the procuracy when a section of the Library's vaulting collapsed in December 1545. Similarly, Grimani played a decisive role in the negotiations between the procurators and the Council of Ten over the completion of the Zecca or Public Mint.[64]

Like Capello, Grimani's influence extended beyond the *procuracy*. He served as a go-between in Sansovino's dealings with the Cà di Dio in 1542, and, together with Capello, Grimani was nominated to supervise the completion of the church of San Geminiano in 1557, for which Sansovino furnished the design for the façade (fig. 191).[65] As noted previously, Capello and Grimani served on the Rialto committee in 1551 and were among the *provveditori* who awarded Jacopo the task of building the Fabbriche Nuove.[66] But his major contribution to Sansovino's patronage lay in the reconstruction of San Francesco della Vigna.[67] In 1542 Vettor acquired the right to build a monument to his grandfather the doge on the façade of the church and the rights to the first chapel on the left of the nave; he further gained the right to erect monuments to himself and other members of his family on the interior façade. Had his intentions been executed, these would have been among the most conspicuous monuments created by Sansovino, but they were abandoned with Vettor's death in 1558.[68]

Sansovino's relationship with Vettor Grimani seems to have been particularly close. It was to Grimani that Sansovino referred Ercole II d'Este when the block destined for his statue of Hercules was lost at sea; Grimani then offered a block of Istrian stone from those at San Francesco della Vigna for the execution of the statue.[69] Even more striking is the account of negotiations between the council of Brescia and the procurators for the services of their *proto*. The Brescian representative in Venice told the councillors that he went to Vettor Grimani to request a leave for Sansovino to visit Brescia, explaining that 'he can give permission for Sansovino to depart from here'. In addition, Grimani supported Sansovino's demand for transportation to Brescia by coach rather than horse.[70] The inference from this episode is that Sansovino was regarded by the procurators as their court artist and someone who had to be accorded the visible trappings of status.

Grimani may also have opened other doors for Sansovino by introducing him to future patrons within his own circle, such as Livio Podocataro and Federico Priuli. Podocataro was a satellite of the Grimani, and Sansovino designed a large monument for him in San Sebastiano (fig. 296).[71] Priuli was a first cousin of Vettor's, and his brother Francesco had also purchased the office of procurator *de supra* in 1522. It was possibly for Federico Priuli that Sansovino designed one of his earliest Veneto buildings, the Villa Treville near Treviso, which anticipated some of the features of the Villa Garzoni near Padua.[72] Together with another patron of Sansovino, Jacomo Cornaro, Priuli witnessed Sansovino's contract with the Arca del Santo in Padua for the relief of the *Miracle of the Maiden Carilla* (fig. 260), and his interest in Sansovino's work can also be seen in the copy of the *Christ in Glory* which he commissioned from Lorenzo Lotto (figs. 168–69).[73]

Naturally, other procurators, like Cavaliere Zuane da Lezze, and friends like Marc'antonio Giustinian played an important part in supporting Sansovino's career, although in the specific case of these two men no direct evidence of their commissioning works from Sansovino exists.[74] But it would give a false impression of Sansovino's Venetian career to suggest that it was succession of triumphs or that the artist spent all his time engaged on momentous projects. The office of *proto* was a bureaucratic post, and much of Sansovino's time was spent countersigning invoices, attending meetings of the procurators, checking broken windows, and the like.[75] This put obstacles in the way of accepting some private commissions and obviously dictated the pattern of Sansovino's Venetian career. Then, too, Sansovino's position was far from invulnerable, as events after the collapse of the Library's vault illustrates. In December 1545 part of the stone vault which Sansovino was constructing for the reading room of the Library fell, and as the person chiefly responsible for the building, he immediately fell into disgrace.[76] Sansovino was briefly put into prison and subjected to a hostile interrogation by the procurators; in a series of letters to mutual friends, Pietro Aretino makes plain the anger and envy which motivated the attack.[77] In the end, Sansovino had to make good the repairs out of his own pocket, although this was offset by an equivalent credit from

the procurators for the Loggetta bronzes and the second series of reliefs for the choir of San Marco.[78] At the same time, Sansovino's salary was suspended, not to be reinstated until February 1547.[79]

Occupying a position like that of *proto* was not unlike riding a tiger: it required deftness and constant attention in order to avoid disaster. That Sansovino managed it at all is a tribute to his talent as an artist and as a tactician. In balance, the benefits of his position definitely outweighed the disadvantages. Sansovino's Venice was a small, plutocratic society whose members either knew or were related to each other. This factor gave Jacopo's career a momentum that encouraged private commissions to come his way, and it was reinforced by his conspicuous position as *proto* of San Marco. Despite the mistrust and acrimony that cast a shadow over his last years as *proto*, Pietro Aretino and the sculptor's son Francesco were right in believing that Venice had as much to offer Sansovino as he gave in return.[80] Besides the patronage lavished upon him, Sansovino enjoyed a tranquil life away from the intrigues of a court society; like Dürer before him, Sansovino found himself treated like a gentleman and assimilated into the citizen class of Venice. These factors contributed to an atmosphere in which Sansovino could work effectively and from which he could not be lured to Rome or Florence or Ferrara.[81]

All of this lay far in the future when Sansovino arrived in Venice and slowly began to acquire commissions. By 1529 he had two from the Arca del Santo in Padua.[82] Over the next few years Sansovino designed a portal for the church of San Salvatore and carved the Arsenal *Madonna* and the *St John the Baptist* for the Frari, besides designing the church of San Francesco della Vigna, an altar for Santa Maria Mater Domini, and the tomb of Alvise Malipiero, formerly in Santa Maria Maggiore.[83] All of these after 1529 came on top of his steady employment with the procuracy *de supra* and his growing artistic commitments in that quarter. Eventually the demands of his position as *proto* of San Marco would exclude all but the most important sculptural commissions from other sources, but in his first years Sansovino was free enough and perhaps needy enough to accept single commissions from a varied clientele.

Probably the earliest surviving commission completed by Sansovino after settling in Venice was the tomb and altar for Galesio Nichesola in the cathedral of Verona (figs. 85–87, 90).[84] A wealthy Veronese nobleman, Nichesola held a canonry in his native cathedral in addition to the see of Belluno. He had lived in Rome and Venice, and Sanudo records his death on the Giudecca in a note dated 26 July 1527.[85] Earlier that year the elderly prelate drew up his will in Venice and requested burial in a chapel to be constructed in the transept of Verona Cathedral on the side of the campanile (i.e., to the right as one faces the high altar) or in another suitable location, to be determined by his executors. The chapel was to be dedicated to the Virgin of the Assumption, and a trust was established to ensure that the chapel would be built within two years of his death. The cost was to be at least 300 ducats, and two houses in Verona plus 200 ducats were set aside for a mansionary. As early as November 1527 the executors had purchased land to be placed under a trust administering the chapel.[86]

Nichesola planned his chapel to be large enough to accommodate both tomb and altar, but the intended concession of a chapel in the transept was countermanded by the bishop, Gian Matteo Giberti, who took possession of his see early in 1528.[87] Giberti had a strong interest in ecclesiastical reform as well as a dislike of conspicuous monuments in churches; in his first years in Verona he began a remodelling of the presbytery and crossing of the cathedral which would have conflicted with Nichesola's wishes.[88] The executors were, however, allowed to purchase the late fifteenth-century chapel of the Cartolari family, the first on the left when entering the nave.[89] The change of plan had meant that the executed tomb and chapel cannot have been begun before 1528; moreover, the necessary separation of the tomb and altar, because of the shallowness of the chapel, has obscured the relationship between Sansovino's tomb (fig. 85) and Titian's *Assumption* (fig. 90). Nevertheless, the altar and tomb appear to

have been erected between March 1530 and November 1532, for on the former date it is referred to as the altar of the Cartolari and on the latter is described as the 'altar of the Assumption, erected through a bequest of the Reverend Lord Galesio Nichesola'.[90]

Nothing in Sansovino's earlier sculpture prepares one for the general format or individual elements of the Nichesola tomb. But, considered together, the tomb and altar demonstrate that synthesis of Venetian vernacular and Central Italian elements common to the sculptural and architectural work of Sansovino in the Veneto. Reasons for the abrupt change in Sansovino's style can, in this case, be traced to the demands and expectations of his patrons, who would have expected something in a traditional funerary mode rather than an example of the Roman avant-garde of the 1520s. Sansovino recast the types of northern Italian altar and wall tomb along the lines of his own artistic language and Tuscan background.

For the altar, Sansovino had to design a frame incorporating Titian's large canvas, and this may have led him to adapt the kind of aedicule frequently employed in Venetian churches of the day.[91] The shafts of the columns, pilasters, and pilaster strips are given colour by the use of red marble, and smaller pieces of green and red marble punctuate the rest of the frame. This application of coloured marble follows an established Venetian convention, but the architectural details stand out as reflections of Sansovino's own style. In particular, the framing of the columns by pilasters and the presentation of the family arms on the columns' bases recur in Sansovino's work as does the combination of Composite capitals with a central bracket and corresponding Composite abacus.[92]

The Nichesola tomb presents an even more distinctive fusion of Venetian and Central Italian monuments. Its restricted site to the left of the altar precluded a very elaborate memorial; hence the decision was made to erect a pendant monument of a kind peculiar to the Veneto. Such tombs featured a sarcophagus with figures of the deceased and saints or virtues, and among the recent examples of this kind that would have been known to Sansovino and Nichesola's executors was the tomb of Giovanni Battista Bonzio by Giovanni Maria Mosca, installed in Santi Giovanni e Paolo around 1525–26 (fig. 91).[93] Its sober architectural framework and subtle polychrome inlay anticipate the general effect of the Nichesola monument. Sansovino conceived the Nichesola monument in similar terms of an effigy with smaller, ancillary figures, but instead of virtues adorning the sarcophagus, the Nichesola tomb has two putti, at the head and foot of the deceased, holding a mitre and a shield. Similar putti had decorated Florentine and Venetian tombs of the fifteenth century and were still to be seen on contemporary tombs during the first half of the sixteenth century.[94]

The Nichesola monument distinguishes itself from contemporary Veneto tombs through its presentation of the deceased with the Virgin and saints in an upper tier. Sansovino treats the figure of the bishop in the manner of the semi-recumbent effigies that Andrea Sansovino introduced into Roman funerary sculpture at the beginning of the century (fig. 13); it is a motif anticipated in only one Venetian tomb, that of Jacopo Pesaro in the Frari (fig. 92).[95] In both cases, the tombs are placed adjacent to the altar, with the deceased portrayed in a similar manner. Given the presence of Titian in both commissions, it seems unlikely that the Nichesola executors ignored the Pesaro altar when considering an analogous site in Verona Cathedral. Sansovino's solution for his tomb, however, is much subtler than that of the Pesaro tomb: where Pesaro is simply turned towards the spectator, Nichesola is rendered more horizontal with his left hand resting on his slightly raised left hip and his right arm and hand bent back to support his upturned head (fig. 85). The pose is doubly effective here because it allows the profile to be seen from below and creates thereby a relationship between the two registers of the monument. The figures of the upper register and their setting recall another Roman tomb, one not finished as planned but apparently known to Sansovino, Michelangelo's design of 1516 for the tomb of Julius II.[96] In both cases, a standing Virgin and Child are featured in the central bay of a Serlian arch while other figures occupy the lateral bays. This echoing of Michelangelo is not unexpected, given the strong traces of Michelan-

gelo's sculpture present in Sansovino's works of the previous decade, and Michelangelo's presence in Venice in the autumn of 1529 may have directed Sansovino's thoughts along such lines just as he was planning the Nichesola tomb.

Though there is a Michelangelesque flavour to the design of the Nichesola tomb, the individual figures of the Virgin and saints point in a different direction. They mark the beginning of a departure from Sansovino's Roman style of the *Virgin and Child* of Sant'Agostino and the *St James* for San Giacomo degli Spagnoli. It is a departure that would become even more pronounced in the sculpture of the next few years. With the Nichesola tomb, Sansovino not only scaled down a Michelangelesque design, but also invested the figures with a Quattrocentesque air (figs. 86–87). The *Baptist* is reminiscent of Donatello's *St John* in the Frari (fig. 97) but even more decidedly of Francesco di Giorgio Martini's analogous statue for the Confraternity of St John the Baptist in Siena (fig. 88).[97] Sansovino returned to the late Gothic tradition in conceiving his figure as adhering to a plane, its weight firmly based on the right leg. The head, though, is more idealized than in either Donatello's or Francesco di Giorgio's and is based upon the classical portrait busts of Aristotle, a copy of which must have existed in Sansovino's own collection of casts, as he returned to it several times in his later career.[98] The *St Sebastian*, too, is patterned upon a work much admired by Tuscan artists in the late fifteenth and early sixteenth centuries, Antonio Rossellino's *St Sebastian* in the Collegiata of Empoli (fig. 89),[99] though its movement has been reversed to accommodate its grouping with the central Virgin and Child and the head corresponds to a type frequently employed by Sansovino.

It is the central group of the *Virgin and Child* that stands out. It, too, derives from an earlier sculpture, but in this case a work from Sansovino's formative years in Andrea Sansovino's workshop, the *Virgin and Child* in Genoa (fig. 5), which Jacopo undoubtedly knew. As with the other figures, Sansovino has refined Andrea's composition, bringing it into line with his own artistic style. The continuing presence of Andrea Sansovino in his disciple's work is striking, as it comes some two decades after their period of collaboration; yet it makes perfect sense in terms of the flavour given to the figurative elements in Nichesola's tomb. Andrea's statue was already archaic by the beginning of the sixteenth century, and Jacopo has ironed out the Gothic curve from his version as well as recast Andrea's intricate loops of drapery in a pattern reminiscent of an antique figure like the *Juno Cesi* (fig. 18). Sansovino does retain the classicizing treatment of the Virgin's head and hair but focuses the expression by emphasizing the eyelids and the benevolent gaze of the Virgin. He strikes a balance here between the original state of his master's composition and a modest updating in terms of his experience of classical sculpture. It is unexpected that he should have chosen such a *retardataire* image for the centrepiece of his composition, but the same train of thought which brought to mind the sculpture of Francesco di Giorgio and Rossellino would have encouraged the use of Andrea Sansovino's Genoese work here. Thus the statuettes of the Nichesola tomb should not be dismissed as a stylistic regression from the Michelangelesque works of the late Roman period, but rather as evidence of a highly developed sense of stylistic decorum, distinguishing all of Sansovino's sculpture and architecture of the Venetian period.

As a group, the figures of the Nichesola monument also demonstrate Sansovino's penchant for integrated compositions. St Sebastian turns in and up towards the Virgin and Child who look down upon the face of the bishop while St John gazes directly at the spectator. Such an arrangement of figures within a composition had its roots in Sansovino's experience of earlier *sacre conversazioni*, particulary those of Andrea del Sarto (fig. 353) or in the treatment of the saints in Arnolfo di Cambio's tomb of Cardinal de Braye in Orvieto.[100] This concern for *ensemble* will become a continual motif in Sansovino's later Venetian sculpture from the Loggetta gods to the *Evangelists* and the virtues on the tomb of Doge Francesco Venier.

The Nichesola commission does not find direct echoes in Sansovino's later tomb projects, but the return to early Renaissance solutions in sculpture and architecture, the blending of

Central and Northern Italian motifs, is indicative of what has been called the 'visual opportunism' of Sansovino's Venetian period.[101] This is an aspect of Sansovino's artistic personality that has received little attention, and it may be worthwhile examining it here, in light of the divergent qualities of his early Venetian sculpture.

It would be difficult—and most probably distorting—to posit a single line of stylistic development for Sansovino's Venetian sculpture. This is not only because his various projects tended to overlap with one another, thus making a mockery of strict chronological development, but also because of the stimulus of a new artistic climate and new kinds of commissions. The period of the 1530s and 1540s was one of particular freedom and experimentation for Sansovino, and it effected a change of direction in his work. This led to a rediscovery of his own roots in Tuscan Quattrocento art and was largely predicated upon the art he saw around himself in Venice and the expectations of his new patrons. To someone like Sansovino, who had experienced the maturation of the High Renaissance in Florence and Rome, to have been in Venice in the late 1520s must have been like stepping back in time to an artistic climate which, with few exceptions, seemed underdeveloped by Roman standards. In retrospect, Sansovino's artistic progress could be described as the reverse of his friend Sebastiano's, and the disappearance of the Michelangelesque component in his early Venetian sculptures was matched by the cultivation of a style that was a form of Quattrocento revival. This stylistic evolution was not peculiar to Sansovino but can be seen in varying degrees in contemporaries like Bandinelli and Silvio Cosini as well as in younger sculptors like Tribolo.[102] Each in his own way sought to maintain stylistic links with the fifteenth century, untrammelled by the example of Michelangelo. In Sansovino's case, the resurgence of earlier artistic traits was consonant with his discovery of Venetian sculpture, especially of the generation before Tullio Lombardo, and of his rediscovery of Donatello, in particular the works in Venice and Padua. Reflections of these sculptures come to the fore in such works as the *St John the Baptist* in the Frari, the Arsenal *Madonna*, and the bronzes for San Marco and the Loggetta.

The marble statuette of *St John the Baptist* now standing in the Cornaro chapel of the Frari has long been admired as one of Sansovino's most accomplished Venetian works (col. pl. V, figs. 93–95). Already in Sansovino's lifetime, attention was drawn to it as a worthy companion to Donatello's wooden statue of the Baptist in the same church (fig. 97), and Sansovino himself expressed a wish to be buried beneath it in his will of 1568.[103]

The original patron, Daniel Giustinian, whose name appears at the base of the font, was an inconspicuous member of a large, noble clan.[104] Some light is cast upon the commission by his will, drawn up on 13 July 1534.[105] This document reveals that Giustinian lived near the Frari in the parish of San Pantaleon and that he requested burial in the Franciscan church, with a holy water font as his memorial. Thus the font executed by Sansovino was intended as a monument for Daniel Giustinian's tomb, and the commission probably came from his family in 1534.

Two other pieces of evidence support an early genesis for the statuette. One comes in a passage in Sansovino's will of 1568, where he asks for burial in the Frari:

> at the entrance to the chapel of the Florentine nation, by the door of the said church, where stands the St John carved by my own hand on the holy water font of the Giustinian. And because in the year 1533 I commissioned a marble sepulchre which is not finished, I wish that it be finished and placed in the wall, for great artists [*vertuosi*] should attend to leaving behind memorials of their achievements. I wish that this tomb be finished and placed on the wall, together with my bust in marble while on the ground there should be made a stone with a short inscription.[106]

The significance of the passage lies in the sculptor's decision to begin his own tomb in 1533, one year before the probable date of the commission for the font from Giustinian's executors.

As a Florentine, Sansovino must have long intended to be buried in his 'national' chapel in Venice, and it would not be surprising if the two projects coalesced in his own mind. The description of his tomb given in the will of 1568 conformed to the tradition of artists' wishing to be buried near one of their masterpieces, in this instance a figure which expressed Sansovino's best artistic capabilities.[107] The other piece of evidence is, by itself, less significant but gains in substance when read in the context of Daniel Giustinian's will. Around 1566 Francesco Sansovino sent a biographical sketch of his father to Giorgio Vasari for use in the latter's revised edition of the *Vite*.[108] In that sketch Francesco Sansovino places the *Baptist* earliest among his father's Venetian sculptures.

When placed in the context of his sculptures of the early 1530s, the *Baptist* can be seen as comparable to the saints on the Nichesola tomb or the Arsenal *Madonna* in representing a return to a Quattrocentesque style. It derives from the traditional type of the young Baptist or San Giovannino, popular in Italy from the thirteenth century.[109] At the turn of the sixteenth century, a number of terracotta *Giovannini* were produced in Florence, and Jacopo made one of the finest in the seated *Baptist* now in the Bargello (fig. 11).[110] The features of the terracotta *Baptist* are cast in a Sansovinesque mould and show an obvious affinity with the youthful appearance and reflective expression of the marble saint in the Frari. Similar, too, is the way in which his robe hangs in large folds about his waist. Here, as with the statuettes of the Nichesola tomb, Sansovino has delved into his earliest artistic experiences, refining his ideas for a different context and medium.

The composition has also been recast in the light of Sansovino's study of the antique. In pose, the seated figure is patterned upon the *Daphnis*, a figure from the celebrated group of *Pan and Daphnis*, which is now in the Uffizi but was then in the della Valle collection in Rome.[111] The *Daphnis* is almost identical in height to the *Baptist* and is an equally poetical presentation of a seated boy. The pose, however, has been reversed, and Sansovino gave his figure a scroll in lieu of pipes. The impassive expression of the *Daphnis* would not have been appropriate for a Christian saint; instead, the head of the *Baptist* has been tilted back and to the right while the brow is knit and the lips parted. There may well be a recollection of the younger son of Laocoon in the cast of the *Baptist*'s features, but the helmet-like cut of his curly hair was modelled upon another classical head, that of the *Spinario*, which Sansovino probably copied in his youth.

Sansovino made the marble *Baptist* into a paragon of his abilities as a sculptor. This is evident not only in the extraordinary passages of technical virtuosity, such as the placement of the arms and legs, and the remarkable folds of the camel's skin, but also in the delicacy of sentiment. The pose takes the principle of the *figura serpentinata* and applies it to a seated figure: a spiral movement starts with the propulsion of the right leg, continues through the torso's diagonal movement, and culminates in the elegant curve of the neck and head. It was probably so conceived because it would have been seen by anyone entering or leaving by the north door of the Frari from the left, from the right, and straight on. Hence the care with which Sansovino employed a curving movement in order to make the *Baptist* equally striking from any of these vantage-points.

The rock on which the figure sits contributes an almost Leonardesque degree of verisimilitude in differentiating the kinds of vegetation growing round it. This effect must have been even stronger before the font received a cover in the early nineteenth century, for, prior to that, the rock would have been seen emerging from the water of the bowl. This may have alluded to the medieval tradition of the youthful Baptist's periods in the wilderness where he rested in a meadow, 'which had about it many lovely and large junipers and other shrubs, and at one side a beautiful stream of water'.[112] Such is the equilibrium of Sansovino's work that these individual elements do not distract from its emotional content. But it is, above all, the wistful expression on the saint's face that remains the dominant impression of the *Baptist*, and this was, as Vasari indicated, a realm of art in which Sansovino had no peer.[113]

No evidence survives to explain why Sansovino was chosen to carve the Giustinian font or when it was finished. Daniel Giustinian was only a distant relative of Sansovino's close friend Marc'antonio Giustinian, and this family connection may have played no part in the commission. On the other hand, as the holy water font was to be adjacent to the Florentine chapel, it may have seemed obvious to Giustinian's executors to discuss the issue with the Florentine consul or simply to approach Sansovino as *the* Florentine sculptor in Venice. Though the work was in place by 1556, it is more likely to have been finished much earlier in Sansovino's Venetian career when the sculptor was still youthful enough and unencumbered by other projects to cope with carving it. In the absence of a conclusive *terminus ante quem*, a date of ca. 1534 seems appropriate.

The site chosen by Giustinian or his executors for the font throws some light on another aspect of Sansovino's figure, namely the way in which he presented it. As noted above, the location was adjacent to the chapel of the Florentine community. The Council of Ten originally granted the Florentines the right to a chapel in Santi Giovanni e Paolo in 1435, but the venue was changed to the Frari the following year. The site was a substantial one, encompassing the north aisle from the main entrance to the transept door.[114] Dedicated to St John the Baptist, the chapel also served as a baptistry for the church, and in 1438 Donatello furnished his wooden statue of the Baptist for the chapel, possibly as the result of an appeal by the Florentine community to Cosimo de' Medici (fig. 97).[115] The chapel enjoyed the same location until the nineteenth century when there was a shuffling of altars which also prompted the removal of the Giustinian font to the Cappella Emiliani. The separation of the font from the Florentine chapel passed unnoted in the discussions of Sansovino's figure, but proximity to Donatello's Baptist would have inevitably conditioned Sansovino's presentation of the same subject. Indeed, Francesco Sansovino's guidebook states that the two statues actually faced one another, making a direct comparison of the two sculptors' handiwork inevitable.[116] Sansovino, therefore, deliberately chose a different image of the Baptist, one that allowed scope for his gifts as a technician and as an interpreter of the *affetti*. Hence, too, his reworking of the seated youthful figure of the Bargello terracotta becomes comprehensible in light of comparisons with Donatello's gaunt and wizzened image of the saint.

It would be difficult to say exactly when Sansovino finished his *Baptist*. As the years passed, the length of time taken over his projects became considerable, a reflection of the growing demands on his time by public and private commissions. The evidence presented here does suggest that this particular commission came early in his Venetian career rather than late; in all probability, it would have been dispatched shortly after its genesis, which must have been around 1534. Whatever its date of creation, the *St John the Baptist* occupied a special place in its creator's affections, and rightly so.

Donatello also figures, more directly this time, in the formation of another sculpture from Sansovino's early Venetian years, the Arsenal *Madonna* (figs. 98–99). Like the Nichesola tomb and the *St John the Baptist*, it shows an unexpected aspect of the sculptor's artistic personality. So different is it from his other sculptures that some scholars have wished to subtract it from Sansovino's autograph works.[117] Indeed, the peculiar nature of the work resists an easy categorization. Its high quality and the importance of the commission argue against Jacopo's having left the statue solely to assistants for execution, and its archaic duality may have originated instead with the type of composition Sansovino was asked to produce.

The Arsenal was still one of the major industries and the largest employer of labour in Venice in the 1530s.[118] Since its foundation in the twelfth century, the Arsenal steadily expanded until it occupied a large portion of the easternmost *sestiere* or district of the city by the sixteenth century. The main land entrance to the complex was from the Campo dell'Arsenale which lies between the Campo di San Martino and the Rio dell'Arsenale. Passing through the mid-fifteenth-century entrance, one comes upon a small vestibule with

an aedicule bearing two inscriptions. On the frieze is carved: ORA·PRO·NOBIS·SAN[C]TA·
DEI·GENITRIS (sic); on the base of the aedicule is: IDEM ANIMVS EADEM VOLUNTAS. Beneath the
aedicule is the date M·D·XXXIIII, with three coats of arms and accompanying initials. The
base of the statue itself carries the signature IACOBVS SANSOVINVS FLORENTINVS F[ACIEBAT].

The date of 1534 has an obvious importance for the chronology of the statue, and the coats
of arms enable us to establish more precise *termini* for the commission. The shields are those of
the *patroni* or lords of the Arsenal in that year, and their names are Gasparo Contarini,
Hieronimo Zane, and Antonio Calbo. As elections of the *patroni* were staggered, the charge to
Sansovino must have fallen between 13 May 1533, when Antonio Calbo entered office, and
18 October 1534, when Gasparo Contarini left it; this leaves a seventeen month period in
which the terms of the *patroni* overlapped and the statue would have been, in all probability,
executed.[119] No documentary evidence concerning the Arsenal *Madonna* exists, and one can
only speculate upon how Sansovino obtained the task. The noblemen involved were not
members of the powerful group who proved so influential in Sansovino's Venetian career,
nor do they appear to have patronized him afterwards. It is plausible that the recommendation
of Sansovino may have come from higher up the Venetian social structure. Sansovino's name
could have been put forward within the ducal college, from the doge and his advisers who
concerned themselves with developments in the Arsenal, or it could have come from Andrea
Gritti himself. At this date, Sansovino was the only major sculptor active in Venice, and his
position within the procuracy *de supra* would have conferred upon him a conspicuousness
beyond any competitors.

As for the subject of Sansovino's statue, this was probably dictated by one or more of three
factors: the Virgin's role as one of the chief protectors of Venice; her particular association
with the Arsenal; and the statue's inscriptions and location within the Arsenal complex. The
Virgin's roles as patron of Venice and as chief intercessor in the Catholic scheme of salvation
hardly need emphasis.[120] Whether there existed a formal precedent for the Virgin as
protectress of the Arsenal is difficult to say, though there was a medieval painting of her on
the external wall of the complex on the Rio dell'Arsenale, just the other side of the canal from
the land entrance.[121] During Andrea Gritti's reign, this mural showed itself to be miraculous,
drawing alms that were eventually awarded to the hospital of the Pietà in 1537. No causal
connection can be proven here, but the popularity of this image and its contemporary
celebrity may have influenced the subject matter of Sansovino's statue. However, the chief
explanation for the sculpture can probably be found in its inscriptions and location within the
complex. As Timofiewitsch observed, the phrase 'Ora pro nobis' derives ultimately from the
oldest of Marian invocations, the *sub tuum praesidium*, in which the Virgin's role as *Theotokos*
or Mother of God and chief intercessor is stressed. This conception is reinforced by the second
inscription, which does not come from a recognizable devotional text but emphasizes the
identity of spirit and will between the Virgin and Christ.[122] The statue's location is also
significant in that it stands not only within the main land entrance to the Arsenal, but also
above the quarters in which the *patroni* were required to live during their term of office. Thus
the Arsenal *Madonna* served the purpose of a talisman or votive image of the kind often found
in Venetian government offices and in the Doge's Palace itself.

Given the context of the Arsenal Madonna, it can be said to have presented Sansovino with
a commission about which his patrons would have definite preconceptions. Its archaic flavour
can be seen as an accommodation to Veneto-Byzantine images of the *Theotokos*, like the relief
of the *Madonna del Baccio* in San Marco or the mosaic of the enthroned Virgin and Child over
the portal of San Giovanni in the atrium of the basilica (fig. 103).[123] This is especially clear in
the presentation of the Christ Child: he is exhibited by the Virgin, his expression solemn, his
eyes staring straight ahead, while in his right hand he holds an orb as sign of dominion; the
Virgin, in this context, can be understood as the throne of Christ, the *sedes sapientiae*.[124] The
remote and almost primitive character of the Arsenal *Madonna* is so unlike any other image of

the Virgin and Child by Sansovino that one can only assume it was a deliberate departure from his normal practice in order to fashion a sixteenth-century version of an icon, much as Giovanni Bellini did with his devotional panels of the Virgin and Child (fig. 104).[125] Bellini's paintings of this subject form a distinctive category in his *oeuvre*, one in which the morphology and presentation of the figures stand apart from his practive elsewhere. Sansovino apparently adopted a similar approach here, although his choice of models was rather different.

Vasari tells us that when Donatello was in Padua, he was asked to make a wooden figure of St Sebastian for some nuns, modelling his statue on an older image.[126] It may well be that Sansovino's attention was directed to an icon or medieval sculpture in a similar fashion; but he did certainly look to a type of Quattrocentesque Tuscan sculpture that seemed well adapted to his task. In particular, his marble groups shows an appreciation of Donatello's decidedly Byzantine *Virgin and Child* on the high altar of the Santo in Padua (fig. 100).[127] Given Sansovino's connections with that church, he would have had plenty of opportunity to study it and Donatello's bronze reliefs. The *Virgin and Child* must have represented an aspect of Donatello's art that Sansovino probably did not know before settling in Venice. From it, he borrowed the distinctive use of intersecting ovals that describe the contours of the design, the impassive presentation of the Child holding the orb, and such details as the cherubic clasp on the Virgin's mantle.

While Donatello's *Virgin and Child* would have been an apposite model for the kind of statue Sansovino was required to produce, his employment of it was seasoned by recollections of an early sculpture by Michelangelo. This was the Bruges *Madonna* (fig. 101), a work Sansovino would have known from the days of his apprenticeship in Florence and one which Raphael had earlier adapted in his *Madonna del Cardellino* and *Belle Jardinière*.[128] The Bruges *Madonna* was one of the most Quattrocentesque of Michelangelo's youthful works, drawing upon that same tradition from which Sansovino emerged but filtered through an experience of Leonardo's art. The similarly low viewpoint in both sculptures, their Donatellesque headdresses and their elaboration of draperies seem too close to be merely coincidental; Sansovino must have had Michelangelo's sculpture in mind when planning his own. With the Arsenal *Madonna*, drapery becomes a central element in the composition as its undulating patterns define the sequence of ovals from the head of the Virgin through her torso and legs. It overflows her seat, and the deep cutting of the marble allows the surface to reflect a variety of tonal nuance, which is one of the statue's most distinctive features.

The predominent impression left by the Arsenal *Madonna* is of a work resolutely grounded in a Tuscan style though not reminiscent of Sansovino's most recent Roman sculpture. We are a long way from the classicizing ethos of the Martelli *Virgin and Child* (fig. 68), and this volte-face is one of the most remarkable in the career of a Renaissance artist. It is also instructive for an understanding of Sansovino's frame of mind in his early Venetian years: when compared with native works like the Lombardesque *Virgin and Child* of the clocktower or the *Madonna della Scarpa* in the Zen chapel (fig. 102), the Arsenal *Madonna* shows how little Sansovino drew upon his immediate local predecessors for inspiration.[129] The classicism of the Lombardo brothers and their followers may have struck him as inert, but his recent experience of Michelangelo's Roman manner may have seemed equally inappropriate, given the kind of art that Venetians preferred. Instead, Sansovino returned to his own native tradition, to the works with which he grew up, in order to find a style complementary to but distinct from contemporary Venetian sculpture. It was an aspect of his artistic personality that he continued to develop throughout his Venetian career.

A bronze *Virgin and Child* by Sansovino can be dated to the period between the Nichesola tomb and the Arsenal *Madonna*. It exists in numerous versions, but the only signed and authentic example is that now in Cleveland (figs. 112–14).[130] The bronze is not a copy or cast from the *modello* for the marble figure as has sometimes been maintained, for it is approxi-

mately half the size of the Virgin and Child on the tomb. It also differs subtly in pose, registering an even greater distance from the original model by Andrea Sansovino and a closer approximation to the ethos of Donatello's bronzes for the high altar of the Santo. The bronze has been slightly modified to turn it into an independent composition by directing the gaze of the figures more to the right instead of downwards. There is less of a curve in the Virgin's torso, and her drapery receives greater attention than in the Nichesola group. These divergencies indicate that the marble served as a point of reference for the bronze, and it was reconstituted by Sansovino as an independent work of art.

The purpose for which the bronze *Virgin and Child* was cast is not recorded. It does testify to Sansovino's continuing fascination with Donatello in the early 1530s, the period of the Arsenal *Madonna* and of Sansovino's first years of involvement with the Santo in Padua. Its approximation to Donatello in pose and dress has often been observed, but the similarity extends to the cast of the Virgin's features. They are reminiscent of the heads of the Virgin and Santa Giustina on the high altar of the Santo and share the same schematic treatment of the head with prominent eyes, full, slightly parted lips, and more meticulously defined waves of hair. Sansovino also seems to have borrowed the motif of the two strands of hair appearing from beneath the Virgin's hood from Donatello's Santo bronzes. The Cleveland *Virgin and Child* can also be seen as one of Sansovino's first experiments with what will become his preferred medium in the next decade, bronze.

The 1530s witnessed a number of individual commissions for Sansovino and his collaborators. Some of these, like the Merceria portal of San Salvatore and the Malipiero tomb for Santa Maria Maggiore, will be discussed in a later chapter, but two works should be mentioned here since they are stylistically related and were probably conceived around 1535.[131] They are the sacramental tabernacle in Santa Croce in Gerusalemme (figs. 110–11) and the terracotta *Annunciation* now in the Thyssen collection (col. pl. VI, figs. 105–06). The sacramental tabernacle bears an inscription with the date 1536 and is documented as by Sansovino in a letter Pietro Aretino wrote the sculptor in November 1537.[132] It was commissioned by the Spanish cardinal Francisco Quignones for the apse of his titular church, where he was buried in 1540.[133] Santa Croce in Gerusalemme enjoyed a succession of Spanish titular cardinals who rebuilt and embellished the apse of the church in the fifteenth and earlier sixteenth centuries. Cardinal Pietro Gonzales de Mendoza restored the balustrade, gave new choir stalls, and may have been responsible for the frescoes in the apse; he was succeeded by Cardinal Lopez de Carvajal, who had the lateral altars built and furnished new marble seats. He died in 1523 and was buried in the apse.[134] Thus the sacramental tabernacle of Cardinal Quignones formed part of a well-established tradition. Its basic design and use of coloured marble invite comparison with the Loggetta in Piazza San Marco, which was also under way in the late 1530s. and the monument seems more comprehensible in terms of Sansovino's contemporary Venetian architecture than it does in its Roman context. What we see today, however, is not exactly what Sansovino intended: the monument was altered in the eighteenth century when the floor level of the presbytery was lowered and its base given an extra fascia of marble; the decorative features above the central pediment may also have been added at this time, as they are also anachronistic for Sansovino's architecture or, indeed, for Roman architecture of the sixteenth century. The only sculptural features that could have issued from Sansovino's shop are the central ones of the *tempietto* and kneeling angels (fig. 111). The little temple has strong overtones of Bramante's Tempietto at San Pietro in Montorio although the attic storey and Brunelleschian dome seem more Sansovinesque. The bronze angels are descended from Donatello's in dress and general appearance, and their generalized, vaguely classical features can be compared with other youthful figures by Sansovino, notably in his bronze reliefs for San Marco, in the marble relief of the *Maiden Carilla*, and especially in the figure of Gabriel from the Thyssen *Annunciation* (fig. 105).

However Sansovino was chosen for the commission, it is unlikely that he designed the structure much before the middle of the 1530s, nor would his role in the affair have meant a

return to Rome: he could easily have sent designs for the architectural membering from Venice, and the angels and temple could have been made under his supervision and then dispatched to Rome. The Quignones tabernacle certainly has the appearance of a work designed elsewhere than Rome, and its sculptural and architectural components are compatible with Sansovino's Venetian works of the 1530s. Although it occupies a peripheral place in Sansovino's oeuvre, its interest lies in its relationship to other commissions of the same period, in particular the Thyssen *Annunciation*.

The *Annunciation* in Lugano is unusual in Sansovino's *oeuvre*, as it is his only surviving pigmented terracotta (figs. 105–106).[135] Most Renaissance terracottas were painted to make them appear more naturalistic and more decorous, but changes in taste dictated that they should be stripped bare of colour and returned to a 'natural' reddish-brown surface. The Thyssen *Annunciation* is composed of two figures of an intermediate size between statuettes and large-scale works, and nothing is known of it before 1900 when it appeared in Florence, reputedly from a Ferrarese collection. Recognized as by Sansovino, the *Annunciation* met with acceptance in critical writings earlier this century but dropped out of discussion until the past few years.

Like the *Baptist* in the Frari, the *Annunciation* has a freshness and distinctly Tuscan quality which could suggest an early work by Sansovino. But neither an early dating nor the previous tendency to place it among Sansovino's later work of the 1550s seems correct. Despite certain similarities with his pre-Venetian sculpture, its strongest stylistic links are with works that were being developed during the late 1530s or shortly thereafter. It has been compared with the Loggetta bronzes, notably *Peace* (fig. 218), and this is highly apt because in both cases one sees that preference for verticality which distinguishes so many of Sansovino's figures in the early 1540s.[136] The resemblance between the Gabriel and the bronze angels of the tabernacle in Santa Croce in Gerusalemme has already been mentioned, and the terracotta can be compared particularly with the angel on the spectator's left in terms of its inclination, the facial expression, the distinctively long lock of hair, and the manner in which the drapery reveals the bare, left leg (fig. 111). In both cases, the matrix of the figure is essentially Donatellesque, although the Gabriel's pose is less conventional and more virtuoso. The striking pose of the Virgin with her head turned to her right and her right hand at her breast finds a correspondence in one of the female spectators in the relief of the *Maiden Carilla* (fig. 264), a work contracted by Sansovino in June 1536. Again, the morphology of the two females in question has a basic similarity, although the woman in the relief is on a larger scale and much more monumental in form.

It is plausible to suggest a dating of around 1536 for the Thyssen *Annunciation*. We know even less about its origins than we do of the tabernacle in Santa Croce in Gerusalemme, but the scale and medium of the work point to a private altar as its destination. From the middle of the 1530s Sansovino was involved in modelling in clay for the bronzes of San Marco, and the *Annunciation* could well be a by-product of that process. In terms of technique, it can be linked with earlier traditions in terracotta, for Sansovino embellished the figures by applying gold leaf covered with a glaze to give the effect of red lustre on the Virgin's robe and the angel's tunic, something found on fifteenth-century terracottas and on at least one of the *cartapesta* reliefs produced by Sansovino's workshop.[137] The use of such a technique may have served to compensate for the relatively humble nature of the basic medium of clay.

The fifteenth-century aspect of the group extends to its presentation as well as its technique. Like most Florentine treatments of the theme, there is here a reminiscence of Donatello's Cavalcanti *Annunciation*, especially in its sense of dramatic incident and its contrapuntal arrangement of figures.[138] Beyond that general indebtedness, the Virgin is saturated in the style of Donatello: her classical coiffure and fillet as well as the mould of her features derive from Donatello's bronze *Faith* on the baptismal font of Siena Cathedral (fig. 108), while her hood and heavy folds of drapery down her back evoke the *Judith* (fig. 107).[139] It may be that Sansovino's choice of models here was prompted by the way in which the *Faith* turns sharply

to the right, suggestive of a Virgin Annunciate. It indicates once again how Sansovino's formative experiences in Florence emerged in his Venetian years.

The Angel Gabriel has a stronger association with Venice and Sansovino's friendship with Titian. The pose is ambiguous, a cross between a bow and a genuflection, but is possessed of a bravura comparable to Titian's studies of similar figures in movement, the *Annunciation* now in the Scuola Grande di San Rocco (fig. 109) and the lost *Annunciation* originally intended for Santa Maria degli Angeli in Murano.[140] Both of Titian's paintings treat the same theme of descending movement in a similar fashion and employed the same features of the serpentine curve and rather effeminate features of the angel. Sansovino's angel is by no means a copy of Titian's, but he could hardly have been unaware of either painting, especially as the later *Annunciation* was the painter's only major altarpiece of the 1530s and the subject of a glowing account by their mutual friend Aretino.[141]

While it would be wrong to insist too heavily upon an explicit relationship between the Thyssen *Annunciation* and Titian's paintings of the same subject, the comparison does throw light upon the dramatic quality with which Sansovino invested his figures. This could well have been in response to features that Sansovino admired in his friend's painting or, perhaps, an example of the competition between painters and sculptors, generally referred to as the *paragone*. Certainly Sansovino's bronze reliefs of the mid-1530s and later responded to the painterly qualities which that medium could express, and he could have found a stimulus for this in contemporary Venetian painting.[142] As the interests of Titian and Sansovino overlapped, it would be surprising if they did not influence each other. One instance of Titian's responding to Sansovino can be seen in the large *St John the Baptist* of around 1530–32 (fig. 351).[143] The sculptural quality of the figure has often been remarked, and Sansovino's name has been mentioned in this context more than once. The painting is unique among Titian's works of the 1530s, almost made to forestall later criticisms of Venetian inadequacy in *disegno*: hence the figure's monumental quality, the concentration on its anatomy, particularly that of the torso, and the distinctive *contrapposto*, all implying recourse to a sculptor's model. Titian's *Baptist* recalls Sansovino's Roman *St James* in its pose, though reversed, and in its weightiness (fig. 80).[144] Although there is no specific source in Sansovino's surviving work for Titian's *Baptist*, it is extremely close in its basic pose to a small Sansovinesque bronze now in the Cà d'Oro (fig. 350), presumably after a lost model by Sansovino.[145]

The existence of the small bronze lends credence to the possibility that Titian here copied a model by his friend. Indeed, the model may have been available to other artists, for a similar version of the *Baptist* was carved by a minor Lombardesque sculptor, Giambattista da Carona, on the exterior of the Cappella Emiliani at San Michele in Isola (fig. 352).[146] Finished by 1531, the statue is one of a pair with a *St Margaret*, which is itself so unlike the *Baptist* that one can only conclude that, in his *Baptist*, Giambattista imitated Sansovino. It is a notable example of Sansovino's early impact upon his Venetian contemporaries; taken together with Titian's painting, it bears witness to the importance of Sansovino as a source of new ideas for Venetian artists from the 1530s onwards.

The sculptures reviewed here mark the first decade of Sansovino's Venetian career. Disparate in media and status, they illustrate none the less the rapid transformation of Sansovino's sculptural style from a Central Italian idiom influenced by Michelangelo and late Raphael to one drawing upon Sansovino's origins in fifteenth-century Tuscan sculpture. In part, this change was imposed by external conditions such as the expectations of Venetian patrons and local artistic conventions; in part, it must have been conditioned by Sansovino's impressions of Venetian art and his encounter with Donatello's Venetian and Paduan works. Running through Sansovino's Venetian sculpture and architecture is a clear sense of a choice of style that could harmonize with prevailing circumstances, drawing upon his roots in Central Italian art as well as stimuli he found in the Venetian scene. In the case of his sculpture, it was, paradoxically, never more Florentine than after he settled in Venice.

IV. The San Marco Bronzes and the Medici Tabernacle

FROM 1 APRIL 1529 until his death on 27 November 1570, Sansovino's official title was *proto-magister* or chief architect of San Marco. As we have seen, this appointment gave him security and prestige as well as access to a network of patronage that proved crucial to his Venetian career.[1] It also meant that much of Sansovino's working life was bound up with projects closely identified with the procurators, particularly, the transformation of the Piazza San Marco with the creation of the Library and Loggetta and responsibility for the fabric of San Marco itself. The maintenance of San Marco occupied more of Sansovino's time than might be imagined, for, in addition to supervising structural repairs, Sansovino inspected and advised on the work of craftsmen and mosaicists, set payments for journeymen, and intervened in a host of practical problems related to the doge's chapel.[2] Besides this, San Marco was the setting for some of Sansovino's most inspired sculptural creations: the reliefs of miracles by St Mark, the statuettes of the four evangelists, and the Sacristy door. These works, together with the Loggetta gods and the Medici Tabernacle, were executed in bronze, a medium unknown in Sansovino's pre-Venetian sculpture but one with profound implications for his sculptural development.[3]

The veneration of St Mark and his physical presence beneath the high altar imparted to the doge's chapel a status and ceremonial privilege long acknowledged within the Catholic Church.[4] It was also the focal point of state ceremonies and of lavish spending on the part of the procurators. In 1561 Francesco Sansovino estimated that more than 10,000 ducats per annum were consumed by priests, staff, candles, and other requirements of the church.[5] In an age in which religious and political gestures were often indistinguishable, the decoration and functions of San Marco reflected the preoccupations of the Venetian state. The deeds of Mark's ministry were present in the mosaics of the Basilica; they were invoked as well in the liturgy of his feast-day.[6] At his investiture, each new doge would swear upon the tomb of the evangelist to protect the rights and prerogatives of his chapel.[7] Indeed, for the doge, San Marco represented one of the few aspects of public life over which he could exercise personal authority. It was for this area that Jacopo Sansovino executed a number of projects, effectively recasting the interior of the *cappella ducale* in a mid-sixteenth-century idiom. In addition to the bronzes, new stalls and a new ducal throne, all with inlaid panels and with tapestries to cover the stalls on feast-days, and new tribunes were created, in each case with designs or supervision by Sansovino. Together, these works made the choir and presbytery of San Marco a more coherent entity, comparable to the appearance of the state chambers in the ducal palace.

Before Sansovino's term as *proto*, little had been done to create an artistic unity in the decoration of the choir of San Marco. The greater problem of the safety of the cupolas had left little time or money for other considerations.[8] Sansovino's first task had been to secure the

structural stability of the cupolas, and this was followed by a restoration of the sanctuary, which was effectively rebuilt by him along modern lines. By the middle of the 1530s, the question of improving the interior of the choir appears to have been raised, for several projects, all dealing with the choir, had been approved by the procurators. It may be that the procurators' attention was directed to the choir as a result of the recent resolutions passed in the *Maggior Consiglio* to clear obstructions from the Piazza; both cases reflect a growing awareness among Venetians of the representational function of public places.[10]

The choir of San Marco was divided into two sections for liturgical purposes. The first or *coro maggiore* was reserved for the doge and those officials most closely associated with him. The second section, elevated by two steps, served as presbytery and choir for the canons of the chapel. The *coro maggiore* was defined by the iconostasis to the west, by the presbytery steps to the east, and by the paired arches separating it from the chapel of St Peter to the north and from the chapel of St Clement to the south (figs. 144, 146). It was entered through the chapel of St Clement or through the central portal of the iconostasis. To the right of the portal stood the doge's throne, made of walnut with gilded columns and a pediment. The throne probably resembled those in the state chambers of the ducal palace, and next to it a row of seven stalls extended along the inside of the iconostasis. They were four Venetian feet in height (1.35 m) and contained decorations in inlay. These seats were occupied by the papal nuncio and other ambassadors who attended the doge on public occasions. A second, grander row of stalls began at the corner of the iconostasis and went a distance of seventeen feet (5.76 m) towards the east end of the church, slightly over half the length of the choir. The second row had six stalls reserved for the magistrates of the six *sestieri* or districts of Venice; above them three panels of inlay, depicting Fortitude, Faith, and Charity, rose to a height of five feet (1.69 m). A final piece of inlay stood in the passage leading to the chapel of St Clement. Eight feet in length, it ran perpendicular to the end of the stalls and contained the figures of St Mark and his lion.

The composition of the stalls and marquetry to the left of the throne complemented those to the right: a row of smaller stalls along the length of the iconostasis, followed by larger stalls with three compartments for the virtues of Prudence, Temperance, and Hope, and a corner panel with the figure of St Theodore, the first patron of the doge's church.[12] The procurators, any male members of the doge's family, and knights of the Republic occupied those stalls on the left-hand side of the choir. The combination of stalls and inlay gave further definition to the area reserved for the ducal court. Much of the ground between the stalls was taken up by six rows of pews for government officials and the senators obliged to accompany the doge in his chapel. On such occasions, four tapestries of the life of St Mark were placed on the backs of the larger stalls and over the inlaid panels of St Mark and Theodore. Woven in Florence in 1551, the tapestries appear to have been designed by Andrea Schiavone under the supervision of Sansovino (fig. 382).[13] Above, the larger stalls were surmounted by two *pergoli* or tribunes, the only one of Sansovino's contributions to the choir still in its original position.[14] They contain bronze reliefs that portray the ministry and miracles of the patron saint of Venice.

Knowledge of the pre-Sansovinesque choir is scant, but in all probability the interior as built by Sansovino replaced a medieval choir with a similar format. This would be consistent with the isolated references to the ducal chapel in Sanudo's diaries of the early 1500s and with the weight of tradition, always an important factor in Venetian architecture.[15]

Of all the projects for the choir, the stalls have suffered the most vicissitudes. The throne, stalls, and pews were removed in the nineteenth century when San Marco became the patriarchal seat.[16] The compartments of inlay fell victim to 'improvements' carried out in 1955.[17] Before they were removed from the choir, the panels of inlay were photographed *in situ* (fig. 147). These photographs point to the interrelationship between the stalls and Sansovino's *pergoli*, something confirmed by the proximity of their dates and by the existence of a medieval tribune, encased in brick, which was found beneath the inlaid panels on the

V. *St John the Baptist*, Cornaro chapel, Santa Maria dei Frari, Venice (cat. no. 13)

choir's right-hand side (fig. 150).[18] Obviously, the introduction of the new stalls obscured the medieval tribune and would have made the creation of a new one necessary. The height of the new stalls allowed for a more monumentally conspicuous tribune to continue the decorative scheme of the choir. In order to insure that the tribunes were visible from below, Sansovino supported them with bands of Istrian stone. Also, in keeping with the decoration of the church's interior, the tribunes were made from pieces of coloured marble; the Doric semi-columns are of pink *breccia* and the relief frames are composed of *pavonazzetto*.

Documentary evidence points to a common genesis for the stalls and tribunes. On 7 June 1535 two carpenters received 40 ducats as a preliminary payment for work on the stalls of the choir, 'according to the design made by the hand of Misser Zahomo Sansovin'.[19] Three days later the procurators drew up a memorandum for the execution of the ducal throne and stalls; apparently the ducal throne was furnished by August 1536 when its Corinthian capitals were cited as models for those of the altar of the Confraternity of the Virgin in Santa Maria Mater Domini (fig. 414).[20] Early in 1538 the procurators' account books list a substantial payment for the gilding, carving, and carpentry of the throne and stalls, which may have been the final settlement for the artisans' work.[21]

The first of the *pergoli* to be completed was the one to the right of the ducal throne (fig. 147).[22] By late 1536 the Doric columns flanking the bronze reliefs were being fluted; early in the following year the marble was being polished. The casting of the bronze panels followed shortly thereafter. Sansovino's design would have been familiar to the Venetian public as a variant of a type of fourteenth-century wall sarcophagus used in the tombs of St Isidor and of the doges in the atrium and baptistry of San Marco.[23] The format suited a decorative programme of relief panels bordered by figural or quasi-architectural elements. The result in Sansovino's tribunes was an archaic prototype modernized through the classical nature of its decoration.

The subject of the first reliefs focused upon Mark's ministry in Alexandria where he legendarily founded the Christian church and established an apostolic succession through his first convert, St Anianus. They were identified in Sansovino's own account submitted to the procurators as the baptism of Anianus (fig. 134), St Mark casting out demons and healing the halt and maimed (fig. 136), and the saint's martyrdom, when he was dragged through the streets of Alexandria while a storm rained down upon his attackers (fig. 138).[24] They were stories made familiar, not only by their repetition in the decoration of San Marco, but also in the contemporaneous cycle of paintings for the Scuola Grande di San Marco; the healing and baptism of Anianus had previously been the subject of two monumental, classicizing reliefs by Tullio Lombardo for the façade of the same confraternity's building.[25] Their choice gave Sansovino his first opportunity to demonstrate to the Venetian public his skill as a narrative artist, and as he began to design the reliefs, he would have been aware of the inevitable comparison with Venetian artists.

Relief sculpture was not entirely new to Sansovino. He had had extensive experience of it during the preparation of temporary architecture raised in Florence for Leo X's entry in 1515.[26] According to Agostino del Riccio, Sansovino also designed two reliefs for the chapel of his great Florentine patron Giovanni Gaddi in Santa Maria Novella; his terracotta models were eventually translated into marble by Giovanni Bandini around the middle of the century (figs. 348–49).[27] Bandini's records of the lost Sansovino reliefs are of great importance because they show a decided continuity between his Florentine and Venetian relief style. The *Marriage of the Virgin* of the Gaddi chapel is particularly close to the San Marco reliefs in its rhythmic distribution of figures across the first plane of the relief and against a classical arcade. The Virgin and her attendants also belong to the same female types that can be seen in the later bronze panels, while the integration of an architectural perspective with foreground figures in the *Presentation of the Virgin* (fig. 348) anticipates the same features in the *Baptism of Anianus* in San Marco (fig. 134).

VI. *The Annunciation*, Thyssen-Bornemisza Collection, Lugano (cat. no. 15)

The continuity between Sansovino's early relief style and the first series of bronzes for San Marco is strengthened by the large terracotta relief now in the Bode Museum in Berlin (fig. 128).[28] The *sacra conversazione* can be dated to the years 1534–35, as its female figures bear a close relationship to Sts Lucy and Barbara on Tiziano Minio's altar of San Rocco, a work documented to 1535 (fig. 293).[29] The Berlin relief displays that same combination of large-scale figures seen against a backdrop of classical buildings that one finds in the Gaddi and San Marco panels. The work in Berlin is one of the most interesting of Sansovino's surviving models and may have been intended as a preliminary study for a bronze relief, never actually cast. The presence of Sts Francis and Clare suggests a Franciscan destination for the work, and the appearance of St James and an unidentified female martyr (perhaps St Catherine of Alexandria) on the left may afford some indication of the patron's identity. In any case, the relief was turned into a decorative work through the use of gilding on the architecture and of marbling on the Virgin's throne. Both the Berlin and Gaddi reliefs illustrate a common approach to relief sculpture, whether narrative or not, one carried over into the first three bronzes for the choir of San Marco. Such differences as there are can be explained by the more dramatic subject matter of the San Marco series and by the intervening experience of Donatello's and Bellano's declamatory style in the Santo bronze reliefs.

The choice of bronze for the tribune reliefs in San Marco also led the way to the later bronze projects in the ducal chapel. For these works, bronze was the most splendid material, as its prolific use in the chapel of Cardinal Zen bears witness.[30] The Venetian interest in bronze had been revived by Verrocchio's Colleoni monument in the 1480s, and Leopardi proposed bronze doors for the Doge's Palace in the following decade.[31] Though the doors were never executed, the suggestion did bear fruit in the shape of the standard bases for Piazza San Marco between 1501 and 1505 (figs. 224–26). In practical terms, bronze offered the perfect medium with which Sansovino could create a model and then leave to others the tedious process of casting. This had much to commend itself to Sansovino during the decade from the mid-1530s to the mid-1540s, a period in which his activity reached its greatest pitch of intensity.

The first stage in the creation of the bronze reliefs would have been the making of terracotta models, and two of these survive in the Palazzo Venezia in Rome (figs. 130, 133).[32] They are splendidly impressive works, despite some surface abrasions, and allow one to see the painstaking preparations that lay behind the finished bronzes. They impress, not only in their dramatic content, but also in the number and variety of figures presented and in the breaking down of the crowd into component elements of two or three figures, some of great delicacy. Their subjects are St Mark healing a demoniac and the martyrdom of the saint; the latter is essentially the original of its corresponding relief, but the former differs considerably in poses and treatment of several figures from the final version. Consequently, it could not have been the casting model for the *Demoniac*, but a preliminary one, which was altered by Sansovino and his workshop in a lost casting model. It is, however, a better indication of the expressive nature of Sansovino's ideas than the final version, as the features of the individual figures are more sharply individuated. This makes the poignancy of groups like the women around the recumbent figure all the greater than in the bronze, which tends to blur and spread facial features. On the other hand, the *Martyrdom* is so close to the final bronze as to appear to be the model employed in casting. The numerous small details found in the finished bronzes but absent from the terracottas would have been added by the workshop in the wax cast from the terracotta. This would include such details as the fluting of the columns, the decoration on the structures in the background, and the like. It is the kind of drudgery that a hard-pressed artist like Sansovino would have had to relegate to his studio.

Any attempt to create a narrative cycle on the life of St Mark would inevitably raise comparisons with the ambitious redecoration of the chapel of St Anthony in the Santo in Padua, for which Sansovino himself had only recently contracted to carve a marble relief. Above all, the Santo boasted the rich legacy of bronze panels by Donatello and Bellano in its

choir, works which served as a touchstone for artists from Mantegna and Riccio to the Lombardo brothers.[33] The stimulus of renewed contact with Donatello's bronzes affected Sansovino's relief style, especially if one compares the San Marco bronzes with the marble copies of his reliefs for the Gaddi chapel in Florence. The San Marco reliefs are more highly charged, more dramatic, even in the relatively static scene of the *Baptism of Anianus* (fig. 134). As a whole, the first three bronzes bear a stronger imprint of a study of Donatello and also Bellano than is the case with the second series of a few years later. Sansovino took away from his examination of the Santo bronzes an impression of Donatello's creation of a perspective surround for the miracles of St Anthony, the dramatic nature of his scenes, and the variety of reactions expressed by spectators at the miracles; he seems to have been struck by the impressionistic nature of Bellano's use of bronze in the choir reliefs in the Santo. The scenes of the miracles and death of St Mark show Sansovino's attempt to synthesize elements from the distinctive styles of both masters. The care with which the Doric arcading of the *Demoniac* and the church interior in the *Baptism* have been drawn attests to the influence of Donatello. In the *Demoniac*, the outlines of the columns were incised in the wax so that they would stand out and create an illusion of depth. Likewise, the same technique was applied to the interior setting of the *Baptism of Anianus* to enhance its visibility.

The development of the architectural backdrop is, however, much less ambitious in Sansovino's reliefs than is the total ambience created by Donatello in works like the *Miser's Heart* or the *Repentant Son*. As Sansovino's reliefs were primarily designed to be seen from the floor of the choir, his figures are chiefly confined to the main plane of the panel and are highly rounded, in some cases to the point of resembling statuettes. They establish the sense of depth within the reliefs, while the architectural element becomes more of a backdrop. Most modern photographs obscure this point, as they are taken on the same level as the reliefs, but we can see that Sansovino has drawn the architectural perspective as if we were looking up into the scenes. This is chiefly notable in the *Baptism of Anianus*, where we see the vaults of the church (fig. 134), and in the *Demoniac*, where we are looking at the soffit of the Doric entablature (fig. 136). Sansovino established his scenes within a classical world, suggestive of Alexandria but essentially in terms of his own architectural idiom. Hence the *Martyrdom* takes place before a Loggetta-like structure, and the church in which Anianus is baptised recalls Venetian churches like San Salvatore and San Geminiano. *St Mark healing a Demoniac* is placed against an arcade reminiscent of Raphael's tapestry cartoon of the *Healing at the Beautiful Gate*; Raphael had shown St Peter healing the lame man against a classical portico seen in perspective, and it may be that Sansovino called upon this when he had to produce a similar episode from the ministry of St Mark. Indeed, Raphael's tapestries constituted a recent series of narratives in the tradition of Donatello's Paduan reliefs or Alberti's *De pictura*, and it is not surprising that so many commentators have linked Sansovino's reliefs with Raphael's cartoons even though the influence seems to be more one of approach and method than of specific citations.[34]

Sansovino also pays attention to nuances of costume in order to convey a suitably exotic setting for his reliefs, but it is more restrained, less self-consciously oriental, than, say, the paintings by Bellini and Mansueti for the *albergo* of the Scuola Grande di San Marco.[35] Here Mark wears a toga, and some spectators, turbans; those attacking him in the *Martyrdom* are dressed like Barbarians, and the group fleeing on the right of that relief appears to have been lifted from a scene of the Dacians in flight on Trajan's Column (fig. 137).[36]

The great care Sansovino lavished on these reliefs is evident, not only in their architectural vistas, but also in the number and complexity of their figures. The manner in which the figures have been arranged in groups and sub-groups around a central event has an obvious affinity with Donatello's miracles of St Anthony. Sansovino shows himself here to be a worthy heir to the narrative tradition of Donatello and Raphael by his ability to enhance the impact of a given miracle through the variety of responses of the spectators. His reliefs are wonderfully evocative in the gamut of reactions shown by the persons caught in the storm in

the *Martyrdom*, ranging from surprise to fear and resignation at the impending disaster (fig. 138). Even more striking is the way in which *St Mark healing a Demoniac* has been subdivided into three distinct elements without impairing the subject's unity. The central miracle is complemented by two groups of waiting spectators: those behind Mark's back are a rogues' gallery of deformed and maimed figures, while those on the other side of the panel are constructed round a moving vignette of women in lamentation over a recumbent body (figs. 131, 136). This latter group is reminiscent of similarly private groups, like the mourners round the swooning Virgin in Sansovino's Roman *Descent from the Cross* now in the Victoria and Albert Museum (fig. 28), or the women supporting the Virgin in the *Entombment* on the Sacristy door (fig. 159). With the *Demoniac*, the group of mourning women has the effect of a visual caesura; wrapped up in their own emotions, they are virtually oblivious to the miracle taking place beside them. It is an extraordinary *coup de théâtre* to place such contrasting images side by side without jarring the total impression, but here, as in the *Entombment*, Sansovino manages this extraordinary double feat.

The attention paid to the grouping of the figures is evident in all three of the first series of panels, both individually and as a group. The figures establish a depth of field through their own greater or lesser relief; at the same time, their movements are carefully coordinated to give greater coherence to their actions. For example, the *Martyrdom*'s figures move in a line from the centre of the panel to its extremities and become more three-dimensional in the process. When seen from an angle, the figures appear to be pushing beyond the bounds of the relief in a swelling arc (fig. 133). Much the same sense of sweep is built into the *Demoniac* with its extraordinary piling up of spectators on the left-hand side of the panel (fig. 131). In a somewhat different fashion, the *Baptism of Anianus* establishes a parallelogram of figures swaying from left to right while St Mark establishes a countermovement from right to left (fig. 134). Not only has Sansovino grouped the figures in an extremely calculated fashion, but he has also varied their scale, giving particular emphasis to Mark by increasing his size in comparison with those around him. Sansovino does this so cleverly that we are not immediately aware of it, but it is evident in the *Baptism*, where his greater scale is somewhat mitigated by Mark's bending over, and in the *Martyrdom*, where the saint has been placed on a level below the other protagonists in the scene.

Seven assistants are listed in the procurators' accounts as being involved in the casting of the first series of reliefs.[37] This has been interpreted as a sign of Sansovino's remoteness from the project, although a better explanation would be that bronze-casting required special skills which many sculptors lacked. Of the seven men paid by Sansovino, Zuane Campanaro and Tiziano Minio were specifically paid for providing and casting the bronze. Both men came from families associated with the craft of founding, and Minio was a protégé of the influential Paduan Alvise Cornaro.[38] Minio gravitated to Sansovino's circle in the years prior to the casting of the first tribune reliefs, his first major work being the altar of the Confraternity of San Rocco, which exhibits an obvious dependence upon the style of Jacopo Sansovino. In 1536 Minio witnessed the contract for the altar of the Virgin in Santa Maria Mater Domini, and over the next ten years was employed by Sansovino and the procurators in a number of capacities. Minio and the founder Campanaro took slightly more than one-third of the money disbursed for the first tribune reliefs. The relatively small sums given to the other workmen suggest correspondingly small services; one imagines that Tommaso Lombardo, Luca, Alvise, and the other sculptors involved in producing the bronze panels performed such tasks as making any changes in the models before casting, assisting in the creation of piece-moulds for casting, and cleaning and polishing the bronzes after casting. Tommaso Lombardo and Luca were also engaged on the project of the marble *Madonna* for San Marco during this same period (fig. 121) and appear to have been trustworthy lieutenants in the realization of Sansovino's models for the panels.

No data survive for the construction of the second *pergolo*, but it was probably finished by

March 1541 when the first payments for the manufacture of the second series of reliefs began. The bronzes were cast in 1542, but cleaning and polishing extended into 1544.[39] The theme of the new panels concerns three posthumous miracles of St Mark: the salvation of a servant from Provence, who came to Venice to venerate the saint's relics without his master's approval; the healing of a paralytic woman from Murano; and the conversion of the master of the Provençal servant (figs. 141–43).[40] Significantly, they were not among the well-known legends of the saint, nor did they figure in the mosaics of San Marco. They had, however, an obvious narrative attraction and complemented the earlier scenes of Mark's active ministry with a testimonial to the miracles worked by his relics; it paid an indirect tribute to the church of San Marco as guardian of the saint's body while providing Sansovino with great opportunities for drama and expressiveness.

Stylistically, the second series constitutes a departure from the previous one. The individual figures are slenderer and are presented more in a row across the front of the panel. Drapery patterns and gestures have been reduced to a minimum, and there is a corresponding simplification of figural types. While the outer panels with the stories of the servant and his patron still employ an architectural background, this, too, is modified in character. The central panel has a more experimental backdrop of clouds which were made by drawing a palette-knife across the wax, and, as Weihrauch noted, this relief is probably the one mentioned in Sansovino's accounts as having been recast.[41] This impasto-like effect is reminiscent of the Sacristy door (fig. 160), and the nude statue in the niche of the relief of the *Patron* brings to mind the *Apollo* of the Loggetta (fig. 213).

The change may, in part, have been a corrective to perceived deficits in the earlier reliefs as much as deliberate stylistic change. Sansovino may have appreciated what some later commentators censured in the first reliefs, namely, that their ambitious narratives were lost in the dimness of the choir. Broader and simpler gestures, less complex backdrops, were more easily perceived. At the same time, the later reliefs demonstrate an affinity with the aesthetic ideals of mannerism as practised by Sansovino's younger contemporaries in Central Italy. The reliefs place a greater premium on grace and virtuosity of poses than was the case with the earlier series; hence the preoccupation with figures in various stages of rising and falling, as in the three tormentors of the servant, who seem to be studies of the same figure in motion (fig. 141). Or, again, in the contorsions of the converted patron or the figure bowing to the ground in the *Paralytic Woman*, Sansovino pursues an aesthetic not unlike that praised by Aretino in a drawing of the Israelites collecting the manna by Vasari. Aretino enumerated the variety of reactions of the crowd, the delineation of the sexes and the various ages of the persons represented, and in particular, one nude 'which, bending towards the ground, shows both its front and back and acts like a magnet to the eyes by virtue of its easy forcefulness and with the grace of its unforced ease'.[42]

Sansovino's interest in this kind of artistic challenge was probably fostered by his contact with the influx of Central Italian artists who worked in or passed through Venice in the late 1530s and early 1540s. Among them were Francesco and Giuseppe Salviati, Giovanni da Udine, Cellini, Tribolo, and, of course, Vasari himself. Several of these were patronized by members of Sansovino's circle: both Francesco and Giuseppe Salviati were employed by Vettor and Giovanni Grimani as was Giovanni da Udine; Giuseppe Salviati received a commission for frescoes in the villa of Federico Priuli through the recommendation of Sansovino, if Ridolfi is to be believed; and Sansovino obtained the painting of the ceiling of Santo Spirito for Vasari, who later abandoned the project.[43] This evidence and the subsequent employment of Andrea Schiavone as the designer of the tapestry cartoons in San Marco confirm a predilection for what would now be called mannerist art on the part of Sansovino and his circle in Venice, and this predilection is amply confirmed by his own bronzes of the 1540s.

Sansovino's attraction to the new *maniera* of Central Italy dovetailed with his own artistic

origins as much as with the contemproary climate of Venice. His apprenticeship to Andrea Sansovino put him in contact with the traditions of fifteenth-century Florentine sculpture under a master who never entirely shook himself free from the world of Ghiberti. Then, too, when faced with the task of creating panels in bronze, Sansovino would have had little guidance from contemporary sculpture. Thus it is not surprising that he reverted to the example of Donatello and Bellano in Padua and even drew upon his memories of Ghiberti's doors in Florence. They were the masters who had established the potential of bronze as a narrative medium, and it was upon their tradition that Sansovino built. Sansovino's second series of reliefs and the Sacristy door drew even more upon the general example of Ghiberti than was the case in the first tribune reliefs. Here one can speak of a demonstrable effect from the Florentine trip of 1540, for Sansovino obviously took advantage of the occasion to refresh his memory of Ghiberti's work. He seems to have been particularly impressed by the Gothic reminiscences of Ghiberti's north door with its emphasis upon figures in high relief against a sketchily defined background.

The recurrent apparition of St Mark becomes a binding element between the panels much as the angel does in Ghiberti's *Nativity* and *Annunciation* (fig. 161).[44] Likewise, the two small panels of St Mark and his lion on the ends of the *pergoli* betray a reminiscence of the evangelists and fathers of the church found on Ghiberti's north door. Though slight, the two panels of St Mark are of interest because they show Sansovino in a whimsical mood, and the droll juxtaposition of the saint and his lion anticipates similar features in the sculpture of Alessandro Vittoria (figs. 452, 456).[45]

The style of Sansovino's bronze reliefs must have come as a surprise to a public accustomed to the more rigidly classicizing style of relief sculpture of the Lombardo brothers. More than his *Maiden Carilla* for the Santo, Sansovino's bronze reliefs for San Marco veered away from the example of antique sculpture in the direction of a painterly style which found its greatest expression in the Sacristy door. Sansovino's intentions were quickly taken up by Venetian artists in the late 1530s and 1540s. Individual figures from the first reliefs were translated into stucco by Tiziano Minio for the decoration of the Odeo Cornaro (fig. 416) and later into bronze for the cover of the baptismal font in San Marco (fig. 423). Minio and Danese Cattaneo also agreed to make relief panels for bronze gates to adorn the Arca del Santo in Padua, although the project was abandoned by the early 1550s.[46] The influence of the *pergoli* of San Marco may even have reached Florence after Cellini's famous visit to Venice in 1542, for Cosimo I agreed to a proposal by Cellini for marble pulpits with bronze reliefs and a bronze door for Santa Maria del Fiore, ideas probably suggested to the sculptor by what he knew of Sansovino's projects.[47]

Painters, too, took note of Sansovino's narrative style. Domenico Campagnola made a precise copy of *St Mark healing a Demoniac* after its installation in San Marco (fig. 135).[48] More ambitiously, the young Tintoretto strove to vie with Sansovino in his large canvas of the *Salvation of the Servant of Provence* for the Scuola Grande di San Marco (fig. 140). The idea of a new cycle of paintings for the confraternity was mooted as early as 1542, and such a commission evidently led Tintoretto to study Sansovino's reliefs with care.[49] His painting of 1547 is the most important testimonial to the novelty of Sansovino's narrative style in mid-century Venice, and it becomes all the more impressive when one reflects upon the extreme disparity between the scale of the bronze panel and Tintoretto's painting after it. The explanation for this interest is furnished by Aretino, who, in a letter to Sansovino in 1537, praised the earlier bronze reliefs for their 'marvellous interweaving of figures'.[50] And it was Sansovino's skill in balancing unity and variety that won for the bronze reliefs the praise and attention of artists and connoisseurs alike.

As the execution of the two *pergoli* drew to a close, Sansovino turned his attention to the second portion of the choir, the *coro minore*. In addition to the clerical stalls and throne of the *primicerius* or chief priest of the ducal chapel, this was the area in which the high altar, the altar

of the Sacrament, and the entrance to the sacristy were located. Around 1550 Sansovino began work on a new enclosure and a series of evangelists for the high altar.[51] The bronze figures are recorded as being placed upon a balustrade before the high altar by the beginning of 1553, two years after the first payments for their manufacture were entered in the procurators' accounts. No date is given for the construction of the balustrade, although it was described as recently finished in February 1551. Since the balustrade was comparatively small and probably made from stone kept in the procurators' storage room, its cost would have been minimal.[52] The expense of the bronze *Evangelists* would have proved an inconsiderable burden on the procurators, for their total cost of 170 ducats was less than either set of tribune reliefs and was further reduced by a contribution of 50 ducats from one Nicolò di Zuane Strazarno.

Until the early seventeenth century, when the lateral chancel rails and bronze *Doctors of the Church* were added to the choir, the high altar and Sansovino's *Evangelists* had been more conspicuous in their isolation. The altar was raised upon four steps and surrounded by the four highly carved alabaster columns that supported the ciborium of green marble. Behind the *mensa* stood the *pala d'oro* and two columns with the figures of the Archangel Gabriel and the Virgin Mary, serving as a reminder of Venice's legendary founding on the Feast of the Annunciation.[53] The balustrade erected by Sansovino was in three sections, with the largest enclosing the *mensa* and two smaller sections serving as a ceremonial entrance to the altar. The *Evangelists* were placed in pairs above the two frontal balustrades and remained there until 1834, when the high altar was rebuilt and the balustrades dismantled. The *Evangelists* now stand on the lateral, seventeenth-century balustrades and are accompanied by Girolamo Paliari's *Doctors of the Church*.[54]

Sansovino's balustrade and sculptural complex would have struck visitors to the church as an impressive *ensemble*, and pale reflections of its setting can be seen in an eighteenth-century engraving by Antonio Visentini (fig. 177) and in a ninteenth-century reconstruction by Antonio Pellanda (fig. 179).[55] From these one learns that the balustrade sustained the *all'antica* effect of the choir tribunes through the use of the same Doric order for its balusters. As with the earlier tribune reliefs on the legend of St Mark, the figures of the evangelists themselves were based upon traditional Venetian iconography. The type of Sansovino's seated evangelists (figs. 182–85) would have been familiar to Venetians through similar representations of the apostles and evangelists in the Pentacost and Ascension cupolas and in the medallions of the evangelists on the *pala d'oro*.[56] Moreover, the presence of the thirteenth-century seated *Evangelists* on the roof of the ciborium would also have been a contributing factor in the design of Sansovino's bronzes.[57] The repetition of this pose in Sansovino's *Evangelists* suggests that it may have been expected by his patrons.

A combination of figures and balustrade could have been suggested to Sansovino and the procurators of San Marco's by the example in the church of Santa Maria dei Miracoli.[58] The half-length figures and classicizing balustrade which the Lombardi designed for the Miracoli would have been a conspicuous example for the task faced by Sansovino at San Marco. Both presbyteries contained an object of popular worship surrounded by images of propitiary saints, though in San Marco the presence of the evangelists also referred to their invocation in the ceremony of ducal investiture. Before his presentation to the people, each new doge was brought to the altar precinct where he swore upon the high altar and upon the gospel to protect the state and honour the church of San Marco.[59] In addition to the quasi-political role of the evangelists in the investiture of the doge, the bronze figures also gave substance to the symbolism of the Emmanuel cupola overhead. There, the signs of the evangelists appear in the pendentives with the following phrases above them: *Quaeque sub obscuris / de Christo dicta figuris / His aperire datur / His Deus ipse notatur.* The signs and words, which refer to the vision of Ezekiel (I:10), invoke the evangelists as the fourfold manifestation of the Word of God; such an invocation would have been made explicit by the reading from the book of Ezekiel on the feast day of St Mark.[60] Thus the twin concepts of the evangelists as witnesses of the ducal

oath and as the embodiment of divine *logos* would have been expressed by the presence of Sansovino's bronze figures upon the altar balustrade.

The *Evangelists* represented an important commission for Sansovino, offering him a rare opportunity to create sculpture that would be seen from several viewpoints. Dislocation from their former setting and proximity to the imitative *Doctors of the Church* have lessened their impact. Their present arrangement—Luke and Mark to the left, Matthew and John to the right as one faces the high altar—does not reflect their original setting, but only in recent times has the question of their initial sequence before the high altar been raised.[61] The engraving by Visentini throws light on this problem by showing three of the four figures (fig. 179). The most clearly discernible is the *St John* on the right of the entrance, and, although the companion figure on the immediate left is not visible, the outer ones can be read as *St Luke* to the far left and *St Matthew* to the far right. By elimination, then, *St Mark* would have been opposite *St John*, a solution which would have followed the presentation of Mark and John on either side of Christ on the roof of the ciborium and in the medallions of the *pala d'oro*.[62] Hence, from the altar's point of view, the most prominent positions would have been given to Mark as patron of the church and to John as the only one of the evangelists to have an altar dedicated to him in the ducal chapel. Moreover, the placing of Luke with Mark and of Matthew with John would also be in keeping with the ancient distinction between the younger evangelists and the elder apostles.[63]

An order of figures which reads, from left to right, Luke, Mark, John, and Matthew would also impart to the group of bronzes a definable stylistic coherence (figs. 182–85). The pose of their heads and bodies gains a sense of orchestration: the comparatively unemphatic Luke and Matthew would have closed the sequence on either side, while the more dynamic Mark and John would have formed a counterpoise about the entrance to the altar. The interplay of movement to create an ensemble was characteristic of Sansovino's other sculptural groups like that of the Nichesola tomb in Verona or the bronzes of the Loggetta, in which the dynamic figures of *Mercury* and *Apollo* pivot towards the entrance, while the attention of *Minerva* and *Peace* is directed towards the Piazzetta.

From the time of Burckhardt onwards, a Michelangelesque reminiscence has been noted in the *Evangelists*, and Sansovino's memories of the prophets on the ceiling of the Sistine Chapel obviously served as a point of departure for the bronzes.[64] The most directly indebted to the Sistine ceiling is the *St John* with its strong suggestion of Michelangelo's *Isaiah*, but Sansovino has recast the figure in a more mannerist idiom, comparable to Michelangelo's reworking of the same figure in a drawing of the 1520s (fig. 178).[65] The head of the figure points to another source of inspiration, Donatello. Sansovino has placed the head of the *St Jerome* in Faenza (fig. 312), a work traditionally ascribed to Donatello, on a Michelangelesque body; its ascetic features and patriarchal mane recommended it to Sansovino as a model for the evangelist just as it did to Andrea del Sarto for St Onophrius in his Gambassi *Madonna* in the Pitti and in the altar for San Domenico Sarzana, formerly in Berlin.[66]

The only surviving terracotta for the *Evangelists* is a preliminary model for the *St John*, now in Berlin (fig. 180).[67] It is very much a sketch model, predominantly made with spatula and claw, and it was probably shown to the procurators for approval and then reworked for casting. In the final stage, Sansovino made the drapery folds more complex, the figure slightly enlarged, and the hair framing the brow in long strands, instead of being brushed back as in the terracotta. The elaborate system of correction indicates the close appraisal to which the *Evangelists* would have been subjected.

Sansovino also turned to Donatello for the idea behind his *St Luke* and *St Matthew* (figs. 182, 185). They recall the seated *St John* which Donatello furnished for the Florentine campanile.[68] Sansovino's *St Matthew* presents the disproportionate torso and emphatic gesture of the right arm across the lap as Donatello had arranged them on his statue of the evangelist. His *St Luke* strikes a pose complementary to the *St Matthew*, but slightly modified

and in reverse. This is a stylistic trait that can also be seen in the *Pallas* and *Apollo* of the Loggetta where the two figures were created through modifying one basic pose (figs. 210, 213). Like Michelangelo's *Isaiah*, Donatello's *St John* has been adapted by Sansovino to a mannerist canon of form; where Donatello lengthened the torso of his *St John* to counter a foreshortened view from below, Sansovino employed the same technique of elongated forms purely as an aesthetic preference in his *Evangelists*.[69] Indeed, among Sansovino's sculptures of the 1540s and 1550s, the lengthened torso was virtually a stylistic hallmark. Another general trait shared by the *Evangelists* is the pronounced treatment of the brow. This also derives from Donatello's example, particularly in works like the *St Mark* where the prominent brow was intended to convey strength of character (fig. 82).[70] With the *Evangelists*, it contributes a sense of vivacity to their expressions while imparting a quality of spontaneity associated with wax or terracotta models.

The monumentality of form with which the *Evangelists* have been invested belies their small scale. *St Mark* dominates the group by the impressive sweep of his figure and by the exaggerated musculature of his back and left arm (fig. 183). In face and pose the saint conforms to a type popularized by Titian in his *St Mark Enthroned* (now in the Sacristy of Santa Maria della Salute) and followed by the Zuccati in their mosaic of St Mark over the main portal in the atrium of San Marco.[71] Like the St Mark in the mosaic, Sansovino's figure was given the clerical tonsure and pontifical robes that tradition held to be Mark's as spiritual heir and apostolic designate of St Peter. The presence of two such images of the saint, the mosaic of 1545 and the bronze of the next decade, is more than coincidental. Both images would have been a reminder of the line of apostolic succession which came to the Veneto through the ministry of St Mark; they would also have been read as a reminder of the traditional independence that the Venetian church enjoyed from all but the most minimal of papal claims.[72]

The last bronzes designed by Sansovino for San Marco, the Sacristy door and the portal of the altar of the sacrament, differ enormously in the degree of freedom allowed their author. The small portal, probably the later work in execution, had to be incorporated in a pre-existing altar, whereas the Sacristy door enabled Sansovino to achieve one of his most imaginative works (col. pl. VII, figs. 151–52). Yet, in spite of their differences, the two works have a stylistic relationship as well as an overlapping of Passion themes dictated by their similar roles with respect to the Eucharist.[73]

Conceived around 1545, the Sacristy door was one of only a few bronze doors executed during the sixteenth century, but was not an isolated phenomenon.[74] Peruzzi also designed a Ghibertian bronze door for Siena Cathedral in the 1520s (fig. 163). In addition, Serlio, who knew Peruzzi's project, published a series of illustrations on how to make a bronze door in his fourth book, first published in 1540 (fig. 162).[75] It may well be that Sansovino's bronze door was being projected as early as the middle of the 1530s when the first tribune was under way. Aretino alludes to Sansovino's making a bronze door in a letter of 1537, perhaps an indication of the sculptor's intention.[76] Even more remarkable was the decision by the Scuola Grande di San Marco to commission a model of a bronze portal for its *albergo* in 1542.[77] Two years later, the confraternity decided to have the door cast by a founder from the Arsenal, but the project languished thereafter. One does not know the author of the model, but the likelihood is that it was Sansovino, who acted as *proto* for the confraternity from 1546. The growing interest in such a project and rivalry with the Scuola Grande di San Marco may have spurred the procurators of San Marco into commissioning the Sacristy door from Sansovino in 1546.

Ghiberti cast a long shadow across all designs for bronze doors in the sixteenth century.[78] Clearly Sansovino would have made a special study of Ghiberti's Baptistry doors when he returned to Florence late in 1540. As noted before, Sansovino's renewed contact with Ghiberti helps to explain the salient features of the Sacristy door. Sansovino, like Peruzzi in his drawing for Siena Cathedral, adapts Ghiberti's format to the tastes of his times. Both Peruzzi

and Sansovino rationalize the wealth of Ghibertian detail in their own projects: where Peruzzi has large narrative scenes alternating with smaller ones, Sansovino concentrates upon two relief panels separated by recumbent prophets. Both artists also give prominence to the architectural members of their doors, with a view towards greater coherence and clarity.

Sansovino introduces other features to make the programme of the Sacristy door more coherent. The curved frame enhances the overall design by drawing the lateral figures of the four evangelists into the main scenes in the manner of a triptych. Their poses, both in the treatment of drapery and in their *contrapposto*, are quintessentially Tuscan, and two of them, the Sts John and Matthew (on either side of the Resurrection) (fig. 160), show a clear derivation from Michelangelo's unfinished *St Matthew*. This is most evident in the figure of St John, which simply reverses Michelangelo's apostle; the figure of St Matthew shares with the *Mercury* of the Loggetta a more complex relationship with Michelangelo's work.[79] Six heads also punctuate the Sacristy door in a manner reminiscent of Ghiberti's Gates of Paradise. Only three can be securely identified on the basis of Francesco Sansovino's description in his guidebook of 1581; they are Sansovino (fig. 154), Aretino, and Titian (fig. 153), who figure on the upper left and right and centre left, respectively. The remaining three heads have been the subject of many conjectural identifications, ranging from Palladio and Tintoretto to Veronese and the two Palmas.[80] Without some documentary evidence, the identification of these remaining heads must remain conjectural, but the most youthful of the three, the one on the centre right (fig. 155), bears a strong resemblance to the features of Francesco Sansovino as they appear in the woodcut accompanying his *Del secretario* of 1565 (fig. 436). The presence of Jacopo's son on the Sacristy door would make sense; Ghiberti, too, had included a portrait of his son Vittore on the Gates of Paradise.[81]

The Sacristy door is the great masterpiece of Venetian bronze-relief casting of the High Renaissance. Its impressive scenes of the *Entombment* and *Resurrection* surpass Sansovino's earlier reliefs in their exploitation of bronze as an artistic medium. In addition to their exceptional quality, the fascination of the panels lies in the commingling of several influences felt by Sansovino in the early 1540s. In particular, the Quattrocento Tuscan tradition of Ghiberti and Donatello merges with newer currents of mannerism in a way that is peculiar to Sansovino's work. Thus one finds unmistakably mannerist features in the Sts John and Matthew as well as in the panel of the *Resurrection* (fig. 160), while in the *Entombment* and its companion Sts Luke and Mark, fifteenth-century influences come more to the fore (fig. 156). A similar juxtaposition of contemporary, early Renaissance, and antique motifs can be found in most of Sansovino's Venetian projects and reflects the sophistication of Sansovino's artistry as well as a natural tendency to draw upon a telling prototype for the task at hand.

One feature common to both panels is the painterly treatment of the setting. This is something to which Francesco Sansovino drew attention in his account of the Sacristy door and which goes back to Ghiberti's use of an atmospheric perspecitve.[82] However, Sansovino disregarded conventional rules of perspective, allowing plasticity of form and an expressive modelling to predominate. With little room to manoeuvre, Sansovino conveys remarkable gradations in the background of the *Entombment* with a view on to hills, the scene of the crucifixion, and a procession of soldiers; in both relief panels, the sky is given a rich impasto of clouds which translates into metal the malleability of wax.

Various sources have been proposed for Sansovino's *Entombment*, ranging from Raphael to Riccio and Lotto, but it is not possible to pin down a specific source for the panel.[83] Some similarities with others can be explained, of course, by the subject matter, which imposes certain prerequisites. Sansovino's conception of the Entombment was grounded in Florentine art, above all, the various versions of this subject by Donatello. Thus the oblique presentation of the tomb and the seated mourner before it recall the *Entombment* on the north pulpit in San Lorenzo (fig. 157), and the gesticulating Magdalen and the heavily veiled women bring to mind the corresponding figures on the Tabernacle of the Holy Sacrament in St Peter's.[84]

Sansovino's relief synthesizes elements from these works as well as Mantegna's famous engraving of the scene without following one or another precedent to the letter. In this way Sansovino was probably responding to the same visual sources as did Raphael, but in a parallel manner.[85] These ingredients were so much in Sansovino's mind and fingertips that, when he came to model the scene, he did so instinctively.

This can be seen in the *Entombment*, which actually consists of two overlapping scenes, the entombment proper and the lamentation of the Marys. Individual figures, whether the Virgin or the man towering behind Christ, assume a prominence that is dictated by expressive considerations rather than strictly logical ones. this manipulation of scale for artistic purposes links the bronze Passion reliefs with the bronzes on the *pergoli* and the larger marble relief of the *Maiden Carilla* (fig. 260).[86] Sansovino has also created a strong chiaroscuro effect through his exaggerated modelling, thus imparting a shell-like effect around Christ and the *tour de force* of the Virgin and her attendants (fig. 159). This last group is all the more striking, as it is essentially a reworking of the same group in Jacopo's early *Descent from the Cross* (fig. 28).[87] Despite its small scale, the *Entombment* is an impressive treatment of its subject. Its painterly qualities were readily appreciated by the sculptor's friend Titian, who took the relief as the basis for the *Entombment* sent to Philip II in 1559 (fig. 158).[88]

The upper panel of the *Resurrection* registers a decided change of style from the *Entombment*. Plasticity is still used with great effect, but the result is unlike that of the lower panel. Sansovino here concentrates high relief in the lowest portion of the scene so that the darker tones fall upon the figures of the soldiers. In exploiting the contrast between their contorted poses and the elegant serenity of Christ, Sansovino returns to the type of dramatic Resurrection essayed by Raphael in a series of drawings around 1514.[89] Raphael's composition proved immensely influential to a number of artists during the 1520s and 1530s, and Giulio Romano and Francesco Salviati returned to it in the years prior to Sansovino's *Resurrection*.[90] Among Giulio's late works was a fresco (now destroyed) for the Cappella del Crocifisso of Santa Paola in Mantua. Two records of a Resurrection survive which may be related to the chapel: one is a well-known drawing formerly in the Ellesmere Collection and now in Berlin; the other, a rare engraving by G. B. Ghisi bearing a date of 1537 (fig. 161).[91] The Berlin drawing is frieze-like and shows Christ stepping out of the tomb, while the woodcut is more vertical and has the Redeemer standing before the tomb. The print anticipates several features in Sansovino's relief, especially the grouping of the soldiers around the triumphant Christ. Instead of the *orans* gesture of Giulio's Christ, Sansovino's figure is silhouetted against his banner. In both compositions Christ is brought into close proximity with the soldiers, and the poses of the principal soldiers beneath the tomb suggest that Sansovino's were patterned upon those in the print.

Sansovino's interest in Giulio Romano was consonant with his attraction to mannerism during the 1540s. His response would also have been reinforced by Giulio's impact upon Titian's ceiling paintings for the new convent of Santo Spirito, a project on whch Sansovino and Titian collaborated.[92] In general terms Sansovino's treatment of the Resurrection is steeped in the mannerism so characteristic of the same period. Part of the other-worldly atmosphere of the Resurrection derives from the low emotional temperature in which the scene is presented. Sansovino eschews dramatic potential to focus upon the elaborately contrived ballet of the soldiers' gestures around the still point of Christ.

It would be difficult to explain works like the Sacristy door or the Loggetta gods or the second tribune reliefs without reference to Sansovino's experiment with mannerism in the bronzes of this period. Modelling and complexity of pose predominate over narrative logic, and there is a common tendency towards attenuated forms and stylized beauty. The *Resurrection*, with its concentration upon this type of formal beauty, represents a high-water mark in Sansovino's exploitation of bronze and mannerism.

Between the panel of the *Resurrection* and the portal of the altar of the Sacrament stands a

third bronze-relief work, the Medici Tabernacle (fig. 165).[93] It shares strong stylistic links with the two Venetian reliefs, being approximately contemporaneous with the Sacristy door and virtually identical in subject matter with the portal of the altar of the Sacrament. The tabernacle comprises two reliefs within an ebony frame surmounted by a high-relief group of putti bearing garlands and the Medici arms. The larger relief depicts the Redeemer against a background of clouds and surrounded by cherubs holding the cross and chalice; above it, a smaller relief of God the Father with cherubs forms a lunette. The facture of the two panels reflects the same painterly manner employed by Sansovino in the Sacristy door. In particular, the figure of Christ shows a preoccupation with the same canon of beauty that distinguishes the second tribune panels and the Sacristy door. Christ is shown as a heroic nude, one of very lean and elongated proportions, like Sansovino's *Apollo* (fig. 213); his gesture is dramatic, like the *Mercury* of the Loggetta (fig. 217), but abstract enough so as not to disturb the essentially decorative nature of the object. The background of clouds is given the same impasto-like effect as those on the Sacristy door reliefs or the central panel of the second series of reliefs about St Mark (fig. 142). The other bronze elements in the Medici Tabernacle are very much in Sansovino's idiom. The addition of the lunette with God the Father was dictated by the traditional iconography required for this kind of devotional image; in style it recalls the figure of God in Ghiberti's *Sacrifice of Noah* on the Gates of Paradise.[94] Sansovino's cursive treatment of the robes of the Deity is a literal reference to the manner of his fifteenth-century predecessor, but the accompanying angels, like those of the main panel, have more in common with the rumbustious cherubs of Correggio than they do with Ghiberti. They are seen in a variety of poses that sometimes border on the irreverent (fig. 167). Above the lunette, three pairs of cherubs carry garlands and the arms of the Medici surmounted by a ducal coronet and the Florentine *marzocco* (fig. 166).[95] Sansovino employed similar complements of putti on the frieze of the Marciana Library, on the Sacristy door, and around the marble *Virgin and Child with Angels* in the Chiesetta of the Doge's Palace (fig. 121).[96] Their origin lies in the vivacious children found in works by Sansovino and his friend Andrea del Sarto in the second decade of the sixteenth century. An example particularly close to the group on the Medici Tabernacle had been frescoed by Polidoro da Caravaggio above the pediment of the altar by Sansovino in the Roman church of Sant' Agostino (fig. 67).[97] Polidoro's fresco represented five putti holding a cloth of honour above Sansovino's Virgin and child, and it is not improbable that the painter's role was simply that of an executant for Sansovino's design. Certainly the Medici Tabernacle subscribes to a similar formula for its crowning decoration, and such a comparison helps to establish that part of the tabernacle as a component of its original design, not something added at a later date.

In terms of facture, the cherubs surmounting the lunette are somewhat rougher than the two relief panels, but they show no significant differences in style. They bear a resemblance to the decorative work of Alessandro Vittoria, and it is tempting to see them as an early example of collaboration between Sansovino and his most gifted pupil.[98] However, chronology argues against this, as Vittoria only entered Sansovino's shop in 1544 and is first documented as an assistant in the cleaning of the second series of reliefs for the choir of San Marco, by which time the Medici Tabernacle would probably have been completed. Nevertheless, the influence of these and other decorative motifs of Sansovino's works of the 1540s had a profound affect upon the artistic development of Vittoria and other members of Sansovino's shop. The lunette with God the Father (fig. 167) was copied by Tommaso Lombardo in the lunette of his altar of St Jerome in San Salvatore around 1547 (fig. 412).[99]

The presence of the Medici arms and the Florentine *marzocco* endorse the conclusion that the tabernacle was intended by Sansovino as a gift for the ruling family of Tuscany. Indeed, it may have owed its inception to Cosimo I's attempt to draw Sansovino into his service during the artist's visit to Florence in 1540. According to Vasari, Sansovino refused the offer, and he may have decided to make the tabernacle on his return to Venice, as a form of compensa-

tion.[100] Whatever the purpose, Sansovino was too pleased with the results to let the work leave his own possesison. It remained as a touchstone for later works and had a bearing upon the reliefs of the Sacristy door and on the portal of the altar of the Sacrament.

Although tradition has it that the Medici Tabernacle was made by Sansovino for the dukes of Tuscany, the work did not actually enter the Medici collection until 1664.[101] Its conception can, however, be dated to 1542, when Lorenzo Lotto recorded a payment for having two works fastened together within a frame as a domestic altar. One is identified only as an allegory of faith and heresy, but the other is described as 'la storia del bassorilevo de la gloria del Cristo del Sansovino'.[102] One year later the Venetian nobleman and friend of Sansovino, Federico Priuli, commissioned a panel of the same subject from Lotto, a work now in the Kunsthistorisches Museum in Vienna (fig. 169).[103] Priuli had extensive interests in the arts, having patronized Giuseppe Salviati for the decoration of his villa at Treville on Sansovino's recommendation and witnessed the contract for Sansovino's *Maiden Carilla* relief for the Santo in Padua in 1536.[104] Priuli may have commissioned a copy of Sansovino's relief from Lotto in the spirit of a *paragone* or competition between painting and sculpture. The debate over the primacy of painting versus sculpture had been a consistent theme in contemporary discussions of art, and it was an issue in which Sansovino and his friends took an interest. Pietro Aretino planned a competition between Sansovino and Titian for a likeness of Giovanni delle Bande Nere de' Medici in 1545, and as late as 1553 he wrote to Sansovino concerning an argument over the *paragone*, which took place in the sculptor's house.[105] There would undoubtedly have been a competitive edge to Priuli's request to Lotto in 1543, but in the event he never purchased the painting.

The nature of the subject is not, strictly speaking, the 'Blood of the Redeemer', as has sometimes been said. While the presence of the cross and chalice alludes to Christ's sacrifice, the imagery employed by Sansovino ultimately derives from the themes of *Pietà* and Man of Sorrows.[106] These themes encompassed a rich visual tradition drawn upon by artists across Europe from the fourteenth century onwards, and in the fifteenth and sixteenth centuries they frequently decorated tabernacles reserved for the Host. Their religious orthodoxy seems not to have been challenged. What is noteworthy about Sansovino's version lies in its variation of this conventional theme into a glorification or triumph of Christ, as Lotto and Boschini variously referred to it. This concept had its source in St Paul's description of Christ assumed into glory and exalted by God the Father after the crucifixion, and the Medici Tabernacle in its totality seems to show just that.[107] By contrast, Lotto shifted the emphasis back to the shedding of Christ's blood, and, as Frizzoni pointed out, the panel in Vienna did show blood coming from Christ's wounds prior to its cleaning early in this century.[108]

In visual terms, both Sansovino and Lotto were working in a tradition that extended back into the fifteenth century. Giovanni Bellini's early painting *The Blood of the Redeemer* (fig. 170) has been proposed as an influence on Sansovino's composition, and it may have been known to him and to Lotto.[109] Moretto's *Christ with Moses and David* in Brescia has also been compared with Sansovino's work, but whether the sculptor would have known the painting is moot.[110] The relationship in both cases may be more generic than specific, but one other example of a *Pietà* with angels may have made a more decisive contribution to the Medici Tabernacle and its variants.

The work in question is a stucco relief made by Silvio Cosini for the Monte di Pietà of Padua in 1534 (fig. 172).[111] It shows the body of Christ elevated by four cherubs while two others hold open a canopy; the relief is especially close to Sansovino's in the pose of Christ's body, the style of the angels, and the impasto-like handling of the clouds. The conception here derives from the meditation on the Passion by St Bridget of Sweden, one of the most popular of devotional texts, in which the saint saw a host of angels, 'as numerous as sunbeams', carrying the body of Christ from the cross and into heaven while mourning and worshipping him at the same time. It was an idea which had been anticipated in a woodcut by

Hans Baldung Grien in which angels carry the dead Christ, shroud, and crown of thorns into the sky where God the Father and the Holy Ghost await (fig. 174).[112] The overlapping of motifs in all three cases is notable, and Baldung's woodcut or something like it would have been the visual stimulus for Cosini's work. That Sansovino knew Cosini's relief seems inevitable, given their friendship and proximity in the early 1530s. Both were then working for the Arca del Santo in Padua, and Sansovino entrusted Cosini with the execution of his own tomb in 1533.[113] Hence it is extremely probable that Sansovino knew Cosini's relief and may even have offered Cosini suggestions on its design. In any case, there is no doubt that the Medici Tabernacle represents the refashioning of a devotional image with a precedent in a Northern print and in the relief sculpture of Sansovino's friend Silvio Cosini. It is also one of the most accomplished of sixteenth-century bronze reliefs as well as a testimonial to an extremely felicitous moment in Sansovino's career.

The sacramental portal is very much a reworking of the Medici Tabernacle, designed to serve as the final element in a pre-existing altar (fig. 171).[114] The procurators resolved to build an altar for the Holy Sacrament in a place of honour behind the high altar as early as 1518. They commissioned Lorenzo Bregno to build one, and the result was a tabernacle-altar in the tradition of those by the Lombardo brothers in the Frari and in the Miracoli.[115] Bregno created a large perspectival surround with the figures of Sts Francis and Bernardine, two angels, and a panel of God the Father as its major features. Consequently, Sansovino had only to produce a simplified version of the central panel of the Medici Tabernacle in order to fill the space left in Bregno's altar, and that is what his workshop did. The image has been cropped and the upper part of Christ's body given more prominence, its modelling being less subtle; the brilliant treatment of the clouds, which is such a conspicuous aspect of the central relief of the tabernacle, has not been repeated here. The drapery of Christ and the principal angels has also lost that transparent quality so noticeable in the Bargello relief. Much the same can be said of the third version of the relief, now in the Staatliche Museen in Berlin (fig. 173).[116] This, too, is a distinctive version by a different hand and is a variant of the relief in San Marco. It preserves something of the vigorous modelling of the original, especially in the suggestion of clouds, but is much closer to the San Marco bronze in format and in the disposition of the angels. The physiognomies of Christ and the angels are diverse in all three versions of the relief, and this points to a common model having been reworked by different hands. Only the Bargello version could be called autograph, and it stands above the copies in Venice and Berlin. This is not to say that Sansovino was completely removed from the process of creating the later versions; instead, one can assume that he would have supervised the production of the San Marco copy, although the reworking would have been entrusted to an assistant. This may well have been the case with the version now in Berlin, which certainly bears the stamp of being a Venetian bronze relief of the latter part of the sixteenth century. In all probability, it was made around the same time as the San Marco bronze, that is, in the late 1550s or possibly the early 1560s, and was destined for a private collector.[117]

The plurality of copies of Sansovino's original relief is indicative of its popularity during the sculptor's lifetime. It also received the unusual compliment of being drawn by two artists. Both drawings seem to be studies after the portal of the altar of the Sacrament, and one version, now in Warsaw, is an exact copy (fig. 175).[118] It has been tentatively ascribed to Domenico Campagnola, although the similarity with that artist's work is strictly generic. On the other hand, it could be the work of an engraver, whose purpose would have been to turn Sansovino's design into a print, which would have been the only such print after a sculpture by Sansovino before the eighteenth century. The other copy is a drawing in a private collection in Rome (fig. 176).[119] It is an unusual drawing, with a provenance including the collections of Resta, Lord Somers, and the elder Richardson. Resta believed it to be by Girolamo Mazzola Bedoli, the cousin and follower of Parmigianino, and his attribution seems a convincing one. Bedoli has taken the pose of the Redeemer, the general effect of his drapery,

and some of the poses of the putti from Sansovino; he has altered the position and scale of the cross as well as endowed many of the angels with a Parmigianinesque air. Although the scale of Bedoli's drawing is approximately half that of the original relief, it is evident that the painter had difficulty in filling his sheet. Whereas the original is a self-contained work, the drawing leaves the corners of the page untouched.

Bedoli's copy points to his having visited Venice during the 1550s or 1560s; he died in 1569. It is not surprising that he should have made a sketch after Sansovino's relief during his stay because Sansovino's composition has obvious affinities with the work of Correggio and Parmigianino, particularly the latter's famous etching of the *Resurrection*.[120] Although he never applied the drawing to any of his known commissions, it remains a rare copy after a work by Sansovino.

The San Marco tabernacle portal may have been the last of Sansovino's bronzes made for San Marco. As with most of the bronzes for San Marco, the amount of money involved was not large, and Sansovino proceeded with a verbal agreement from his masters, receiving a retrospective reimbursement in 1565. Only with the case of the Sacristy door, which represented a considerable expenditure, did Sansovino come to a formal agreement at the outset, though the casual nature of his understanding with his employers caused problems for his son and heir, Francesco. Jacopo presented the procurators with a bill for his expenses in the creation of the door in February 1570, only a few months before his death. It was agreed that a separate payment for his own labour and the artistic merit of the work would be made after an independent valuation. Such agreements were common in artists' contracts, but nothing was done before Sansovino died in November 1570.[121] Finally, a petition was sent by Francesco Sansovino to the procurators in March 1517; in it, he urged them to deal with the valuation of the Sacristy door. The procurators, however, were not in a giving mood and rejected the claim. Consequently, Francesco took the case to the Giudici di Procurator, whose job it was to examine complaints against any of the three procuratie. The procurators defended their refusal to allow an appraisal by maintaining that Jacopo spent more than they had wished in creating the Sacristy door and that he had been well enough paid by them during his lifetime to make further payments to his heir unnecessary. The case was referred to the Dieci Savi, who had jurisdiction over debts, on 30 April 1571, and dragged through the summer, but the Savi finally ruled in favour of Francesco in September. The judgement required an appraisal as had been stipulated in the agreement between Jacopo and the procuracy in February 1570. After much haggling over their respective experts, the procurators chose Francesco da Segala, and Francesco Sansovino nominated Danese Cattaneo. Their appraisal, delivered in November 1571, must have come as a shock to the procurators, for they awarded Francesco 1,650 gold scudi, at 7 lire per scudo, over and above the money paid his father in 1570.[122] The procurators apparently felt that the two experts had favoured Francesco Sansovino unfairly, and they were determined to find more neutral experts to conduct another valuation. Their next candidate, Benetto dei Alchieri, was considered unsuitable by Francesco Sansovino, as he was a mere smith (*favro*) and not a sculptor. They then proposed Giacomo del Duca, an enlightened and unexpected choice because he had never been in Venice and was a protégé of Michelangelo.[123] To this, Francesco Sansovino also demurred, saying that it would take too long for him to reach Venice if, indeed, he would come.

This toing and froing went on for some time until Niccolò dei Conti and Girolamo Campagna had been chosen by the procurators and Sansovino, respectively. Unfortunately, they could not agree on a valuation. The matter was finally resolved in August 1572 when Federico Contarini, the treasurer of the procuracy, and Francesco came to terms. The procurators agreed to abide by the first valuation of Cattaneo and Segalla but would pay 1,350 ducats of account (6 lire 4 soldi per ducat) to Francesco, deducting 120 ducats for two years' rent on the apartments in which he had lived since the death of his father.[124]

This episode makes a sad postscript to Sansovino's years as *proto* for San Marco but does

illuminate several aspects of his relationship with his masters and with other sculptors. Older procurators like Vettor Grimani and Antonio Capello had been at one with Sansovino in their determination to transform the interior of San Marco, just as they were over their buildings by Sansovino in the Piazza. Unfortunately, these projects committed the procuracy to large outlays of money which stretched the procurators' finances as well as provoked hostile criticism in some quarters.[125] Sansovino himself had the mixed fortune to survive his keenest supporters among the procurators of San Marco, and the youger men who assumed office in the 1560s and 1570s must have held him to blame for the casual way in which he conducted the business of the procuracy. If the squabble over the Sacristy door shows the procurators in an unbecoming light, it also points to the pervasive influence of Sansovino over the next generation of sculptors. So many commissions had been placed in Sansovino's hands that it was extremely difficult for the procurators to find a sculptor who had not studied under or been employed by him. By the end of his life, Venetian sculpture had become Sansovino's creation, its practitioners, his *creati*, as Vasari would have said. As we shall see, the effects of his monopoly on Venetian sculpture were to be felt well into the seventeenth century through the pupils of his pupils.

Though financial scandals clouded the last years of Sansovino's service to the procurators, the balance was, in artistic terms, highly rewarding. His experiments in bronze led to a remarkable series of reliefs and to one of his greatest masterpieces in the Sacristy door. With bronze, Sansovino found a new medium and a new style, untrammelled by the restrictions and preconceptions of his work in marble. With the Loggetta statues, bronze led to a new figural canon which would have even greater repercussions on Venetian sculpture down to the eighteenth century.

VII. Sacristy Door, San Marco, Venice (cat. no. 23)

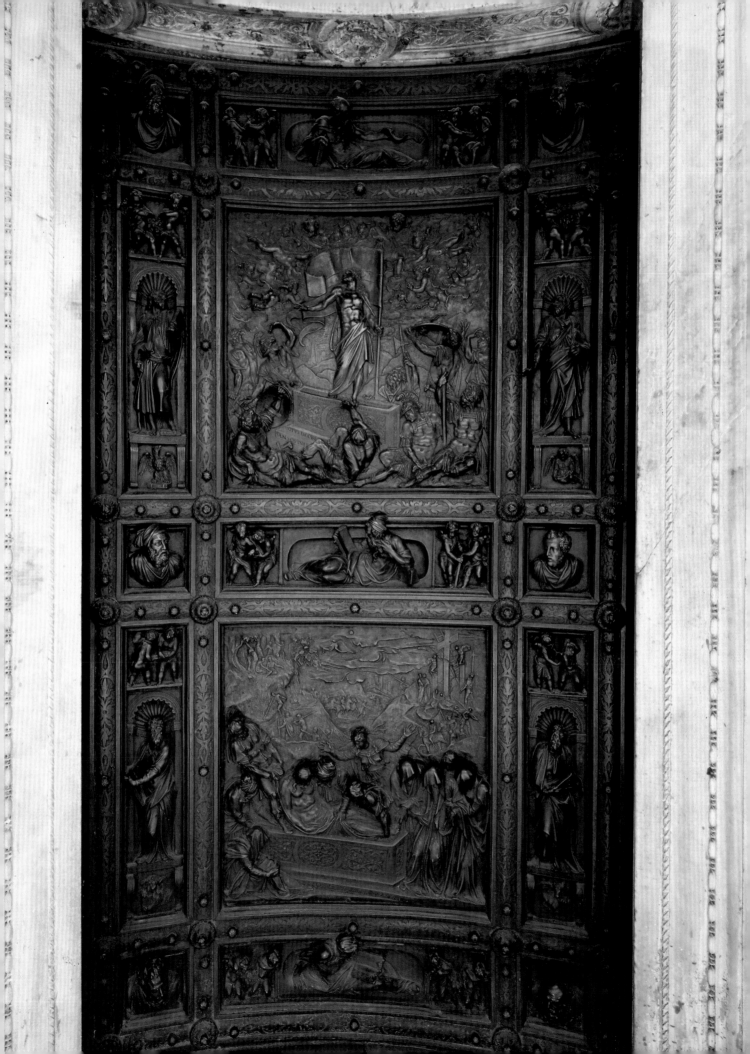

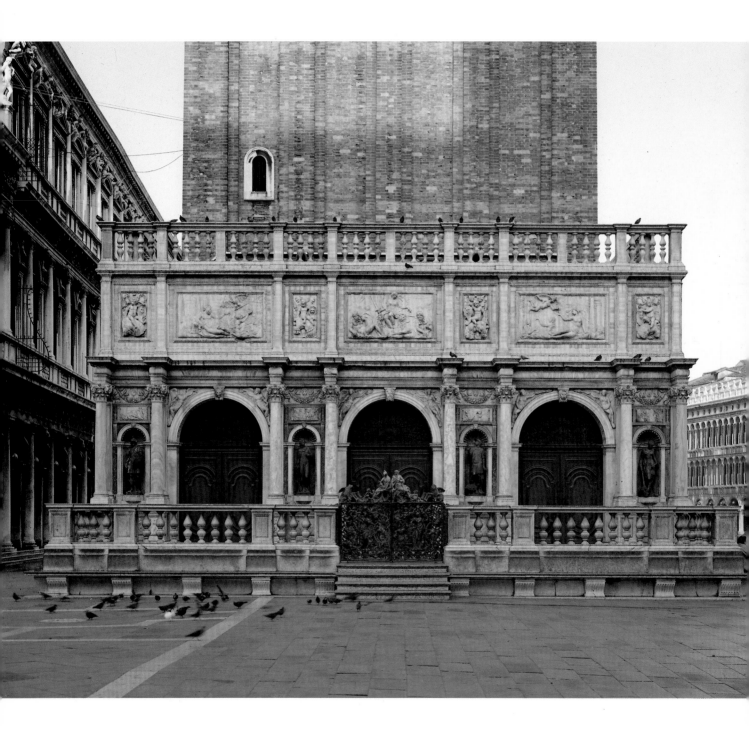

V. The Loggetta in Piazza San Marco

THE LOGGETTA IN Piazza San Marco undoubtedly marked the apex of Sansovino's Venetian career (col. pl. VIII, fig. 195). It was also his most felicitous contribution to Venetian architecture and sculpture, for it introduced a new vocabulary of forms to Venetian art. As architecture, it was to be influential upon the subsequent work of Palladio and Vittoria, among others; as sculpture, the four bronze statues can be seen as an extraordinarily fruitful example of Sansovino's response to Venice and to the medium of bronze. The importance of the Loggetta gods for Venetian sculpture cannot be over-emphasized, and within Sansovino's *oeuvre* they constitute one of his last, great artistic inventions.

There had been a loggia on or near the Piazza since the thirteenth century.[1] The loggia was an enclosure reserved for the meeting-place of noblemen, and by the fifteenth century it stood at the foot of the great bell tower of San Marco. The impulse to rebuild the simple wooden and stone structure sprang from the same impulse that led to the transformation of the Piazza's appearance during the sixteenth century. This began as early as 1501, when Alessandro Leopardi delivered the first of the bronze standard bases, and continued with the reconstruction of the Procuratie Vecchie on the northern side of the Piazza from 1513 (figs. 224–26).[2] The genesis of Sansovino's Loggetta was intrinsically linked to the next stage in the redevelopment of the Piazza, namely, the procurators' decision to build new houses for themselves on the southern side of the square in July 1536.[3] Between that date and March 1537 the procurators chose to begin construction of the new Procuratie on the south-eastern corner where the Piazza and Piazzetta intersected. Sansovino, as their architect, persuaded the procurators to build the new houses some five metres away from the bell tower, a move that had the twin effects of isolating the Campanile and enlarging the breadth of the Piazza.[4]

By the time that work began, it was decided that the first section of the new building fronting the Piazzetta would contain the important bequest of manuscripts left to the Republic by Cardinal Bessarion in the fifteenth century.[5] The construction of what is now known as the Library of San Marco must have drawn attention to the sad state of the old loggia. It had been damaged when lightning struck the Campanile in 1489 and, again, by an earthquake in 1511. Lightning also caused serious damage to the bell tower in August 1537, and its restoration must have brought the question of the loggia to the fore, as Sansovino's project for the new Loggetta was finished by November of that same year.[6] As with the Library or the contemporary projects for the doge's chapel, the Loggetta embodied the new architectural and sculptural style of Central Italy, the style that Sansovino and his patrons were intent upon introducing into Venice.

Work on the Loggetta was certainly under way by February 1538 when a large payment was made for marble, columns, bricks, and workmen. By 1540 the basic structure of the Loggetta was nearing completion, and marble was purchased for its façade. Little is known

VIII. The Loggetta, Piazza San Marco, Venice (cat. no. 27)

about the history of its sculptural complement, but the procurators' accounts show that Sansovino began working on the bronze figures by February 1541 and was actively engaged on them in the following year; by February 1546 the bronzes were installed, and Sansovino received a settlement worth 600 ducats for them.[7]

The Loggetta was Sansovino's first major Venetian work to be finished, and its original appearance can best be appreciated in Giacomo Franco's engraving of 1610 (fig. 193). The main body was a rectangular block, raised five steps above the level of the Piazza and divided into three bays by free-standing columns. There were benches on the basement level of the building in the manner of those on the façade of the Scuola di San Rocco or Sansovino's tomb for Doge Francesco Venier (fig. 284). Each bay of the façade had a round-headed arch, the central one serving as entrance and the lateral ones as windows. Panels of relief sculpture adorn the base of the façade, and the four bronze figures of Pallas, Apollo, Mercury, and Peace stand in niches between the columns. More relief sculpture comes above the statues' heads, in the spandrels and soffits of the arches, and across the attic. Later changes to the building are not pertinent to an analysis of Sansovino's façade, but they include the terrace, added in the seventeenth century, the two outer relief panels on the attic and the bronze gates, added in the eighteenth century; the whole structure was destroyed by the fall of the Campanile in 1902 and restored again by 1912, using approximately half the original marbles in the process (fig. 194).[8]

The Loggetta is the most richly adorned of Sansovino's Venetian buildings and, in concert with the Library, presents the architect in his most classical and Roman manner. The relationship between the design of the Loggetta and Library is very close, not only through reasons of proximity, but also through Sansovino's highly developed sense of architectural decorum.[9] Both buildings were designed for the procurators *de supra* and stand on the principal square of the city. Both were given façades in the Roman style with round-headed arches framed by columns and with sculptural decoration based upon antique themes.[10] As public buildings intended as offices and as a meeting-place for the nobility, the Library and Loggetta were intended to express something of the dignity and wealth of the Venetian state. Moreover, the site demanded that both should be distinguished, given that they face the Doge's Palace.[11] Sansovino conceived the block housing the library and offices of the three procuracies as a two-storey building of twenty-one bays, clad in Istrian stone. By contrast, the Loggetta is much smaller but its façade is an opulent mixture of oriental and Italian marbles: pink Verona for much of the membering, small bands of white Carrara, *verde* and *giallo antico*, and cipolin. The shafts of the columns, assuming that they follow the original colour scheme, are orchestrated in pairs from cipolin, to violet blue to pink breccia.

The choice of order, the Composite, and other architectural details are as learned and recondite in their own way as is the famous split metope of the Library.[12] The Composite order was held to be superior to all others by Serlio and specifically connected by him with Roman triumphal arches.[13] Its choice for the Loggetta may have been prompted by such considerations, just as the use of oriental marbles conveyed a sense of Venice's eastern empire and luxury appropriate to its nobility. These associations are clearly present in Aretino's approving description of the Loggetta in November 1537: 'Che bel vedere farà l'edificio di marmo e di pietre miste ricco di gran colonne che dee murarsi appresso la detta [i.e., the Fabbrica nuova or future Library]! egli havrà la forma composta di tutte le bellezze dell'architettura servendo per loggia, nella quale spassegeranno i personaggi di cotanta nobilitade.'[14] Moreover, the Composite order is here combined with two other elements that would have been unfamiliar to a contemporary Venetian audience but were the fruit of Sansovino's Roman studies: the order's elaborate base mouldings and the pulvinated frieze (figs. 197–98). The base mouldings were those called Composite by Palladio and were probably taken by Sansovino from the columns of the Lateran Baptistry or the Arch of Titus, and the pulvinated frieze with the Composite order would have been known by Sansovino

from the Lateran Baptistry or Santa Costanza.[15] The base mouldings were a particularly learned citation and were employed by Sansovino only one more time on a Venetian building, in the major Ionic order of the Library.[16] Together, these elements would have conveyed that modern application of the ancient orders which is such a distinguishing feature of Sansovino's major Venetian commissions.

Many of the features of the Loggetta were already present in Sansovino's pre-Venetian architecture.[17] It has an obvious affinity with descriptions of the temporary façades and triumphal arches that Sansovino designed in Florence and perhaps in Venice as well. Elements of its design can also be found in Venetian works originating from Sansovino and his circle. For example, the pulvinated frieze is already present in the Malipiero tomb of the early 1530s (fig. 322), and some basic features of the Loggetta are anticipated in Minio's altar of San Rocco of 1535 (fig. 404).[18] Then, too, Sansovino had experimented with polychrome marbles in the tabernacle in Santa Croce in Gerusalemme, which he designed for Cardinal Quignones in 1536 (fig. 110).[19]

Though much in the Loggetta's appearance was already present in Sansovino's pre-Venetian architecture, some elements were not entirely unknown to Venice. Coloured marbles had been applied to buildings since the Middle Ages, San Marco being only the most conspicuous example.[20] Important buildings, especially those of a public nature like the Doge's Palace or San Marco, bore impressive programmes of statues and reliefs.[21] More recently, bronze was employed in major public commissions, such as the base of the Colleoni monument or the interior of the Zen chapel.[22] Sansovino's genius lay in integrating these features in a new manner, consonant with his training in Florence and Rome. The catalyst that brought these disparate elements together in Sansovino's own mind was the work of a contemporary from his Roman years, rather than any classical or Venetian monument. That work was Baldassare Peruzzi's tomb of Hadrian VI in Santa Maria dell'Anima (fig. 196).[23] Though rarely mentioned, the tomb of Hadrian VI exercised great influence over the subsequent use of polychromy in such works as Ligorio's monument to Paul IV in the Minerva or the Sistine chapel in Santa Maria Maggiore; it was also an enlightened critique of the famous sepulchral monuments by Andrea Sansovino in Santa Maria del Popolo (fig. 13). Its importance for Sansovino's Loggetta lay not only in the coloured marbles which underscore the structure of the monument, but also in the introduction of the Composite order and convex frieze to Renaissance architecture. Peruzzi's example may have had more effect upon Sansovino than is generally appreciated. Howard Burns has called attention to the similarity between the rusticated building in the background of Peruzzi's *Presentation of the Virgin* in Santa Maria della Pace and Sansovino's Zecca or Public Mint.[24] The similarity seems more than coincidental, given the rapport between the Loggetta and the tomb of Hadrian VI. In the latter case, there is a known connection through the employment of Sansovino's pupil Tribolo by Peruzzi as one of his assistants on the tomb.[25]

The evidence points to a definite awareness of Peruzzi's tomb by Sansovino, and it is not inconceivable that the two artists discussed the project during its early stages. Alternatively, Sansovino might have been reminded of it by Peruzzi's pupil Serlio, who was in Venice and moved in Sansovino's circles during the 1530s.[26] Of course, Sansovino did not merely adapt Peruzzi's design *tout court* when he came to plan the Loggetta. He rang changes on its original format by expanding it to a sequence of three bays with single statues instead of Peruzzi's double order. He further gave the bases of the niches a type of moulding found beneath Rizzo's *Adam* and *Eve* on the Arco Foscari.[27] The small reliefs above the bronze gods (see fig. 217) are framed by strips of *giallo antico* in a design that has its origin in the base of Donatello's *Judith and Holofernes*.[28] Sansovino's approval of Peruzzi's general scheme was subsequently endorsed by his adaptation of it for another semi-official commission, the tomb of Doge Francesco Venier in San Salvatore (fig. 284).

The focal point of any discussion of the Loggetta must be the bronze figures of *Pallas*

(fig. 210), *Apollo* (fig. 213), *Mercury* (col. pl. IX, fig. 217), and *Peace* (fig. 218). They have long been regarded as unusual and unusually beautiful components of Sansovino's *oeuvre*; yet the motives leading to their appearance remain inadequately defined. Perhaps the most essential ingredient in their make-up is their medium, bronze, a medium that had far-reaching implications on their manufacture. On a practical level, bronze enabled Sansovino to fashion models that could be produced to a high level of accuracy with a minimum of effort on his part. The novelty of the medium, too, would have contributed to making his studies for the figures more experimental and fresher than he could be with his models for marble and stone statues like the *giganti* or the virtues on the tomb of Doge Venier. The Loggetta bronzes have a sense of movement and novelty suggestive of small bronzes or cabinet pieces. In fact, at least one putative model, a stucco figure of the *Apollo*, did find its way into the collection of Sansovino's friend Marco Mantova Benavides, and it is tempting to see the figures of *Minerva* and *Mars*, given by the sculptor to the printer Marcolini, as the fruit of an early stage in the evolution of the Loggetta figures.[29] As early as January 1541, Aretino praised Sansovino's equal mastery of bronze and marble figures in a poem acknowledging the gift of a bronze *St Catherine*.[30] Small projects like the lost *St Catherine* would have served as preparation for the demanding task of creating models for the Loggetta gods. The most intensive period of work for Sansovino would have fallen between 1541 and 1542, as the surviving payments to him suggest. Documentary evidence for the casting stage is non-existent, but the procedure can be surmised from the contemporary projects for San Marco. The casting models for the gods would have been made by Sansovino in his own workshop and then handed over to professional founders like Minio or Zoppo or one of the men regularly employed by the Arsenal.[31] The documents do show, however, that the bronzes were cast after February 1542 and before February 1546, when Sansovino was credited for their production in the accounts of the procurators. An examination of the figures shows that they were cast in the lost-wax method; they are composed of a very thin sheet of metal and left open at the back, for ease and economy in casting (fig. 219).[32]

If bronze had a practical effect on the nature of the Loggetta gods, it also had an aesthetic one, for it led Sansovino to think in terms of one set of prototypes rather than another when he came to design the four figures. In this case, Donatello acted, once again, as a guiding influence. This is especially notable in the *Mercury*, which took its point of departure from Donatello's celebrated *David*, one of the most remarkable bronze figures of the previous century (fig. 216). Donatello's bronze is so reminiscent of a classical figure that some scholars have argued that its true subject is Mercury with the head of Argus; clearly Sansovino came to similar conclusions about its suitability as a model for an antique subject.[33] It was not only a question of formal type, the hero with the head of Goliath being translated into a pagan god with his grisly trophy, but also of a preference for a kindred type of beauty. There is a distinctly Quattrocentesque air about Sansovino's *Mercury* and *Apollo*, aligning them with the tradition of the *David*. The parallel is especially clear with the *Apollo*, whose lean, unmuscular body with its unclassical pose is completely visible (fig. 213). Beyond that, Donatello's *David* was on a similar scale (159 cm versus 146 cm for *Mercury* and 144.5 cm for *Apollo*) and had originally served a decorative function in the courtyard of the Medici Palace in Florence. So it is hardly surprising that Sansovino's mind reverted to it when called upon to create analogous bronze figures. Donatello's influence also extended to the formation of *Pallas* (fig. 210). Stripped of her helmet and shield, the goddess is recognizable as a derivation from the *St George* on Or San Michele (fig. 211).[34] The reference to the *St George* in the case of *Pallas* may seem, at first glance, puzzling; yet the logic of Sansovino's choice is clear. Given the absence of antique prototypes for the kind of figures he wanted, Sansovino fell back upon modern 'classics' such as Donatello's *St George* and *David*, the one for its embodiment of the martial hero, the other by virtue of its formal analogies.

A comparison with fifteenth-century sculpture can be extended to the *Apollo*, superficially

the most 'classical' of the four bronzes (fig. 213). In spite of the obvious references to the *Apollo Belvedere*, Sansovino's figure has a ponderation and proportions that recall the work of Donatello or Andrea Sansovino.[35] Not only has the body's pose been recast, but the features of the head have been softened, made more expressive and more feminine than in the original (figs. 214–15). Jacopo Sansovino's *Apollo* is still recognizable as a descendant of the *Belvedere*, but as interpreted by a sixteenth-century artist whose vision of antiquity was filtered through the representations of it in works by his predecessors and contemporaries. In this context, one can compare Sansovino's Sun God with the famous figure of Apollo designed by Raphael in the *School of Athens* (fig. 212) or a later interpretation of the *Apollo Belvedere* by Girolamo Mazzola Bedoli.[36] In each case, the figure has become more sinuous and slender than in the antique model; the total effect is of a decorative and rather feline grace. This blurring of the distinctions between male and female is a general characteristic of many of Sansovino's figures and is particularly evident in the Loggetta gods. The conception of beauty as androgynous seems to have pleased Sansovino's contemporaries, for it can be found in the pages of Angelo Firenzuola's *Della bellezza delle donne* as well as in Dolce's famous passage on Titian's *Venus and Adonis*.[37]

After Donatello, the modern artist whose influence is most clearly evident upon the Loggetta gods is, of course, Michelangelo. His impact is strongest in the *Mercury*, where the tranquil model of Donatello's *David* has been infused with a dynamism suggestive of the unfinished *St Matthew* for Florence Cathedral (fig. 52). The right leg of Mercury has been brought forward, bending and resting upon the head of Argus, his right arm and shoulder raised, his left arm firmly adhering to his side, the impression being that of a mirror image of Michelangelo's *St Matthew*. Typically for Sansovino, the *St Matthew* has been put to purely decorative use, as was the case with the high relief figures of Sts John and Matthew on the Sacristy door in San Marco (fig. 160). The dramatic potential of the original model has been stilled, and the gesture of Mercury, though more expansive than those of the other bronzes, seems somewhat ambiguous. It may well be that his right hand contained a pipe in the manner of Rosso's engraved Mercury, a work which presented the god in a similar fashion.[38]

Peace, like *Apollo*, bears a generalized resemblance to classical statues of maenads or *kore*, but once again filtered through the alembic of recent representations.[39] The sixteenth century saw a revival of figures of Peace based upon antique coins, chiefly in the context of medals and triumphal entries. Two contemporary figures of Peace are worth mentioning here. One is that made by Sansovino's former pupil Tribolo for the entry of Charles V into Florence in 1536.[40] It had been described by Vasari in a letter to Aretino as a statue some eight *braccia* in height, burning arms and armour with one hand and extending an olive branch to the emperor with the other. The other, more significant, depiction of Peace was by Vasari himself. It was included by the artist in his decorations for Aretino's *La Talanta*, just as Sansovino was engaged on the models for the Loggetta gods. The recent identification of a drawing by Vasari for his fictive statue of Peace (fig. 221) demonstrates that the resemblance between his programme for *La Talanta* and Sansovino's for the Loggetta extends to individual figures.[41] Both artists establish the ponderation of the figure through the motif of the burning of armour, and both bend the right leg above it. Vasari's work makes this into a much more dramatic gesture by twisting the body into a serpentine curve with the right arm holding the olive branch behind the upturned head. Sansovino's *Peace* is, by contrast, much more static and self-contained. The differences can be ascribed to the greater freedom enjoyed by a painter designing fictive sculpture and to the much stronger element of Michelangelo's later sculpture in Vasari's work as a whole. His *Peace* looks back to works like the *Rebellious Slave* and the *Victory* for the tomb of Julius II. Such works sanctioned the exaggerated torsion of Vasari's figure; their employment by Vasari also underscores a fundamental difference between artists of his generation in Central Italy and an older artist like Sansovino: for Vasari, Michelangelo was *the* touchstone of artistic excellence; for Sansovino, his elder contemporary

and sometime rival was only one touchstone among many. If Vasari and his generation never completely freed themselves from the burden of Michelangelo's example, Sansovino may be said never to have felt that burden in full, being either ignorant of or unresponsive to Michelanglo's sculpture after the early 1520s.[42] In Sansovino's version of *maniera*, the example of fifteenth-century sculptors like Ghiberti and Donatello predominate over that of Michelangelo. None the less, the general resemblance between Vasari's and Sansovino's *Peace* reminds us that the two artists had a considerable degree of stylistic rapport in the early 1540s, perhaps in part owing to their mutual friendship with Pietro Aretino.[43]

The unclassical nature of the Loggetta gods perplexed Sansovino's nineteenth-century admirers, but an explanation for their appearance can be found in contemporary attitudes towards the antique and towards what constituted a beautiful figure. The mixture of antique and modern models used by Sansovino for the Loggetta bronzes would not have raised eyebrows among his contemporaries any more than did Botticelli's inclusion of modern figures in his *Calumny of Apelles* (fig. 209). Botticelli's painting is a particularly interesting example of the mixture of modern and antique because it is a work in which the painter attempted to recreate a lost work of antiquity. Although the action of the foreground unfolds according to Lucan's description of Apelles' painting, the statues adorning the piers in the background show a formal debt to Donatello not unlike Sansovino's. The statue of the knight in armour recalls the *St George*, and the draped form on the adjacent pier employs that same fifteenth-century *contrapposto* used by Sansovino in his *Apollo*. Clearly, then, the liberty taken by Sansovino in fashioning his four bronzes was not so singular as might at first appear: both Sansovino and Botticelli paid the same tribute to Donatello that Vasari had done in the *Vite* or Francesco Bocchi did in 1571 with the publication of his short treatiese in praise of the *St George*.[44] They, like Bocchi, regarded Donatello's sculpture as worthy of ranking with the best sculpture of antiquity.

Beyond that, the tapering, feminine bodies and the small heads and hands of the Loggetta gods approximate to contemporary ideas of how graceful figures should seem. The aesthetics behind the four bronzes not only drew upon current ideas of beauty, but also upon an appreciation of antique statues at variance with more modern notions of classical sculpture. the attainment of grace and graceful forms is a recurrent theme of antique and Renaissance treatises on the arts, 'un non so che' which was a *topos* of discussions of beauty from ancient rhetoricians to the eighteenth century.[45] In terms of the plastic arts, one can see a connection between the appearance of Sansovino's bronzes and the kind of stylized beauty advocated by Dolce, Vasari, and even Leonardo. In his *Trattato*, Leonardo counsells artists to make beautiful figures by giving them attenuated limbs and few evident muscles; he states these precepts in a matter-of-fact way, which suggests that this was common knowledge in artists' workshops, perhaps as a gloss on the type of slender figure often found in Gothic and Renaissance art.[46] But his aesthetic ideal had evident classical overtones, and Leonardo may also have been paraphrasing Pliny's remarks on the Lysippic canon, in which an impression of greater height and elegance was achieved by giving statues leaner bodies and smaller heads.[47] It was an attitude reflected in Vitruvius's analysis of the orders, where the most beautiful column, the Corinthian, is also the tallest and slenderest.[48] By Sansovino's day, such ideas had received currency in the writings of Ghiberti, Pomponius Gauricus, and Albrecht Dürer, and Daniele Barbaro's commentary on Vitruvius specifically connected such ideals with the nature of antique sculpture: 'The ancients paid attention to grace as well as proportion in order to create a satisfying appearance. Therefore they made bodies rather long and their heads small, their flanks long; this constituted gracefulness.'[49] Barbaro probably had in mind classical bronzes like the *Idolino* or the *Hercules* of the Capitoline Museum or even the *Apollo Belvedere* as opposed to statues like the Farnese *Hercules* or the *Torso Belvedere*, which show a rather different aesthetic at work. One can see a similarity between the advice of Leonardo and other writers, the kind of figures Sansovino produced, and antiques like the *Idolino* or

Apollo Belvedere, in which the presentation of the torso is less overtly muscular and the ideal of beauty is feminine.[50]

As far as one knows, Sansovino never enjoyed the reputation of being an intellectual artist, but he did move in a circle of intellectuals and popularizers, including Aretino, Serlio, Dolce, and his own son, Francesco Sansovino. In their writings, these men displayed a familiarity, not only with classical and modern writers on beauty, but also with more narrowly specialist texts, such as Vitruvius's *Decem libri*.[51] Ludovico Dolce has already been cited for his discussion of the androgynous beauty of some of Titian's figures, but in his essay in defence of Venetian art, *L'Aretino*, he puts into Pietro Aretino's mouth an unusual argument in praise of delicate as opposed to muscular figures:

> I think myself that a delicate body ought to take precedence over a muscular one. And the reason is that, in art, the flesh areas impose a more strenuous task of imitation than the bones do. For nothing goes into the latter except hardness, whereas only the flesh areas embody softness, the most refractory element in painting—so refractory, indeed, that the number of painters who have it at their command in the past or give it satisfactory expression in their work tody is very small indeed . . . The man who works in the delicate manner . . . gives an indication of the bones where he needs to do so; but he covers them smoothly with flesh and charges the nude figure with grace. And above and beyond the fact that a tender and delicate nude is naturally more pleasing to the eye than a robust and muscular one, let me refer you in conclusion to the works produced by the ancients, whose practice it was, by and large, to make their figures extremely delicate.[52]

When Aretino's interlocutor challenges him by terming his ideal figure feminine as opposed to masculine, he replies, much as Firenzuola did in similar circumstances, by stating that delicacy is an aspect of gentlemen as much as of women, buttressing his aesthetic arguments with social ones.[53] Obviously Dolce's championing of the *nudo gentile* had a polemical, anti-Michelangelesque bias, but it also argues a position not unlike Sansovino's when designing his Loggetta gods, if one can judge by their rarefied appearance.

There is other evidence to suggest that Sansovino did have a knowledge of contemporary discussions of beauty and decorum, namely in his ability to vary his architectural style to suit the nature of a given building. This is seen in such famous examples as the contrast between the Mint and Library on the mole of the Bay of St Mark in Venice, and, as Onians has shown, the variety in Sansovino's buildings was related to the theories of architectural decorum found in the writings of Vitruvius, Aretino, and Serlio.[54] With the Loggetta gods, there again appears to be a specific reference to architectural theory, namely Vitruvius's anthropometric account of the orders Vitruvius formulated his proportions for the orders in terms of fractions or modules of their total length and drew an analogy between the Doric, Ionic, and Corinthian columns and the bodies of a man, a matron, and a maiden, respectively.

The Corinthian order was the most graceful because it imitated the slender figure of a maiden, and, by analogy, slenderness and height were the requisite features of any figure that would be graceful and elegant. Two pieces of evidence indicate an awareness, on Sansovino's part, of the Vitruvian canon: one is that the Loggetta gods are approximately ten faces high, following the proportional system given by Vitruvius in his third book; the other is Sansovino's use of figures in lieu of columns on the fireplaces he designed for the Villa Garzoni at Ponte Casale and for the Doge's Palace (fig. 430).[55] The seemingly unorthodox appearance of the figures can be explained by the sculptor's having followed Vitruvius. In so doing, Sansovino also had an obvious precedent in Serlio's woodcuts of Corinthian and Composite fireplaces, in which terms were substituted for columns (fig. 222).[56]

The bronzes are also calculated so that their niches seem to have been moulded round them, giving the figures an added resonance. This seems to have been second nature to Sansovino, as he did it with the Martelli *Virgin and Child* in Sant'Agostino in Rome (fig. 68) and did so

again with the virtues on the Venier monument (fig. 289). A concern for the effect of the
niche upon sculpture had been a Tuscan preoccupation since the famous controversy over
Donatello's *St Mark* for Or San Michele, and Sansovino probably learnt about it in his
apprenticeship with Andrea Sansovino and from the example of earlier Tuscan sculptors.[57] At
the same time, a similar rapport between statues and niches had grown up in Venetian
funerary monuments of the fifteenth century, producing a style of figure that was slender,
tall, and framed by narrow niches, as with the virtues on the tomb of Niccolò Tron (fig. 227).
This kind of decorative figure, with a residual element of Gothic curve, was also favoured on
more public monuments like the Porta della Carta or the Arco Foscari and seems to have
exerted an influence on Paolo Savin's caryatids for the tomb of Cardinal Zen in San Marco
(fig. 228).[58] An artist as sophisticated as Sansovino was obviously capable of producing a type
of decorative statue that was reminiscent of local sculpture while remaining essentially faithful
to his own roots in the Tuscan Quattrocento.

The primarily decorative nature of the statues is manifest when they are considered as a
group. Sansovino took one basic figural type and deployed it in a number of complementary
poses. All four statues share a common facial type and uniformly long torso; their poses
reflect variations on the *figura serpentinata* as developed by Leonardo, Michelangelo, and
Sansovino himself earlier in the century.[59] The modified *serpentinata* is most evident in the
Apollo, whose torso is turned at an angle to the depth of the niche while his left arm crosses
the chest to establish the curve (fig. 213). *Pallas* responds with the same basic curve, modified
by the position of the left arm and leg (fig. 210). *Peace* and *Mercury* are also a corresponding
pair (figs. 217–18). Both project frontally from their niches, their weight resting on the left
leg while the right leg is bent at the knee. *Mercury*, like *Apollo*, is more sinuous in the
movement of torso and head; *Peace* and *Pallas* are more static and self-contained. Together,
the four bronzes establish a kind of symmetry not unlike the later pair of *Mars* and *Neptune* in
the courtyard of the Doge's Palace (fig. 307) or the *Evangelists* before the high altar of San
Marco (figs. 182–85). The outer figures are the most tranquil and form a visual stop at either
end of the Loggetta; their male counterparts relate to the central doorway, pivoting their
bodies in a convincing simulation of movement. Through this syncopation, Sansovino
masked the simple matrix of his bronzes.

The significance of the Loggetta naturally extended beyond its sumptuous decoration and
classical resonances. As a possession of the procurators *de supra* and as a meeting place for the
nobility, its appearance would have been expected to mirror the dignity and honour of the
Venetian state. The iconographic programme of the Loggetta is reasonably straightforward
and tells us much about Venice's image of herself around the middle of the sixteenth century.
The earliest and best guide to the Loggetta's meaning remains Francesco Sansovino, who
published an explanation of the statues as early as 1546 and again in 1556 and 1581. 'And so
you see,' he wrote in a guide to Venice of 1556, 'that the façade of this small structure
embodies the sea and land empire of their lordships.'[60] That, in essence, is the meaning of the
Loggetta's façade.

Francesco's words purport to record the explanation of the sculpture of the Loggetta as
given by his father. This may be, although much of the learned dressing would have been
supplied by Francesco himself when he wrote his guides to Venice. He explains that the three
large reliefs of the attic depict Venice in the guise of Justice with Jupiter as Crete and Venus as
Cyprus on either side (figs. 199–201). Venice's *terraferma* empire also figures through the
presence of river gods pouring out their waters at her feet. The virtues supporting the
Republic are personified by the bronze figures in their niches. Pallas represents that active
wisdom by which the state defends itself; Apollo conveys the uniqueness and harmony of the
Republic; Mercury stands for the eloquence and learning of Venetian noblemen; and Peace is
literally that divine gift vouchsafed to Venice through her evangelist St Mark (figs. 210, 213,
217–18). Clearly there is nothing surprising about the iconography of the Loggetta, either in

general or in specifically Venetian terms; indeed, many of these ideas were to become commonplace to all celebrations of Venice during the sixteenth century. To Sansovino fell the task of giving the myth of Venice one of its first major presentations, one which had a decisive bearing on its subsequent pictorial representation. He did this by combining mythic and allegorical themes with an architectural framework similar to a triumphal arch.[61] To understand how Sansovino did this, one must appreciate two factors: one is the principle of artistic decorum as practised by Sansovino and his contemporaries, and the other is the significance of mythology as a political language in the Renaissance.

If the ideas behind the Loggetta's decorative scheme were to become commonplace, one must still ask what made an artist like Sansovino approach his task in such a manner. The explanation lies in the concept of decorum in the sense of the suitability of an exposition to a given subject.[62] Decorum had an extensive literary tradition which went back to treatises on rhetoric and works like Aristotle's *Poetics*. As far as ancient times were concerned, the application of decorum to the visual arts had been by inference. Thus Quintillian illustrated figures of speech with images drawn from sculpture, as in his famous citation of the *Discobolos* of Myron.[63] Vitruvius adopted the notion of decorum or *decor* as he termed it when recommending particular forms of temples for individual gods or, again, when he compared the nature of the orders with the human form.[64] In the Renaissance, Alberti drew upon Vitruvius and Cicero, both for his concept of decorum in temples and houses and for his notion of decorum of types in the *De pictura*.[65] Alberti's theories had a definite bearing upon subsequent discussions of appropriateness, especially in Leonardo's discussion of physical types in the *Trattato* and in Serlio's presentation of the orders.[66] Sansovino appears to have had a knowledge of all three writers' works, as did most of his Central Italian contemporaries. His choice of subject matter for the Loggetta's decoration was informed by a sense of decorum similar to that which led to his selection of the Composite order as its principal architectural embellishment. Nor was Sansovino's approach to decoration an isolated or unusual phenomenon in his own time: most temporary decorations for joyous entries of sovereigns into cities or marriages of royal persons partook of the same pool of ideas and associations.[67] To appreciate this, one has only to turn to Vasari's account of his decorations for Aretino's *Talanta* and to his analysis of Montorsoli's Orion Fountain in Messina.

Vasari's account of the *Talanta* decor is pertinent to Sansovino's Loggetta for two reasons. First, it is an explicit account of how Sansovino's younger contemporary and friend set about designing a system of decoration analogous to the Loggetta's, and, second, *La Talanta* was performed in February 1542, just when Sansovino's activity on the Loggetta's sculpture was at its height. Vasari had been invited to Venice in the autumn of 1541 by his compatriot Aretino in order to design the stage set and to decorate the room in which *La Talanta* would be performed. Vasari described his *apparato* in a letter to his patron Ottaviano de'Medici in 1542 and again in his life of Cristofano Gherardi.[68] In both, he explains that the set consisted of a perspective view of Rome, the locale of Aretino's play. His description of the ceiling and main walls of the auditorium are most interesting. The ceiling contained celestial subjects appropriate to such a location: allegories of the times of day, figures of the twenty-four hours, the Sun, the Moon, Aeolus, Juno, and Iris. The walls, however, celebrated Venice and her dominions. There were eight large panels, ten niches with figures, and twenty terms, the terms being executed in stucco by Sansovino's protégé Tiziano Minio, among others. The first of the panels on the right of the stage showed Venice as Adria, the Adriatic, 'in the middle of the sea and seated on a rock with a branch of coral in her hand, around her stood Neptune, Thetis, Proteus, Nereus, Glaucus, Palemon, and other gods and marine nymphs, who gave her jewels, pearls, gold, and other riches of the sea'.[69] The other panels on the same wall contained river gods personifying regions of the Veneto. Opposite Adria-Venice was a scene of the infant Jupiter being suckled by the goat as a representation of Crete, followed by three panels showing rivers, lakes, and mountains, to stand for parts of the Venetian

possessions in the Veneto. The niches were filled with fictive statues that personified Liberality, Concord, Piety, Peace, Religion, Fortitude, Prudence, Justice, Victory, and Charity. Preliminary sketches for the wall decorations survive, and they help one to visualize the appearance of the hall (figs. 221, 223). They also point to a decorative style strikingly similar to Sansovino's, although Vasari's expands horizontally, whilst Sansovino's had to be more vertical, commensurate with the dimensions of the Loggetta. Vasari's panel of Venice as Adria corresponds to Sansovino's large relief panel of Venice as Justice, both figures flanked by aqueous beings. Even more remarkable is this close correspondence between their conceptions of Peace and the way in which the act of burning the armour is the basis of their *contrapposto*. This is not to say that Vasari copied Sansovino or vice versa; rather, the overlapping nature of the *Talanta* and Loggetta decoration reflects the nature of the problem set both artists: the celebration of Venice and its possessions.

Vasari tells us more about the associative use of mythology when he writes about Montorsoli's fountains in Messina.[70] In 1547 the Florentine sculptor Giovanni Angelo Montorsoli was entrusted with the creation of a fountain in honour of Orion, the legendary founder of Messina. River gods provided topographic references to the area around Messina, and twenty myths adorned the base of the fountain. They dealt with subjects like Arethusa, Europa, Narcissus, and the origin of the Castallian spring, all water myths and, as Vasari put it, subjects appropriate to fountains and water'. One can find a similar rationale employed by Vincenzo Borghini in planning the decorations for the marriage of Francesco de'Medici and Giovanna d'Austria in 1567; thus he suggested that the villa of Poggio a Caiano should be adorned with figures of rustic deities, the Porta al Prato with virtues that flourished in Florence, and a fountain at Ponte Santa Trinita with Thetis, Proteus and Aristeus, and a host of maritime creatures.[71] Such examples are indicative of the common body of ideas on decorum that were shared by artists and their patrons in the Renaissance. By the 1580s, writers like Armenini and Lomazzo began to codify kindred observations, and this very fact underscores how wide-spread such notions had become.[72]

While decorum supplied Sansovino and Vasari with general guidelines for celebrating Venice, both artists could draw upon a wealth of literary and visual imagery peculiar to the Republic itself. The insistence upon Venice as a maritime power, one of the major themes of the Loggetta and the *Talanta* decorations, had its origins in the history of Venetian expansion in the Adriatic and its gradual acquisition of an eastern empire. By the fourteenth century the northern Adriatic was commonly referred to as the Gulf of Venice, and her unique setting within the lagoon made Venice exempt from the jurisdiction of the emperor.[73] Both her eastern possessions and her role in the trade routes to the East made Venice into an international power, and it is not surprising to find this idea commemorated on a medal of Doge Pietro Lando in 1539, where Venice is depicted holding the scales and cornucopia between a galley and armour with the inscription *Adriaci Regina Maris*.[74] During the fifteenth century the Venetian sea empire was coupled with a growing dominance over the Veneto so that by the early sixteenth century the elements of the myth of Venice were already established.[75]

One of the earliest and most important visual emblems of the Venetian empire was the group of three standard bases on the Piazza (figs. 224–25). Designed and executed by Alessandro Leopardi between 1501 and 1505, they anticipate much of the Loggetta's iconography and would have been the most conspicuous source of inspiration for Sansovino's treatment of the same themes. The best contemporary account of the imagery of the standard bases occurs in a lengthy poem called *Argoa voluptas* about Venice and its institutions.[76] Its author was an obscure nobleman named Pietro Contarini, who published the poem in Latin in 1541 and again in Italian before his death in 1543. His account of the standard bases comes in a description of the Piazza in the fourth book of the poem and is worthy of note, not only as the first published description of them, but also as the most extensive explanation of their

inconography. According to Contarini, the central standard shows Justice arriving by ship in Venice while a Triton blows his conch and a dolphin carries Ceres (fig. 225). Two other boats are also being brought to shore by Portunus, the god of ports; one contains his wife, the nereid Cymothoe, and the other, Victory holding a palm and accompanied by spoils (fig. 226). The second standard, on the Merceria side of the Piazza, has Thetis with a cornucopia of fruits of the sea, Glaucus carrying Scylla, Peleus with a cockle full of fruit, Palemon and Phorkys with his daughter Euriale, and a faun with a crab. The third standard, by the Campanile, has more marine gods, including Neptune, Amphitrite, Galatea, Nereus, and Galena, who kept the seas calm. Although some of the figures that Contarini identifies are very minor legendary beings, they would have been known to any contemporary familiar with standard classical authors like Ovid and Virgil.[77] Whether Contarini had access to the original programme set for Leopardi or was responding to the same sources is a moot point. What is significant is that Contarini's poem was contemporary with the building of the Loggetta (to which he refers in passing) and was an explanation of the bases' programme then in circulation.

The standard bases formed the first stage in the transformation of the Piazza during the sixteenth century. Like the Loggetta, they were commissioned by procurators *de supra*, whose names appear on each base, together with the profile of Doge Loredan and the winged lion of St Mark. Francesco Sansovino records that there are three standards, in order to represent the three realms of Venice, Crete, and Cyprus.[78] Crete and Cyprus were the most important of the islands owned by the Venetians in the Adriatic, and they figure in Contarini's poem when Neptune reminds Jupiter of his favours to Venice during a council to decide upon the next doge.

The association of Jupiter and Venus with Crete and Cyprus is common to Contarini's poem and to Sansovino's Loggetta and derives from the euhemeristic tradition that the gods once ruled over the two islands.[79] Francesco Sansovino glances at this tradition in his account of the Loggetta in 1556 when he cites Lactantius on Jupiter's burial in Crete, noting that the labyrinth on the relief of Jupiter was a second reference to the island (fig. 199).[80] Likewise, he mentions the discovery of the tomb of Venus by his friend Gian Matteo Bembo near Famagusta as proof of the legend that the goddess had lived on Cyprus. However, the discovery of the putative tomb of Venus happened only in 1548, several years after the Loggetta's completion, though Bembo's attempt at archaeology testifies to the strong sense of cultural links between Venice and her eastern possessions, even to the extent of willing them into existence.[81] Certainly the association of Venus with Cyprus was no novelty in Venetian art. Titian employed a fictive relief of Venus as a reference to Cyprus in his early votive painting of Jacopo Pesaro, and there was a poetical tradition that held the Venetians to be children of Venus, the name *Venetia* being considered a derivative of Venus. By other traditions, Venice was held to be the daughter of Jupiter, as in the canzone 'Ecco Vinegia bella'.[82]

With these myths of divine parentage were woven others that held the Venetians to be the descendants of Trojan noblemen rather than fishermen native to the lagoon.[83] This mythology served two purposes: first, it linked Venice, Crete, and Cyprus inextricably in the popular mind, and, second, it cast an aura of antiquity over the Venetian empire, something it lacked by comparison with Rome or Byzantium. Since the role of Venice as an international power was strongly linked to her position in the Adriatic and on the Italian peninsula, it is not surprising to find these themes given prominence in the attic of the Loggetta. Moreover, her empire would have been of topical concern during the period in which the Loggetta was designed and built. The Peace of Bologna in 1529–30 sanctioned the independence of the Venetian state and the reconquest of her *terraferma* empire.[84] On the other hand, Venice faced a continual threat in the east from the Turks, and from 1537 to 1540 tension between the two powers ran very high, culminating in a short war.[85] When peace was declared in October

1540, the Venetians managed to keep Cyprus but ceded all their other islands in the Aegean. The insistence upon her major possessions of Cyprus and Crete being in the decorative programme of a public building like the Loggetta should be seen in this context.

In the main panels of the Loggetta's attic, Jupiter and Venus appear in the outer reliefs and Venice sits enthroned in the centre (figs. 199–201). The gods perform a double function of alluding to the mythic origins of Venezia, the personification of the Venetian state, and the islands of Crete and Cyprus. They are shown in complementary poses, semi-recumbent, with nereids and tritons at their feet and classical temples behind them. As Francesco Sansovino notes, the accompanying figures identify them: Jupiter receives his sceptre from the eagle, and Venus takes the arrow from her son Cupid. Their poses, like those of the river gods in the central panel, suggests the idea of fealty to the enthroned figure of Venice. The smaller panels of relief that separate Jupiter and Venus from Venice contain putti holding the shield of St Mark and resting on martial trophies (fig. 426). Although they are not explained by Francesco Sansovino, their meaning seems to be the triumph of the Venetian state over its enemies, a *leitmotiv* of the Loggetta as a whole.[86]

About the central panel of Venice, Francesco Sansovino is quite explicit: 'volendo figurare, si figura una santissima giustitia'.[87] This was in keeping with the oldest surviving image of Venice, that on the Doge's Palace, in which a female figure is seen with the attributes of justice and fortitude.[88] The appeal of this personification of Venice was enhanced by its affinities with the iconography of the Virgin Mary, as in Jacobello del Fiore's Allegory of 1421, in which the distinctions between Justice, Mary, and Venice are blurred.[89] Also in the fifteenth century, medals of the doges Francesco Foscari and Cristoforo Moro had obverses with Venice as Justice, and Sansovino included three similar panels of Justice in the decoration of the mint in the early 1540s.[90] Hence this personification of the Republic made a logical centrepiece to a façade dedicated to extolling its virtues. The river gods beneath her feet not only symbolize the Veneto states of the Venetian empire, but also reflect the analogous figures on the spandrels of the Library. One can appreciate the use of similar motifs, including victories and decorative panels in the soffits of the arches, as a means of relating the appearance of the Library and Loggetta; as projects for the procurators *de supra*, both buildings reflect two aspects of the same *all'antica* style while celebrating the wealth of the Venetian state and its elected officials.

Below the attic, the most conspicuous feature of the Loggetta's main storey are the four bronzes: Pallas, Apollo, Mercury, and Peace. The tradition of embellishing public buildings with the gods can be traced back to the late Middle Ages, drawing upon moral and pseudo-historical explanations for their citation.[91] Sansovino, like Leopardi earlier in the century, invokes the gods as allegorical figures who personify different attributes of the Republic. This is made clear by a comparison of the Loggetta's imagery with passages in the *Argoa voluptas* and canzoni written about 1550 by Domenico Venier and set to music by Baldassare Donato. In Contarini's Latin poem, the Olympian gods shower gifts upon the newly elected doge: Jupiter gives him a crown of laurel; Juno, riches; Pallas, wisdom; Mars teaches him the art of war; Mercury, eloquence; Themis, law; Prudence gives him three eyes; Clemency, good behaviour; Justice, a golden mantle, and so forth.[92] In Domenico Venier's poems 'Quattro Dee' and 'Viva sempr'in ogni etate' Venice is celebrated as the virgin state, honoured by the gifts of Victory, Peace, Wisdom, and Fame.[93] Significantly, both Venier and Francesco Sansovino echo the famous metaphor of Petrarch when they hail Venice as the home of peace and justice.[94] As for the bronze gods of the Loggetta, more light is cast upon their meaning by examining Francesco Sansovino's account in terms of traditional commentaries on mythology and in terms of the similar programme drawn up for the decoration of the *antipregadi* of the Doge's Palace in 1577.

The four gods are represented twice in each bay of the Loggetta, both as statues and in a small relief above each statue's head. The reliefs gloss the particular aspect of the god being

celebrated. Hence, in the case of Pallas, the relief shows her slaying a giant (fig. 210). The subject was a rather minor myth but is significant here as explaining the origin of her name. By killing a giant called Pallas, Minerva appropriated his name.[95] The story is mentioned by Boccaccio and Jacopo da Bergamo in their accounts of Minerva, and on the Loggetta, it may also convey a broader allusion to the *gigantomachia* or the just punishment of presumption. This martial side of the goddess's nature is underscored by her appearance in the bronze figure with her helmet, cuirass, and shield. 'Pallade armata', Francesco Sansovino calls her, and he may have been thinking of Boccaccio's account of Pallas as Bellona, the inventor of war and sister of Mars.[96] The sense in which Pallas is to be understood is very close to the explanation of her role in the decorative scheme for the *antipregadi* chamber of the Doge's Palace in 1577.[97] There Pallas was to occupy a place between Peace and War, involved with both as protectress of the arts and as that active wisdom which was prepared to defend the state if need be.

By contrast, the imagery of Apollo is much more straightforward. There are three interconnecting ideas: the sun as unique among the planets; Apollo as god of music; and music as a metaphor of harmony. The god's appearance is strongly reminiscent of the Apollo Belvedere, though with a quiver in his right hand and the fragment of a lyre in his left (fig. 213). The relief above shows the flaying of Marsyas by Apollo, an allusion to the end of the hapless musical competition between the two. The uniqueness of the sun had been employed by Cicero as an explanation of the derivation of the noun *sol* from the adjective *solus*; the sun was called *sol* because it was singular among the heavenly bodies and at its rising eclipsed the stars.[98] According to Francesco Sansovino, Apollo here embodies the singularity of the Venetian government, which was alone of its kind. The secondary sense of Apollo as the god of music gains reference through the figure's lyre and the relief with the story of Marsyas. Music not only conveys the great pleasure that the Venetians had in that art, but also the wider implication of music as harmony. In this context, Apollo is the source of the harmony governing the cosmos and the concerted activities of the Venetian government, and so Francesco Sansovino writes: 'since the unusual harmony which perpetuates this immortal government derives from the marvellous harmony of its magistracies, *Apollo* has been fashioned to represent harmony.' This was a pervasive topos of classical literature, but the most probable source for its political overtones here would have been Cicero's *Republic* and especially the *Somnium Scipionis*, which contained an extensive account of 'mixed' governments similar to that of Venice.[99] Indeed, the concept of 'harmonic proportion' was seen by the French theoretician Jean Bodin as the basis of Venetian prosperity and stability in his account of the Republic in 1576.[100] Consequently, this aspect of the Loggetta's iconography would not have been lost upon the sixteenth-century public.

The key to the explanation of Mercury lies in the grisly trophy at the god's feet and in the scene of Mercury playing for Argus in the relief above (fig. 217). As Ovid tells the story, Mercury disguised himself as a shepherd to lull Argus to sleep with the music of his pipes. He then killed Argus in order to free Io, who had been consigned to Argus's keeping by Juno.[101] Commentaries on the *Metamorphoses* interpreted the myth as a fable of prudence deceived by eloquence; Mercury's playing of the pipes was held to represent wisdom and eloquence.[102] Cicero and Lactantius referred to the slaying of Argus as the motive behind Mercury's flight to Egypt, where he was worshipped as the founder of laws and literature.[103] This explanation of the myth of Mercury and Argus was not peculiar to Sansovino's Loggetta in the sixteenth century, for it also appears on the reverse of a medal of the poet Torquato Tasso besides figuring on the soffit of the arch of Mercury on Sansovino's Library.[104] Jean Seznec drew attention to the unclassical presentation of Mercury on the Loggetta, linking Sansovino's figure with the image of the god on the so-called *tarocchi* of Mantegna; there the god is dressed in a simple tunic with pointed cap and soft boots, along with his more conventional attributes of pipes, caduceus, wings, cockerel, and the head of Argus. Sansovino's decision to portray Mercury as a rustic shepherd may well have some connection with the *tarocchi*, but it was not

owing to an unfamiliarity with the standard image of the god with caduceus and petasus. Sansovino used the more conventional image of Mercury on the arch dedicated to him on the Library. He may have chosen the less obvious presentation of the god as an allusion to his disguise when he played before Argus and as an allusion to Mercury as god of eloquence.[105]

The fourth bronze, Peace, is shown in the act of burning armour (fig. 218). The image derives from Roman coins with the *Pax Augusta* presented as a woman holding an olive branch in one hand and setting fire to armour with the other.[106] It was revived earlier in the sixteenth century on the reverse of a medal of Leo X by Pier Maria Serbaldi da Pescia and subsequently appeared on other Medici medals by Cellini and Francesco del Prato.[107] Peace, like Plenty and Justice, was a conventional attribute of good government, but in the case of Venice it also carried overtones of the legendary words heard by St Mark when he arrived in the Venetian lagoon: *Pax tibi, Marce, evangelista meus*.[108] Moreover, history had shown that Venice was impervious to the assaults suffered by mainland Italian cities and that she was rarely troubled by internal strife of sedition. Her reputation for peace and liberty had been consecrated by Petrarch and again in the 1480s by the *Supplementum chronicarum* of Jacopo da Bergamo.[109] Peace, as an ideal and as a policy, gained even greater importance for Venice in the early sixteenth century with the wars of the League of Cambrai and the Treaty of Bologna in 1529.[110] Though the treaty recognized Venetian rights to an empire in the Veneto, it put an end to any hopes of expansion within the peninsula. The most that Venice could hope for was a maintenance of the status quo, and a peaceful neutrality became her chief policy from the 1530s onwards.[111] The embodiment of Peace on the Loggetta would have been inescapable under the circumstances. According to Francesco Sansovino, Peace represents two things: the legendary words spoken to St Mark and the more recent idea of Venice as 'L'albergo vero della sacratissima pace', a concept which, as noted earlier, was given its classic expression by Petrarch and invariably repeated by later writers. On the Loggetta, Peace seems visually to balance Pallas, representing war. The relief above the figure's head, which shows Peace with a cornucopia, paying homage to a seated warrior, represents not a myth but rather an allusion to peace as the product of war, as in the saying *ex bello pax*.[112] Certainly, a similar sentiment is expressed in the 1577 programme for the decoration of the *antipregadi* of the Doge's Palace where figures of Peace and War flank Pallas above the entrance to the *pregadi*.[113]

Up to this point, the iconographic programme of the Loggetta is clear. The attic refers to the Venetian empire; the statues, to those virtues peculiar to the well-being of the Republic. Below the statues are further reliefs that decorate the base of the façade. Their significance seems to be more generic than specific, and like the minor motifs on Leopardi's standard bases, the connecting link here seems to be aquatic imagery. Of the four larger panels below the statues, only the one beneath Peace can be identified with security. It is Phrixus and Helle and appears as a reference to the Hellespont and Venetian interests in the orient (fig. 202), much as the same myth was employed in Mons on a tableau in honour of Charles V's exploits in the east.[114] The companion relief under Mercury shows a female deity succouring a young man in water. Selvatico tentatively identified it as Thetis coming to the aid of Leander, which would be a second myth relating to the Hellespont.[115] The companion reliefs under *Apollo* and *Pallas* have resisted positive identification, all the more so in their present fragmentary state (fig. 203). They contain representations of a female deity, perhaps Venus, in a carriage drawn by dolphins and accompanied by two sea nymphs in the panel beneath *Apollo*, or two tritons, in the other.

The remaining figural panels decorate the bases of the columns and allude to major and minor maritime deities. At this point, the programme grows slack, with Saturn appearing twice and Neptune two, possibly three, times (figs. 203–05). One of the Neptunes may be Portunus, and the other panels include Scylla, Triton, and perhaps Amphitrite or Thetis (figs. 207–08). Their precise identification apparently did not exercise Sansovino, or anyone else, for that matter; instead, the purpose of the minor reliefs was comparable to the host of sea

beasts that crowd Leopardi's standard bases, namely, to provide a counterpoint to the principal themes of the work which are expressed by the major figures above. The choice of aquatic imagery was dictated by the same ideas of artistic decorum employed by Leopardi, Vasari, and Montorsoli: they were appropriate to the celebration of a maritime city-state.

The Loggetta's façade was not the only celebration of the 'myth of Venice' on which Sansovino worked during the later 1530s, for he probably had a major role in the decoration of the balcony or *finestrone* on the Piazzetta side of the Doge's Palace (fig. 429).[116] The balcony gave on to the Sala dello scrutinio or *libreria* and must always have been intended to complement the great Gothic balcony on the *molo* or water façade of the palace. The programme of the Piazzetta balcony was only devised, however, under Doge Andrea Gritti, whose arms and kneeling figure are among its principal features. Although the balcony bears a general resemblance to its older companion, the burden of its sculpture is mythological rather than religious allegory: in the main niches are statues of Mars (fig. 428) and Neptune by Sansovino's erstwhile pupil Pietro da Salò and, above, later figures of Mercury (fig. 427) and Jupiter by Alessandro Vittoria. Given that Sansovino was involved in the preliminary discussions concerning the adaptation of the *libreria* chamber for the Senate and that his employer, the procurator Jacomo Soranzo, was put in charge of the remodelling in 1532, it seems unlikely that the use of mythological divinities in the balcony of the palace *and* Loggetta was purely coincidental; rather, it must have been a decision taken in the highest quarters of the government, possibly involving agreement between the doge, the Council of Ten, and the procurators *de supra* of San Marco. Together with the standard bases, one finds in these more monumental projects a decisive break with the older tradition of employing virtues and saints to embody the moral qualities of divine favour enjoyed by Venice; moreover, one finds a similarity of poses for the statues, and virtually the same members of Sansovino's workshop involved in the realization of both the Loggetta and the *finestrone*. Each project reinforces the significance of the other as well as the elevation of the myth of Venice to a new place in the late 1530s.

The 1530s and 1540s witnessed a number of impressive projects by Sansovino, but few were more influential than the Loggetta and its sculpture. In particular, the four bronzes are among the most beautiful creations of sixteenth-century Italian sculpture, certainly the most felicitous expression of Sansovino's Venetian career, one in which the experimental nature of their medium, the personal style of their maker, and contemporary artistic currents coalesced. Their Quattrocentesque reminiscences, combined with a sinuosity of movement more firmly of the mid-sixteenth century, imparts to the bronze gods the air of being *Kunstkammer* objects enlarged to a greater scale; with them, Sansovino's art comes close to that of Giambologna. But even though the aesthetic that informs the bronzes in San Marco or the Loggetta gods can be termed mannerist, it would be a mistake to label Sansovino or the majority of his Venetian contemporaries as 'mannerist' *tout court*. For Sansovino, as for most sixteenth-century artists, mannerism was only one *maniera* among many, a style suitable for a decorative work like the Loggetta but not appropriate for *giganti* like his *Mars* and *Neptune* or the virtues placed on the tomb of Doge Francesco Venier. Sansovino arrived at a mannerist style thanks to the stimulus of younger artists like the Salviati and Vasari, but also because of his own very deep roots in the Quattrocento styles of Donatello and Ghiberti. With the Loggetta, he created figures parallel to those of Vasari or, for that matter, Parmigianino, but *via* different means and different masters.

The influence of the Loggetta upon later Venetian art was so pervasive that it has often gone unrecognized. The stylized poses and attenuated proportions of the bronzes formed the basis of many of Alessandro Vittoria's later works (figs. 455–56).[117] Sansovino's integration of sculpture and niche and of sculpture with architecture was taken up by Palladio and the artists of his circle. Palladio employed solutions based upon the Loggetta in his elevations for the Rialto Bridge project and in his façade for the Scuola Grande della Misericordia, the latter being a completion of a project of Sansovino's.[118] Similarly, Danese Cattaneo employed

elements from the Loggetta in his tomb of Doge Leonardo Loredan (fig. 453) as an attempt to create a new kind of public monument.[119] More surprising, perhaps, is the favour which the Loggetta's decorative scheme found with painters. Zelotti painted fictive bronze statues of gods in the salone of the Villa Godi and again in the Villa Emo, during the 1550s and 1560s; here it is impossible to avoid the conclusion that Zelotti sought to adapt the Loggetta's format to the interior of a house (fig. 229).[120] In much the same way, Veronese actually copied Sansovino's *Peace* in one of the frescoes in the Villa Barbaro at Maser (fig. 230); he and his associates also paid tribute to Sansovino in the painted decorations of the Sala d'Oro of the Marciana Library, where the philosophers stand in niches based upon those of the Loggetta and sometimes in poses reminiscent of Sansovino's statues (fig. 231).[121]

In terms of iconography, the impact of the Loggetta was equally vast. The first public monument erected after the Peace of Bologna, the Loggetta was, together with the *finestrone* on the Piazzetta side of the Doge's Palace, the first large-scale presentation of the 'myth of Venice', that carefully rehearsed celebration of the Republic's antiquity and independence. Sansovino adapted the allegorical treatment of the myth as employed by Leopardi on the standard bases and turned it into a series of reliefs and separate figures. Only subsequently, it would seem, did this allegorical embodiment of the virtues of the state find its way into the paintings of the Doge's Palace. Here, again, it is Veronese's ceilings for the *sale* of the Council of Ten (1553–54) that established the change from the earlier historical and religious cycles to the allegorical ones of the late sixteenth century.[122] Moreover, the programme for the decoration of the *antipregadi* of the Doge's Palace after the fire of 1577 employed sculpture in a manner that owed much to the Loggetta's example.[123]

Thus the significance of the Loggetta upon figural styles and public iconography was probably greater than has previously been thought. It is one of those rare works in which one can actually pinpoint a new aesthetic in gestation. The Loggetta bronzes remained a touchstone for elegant and graceful figures even down to the eighteenth century, and it comes as something of a pleasure to see the spirit of *Mercury* and *Apollo* revived in Giovanni Marchiori's *David* and *St Cecilia*, executed for the church of San Rocco in 1743 (fig. 232).[124]

VI. Sansovino's Reliefs for the Arca del Santo

SANSOVINO'S RELATIONSHIP WITH the church of St Anthony in Padua spanned virtually his entire Venetian career. His name first appears on the account books of the Arca del Santo a little over a year after his arrival in Venice, and the last reference occurs only seven years before his death. During that period, Sansovino completed two of the nine relief panels which adorn its chapel (fig. 240); moreover, he gave advice on the chapel's decoration besides providing his own pupils and associates as executant sculptors. Through the work of pupils of his own pupils, his influence can be said to have extended to the end of the sixteenth century. Above all, with the relief of the *Maiden Carilla* (fig. 260), Sansovino created one of the major works of his Venetian career, and it remains the most important testimony to his conception of relief sculpture, one that differed significantly from the prevailing style of Tullio and Antonio Lombardo.

To understand how Sansovino came to play such a dominant role in the history of the shrine of St Anthony, one must first consider the saint himself and his peculiar relationship with the city of Padua.[1] Born around 1195, St Anthony came of a wealthy family in Lisbon. He entered the Canons Regular at the age of fifteen but was inspired to become a Franciscan in 1220. Despite his first wish to suffer martyrdom by carrying the gospel to the Saracens, he spent much of his mature years combatting heresy in Sicily and Rimini. He taught in Bologna between 1223 and 1225 and was in France from 1225 to 1227. His abilities were recognized by his order in the latter year when he was appointed minister of the province of Emilia. Anthony also gained recognition as a preacher when he spoke in Rome before Pope Gregory IX in 1229. From that year until his death in 1231, he spent much of his time in Padua, where he composed his *Sermones*. Some days before his death, Anthony went on a retreat to Arcella, just outside Padua, dying there on 13 June. His body was brought back to Padua and buried in the church of Santa Maria Mater Domini. He was canonized by Gregory IX in 1232.

St Anthony has always been the most popular Franciscan saint after Francis himself, and his body soon became an object of veneration and pilgrimage, much as St Mark's was in Venice. The church of St Anthony, called simply il Santo, was begun in Padua around the middle of the thirteenth century, incorporating the earlier church of Santa Maria Mater Domini.[2] Construction proceeded into the fourteenth century, and the plan of the Santo reflects a combination of influences, ranging from Italian mendicant churches for the large nave and aisles to French Gothic cathedrals for the choir and presbytery (fig. 241). Around the middle of the fourteenth century, a chapel, conceived as a resting place for the saint, was added on the left-hand side of the nave at the transept. Evidence suggests that it resembled, indeed served as a model for, the late fourteenth-century chapel of San Felice (fig. 242),[3] directly opposite the present chapel of St Anthony. It had an arcading of porphyry columns and four corner piers supporting a flat entablature and a ceiling painted in tempera and gilded

arabesques; the walls were covered with frescoes of St Anthony's miracles by the painter Stefano da Ferrara, though these had deteriorated by the late fifteenth century.[4]

As early as 1470 there was an attempt to improve the chapel's appearance by commissioning a new entablature designed by Bartolomeo da Ponte.[5] By 1497 it was generally felt that the state of the chapel was both perilous and not sufficiently grand for the church or its saint. The general of the Franciscan order, Francesco Sansone, promised financial help for the chapel's restoration, and the city's council passed a resolution requiring the *massari*, a group of Paduan noblemen who administered the Arca, to set aside a portion of the Arca's revenue towards the restoration of the chapel and the general maintenance of the church as a whole.[6] Two models for a new ceiling to the chapel were duly ordered that same year, and the one by Piero Antonio da Lendinara was executed in 1498.[7]

This piecemeal approach to the chapel's restoration might have continued if the shrine of St Anthony had not received a large bequest of 3,000 ducats from Francesco Sansone, who died in late October 1499. Two months later, the money entered the coffers of the Santo, and a model for a new chapel was ready by February 1500.[8] Purchases of marbles for the new structure were made in Venice and elsewhere while the nature of the model was under discussion. A definitive model was ready by June 1500, and a local stonemason named Giovanni Minello became *proto*, or supervising architect, of the project that same month. Work continued on the chapel's structure until 1532 when it was dedicated; the following year saw the construction of a cane vault and stuccoed ceiling under Giovanni Maria Falconetto.[9]

The new chapel conformed in type to the old one: columns and four corner piers articulated the walls of the chapel, creating an arcade of five bays across the entrance to the chapel and a fictive arcading of five bays across the rear wall and three bays on both of the lateral walls. Nine of the eleven internal bays were to be decorated with scenes from the life and legends of St Anthony, but, unlike the first chapel, the second would have marble reliefs instead of frescoes. The first two reliefs were commissioned from Tullio and Antonio Lombardo in July 1500.[10]

The designer of the chapel is not named in any of the surviving documents, though it is customarily attributed to Andrea Riccio. The attribution goes back to Bernardo Gonzati, the author of a mid-nineteenth-century history of the basilica.[11] Gonzati based his conclusions on the fact that Riccio was paid for making the wax figures and reliefs that adorned the model of the chapel and that he was named as the 'author' of the chapel in the notes of Marc'antonio Michiel. Only in comparatively recent times has Gonzati's theory been challenged, by Erice Rigoni, who rightly observed that Riccio was paid only for making the figures and was not mentioned elsewhere in the accounts of the Arca during the period before the model's adoption.[12] To her arguments, one might add that Michiel was not always a reliable witness, nor can anything remotely like the chapel of the Arca be found in the known work of Riccio.[13] While Rigoni's arguments against Riccio seem plausible, her advocacy of Minello as the chapel's designer is less convincing. Giovanni Minello was a provincial follower of Pietro Lombardo, under whom he worked in Padua from 1464 to 1467.[14] His known works reveal a conservative nature and a limited imagination, which would argue against his being the creator of such an impressive and distinctive work as the chapel of the Arca del Santo. Moreover, his role at the Santo was that of a day-to-day building supervisor, and there is not a hint in the documents that his writ ran beyond that. This still leaves the question of the chapel's designer unanswered, but one obvious candidate would be the pair of brothers chosen to carve the first two reliefs, Tullio and Antonio Lombardo.

The most striking feature of the chapel of the Arca del Santo lies in its combination of panels of relief sculpture with a framework of artificial perspective; in this, it bears a close resemblance to only one other work, the façade of the Scuola Grande di San Marco in Venice (fig. 242). The Scuola had been reconstructed from 1485 to 1495, part of that time under the direction of Pietro Lombardo and with relief sculpture by Tullio and possibly Antonio

Lombardo.[15] The combination of sculpture and architecture on the Scuola's façade and in the chapel of St Anthony is unique in Venetian or, for that matter, Italian Renaissance architecture. In both, the elevations are treated as a perspective backdrop for a scene that occurs in high relief sculpture. The Scuola's façade contains four panels of relief arranged in pairs round two doors; the areas above them are designed to represent arcades with vanishing points converging in their respective doorways. The solution employed in the chapel of the Arca is very much like the façade of the Scuola wrapped round the interior of a room, and in this case the fictive arcading is the setting for high relief scenes of the miracles of St Anthony.

The relationship between the perspective and high relief elements is more difficult to appreciate in photographs of the chapel of St Anthony than of the Scuola Grande di San Marco, but an eighteenth-century engraving of the chapel brings out what may have been the original intentions of the designer (fig. 243).[16] The engraving shows a view into the chapel from the transept of the Santo, in which the lines of the fictive arcading converge upon the central bay, much as on the façade of the Scuola. In fact, this must have been the aim of the chapel's creator, though it was not strictly adhered to beyond the earliest bays of relief by the Lombardo brothers and Antonio Minello. These earliest reliefs, the *Miracle of the Repentant Son* (fig. 249), the *Miracle of the Speaking Babe* (fig. 250), and *St Anthony receiving the Franciscan Habit* (fig. 252), are also the only ones that attempt to relate the perspectival backdrop to the relief proper.

The source for this combination of relief sculpture and perspective may ultimately go back to Donatello's reliefs on the high altar of the Santo, in which the saint's miracles are enacted against striking perspective backdrops (fig. 245). Certainly Tullio Lombardo was very much aware of Donatello's reliefs, and any attempt to retell the legends of St Anthony had to take account of Donatello's classic examples.[17] One other source of inspiration for the chapel's appearance may have come in another 'classic' of fifteenth-century art, the sketchbooks of Jacopo Bellini. There is, in particular, a drawing for an arcaded structure similar to the chapel of the Arca in the Louvre sketchbook (fig. 246).[18] Like the chapel of the Arca, the temple in Bellini's drawing is an attempt at classicizing a Gothic building type and could have been known either through the drawing now in the Louvre or through a lost painting of the same subject executed by Bellini for the Scuola Grande di San Giovanni Evangelista.

However, the most plausible explanation for the similarities between the Scuola di San Marco and the chapel of St Anthony is in the participation of the Lombardo family in both projects. Tullio frequented a circle of Paduan connoisseurs and scholars whose serious interest in all aspects of art is documented in the treatise of Pomponius Gauricus.[19] From a letter of 1526, one can also appreciate that Tullio was well versed in the language of the *paragone* or the debate over the superiority of sculpture versus painting. Writing to a prospective patron in Rovigo, Tullio assured him that a marble relief would endure longer than a painting for his chapel: 'It will be an eternal memorial as your lordship can judge because painting is ephemeral and . . . sculpture incomparable, not to be considered with painting by any means, especially since ancient sculpture has survived in our times while of antique painting nothing remains.'[20] One can imagine Tullio's advancing the same sort of arguments before the administrators of the shrine of St Anthony during their debate on the new chapel's decoration.

The design of the chapel of the Arca, like the façade of the Scuola Grande di San Marco, is the product of a mind conditioned by training as a sculptor. Its novel combination of relief and perspective would have been beyond the ken of Giovanni Minello and improbable as the creation of Andrea Riccio, whose expertise lay in goldsmithing and bronze-casting. This leaves Tullio Lombardo, together with his brother Antonio, as the most likely proponent of the chapel's design, given that the kind of relief sculpture chosen for the chapel's bays was *mezzo rilievo*, a speciality associated with the work of the Lombardo brothers in Venice.

As defined by Vasari, *mezzo rilievo* was the type of sculpture employed by the ancients for decorating walls and triumphal arches where free-standing figures could not be used (fig.

248); protagonists appeared in half relief or slightly more than half while other figures were in gradations of lower relief with the background little more than *schiacciato*.[21] These features are evident in the first two reliefs of the series, Tullio's *Repentant Son* and Antonio's *Speaking Babe*, both in place by 1505 (figs. 249–50).[22]

The stories chosen were ones that had previously been frescoed by Stefano da Ferrara and concerned two of the most popular legends grown up in the thirteenth and fourteenth centuries. One portrays the saint making whole the foot cut off in anger by a now-repentant young man, and the other concerns the testimony of a two-month-old child who proved his mother's fidelity to her husband. Although both reliefs evoke a classical idiom, the influence exerted by Donatello's bronze panels for the high altar is none the less perceptible here. Both brothers had, after all, been set two of the legends previously depicted by Donatello, though only Tullio responded strongly to the Tuscan sculptor's presentation. Antonio's solution is the more uncompromisingly classical, casting the scene of the child defending its mother's chastity along the lines of an antique sacrifice. In this sense, Antonio's work is the most ambitious and subtle of the whole series, as it is the one which most successfully conveys the spirit of classical art. This is seen not only in the pose of individual figures like the mother on the far right, but also in the whole ensemble. The figures relate to each other and to the spatial context in a complex manner: the centre of the composition has been shifted to the left so that it is central to the fictive architecture above and behind; as a counterweight, the woman and child on the far right are seen walking out of the arcade a few feet in front of the woman behind them. Though showing a similarly antique formula, Tullio's *Repentant Son* is far less static as a composition. Where Antonio deliberately turned his back on Donatello's version of the same subject, Tullio's classicizing manner has been tempered by an awareness of Donatello's bronze relief of the *Repentant Son*. The scene is pitched at a higher key and is generally bolder in its undercutting of hair and figures, such as the young man at the centre of the incident. There is also a greater tendency towards virtuoso carving, as in the elaborately plaited hair of the woman on the right or the intertwining of limbs of the central characters.

In 1501 the *massari* of the Arca del Santo may have anticipated the conclusion of the chapel's decoration within a relatively short period of time. They commissioned two more reliefs from the Lombardo brothers, the death of the saint from Tullio and the miracle of the miser's heart from Antonio; in 1502 another sculptor, Giovanni Battista Bregno, was brought into the project with a commission to carve the miracle of the glass, and Giovanni Minello and his son Antonio were also promised a relief.[23] Unfortunately for the Arca, events took a far different turn: Antonio Lombardo left for Ferrara in 1506, without having executed his second relief; Bregno also reneged on his obligation; and Tullio did not begin his second panel until 1520. Some light is shed on this lost period in the chapel's history by a pen and ink drawing which recently appeared in a private British collection (fig. 247).[24] The drawing's proportions, format, and subject matter all demonstrate a close affinity with the programme of the chapel of the Arca, and it is difficult to conceive of its not being directly connected with that relief cycle. Moreover, the treatment of the figures and their drapery are pronouncedly Lombardesque. While Tullio did go on to carve the *Miracle of the Miser's Heart* in the 1520s, the drawing shows stronger affinities with the calmer style of Antonio's *Speaking Babe*; individual poses can be paralleled between the two, and both have the distinctive backdrop of drapery. By contrast, Tullio's finished version of the same scene is much more agitated and far removed from the world of the first two reliefs in the series. It seems more plausible, therefore, to place the drawing around 1501 and by or after Antonio Lombardo.

The pace of work on the chapel of the Arca slowed considerably after the first few years. Undoubtedly the greatest single factor was the War of the League of Cambrai, which not only disrupted the economy of the Veneto as a whole, but also caused a cessation of work at the Santo for nine years from 1508 to 1517.[25] The only relief executed during this period was *St Anthony receiving the Franciscan Habit* by Antonio Minello, with which the *massari*

were not much pleased (fig. 252). Part of their displeasure stemmed from the fact that a relief of the miracle of the Eucharist had been commissioned from Giovanni Minello and his son in 1501, but the relief presented in 1517 was by Antonio alone and of a different subject. In their view the sculpture was not only badly executed, but also done by the sculptor without a specific agreement with his patrons.[26] Even a cursory examination of the relief bears out the negative judgement of the *massari*, for Minello simply followed the general format of Antonio Lombardo's relief on the opposite wall, though without showing any of the native ability of his predecessor. The gestures of the individuals are vacant, and there is no attempt to convey the spatial complexity of Antonio's relief or the technical accomplishments of Tullio's. He was paid only 60 ducats for his trouble, about one-seventh of Tullio's payment for his first relief.[27]

A new commission went out in 1516, this time to Lorenzo Bregno, brother of Giovanni Battista.[28] His subject was the miracle of the woman who had been stabbed by a jealous husband and healed by St Anthony. This had recently been the subject of a painting by Titian in the adjacent Scuola del Santo.[29] Rivalry between the Scuola and the Santo would have sharpened the sense of urgency about the execution of their respective cycles on the life of St Anthony. Though the paintings of the Scuola were finished in a relatively short span of time, they suffer from the similar inequality of execution that plagued the cycle of the Arca del Santo. Bregno defaulted on his contract, and by 1520 the chapel still had only three reliefs completed. More commissions were issued that year, with Tullio obtaining the story of the miser's heart, Gianmaria Mosca the miracle of the glass, and Antonio Minello the legend of the child Parisio.[30] Four years later Giovanni Rubino, a Milanese sculptor and protégé of Alvise Cornaro, contracted to sculpt the story of the jealous husband.[31] Of all these reliefs, only the *Miser's Heart* was finished by the artist originally assigned to it. Minello died in 1528 and Rubino in 1529; Mosca eventually abandoned his project in favour of an offer to serve Sigismund II of Poland. Although Tullio Lombardo agreed to carve a third relief, the *Miracle of the Eucharist*, he did not touch the marble block allotted to him before his death in 1532.[32]

Thus death, migration, and economic difficulties thwarted a quick termination to the programme of relief sculpture. At the same time, the *massari* were not happy with the quality of work produced or with the available pool of sculptors. There was a lengthy disagreement between the *massari* and the Lombardo brothers over the amount of a bonus to be paid them for the first two reliefs; Minello's work, as noted above, did not meet with their approval; and a dispute between the *massari* and Mosca led to his replacement by the Milanese sculptor Paolo Stella.

The fruits of this second stage of completed commissions were definitely mixed. Tullio Lombardo's *Miracle of the Miser's Heart* outdistanced the rest in quality and originality (fig. 251). Executed between 1520 and 1525, the relief retells a legend that had appeared in the frescoes of Stefano da Ferrara and in Donatello's high altar reliefs.[33] It was a cautionary tale against greed, and Tullio condensed the scene to the essential moment in the legend when the miser's body was split open to reveal that his heart was not in its rightful place but in his money box. The figures are sparer than in the first panel, their gestures more stylized. The dramatic content has been heightened, as the protagonists appear to react in a Bacchic frenzy of movement. The *Miser's Heart* represents a far different vision of antique relief sculpture than that seen in Tullio's or Antonio's earlier reliefs, one closer to Donatello's *Entombment of Christ* on the Santo's high altar.[34] A very personal work, Tullio's relief is also a technical *tour de force* with brilliant use made of undercutting, especially in the drapery folds. They have been worked to a remarkable depth under the body of the miser and on the bearded man above him.

By contrast, Mosca's *Miracle of the Glass* could hardly be described as other than sub-Antonio Lombardo. This was the first of the posthumous miracles to be treated in the chapel and was one of the less frequently depicted legends of the saint.[35] It deals with a skeptical

knight who vowed to become a Christian if a glass dropped from a balcony did not break. An earlier version of this story, painted for the Scuola del Santo, depicted it in two scenes, but Mosca did not have this option and reduced the story to the moment of recognition of the unbroken glass (fig. 254). The figures are steeped in the style of Antonio Lombardo, particularly the curly-headed man on the left and the woman bending towards the glass. The general standard, however, falls short of both Lombardo brothers. The faces of the protagonists are unfocused, their glances shooting above or below one another, which contributes to a general lowering of the dramatic potential, as does the figure of the female spectator on the far left, who is both undersized and staring fixedly at her companion's elbow. Rubino's panel has a similarly awkward grouping of figures, straining after drama only to achieve melodrama (fig. 253). Like Titian's earlier fresco of this same subject in the Scuola del Santo, Rubino's relief focuses on the husband's stabbing of his wife; the saint's intervention is included only in a stucco panel above, added towards the end of the century. Rubino died before he could complete the relief, and this was entrusted to one of Sansovino's collaborators, Silvio Cosini, in 1534.[36] While the basic composition is unquestionably Rubino's, the presence of Cosini's hand is probably more considerable than may appear at first glance. The separate panel of spectators on the left, showing the three ages of woman, anticipates the analogous grouping at the centre of Sansovino's *Miracle of the Maiden Carilla* (fig. 265), and the child, the woman behind him, the man restraining the husband's knife, and the young man supporting the wife all show a Tuscan stamp, which would indicate that Cosini was at work here.

Sansovino's entry into the affairs of the Arca del Santo followed the death of Antonio Minello in 1528 and resulted from the dearth of good sculptors in Venice and Padua at that time. Minello had contracted to provide the *massari* of the Arca with a second relief in 1520, though his model was only accepted three years later.[37] The story chosen concerned a nephew of St Anthony who drowned while playing on a boat; his body was recovered by fishermen and given to his mother, who vowed to place her son, Parisio, in the Franciscan order if he could be restored to life. The miracle that followed was attributed to the divine intervention of St Anthony. Minello apparently worked steadily on the relief between 1523 and 1526, for by the latter year he had earned two-thirds of his basic 240 ducat fee. Precisely when Sansovino acquired the charge of completing Minello's work is not known, but it must have occurred in the first half of 1529. In January of that year Jacopo, described as 'scultore excellentissimo et raro a questa nostra età', agreed to carve a marble figure of St Sebastian for the Arca, and he subsequently advised on the value of Paolo Stella's completion of Mosca's *Miracle of the Glass*.[38] Evidence is ambiguous concerning the execution of the *St Sebastian*, and it may be that the project was set aside under the pressure of other work. In any case, Minello's unfinished relief was removed from his workshop and entrusted to Sansovino in July 1529. Five years later, it was finished.[39]

When considering the relief of the *Miracle of the Child Parisio*, one must first apportion the roles of the two sculptors. Both of Minello's reliefs distinguish themselves from the others in the chapel by favouring a large number of protagonists stretched artlessly across the front plane (figs. 252, 255). The *Child Parisio* crowds sixteen figures into the scene, and the effect dilutes whatever impact the subject might have had. It is an approach wholly alien to Sansovino's style as revealed in the *Maiden Carilla* relief (fig. 260).[40] Both of Minello's reliefs are not only poorly conceived but also heavily derivative: the earlier panel follows closely the example of Antonio Lombardo; the later one is clearly indebted to Gianmartino Tranzapani's painting of the story of Parisio in the Scuola del Santo (fig. 256).[41] Again, a comparison between the *Child Parisio* and the *Maiden Carilla* only emphasizes the different and fundamentally Central Italian artistic principles underlying the latter work. Given this and the record of payment to Minello, the composition of the *Child Parisio* must essentially be by him, with the role of Sansovino being confined to the completion of individual figures.

Minello borrowed from Tranzapani's fresco the main features of his presentation of the

story. In both, the saint features as an active participant even though the written sources state that he was not present. The confrontation between the mother and her brother becomes the focal point, amplified by the friars to the left, a group of women and a baby on the right, and the fishermen in the centre. Whatever nuances were added by Sansovino would have been circumscribed by the forms already present in the panel, and he probably touched up most of the main figures besides carving all the heads in low relief. More specifically, the group of friars to the left of the saint, the two fishermen behind the mother, and the woman on the far right bear the clearest indications of Jacopo's attention. In their various ways, they reflect a command of anatomy, pathos, and drapery far beyond the abilities of Antonio Minello and of a different order from the more histrionic effects of Tullio's *Miser's Heart* (fig. 251). The pronounced musculature of the middle-aged fisherman is wholly alien to the schematic treatment of anatomy in Minello's first relief, and the figure's massive, bald head and furrowed brow anticipate the appearance of the old man on the far left of the *Maiden Carilla* relief (fig. 263). Likewise, the faces of the younger fisherman above the mother and the bearded friar next to St Anthony bear a family resemblance to other figures by Sansovino, namely the *Bacchus* in Florence (fig. 35) and the figure of St Francis on the terracotta relief in Berlin (fig. 128). The heads of the other young men share a type of idealized beauty and thick, curly hair found in Michelangelo's *David*. St Anthony, his sister, and the group of women on the right show less evidence of Sansovino's attention, although the woman on the far right is draped in a manner that recalls the Nichesola *Virgin and Child* (fig. 112). Sansovino probably expended more energy on drapery and touching up features than on anything else. He may well have intensified the expressions of the saint and his sister as a means of heightening the scene's dramatic content. Though the basic composition must be seen as Minello's, Sansovino none the less made subtle changes to it, imparting to it a substance and expressive quality it had lacked.

Sansovino may have accepted the task of finishing another sculptor's work as a means of gaining a commission from the Arca del Santo. He incorporated into Minello's relief as much of his own stylistic vocabulary as he could in order to provide an illustration of his capabilities as a sculptor: a greater ability in anatomic detail; pathos; and a greater verisimilitude of human types than was evident in the earlier reliefs for the chapel of St Anthony. In December 1532 the *massari* of the Arca decided to award Sansovino the relief previously assigned to the now-deceased Tullio Lombardo, and Jacopo signed a contract with the Arca on 3 June 1536 under extremely favourable conditions.[42] According to the terms of the contract, Sansovino was to carve the legend of the Paduan girl, Carilla or Eurilia, who drowned in a ditch and was then recalled to life by St Anthony, who was to appear in the air.[43] Significantly, the price agreed was 300 gold ducats, fifty more than the basic fee paid to any other sculptor by the Arca; there was the additional promise of a bonus to be paid by the Venetian patricians Jacomo Cornaro, then *capitanio* of Padua, and Federico Priuli, a procurator and patron of Sansovino.[44]

Despite these inducements, the execution of the *Maiden Carilla* relief proved long and cumbersome, resulting in distrust between Sansovino and the *massari*, a situation not fully resolved until the work was installed in 1563. The reason behind this is not hard to fathom: Sansovino simply took on too many commissions for the time available. While in his first Venetian years there had been no undue delays in completing the Nichesola or Malipiero monuments or the Arsenal *Madonna*, the situation became more complex by the mid-1530s because Sansovino's work as *proto* of San Marco increased severalfold. A new Loggetta and the Procuratie Nuove were being planned and built; there were palace commissions, including one from Jacomo Cornaro's family; and there was an extensive project for the redecoration of the ducal chapel of San Marco itself.[45] Inevitably this led to a much slower rhythm of production in later years, especially where sculptural commissions were concerned.

The very length of time involved in completing the *Maiden Carilla* poses a problem in terms of placing the relief within the sequence of Sansovino's Venetian sculpture. Early com-

mentators ignored the question of date or simply recorded the dates of commencement and delivery; more recently it has been argued by Weihrauch, among others, that Sansovino's relief was carved in two phases, one around 1536 and another, reflecting a 'late' style, between 1557 and 1563.[46] Such an argument is, however, inherently implausible since it implies that Sansovino worked upon the relief in a piecemeal fashion, modifying his style between the two periods. A careful examination of the *Maiden Carilla* indicates that such an elaborate network of forms in low and high relief is too tightly knit to admit of a piecemeal approach; neither, for that matter, do the figures betray the kind of stylistic breaks which Weihrauch wanted to see. It seems more probable that Sansovino arrived at a general conception, blocked out the subject in a relatively short period of time, and then left the completion to take its course over a longer period.

There are, moreover, concrete reasons for doubting an execution of the relief in two phases. Payments by the *massari* show that Sansovino received 180 ducats between 1536 and 1557, almost two-thirds of the agreed price.[47] The most concentrated period of work on the relief fell between 1542 and 1551 when payments occurred at three or four yearly intervals. During these years the basic appearance of the relief was probably determined; given the *massari*'s policy of paying sculptors as they worked, this seems a reasonable conclusion.[48]

Beyond this, stylistic considerations also point to the 1540s as the decisive time for planning and execution of the relief. If one compares the *Maiden Carilla* with Sansovino's reliefs of the middle and late 1530s (figs. 128–29, 131, 133–34, 136, 138), one finds a conspicuous difference in the proportions of the figures.[49] The Paduan relief favours a pronounced elongation of the torso, which is a common stylistic feature of Sansovino's sculpture of the 1540s, as the later series of bronze reliefs for San Marco, the Medici Tabernacle, the Loggetta gods, and the Sacristy door bear witness. Around 1540 Sansovino began to experiment with a new canon of proportions and a preoccupation with form over content, features that align his work with Central Italian *maniera*. This was not an entirely new phenomenon. In his *Trattato*, Leonardo equated 'delicate and elongated' figures with attractiveness, and this was already a commonplace of Florentine art.[50] Then, too, many of Sansovino's younger contemporaries like Vasari, Francesco Salviati, and Andrea Schiavone were developing comparable styles in the same years. Whether this shift in Sansovino's sculpture came as the result of contact with younger artists or his visit to Florence in 1540 or a resurgence of an earlier Florentine tradition, his new approach to figures can be seen in the *Maiden Carilla*, particularly in the three men who close the scene on either side (fig. 260). The elongation is especially pronounced in the two younger men whose girdle and belt emphasize the unusual length of their torsos (figs. 263–64). At least one of these three, the old man on the far left (fig. 263), must have been fairly advanced by the late 1540s because it served as the model for Tommaso Lombardo's *St Jerome* in San Salvatore, a statue probably executed under Sansovino's supervision (fig. 412).[51]

Besides its distinctive approach to human proportions, the *Maiden Carilla* differs from the earlier reliefs in its approach to composition. Unlike his predecessors in the chapel of St Anthony, Sansovino does not appear to have been so strongly inspired by the relief sculpture of Donatello or the antique. Instead, his treatment of the scene is rooted in the type of narrative art current in Central Italy during Sansovino's youth. The story of the Paduan mother's appeal to St Anthony for the restoration of her daughter's life obviously put Sansovino in mind of a lamentation over the dead Christ or a *Pietà*, and elements of both inform his relief. The arrangement of figures in such terms may have been suggested by Raphael's early Lamentation study for the *Entombment of Christ* of 1507, which had been engraved by Marc'antonio Raimondi (fig. 262).[52] The insistence upon a composition being inscribed by simple geometrical forms was a recurrent theme in Central Italian art of the High Renaissance but not in Venetian painting and sculpture.[53] Sansovino's alignment with the manipulation of the human body to fit a conceptual form is most strikingly seen in the central group of the drowned girl, her mother, and the old woman above them (fig. 265). The three figures describe a

pyramid and their sizes are graduated so that the young girl is small, her mother on the scale of the standing figures, and the old woman perceptibly larger than any other figure in the relief except, perhaps, the old man on the far left. Works like Leonardo's cartoon (fig. 6) or Michelangelo's *Pietà* in St Peter's had taken similar liberties with scale, but they were working within a tradition of such devotional images, like the wooden *Virgin and Child with St Anne* formerly in Or San Michele.[54] Sansovino's manipulation of scale to achieve a comparable effect lacks the sanction of traditional imagery, but it is in keeping with the more elastic treatment of proportions common among artists of Sansovino's day. Vincenzo Danti's *Trattato delle perfette proporzioni* expresses very well the theory behind this creative license:

> proportion, properly speaking and according to my opinion, is nothing else than a way to combine objects such that one agrees with the other and likewise the whole with its parts in a measured quantity . . . according to the purpose for which the objects are combined. This commensurability can be with like or unlike things, but the ratio of unequal objects will always be more ingenious and will cause greater beauty than that of like objects.[55]

As Danti would argue, proportion in figures does not depend upon an abstract canon but is strictly related to a given composition, and the virtuosity of Sansovino's relief lies partly in his ability to combine, with consummate skill, the three figures at the centre of his composition.

Beyond this specific concern with proportionality, Sansovino's relief shows a clear influence of contemporary theories of aesthetics. Ever since the time of Alberti, the cognate nature of painting and sculpture had been widely accepted, with both art forms aspiring to the quality of relief.[56] This ideal has frequently been mentioned in discussions of works by Sansovino and Andrea del Sarto during their period of close collaboration, and it is not surprising to find Sansovino applying pictorial principles of composition to the *Maiden Carilla*. Indeed, there is a notable consistency of approach between the Paduan relief and the series of bronze reliefs for the choir of San Marco (fig. 141).[57] Both favour simple, geometrical, balanced compositions; there are figures of both sexes, a variety of ages and poses, and a semidraped figure. These elements had been advocated by Alberti in *De pictura* and by Leonardo in his treatise as well as in his own compositions. The two men furnished the only significant discussion of composition before Lomazzo's *Trattato della pittura* of 1584. Thus their words have great importance in understanding certain features of a work like the *Maiden Carilla*.

Both Alberti and Leonardo treat of composition in terms of *historia* or narrative. Alberti advises the artist to employ a limited number of figures, never more than nine or ten, and to observe a decorum of types and of action; the best *historiae* move the spectator through gesture and expression and have a pleasing variety.[58] Leonardo built upon Alberti's ideas in his works, especially in his treatise on painting, but he stresses a more naturalistic treatment of figures and recommends the juxtaposition of contrasting types to heighten dramatic effect:

> The painter takes pleasure in the abundance and variety of the elements of narrative painting and avoids the repetition of any part that occurs in it, so that novelty and abundance may attract and delight the eye of the observer. I say that, depending on the scene, a narrative painting requires a mixture of men of various appearances, ages, and costumes, and also mixed with women, children . . . one ought to mingle direct contraries so that they may afford a great contrast to one another, and all the more when they are in close proximity; that is, the ugly next to the beautiful, the big to the small, the old to the young, the strong to the weak, all should be varied as much as possible and close together.[59]

Leonardo's words illuminate the tradition in which the *Maiden Carilla* was conceived as well as point to a number of differences between Sansovino's relief and the earlier ones for the chapel of St Anthony. Sansovino's panel is more coherent and restrained in its action than Minello's or Rubino's or Mosca's reliefs. He not only peoples his relief with persons of both sexes and various ages, but also accentuates the differences between one type and another.

Thus one finds the magnificent group of the adolescent Carilla, her mother, and the wizened old woman in the centre of the composition, the placing of an old man and a young man on the left, a young man and a young woman on the right.[60] By contrast, the reliefs of the Lombardo brothers and their followers tend to present all their figures as variations upon an idealized type; the only other relief to show the kind of naturalistic rendering of types before the *Maiden Carilla* is the group of three women and an old man added by Sansovino's associate and fellow Tuscan Silvio Cosini on the left of Giovanni Rubino's *Miracle of the Jealous Husband* (fig. 253).[61]

Coupled with this naturalism is an insistence upon the mastery of the human form, which distinguishes Sansovino's relief from those of his predecessors. Sansovino gives particular prominence to the nude man on the left, who fished Carilla out of the water, turning him from a subordinate into a dominant element of the composition.[62] He seems to be a composite work: the head is modelled on the so-called bust of Aristotle that Sansovino employed frequently; the torso is possibly based upon an antique *Discobolus* type.[63]

Despite these antique reminiscences, the figure reflects a sixteenth-century preoccupation with anatomy, a pursuit Sansovino shared with his Central Italian contemporaries.[63] While the other male figures are draped, their garments nevertheless reveal the contours of their bodies. The other two males are less antique in inspiration. The young man on the left is comparable to the *Mercury* of the Loggetta (fig. 217) in deriving his pose from Michelangelo's unfinished *St Matthew*; the head, too, bears typically Florentine features. The man who closes the composition on the far right is a more direct quotation from Michelangelo: the *Christ* of Santa Maria sopra Minerva.[64] The debt is partially disguised by the figure's head, which is turned inwards; yet the serpentine twist of the torso and the folding of the left arm across the torso leave no doubt about the source of the idea. What makes this citation of Michelangelo especially interesting is that the *Christ* would have been the most recent sculpture by Michelangelo seen by Sansovino before his departure from Rome in 1527. At the same time, Michelangelo's *Christ* is a figure in which formal virtuosity predominates over content.[65] It was prophetic of a tendency in mid-sixteenth-century art towards a display of bravura at the expense of decorum, and Sansovino was not immune to this tendency when he came to design the *Maiden Carilla*.

The place of the *Maiden Carilla* in Sansovino's sculpture falls between the first and second set of bronze panels for San Marco, both chronologically and stylistically. It is like the first series, in looking back to early works by Leonardo, Raphael, and Michelangelo for the sobriety of its composition, but it also shares with the second series a penchant for elongated forms and a display of technical virtuosity. Sansovino does not go as far in the marble relief as he did in his bronzes in experimenting with *maniera*, and the differences can be ascribed partly to medium and scale, although decorum also played a part in determining the appearance of the *Maiden Carilla* relief. The relief was, after all, a narrative in the grand manner, and, as Alberti observed, *historiae* should have 'abundance not only furnished with variety, but restrained and full of dignity and modesty'.[66] Sansovino has attempted to balance these ideals with the greater knowledge of the human form and of antique sculpture available to a mid-sixteenth-century sculptor. Unlike many of his younger contemporaries, Sansovino here manages to strike a balance between form and content by focusing upon what best lay within his capabilities, namely, the distillation of emotions. He powerfully exploits the drama of the mother's grief which radiates to the other protagonists and to the spectator. So single-mindedly does the sculptor concentrate on this moment before the miracle actually occurred that he dispenses with the presence of the saint, stipulated in the contract to be 'in aere'. Sansovino probably decided early on that St Anthony was superfluous here.[67]

When it came to the completion of the relief cycle, the last panel in the series was awarded to Sansovino's protégé and sometime collaborator Danese Cattaneo, in 1571. He died the following year, shortly after beginning work on the relief, and the project subsequently came

to Cattaneo's disciple Girolamo Campagna.[68] Installed in 1577, Campagna's *Miracle of the Raising of the Youth at Lisbon* (fig. 267) eschewed the classicizing forms of the Lombardo brothers for something more akin to Sansovino's pictorial language. It is one of only two conspicuous examples of marble relief sculpture from the later sixteenth century, the other being an altarpiece by another Sansovino follower, Domenico da Salò, in the Venetian church of San Giuseppe di Castello (fig. 268).[69] In both cases, the artists' solutions follow closely upon the precedent of Sansovino in orienting relief sculpture towards the principles of Central Italian pictorial composition.

The impact of the *Maiden Carilla* was limited, but that is in the nature of large-scale reliefs. Few were commissioned in the sixteenth century, and nothing, not even the Casa Santa of Loreto, compares with the boldness of conception and scale found in the chapel of St Anthony. Sansovino's contribution to this great cycle is of undeniable importance for his career and for an understanding of the developments in relief sculpture during his lifetime. It was a major commission, for which Sansovino pulled out all the stops. In it, the sculptor blended the classical and the contemporary in a manner peculiar to himself while capitalizing on those narrative techniques best suited to his own gifts. The relief was calculated to dazzle the eye in a manner unlike, for example, the *Miracle of the Miser's Heart* by Tullio Lombardo, for it created an elaborate network of overlapping figures and juxtaposed types on differing scales to great effect.

If judged by the terms of the Lombardo brothers' reliefs or by the standards of classical sculpture, the relief of the *Maiden Carilla* was a failure, and so it was judged by Neoclassical critics like Cicognara.[70] But such a conclusion arises from a misunderstanding of Sansovino's principles as a relief sculptor, principles which correspond to the theory of composition articulated by Alberti and Leonardo. More than any of his predecessors in the Santo, Jacopo put into practice a recurrent theme from contemporary artistic theory, the reciprocal ideals of painting and sculpture. Hence, his presentation of the drowned girl recalls the pictorial compositions of his youth, chiefly those of Raphael and Andrea del Sarto. Likewise, his recourse to geometrical configurations and pairs of contrasting individuals can best be appreciated in the light of Leonardo's writings and compositions; his preference for elongated figures and his display of human anatomy were also concomitant developments in the art of Sansovino's age.

VII. The Later Virgin and Child Compositions

VASARI'S BIOGRAPHY OF Sansovino pays the sculptor one unusual compliment:

> Connoisseurs say that, however much he may have yielded the palm to Michelangelo, he was, none the less, his superior in certain things. In his drapery, in children, and in the demeanour of his female figures, Jacopo had no equal . . . he made his children soft and tender without the musculature of adults and with little arms and legs, so life-like that they seemed to be of flesh. The expressions of his women were sweet and charming, as graceful as could be, just as one sees in various Madonnas created by him in several places, both in marble and relief.[1]

It is a passage that has drawn comment, chiefly because it sets Sansovino in the category of Raphael, since Vasari regarded both artists as alternatives to the example of Michelangelo. But Vasari's words also give a concise definition of where Sansovino's talents lay. Though he never made as many or as varied examples of this genre as did Donatello or Luca della Robbia, his best works convey an intensely human and poetic quality that raises them to the level of Sansovino's great predecessors. Moreover, in his Venetian period, Sansovino adopted the methods of fifteenth-century sculptors for producing multiples of his reliefs, thus capitalizing on his flair in this field.

Depictions of the Virgin and Child form one of the oldest and richest veins in Western art.[2] Over the centuries the hieratic nature of such images was superceded by more accessible ones focusing upon the human element in the relationship between mother and child. In Italy, these changes were under way from the thirteenth century, and by the fourteenth a special category of small devotional images of the Virgin and Child had become commonplace. An indication of this can be found in Fra Giovanni Dominici's treatise on household management, written shortly before 1400.[3] In it, Fra Giovanni recommended sacred pictures as a moral example for children. These could be of the Christ Child or infant Baptist or St Agnes or similar figures with whom children could identify; they could also be of the Virgin and Christ Child, sometimes with a bird or apple in his hand or with the Child sleeping or nursing or simply gazing at his mother. A special class of artists called *madonneri* produced nothing except such works, but artists of greater calibre also exploited the growing demand. In the fifteenth century, men like Ghiberti, Donatello, and Luca della Robbia experimented with creating sculptures of the Virgin and Child in media like terracotta and stucco as well as marble and bronze.[4] At the same time, they elevated this kind of work to a state of freshness and naturalness that places such sculptures among the most perennially attractive achievements in Renaissance art (fig. 235). Donatello and Luca lent their skills to experimenting with modelled reliefs that could be pigmented to produce raised paintings, and they also designed devotional reliefs for systematic reproduction (figs. 236–37).[5] Their popularity is attested

by the many replicas that survive, and their example was later followed by Desiderio da Settignano, Antonio Rossellino, and others. The great outpouring of Quattrocento talent in this field remained fundamental for the evolution of later works by Leonardo, Michelangelo, Raphael (fig. 238), and their followers.[6]

Such works were equally important for Sansovino, who, like all Florentines, literally grew up with these images in street tabernacles, churches, and probably his own home. One latter-day practitioner of this kind of sculpture whom the young Sansovino would have known was Andrea della Robbia.[7] A nephew of Luca, Andrea entered his uncle's workshop around 1450 and effectively took control of it around a decade before Luca's death in 1482. It was Andrea who expanded the technique of glazed terracotta into a variety of new compositions capable of an almost endless replication by means of piece-moulds and a well-organized workshop. His sculptures were destined for other Italian cities as much as Florence, and through his five sons Andrea's shop continued well into the sixteenth century. Much under-rated now, Andrea della Robbia can still be seen as a bridge between the world of his uncle Luca and the generation of artists active in Florence when Sansovino was an apprentice. At his best, as in a relief like the *Madonna of the Architects*, Andrea elaborated compositional ideas of Luca, but in a less classical and more direct manner. He also turned the process of reproductive art into an industrial one through the manufacture of hundreds of copies of basic devotional images (fig. 239), rarely modelled by Andrea himself but largely executed by collaborators who pressed clay into a negative matrix or mould.[8] Andrea's career demonstrated an interest in and continuing demand for such works; his success and the mechanical means employed in turning out devotional reliefs were not lost on Sansovino.

As a young man, Sansovino emerged from the same ambience in which Andrea della Robbia moved. An early work like the terracotta *St John the Baptist* in the Bargello (fig. 11) has affinities with productions from the della Robbia shop as well as those grouped loosely under the title of the Master of the David and St John Statuettes.[9] Vasari also tells us that Andrea and his sons were friends of Andrea del Sarto, who depicted them in the frescoes of his San Filippo Benizzi cycle of 1510; given the strong ties of friendship between Sarto and Sansovino, it would have been unusual if Sansovino were not included in Sarto's contacts with the della Robbias.

Recollections of this world would prove important in Sansovino's Venetian career when his abilities in the Virgin and Child genre were given ample scope. From his pre-Venetian career, the only Virgin and Child compositions that now survive are the sketch model for the Mercato Nuovo competition (fig. 58) and the Martelli altarpiece (fig. 68).[10] As we have seen, the former work, now in Budapest, developed an idea already present in a painting by Albertinelli (fig. 60), albeit in a weightier and more dynamic form. This tendency to balance avant-garde with more conservative stylistic features is characteristic of Sansovino's method of operating here, and it is also evident in the monumental group in Sant'Agostino in Rome. In the latter sculpture, Sansovino's conception is more remote from the Quattrocento tradition despite superficial similarities with the work of Andrea Sansovino and genre details such as the presence of the goldfinch. Instead, the Martelli *Virgin and Child* is coloured by an awareness of Michelangelo and late Raphael as well as the antique. What Sansovino achieved was a sculptural equivalent to the work of his close friend Sarto, especially in a work like the Porta Pinti *Madonna* (fig. 73).

Sansovino was true to the artistic principles of his generation in fashioning those figures, but, once established in Venice, his pattern became modified. His first Venetian sculptures of the Virgin and Child, the Nichesola (fig. 86, and see figs. 112-13) and Arsenal *Madonnas* (figs. 98-99), have been considered in a previous chapter.[11] There a recrudescence of Quattrocento formulae from Andrea Sansovino and Donatello was noted as an example of Jacopo Sansovino's ability to tailor his style to suit the prevailing artistic climate. His reworking of fifteenth-century and Byzantine models, particularly with the Arsenal *Madonna*, can be

compared with Giovanni Bellini's exploitation of comparable elements in his half-length
paintings of the Virgin and Child (fig. 104), which form a special category within his *oeuvre*.[12]
In Venice, too, Sansovino would have found a large number of Byzantine images of the
Virgin and Child made by the local *madonneri*, and his subsequent production of *cartapesta*
reliefs may have been stimulated by a ready market for such devotional images.[13] Such fac-
tors, as well as the evident success of Giovanni Bellini in this field, may have conditioned
Sansovino's approach to the theme in his Venetian career.

In addition to the Arsenal *Madonna*, three other statuary groups on the subject of the Virgin
and Child date from the middle of the 1530s. This was the period in which Sansovino's career
gained momentum, and this is reflected in the lengthy gestation of his sculptures. In this case,
the works in question are the *Virgin and Child with Angels* now in the Chiesetta of the Doge's
Palace (figs. 121–23) and the terracotta *Virgin and Child with the Infant St John*, fragments of
which are now inside the Loggetta, having been damaged by the collapse of the campanile in
1902 (fig. 115). In addition, two minor works can be connected with them: a damaged model
in stucco and canvas found several years ago in the former hospice of the Muneghette in
Venice, and a gilt-bronze *Virgin with sleeping Christ Child* now in the sacristy of the Redentore.
As they form a coherent group, it would be appropriate to discuss them together.

Both the marble group in the Doge's Palace and the terracotta in the Loggetta have been
seen as kindred compositions.[14] In both, the Virgin and Child are presented as rising to meet
a third person, absent in the marble but present in the terracotta; in both, Sansovino adapted
ideas that went back to his years of collaboration with Andrea del Sarto. Although the marble
can be documented as under way by 1536, the terracotta has a documentary *terminus ante quem*
of only 1565. There is, however, visual evidence to show that both were fairly advanced by
the early 1540s.

The *Virgin and Child with Angels* is one of the best-documented works by Sansovino.[15]
From surviving accounts, we know that Sansovino's assistants were engaged on 'una nostra
donna di marmo' from approximately October 1536 to February 1537 and that the marble
was destined for the 'portal della chiesa' or doorway of San Marco. In November 1537 Pietro
Aretino described a sculpture by Sansovino of 'that admirable mother of Christ, who offers
a crown to the protector of this unique state', referring in this last phrase to St Mark himself.[16]
Later Vasari would also write of 'a marble statue of Our Lady, life-sized' as already in place
over the portal of San Marco although this was not in fact the case.[17] Extensive reference to
the marble Madonna comes in 1573 when Jacopo's son Francesco Sansovino initiated legal
action against the procurators of San Marco for the recovery of 100 ducats against his father's
labour on 'a marble image of the Blessed Virgin Mary with little angels and *puttini* . . . to
be placed in the church of San Marco'. In support of his claim, Francesco adduced the series
of payments dating from the years 1536–37, but the procurators issued a restraining order
against the suit. When the case finally reached the Collegio, an advisory council of the Venetian
government, the decision favoured the procurators. Then Francesco offered a compromise,
namely an appraisal of the statue's value by experts, as had previously been the case with the
Sacristy door (fig. 152); the procurators dug in their heels, possibly because they had been
forced to make a large payment in Sansovino's favour in that case.[18] Both sides battled into
1575, when Francesco was invited by the procurators to remove the marble, and, after a vain
attempt to sell it to the Duke of Bavaria, Francesco gave the statue to the Senate. It was first
placed in a niche in the Great Council chamber and subsequently in the chapel or Chiesetta
where it can be seen today. Despite this fairly detailed information, one major problem
remains: was the statue actually intended for the portal of San Marco?

That question was posed by Weihrauch half a century ago.[19] He conjectured that the
marble group under way in 1536 was destined for the lunette over the main portal of San
Marco, which did receive a Sansovinesque frame in the sixteenth century (fig. 127). But
Weihrauch also observed that the dimensions of the statue now in the Chiesetta were too large

for the present niche, thus precluding it from consideration. Consequently, he argued that the terracotta group in the Loggetta must have been the model of the work for the church's portal and that it would have had a figure of St Mark to complete it, rather than the *Giovannino* (fig. 127). While Weihrauch saw the terracotta as consistent with Sansovino's style around 1536, he relegated the marble group to Sansovino's workshop, believing it to be a product of the sculptor's old age.[20] According to his theory, the project for the *madonna di marmo* was abandoned at some point after 1537, and the terracotta model was installed in the Loggetta around 1550, at which time the *Giovannino* would have been made to finish the group.

Notwithstanding some perceptive observations, Weihrauch's theory founders on several points. In the first place, documentary evidence links the marble statue begun by 1536 with that now in the Chiesetta, and Weihrauch never seriously deals with this major obstacle to his theory. While it is true that the present niche could not encompass the statue, it does not follow that the niche predates the marble; instead, it may be a later adaptation, dating from the arrival of the relief called the *Dream of St Mark*.[21] The basic dimensions of the lunette above then main external portal are sufficient to receive the statue, as Davis observed, and this would be the only apposite site on the external or internal façades.[22] In addition, both Vasari and Francesco Sansovino state that the *madonna di marmo* was to go above the door of San Marco, which indicates that the idea was still current in the 1560s. One further piece of evidence strengthens the hypothesis of the lunette as the intended location: the presence of a gilt Virgin and Child in the same position is recorded in Gentile Bellini's view of Piazza San Marco in 1496.[23] Given the precedent of such an image in the lunette, one can argue that Sansovino and his patrons must have entertained the idea of substituting a newer work for the gilt Virgin during the 1530s, and this should be understood in light of the general refurbishment of San Marco during those years and afterwards.

What happened after the initial flurry of activity on the *Virgin and Child with Angels* can only be conjectured. Although Aretino refers to the Virgin as crowning St Mark, no such accompanying figure was ever begun. From Francesco Sansovino's lawsuit, one learns that Jacopo and his assistants worked on the statue over a number of years, presumably intending it for the same site. In the meantime, the change in composition of the procurators and the delay in completion obscured the project in their minds so that they could actually accuse Sansovino of having begun the statue of his own initiative and without permission.[24]

In all probability, Sansovino never finished the marble group. Its presence in the procurators' storerooms in 1573 must mean that he stopped work on it before his death, probably many years before. An examination of the statue corroborates this in two ways. First, the Virgin's face, nostrils, and hair seem only to have been sketched in (fig. 122). The presence of stars in her hair may represent a rationalization of the height of her headdress, in which Sansovino may have planned to carve cherubs like those crowning the Loggetta *Madonna*. Then, there is the curious lack of rapport between the folds of drapery on the Virgin's arms and chest and those on her lower torso and legs (fig. 123). This, more than any other feature, illustrates the discontinuity in the statue's gestation. While the folds across the legs and abdomen create a credible sense of fabric as in Sansovino's other statues, the upper folds are more schematic, virtually rectangular channels in the marble. The basic pattern for the drapery over the Virgin's breast invites comparison with the same passage on the Virgin of Sant'Agostino in Rome (fig. 124), but in execution it has been transmuted into an idiosyncratic and un-Sansovinesque piece of carving.

The discrepancy in quality between the upper and lower portions of the statue point to two different styles of carving. Other than the general composition, the only areas that reflect Sansovino's style are the Virgin's legs and, to a lesser degree, the Christ Child and angels. The drier treatment of the Virgin's face and upper drapery indicate that a less-talented hand or hands intervened. We know that Luca Lancia and Tommaso Lombardo worked on the marble, at least in the initial stages, but Lancia is merely a name and Lombardo is scarcely

more.[25] The only element in the statue that invites comparison with work by one of Sansovino's followers is the drapery folds on the Virgin's arms and upper torso. Similarly dry, tubular folds can be seen on the statues of *Abundance* and *Charity* by Francesco Segala on the Scala d'Oro of the Doge's Palace (fig. 125).[26] Segala had worked for Sansovino in the late 1560s when he executed the bronze *St John* for the baptismal font of San Marco, and he may have been entrusted with bringing the upper part of the Virgin to completion at that time or, more likely, after Jacopo's death when his son Francesco tried to sell the statue to the Duke of Bavaria. Certainly, the transition between the upper and lower portions of the statue could hardly have been tolerated by Jacopo himself, and it has the appearance of a later rationalization.

Much less is known about the Loggetta *Madonna*, but a strong case can be made for its inception in the late 1530s (fig. 115).[27] Weihrauch's comparison of it with the marble group in the Chiesetta is apt in so far as it strengthens the plausibility of an early dating for the terracotta; he was also right to compare the Loggetta *Madonna's* features with those of the Arsenal *Madonna*, and there is a strong reminiscence of Donatello in the Virgin's cherubic diadem and clasp, as well as in the figured capitals of her aedicule.[28] The *Giovannino* may also be compared with the marble *St John the Baptist* in the Frari, a work which may have been commissioned as early as 1534 (fig. 94); the *Giovannino* seems a natural complement to the group as a whole, by no means a later interpolation as Weihrauch wanted it to be.[29] These aspects of the terracotta offer grounds for seeing it as another example of the Quattrocento revivalism which is so conspicuous a feature of Sansovino's sculpture in the 1530s.

There is, in addition, further evidence for seeing both the Loggetta and Chiesetta groups as well defined by the early 1540s. It consists mainly of a group of paintings ascribed to the young Tintoretto and a marble by Sansovino's assistant Tommaso Lombardo. Some years ago Shearman made a connection between the Loggetta *Madonna* and a series of paintings associated with Tintoretto and dating from around 1540; it does seem that works like the *Virgin and Child* in the Boymans-van Beuningen Museum (fig. 117) or in the Curtis collection in Venice are predicated upon a knowledge of the Loggetta terracotta while others in this group, for example the *sacra conversazione* in the Wallraf-Richartz Museum, suggest borrowings from the marble *Virgin and Child with Angels* of the Chiesetta.[30] The visual evidence shows that Tintoretto painted variations on both of Sansovino's sculptures, elaborating the Virgin's *contrapposto* and working changes on the basic idea much as Sansovino himself did. Tintoretto's interest in both works can be interpreted in light of his openness to new artistic stimuli and his regard for Sansovino as a conduit of Central Italian ideas. In this instance, the painter was probably drawn to the very un-Venetian nature of Sansovino's Virgin and Child compositions just as he would be to Sansovino's bronze reliefs for the basic conception for his large narrative of the *Miracle of St Mark* in 1548; nor was he alone in this, for an even closer copy was made by an anonymous Veneto painter around mid-century (fig. 116).[31]

If Tintoretto's paintings indicate that both sculptures reached a degree of completion by the early 1540s, Tommaso Lombardo's altar group in San Sebastiano proves that the Loggetta terracotta was largely finished by 1546 (fig. 413). According to Vasari, it was executed shortly after Lombardo left Sansovino's shop, that is, around 1546. The chapel in San Sebastiano was ceded to the patron, Melio da Cortona, in that same year and bears a dedicatory inscription of the following year, so one can assume that Lombardo's sculpture was produced in that year and delivered by the date of the dedication.[32] Francesco Sansovino observed that the work is a copy of the Loggetta terracotta with only a slight variation in the pose of the *Giovannino*.[33] Even without the documentary value of Francesco Sansovino's comment, the relationship between the two works is very clear.

The evidence thus points to the genesis of both the *Virgin and Child with Angels* and the Loggetta *Madonna* as dating from the later 1530s. They would have been overlapping commissions, and their similarities can be seen as variations on the same theme. Yet, given their

IX. *Mercury* from the Loggetta (cat. no. 27)

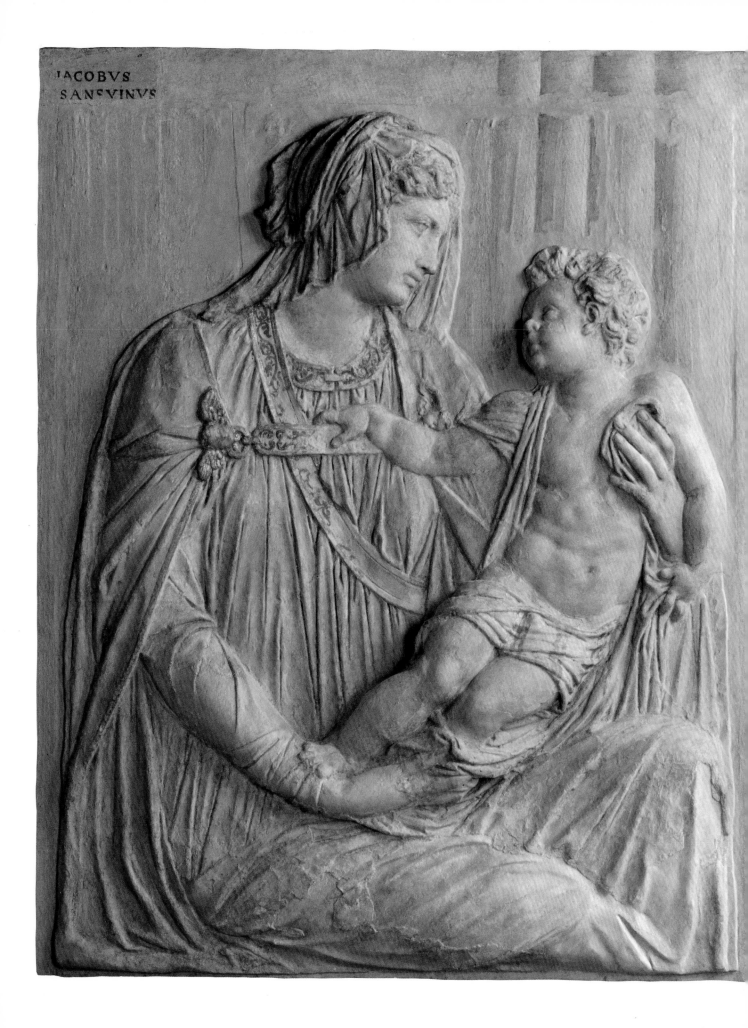
IACOBVS
SANSVINVS

common ground, how can one explain the obvious differences in appearance? Three factors contribute to the unevenness of quality: scale, medium, and degree of finish. The first two are interrelated in Sansovino's marble works, in which the finished product is often further removed from the *primo pensiero* than in his bronzes or, in this case, a work modelled in clay. Then, too, the marble group is slightly over, the terracotta slightly under, life-size; the clay has lent itself to a more spontaneous and autograph expression while the marble is visibly a case of workshop execution. When compared closely, the features of the two Virgins are similar, and the heads of the two infant Christs are recognizably from the same model even though the carving of the marble head is inferior. We must bear in mind that the Loggetta group has to be judged from photographs taken before the collapse of the Campanile and that the terracotta was not a finished work. In all probability, Sansovino must have planned to cast the Loggetta group in bronze, to match the four external figures, but economic retrenchment probably overrode the idea some time before 1565. Thus the group was gilded to render it more 'finished' and installed. Its virtual destruction with the collapse of the Campanile in 1902 dealt a grievous blow to our knowledge of Sansovino's Venetian sculpture.[34]

Shearman called the Loggetta *Madonna* 'unusually pictorial in conception', and the same could be said of the Chiesetta *Virgin and Child with Angels*.[35] Both depend upon Sansovino's reworking of the same models, and the models in question were Florentine ones from the fruitful period of his collaboration with Andrea del Sarto. For the basic concept of the Virgin and Child turning towards a third person, Sansovino must have had in mind a work like Sarto's *Madonna della Scala* (fig. 118) or, perhaps, Sarto's own source in the *Madonna del Pesce* by Raphael.[36] If anything, Sansovino's presentation of the Virgin and Child in the Chiesetta sculpture is closer to Raphael, especially for the pose of the blessing Christ Child, though, for the angels, he returned to the analogous motif in Sarto's *Charity* in the Chiostro dello Scalzo where the face of one of the putti is also partially obscured by his arm and the drapery (fig. 62).[37] The Loggetta *Madonna* finds its origins in another Sartesque work, the Neeld *Madonna*, in which the Virgin and Child are enthroned in a niche and the infant Baptist is seated on a ledge at their feet (fig. 120).[38] Though a workshop product, the Neeld *Madonna* must ultimately derive from an idea by Sarto like the Porta Pinti *Madonna* (fig. 73), which, in turn, may have reflected an early model by Sansovino for the Martelli altar in Sant'Agostino (fig. 68).[39] Both the Neeld and Porta Pinti *Madonnas* are tantalizingly sculptural in character, and behind both lurks the question of Sansovino's relationship with Sarto. Whoever may first have conceived the idea, Sansovino transformed it into an animated composition in the Loggetta *Madonna* where the Virgin and Child bend forward to caress the *Giovannino*. It may be that the narrow format of the niche prompted the deployment of the Neeld *Madonna*, but Sansovino turned this to his advantage by extending the sculpture beyond the confines of the architectural frame much as Verrocchio did with his *Christ and St Thomas* on Or San Michele.[40]

Neither of the sculptures was ever finished in the accepted sense of the word, but they proved among the most influential of Sansovino's Venetian compositions. Mention has previously been made of Tintoretto's recourse to both works for some of his early paintings where even the morphology and drapery patterns assume a Sansovinesque quality. With Veronese, one can observe a comparable phenomenon from the late 1550s. This was a period in which the painter and Sansovino were both at work in the church of San Sebastiano, the former on his cycle of paintings and the latter on the tomb of Livio Podocataro (fig. 296).[41] Veronese began to draw upon Sansovino's compositions for new ideas, and it is evident that a small *Holy Family* now in the Venetian church of San Barnabà (fig. 126) reflects the basic outlines of the Chiesetta *Virgin and Child with Angels*.[42] This is all the more significant because the sculpture was neither finished nor on view until much later, and access to it could only have been given to Veronese by Sansovino himself, suggesting that Veronese must have found favour with Sansovino. This particular borrowing was not an isolated incident.

X. *Virgin and Child*, Museo del Cenedese, Vittorio Veneto (cat. no. 55)

Attention has been drawn to the impact of the Loggetta gods on Veronese's philosophers in the Library (fig. 231), and one can find echoes of both of Sansovino's Madonnas in several of Veronese's Venetian paintings, from the early Giustinian altarpiece in San Francesco della Vigna to the mature *Virgin and Child with Saints and Donor* in the Louvre.[43] Clearly the inventive quality of Sansovino's groups as well as their Central Italian associations recommended them to younger Venetian contemporaries, both painters and sculptors. Through Girolamo Campagna's altarpieces in San Salvatore and San Giorgio Maggiore, Sansovino's composition passed into the Venetian sculptural tradition and appeared frequently in small bronzes by artists like Roccatagliata (fig. 119).[44]

Two other works associated with Sansovino are stylistically related to the Chiesetta and Loggetta groups and may have been evolved in close proximity to them. The first is a stucco and canvas model formerly in the hospice of the Muneghette and now in the collection of the Istituzioni di Ricovero ed Educazione in Palazzo Sceriman (figs. 327, 329).[45] It is a rare example of a working *modello*, in part taken from casts, in part shaped directly by hand. Discovered more than ten years ago, its singularity became apparent through restoration when it was recognized that the sculpture was not merely a popular artefact, but the work of a sculptor accustomed to working in a variety of media and with a technical skill beyond that of a simple artisan. It is essentially composed of plaster and canvas dipped in size with traces of *papier mâché*, with some areas of the Virgin's drapery being simply modelled in plaster. By contrast, the heads of the angels flanking the Virgin and Child are casts, probably taken from clay models, but that of the Christ Child appears to be the work of an early restoration. Traces of a layer of beeswax have been observed on the model's surface, which would indicate that piece-moulds were taken from the sculpture; this conclusion is strengthened by the presence of small wooden pegs, used for holding sections of the piece-moulds in place.

The exact relationship between this work and Sansovino's sculpture has generated disagreement.[46] Though the Sansovinesque nature of the work is apparent, its damaged and restored state must preclude an absolute attribution to Sansovino himself. What we can say is that the work is a hybrid of a kind that has rarely survived, for it is a working model in which the sculptor elaborated an idea, in part through direct modelling, in part through recourse to ready-made casts. The work does fit naturally within the arc of Virgin and Child compositions by Sansovino, extending from the Arsenal *Madonna* to the Chiesetta and the Loggetta groups. Though grosser in features, the Virgin's face recalls that of the Arsenal *Madonna*, and the semi-rising pose invites comparison with the *Virgin and Child with Angels* and the Loggetta *Madonna*. At 91.5 cm, the height of the model from the Muneghette hospice suggests that it was made with a specific location in mind, perhaps something analogous to the *madonna di marmo* for San Marco. Certainly it has the appearance of a sculpture that either came from Sansovino's shop or was fashioned by someone thoroughly familiar with his working methods. The possibility that it preserves the design of a lost Sansovinesque project seems strong.

The case of the bronze *Virgin with sleeping Child* in the Sacristy of the Redentore comes under a similar category (figs. 326, 328); it has received little notice since Lorenzetti catalogued it as a possible work by Girolamo Campagna.[47] Though Campagna's Virgin and Child compositions derive from Sansovino's, the bronze in question has little in common with them. It draws more directly from Sansovino and is, like the *modello* of the Muneghette, more directly inspired by his Virgin and Child compositions of the 1530s. The similarities are immediately apparent in the rising pose of the Virgin and in her Donatellesque costume, reminiscent of both the Nichesola and Loggetta Virgins. The Virgin's features find a parallel in those of the Virgin of the Chiesetta, particularly in a profile view.

The work is heavily gilded, which poses problems in evaluating its quality. It has, nevertheless, the appearance of being a cast after a model by Sansovino, made with a view towards preserving its design or as a gift for a collector. In this context, it is worth mentioning that

Tommaso Rangone, Sansovino's friend and patron, owned an 'imago cuprea' of the Virgin and Child which was ascribed to Jacopo in the inventory of his library.[48] As Rangone's library passed to the Capuchin monastery at the Redentore, the gilt bronze in the sacristy may well be the object mentioned in the inventory. Certainly it is a unique work among the sculptures by or after Sansovino, and his friendship with Rangone may be the explanation for its survival.

Its subject, the Virgin and sleeping Child, was a Venetian theme *par excellence*.[49] Once again, Sansovino ignored local examples in favour of versions by Raphael and his friend Sebastiano del Piombo.[50] The Virgin's gesture of lifting the veil to reveal the Christ Child goes back to Raphael's *Vierge au diadème bleu*. The Virgin's *contrapposto* also recalls the models by Andrea del Sarto that anticipated the Chiesetta and Loggetta sculptures, albeit in a looser manner.

The works considered thus far have all been individual compositions, chiefly in marble or bronze. But Sansovino's treatment of the theme of the Virgin and Child also led to his only known experimentation with multiple sculptures in two series of *cartapesta* reliefs and related variants in stone and stucco. The earliest contemporary reference to these works comes in a letter from the typographer Francesco Marcolini to Pietro Aretino in September 1551.[51] There Marcolini expressed astonishment at the beauty and emotive quality of a relief of the Virgin and Child that Sansovino had given to Aretino. This same relief prompted some of Aretino's most incisive comments about Sansovino's skill in fashioning such images, in terms anticipatory of Vasari's famous remark concerning Sansovino's excelling even Michelangelo in this genre.[52] Aretino gave his relief to the Duchess of Urbino the following year, and it has disappeared. Five distinct types of related reliefs still survive, all of varying degrees of autography but bearing the clear imprint of Jacopo's style. They include two distinct series of reliefs in *cartapesta*; one unique stucco formerly at Pontecasale and now in the Museo Civico, Vicenza; a marble lunette relief now in the Cà d'Oro; and an Istrian stone relief in the Doge's Palace.

Little is known of any of these works. The ones in *cartapesta* received no serious critical attention prior to the late nineteenth century, and the others came to light after 1900. Consequently, it has only been in fairly recent times that they could be examined systematically.

Sansovino's *cartapesta* reliefs are known to survive in at least thirteen examples in museums and private collections around the world. They can be divided into two kinds, which for convenience will be called the Vittorio Veneto and *Pardelfell* types. The former type was first mentioned by Cicogna, who found an example in the Santuario di Sant'Augusta of Serravalle with the inscription IACOBVS SANSOVINVS F[ACIEBAT]; in all probability, this must be the same relief now in the Museo del Cenedese of Vittorio Veneto, (col. pl. X, fig. 336), the type of which is known in at least ten other examples (figs. 333–35, 337).[53] Both this and the *Pardelfell* type were first ascribed to Sansovino by Bode on the basis of a signed version of the Vittorio Veneto kind which he claimed to have seen on the art-market in Italy.[54] The second version, now commonly if mistakenly referred to as a *Muttergottes mit dem Pardelfell* (i.e., leopard skin), survives in only two copies, one acquired by Bode for Berlin in 1881 (col. pl. XI, fig. 331) and the other in Bode's day in the von Beckerath collection but now in Budapest (fig. 332).[55] Bode conjectured that both types were copies after a lost marble or bronze relief by Sansovino and dated them ca. 1540. His arguments were largely accepted by Schottmüller in her catalogues of the old Kaiser Friedrich Museum, although she placed the *Pardelfell* version around 1545, contemporaneous with *Peace* on the Loggetta (fig. 218), and gave a more general bracket of 1536 to 1563 to the Vittorio Veneto type, chiefly by comparison with the female figures in the relief of the *Miracle of the Maiden Carilla* (figs. 260, 264).

Early in this century, Pittoni first published the large and unique stucco relief in the villa Garzoni at Pontecasale, which she dated together with the similar *cartapesta* versions around the time of Marcolini's letter to Aretino in 1551 (figs. 233–34).[56] Lorenzetti subscribed to her basic arguments and bracketed together both the *Pardelfell* and Vittorio Veneto versions

around 1550; in addition he drew attention to two further variants, one of Istrian stone in the old *Magistrato dei Feudi* of the Doge's Palace (fig. 330) and the other a marble lunette from the church of the Zitelle, now in the Cà d'Oro, the latter being in his opinion an autograph work of Sansovino's from the 1530s (fig. 325).[57]

These, then, are the known reliefs of this genre by Sansovino. The mid-century dating of the *cartapesta* reliefs must be broadly correct for the reasons that Bode and other scholars have indicated. Though the *Pardelfell* version has more obvious affinities with the Quattrocento, it is unmistakably the work of an artist of the High Renaissance. In this case, Sansovino returned to his statue of the Virgin and Child in Sant'Agostino for the basic pose of mother and child and for the Virgin's massive form, high waist, and small breasts (fig. 68). He shifted the faces of the figures so that they confront each other in three-quarter profile; the Virgin has the Florentine features discernible in the Virgin of the Martelli altar in Rome, and an exact parallel of her profile and coiffeur can be found in one of the female spectators on the right-hand side of the *Miracle of the Maiden Carilla* (fig. 264). As the contract for this relief was signed in 1536, it would give a *terminus post quem* for the *Pardelfell* Virgin.[58] This would make sense stylistically, too, since the Virgin of the *Pardelfell* type is closely related to the figure of *Peace* on the Loggetta (fig. 218). This suggests that the *Pardelfell* composition would have been a production of the late 1530s or early 1540s when the *Maiden Carilla* and the Loggetta were being planned. Despite the poor state of both surviving versions, the composition has a freshness and lyricism which reflects Sansovino's peculiar gifts in this genre. Whether its relatively restricted edition is the result of chance or an indication of lesser popularity remains unclear.

The Vittorio Veneto type and the stucco in the Museo Civico of Vicenza are closely related, as has often been noted. The latter has never enjoyed the fame it merits, partly because it remained largely inaccessible until its donation to Vicenza. In recent times, doubt has even been cast upon its authenticity and provenance, but a careful reading of the few studies that dealt with it prior to its removal from Pontecasale proves that the relief now in Vicenza is the same object as that conceived by Sansovino for the Villa Garzoni.[59] Any doubts would be dispelled by the work itself, which is of outstanding quality and among the most inspired creations of Sansovino.

A work of extraordinary character, the relief formerly at Pontecasale is unquestionably the most beautiful of its kind to have issued from Sansovino's hands (figs. 234). It was long thought to be a terracotta, but recent tests have vindicated Pittoni's identification of the medium as stucco on wood.[60] Stucco was a favourite medium for ephemera and inexpensive works; in its natural state, it resembled marble, but it could be gilded or painted to resemble bronze. Thus Pittoni's description of the relief's surface as 'di colore opaco che imita il bronzo annerito' is apposite in suggesting that the work may have been intended to resemble bronze, a vastly more expensive medium. The use of stucco here also gives resonance to Aretino's account of his relief as 'di marmorea durezza composto', which may mean stucco or *cartapesta* given a marble-like appearance.[61]

The Pontecasale relief must illustrate other features similar to those that Marcolini and Aretino found so arresting in the latter's version of the same subject. Both the Pontecasale and the lost work formerly in Aretino's collection may have been the only autograph examples of their kind by Sansovino, one made for an important patron, Alvise Garzoni, the other for one of the sculptor's closest friends. Garzoni was distinctive among Sansovino's patrons in coming from a wealthy citizen family as opposed to a noble one.[62] His villa near Padua, which Sansovino designed around the end of the 1530s, was one of Sansovino's largest commissions, recorded by Vasari as exceeding the Fondaco dei Tedeschi in its dimensions. The sculptures executed by Sansovino and his shop for the villa are generally dated to the 1540s, and the relief may come from the end of that decade, close in time to the one that Jacopo gave Aretino around 1551. Its form is both larger and more monumental than the *Pardelfell* or the

Vittorio Veneto types. There is less of the lyrical content of the *Pardelfell* relief but a compensating intensity of expression in the gaze between mother and child. It was probably this palpable sense of an emotional bond between the two that won the frank admiration of Aretino. It is true that Italian Renaissance art does not suffer from a lack of reliefs of this subject, but, when compared with Sansovino's achievement here, most of them, even Michelangelo's and Rustici's, seem almost academic exercises. One would have to return to Donatello to find a work of comparable presence (figs. 235–36).

Coupled with its emotional content, the Pontecasale stucco displays an extraordinary subtlety of modelling and boldness in the effects of foreshortening; this is particularly apparent in the head of the Virgin, whose ear is suggested underneath her headdress, a motif picked up from Donatello (fig. 236), or the angle at which the Child's head emerges from the background. Like the other reliefs under review here, the stucco version develops from the same matrix as do the female figures in the *Miracle of the Maiden Carilla* and later works like *Hope* on the Venier monument (fig. 289). Sansovino may have been aware of the Pazzi *Madonna*, or variants like the Verona Madonna type, adapting its pyramidal sturcture and concentration to his own ends. But the monumentality and morphology of the Pontecasale relief are the fruit of Sansovino's knowledge of the Roman High Renaissance and distinguish it from Quattrocentesque models. The sculptor was able here to create a highly focused work, one whose naturalness and spontaneity conceal the care and observation behind it. With the Pontecasale relief, Sansovino took his place in the tradition that led back to Donatello and Luca della Robbia.

The success of the Pontecasale relief and of the lost panel given to Aretino may have encouraged Jacopo to experiment with variations on the same theme in the *cartapesta* works of the Vittorio Veneto type. This must have been one of Sansovino's most popular compositions, to judge from the number of copies still surviving.[63] Its affinity with the Pontecasale sculpture is obvious, although it may have had an even more direct relationship to a lost work like Aretino's relief. The changes between the *cartapesta* and stucco versions would have been dictated by the necessity of producing the former in piece-moulds. Thus the rapport between the two figures is more open and relaxed, the composition is generally flattened and less plastic. This is particularly evident in the pose of the Child, whose body is now held by the Virgin parallel to the picture plane. Inevitably, the image that has emerged from the mould is less precise than the stucco and varies in quality from example to example (figs. 235–37). Though intrinsically beautiful, there is a reliance on formulae, as in the head of the Virgin, which is predicated upon the Pontecasale stucco, or in the pose of the Child, reminiscent of the corresponding element in the Nichesola *Madonna* (fig. 112). As for its dating, the conventional view of 1551 is probably correct, and in this case it would have followed from either of the two documented examples.

These *cartapesta* reliefs would have been the sort of minor project that Sansovino could have left to his workshop assistants. The medium lends itself to an assembly-line production and is comparable to the inexpensive works in gesso and terracotta frequently recorded in inventories. Because so little has been written about these reliefs, it might be useful to discuss their technique. *Cartapesta*, or *papier mâché* as it is also known, is the art of moulding objects from repulped paper, generally mixed with an adhesive element like animal glue or plaster.[64] In the Renaissance, the mixture would often be viscous and poured into a hollow mould so that it filled every part. When dry, the *cartapesta* would be removed from the mould, and if a piece-mould had been employed, the various pieces would then be glued together and sometimes covered with gesso before painting. The technique of *cartapesta* must date from the fourteenth century, and Vasari credits Jacopo della Quercia with the invention of an analogous technique in the equestrian figure of Giantedesco for Siena Cathedral.[65] It was an ideal medium for ephemera, and Sansovino must have practised it from his earliest years, especially for figures like the apostles on his temporary façade for the entry of Leo X in Florence.[66] As a vehicle

for reliefs of the Virgin and Child, *cartapesta* is especially associated with fifteenth-century Tuscan artists like Neroccio de' Landi and, above all, Donatello and his followers. In the sixteenth century, however, Sansovino's *cartapesta* reliefs constitute a singular survival, as no other examples by a major artist survive.[67] Why Sansovino should have produced them so late in his career remains a puzzle, but the idea may have come to him through his experience of using piece-moulds for bronze-casting and from his early experience of seeing similar devotional reliefs made by the workshop of Andrea della Robbia (fig. 239). The vitality of the della Robbia style and its popularity well into the sixteenth century would not have escaped Sansovino's notice, and the use of moulds to replicate the more successful of Andrea's designs must have been in Jacopo's mind when he experimented with a similar medium. Then, too, such reliefs could be treated as raised paintings to create a richer effect, which apparently had an appeal for clients who wanted a cheaper version of Sansovino's art. In a small way, these reliefs can be seen as an equivalent of the multiple versions of Giambologna's small bronzes later in the century.[68]

The recent conservation of two reliefs of the Vittorio Veneto type, that in Vittorio Veneto itself and the example now in the Kimbell Art Museum, has furnished new information about their manufacture.[69] In both cases, the relief was made by putting a thin layer of *cartapesta* in piece-moulds; when dry, the mixture was removed from the moulds and joined together. The joins are visible on most of the reliefs and are most easily seen across the torso of the Virgin and above the right leg of the Child. The Vittorio Veneto version was found to have been painted white with traces of cinnabar and gold on the border of the Virgin's mantle; this is exceptional among the surviving copies but may have been designed to give a feigned marble appearance to the work, something not uncommon among Renaissance ephemera. The Kimbell version contains no stucco in the *cartapesta* mixture but was coated with a thin layer of size over which the colours were applied. In addition, the Virgin's robe was created by applying gold leaf on to the size and then covering it with a red glaze. This imparts a reddish-golden effect to her dress and is identical with at least one other relief of the Vittorio Veneto type, that in the Kress Collection in Washington (fig. 337).[70] How common this practice was cannot be said until other examples have been studied, but the similar technique employed on the Kimbell and Kress reliefs does confirm the suspicion that Sansovino applied to his Venetian reliefs a technique which has been found on Tuscan Quattrocento terracottas, and it comes as no surprise to find that the identical technique was used by Sansovino on the Virgin's dress in the Thyssen *Annunciation* (fig. 105).[71]

Finally, the two reliefs in the Cà d'Oro and the Doge's Palace can be classed as variations on the same theme. The relief in the Cà d'Oro is undoubtedly earlier, dating from the late 1530s or possibly early 1540s (fig. 325). Lorenzetti drew attention to the resemblance between the central passage of the Virgin and Child and the corresponding figures in the large terracotta relief now in the Bode Museum, Berlin (fig. 128), which would suggest a *terminus ante quem* of around 1535.[72] At the same time, the angels filling the spandrels are reminiscent of works by Silvio Cosini, who was then working around Sansovino in Venice and Padua. The angels are also similar in type to the telamones on the fireplace in the Villa Garzoni at Pontecasale (fig. 339) and also have something of the soft, sensuous feel of the Loggetta bronzes (fig. 218). These comparisons would establish a bracket for dating the work between 1535 and the early 1540s at the latest. Both Lorenzetti and Weihrauch saw the basic conception of the Cà d'Oro relief as stemming from Sansovino, though Weihrauch felt that the execution was left to an assistant.[73] This must be correct, and the flat, dry treatment of the marble, especially the Virgin and her drapery, is at a remove from Sansovino's characteristic handling of drapery, as in the *Miracle of the Maiden Carilla* where stone assumes the nature of fabric (fig. 265). Even the best achieved parts, such as the head of the Christ Child and the flanking angels, betray a certain dryness and an inexpressive quality suggestive of a faithful copiest rather than Sansovino himself.

No evidence survives to tell us who ordered the relief or why. It was obviously designed as part of an altar or as a lunette over a portal but was never installed. It was eventually acquired by the procurator *de supra* and noted collector Federico Contarini, who placed it in the lunette over his family altar in the church of the Zitelle around the early 1590s. Contarini could have acquired the relief from the stores of the procuracy *de supra*, but the more likely explanation is that it was sold or given to him by the sculptor's son Francesco after the successful resolution of the dispute over the Sacristy door in which Contarini played a decisive role.[74] All that can be said for certain is that the relief fits stylistically into Sansovino's works of the late 1530s or early 1540s. In all probability it was designed by Sansovino, though left to an assistant to execute, but exactly which assistant would be difficult to say. It stands in direct relationship to the series of reliefs that cluster about the Pontecasale stucco and may have anticipated them slightly.

The Istrian stone relief in the Doge's Palace must be the last in the line of Virgin and Child reliefs associated with Sansovino (fig. 330). It bears the date 1562, three coats of arms, and the inscription DEI ET IVSTITIAE CVLTORES. Zanotto first drew attention to it on the left-hand wall as one entered the old office of the Magistrato dei Feudi; he also identified the arms as those of Vettor Donato, Triffone Polani, and Pasquale Malipiero, overseers of the magistracy at that time.[75] Although the relief conforms to the general style of the *cartapesta* reliefs, it cannot seriously be entertained as an autograph work by Sansovino. The hand in the Doge's Palace relief is an able one, and it is probably the same hand that carved the roundel of the Virgin and Child on the tomb of Livio Podocataro, executed a few years before (fig. 300). But it is far different from Sansovino's autograph reliefs, such as the *Miracle of the Maiden Carilla* or the Pontecasale stucco. If anything, the Istrian stone relief is a reworking of the Pontecasale design: the Child's head is at a similar angle though the Virgin is seen slightly more in profile; the Child's body performs a remarkable *contrapposto*, but, as a whole, the relief conveys less of a sense of plasticity than its stucco prototype. The relief for the Magistrato dei Feudi was probably carried out in Sansovino's workshop, under his supervision though without his direct participation in its carving. It has, as Lorenzetti first noted, that strong sense of the Michelangelesque, particularly in the monumental proportions of the Virgin, which resurfaced at the very end of Sansovino's Venetian career.[76]

The works reviewed here span much of Sansovino's Venetian career; yet all of them are rooted in his experiences of Florence and Rome. Perhaps in no other aspect of his sculpture does the intersection between Sansovino's Central Italian heritage and his influence on Venetian art emerge as clearly as in these variations on the theme of the Virgin and Child. It was a theme that occupied Sansovino from his earliest years in Venice, and a number of such works reflect the overlapping ideas that engaged the sculptor from the middle of the 1530s. For them, Sansovino characteristically returned to the great Tuscan tradition of Donatello, the della Robbias, and early Michelangelo in order to fashion images that would complement the prevailing tastes of Venetian art and of his patrons. In doing so, Sansovino established new prototypes for generations of Venetian painters and sculptors besides making one of his most distinguished contributions to Italian Renaissance art.

VIII. Sansovino's Venetian Tombs

By 1550 SANSOVINO had attained the peak of his fame and influence in Venice. The débâcle of the Library had been amended, the Loggetta finished, and work on the Doge's Chapel was almost at an end. At the same time, that generation of Venetian noblemen who promoted Sansovino's career were occupying major positions in which they could bring other projects to their protégé. Thus Sansovino won the commission to sculpt the *giganti* for the Doge's Palace and the competitions for the Fabbriche Nuove and the Scala d'Oro, all within the first five years of the new decade.[1] His private practice also flourished during this period, with a number of palaces and churches in hand as well as his most important Venetian monuments: the tomb of Livio Podocataro, Archbishop of Nicosia, in San Sebastiano and that of Doge Francesco Venier in San Salvatore, and the memorial to Tommaso Rangone on the façade of San Giuliano. Given the nature and multiplicity of Sansovino's commissions during this period, it is not unexpected to find his role confined to one of designer and occasional participant; indeed, Sansovino's later career parallels Primaticcio's at Fontainebleau or Giambologna's in Florence, with his becoming more like a courtier-artist whose chief task was to provide ideas executed by other architects or sculptors.[2] It is with Sansovino's sepulchral monuments that this process of disengagement from the role of an active artist can be seen most clearly. Moreover, they furnish us with documentary evidence of the delegation of responsibilities in Sansovino's commissions that is complementary to our knowledge of other projects like the *giganti* or the Scala d'Oro.

Although Sansovino did not design many tombs, they do form a conspicuous part of his Venetian sculpture. The three he executed during the 1550s embody many of the characteristics common to High Renaissance thinking on memorials and some features more peculiarly Venetian. Renaissance tombs, like Renaissance palaces, were bound up with those principles expected of persons of some eminence, chiefly magnificence and liberality. The Ferrarese writer Lilius Giraldus wrote of tombs in his treatise *De sepulchris* in terms reminiscent of architectural decorum: simple burial was considered plebeian; marble sepulchres were for gentlemen; for princes and potentates, bronze or porphyry was requisite.[3] The evidence of palaces and tombs erected from the fourteenth century to the end of the Republic amply confirm Giraldus's observations, and they also show a sense of sepulchral decorum in operation as early as the fourteenth century.

Both the number and the essentially conservative nature of Venetian tombs reflect the stability of the Republic, its great private wealth, and its long tradition of ancestor worship. Whereas most Renaissance societies were built upon a tacit acceptance of hierarchy, the Venetians consciously extended this to almost every aspect of life.[4] In Venice as in any hierarchical society, one's rank was proclaimed by one's dress. Although all Venetian nobles were of equal rank, magistrates, university graduates, knights, and of course the doge had costumes

laid down from 1360; even earlier, in 1334, a statute decreed that the doge, doctors of law and medicine, and knights were exempt from burial in a shroud.[5] Indeed, after death, one's social standing extended to the size and expense of one's funeral and to the monument raised by one's heirs.[6] Monuments in particular exercised the imaginations of many testators, for a memorial in a church paid homage, not only to the individual, but also to his family, other members of which would often share the same tomb. In this context, the will of the Venetian nobleman Pietro Bernardo, who died in 1538, is especially illuminating. Bernardo specified an elaborate embalming for his body, two coffins (lead and cyprus), and a marble monument worth 600 ducats. Bernardo requested that the monument be sited in the Frari and have figures of Christ and St Peter as well as himself (fig. 269); a poet was to be hired to write eight hexameters at a price of half a ducat per line. Both verses and figures were to be visible at a distance of twenty-five feet. Bernardo further stipulated that a poem celebrating the deeds of the house of Bernardo be commissioned, and left 800 ducats to that end.[7]

This will is unusually explicit, but it underscores several factors that were increasingly to impinge upon the design of Sansovino's tombs; namely, the dominant role which a determined patron could assume, an awareness of the site of the monument, and the identification of the monument with the glory of one's house. Among Sansovino's tombs of the 1550s, these elements recur persistently. In each case, Sansovino adapted his own style to a type of monument commensurate to the status of his patron, whether a wealthy academic like Tommaso Rangone, a doge like Francesco Venier, or a cleric like Livio Podocataro, archbishop of Nicosia.

Of all the patrons for whom Sansovino worked, none surpassed Tommaso Rangone in his desire to leave behind a tangible memorial to his existence. Born in Ravenna in 1493, Rangone came of a modest family named Giannotti but rose in the course of a long life to become a university lecturer, equally at home in languages, medicine, and astrology, doctor to the Venetian fleet, and adviser to the Republic on sanitation, finally dying wealthy, a knight and count palatine of the Holy Roman Empire, in 1577.[8] While it is difficult to separate the charlatan from the scientist in Rangone's career, there is no difficulty in appreciating his aspiration for status, especially after his settling in Venice in 1528. He changed his name twice, dropping Giannotti in favour of Filologo da Ravenna and ultimately adopting the name of his sometime aristocratic patron, Guido Rangoni.[9] From the early 1550s he translated a portion of his wealth into a variety of benefactions and to major and minor works of art that adorned his residence, one of the *case nuove* on the north side of Piazza San Marco.[10] Rangone may have harboured dreams of being admitted into the Venetian nobility, and like many *nouveaux-riches* he sought to purchase a reputation through conspicuous expenditure. As viewed by the Venetian nobility, Rangone must have seemed a puzzling phenomenon, someone whose social origins and wealth seemed desperately at odds. In the event, these misgivings led to the restrictions imposed upon Rangone's monument to himself, the façade of San Giuliano (fig. 276).

Rangone made his first attempt to build a memorial to himself in 1552. That was the year in which he founded a college in Padua for students from Venice and Ravenna, and it signalled the beginning of his impressive career as an architectural patron. At the same time he approached his parish priest with an offer to pay for a façade for his church in return for the right to incorporate a monument on it. This was not an unusual bargain by Venetian standards, as other façades contained such memorials. The boldness of Rangone's gesture lay in the location of his parish church, for it was San Geminiano, which faced San Marco on the Piazza.[11] It has been proposed that Rangone and the parish priest, Benedetto Manzini, petitioned the Senate to grant permission for building a façade, designed by Sansovino and incorporating a statue of Rangone.[12] The petition was not accepted by virtue of the long-standing custom that no monuments to individuals could appear in the Piazza, but Rangone's offer prodded the government into doing something about the incomplete state of the church.

In March 1557 the Collegio decreed that two of the procurators *de supra*, Antonio Capello and Vettor Grimani, should be elected to supervise the fabric of San Geminiano, and within a fortnight Sansovino's design for the façade was seen and approved by the Collegio.[13]

The refusal of the proposal for San Geminiano did not deter Rangone for long. In September 1553 a similar proposal was agreed with the chapter of San Giuliano to pay for a façade that would contain his monument.[14] The choice was certainly the next best thing, for San Giuliano stood on a campo in the Merceria, the mercantile thoroughfare connecting the Piazza with the Rialto. It, too, was of great antiquity and had been rebuilt in a basilical plan during the Middle Ages by the Balbi family. The agreement gave the chapter of San Giuliano 1,000 ducats and Rangone the right to erect a façade, on which, as the formal petition by the chapter to the Senate states:

> he may place for all eternity his figure and image in bronze, taken from life and standing or seated as seems best to your Lordships, the said image made at his own expense for the façade of the church, together with his arms, inscriptions, and every other thing pertinent to a benefactor, over and above the aforementioned one thousand ducats.[15]

Many of the elements mentioned in the petition can be found on the façade of San Giuliano as built (fig. 276): the bronze figure of Rangone, his coat of arms, and the various inscriptions in Latin, Greek, and Hebrew. It may well be, as Weddigen has suggested, that the initial design agreed upon by Rangone and the chapter of San Giuliano was the same as had been proposed for the façade of San Geminiano, and certainly engravings of both façades bear this out (figs. 191, 277).[16] The petition was granted by a vote of the Senate on 1 September 1553, but one notable change was made to the formula describing the donor's statue: the phrase 'in piedi over sentata' (i.e., standing or seated) was written almost as in the original request, but the words *in piedi* were then cancelled by the scribe.[17]

The Senate's denial of a standing figure for Rangone's monument can be explained by the well-established conventions governing memorials in Venice. Buying the right to a façade monument was not novel by the middle of the sixteenth century. Already in the thirteenth century, Doge Jacopo Tiepolo and his son Lorenzo were buried in a tomb on the façade of Santi Giovanni e Paolo, with other tombs subsequently erected.[18] Vettor Capello, the naval commander who died in 1467, was commemorated by a statue of himself kneeling before St Helen on the façade of Sant'Elena (fig. 270); this convention was continued in the sixteenth century by the memorial to Pietro Grimani, son of Doge Antonio, on Sant'Antonio di Castello and that of Vincenzo Capello, the distinguished naval commander, on the façade of Santa Maria Formosa (fig. 272).[19] Of these monuments, Vincenzo Capello's furnishes the closest idea of what Rangone's original intentions may have been; the façade is also one in which Rangone would have taken an interest, because he had served under Capello as a doctor to the Venetian fleet in 1534 and because it would have been under construction in the years prior to San Giuliano's rebuilding.[20] Although Domenico da Salò's statue of Capello cannot be dated with precision, the façade of Santa Maria Formosa must have been under construction around 1542, more than a decade before San Giuliano.[21] Indeed, Sansovino may have had some role in the design of both façades. Capello had been a procurator *de supra* from 1539 and, hence, one of Sansovino's employers.[22] The façade of Santa Maria Formosa bears a family resemblance to other façades by Sansovino, like San Martino or as represented on the foundation medal for San Francesco della Vigna, in its division into three bays by an order of pilasters with a smaller order framing the central portal. The figure of Capello occupies the central bay and stands on a fictive sarcophagus that rests upon the columns of the portal. Its point of departure was the traditional Venetian monument for a military leader, like those of Vettor Capello at Sant'Elena or Benedetto Pesaro's above the Sacristy door in the Frari (fig. 271), but the façade of Santa Maria Formosa was the first example of a whole façade being conceived entirely as a commemorative memorial.[23]

The signal difference between Rangone's proposed monument and those just mentioned lies in the fact that previously only Venetian noblemen had availed themselves of the right to such a memorial; Rangone was neither Venetian nor of noble birth. By allowing him the less-distinguished option of a seated figure, the Senate must have been guided by its desire to reserve to the nobility the special dignity accorded to the standing figure since the Republic first honoured one of its own nobles in such a fashion—Vettor Pisani, the hero of the war of Chioggia, who died in 1378. As Francesco Sansovino mentioned in his account of Pisani's memorial in Sant'Antonio: 'honoured with a public funeral by the Senate, he had, by virtue of his valour, a pedestrian statue.'[24] Sansovino's words are the most explicit contemporary reference to the standing figure as the right of the most eminent of public persons, something borne out in Venice as elsewhere in Italy. In Venice, the standing figure was the prerogative of doges and military commanders; the notion of one erected for a commoner may have seemed presumptuous.[25]

Work began on the façade in 1554, and Rangone had a medal struck by another member of the Sansovino circle, Alessandro Vittoria, to celebrate the event.[26] Sansovino is first mentioned as the architect of the façade in the notarial agreement between Rangone and the chapter of San Giuliano for the rebuilding of the body of the church in 1558. His name already appears, however, in documents from August 1554, by which date the wax model for the bronze figure of Rangone was ready for casting.[27] Sansovino's role in the creation of the façade and of Rangone's monument is unquestionable; yet, as Tommaso Temanza first pointed out, there is also evidence of another hand at work, that of Sansovino's former pupil Vittoria.[28]

As noted above, the general solution to the façade corresponds to that of San Geminiano. The two storeys of the rectangular body of the church are differentiated respectively by Doric and Ionic orders, and each is divided into a wide central bay and narrower lateral ones. On the ground floor, the Doric order rests on a high base as it did on the corresponding floor of San Geminiano; overlapping pilasters frame the lateral bays, and half-columns bring forward the central area of the façade. The lateral bays contain round-headed windows surmounted by triangular pediments resting on consoles, but the central bay is given over to Rangone's monument, which frames the portal. Elaborate decorations containing Rangone's arms and inscriptions fill the space between the paired Doric half-columns.[29] The Doric half-columns frame an applied arch, inside of which is the portal and the central portion of Rangone's monument. The central monument rests upon a small order of applied Doric columns that frame the door and consists of the bronze figure of Rangone (fig. 280) seated on a fictive sarcophagus and flanked by a table with books and a terrestrial globe on his right and by a lectern and celestial globe on his left (fig. 274). The floor above conforms to the same pattern but is articulated by Ionic pilasters. The lateral bays again contain windows, here enclosed by a broken triangular pediment; the central portion of the façade, however, is given over to a large Latin inscription directly above Rangone's statue, together with a pair of empty niches above the decorative panels on the ground floor. Above, a large pediment spans the width of the façade, in the centre of which is a Serlian window, itself framed by a broken pediment.

Clarification of Sansovino's part in the façade of San Giuliano can best be understood by bearing in mind certain facts of the building's history as well as by comparing his architectural language with that of Vittoria. In the first instance, the church as originally designed by Sansovino was to have been a basilica along the lines of the medieval San Giuliano. This remained the intention until 1566, seven years after the façade was finished.[30] At that date, the project to complete the church's rebuilding was revised to a simpler rectangular plan as a measure of economy. Another major piece of evidence comes in Rangone's will of 1577, which implies that he commissioned three projects for the façade: one by Sansovino, another by Vittoria, and a third by Giovanni Antonio Rusconi, who had been recommended to him by Domenico Bollani. Even more significantly, Rangone's will goes on to mention a design

'of the anterior façade of the aforementioned church, amplified by Alessandro Vittoria, a most talented sculptor, architect, and *proto*.'[31] As Weddigen first remarked, Rangone's will offers the strongest evidence to support an intervention by Vittoria in the façade of San Giuliano. The division of responsibility would seem to have been along the lines suggested by Temanza: the windows enclosed by a broken pediment on the upper floor do not correspond to Sansovino's style but are a feature of Vittoria's architectural vocabulary, as can be seen in the altar of the Mercer's guild in San Giuliano or the window frames on the façade of the Scuola di San Fantin (fig. 278).[32] The chief 'amplification' made by Vittoria to the façade of San Giuliano is the pediment, which reflects the change of plan from a basilical to a box-like structure and must be a fairly late alteration to Sansovino's first design. The pediment is unlike any other in Sansovino's work, and one can imagine that Sansovino intended for the basilical plan a central attic storey surmounted by a small pediment and flanked by volutes. That was Sansovino's habitual response in analogous façades like San Geminiano, San Francesco della Vigna, and Santo Spirito in Isola.[33] The pediment of San Giuliano can be paralleled in a later work designed by Alessandro Vittoria, namely the pediment of the Scuola di San Fantin, where a relief of the crucifixion is set within a broken pediment in a manner not unlike the dramatic treatment of the Serlian window in the pediment of San Giuliano. On balance, then, the un-Sansovinesque elements in the façade of San Giuliano must be those additions to the original design mentioned in Rangone's will.

Vittoria's intervention extended beyond the design of the façade to include the image of Rangone himself (fig. 280). Until fairly recent times, the statue had been accepted as wholly Sansovino's , but, as Gallo pointed out, the documents tell a different story.[34] From them, one gathers that Sansovino's wax model of 1554 was damaged while in the possession of Giulio Alberghetti, the intended founder, and that it was replaced by a second model made by Vittoria in 1556. This was the model from which the final cast was made, and the difference of 70 ducats between the first contract with Alberghetti and the second with the actual founders, delle Sagome and di Conti, further suggests that the second model was larger in scale, requiring more metal. It may be that the first model was judged too small for the façade and was scrapped in favour of a larger one. Then, too, the emergence of Vittoria's name in the second contract may simply be a recognition of his responsibility for the sculptural part of the façade, albeit under Sansovino's supervision. This would conform to the pattern of the relationship between Sansovino and Vittoria during the 1550s when Vittoria served as a factotum for the caryatids of the Library (fig. 434) and the stucco decoration inside it (fig. 373) as well as for the Scala d'Oro (fig. 432) and the Venier tomb.[35] Over this period, Sansovino scaled down his direct participation in sculptural projects to a minimal level, as his letter to the Duke of Ferrara in 1550 states.[36] Vittoria was then emerging as Sansovino's great successor among Venetian sculptors and began to enjoy an ascendancy under Tommaso Rangone's patronage.[37]

On a stylistic plane nothing in the figure or in the head of Rangone's statue is incompatible with other works by Vittoria. Differences between the statue (fig. 280) and the later bronze bust of Rangone (fig. 281) by Vittoria are not as significant as is sometimes claimed. One must remember that, unlike the bust, the statue has suffered from the elements; then, too, the bust may date from fifteen years later in Vittoria's career.[38] The head on Rangone's statue bears marked affinities with another portrait bust that Vittoria had in hand by the early 1560s, the marble head of San Geminiano's priest, Benedetto Mancini (fig. 282).[39] Both share a similar treatment of hair and beard in terms of low relief, with lightly chiselled grooves to suggest locks. If we compare these busts with the only bona fide series of portraits by Sansovino—the small heads on the Sacristy door in San Marco (figs. 153, 155)—we see a much more plastic modelling of hair in large locks occasionally punctuated by grooves.[40] Even conceding the small scale of these portraits, they demonstrate a much more forceful

conception of portraiture than is the case in Vittoria's early works. The same dissimilarity between the style of Rangone's statue and Sansovino's autograph works can be seen in the presentation of the torso and its draperies. Here, we can compare the seated figure of Rangone with slightly earlier seated figures by Sansovino in the four *Evangelists* made for the choir of San Marco (figs. 182–85).[41] Sansovino's presentation of the evangelists is based upon a clear conception of the human frame, which is amplified by its accompanying drapery. Just the opposite occurs with the figure of Rangone, in which the drapery is conceived in terms of a pattern bearing little relation to the figure underneath. The result diminishes the sense of a corporeal presence in a manner quite foreign to Jacopo's. But a complementary approach to form and drapery can be found in the work of Vittoria, especially in a statue like his *St Thomas*, made for Rangone in the early 1560s (fig. 283).[42] In both works the modelling of drapery takes the form of broad, flowing folds which seem superficial and fussy by comparison with Sansovino's. We must conclude that the documentary evidence of Vittoria's having furnished the wax model is borne out by the visual evidence of the statue itself.

There is also a body of circumstantial evidence that helps to explain the supplanting of Sansovino by Vittoria in the project of San Giuliano. Sansovino never seems to have shown much interest in portraiture during his long career, while Vittoria made portrait busts one of the staples of his sculptural practice.[43] Then, too, Rangone and Vittoria did become close friends during the 1550s and 1560s; in those same years Sansovino's powers were declining, and in the years prior to his death in 1570 his activities were sharply curtailed.[44] Yet it would be simplistic to say that Sansovino was remote from the creation of the bronze statue of Rangone, any more than from the rest of the façade. It was a collaborative effort in which the patron as well as the two chief artists had a great deal to say. Judging the episode of San Giuliano in terms of the *oeuvre* of one or another artist misses a more fundamental consideration, namely the Venetian custom of employing a number of artists to work together or sequentially on a project, each contributing to some aspect of the design without anyone necessarily dominating the whole. It is a phenomenon that repeats itself, over and over again, in large projects like the *scuole* or the Doge's Palace as well as in smaller projects like the rebuilding of San Giuliano.[45] Sansovino was certainly responsible for the overall design of the façade of San Giuliano and of Rangone's monument, but, as with his other architectural responsibilities, he delegated much of the work to Vittoria, who probably acted as the *proto* here as he did for the Venier monument.[46] Whether or not his alterations to the façade were personally approved by Sansovino is a moot point: the final decision rested with the patron, who would have had strong views, especially regarding his own monument.

Rangone must have exercised particular control over the curious iconography of his memorial which is, like everything he wrote, immensely learned and intensely obscure. The main burden of the monument is, however, fairly clear and relates to the traditions of the scholar's tomb in which the deceased was often depicted surrounded by books or in the act of lecturing.[47] As a young man Rangone would have seen numerous examples of such monuments in university towns like Padua, and he obviously knew Pietro Lombardo's monument to Dante in his native Ravenna.[48] Earlier sixteenth-century examples occasionally showed the deceased scholar with his books and a fictive sarcophagus, and in one example, the monument to Lodovico Gozzadini in Santa Maria dei Servi, Bologna (fig. 273), there is a clear anticipation of Rangone's memorial on San Giuliano.[49] The Gozzadini monument is by Giovanni Zacchi, an artist who had been in Venice in 1536 and obviously incorporated elements of Venetian tombs in his design.[50] It is conceived as a two-storey triumphal arch framing a doorway and with the seated figure of the professor of law above the portal. Gozzadini sits on a fictive sarcophagus, as does Rangone, but he is flanked by personifications of virtues while above him are the Virgin and Child and God the Father. Whether there is a direct relationship between the two monuments remains conjectural; in both cases, there is an allusion

to a specific kind of Venetian memorial that was built around a doorway.[51] The Gozzadini monument also indicates that Rangone and Sansovino were not the first to adapt traditional Venetian monuments to a novel effect.

Rangone's monument shares with Vincenzo Capello's on Santa Maria Formosa the nature of a commemorative memorial almost entirely devoid of religious context. Above all, the façade of San Giuliano is a celebration of the doctor's career and is contrived with great ingenuity. The inscriptions in Latin, Greek, and Hebrew demonstrate his familiarity with ancient tongues that gained him the name of Philologus; they also commemorate his foundation of a college in Padua, his many books, his career as a lecturer, and his discovery of a means to prolong man's life to the patriarchal age of one hundred and twenty years.[52] His arms, embellishing the lateral parts of the façade, proclaim Rangone's gentility, while Rangone himself is shown seated above the main entrance.

His statue occupies the centre of the lunette, on either side of which stand objects reflective of his career: the books, his scholarly pursuits; the globes, his interest in astrology and geography; and the branch, his knowledge of medicinal herbs.[53] More obscure is the device embossed on the plaque in Rangone's left hand (fig. 279). At the top is inscribed DEVS HI, the abbreviated form of a phrase, and beneath it a standing lion, facing right. Then come three concentric circles with a dragon facing left. Though the exact sense of the device has resisted analysis, the lion probably embodies Leo, the astrological sign of Rangone's birth, and the dragon, perhaps healing or regeneration.[54] The plaque complements the recondite and slightly eccentric nature of the façade as a whole and, like the façade, must be chiefly of Rangone's own design.

Much the most interesting aspect of the façade, however, is its manipulation of the traditional elements of the scholar's monument-books, lectern, and the portrait. By combining relief and three-dimensional sculpture, Sansovino created the illusion of Rangone seated in his study while defining a spatial context for his statue.[55] No other Venetian monument before or after the façade of San Giuliano ever attempted this; it remains the most original of Sansovino's monuments, one in which he fully met the challenge of an unusual patron.[56]

During the early phases of work on the façade of San Giuliano, Francesco Venier was elected doge. His reign lasted barely two years (1554–56), but this was enough time for Venier to decide upon a splendid tomb as a commemoration of his career and of his family.[57] The commission for the Venier tomb fell to Jacopo Sansovino, a choice dictated no doubt by Sansovino's artistic ascendancy, although other reasons may have played their part. Venier was a member of the confraternity of the Misericordia and a correspondent of Paolo Manutio.[58] He must have been well acquainted with Antonio Capello, who was one of his electors and served on the committees that awarded the Rialto *fabbriche*, the *giganti*, and the Scala d'Oro of the Doge's Palace to Sansovino.[59] All of these commissions came during the reign of Francesco Venier, and the doge himself would have been directly concerned with the *giganti* and the Scala d'Oro since they affected the appearance of his palace. So it must have been a foregone conclusion that the doge's monument would be placed in the hands of Sansovino. Although the general history of the Venier monument has been well known for many years, the circumstances surrounding its origin have been less well documented.[60] They illustrate the traditional expectations bound up with the office of doge, expectations that overrode personal preferences and were virtually immune to changes in fashion, religious or otherwise.

It would be useful to recall here the conventions that circumscribed the doge's family after his death.[61] The funeral of the doge followed a set pattern from the fourteenth century. The doge's body was first dressed in the ducal robes with sword and spurs; the day after death, it was taken to the Sala del Piovego and placed on a catafalque. The body remained there for three days, guarded by members of the Signoria dressed in scarlet robes. Then it was taken through the Piazza in a grand funeral procession with members of the clergy, the *scuoli grandi*, the chiefs of the Arsenal, the Jesuates, the doge's family, the Signoria with the diplomatic

corps, members of other confraternities, and the children of the hospitals. The procession paused before the church of San Marco, where the doge's body was raised and lowered nine times, and then proceeded to Santi Giovanni e Paolo for a state funeral with orations. With this, the public ceremonies were ended, and the body was given over to the family for burial. As far as the state was concerned, the nature and kind of memorial erected to a doge was a family decision, but there was a strong expectation that he or his heirs should provide a memorial in one of the larger churches like Santi Giovanni e Paolo or the Frari.[62] Among the earliest surviving wills in which a doge makes reference to his tomb is that of Doge Marco Cornaro (1365–68), who expressed a wish for burial in Santi Giovanni e Paolo in a site suitable 'nobis et statui nostro'.[63] Throughout the fourteenth and fifteenth centuries, the most elaborate and imposing sepulchral monuments were built by or for doges. Decorum probably prevented private persons from emulating them too closely. Doge's monuments generally included a recumbent effigy and figures of virtues or patron saints, often placed within an architectural framework.[64] As with many other tombs, the doge's memorial celebrated his family and *casata* as well as himself; sometimes the presence of more than one doge within a family led to dynastic monuments, as in the famous Barbarigo tombs, formerly in the Carità, or the Mocenigo tombs in Santi Giovanni e Paolo.[65] There was also a corresponding change in size of tombs from the fourteenth to the fifteenth century: monuments now began to cover whole bays or entire walls of churches. Not every doge followed this course, but exceptions, like Francesco Venier's predecessor Marc'antonio Trevisan, were rare.[66]

In the case of Francesco Venier, public expectations overtook personal ones. This is clear from the change in his plans for burial from his will of 1550 to the codicil added in September 1555, a little over a year after his election as doge.[67] In the former document, Venier wrote that he wished to be buried at San Francesco della Vigna 'with as little pomp as seems suitable to my executors'. He had no personal motive for a large funeral or monument prior to his election as doge. His new dignity, however, forced Venier to reconsider. In the codicil of 1555 he states:

> And as it is suitable that we give some instruction concerning our burial, we wish that in so far as the ceremonies are concerned, they should follow those customarily given to our predecessors by their heirs in additon to that which for the public is normally done. We wish to be buried in the church of San Salvatore in the site which we have chosen and which has been conceded to us by the reverend fathers of that monastery.[68]

It was not so much a question of private wishes but of public expectation and custom that dictated the change in site and the necessity for a monument. The monument celebrated the Venier family as much as it did the doge himself. The large sum of one thousand to fifteen hundred ducats was set aside for its construction, and his brother and nephews were made executors.

Francesco Venier had previously struck an agreement with the canons of San Salvatore, on 1 April 1555.[69] In exchange for a mansionary of 400 ducats, the doge was given the right to build a sepulchre for himself and his family in one of the most prominent sites in the church: the wall of the fourth bay on the right-hand aisle of the nave, directly opposite the portal that leads to the Merceria (col. pl. XII, figs. 284, 288). Work on the tomb may have been under way before Venier's death on 4 June 1556, although Francesco Sansovino reports that its execution was supervised by the doge's brother Piero, himself a candidate for doge in 1559; it was probably finished by 1561 when Piero Venier was buried alongside his brother in the vault beneath the tomb.[70]

There is no mention of Sansovino in any of the surviving documents, but the design of the tomb is ascribed to him by Vasari and Francesco Sansovino.[71] His one ducal tomb conforms almost rigidly to the pattern of late fifteenth and early sixteenth-century Venetian tombs. Its particular indebtedness to Tullio Lombardo's monument for Doge Giovanni Mocenigo in

Santi Giovanni e Paolo has often been noted (fig. 287).[72] The Mocenigo tomb was executed only a few years prior to Sansovino's arrival in Venice and anticipated Sansovino's use of the Composite order, subdued polychromy, austere lines, and the inclusion of the deceased's coat of arms in the attic storey. The retrospective quality of the Venier monument may have been a deliberate intention on the part of Sansovino's patrons and of Sansovino himself, given the conservative nature of Venetian tombs and the desire to satisfy public expectations which so motivated Francesco Venier. Both Sansovino and the Venier family would also have been aware of the notable tomb of an early Venier doge, Tommaso (1382–1400), in Santi Giovanni e Paolo.[73] Tommaso Venier's tomb was one of the first to display the standard features of a ducal tomb with its elaborate architectural framework, figures of virtues and patron saints, and a recumbent effigy. Francesco Venier must have wished for something similar, cast in a more contemporary style, to sustain the honour of the Venier *casata*, and Sansovino fulfilled his brief by creating what could be called the last of the High Renaissance ducal tombs (fig. 284). Like earlier essays in this field, the Venier tomb is conceived as a triumphal arch divided into three bays, with the doge's effigy in the large central bay and allegorical figures occupying the flanking ones.

In its details, however, the tomb is more closely related to Sansovino's Loggetta rather than to his other Venetian tombs. This is not remarkable, considering that the Loggetta's façade derives from Peruzzi's tomb of Hadrian VI (fig. 196).[74] The interrelationship of all three works becomes clear through a comparison of the two tombs, for here the correspondences are more direct, as in the tripartite division of both tombs, the use of free-standing columns, the Composite order with pulvinated frieze, and the polychromy. Although it is natural to find Sansovino reapplying the formula of Peruzzi's tomb to the Venier monument, the solution is not as happy as it is with the Loggetta. In the Loggetta the proportions adhere more closely to those of Peruzzi's original design, but in the Venier tomb, the proportions are too tall and too narrow for the scale on which Sansovino was forced to work.

The Composite order on the tomb invites comparison with the same order on the Loggetta, and the Ionic with that on the *piano nobile* of the Library and on the adjacent altar of the Annunciation in the third bay of San Salvatore. The Corinthian order of the niches is of a Venetian vernacular type which Sansovino employed on the third storey of Palazzo Delfin.[75] The sarcophagus simply varies the kind used in the Malipiero and Rangone monuments. In the Venier monument, however, the sarcophagus and effigy are raised to a conspicuous height by a plinth containing the memorial inscription.[76] The figure of the doge thus becomes the centre of a triangular composition defined by the Pietà at its apex and two statues of the virtues at its base.

Though the design of the tomb is unquestionably Sansovino's, one can only speculate as to his role in its execution. What evidence there is about Sansovino's works of the 1550s suggests that his active participation was minimal. Much of the work would have been subcontracted, with a stonemason executing the architectural elements and a sculptor, the figural ones. Sansovino's role as architect probably ended with the furnishing of drawings and moulding designs for the stonemason. This was to be the case with the Podocataro tomb, and Sansovino may even have engaged the same firm of stonemasons, although no documents survive to support this. However, two sculptures from the Venier tomb, the relief of the Pietà and the effigy of the doge, are documented as having been executed by Alessandro Vittoria and two assistants.[77]

Although Sansovino's responsibility for the tomb may have included supervising Vittoria's work, Vittoria was paid directly for his labours by Giovanni Venier, a nephew of the doge. The *Pietà* also figures in Vasari's account of Vittoria's works, and there is no reason to doubt that it is an original composition, albeit dependent upon Sansovino's idiom.[78] Sansovino's influence is most evident in the morphology of the figures of the Virgin, Christ, and St Francis (fig. 285). The Virgin is like the hooded woman in the background of the *Child Parisio*

XI. *Virgin and Child*, Staatliche Museen, Berlin-Dahlem (cat. no. 46)

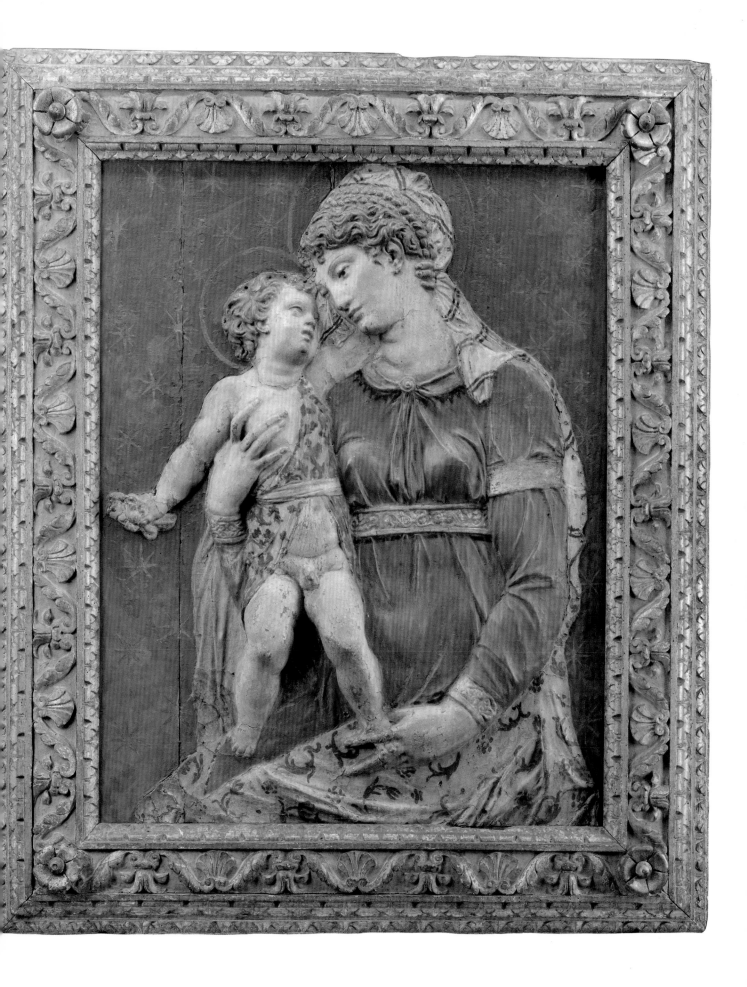

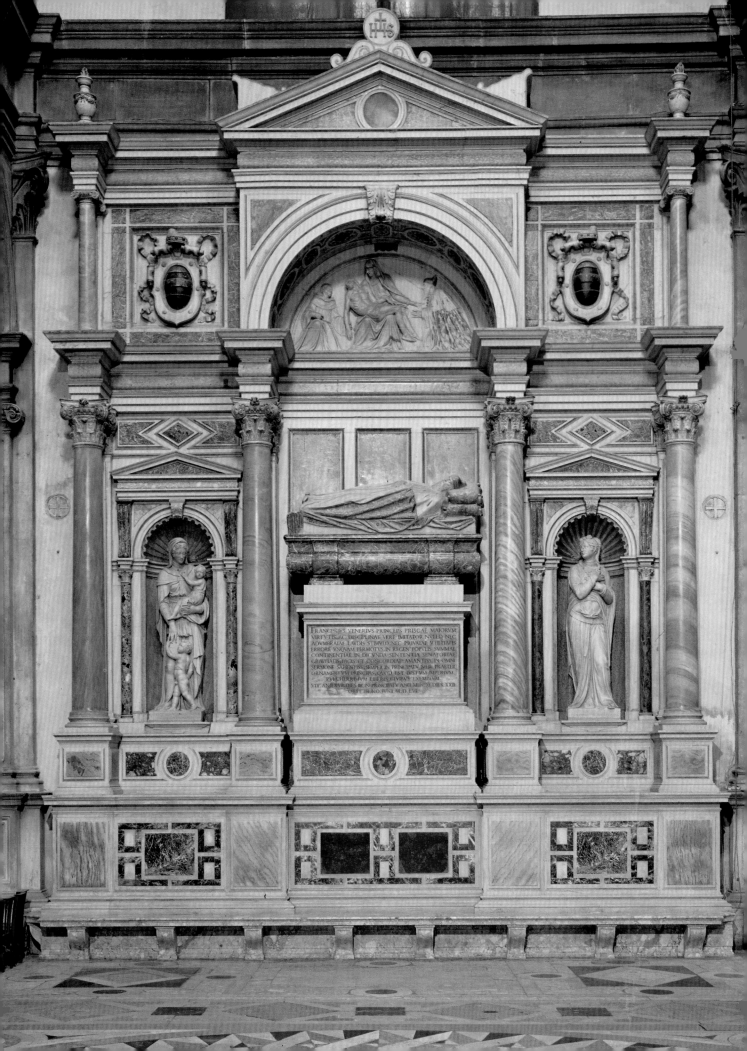

FRANCISCVS·VENERIVS·PRINCEPS·PRISCAE·MAIORVM
VIRTVTIS·AC·DISCIPLINAE·VERE·IMITATOR·NVLLO·NEC
ADVMBRATAE·LAVDIS·STIMVLO·NEC·PRIVATAE·VTILITATIS
ERRORE·VNQVAM·PERMOTVS·IN·REGEN·POPVLIS·SVMMAE
CONTINENTIAE·IN·DICVNDA·SENTENTIA·SENATORIAE
GRAVITATIS·PACIS·ET·CONCORDIAE·AMANTISS·IN·OMNI
SERMONE·SAPIENTISS·SEMPER·IN·PRINCIPATV·MVII·PRAETER
ORNAMENTVM·PRINCIPIS·QVOD·EST·IVSTVM·IMPERIVM
·····PVLCHERRIMVM·LIBERIS·CIVIBVS·EXEMPLVM·····
VIXANN·LXVII·RES·PRINCIPAL·ANN·MENS·VI·DIES·XXII·
·······OBIIT·IX·KO·IVNII·M·D·LVI·······

relief in the Santo or the female figures in the relief of the *Entombment* on the Podocataro tomb (fig. 298). Likewise, he has turned the traditional static grouping of such reliefs into a composition through the gesture of St Francis. The saint touches the right arm of Christ while his namesake, Francesco Venier, watches attentively. The scene thus becomes a visual metaphor of intercession and a worthy example of the young sculptor's skill.

By comparison, the effigy is a more mechanical piece of carving that hardly deviates from fifteenth-century ducal effigies or the subsequent effigy for Livio Podocataro (fig. 286). Life-sized and carved of Istrian stone, the doge's body has been inclined so that his features may be more easily seen from below. His head looks to have been copied from a death mask and the draperies and pillows have been worked and painted to simulate gold brocade. Although Sansovino's Nichesola monument subscribed to the Central Italian fashion for semi-recumbent figures, both Francesco Venier and Livio Podocataro are presented as *gisants*. The semi-recumbent figure seems to have met with some opposition in Venice and was used only twice for ducal monuments, in both cases by Girolamo Campagna at the end of the century.[79] Public opinion in Venice may have held that semi-recumbent figures were not suitable for doges.

Sansovino's ceding of the *Pietà* and effigy to another sculptor is understandable, given that the relief was to be seen from a great distance and the effigy was to give little scope for creativity. The statues of the virtues which flank the central bay were executed under Sansovino's supervision, as the signatures attest.[80] They are of Istrian stone and were carved from blocks of approximately the same dimensions.

Like the Loggetta bronzes, the virtues of the Venier tomb are effectively scaled to their niches, which seem to be moulded round them. Their proportions, however, are more conventional than the Loggetta bronzes, being eight faces high instead of ten. This is in keeping with the larger scale of the figures and the more conservative nature of the Venier tomb. The two statues do share one morphological feature with the Loggetta bronzes, and the *Maiden Carilla* relief (fig. 260), namely the elongated torsos and thighs that appear to have been favoured by Sansovino from the 1540s. Here, too, Sansovino plays with proportions to take account of viewing from below as well as to scale the two statues to the overall dimensions of the tomb. Neither statue is highly finished: claw-chisel marks are visible across both figures, as are drill holes in the hair and folds of drapery. But because they were never meant to be seen from close at hand, Sansovino let them leave his studio in this state (figs. 290, 292).

Both statues tell a great deal about Sansovino's working methods, although it would be hazardous to call them examples of the sculptor's 'late style'.[81] Neither are they essentially homogenous creations, as both statues descend from models that Jacopo created at different stages in his Venetian career. *Charity* is close in format to a small bronze of the Virgin and Child with St John the Baptist generically ascribed to Sansovino, and the figure of the virtue herself was anticipated by the *St Lucy* from Tiziano Minio's altar of San Rocco of 1536 (fig. 293), a work heavily indebted to Sansovino.[82] The *St Lucy* has the same inclination of the head, similar features, and overlapping folds of drapery found in Sansovino's *Charity*. Presumably, when Jacopo began to design the *Charity*, his thoughts turned to the model that Tiziano Minio had copied some twenty years earlier; to this basic figure Sansovino added a child on one arm, in the manner of the Nichesola Virgin (fig. 112), and a second child beneath. The children also have a family resemblance to Sansovino's other infants. The child cradled in the woman's arms has the face of the Christ Child inside the Loggetta (fig. 115), whereas the standing boy is reminiscent of the putti pressing round the Virgin and Child in the Chiesetta (fig. 121). *Charity* seems a product of the workshop in which component parts of Sansovinesque models have been dutifully if dryly assembled for a large-scale statue. Even making allowances for the subject matter, it would be hard to imagine Sansovino having spent much time on the *Charity*, for it lacks that element of spirit or *fierezza* which characterizes its companion.[83] Without documentary evidence, it is difficult to assign the statue to

XII. Monument to Dogo Francesco Venier, San Salvatore, Venice (cat. no. 32)

one or another member of Sansovino's shop; bearing in mind that a squadron of sculptors assisted Sansovino on the *giganti*, a similar complement of assistants cannot be excluded here.[84] Ironically, the one sculptor put forward as Sansovino's collaborator on the *Charity* could *not* have held such a role. Tommaso Lombardo, who worked under Sansovino on many projects in the 1530s and early 1540s, left the studio some years before the Venier tomb was begun.[85] It is more likely that Sansovino relied upon the same assistants who helped him finish the *giganti* and the Chiesetta *Virgin and Child with Angels*.

Iconographically, *Charity* marks a departure from previous treatments of that virtue on Venetian tombs.[86] Earlier monuments usually presented the virtue as *caritas Dei*, a female figure with a cornucopia or flaming heart. The presence of children implies *caritas proximi*, a virtue appropriate to the prince of the Venetian state.[87] The type created by Sansovino is close to the famous *Charity* for the Fonte Gaia in Siena by Jacopo della Quercia, as Pittoni noted, but a composition with only two children, rather than three, was better suited to the dimensions of the niche and those of the original block of stone.[88]

Charity's companion has long been regarded as the more arresting of the two statues and generally considered the finest of Sansovino's late autograph works (figs. 289–90).[89] Although commonly identified as *Faith*, the correct title of the statue is more probably *Hope*, as Burckhardt noted.[90] The presentation of the figure with hands folded upon her chest and her face turned upwards corresponds with the conventional iconography of Hope rather than Faith, who customarily holds a chalice or a cross.[91] Sansovino's embodiment of Hope is very close to an engraving from the school of Marc'antonio Raimondi in which a woman is shown seated and with her hands crossed on her breast (fig. 294); it also follows a conventional type of Hope that appears on Rizzo's monument to Doge Niccolò Tron in the Frari (fig. 295).[92] Both iconographically and aesthetically, Sansovino's *Hope* marks something of a *rapprochement* between the sculptor's personal style and Venetian sculpture of an earlier generation. This affinity may have been partly deliberate, given that Sansovino must have studied earlier Venetian tombs and chosen a figure like the *Hope* from the Tron monument as a model. One senses, too, that a subject like Hope engaged all that was best in Sansovino's artistic temperament, for it was a figure in which everything depended upon gesture and expression of the tenderest kind. It came under that category of sculpture singled out by Vasari as Sansovino's special domain, the ability to convey the expressions of female figures and of children.[93]

Sansovino's *Hope* is of no little importance as one of the last works to emerge from Sansovino's shop bearing the imprint of the master himself. Like *Charity, Hope* shows a family resemblance to other works by Sansovino and marks the re-emergence of that Sartesque *douceur* that informed many of Sansovino's earlier sculptures. The figure is posed in Sansovino's characteristically modified *figura serpentinata*, first employed in the Florentine *St James*. This brings into prominence the right shoulder and the left leg and imparts to the whole figure a sedate curve. The closest analogies with the female type of *Hope* come in works of the 1540s and early 1550s. In general terms it corresponds to the caryatids of the fireplace in the Villa Garzoni at Pontecasale (figs. 338, 340–41). They show the same kind of *serpentinata*, and similar faces and costumes, though their proportions are considerably more attenuated.[94] The Pontecasale caryatids were subsequently adapted by Sansovino and Vittoria when the latter sculptor carved the over-life-sized *feminoni* for the entrance to the Library in 1553. (fig. 434).[95] The *feminoni* constitute a link between the diminutive figures at Pontecasale and the monumental *Hope* of the late 1550s; in all three cases Sansovino made simple variations on a single model to suit a particular context. Where the figure of *Charity* put him in mind of his own Virgin and Child compositions, *Hope* was fashioned from the inspired conception of the Pontecasale caryatids. In short, to call the statues on the Venier tomb examples of a 'later style' not only misrepresents Sansovino's manner of creating figures, but also obscures the relationship between the late statues and earlier ones. With the exception of his bronzes, Sansovino did not have the kind of distinctive late style which one finds in the work of Michelángelo or of Titian.

Another feature that distinguishes *Hope* from its companion *Charity* and the Pontecasale caryatids is the expressive quality of the face (fig. 290). The energy that Sansovino applied to this sculpture must have been largely directed to this portion. It is the remarkable beauty of the face that raises this statue above anything else produced by Sansovino's shop in the last years of his career. As has been noted by many commentators, *Hope* is a remarkable tribute to Sansovino's powers when he would have been well into his seventies.[96] Even allowing for substantial intervention by his assistants, it would be difficult to find any other sculptor of Sansovino's immediate circle capable of imparting such emotional content to a statue. In the figure of *Hope*, one sees for the last time Sansovino's peculiar genius as a sculptor, his gift for informing a potentially static composition with an expressive *raison d'être*: where *Charity* does not transcend the mere status of an external tableau of its virtue, *Hope* does become an embodiment of its virtue, and this is reflected in every aspect of the figure. It is, as Burckhardt observed, one of the loveliest of Sansovino's Venetian sculptures and a figure in which the various strands of his career, both Central Italian and Venetian, are brought together.[97] It draws upon a tradition of such figures on Venetian tombs, as in the Tron monument (fig. 295), while clothing it in a pose and in proportions that recall Sansovino's pre-Venetian sculpture.

One of the last works designed by Sansovino, the tomb of Livio Podocataro is also one of the best documented (fig. 296). It furnishes much evidence for the delegation of responsibilities in Sansovino's sculptural commissions, both within his own workshop and without. The tomb was erected in the church of San Sebastiano and commemorates the Cypriot nobleman Livio Podocataro and his family.[98] Podocataro, like Francesco Venier, moved in the same intellectual and artistic circles as did Sansovino. His family had resided in Venice since the early fifteenth century but came into prominence with Livio's uncle Lodovico, who became a cardinal under Alexander VI. Lodovico had a celebrated collection of antiquities in his Roman residence and paved the way for his nephew's entrance into the Church. Livio became his uncle's chief heir in 1506 while, at the same time, he methodically climbed the ladder into preferment, becoming archbishop of Nicosia in 1524. Livio was a friend of Pietro Bembo and lent his house in Rome to Bembo's close friend Carlo Gualter; he was also on good terms with Alessandro Piccolomini, who dedicated the second edition of his *Institutione di tutta la vita dell' huomo* to Podocataro in 1552.[99] Podocataro may have known Sansovino in Rome or through Bembo, but the two would definitely have been acquainted by 1536 when Podocataro's secretary, Fortunio Spira, was one of the signatories of Francesco Zorzi's memorandum on San Francesco della Vigna.[100]

Like the Venier tomb, the Podocataro monument is a retrospective work, looking back to the kind of tomb fashionable at the turn of the century. Indeed, it scarcely represents an advance on the tomb that Livio Podocataro built in memory of his uncle in Santa Maria del Popolo (fig. 299): both feature a recumbent effigy and relief sculpture set within an architectural framework.[101] Livio or his brother Cesare may have expressed the wish for a monument similar to their uncle's or even to Francesco Venier's. Certainly the Podocataro tomb gives the impression of a scaled-down version of the Venier tomb in Istrian stone rather than polychrome marble. In both cases, the deceased rests in an identical pose upon a sarcophagus of similar design and framed by an aedicule. Where the Venier monument fills its bay like a great triumphal arch, the Podocataro tomb's aedicule is framed by round-headed windows, also designed by Sansovino, and surmounted by reliefs. The aedicule and transept wall are articulated by a Corinthian order, resting on a sockle of two fasciae that is decorated with the Podocataro arms (fig. 296). As with the Venier tomb, the division between sculpture and architecture is clearly defined, the sculpture fitting neatly into designated places in the architectural structure.

The major sculptural components are the reliefs of the *Virgin and Child*, the *Resurrection* (fig. 297), and the *Entombment* (fig. 298). There is no evidence as to which member or members of Sansovino's shop may have executed them or the victories and effigy, but they do not

suggest any direct participation by Sansovino himself. The level of execution, especially in the two lateral reliefs, is scarely more than competent and gives the impression of deriving from a concoction of ready-made models. This is particularly the case with the Passion reliefs, which are very much résumés of Sansovino's reliefs for the Sacristy door (figs. 156, 160). As the Sacristy door reliefs were only cast in 1553 and remained in Sansovino's studio until the end of his life, it is not surprising that they should have served as touchstones for the subsidiary reliefs on the Podocataro tomb.[102] The *Entombment* shows only a slight rearrangement of the corresponding bronze panel; the figure of Christ, itself an adaptation of the *Bed of Polyclitus* relief, has been moved to the centre with the two Marys standing on the left and two soldiers on the right. The heads of the bearded male figures all depend upon types found on the bronze panels in San Marco and the *Evangelists*. The *Resurrection* suffered more in transposition from bronze to stone, and the figures have been crowded into the relief's plane. What one witnesses here is very much a scaling down of the Sacristy door reliefs to the level of decorative accessories on the Podocataro tomb. This is the sort of exercise that would have been carried out by Sansovino's shop without intervention from Sansovino himself. The tondo of the Virgin and Child is somewhat stronger as a composition (fig. 300), deriving from earlier Sansovinesque works like the Arsenal and Nichesola *Madonnas* without being a literal copy of either. Like the Nichesola *Madonna*, the heads in the relief are turned towards the deceased in a sign of benevolent regard. While the names of those responsible for the reliefs are not mentioned in the documents, the reliefs bear an affinity to the large Istrian panel of the Virgin and Child in the Doge's Palace, bearing the date of 1562 (fig. 330).[103] Given that Sansovino's payment for the Podocataro tomb came only in 1565, it is highly probable that the tomb's sculpture was still under way in the early 1560s and executed, at least in part, by the same hand as the panel in the Doge's Palace. The victories, on the other hand, are fairly mundane works, comparable to the figures in the spandrels of the Library (figs. 418–19). They are an element which can be traced back to Sansovino's earlier works like the altar of the Martelli family in Sant'Agostino (fig. 66).[104] The effigy is the only sculptural component of the Podocataro tomb to be highly finished, but it, too, would have been executed by assistants, as was the figure of Doge Venier. Indeed, both effigies are virtually identical in presentation, with the figure tilted towards the spectator and its right hand resting on its cope. As in the case of the Nichesola tomb, this is the element that held the greatest importance for the executors and required an accurate representation of the deceased; it is also the only part of the tomb executed in marble.[105]

The genesis of the Podocataro tomb came with the testament of Livio on 10 January 1556, nine days before his death.[106] In his will, Podocataro explains that the Hieronymite fathers granted him the right transept wall for his tomb in exchange for a mansionary of 500 ducats. He further set aside between 700 and 1,000 ducats for the construction of a tomb as well as 500 ducats for a tapestry for the cathedral of Nicosia. His brother Cesare, archbishop-elect from 1552, was made his principal heir, and two Venetian noblemen, Matteo Dandolo and Matteo Bragadin, were appointed executors, the latter subsequently being replaced by Stefano Tiepolo. Podocataro also requested a funeral commensurate to his status, which was in fact satisfied by a ceremony in San Marco itself.[107] Little progress was made on building a tomb, as Cesare Podocataro himself died in November 1557. From his will, one learns that a design had been prepared for a tomb which would cost 600 ducats, 500 for the materials and 100 for workmanship.[108] Three men were appointed to supervise the construction of the tomb: Cesare's brother, Matteo Dandolo, and Jacopo Sansovino. Sansovino's precise role in the affair was clarified by a contract of 3 November 1557, which is appended to the will itself. The contract was between Cesare Podocataro and a *bottega* of stonemasons for the execution of the monument. This is the only contract that survives for any of Sansovino's works, and, as such, is of great interest. The terms called for the masons to build a tomb twenty-seven Venetian feet wide and twenty-three feet high; Sansovino would furnish them with the

general design and detailed drawings for mouldings. The masons were concerned only with the architectural elements, not the figural ones, and pledged to have the work finished within one year or pay a fine of 50 ducats. The masons agreed to remove the old transept windows and replace them with new ones copied from the façade of San Giuliano.[109]

Construction of the tomb probably proceeded apace, as it is referred to in the contract with the same *bottega* of stonemasons for the execution of the high altar in 1559.[110] Apparently Sansovino was left in charge of furnishing the sculpture, as no other sculptor is mentioned in the accounts for the tomb. He received a payment of 166 ducats in 1565, wich would have covered the cost of the effigy, the three reliefs, and two victories.[111] By analogy with the Venier tomb, one can imagine that the larger part of the money, perhaps as much as one third, would have gone on the effigy of the archbishop, with the reliefs costing proportionately less and Sansovino's drawings only a small amount.

Although the names of Sansovino's sculptural collaborators are not known, the partners of the architectural *bottega* are named in the contract of 1557. They are Georgio de Venetis, Zuane Pietro de Zanchis, and Salvador quondam Vettor; their workshop was situated in the old *casa brusada* of the Cornaro palace at San Maurizio, a site to which they moved in 1551.[112] The architect of the new Cornaro palace was Sansovino, and he would have known this *bottega* if only through its location on Cornaro property. Sansovino's collaboration with this *bottega* predated the contract for the Podocataro tomb, for the same *bottega* had contracted to build twelve bays of the Fabbriche Nuove at Rialto in May 1556, a project designed by Jacopo Sansovino.[113] Two years earlier, Salvador had witnessed the consignment of Sansovino's wax model of Tommaso Rangone to the bronze-caster Giulio Alberghetti.[114] Subsequent to the contract for the Podocataro tomb, the same *bottega* executed the high altar of San Sebastiano after a design by Paolo Veronese, which took into account both the scale and details of the Podocataro memorial.[115] The most significant sign of favour shown by Sansovino towards this group of stonemasons came in his will of 1568 where Salvador was named as an executor along with the sculptor Danese Cattaneo and Francesco Sansovino; Salvador also inherited Sansovino's architectural drawings in the same will.[116] In this group of stonemasons, Sansovino obviously found a group of artisans capable of following his instructions and familiar enough with his architectural style to execute works with a minimum of supervision. The San Maurizio *bottega* was comparable to the workshops of sculptors like Vittoria and Cattaneo, to whom Sansovino could subcontract his sculpture with confidence. It is highly likely that the same *bottega* would have been involved in such projects as the façade of San Giuliano and the Venier tomb where documents for the stonemasons' work do not survive.

One final tomb by Sansovino should be mentioned here even though it was never finished and no longer survives, Sansovino's own. This had a protracted history, and some elements have already been touched upon in the discussion of the *St John the Baptist* in the Frari.[117] Sansovino's concern for leaving a suitable memorial to himself was manifest as early as 1533 when he commissioned a monument from his sometime collaborator Silvio Cosini.[118] According to Sansovino's last will, the sculptor wished to be buried in the Florentine chapel of the Frari by the holy-water font on which his own marble *St John the Baptist* stood (fig. 93). Sansovino's will expands upon his tomb for several reasons, among them the conventional fear of most testators for the completion of their monuments, but another reflecting a concern for his artistic fame. 'Virtuoso artists,' Sansovino writes, 'should have a care to leave a memorial to their accomplishments.'[119] He was probably thinking of other monuments to artists, such as the wall monument to the Pollaiuolo brothers in San Pietro in Montorio in Rome or Mantegna's funerary chapel in Sant'Andrea in Manuta.[120] Such tombs, and others, provide a clue to the kind of monument intended by Sansovino. One can imagine that the wall monument begun by Cosini may have been a decorative cartouche or fictive sarcophagus along the lines of his Florentine works like the Minervetti or Strozzi tombs in Santa Maria Novella (fig. 324).[121] There would also have been a niche for Sansovino's bust and an inscrip-

tion. This would have gone in the wall of the Florentine chapel near Sansovino's place of burial by the font with his figure of the Baptist. Thus Sansovino would have been doubly celebrated, as a distinguished member of the Florentine community in Venice—he always considered himself a Florentine—and as an important artist.[122] The visitor to the Florentine chapel would have been able to see two celebrated examples of Sansovino's skill as a sculptor: the *St John the Baptist*, which testified to his ability to create figures of great expressive qualities, and his self-portrait, the extraordinary technical feat which Francesco Sansovino records as having been carved using a mirror.[123]

Unexpectedly, Sansovino changed his plans for burial in June 1570, only five months before his death at the age of eighty-six. At that time, Sansovino entered into an agreement with the chapter of San Geminiano for the right to use the chapel of the Crucifixion as a burial place for himself and his family.[124] Sansovino had been responsible since 1557 for the completion of the church, and in 1566 he also rebuilt the narrow house that stood between the church and the Procuratie Vecchie. The ground floor of the house was divided into two sections: that facing the Piazza contained the chapel of the Crucifixion; the rear was subdivided into two shops. The façade contained an applied arch with a two-light window of a Codussian style on the ground floor and arcading in the manner of the Procuratie Vecchie on the upper floors (figs. 191, 363). In exchange for the chapel, Sansovino pledged to remove some tombs of the chapter and the Confraternity of St Catherine to a new location and to furnish a new altar and crucifix. Some of the work required in the chapel may have been done before Sansovino's death in November 1570, but little of the more elaborate memorial described by Francesco Sansovino in his *Venetia* was ever put into effect.[125] Presumably the tombs mentioned in the agreement of June 1570 were removed so that a vault containing Sansovino's body could be made on the chapel's floor. This was covered by a stone slab with a brief inscription. On the wall Francesco Sansovino intended to place a commemorative tablet and his father's self-portrait; a bust of Francesco and a second inscription were to go on the wall opposite. However, both Temanza and Morelli reported that the chapel contained only the inscription over Sansovino's tomb and that Sansovino's portrait remained in the hands of his family.[126]

Sansovino's belated change of plans had unfortunate consequences for his posthumous memorial, but the opportunity of obtaining a chapel in one of the most prestigious sites in Venice, one which Sansovino could number among his own creations, must have been irresistible. Although his own memorial was never fully completed, it did set a pattern for the tombs of other Venetian artists, such as Veronese's in San Sebastiano, Tintoretto's in the Madonna dell'Orto, or Vittoria's in San Zaccaria (fig. 333).[127] Like Sansovino, each of these artists was buried in a church associated with his own art. Vittoria's, begun as early as 1566, though not completed until 1605, probably offers the closest parallel to Sansovino's intentions. Vittoria's monument, which includes a bust of the artist, stands on the left-hand side of the nave. Vittoria also gave two statuettes of the Baptist and San Zaccaria to the church, and they stand on fonts to either side of the main entrance. The visitor can thus admire examples of the sculptor's skill in the form of the statuettes and the sculptor's bust, just as Sansovino had intended with his own memorial.

Sansovino's tombs form a fairly homogeneous group within his sculpture. They show that his general concepts were fully formed by the end of his years in Central Italy, with the works of Peruzzi and Andrea Sansovino being of paramount importance. They also give a clear indication of Sansovino's role as a designer rather than active participant, a role that became accentuated in the years after 1550. The tombs were built by masons after designs furnished by Sansovino, and the sculpture was either created in Sansovino's shop or subcontracted to former pupils; in both instances, Sansovino had trained specialists capable of reproducing his own ideas with a minimum of supervision, though without, of course, the high quality of a wholly autograph work.

These monuments do not constitute a new chapter in Venetian sculpture, but rather the final pages in an old one. They blended in well with contemporary Venetian tombs by virtue of their common ancestry in fifteenth-century Florentine models. Their virtues lay in the clarity with which Sansovino fitted sculpture into a strong architectonic framework and in the 'correctness' of their architectural forms. Their weaknesses are especially apparent on the larger works like the Venier tomb in which an essentially small-scale design looses coherence by enlargement. Both Sansovino's tombs and his church façades reflect the same tendency to subdivision by a sequence of orders rather than having recourse to a single giant order. In this way, Sansovino marks himself as of an older generation than Palladio, Danese Cattaneo, or Bernardo Contin.[128] Their tomb designs experiment with the giant order and show an awareness of Central Italian models of a more recent vintage than those habitually employed by Sansovino. It was for the next generation of sculptors and architects to recast the conventions, as Cattaneo did with his Fregoso and Loredan monuments (figs. 449–50, 453) or Vittoria with his memorial to Marc'antonio Grimani (fig. 454) and his da Lezze monument (fig. 386).[129] For scale, design, and iconography, these remained a touchstone for later architects and sculptors down to the seventeenth century (fig. 387).[130] By contrast, Sansovino and his patrons formed their taste in the first decades of the sixteenth century. Their expectations of what a tomb should look like must have been fairly compatible, and Sansovino was apparently content to produce variations on the same theme when not challenged by a demanding patron such as Tommaso Rangone. Above all, it was the retrospective orientation of such works as the Venier and Podocataro monuments that make them more of a swansong than a portent of later sixteenth-century Venetian tombs.

IX. The Giganti

All'entrare delle scale del palazzo di San Marco fa tuttavia di marmo in forma di due giganti bellissimi, di braccia sette l'uno, un Nettuno ed un Marte, mostrando le forze che ha in terra ed in mare quella serenissima republica.

<div align="right">Vasari</div>

Goffi sì, e non bellissimi com'egli che li commenda.

<div align="right">Annibale Carracci</div>

THE COMMENT BY Annibale Carracci in his copy of Vasari's *Vite* sums up the modern reaction to Sansovino's *giganti* and to much of colossal sculpture in general.[1] The sixteenth century's taste for over-life-sized sculpture remains one that modern observers have found especially hard to appreciate, even though the genre includes some of the most distinguished works of the period, from Michelangelo's *David* to Cellini's *Perseus* and Giambologna's *Rape of the Sabines*. In most cases, however, the aesthetic claims of such works fall short of what would be judged beautiful, and here one would have to place Sansovino's three essays in the colossal: his *Hercules* for Ercole II d'Este, Duke of Ferrara, and his *Mars* and *Neptune* for the Signoria of Venice. To understand the appeal of the colossal for sixteenth-century artists and patrons, we must first try to appreciate the criteria by which such works were judged and the uses to which they were put.[2]

The most succinct definition of the attraction of colossal sculpture for the Renaissance is that given by Benvenuto Cellini as 'the most difficult and admirable task of all'.[3] The technical challenge and the rivalry with the colossi of antiquity spurred sculptors and their patrons to the creation of modern equivalents; anyone who read Pliny or visited Rome would have had his imagination fired by descriptions of fabled statues such as the Colossus of Rhodes or the bronze statue of Nero that once stood in the forecourt of the Domus Aurea or surviving works like the *Dioscuri* on the Quirinal.[4] Just as colossi had been principal ornaments of many ancient states, so, too, they became symbolic of the aspirations of Renaissance cities. The accumulation of large antique statues on the Capitoline formed part of the papal *renovatio* of modern Rome, and the combination of ancient and modern statues in the Piazza della Signoria played a similar role in Medicean Florence.[5] Then, too, Pliny's account of colossi carved from a single block of stone and the rarity of blocks large enough to accommodate such figures led to fierce competition among sculptors for these commissions, as the history of the blocks that became Michelangelo's *David* or Bandinelli's *Hercules and Cacus* or Ammannati's *Neptune* makes clear.[6]

Alberti had encouraged artists to practise on large-scale works because they would reveal weaknesses of technique which smaller works often concealed.[7] In terms of colossal sculpture,

the challenge lay in solving a number of interrelated problems: the successful scaling up of models to a size larger than life; the creation of compositions that could realistically be carved or cast; and the translation of the model into the final medium of stone or bronze. It was a challenge to which any ambitious sculptor would rise and can be seen as a *leit-motif* of sixteenth-century Italian sculpture: for Bandinelli, Vasari tells us that colossi formed a continual interest; Cellini's *Perseus* won for the sculptor critical fame as did Ammannati's *Hercules* for Marco Mantova Benavides (fig. 304).[8] Indeed, virtually every major sculptor of the sixteenth century tried his hand at the task of producing sculpture larger than life-size.

 Though Renaissance discussions of sculpture rarely expand upon the technique of creating colossal figures, one can glean a certain amount of information from the writings of Vasari and Cellini as well as from specific cases.[9] While traditional sculptural practice envisaged the sculptor as working from a drawing or small model, the situation had changed by Sansovino's day.[10] If Vasari and Cellini are to be believed, most sculptors first made a rough sketch or *bozzetto* in clay, wax, or plaster, which was followed by a second, more definitive model in clay or gesso. This definitive model would then be enlarged to the scale of the projected statue by the construction of a wooden or iron frame of the same size as the statue and with its members in the same position as the smaller model. The proportions of the figure were created by small pieces of wood placed over the frame and covered with a mixture of straw or tow dipped in wet gesso; over this went a layer of lime and gesso, almost to the final size of the work. The surface was then smoothed with rasps before the application of stucco as a final coat. Once the full-scale model was completed, work began on the marble. Both the model and the roughly trimmed block would be placed side by side on tables of similar dimensions and of the same height. A square of seasoned wood was fastened above the two so that plumb lines could be dropped for comparative measurements. Such measurements were established by the use of a stick, a compass, the lines, and often a measuring scale on the wooden square (fig. 317). In this manner, the sculptor would transfer the major features from the model to the block; when this was done, he could continue work by trusting to his own judgement. Such was the way in which most sculptors seem to have worked. The more ingenious, not to say obscure, programme for enlarging a figure that Cellini employed in his *Trattato della scultura* may simply have been the result of difficulties encountered in making a statue forty braccia high (23.36 m).[11]

 The complexity of marble carving naturally meant that stone sculpture was often less daring than bronze, as Francesco Bocchi noted in his appreciation of Donatello's *St George*.[12] This complexity was multiplied in the case of colossal sculpture, and it was widely noted that sculptors often had to abandon ambitious models in favour of more restrained ones. Bandinelli found he could not accommodate his original model in the block from which he eventually carved his *Hercules and Cacus*, and the same problem affected the design of Ammannati's *Neptune* for the Piazza della Signoria.[13] Moreover, large sculptural projects generally required the employment of a team of assistants and specialists to aid the principal sculptor, a custom which Bandinelli once justified on the example of Ghiberti and Donatello.[14] Such drawbacks did not trouble the patrons of colossal sculpture, for their interest in the genre complemented that of the sculptors themselves. They, too, were attracted to the technical challenge of over-life-sized sculpture as well as to the emulation of ancient patrons of colossi. Evidently, they were also prepared to place a lower aesthetic value on such sculpture than they would have done on life-sized or smaller statues. Rather, it was its decorative and symbolic value that won for colossal sculpture its notable role in Renaissance squares and fountains, on public buildings, and in gardens.

 Sansovino's experience of producing over-life-sized figures went back to his Florentine years when he and Andrea del Sarto were responsible for the temporary façade of the cathedral and for a large equestrian group before Santa Maria Novella in honour of Leo X's entry in 1515.[15] For the cathedral, Sansovino designed statues of the apostles as well as an

architectural framework and a series of reliefs after Old Testament subjects. Though no drawings or copies after the statues are now known, they must have been on a very large scale in order to register against the dimensions of the cathedral's façade, as had been the case with Donatello's *St John the Evangelist*.[16] Beyond this, Vasari tells us that Sarto and Sansovino created an equestrian group some eleven metres high, which won special praise. Accounts describe this as a horse with a figure beneath it, and it was compared to both the *Dioscuri* and the *Marcus Aurelius*, although several sources describe the figure as being a prostrate *gigante*.[17] In the same *entrata*, the young Baccio Bandinelli also attracted attention with his clay *Hercules* which stood nine and a half *braccia* high under the Loggia dei Lanzi.[18] Sansovino's awareness of Bandinelli's work, particulary his penchant for creating colossi, is notable in the context of his own *giganti*, for it was Bandinelli and Bandinelli's pupil Ammannati whom Sansovino invoked as possible judges when challenged on the quality of his *Hercules* for Ercole II d'Este.[19]

Colossal scuplture played a notable part in the development of fifteenth and sixteenth-century Florentine art. After the *giganti* by Donatello and Nanni di Banco for the cathedral, a lengthy history beset the marble block that eventually became Michelangelo's *David*. In addition, there were temporary figures like Bandinelli's *Hercules* for the entry of Leo X and his marble *Hercules and Cacus* of 1534 and Cellini's *Perseus* of 1554. By 1550 there was also a project for a fountain in the Piazza della Signoria which subsequently led to Ammannati's carving of a colossal *Neptune*. Venice, by comparison, seems to have taken up the idea of colossal sculpture much more slowly. The first sign of real interest came with the arrival of Ammannati in 1543.[20] One of his first tasks was to execute a figure of *Neptune*, four *braccia* high (2.3 m) or just over life-size and destined for the corner of the balustrade on Sansovino's Library.[21] The *Neptune*, which was destroyed in the eighteenth century, may have led to a more significant commission from Sansovino's friend the Paduan connoisseur Marco Mantova Benavides. This was the celebrated *Hercules* that still stands in what was once the courtyard of the Mantova Benavides palace in Padua (fig. 304).[22] Both its scale (almost nine metres) and its swift completion by 1544 testify to the skill of its creator. Its size prohibited completion from one block of stone; instead, the sculptor joined together eight blocks of stone with consummate skill. The pose suggests Hercules resting from his labours, which figure on the pedestal; yet the colossus also conveys a striking impression of brute force and potential energy as it turns to rivet those entering the courtyard. Both sculptor and patron took great pride in the feat. Benavides praised Ammannati as the first modern sculptor to have created a colossus to rival those of antiquity, and in 1549 he wrote to the archbishop of Florence to say that Ammannati's *Hercules* had won the admiration of Genga, Palladio, Sansovino, and others.[23]

It may well be that Sansovino's admiration was tinged with envy at the success of his protégé, who became Benavides's preferred sculptor until his return to Central Italy a few years later. However, Sansovino had his own chance to carve a statue of Hercules in 1550 when he was approached by Girolamo Feruffino, the Ferrarese agent in Venice.[24] The history of the commissioning and execution of Sansovino's *Hercules* smacks more of a picaresque novel than of the drier fare which is the customary diet of art historians. It is a tale of double-dealing and double-crossing, from which virtually no one emerges with credit. But the persistence of Feruffini in tracking down the dilatory Sansovino throws much light on Sansovino's working procedure and on his shop.

The commission originated with Ercole II d'Este's wish to have a commemorative statue for the new gate to the extension of Modena. As the suburb was called the Addizione Erculea and the gate, the Porta Erculea, it is not surprising that the statue intended was a Hercules. Apart from the standard association of Hercules with good government, the choice would have been an obvious compliment to a ruler named Ercole.[25] Pomponius Gauricus made an extended analogy between Ercole I d'Este, grandfather of Ercole II, and Hercules in the

dedication to his *De sculptura* of 1504.[26] More to the point, perhaps, Ercole II chose to appear in the god's lionskin on a medal of 1538 (fig. 303); in this, the duke was merely following the lead of Roman emperors and of Alexander the Great, all of whom had borrowed the attributes of Hercules for their official imagery.[27] Antonio Begarelli was entrusted with the task of making a model for a Hercules in 1549, with the intention that the model be given to a stonemason for carving.[28] Evidently, Begarelli's model did not satisfy the duke, who turned to Sansovino. His choice is not surprising, as Ercole had tried to persuade the sculptor to settle in Ferrara when Sansovino passed through that city in 1540.[29]

Either Ercole or his agent Feruffino hoped to obtain Sansovino's services cheaply because Feruffino originally claimed to be acting on behalf of a Ferrarese nobleman. His first agreement with Sansovino, drawn up early in 1550, entailed a price of 120 ducats, 50 of which were put down as earnest-money, and called for the statue's completion within eight months.[30] Shortly thereafter, Feruffino changed tack and told Sansovino that the Duke of Ferrara had heard of the commission and had persuaded the nobleman to cede the commission to himself. Thus it was hoped that Sansovino would exert more care and diligence in his work.

These facts can be gleaned from Sansovino's letter to the duke of 12 September 1550, a letter which is particularly revealing of his working methods towards the end of his career.[31] In it, Sansovino tells his patron that his usual method is to make a model for such a commission and then to turn the model over to one of his assistants for execution, 'guiding and correcting him without touching the stone myself, just as I am accustomed to do here with many other sculptures since the buildings of which I have charge prevent me from carving with my own hands'. The duke is then told that Sansovino had almost withdrawn when he had learned the true identity of his patron, feeling that such a system was not worthy of Ercole II. Sansovino adds that he would have taken up the tools himself had not the stone been lost at sea with a cargo of other stone being shipped from Istria.[32] However, Sansovino has thought of a way out of this impasse; he advises the duke to ask Vettor Grimani for a block of stone suitable for the purpose. Once the stone is selected, Sansovino promises to dispatch the statue as soon as possible.

There was, of course, a great deal of self-serving humbug about Sansovino's letter, as the duke subsequently noted.[33] Yet, his candour about his working methods is illuminating, both of itself and in terms of what it reveals his patrons expected from him. By 1550 Sansovino would have been able to regard himself as a veteran of almost fifty years' work in his field; he knew his career was almost over and he had just finished two demanding decades of service with the procurators of San Marco *de supra*. With the exception of the *Maiden Carilla* relief for the Santo, Sansovino probably had little or no experience of carving in marble since the 1530s, given that his more recent works had been predominately in bronze. Consequently, his lack of relish for the sculptor's tools was understandable as was his tendency to delegate authority to his assistants and pupils. Sansovino had extensive experience of running a large sculptural practice from his work on the Library and Loggetta as well as his work for private clients. Other than those projects of the procurators, for which he served as *proto*, Sansovino would not have been able to supervise personally the many palaces and tombs which he designed. Therefore, he had to adopt a system of delegating powers to trusted assistants, persons trained under himself and capable of following his lead. In this way, Sansovino's policy for his private architectural and sculptural commissions was broadly analogous: he furnished a design or *modello* which was then handed over to others for completion. This was very much the way in which a large artist's shop was conducted, and in Sansovino's case one can see an obvious parallel with Raphael's studio, where a highly sophisticated division of labour operated.[34]

The choice of Istrian stone as the medium for the statue also deserves comment. It indicates how much Sansovino had accommodated himself to Venetian practices by this date, as the porous white stone from Capo d'Istria in modern-day Yugoslavia was the standard building

material in Venice. Its plentifulness and availability in blocks of almost any size commended Istrian stone to Sansovino for his architectural practice, but it was as well frequently used for sculpture where it could be polished to glow like marble.[35]

The delays and excuses did not seem to have bothered Ercole II, who may not have been an exacting patron. In any case, he would have been familiar with such procedures from his experience of other artists, not to mention the difficulties experienced by his father Alfonso in obtaining a work from Raphael or Michelangelo.[36] His reply to Feruffino directed his agent to approach Grimani for the stone and even allowed for the statue to be made in two pieces if that would facilitate matters. Vettor Grimani gave the duke a block of stone as a gift, possibly in recognition of a favour to his sister by Ercole some years before.[37] Meanwhile, Sansovino finished the model for the statue by 2 November 1550, when Feruffino inspected it.[38] This model may have been a large-scale gesso, because Feruffino adds that Sansovino would finish polishing the model within a week; he also notes that the sculptor would go to San Francesco della Vigna in order to select one of the larger blocks from those owned by Grimani.[38] Sansovino further promised to have the block sent to his studio and to begin work on blocking out the figure within fifteen days. The whole project would then be completed within five months.

This was a promising beginning, and in June 1551 Sansovino told the inquisitive Feruffino that three of his assistants were working steadily on the figure and that it would be finished by August.[40] When August did come, Sansovino asked for an advance of 25 ducats to pay his assistants, which he received in September. Sansovino's bad health then interrupted work, and the project was still unfinished at the end of the year.[41]

By April 1552 the duke's patience was wearing thin, and he was also receiving reports that the statue was not turning out as well as he might have hoped. In view of this, he instructed Feruffino to inspect the statue in the company of Alessandro Vittoria.[42] In selecting Vittoria as his expert, the duke made a tactical error, for he had chosen one of Sansovino's most gifted pupils but one with whom Sansovino had quarrelled spectacularly some two years before.[43] When Feruffino attempted to gain entry to Sansovino's studio with Vittoria and a painter identified as Isepo Vicentino, the sculptor was unavailable and no one of his household could find the key to the room that housed the statue.[44] Unsuccessful in their mission, the three men departed, but Sansovino sent a message to Feruffino that evening, saying that he would not allow the Ferrarese agent to visit his studio in the company of his former pupil. He also added, rather tartly, that if the duke wanted an outside opinion, he should send to Florence for Baccio Bandinelli or to Rome for Ammannati.[45] Feruffino relates that the painter Vicentino had heard that the statue was so bad that Sansovino was seriously considering carving another with the help of those more skilled than he in the study of the nude.[46] Emboldened by what he had heard, Feruffino reported his own criticism of the statue, which he had put to Sansovino three or four months earlier. He felt that the legs and thighs of the statue did not agree with the overall dimensions of the body, to which defects Sansovino had reluctantly admitted.

Vittoria meanwhile returned to Vicenza where he was at work on the stucco decorations to Palazzo Thiene.[47] By the end of May he informed the duke that his own model for a statue of Hercules was complete and that he would welcome comparison between his work and Sansovino's.[48] However, there was a cessation of hostilities between master and former pupil and the competition did not go any further. Vittoria dropped plans for the projected statue and closed ranks with Sansovino; possibly Sansovino bought off his potential adversary by offering Vittoria the chance to carve the over-life-sized *feminoni* for the Library's entrance, two works that Vittoria completed in 1553.[49] Feruffino's reports were not unaffected by this reversal of alliances, and his comments on the statue became more optimistic in 1553. That January, Sansovino promised to finish and polish the statue within twenty days; two months later, Feruffino approached the sculptor again, only to be told that work would be completed within a dozen or so days. The same promise was given in April, and finally the agent wrote

to Ferrara with news of the statue's completion in June 1553, almost three years after the fashioning of Sansovino's model.[50]

The rest of the statue's history fills only a few lines. After a delay over payment of export duty, the duke was allowed to ship the figure by August. It went first to Francolino by water and then up the Po to its new destination of Brescello. The town of Brescello was a strategic centre of some importance on the frontier of the Este duchy, 'borrowed' by Imperial forces in 1551 and only recently returned to Ercole II.[51] Brescello was given new fortifications and briefly struck its owner's fancy as a possible site for urban development. Hence, Sansovino's statue was designated the prinicipal ornament of its chief square. Toppled from its pedestal by French troops in 1704, the statue was re-erected with an inscription by Muratori in 1727. Its earlier history was by then forgotten, and Sansovino's *Hercules* had the honour of being taken for the work of an ancient Greek.[52]

Sansovino's *Hercules* stood until recently in the centre of Brescello on a plinth of classical inspiration (figs. 301–02). It is an over-life-sized figure of Istrian stone, showing the god with his customary attributes of club and lionskin. Its torso of bulging muscles bears a generalized resemblance to antique statues of Hercules that Sansovino would have known. In basic design, the *Hercules* invites comparison with the statue of *Commodus as Hercules* discovered in 1507 and purchased by Pope Julius II for his collection of statues in the Belvedere.[53] From it, Sansovino adapted the type of the head with short, curly hair and fillet as well as the pose of the right arm and club, which define the statue's flank, and the block-like torso. Sansovino did not follow the Polykleitean *contrapposto* of the *Commodus*, nor does his figure extend its left arm; these decisions may have been forced upon the sculptor by the narrowness of his original block, if the dimensions of the base are anything to go by.[54] The upturned head and raised left shoulder may also recall the *Pasquino* that had been set up near Piazza Navona in 1501.[55] Modern precedents were equally important for the formation of Sansovino's statue, particularly in Florentine sculpture. The *Hercules* especially recalls the formula used by Donatello in his *St Mark* or *St George* for Or San Michele (figs. 52, 217), works in which the figure is posed with the right shoulder pulled slightly back, the left leg bent at the knee, and the left arm extended across the torso. Sansovino may have been encouraged to cast his statue in a Quattrocentesque mould by having seen the recently completed *Hercules and Cacus* of Baccio Bandinelli during his Florentine visit of 1540 (fig. 305), but the slight resemblance between the two statues may be explained more by the recourse to a common tradition than to Sansovino's having borrowed from Bandinelli's work.[56] If anything, Sansovino's *Hercules* adheres more closely to traditional Florentine sculpture by virtue of its long torso and short legs (fig. 301).[57] This was the criticism made by the Ferrarese agent when he saw the statue in Sansovino's studio, but it may be that Sansovino deliberately made his figure in this fashion, just as Donatello had done with the *St Mark*, in order to take into account viewing from below.[58]

When seen from nearby, the statue does confirm Feruffino's suspicions, for it seems like nothing so much as an ill-assorted assemblage of parts: the legs and thighs are definitely too thin for the bulk of the torso while the torso's girth has been heightened by the exaggerated musculature of the figure's arms, the under-sized head, and the absence of a neck. Though many of these faults are mitigated when the statue is seen from some distance (fig. 302), Sansovino does seem guilty of miscalculations in his final model. This is evident if one compares the *Hercules* with other figures by Sansovino on a smaller scale, such as the two men on the left of the *Maiden Carilla* relief (fig. 263).[59] In all three cases, an elongated torso is placed on under-sized legs; a comparison between the *Hercules* and the old man is especially instructive. Both seem to be based on the same Hellenistic torso with exaggerated muscula-ture, squat neck, and small, classicizing head. While this formula is not disconcerting on the smaller panel of relief sculpture, it does look somewhat comical on the *Hercules*.

The failure of Sansovino's *Hercules* as an effective piece of colossal sculpture may be

attributed to Sansovino's inability, in this case, to translate his personal idiom to such a scale. Though there may have been technical problems, such as the dimensions of the block of Istrian stone, the basic concept is timid, the result, bland. The *Hercules* also bears out the criticism reported in one of Feruffino's letters and commonly shared by connoisseurs of sculpture that Sansovino lacked a sufficient command of human anatomy to create a plausible, giant nude.[60] Feruffino's passing remark is a revealing one, both in terms of contemporary judgement of Sansovino's work and in terms of the shortcomings of his colossal sculptures. Sansovino's most successful nude figures, his *Bacchus* and *Apollo*, are both under-life-sized while his most imposing large-scale works, the two *St Jameses*, are draped. When required to carve colossal nudes, Sansovino showed some inadequacy in creating convincing figures such as Michelangelo or Bandinelli or Giambologna could create. Beyond that, Sansovino clearly put little effort into the work, despite his protestations to the duke's agent. He may well have felt that the duke simply wanted a piece of decorative statuary for a city gate, a work that would never be seen from close at hand. In defence of Sansovino, it is worth noting that Ercole II did not object to the use of assistants in the enterprise and even suggested having the statue made in two pieces. The Duke of Ferrara simply wanted something in a hurry, and what he thought of the final result is not recorded.[61]

But Sansovino was not alone in this deficiency, and his incomplete mastery of anatomy can be paralleled in large-scale works like Bandinelli's *Adam* and *Eve* or Cellini's *Perseus*. Bandinelli's biblical pair show defects comparable to Sansovino's *Hercules* in that they have the appearance of small-scale models enlarged unsuccessfully.[62] This is more evident with *Eve*, whose torso, breasts, and limbs combine awkwardly, whereas Adam's etiolated proportions sit more easily on his frame. Similar criticisms were levelled against the *Perseus*, and one contemporary wrote a mocking poem describing the statue as having the torso of an old man with the legs of a young girl.[63] There is much truth in this observation, and a comparison of the small bronze *modello* with the finished work makes the latter's miscalculations more apparent.

Changes in scale from model to finished work introduced problems into the creation of life-sized or larger statuary, problems which many Renaissance artists underestimated. Their oversight may have stemmed, in part, from their education. When Raphael in his letter on the *Galatea* or Vasari in his *Vite* speak of combining the best features from a variety of figures in order to make one beautiful one, they were not merely paraphrasing classical tags; instead, they were referring to a method of learning by copying which held sway in artistic education for centuries.[64] By studying and selecting the most admired classical and modern figures, by assimilating and reproducing their components in his own work, the young artist could be reasonably assured of a sympathetic reception. A pictorial analogue to Vasari's remarks in the *Vite* can be seen in *Zeuxis painting the Maidens of Agrigento*, which Vasari painted in his houses in Arezzo and Florence (fig. 318).[65] The story, which comes from Pliny, is similar to the more celebrated one of Zeuxis and the maidens of Croton, but in this instance the Greek painter selected five women of Agrigento to model for a painting of Diana of Ephesus. As a concept, this theory of creating figures by the manipulation of parts had a strong hold on the imagination of Renaissance and later artists, even though some, like Bernini, ridiculed it.[66] Its advantages lay in a good grounding in figural design and, by extension, composition, but its disadvantages pointed in the direction of a mechanical repetition of types and an unhappy combination of elements that did not cohere. While such difficiencies could be masked in painting, with sculpture, particularly on the scale of life or over, the fissures in the system could become glaringly obvious.

Whatever doubts others may have entertained about Sansovino as a sculptor of colossi, his own self-confidence was apparently unruffled by the episode of the *Hercules*. A little less than a year after the dispatch of that statue to Brescello, Sansovino had agreed to carve two more *giganti*, this time for the Doge's Palace. It proved to be his last major commission for the

Venetian state and one which ended in considerable financial loss for Sansovino and his family.[67]

The episode began on 31 July 1554, when an agreement was drawn up between Sansovino and the three noblemen who served as overseers of the fabric of the Doge's Palace, Mafio Venier, Antonio Capello, and Giulio Contarini.[68] They commissioned Sansovino to carve two *giganti* from two blocks of stone some ten Venetian feet in length.[69] The stone had been designated for the decoration of the doge's apartments, but it was decided to use them for sculpture, in whatever part of the palace was deemed appropriate. The agreement paid fulsome tribute to Sansovino, who pledged to finish the statues within one year for the sum of 250 ducats. Sansovino was to receive 15 ducats a month on account, beginning the next month, August, and the balance would be paid him upon completion.

Sansovino was, of course, the obvious choice for such a commission. His projects in the Piazza had already changed the face of Venice's chief square, and he was subsequently to be given the commission to design the Fabbriche Nuove at Rialto, the tomb of Doge Francesco Venier, and the Scala d'Oro of the Doge's Palace.[70] Another point in his favour was the presence of the procurator Antonio Capello among the overseers of the ducal palace and on the committee to choose a model for the new building at Rialto. Moreover, Capello served as one of the electors of Doge Venier in 1554 and was on terms of familiarity with him.[71] The presence of such a consistent supporter of Sansovino's on the board of overseers for the palace would certainly have helped him win the commission for the *giganti*, not to mention the tomb of Doge Venier. And Sansovino's successes of the 1540s played no small part in maintaining the momentum of his career well into the 1550s.

The contract does not mention a specific location for the *giganti*, but the probable intended site was the ceremonial staircase to which the statues eventually gave their name (figs. 306, 308). Francesco Venier's arms appear above the central arch at the top of the stairs (fig. 307), a gesture that may have anticipated the arrival of the *giganti* as part of the same decorative scheme that later included the Scala d'Oro. This conclusion is reinforced by the presence of a reference to the statues' site in the 1561 edition of Francesco Sansovino's *Delle cose notabili*: 'you will soon see two giants of marble which must be carried to the staircase in the courtyard of the Palazzo'.[72]

The idea for a ceremonial staircase with symbolic figures was not entirely new to Venice. The Louvre sketchbook of Jacopo Bellini contains a folio of a palace, reminiscent of the Doge's Palace, with an imposing staircase and balcony, the latter decorated with large figures (fig. 309).[73] Whether Bellini's drawing represents an actual staircase or a more fanciful project is moot, for whatever staircase there may have been in the Doge's Palace would have been swept away by the fire of 1483. This led to the rebuilding of the eastern wing of the palace under the Veronese architect Antonio Rizzo, and it was he who conceived the splendid marble structure with *niello* decorations leading from the Arco Foscari to the new portion of the palace. The genesis of the staircase can be traced back at least to 1485 when it was decided that each new doge would receive his cap and say his oath 'in Palatium redierit super scallas illius ad accipiendum iuramentum a Dominio'.[74] Rizzo's staircase, like Michelangelo's later staircase to the Laurentian Library, was conceived as a monument in its own right as much as a necessary transition from the shallow courtyard to the upper floors of the palace. It is in the tradition of free-standing staircases for public palaces in Central Italy, such as the Palazzo dei Consoli, Gubbio, or the Palazzo dei Priori, Perugia, but is distinctive for its elaborate and obscure decorative programme.[75] Rizzo probably thought of the staircase as complete within itself, and certainly there was no attempt to embellish it with statues before Sansovino's time.[76]

The decision to commission two *giganti* for the staircase must reflect the taste of mid-sixteenth-century Italians for such sculpture. A nobleman like Capello would have been aware of the role colossal sculpture played in the restoration of the Capitoline Hill or could

have seen the *giganti* before the Palazzo Vecchio in Florence or Ammannati's *Hercules* in Padua. Sansovino obviously shared the enthusiasm for colossi; he had admired the work of Ammannati, and had just finished the *Hercules* for the Duke of Ferrara. Consequently, the preferences of Sansovino and his patrons were one and the same in the kind of sculpture necessary for the Doge's Palace.

Where the Florentines chose David and Hercules as emblems of their state, the Venetians chose Mars and Neptune to embody the fact that 'these our lords are masters of the sea in the affairs of war'.[77] These were almost inescapable choices, especially as the sculpture would have been conceived with respect to the staircase, which marked the spot where the doge was crowned and the entrance to the state chambers of the palace. The selection of mythological as opposed to purely allegorical figures also made sense in view of the recent precedents of the standard bases and the Loggetta bronzes, which registered a preference for celebrating the 'myth of Venice' in a classical vein.[78] There was also a precedent for the coupling of Mars and Neptune on the monument of the Venetian Captain General Benedetto Pesaro in the Frari (fig. 271). On that monument, the nude figures of the gods were a clear reference to Pesaro's military career and to the struggle to maintain the Republic's maritime possessions. Neptune also figured in the iconography of Leopardi's standard bases and Sansovino's Loggetta, but perhaps the most important precedent was the inclusion of Mars and Neptune among the statues carved by Pietro da Salò and other members of Sansovino's circle for the *finestrone* on the Piazzetta side of the Doge's Palace.[79]

So there was nothing unexpected about the choice of figures carved by Sansovino's shop, nor can one say that the final result is unexpected in terms of Sansovino's *oeuvre*. As with the *Hercules* of Brescello, the *giganti* draw less upon specific antique prototypes than upon a generalized impression of classical statues through motifs such as heroic torsos, a classical helmet for Mars, and a head reminiscent of a river god for Neptune. The explanation for this is not hard to fathom: classical statues of Mars and Neptune were thin on the ground in the early sixteenth century. In Rome there was a colossal statue of Mars, now in the Capitoline Museum, that Heemskerk and Hollanda drew.[80] Sansovino would have known the statue of *Neptune with Triton* in the Della Valle collection and analogous works like the *Marforio*, now on the Capitoline Hill.[81] Yet Sansovino followed none of these types but turned to more modern masters for his inspiration.

Mars (fig. 314) represents Sansovino's most undisguised tribute to Donatello's *St George* (fig. 211), a work he had previously employed for the *Pallas* of the Loggetta (fig. 210) and, possibly, for the alert pose of the *Hercules* (fig. 302). Sansovino, like his fellow-sculptor Bandinelli or the writer Francesco Bocchi, found the *St George* a quintessential embodiment of valour, a work which was the equal of any ancient statue.[82] From the *St George*, Sansovino took the basic stance of his *Mars*, the left leg forward and the right drawn back; where the left hand of St George is brought forward to support a shield, Mars employs this gesture simply to cover his private parts. For the facial type of his *Mars*, Sansovino drew upon his own repertoire, and heads similar to Mars's can be found in the *Maiden Carilla* relief or the bronze reliefs in San Marco.[83] Together with the *Minerva*, the *Mars* illustrates the rather superficial use of classical sculpture by Sansovino as well as his readiness to employ modern 'classics' to fill the gap in his knowledge of ancient ones.

With *Neptune*, the relationship with antiquity is more complex. The pose may owe something to a statue formerly in the Grimani collection and now in the Museo Archeologico of Venice (fig. 316). The statue was believed to represent Augustus's admiral, Vipsanius Agrippa, and shows him as a heroic nude, his weight resting on his right leg, his right arm slightly raised, his left leg bent back at the knee, and his left arm parallel to the flank of his torso.[84] The figure was identified as the statue of Agrippa in the guise of Neptune that had once stood under the portico of the Pantheon. The inscription on the statue's plinth discloses that the figure was part of the collection of antiquities assembled in Rome by Cardinal

Domenico Grimani; when the bulk of the Grimani collection was finally made over to the Republic in 1593, the *Agrippa* and a statue of Augustus remained at the Grimani Palace of Santa Maria Formosa until 1864 when the *Agrippa* became part of the collection of the Museo Archeologico. As a creature of the Grimani family, Sansovino undoubtedly knew the *Agrippa* and may well have advised on its restoration, which was probably undertaken in the sixteenth century as was the case with many of the Grimani sculptures.[85] Whether Sansovino's *Neptune* preceded the restoration of the *Agrippa* is conjectural, but that is not, in any case, crucial. Sansovino would have known the head and torso of the *Agrippa*, and from that, he could have drawn his own conclusions as to the original appearance of the sculpture. Certainly, the similarity between the two statues is notable: in both figures, the legs are placed on the diagonal while the left arm is parallel to the torso and grasps the tail of a dolphin. Where the right arm of the *Agrippa* extends forwards dynamically, the pose of Sansovino's *Neptune* is more constricted and must be the result of a narrow block of marble.

It may well be that the *Neptune* does have a clearer connection with classical sculpture than does the *Mars*, but the head of Neptune does not appear to have been inspired by an antique river god or similar figure. Rather, Sansovino has adapted the head of the Donatellesque *St Jerome* in Faenza (fig. 312), which also served as the basis for his bronze *St John the Evangelist* in San Marco (fig. 184).[86] Like the reference to the *St George* for *Mars*, the citation from Donatello or his imitator for the head of Neptune is instructive, for it shows that Sansovino thought of his sculptures in terms of types or models. Whereas the *St George* embodied a martial spirit that could be transformed into the god of war, the *St Jerome* of Faenza conjured up the image of a resolute old man, appropriate for the character of the god of the sea. Sansovino's employment of physiognomic types was consistent with contemporary theories on the relationship between personality and appearance, and he made his Neptune even more emphatically leonine than his model of *St Jerome*, possibly to suggest the martial symbol of Venice, the lion of St Mark.[87] Such an explanation for the head of Neptune is confirmed through the presence of Neptune with the lion of St Mark on Veronese's ceiling for the Collegio of the Doge's Palace; there, the similarity between the two figures is pointedly brought out through their juxtaposition (fig. 315).[88]

Mars and *Neptune* were obviously planned as a pair, their feet placed widely apart and their heads, arms, and bodies turned at complementary angles (fig. 307). Their relationship can be seen as a variation on Sansovino's standard approach to *conversazioni* from the saints on the Nichesola monument to the bronzes of the Loggetta and the *Evangelists* in San Marco. Here, the complementary nature of the two figures extends as far as their torsos, which are articulated in virtually the same manner and are also reminiscent of the torso of the *Hercules* in Brescello (fig. 301). Possibly all three are based on the same antique prototype, something like the torsos of the *Dioscuri* on the Quirinal, which Sansovino would have known as a young man.[89] These similarities as well as the general likeness of all three figures lead one to believe that they drew upon a repository of forms and models within Sansovino's workshop, of which he speaks in his will of 1568.[90]

Like the *Hercules*, the *Mars* and *Neptune* called for assistants on an industrial scale, and the story preserved in the Venetian archives reflects many of the procedures and problems observed by the Ferrarese agent.[91] A great deal has been preserved concerning the *giganti* primarily because Francesco Sansovino petitioned the Senate in 1582 for reimbursement of his father's expenses. To support his claim, Francesco gathered a series of affadavits from several of the stonemasons and sculptors who worked for his father. This is one of the most interesting series of documents on sixteenth-century Italian sculpture, for it shows the kind of collaborative effort common to most large workshops of the period. It is also revealing of the role adopted by Francesco Sansovino, first as his father's secretary, then as his executor.[92]

Though the case went before the Senate only in 1582, material was being gathered as early as September 1567, when the Salt Magistracy sent questions to Florence concerning the work

of Francesco il Toccio on the *giganti*. The questions were drawn up at the instigation of Jacopo Sansovino and may reflect his own concern to reclaim money disbursed on the statues.[93] The points raised must have been the same ones put to the other collaborators, namely when were the *giganti* begun, who else worked on them, how long did the respondent spend on the sculptures, and what was he paid. Francesco il Toccio's replies are not kept, but another document produced by the Salt Magistracy gives his period of work as seven years at a standard rate of 29 soldi per day for a total of 300 ducats.[94] The other men who worked on the statues were all interviewed in 1572, presumably at the instigation of Francesco Sansovino. They were as follows: Domenico da Salò, son of Sansovino's former pupil Pietro; Domenico Bernardini; Battista quondam Bernardini; and Antonio Gallino of Padua. Their depositions tell us that Domenico da Salò spent three years on the statues and received 180 ducats; Domenico Bernardini worked only eight months at 30 soldi per day for 48 ducats; and Battista quondam Bernardini, the longest serving collaborator, worked continuously for five years and collected 360 ducats, more than anyone else. Battista also found two other men to work with him, Zuanne and Gasparo de Zorzi, who were also paid a standard rate of 30 soldi per day. Antonio Gallino was interviewed in Padua and gave the most expansive account of work on the *giganti*. He stated that he helped carve the *giganti* for a year while staying in Sansovino's household as a *garzone* or apprentice; afterwards, he spent another six months with Sansovino as an assistant at 34 soldi per day. Gallino also recorded the presence of Jacopo de' Medici as a *garzone* during that same period and the collaboration of Battista and Francesco il Toccio. Gallino further confirmed that the rhythm of work was not continuous but depended upon the pressure of other commitments upon the workshop. He thought the *giganti* were finished seven years after his time with Sansovino.

From these accounts, one can draw several conclusions about Sansovino's working procedure for the *giganti*. First, Sansovino employed at least nine men to carve the two statues, over and above any work he might have done himself. Although one cannot say how long Vittoria, Jacopo de' Medici, Zuanne, and Gasparo de Zorzi spent on the project, it is clear that work continued for about eleven years if not the twelve years declared by Francesco Sansovino.[95] Moreover, Sansovino seems never to have employed more than three or four at any one time, nor did the men work steadily on the project.[96] Most were paid the average daily wage of a stonemason, around 30 soldi, the same as Sansovino paid his earlier collaborators for the roughing out of the marble *Madonna and Child* in the Doge's Palace or the creation of the reliefs for the choir of San Marco.[97] It is clear that the commission passed through several hands in the course of more than a decade's work.

All of this corresponds to what is known of Sansovino's working process for much of his Venetian career. His shop always contained a number of projects on which work proceeded simultaneously. This was to Sansovino's advantage, as it meant that he could furnish his apprentices and younger assistants with a variety of work necessary to their training. It did, however, create a number of problems: projects tended to drag on, as the volume of work exceeded the available number of hands; this led to delays in final settlements for work already paid for; and, as several of the men called upon to testify on the *giganti* state, Sansovino spent a large amount of his own money in seeing the projects through to completion. Given that, it is not surprising that the *giganti* did take so long to be finished nor that Jacopo and Francesco Sansovino should both have been so concerned about gathering evidence to support their claim for additional compensation.

The *giganti* were finished by the end of 1566 and were installed by Antonio da Ponte, *proto* of the Salt Magistracy, in January 1567, at a cost of 326 lire and 16 soldi. This included the cost of removing the statues from Sansovino's workshop, having bases made for the statues, having a trident and lance made for the hands of Neptune and Mars, respectively, and erecting the statues at the summit of the staircase.[98] The relative haste and modest expenditure of the installation caused problems subsequently, when the statues' bases had to be replaced and

reinforced in the 1720s. Antonio Corradini, the sculptor entrusted with the restoration of the staircase and the *giganti*, urged the resiting of the statues because their location had weakened the staircase and they jarred with its style; he also proposed that the statues be shifted to the corners of the staircase so that they would not impede circulation in and out of the arcading of the palace. The new location would have had the advantage of positioning the *giganti* on the strongest part of the structure, the corner piers of the staircase.[99] Corradini's proposal, which also had the support of the then *proto*, Andrea Tirali, was rejected and the *giganti* remain where they were before restoration. Presumably, the lance and trident were not replaced at this time, nor was the loss of Neptune's hair made good, but the original make-shift bases for the statues were replaced by ones designed by Corradini, bearing the date 1728 and the name of the reigning doge, Alvise Mocenigo.[100]

The unsuitability of the *giganti*'s location has often been noted since Corradini's time, but it has been a problem without an obvious solution.[101] The contract of 1554 did not specify their intended location, employing the vague phrase 'dove meglio cascheranno'; yet the top of the staircase must have been selected before the death of Francesco Venier in 1556, as noted above. The site had the merit of bringing the figures into view as one entered the palace via the Arco Foscari on the main ceremonial axis of the building. In this way, too, the statues flanked the entrance to the palace in a manner analogous to the *giganti* by Michelangelo and Bandinelli before the Palazzo Vecchio of Florence or the colossal sculptures decorating the Capitoline Hill at Rome. But the disadvantages of the position were not given much consideration by da Ponte, who first erected the *Mars* and *Neptune*, nor by anyone else. As Corradini noted, the author of the staircase had to angle the line of the stairs because the entrances to the palace and the *portego* of the Arco Foscari were not aligned. The addition of Sansovino's statues simply drew attention to this conflict, Moreover, the first view of the statues which the visitor receives is of their legs, the rest of the figures only gradually being revealed as one approaches the foot of the stairs.[102] The explanation for the decision to keep the statues where they were placed by da Ponte may have been the result of the conservative bias of the Senate and the feeling that any other position would weaken the impact of the *giganti*. In a sense, the Senators were probably right, and the criticisms of Corradini and others were overly subtle for the requirements of the statues.

The approach of Sansovino and his patrons to the *giganti* has been well defined by Jacob Burckhardt, who wrote of them:

> The disadvantages of the pose, at least when viewed straight on, prejudices their attractive qualities, which are appreciable when compared to the trivialities of a Bandinelli. Above all, these are works without pretension, created with faith, without violent movements or exaggerated musculature, true works of the Renaissance; the types, if not perfect, are at least original, and by an artist capable even of sustaining defective motifs with the grandeur of his design.[103]

Burckhardt here touched upon the essential worth of the statues by praising their decorative value, which goes some way towards compensating for their imperfect poses. *Mars* and *Neptune* were conceived as ornaments for the stairs and façade of the Doge's Palace. A violent or exaggerated pose would have detracted from the ceremonial played out beneath them. Sansovino thus had to strike a balance between the decorous and the heroic, something he broadly managed to achieve. While the duplication of pose neutralizes some of their individual impact, the *giganti* do convey a suggestion of potential energy; they look menacing without drawing too much attention to themselves. This is more the case with the leonine head of Neptune, for the features of Mars are too understated to register (figs. 311, 314).

It has been said that the failure of Francesco Sansovino's claim for compensation stemmed from governmental displeasure with the *giganti*.[104] The truth, however, had little to do with aesthetics, which does not seem to have entered into the debate, but it had much to do with

economics. Francesco Sansovino made himself extremely unpopular with the Venetian government by pressing several claims for compensation against the procurators and the Salt Magistracy. His cases against the procurators put his father's former employers in a bad light and led to a large cash payment for the Sacristy door and the return of the marble *Virgin and Child with Angels*.[105] The decision not to compensate Francesco for the *giganti* was probably a simple case of retaliation by the Venetian ruling class against someone whom they regarded as a tiresome pest. Francesco's motives may have reflected concern for his own inheritance, but one can also point to his court cases as a reflection of his concern for the value of his father's work and the esteem in which it was held, also manifest in his secretarial assistance to Jacopo and in his writings about his father's work.

Were it not for Francesco's lawsuits, we would be much the poorer in our understanding of how his father ran his workshop. These documents and the letters concerning the *Hercules* in Brescello show that Sansovino's role generally ended with the making of models, which could then be turned over for an almost industrialized execution by his assistants. Whether or how much Sansovino would carve is a moot point, but, knowing the demands placed on his time by the duties of *proto* of San Marco, it must have been very little. Yet the intervention of his shop does not appear to have troubled Sansovino's patrons; they knew the situation and were content to have something designed by the artist and executed by his shop. In the case of over-life-sized sculpture, questions of autography would have been even more out of place.

This was a well-recognized feature of sculptural workshops of the period. Bandinelli justifies his use of a large workshop by pointing to the practice of Ghiberti and Donatello; only thus, he told Cosimo I de' Medici, could the great sculptors of the Quattrocento have completed their *oeuvres*.[106] Sansovino, who received his training in that same tradition, would probably have said much the same if challenged. Among those who collaborated on the *giganti*, Antonio Gallino and Jacopo de' Medici both worked on the statues as *garzoni* while others, like Domenico da Salò and Francesco il Toccio, may have started on them as *garzoni* before becoming journeymen; the others seem to have been brought in for various periods when the pressure of other work dictated this.[107]

The demands imposed by colossal sculpture were greater than those made by the generality of Sansovino's Venetian projects. It required a virtuoso combination of talents to solve the problems of design and stress as well as the related questions of perspective, proportion, and optical effects. It was with the problem of scale that Sansovino seemed to have most difficulty. His younger contemporary Vincenzo de' Rossi once acknowledged that the quality of design achieved in a small model was not always present in the finished work.[108] Clearly Sansovino would have sympathized with this observation. His *Hercules* suffers from a timidity of conception and miscalculation in the relationship of its parts that is distracting on a large scale. On the other hand, his *Mars* and *Neptune* are much more successful both as a pair and individually. This is especially true of *Neptune* when viewed from the staircase below: despite the constraints of its block, the figure admirably conveys a sense of authority and raw power appropriate to the god of the sea (figs. 310–11). Such figures did not come as easily to Jacopo as they did to Michelangelo or Giambologna. His achievements here can best be compared, as Burckhardt did, with those of Bandinelli, since both sculptors remained truer to the traditions of Quattrocento figures of this type than did Michelangelo or Giambologna.

Although the *giganti* do not rank among Sansovino's greatest works, they still exerted an influence over Venetian artists. Borghini wrote of Tintoretto's study of the *giganti* as complementary to his drawings after the figures from the Medici chapel.[109] One cannot now point to specific drawings that show Tintoretto employing figures like the *giganti*, but Borghini's statement is consonant with what is known of the artist's study of sculpture in general. It may well be that Borghini was referring broadly to Jacopo Sansovino's influence on the younger generation of Venetian artists, like Veronese and Vittoria as well as Tintoretto. Certainly the most direct copies of Sansovino's statues can be found in Veronese's

ceilings for the Doge's Palace. In the ceiling of the Sala del Collegio, Veronese created a panel of Mars and Neptune in which Mars is a warrior in the artist's own style while Neptune is very much in the mould of Sansovino's colossal figures (fig. 315). The same pairing of Mars and Neptune can be seen in Veronese's *Apotheosis of Venice* on the ceiling of the Maggior Consiglio; there the two gods serve a decorative purpose analogous to that performed by the *giganti* on the stairs of the palace and resemble their prototypes closely.[110]

Whether Sansovino could not or would not attempt more dramatic poses for his colossi cannot be stated with certainty. What should be stated, however, is that the *giganti* do not embody a change in their creator's sculptural style after 1550 as has been suggested.[111] Their peculiar features can be better ascribed to the demands imposed by scale and to the decorum of subject matter rather than to a putative 'late style' of Sansovino's. Colossal figures were, by definition, monumental and belonged to a genus of Renaissance sculpture as distinct as either small bronzes or relief sculpture. What one can say about Sansovino's venture into this field is that it demonstrates an approach comparable to that of his other Venetian sculpture. His *giganti* show that same reliance upon proven formulae, that same mixture of the classical and the Quattrocentesque found in the Loggetta bronzes or the *Maiden Carilla* relief or the *St John the Baptist* in the Frari. Their histories demonstrate Sansovino's reliance upon a team of assistants and his customary habit of leaving the completion to his shop after the initial model was made, and this, too, is consistent with what is known of the creation of the bronze reliefs for San Marco or the marble *Virgin and Child with Angels* in the Doge's Palace. Sansovino does not appear to have made a secret of his working method, which was in any case common to any large sculptor's shop; by the same token, his patrons did not object to this procedure. The common interest of patron and sculptor alike lay in the technical problems posed by colossal sculpture and in their potent, if unsubtle, value as propaganda. As in many other instances, Sansovino here gave his masters exactly what they wanted.

X. Sansovino's Workshop and Assistants

THE PREVIOUS CHAPTERS have outlined the extent to which Sansovino delegated responsibility and collaborated on virtually every recorded work of his years in Venice. An examination of his use of assistants and collaborators is, consequently, an essential part of any study of his Venetian career, and it is inseparable from the broader question of his influence on later generations of Venetian sculptors. Though attempts have been made to place Sansovino and his followers within the contours of Venetian sculpture, these have primarily focused upon the question of attribution.[1] The approach essayed here will follow a different tack and look more at the evidence of whom Sansovino employed and when, drawing thereby some conclusions about the operation of his workshop and the shared responsibility for many of his commissions. The evidence will be interpreted in the light of what is known concerning workshop practice in general; attributions and general biography will feature less than in other studies of Venetian sculpture of this period because some figures mentioned in documents have little, if any, known artistic personality while others are major figures deserving a more detailed treatment, which will come in the final chapter on Sansovino and his School.

Sansovino's workshop must have been the largest centre of sculptural activity in mid-sixteenth-century Venice. Its existence enabled him to accept and execute a substantial number of commissions while maintaining a busy architectural practice and carrying out his permanent duties as *proto* of San Marco. When taken together, all three spheres of activity can be seen as reinforcing his dominance in Venetian sculpture and architecture. Sansovino's position as *proto* brought him several conspicuous assignments like the Loggetta and the Library, and these enabled him to employ a number of assistants for their sculptural decoration; his reputation as an artist produced the bonus of private commissions, which he could carry out thanks to the workshop system and to the policy of subcontracting that he exploited throughout his years in Venice.

Sansovino's early career indicates that collaboration was already a conspicuous feature of his working procedure even before Venice. He was in demand as a maker of models for other artists, like Nanni Unghero, Perugino, and Andrea del Sarto; he also supervised assistants like Tribolo or Benedetto da Rovezzano in the execution of his own designs. Occasionally Jacopo was on the receiving end of such relationships, as in the case of his putative collaboration with Michelangelo on the façade of San Lorenzo or subsequently on the tomb of the Duke of Sessa.[2] Sansovino's readiness to work with others was in sharp contrast to the behaviour of Michelangelo, for whom collaboration seemed to represent compromise with his artistic ideals. Sansovino's pragmatic approach to collaboration must have been more typical of sixteenth-century sculptors, and he would certainly have endorsed the explanation given by Bandinelli to Cosimo I on the need for assistance in sculptural projects:

a long experience of my craft has made me ask the assistance of two apprentices [*garzoni*], which is nothing in comparison with what would be necessary, and I gave Your Excellency the example of the door of San Giovanni [i.e., Ghiberti's doors], recalling that some who worked with Donatello told me that he always had eighteen or twenty apprentices in his workshop; otherwise he would never have completed the altar of Sant'Antonio in Padua and other works. In Rome, the historiated columns, each of which is the life work of twenty masters, show clearly that the design and composition came from one mind alone; nevertheless, the figures, being infinite in number, are carved in many styles, all good and lovely, because an able designer guided all those masters.[3]

Like Bandinelli, Sansovino had been trained in that same tradition of Florentine workshops and would have heard many of the same stories about the creation of Ghiberti's Baptistry doors and Donatello's bronzes for the Santo. He would also have experienced the system at first hand through his study under Andrea Sansovino and his acquaintance with other artists like Andrea della Robbia, Perugino, and Raphael.[4] Of all these experiences, observation of Raphael's Roman workshop with its highly sophisticated division of labour would probably have made the greatest impression upon Sansovino, and doubtless he kept it in mind when faced with a similar situation in Venice.

Whether Sansovino kept a large shop before coming to Venice is debatable, though the evidence suggests not. Vasari mentions only four pupils from Sansovino's Central Italian years, Tribolo, Solosmeo, and Pippo del Fabbro in Florence, Danese Cattaneo in Rome.[5] Neither the scale nor the number of his early commissions matched those he would acquire in Venice, and he probably kept a small *bottega*. When he arrived in Venice, Sansovino found a situation unlike that he would have known in Florence or Rome, namely the existence of large dynastic workshops of stonemasons which were run on an industrial scale. The great age of such workshops had come in the latter half of the fifteenth century with the rebuilding of several churches and the eastern wing of the Doge's Palace and the creation of the first Renaissance palaces and monumental tombs.[6] In 1496 Pietro Lombardo could tell the Marquis of Mantua that he had twenty-five men in his employ, and the demands placed upon his time and that of competitors like Antonio Rizzo lend credence to his statement.[7] While Sansovino never had that many helpers, he could call upon an extended network of apprentices, journeymen, protégés, and specialists to create what Vasari aptly termed a 'sculptural seminary'.[8]

Sansovino was fortunate, not only in the choice of Venice as his adopted city, but also in his timing. By 1530 most of the Lombardo school had passed from the scene: Pietro died in 1515 and his son Antonio the year after; Tullio would die in 1532. The only conspicuous younger member of their school, Gian Maria Mosca, quit Venice for Poland around 1530. Consequently, the competition was minimal, and Sansovino effectively filled an artistic vacuum.

Sansovino probably established a sculptural workshop soon after his arrival in Venice, as he had a number of projects under way by the early 1530s. Whether he became involved with the Venetian guild of stonemasons or Scuola di Tagliapietra is not recorded. The guild regulated the number of apprentices and journeymen that could be employed by a *bottega*; it sought to maintain standards through tests of ability and to protect its members' interests by lobbying the government over 'foreign' competition and other matters.[9] Though the guild seems to have been ineffectual in most instances—the repeated passing of the same resolutions implies as much—its statutes reflect upon the nature of Venetian sculptors' studios and convey an approximate idea of the situation within Sansovino's shop.

Most Venetian *botteghe* were run as family affairs with fathers, sons, uncles, and cousins employed. Children were apprenticed for five to eight years and had to be registered with the Giustizia Vecchia, the magistracy responsible for the guilds.[10] Though no records for apprenticeships survive before 1575, the agreements drawn up between Sansovino and his

garzoni would not have differed substantially from those found in the account books of Alessandro Vittoria.[11] Generally the master agreed to pay his apprentice a small wage, which rose over the course of the period of apprenticeship, as well as provide room, board, and sometimes clothing. In return, the apprentice would perform menial tasks within the shop while gradually becoming initiated in a given art. In Venice, apprenticeship as a stonemason ended with the passing of a *prova*, a test of skill, or by having worked at the trade for a sufficient number of years. Masters were of two kinds: *lavoranti* or journeymen, who worked for other masters and had one apprentice or assistant; and *patroni*, who ran larger shops with three apprentices and a number of *lavoranti*.[12]

From his arrival in Venice, Sansovino functioned in the manner of a *patrono*, drawing upon several assistants. Among them would have been Danese Cattaneo, who probably followed Sansovino from Rome to Venice, and possibly Bartolomeo Ammannati.[13] They may have been available to Sansovino for such early Venetian projects as the tomb of Galesio Nichesola (fig. 85).[14] Another early assistant or perhaps pupil may have been Giuliano da Firenze. He was employed by the *massari* of the Arca del Santo for the execution of the perspective reliefs of the chapel of St Anthony from 1529 to 1532, during which time he travelled from Padua to Venice for consultations with Sansovino on his work for the chapel; he may also be the same 'mistro Giuliano taglia pietra' employed by Sansovino in San Marco during 1536–37.[15]

Sansovino's activity in his first Venetian years cannot be plotted with any great accuracy, but the growth of his shop and commissions are better known from 1530 onwards. That year saw the execution of the earliest documented work in which the names of his collaborators are known, the Merceria portal of San Salvatore (fig. 409).[16] This had been commissioned by the Venetian patrician Girolamo Priuli and executed by Sansovino with the help of Cattaneo and a Venetian sculptor named Jacopo Fantoni, also called Jacopo Colonna. Francesco Sansovino describes Fantoni as a pupil of his father and gives a detailed account of his works in his 1581 guidebook to Venice.[17] He also states that the statuettes of *St Jerome* and *St Lawrence* which Cattaneo and Fantoni executed for the portal of San Salvatore were done in competition (figs. 410–11). Francesco's words place Fantoni among the first of his father's Venetian followers, and the statuettes are among the earliest known works by either man. Both statuettes clearly reflect Sansovinesque prototypes, and it is likely that in this case, as earlier with Nanni Unghero and Tribolo, Sansovino furnished the models from which the younger sculptors worked. Thus the procedure by which so many of Sansovino's Venetian projects were executed is apparent from the first years of his Venetian period.

Surveying the pattern of Sansovino's sculptural activities from 1530 onwards, one can say that his practice was run along industrial lines. This was probably true of any large artistic workshop where specialization would have been encouraged by the volume of work.[18] In Sansovino's case, the reasons are not hard to fathom: the constant pressure of work for the procuracy *de supra* on San Marco and other properties as well as the numerous public and private commissions could only have been accomplished by a disciplined and highly sophisticated division of labour, one in which Sansovino's powers were concentrated on the most important stages in the creation of sculpture. In each case, whether the end result was in marble or bronze or even *papier mâché*, the first step would be the making of a sketch model or *bozzetto* in wax, clay, or stucco (fig. 319).[19] The employment of small models began in the fifteenth century and was common practice by Sansovino's day. Sansovino favoured clay for his models, though he occasionally used wax or plaster. Once he had established a definite design on a small scale, he could turn over the enlargement of the model to assistants. This was done by making a wooden frame for the size of the finished statue and with its limbs placed in the same attitudes as the small model. The wooden armature was then covered with hay or tow and invested with clay or plaster; once the full-scale model was finished, it was placed next to the block of marble and measurements were transferred from the model to the marble by means of a carpenter's square, plumb lines, and a pointed stick (fig. 317).[20]

The stages in the creation of a full-scale model entailed a mechanical process for which the continuous presence of the sculptor was unnecessary. Similarly, the early stages in the carving of marble were often turned over to specialist stonemasons called *squadratori*.[21] They began the roughing out and blocking out of figures, and their work was succeeded by other assistants carving with a series of claw-chisels of increasing fineness. In the later stages of carving, the master would return to the work, either going over the surface in general or concentrating on important features such as the face. Sansovino describes a comparable procedure in a letter to the Duke of Ferrara in 1550, and one can find similar examples in the accounts of Sansovino's pupil Alessandro Vittoria.[22] Marble carving was, after all, a demanding job in terms of time and energy, and the older Sansovino grew, the more he relied upon delegating the process of carving to others.

By the same token, Sansovino's exploitation of media such as bronze and *cartapesta* in his Venetian career was influenced by the need to conserve his energy and by the success with which his models could be mechanically reproduced. One can draw a parallel here with the practice of Donatello, who virtually abandoned marble carving for work in bronze after the age of fifty.[23] Certainly Sansovino's most notable sculptural achievements in Venice were in modelling rather than carving. For his bronzes, a standard pattern emerges from the documentary records. After the definitive clay model had been fired, a gesso piece-mould would be made and a wax cast would be taken from it. At this stage, cleaning and alterations could be made, and here Sansovino would intervene, working directly in the wax and supervising his assistants. The wax cast would then be handed over to a professional founder for casting in bronze in the *cire perdue* or lost-wax method.[24] The final cleaning and polishing would again be done in the sculptor's own studio. Even from such a brief outline of the process, one can see why bronze offered Sansovino an ideal medium for producing reliefs and statuettes with minimal effort beyond making the model; the later stages could be left to the workshop and the casting to a trained founder. Few sculptors were skilled in casting their own works.

How did Sansovino organize his shop? Records of his work for the procuracy *de supra* furnish the clearest indications of the delegation of labour. Through the dispute between Francesco Sansovino and the procurators over various commissions, some fragments of Jacopo's accounts from the 1530s and 1540s have been preserved. They are instructive on Sansovino's method of operation and upon his deployment of assistants on a variety of projects simultaneously. This is especially true of the pages from Sansovino's accounts of October 1536 to February 1537.[25] These consist of weekly disbursements by Sansovino for the restoration and embellishment of San Marco, including some to the Paduan artist Tiziano Minio for stucco decorations to accompany new mosaics in the atrium of the basilica, lead for cupolas, and so forth. There are as well some isolated payments for the fashioning of the first of the marble tribunes or *pergoli* (fig. 147) and a larger number for the marble *Virgin and Child with Angels* now in the Chiesetta of the Doge's Palace (fig. 121). Both projects involved the same assistant, Tommaso Lombardo. The payments show that Tommaso worked on the model, presumably full scale, of the *Virgin and Child* for one week, on the marble itself for seventeen weeks, and on the marble block and the first of the *pergoli* during one week. For ten weeks Tommaso was assisted in his work on the statue by one Luca *tagliapietra*, almost certainly to be identified with Luca Lancia.[26]

Some additional evidence for the history of the marble *Virgin and Child with Angels* comes in the lawsuit begun by Francesco Sansovino against the procurators in 1573.[27] Francesco argued that the statue was begun in 1536 with the approval of his father's employers and that Jacopo's assistants then began the process of blocking out the figure, to which the payments of 1536–37 refer. After this initial period of work, Francesco stated that the statue was worked over by his father and assistants for a number of years. The evidence allows one to reconstruct the early history of the project as follows: Sansovino first made a small model of the

sculpture, which was approved by the procurators, perhaps only verbally; this was then turned into a scaled model, to which the payment to Tommaso Lombardo must refer; then work on the marble block began, with the scaled model being used for measurements and pointing; when the block was roughed out, Sansovino supervised its gradual completion with the help of one or more assistants. This was the pattern that would be repeated in most of Sansovino's Venetian works over the next three decades.

Tommaso Lombardo was Sansovino's chief factotum from the mid-1530s to the mid-1540s, and his name occurs in connection with all the major documented projects of that period.[28] His wages and those of Luca's, as recorded in Sansovino's accounts for 1536–37, amount to approximately one lira a day, suggesting that they were employed as journeymen.[29] Nothing is known of Tommaso before his appearance in Sansovino's shop, though Vasari records that he came from Lugano and worked with Sansovino for many years. His surname and his place of origin indicate that Tommaso came from the large tribe of Ticinese stonemasons who migrated to Lombardy and the Veneto from the Middle Ages onwards. While at work on the marble *Virgin and Child with Angels*, Tommaso also played a prominent role in the creation of the first *pergolo* for the choir. He is recorded as having performed unspecified work on the *pergolo* itself, probably the carving of some of its marble decorations; two other men were also paid for work on it, one Zuane, who carved one of the small columns, and one Cipriano, who polished three of them.[30] While the marble frame was being made, the tribune's bronze reliefs were being manufactured. Again Tommaso and Luca were engaged on the panels, together with collaborators named Francesco, Alvise, Diego, Tiziano Minio, and Zuane Campanaro.

Our knowledge of the stages in creating the reliefs is amplified by two surviving terracotta models (figs. 129–31, 133).[31] This is the stage at which Sansovino's attention would have been most fully engaged by the project, and there is no reason to doubt the autograph status of the works. Probably these and others now lost were shown to the procurators of San Marco for approval before casting, and in some cases alterations or new models would have been made. After that, Sansovino turned over the rest of the procedure to his shop under the general supervision of Tommaso Lombardo. The payments for the first series of reliefs point to a demarcation along the lines of specialization: Tommaso, Luca, Alvise, Francesco, and Diego were paid for their involvement in the sculptural side; Tiziano Minio and Zuane Campanaro were paid 'per bronzo et loro fatiche', that is, for supplying and casting the bronze, receiving one-third of the total amount disbursed for their efforts.[32] This has led some scholars, notably Lorenzetti, to see Minio as having played a decisive role in the artistic creation of the reliefs, but such a conclusion is a misunderstanding of the process of casting bronze.[33] What the payments by Sansovino do suggest is that his own assistants prepared the piece-moulds and wax casts which were then turned over to Minio and Campanaro for translation into bronze. Like Donatello or his own pupil Alessandro Vittoria, Sansovino lacked the expertise for casting bronze and always relied upon professionals for his Venetian bronze sculpture.[34]

An identical process occurred between 1541 and 1544 for the second series of reliefs for the choir of San Marco, again with Tommaso Lombardo playing a prominent role.[35] Here the accounts do mention the fashioning of wax models by Tommaso and an assistant named Julio. The wax models would have been cast from piece-moulds taken from the original terracotta models and were cleaned by Julio and other members of the shop, including the young Alessandro Vittoria, who became one of Sansovino's apprentices in 1543.[36] The bronze-casting was done by another member of the Campanaro family by the name of Girolamo.

The last major project with which Tommaso Lombardo was connected was the Sacristy door, and here, too, we can follow a similar pattern of delegation and demarcation (fig. 152).[37] Again the surviving documents help us to reconstruct the process, and Sansovino's

account submitted in 1570 is particularly informative. To judge from the order in which Sansovino itemized his expenses, it would seem that the master models for the door's panels were made of wax and that Jacopo was assisted in their production by Tommaso Lombardo. Then piecemoulds of the door's elements were made of gesso and wax copies cast from them by a *gessaro* or plaster-cast maker named Andrea.[38] These second wax copies, from which the bronzes would be cast, were then cleaned by Vittoria and another helper called Antonio, under the supervision of Sansovino himself. The process of casting was again farmed out; this time the posts and runners of the door went to the bronze founder Bortolo di Cavedoni, and the figural elements to the Paduan sculptor and caster Agostino Zoppo. Since Jacopo never received a large advance from the procurators for the casting, it was done piecemeal over a period of years. Thus Zoppo's final payment from Sansovino came only in 1563 although the casting started ten years earlier. Bronze for the ornamental parts of the door was purchased from Piero Campanaro and cast by Bortolo di Cavedoni in 1562. The friezes and ornaments were engraved by a professional graver named Menico in 1568; the parts were assembled by a smith the same year, and the door was ready for installation in 1569.

Few other projects by Sansovino are as thoroughly documented as the Sacristy door, but evidence connected with the bronze *Evangelists* and the Loggetta gods supports the conclusions drawn from the door and the tribune panels. A terracotta model of the *St John* exists but does not correspond exactly to the finished bronze (figs. 184, 180).[39] Like the terracotta of *St Mark healing a Demoniac*, the model of St John has the appearance of a *bozzetto* to be shown to Sansovino's employers for approval before a second version, slightly enlarged and with rearranged drapery, was prepared for casting.

The evidence for the Loggetta bronzes is equally fragmentary but even more illuminating (figs. 210, 213, 217–18). Sansovino was given two payments towards their manufacture in 1541 and 1542.[40] These were advances on the cost of making the models and having them cast, but no other payments survive to explain the procedure. Unquestionably, Sansovino first made small models of the four figures, most probably in clay, for the approval of the procurators. These would then have been scaled up in gesso to the requisite size for casting by the workshop; a plaster Apollo was later recorded in the collection of Sansovino's friend Marco Mantova Benavides.[41] The bronzes themselves are of a thinness consistent with the *cire perdue* method of casting which was commonly used in Venetian founderies. The final payment for the Loggetta bronzes came in a decree by the procurators of February 1546.[42] The settlement covered not only the cost of the Loggetta gods, but also the bronze panels for the second *pergolo*, finished a couple of years before. The wording of the document explains that Sansovino made both sets of bronzes 'senza alcun accordo fatto', or without written agreement with his employers, who now agreed to reimburse him for his troubles to the sum of 900 ducats. This money was a bonus to cover the artistic worth of the bronzes, not the cost of their casting which, as the accounts kept by Sansovino show, was paid out of the procuracy's current accounts.

The agreement of 1546 is of great significance in explaining how much freedom his employers gave Sansovino in the creation of his projects for San Marco. In addition, it testifies to a community of interests between Sansovino and the procurators as well as to the esteem in which they held their *proto*. The difficulties of Sansovino's later career were, as we have seen, a consequence of the free and easy relations Sansovino enjoyed with the procurators in the 1530s and 1540s. A similar bonus was expected in the case of the Sacristy door, but the length of time taken to complete the work caused litigation, as it did also with the marble relief of the *Maiden Carilla* for the Santo in Padua and the *giganti* for the Doge's Palace.[43] Greed or self-delusion led Sansovino to overcommitments in terms of the time and labour he could apply to the projects in hand. This led to a number of lawsuits being waged by his son Francesco in pursuit of what he felt to be his father's lost earnings.

Having considered some of Sansovino's projects during the most active years of his

Venetian career, it might be useful to ask what he looked for in his assistants. Probably someone like Tommaso Lombardo embodied the ideal assistant to Sansovino during this period. His presence in Sansovino's shop is documented from 1536 to 1546, the busiest time in Sansovino's Venetian career. His utility lay in his being a sculptor with a fair degree of competence in techniques such as stone carving and in the general supervision of sculptural projects; at the same time, Tommaso lacked the flair or virtuosity to become a serious rival to Sansovino. This is evident in his two known works as an independent sculptor, the *Virgin and Child with the Infant St John* (fig. 413) in San Sebastiano and the *St Jerome* in San Salvatore (fig. 412). Vasari states that Tommaso left Sansovino's shop just prior to the commission for San Sebastiano, which must have occurred in the second half of 1546, as the chapel was ceded to the patron, Melio Cortona, by the Hieronymite fathers in November of that year and contains an inscription with the date 1547.[44] The statue bears the inscription OPUS TOMASI LOMBARDI F and is a close copy of Sansovino's Loggetta *Madonna* (fig. 115), as noted by Francesco Sansovino.[45] A comparison of the two groups shows that Tommaso simply turned his Baptist so that its back is towards the spectator. Otherwise, his composition remains faithful to Sansovino's basic design.

By the same token, Tommaso's *St Jerome* betrays a strong dependence on Sansovino's contemporaneous works.[46] The statue and its accompanying relief completed a chapel begun for Hieronimo Priuli by Guglielmo Bergamasco in the 1520s. The chapel is adjacent to the Merceria portal, which Sansovino designed for Priuli in 1530, and it is highly likely that both chapel and portal were part of the same impulse by Priuli to commemorate himself and his family, in both cases with recourse to Sansovino and his followers. The *St Jerome* is based upon the semi-draped old man on the left of the *Maiden Carilla* relief, as has often been noted, and the relief of God the Father in the lunette above is a free adaptation of the corresponding feature of Sansovino's Medici Tabernacle (fig. 167). If Vasari is correct, the *St Jerome* was contemporaneous with the *Virgin and Child with the Infant St John* in San Sebastiano and dates from the period immediately after Tommaso's close association with Sansovino; Priuli's death in July 1547 endorses such a conclusion.[47] One could go even further and suggest that Priuli's employment of Tommaso may have been on the advice of Sansovino, who also possibly advised in creating the statue's model.

These surviving sculptures show a slavish dependence upon Sansovino's work, regardless of whether or not they reflect collaboration with him. What little critical attention they have received has been without exception negative. It was precisely for his poverty of imagination that Tommaso was a valuable assistant to Sansovino. He was capable enough to follow Sansovino's orders without being good enough to pose a threat to Sansovino's monopoly of sculptural projects. In this way, he stood in relation to Sansovino as Girolamo Dente did to Titian, namely, as a self-effacing assistant whose personality was lost in that of his master. Both Tommaso Lombardo and Girolamo Dente can be contrasted with stronger artists like Danese Cattaneo and Alessandro Vittoria, who broke away from Sansovino, or Paris Bordone and Tintoretto, whom Titian turned out of his studio.[48] Indeed, Sansovino's often turbulent relationship with Cattaneo and Vittoria reflected the threat that their independence posed; it was always the less-gifted men, like Tommaso Lombardo or Domenico da Salò or others known only by name, who stayed with Sansovino for years.[49]

From the 1530s onwards there are numerous examples of Sansovino's delegation of sculpture to a fairly closely knit group of associates and former assistants. They included Cattaneo and Jacopo Fantoni, Tiziano Minio, and Silvio Cosini. Subsequent to their collaboration with Sansovino on the Merceria portal of San Salvatore, Cattaneo and Fantoni joined Minio in the decoration of the chapel of St Anthony in the Santo and also passed into the circle of the Paduan maecenas Alvise Cornaro.[50] Fantoni and Cattaneo appear to have formed a partnership in the years before Fantoni's removal to Bologna in 1540. In particular, the two are recorded as working together on the figural decoration of Sebastiano Serlio's altar

for the Bolognese church of the Madonna di Galliera, a work which Sansovino and the Venetian nobleman Gabriele Vendramin were called upon to evaluate in 1539.[51] Cosini was a fellow Tuscan who arrived in the Veneto in 1533 and remained there for much of the remainder of the decade. Shortly after his arrival, Cosini was employed by Sansovino in carving his own tomb and by the *massari* of the Arca del Santo for the stucco decoration of the chapel of St Anthony.[52] Following that, Cosini completed the relief begun by Giovanni Dentone for the same chapel and contracted to furnish a second one in 1536, the same years as Sansovino received the commission for the *Maiden Carilla*. With interconnecting circles of patronage such as these, it was easy for Sansovino to establish himself as a conduit for sculptural commissions in and around Venice.

Two cases of what must have been delegation to assistants can be found among the earliest works associated with Sansovino's Venetian career, the Malipiero tomb in the church of the Misericordia (figs. 322–23) and the altar of the Virgin Mary in Santa Maria Mater Domini (fig. 414). The Malipiero tomb originally stood in the church of Santa Maria Maggiore and was built between 1533 and 1537.[53] Though the Malipiero tomb cannot be documented as by Sansovino, it bears the hallmarks of his style. The basic design recalls the Florentine formula of a sarcophagus within a semicircular arch framed by pilasters. The Ionic order is similar to that found on the Nichesola monument in Verona, while the frieze is of the same pulvinated kind later employed by Sansovino on the Loggetta. The sunken panels of the pilasters and the design of the sockle can be paralleled in the altar of Santa Maria Mater Domini, which was under way in 1536.

Other elements, however, reflect a different style and suggest collaboration in the design process. Silvio Cosini's tomb of Ruggiero Minerbetti in Florence (fig. 324) offers notable points of comparison with the unSansovinesque features of the Malipiero tomb.[54] The Minervetti tomb was carved under the influence of Michelangelo's New Sacristy, where Cosini was employed as a decorative sculptor, and Cosini adapted elements from Michelangelo's vocabulary, as in the pilaster capitals and fanciful trophies or in the aggressive profile of the sarcophagus. The motif of the patron's shield in the spandrels of the arch is common to the Minerbetti and Malipiero tombs but not found elsewhere in Sansovino's sepulchral monuments. The finial with a double order of scrolls on the Malipiero tomb also goes back to a design by Michelangelo, a black chalk study from the period of the New Sacristy.[55]

The lunette relief of the Malipiero tomb can be paralleled in another work, the relief carved by Ammannati for the altar of the Holy Martyrs in Pisa Cathedral in 1536.[56] It is interesting to observe these similar reliefs carved by two sculptors at about the same time; in both works, the affinities with Sansovino's art are striking though in neither could the hand be mistaken for Sansovino's own. The explanation probably lies in a common source, in a sketch or design by Sansovino which Ammannati and the executant of the Malipiero lunette utilized. Sansovino himself made use of it some years later when modelling the lunette of the Medici Tabernacle (fig. 167), and it was also cited by Tommaso Lombardo for the marble relief of the altar of St Jerome in San Salvatore (fig. 412). It seems probable then that Sansovino made the basic design for the Malipiero tomb and turned to Cosini for its embellishments and, perhaps, its execution. The crude execution of the lunette relief points to a second collaborator, an unknown member of Sansovino's shop relying upon a design by Sansovino.

A comparable example of collaboration and delegation can be found in the altar of the Confraternity of the Virgin Mary in Santa Maria Mater Domini (fig. 414). A contract for its execution was drawn up in 1536, and it states that the architectural details were to be carved by Antonio Buora after designs by Sansovino. No mention is made in the contract of the principal ornament of the altar, the statue of the Virgin and Child (fig. 415).[57] As with the Malipiero tomb, here, too, the sculptural component is reminiscent of Sansovino's idiom albeit in a dilute way. A clue to the author of the statue may be given in the contract of 1536, which was witnessed by Sansovino and Tiziano Minio. Stucco, like bronze-casting, was one

of Minio's specialities, and he later made free copies of elements from Sansovino's bronze reliefs in San Marco as a stucco frieze in the Odeo Cornaro in Padua (fig. 416).[58] The statue in Santa Maria Mater Domini is in stucco and is a rather weak and distant reflection of Sansovino's style; it must reflect the same process of delegation of unimportant commissions to collaborators and followers, in this case the stonemason Buora and possibly the stuccoist Minio.

Such cases as the ones mentioned above are not isolated examples of Sansovino's recourse to assistants to fulfil projects, for the same process occurred on a grander scale in his major buildings of the 1530s and 1540s: especially the Library and the Loggetta. In each case, the same group of sculptural hands furnished the reliefs and figures, either after designs by Sansovino or in harmony with his own work as a sculptor. The principal members of this group were Danese Cattaneo, Tommaso Lombardo, Pietro da Salò, Girolamo Lombardo, Tiziano Minio, and Alessandro Vittoria, one other who briefly became part of this circle was Sansovino's fellow Florentine Bartolomeo Ammannati, although his direct participation was probably limited to 1543–44.[59] They were aided by other assistants and pupils from Sansovino's workshop proper, the composition of which changed during the course of the years.

The Library and Loggetta are more important examples of Sansovino's employment of other artists for the execution of his own designs (figs. 190, 195). Both buildings were planned as complementary elements in the renovation of the Piazza during the years 1536–37, and they are laden with every conceivable variety of sculptural decoration, so much so that they could be seen as a public works project for local stonemasons and sculptors over a score of years.[60] The major sculptural elements of the Library are the decorative and mythological panels on the soffits of the arches, the keystone heads of gods and lions, the river gods and victories in the spandrels, the Doric and Ionic friezes, and the statues on the balustrade, of which only one, by Ammannati, was completed during Sansovino's lifetime.[61] The creation of the Library was a complex process analogous to the Zecca, but one over which Sansovino would have had more day-to-day control. In addition to the drawing of mouldings for the stonemasons and the awarding of contracts to the masons and sculptors, Sansovino would have approved the finished work and made weekly accounts for his employers. Although the daily progress of the building is not recorded in the archives of the procurators, we can piece together a picture of how Sansovino and his collaborators worked by analogy with other projects and by drawing upon such evidence as has been found.

If the case of the Fabbriche Nuove at Rialto is comparable, we can surmise that the erection of the bays of the Library were contracted to stonemasons whose work would ultimately be under the control of Sansovino.[62] While this was under way, the sculptural decoration would have been executed by sculptors from Sansovino's circle. We know the Sansovino's intervention in the relief sculpture of the Library was limited, given the demands upon his time made by his work as *proto* of San Marco and his numerous private commitments. This is, in any case, confirmed by Vasari and Francesco Sansovino, who identify several of the other participants in both the Library and the Loggetta. Francesco specifically mentions the names of Danese Cattaneo, Pietro da Salò, and Bartolomeo Ammannati with respect to the keystones, and Vasari states that Girolamo Lombardo carved works in *mezzo rilievo*, and that Tommaso Lombardo and Danese Cattaneo carved figures for the Library and the Loggetta.[63] From a reading of both sources together, we can say that Girolamo Lombardo may only have executed panels of relief for the soffits of the Library, and that more senior figures such as Cattaneo, Tommaso Lombardo, and Ammannati executed the more conspicuous high-relief figures of river gods, victories, and keystones, which in all probability they would have contracted to carve. Alessandro Vittoria, who received payment from Sansovino in 1550 for four river gods for the Library, and presumably the other sculptors were paid directly by

Sansovino, who would have had to approve their work before it was inserted into place; whether Sansovino provided designs in every case is more conjectural.[64]

Certainly the basic design for the soffits and other relief carvings on the Library would have been made by Sansovino and approved by the procurators, possibly as early as 1536. The basic design of the soffits was inspired by the analogous element in Raphael's Vatican Logge where ornamental and figural compartments inspired by the antique were fashioned in stucco by Giovanni da Udine.[65] There Giovanni had worked with assistants, and the quality of the reliefs varies from one bay to the next, and much the same can be observed in the Library reliefs. Here, too, the reliefs reflect a basic style and suggest a generic dependence upon models by Sansovino.

There was obviously a hierarchy of importance among the sculptures for the Library: the best available sculptor, Ammannati, carved the *Neptune* for the crowning balustrade; Ammannati and the more seasoned among Sansovino's followers made the keystone-heads, the river gods, and victories; the soffits of the arches and the putti of the Ionic frieze were given to the more junior members of Sansovino's circle. Among recent scholars, only Ivanoff has addressed himself to the question of identifying the hands employed and the iconographic theme of the Library's decoration.[66] His attributions seem broadly acceptable, though the exercise is bedevilled by lack of secure knowledge concerning other works by several of the sculptors involved. The divergence in accomplishment from one river god to another can be striking: some are mediocre and others highly accomplished. The mythological reliefs of the soffits are much humbler in quality (figs. 418–19), some of them being as crude as poor woodcuts. In some cases, there are identifiable classical or contemporary sources for the reliefs which suggest that the executant was copying a design in Sansovino's possession.[67] The only soffit reliefs that show a consistently high standard of execution are the grotesques, but these would have been carved by a specialist in that field, known as an *intagliatore*.[68]

An analogy can be drawn between the chain of command in operation on the Library's exterior and its interior. Sansovino designed the pattern for the ceiling of the Sala d'Oro and approved the *tondi* executed by the artists (fig. 420). Similarly he approved Vittoria's stucco decorations for the staircase of the Library (fig. 421), no doubt after preliminary discussions and a basic sketch submitted by the younger man.[69] It is not surprising to see a similar delegation of minor commissions among Sansovino's other activities for the procurators of San Marco. Thus the tapestries woven by Giovanni Rost were based upon drawings by Schiavone that carried the approval of Sansovino (fig. 382).[70] The bronze reliefs and statue of St John the Baptist on the baptismal font in San Marco are another case in point (figs. 422–23). Tiziano Minio and Desiderio da Firenze contracted to make the reliefs for the font in 1545, with Minio's patron, Alvise Cornaro, standing surety; as with the tapestries, the designs for the reliefs were vetted by Sansovino.[71] Twenty years later the decoration of the font was completed by the casting of a bronze Baptist by Danese Cattaneo and Francesco da Segala, the latter sculptor having been recommended to Cattaneo by Alvise Cornaro.[72] Both the reliefs and the *Baptist* conform to the general features of Sansovino's style, as one would expect from artists who were protégés of Sansovino; yet neither work could be mistaken for an autograph sculpture by Sansovino. Instead, the sculptors involved were working in a manner approximating Sansovino's, for the sheer volume of work that passed through Sansovino's hands made a high degree of collaboration and subcontracting necessary.

The Loggetta demonstrates the same pattern of delegation found in the Library. Again Vasari is our chief source of information on Sansovino's assistants. He singles out three in particular, Girolamo Lombardo, Tiziano Minio, and Danese Cattaneo, though he does not go into particulars.[73] Much ink has been spent over which artists did the various reliefs, but the essential point in this context is the visible hierarchy of collaboration. Thus the minor reliefs of marine gods and goddesses along the base of the façade, the small panels directly above and

below the bronze figures, and the soffits of the three arches are all modest in their dimensions and fairly rudimentary in execution. In the spandrels, each pair of victories seems to be by a different hand, all of whom are more competent than the hands of the minor reliefs and soffits. The larger attic panels of Venice, Venus, and Jupiter are both more conspicuous and better achieved than any of the other reliefs.[74]

The examples dealt with so far are ones in which Sansovino must have kept a reasonably tight rein on his assistants, but there are other projects of the 1530s and afterwards in which Sansovino's role would have been more that of consultant or impresario, with a greater latitude left to those engaged on the project. As noted earlier, this must have been the case with the tapestries for the choir of San Marco and the bronzes for its baptistry; other examples include the decoration of the *finestrone* on the Piazzetta façade of the Doge's Palace, the two fireplaces also in the Doge's Palace, and the stucco decorations by Vittoria for the Scala d'Oro and the staircase of the Library. Indeed, the whole question of Sansovino's relationship with Vittoria demonstrates how unsatisfactory simple attempts at determining one hand from another can be.

From 1531 Sansovino became involved with changes to the decoration of the Doge's Palace. The first occasion arose from the decision to adapt the chamber now known as the Scrutinio for meetings of the Senate. Not only was Sansovino's opinion consulted, but one of his employers, the procurator Jacomo Soranzo, became the overseer of the chamber's adaptation. During the next few years, the Scrutinio, or Libreria as it was then called, received an elaborately carved ceiling, which Serlio designed and for which Pordenone made paintings. From October 1536 it was decided that the doge should receive weekly accounts of work in progress, and this continued until 1542 when work was largely completed.[75]

Sansovino's name does not appear again in the official accounts for the Scrutinio, but two payments in favour of his disciple Pietro da Salò survive from 1536 and 1540.[76] They concern unspecified work on the large, ornamental balcony that gives on to the Piazzetta façade of the building (fig. 429). This balcony was obviously conceived as a pendent to the early fifteenth-century *finestrone* on the southern façade of the palace. That *finestrone* subscribed to an overtly religious sculptural programme, with statues of virtues, saints, and Doge Michele Steno.[77] The contrast between the fifteenth-century original and its sixteenth-century imitation is instructive because it signals a change in the official iconography of Venice comparable to the Loggetta's; for in place of the virtues and saints are four classical gods: Jupiter, Mars, Apollo, and Mercury. Above them appears an image of the doge under whom most of the work was carried out, Andrea Gritti. Again we have it from Vasari that the statues of the gods were executed by followers of Sansovino, namely, Pietro da Salò, and possibly Danese Cattaneo and Alessandro Vittoria.[78] Given the presence of two of Sansovino's patrons and three of his followers, Sansovino's advice surely would have been sought as the project evolved during the 1530s.

In appearance, the new *finestrone* is the vertical equivalent of the Loggetta's iconographic programme, which is not surprising, as their gestation overlapped and as Sansovino and his close followers worked on both projects. Sansovino's role on the *finestrone* would have been more circumscribed than on the Loggetta, a project directly under his control as *proto* of San Marco. He would have made a recommendation on the completion of the balcony's decoration and perhaps further advised on the choice of sculptors. Obviously the presence of Salò and eventually Vittoria underscores the connection between the two projects, which extends to the poses of the individual statues. *Neptune* echoes Sansovino's bronze *Apollo* while Vittoria's *Mercury* (fig. 427) is reminiscent of both the bronze *Mercury* and the *Apollo* from the Loggetta; Salò's *Mars* (fig. 428) recalls the analogous figure from the monument to Benedetto Pesaro (fig. 271).[79]

A few years after the completion of the *finestrone*, Salò and Cattaneo worked for the Council of Ten on two fireplaces in newly redesigned rooms in the Doge's Palace. In 1540 the

council decided to make a small room for its executive and again consulted Sansovino.[80] His proposals are not recorded but probably included the creation of a new fireplace. In the event, two complementary fireplaces were created, for the Stanza dei Tre Capi and the adjacent Sala della Bussola, though not until the reign of Doge Marc'antonio Trevisan (1553–54). The rooms are on the second main floor of the palace and are contemporaneous with ceilings by Veronese and his circle.[81] Designed by Sansovino, the fireplaces were carved by an unknown *intagliatore* and by Pietro da Salò and Danese Cattaneo, who were responsible for the figural elements (figs. 430–31). On both fireplaces two figures support a pulvinated frieze, embellished by the Trevisan arms, foliage, lizards, and the like. The two herms in the Bussola and the two caryatids in the Tre Capi were, in each case, carved one by Salò and one by Cattaneo. Although the members of each pair of figures are similar to each other, they are not identical, and they reflect very clearly the style of the two masters. Both Cattaneo's male and female forms are slender and tend towards the feminine; Salò's are just the opposite: large and rather masculine.

It is unlikely that Sansovino did more than make drawings for these fireplaces, leaving the poses of the supporting figures to be settled by the sculptors themselves. It was a type of fireplace that appears to have been introduced into the Veneto by Sansovino, although the inspiration came, via Serlio, from designs by Peruzzi (fig. 222).[82] Sansovino designed a fireplace with two supporting figures and a stucco overmantel for a room in his own apartments in Venice, which does not survive, and two others for the Villa Garzoni at Pontecasale, which do (figs. 338–42).[83] The fireplaces at Pontecasale are of approximately the same date as those in the Doge's Palace and follow the same formula, with the exception of their friezes. The vast scale of the Villa Garzoni meant that it held an important place in Sansovino's private commissions, and the two fireplaces there may have been more directly under Jacopo's supervision. But it is doubtful whether he actually carved them, even though the caryatids bear his name. The caryatids are more finished than the herms and invite comparison with the figure of Peace on the Loggetta, but on closer inspection (fig. 341), they betray the perfunctoriness of a copyist and lack the animation which Sansovino imparted to *Peace* (fig. 218). The most likely members of Sansovino's entourage to have made the figures for the fireplaces at Pontecasale were Cattaneo and Salò, and a comparison of the fireplaces in the Doge's Palace with those at Pontecasale points to Salò as the sculptor of the herms and Cattaneo as the sculptor of the caryatids of the villa's fireplaces. The closest analogy with the herms of Pontecasale is to be found in the herm by Salò in the Sala della Bussola while the mannered types of the caryatids correspond more closely with Cattaneo's feminine types in the palace.

The presence of Cattaneo and Salò at the Doge's Palace and at Pontecasale again brings up the familiar pattern of design by Sansovino and execution by an assistant. At Pontecasale, the presence of the 'signature' should not be construed to mean autograph work, in the modern sense, but rather something akin to copyright of a design or what would now be termed 'quality control'. In employing Sansovino, his patrons seemed more concerned with obtaining something that embodied his style, not necessarily an autograph work. In this sense, we can compare many of the works produced by Sansovino's shop with the products of a modern *couturier*, who lends his name to a variety of clothes made in a distinctive style. Autography appears to have counted for less with many of Sansovino's patrons than the visible results.

The decorations for Sansovino's last major work in the Doge's Palace, the Scala d'Oro, fall into the same category as the works just discussed. A competition for the new ceremonial staircase leading to the state chambers on the eastern side of the palace was held in 1556; Sansovino won it, though discussions about the nature of the staircase were still being held in 1557.[84] Work on the new staircase was well enough under way for the stucco decoration to be applied during 1558–59.[85] The main design for the decoration of the first flight (fig. 432)

is very much in a Sansovinesque mould and based upon the pattern of the Sacristy door (fig. 152).[86] The second flight has, in contrast, alternating square, oval, and octagonal frames with painted and sculptural decoration, reminiscent of the coffering by Sansovino in the arcades of the Library and elsewhere. If the general design implies a debt to Sansovino's vocabulary, the forms of the individual stucco figures by Vittoria do not, as Leithe-Jasper observed (fig. 435).[87] Again the most plausible explanation for Sansovino's role is that of overseer or of someone establishing the broad lines of the design which are then to be filled in by an assistant.

This is confirmed by Vittoria's subsequent contract for the stucco decoration of the Vault of the Library's staircase in February 1559 (fig. 421).[88] According to the terms of the agreement, Vittoria made an essay of his proposal, which was then approved by the procurators before work began. Sansovino witnessed the contract in his role as *proto* but is *not* mentioned as furnishing a design or participating directly in the work. While Sansovino would have discussed the design with his former pupil, he must have given Vittoria *carte blanche* here as with the Scala d'Oro. Vittoria's proven skill as a stuccoist made him as invaluable a collaborator as was Minio or Zoppo for bronze-casting.

Vittoria was obviously a special figure among Sansovino's followers and collaborators, particularly during the 1550s. He came into Sansovino's studio in 1543 and broke away from his master as early as 1551. He first made a name for himself as a stuccoist in Vicenza, where be created some of the most accomplished ceilings of the century in the Palazzo Thiene.[89] He later attempted to steal the commission for the statue of Hercules from Sansovino by offering his own services to the Duke of Ferrara in 1552 but was subsequently reconciled with Sansovino upon receiving the commission for the *feminoni* or caryatids of the Library's entrance (fig. 434).[90] Vittoria worked on these over-life-sized figures, together with several assistants, during 1553, and they are recorded among his early works by Vasari. They are, however, closely related to the caryatids at Pontecasale (fig. 340) and to the figure of *Hope* on the Venier tomb (fig. 289). This is not to minimise Vittoria's accomplishment with the *feminoni*, but rather to stress that simplistic notions of an artist's *oeuvre* are not always appropriate in Renaissance sculpture, particularly when dealing with a large and variegated practice such as Sansovino's. It would be more pertinent to conclude that Sansovino had a stock of models which could serve a multitude of purposes, and such a one stood behind the caryatids, *Hope*, and the *feminoni*. Vittoria may have been given that model to work from, or it may have suggested itself unconsciously; his *Mercury* owes a similarly patent debt to Sansovino's.

A correspondingly close overlapping of styles may have operated in the case of the bronze figure of Tommaso Rangone for the façade of San Giuliano (fig. 280). An abundance of documentation survives for this project, and it proves that Sansovino's original wax model for the bronze was damaged and replaced by a second wax casting model made by Vittoria.[91] Discrepancies in the cost of casting the two figures rule out the possibility that Vittoria simply repaired the original, and on stylistic grounds one can argue that the finished work is closer to Vittoria's sculpture than to Sansovino's. Yet it would be an oversimplification of the way in which Sansovino and Vittoria worked to assign the bronze to one of them *tout court*: Vittoria was working with Sansovino on the project, and both were in the pay of a highly independent patron in the person of Tommaso Rangone. Just as the finished façade represents a design by Sansovino with embellishments by Vittoria, so, too, the bronze figure must have been approved by Sansovino though carried out by his younger colleague.

During much of the 1550s, the division between Sansovino's shop and Vittoria's must have been somewhat fluid. Vittoria did not become a fully fledged member of the stonemasons' guild until 1557, and before that date he sought employment either outside Venice or through Sansovino. Vittoria even shared an apprentice with Sansovino during 1555, and this also implies a degree of collaborative effort.[92] About the same time, Sansovino had a falling out

with Danese Cattaneo which led to his cutting Cattaneo out of his will in 1556.[93] So it is not surprising that Vittoria became something of a deputy for Sansovino in the penultimate decade of his life.

By that time Sansovino was both well known and well enough connected to receive a number of lucrative commissions that enabled him to distribute his own patronage. One sees this very clearly with the tombs of Doge Venier and Livio Podocataro, the Fabbriche Nuove at Rialto, and the *giganti*. In each of these cases, whether sculptural or architectural, the pattern followed was essentially the same: designs and detailed drawings of mouldings by Sansovino were executed and supervised by stonemasons, or sculptural models by Sansovino were executed by sculptors from his own studio or that of a trusted colleague. This is reflected in the contract for the tomb of Podocataro, in which work was divided between the architectural and sculptural, with Sansovino's own shop providing the latter.[94] In the case of the Venier tomb, we also know that some of the sculpture was contracted out to Vittoria, who executed the effigy and the relief panel with an assistant (figs. 285–86).[95] This process appears to have been fairly common in Venice, for it was also employed by the Contarini family for a monument to Alessandro Contarini, designed by Sanmicheli but executed by a number of sculptors.[96]

Towards the end of his career, Sansovino's disengagement from the process of carving stone was all but absolute. His letter to the Duke of Ferrara of 1550 is fairly candid on that point: he lacked the time and energy to follow statues through each stage in their execution; his role was to provide models for others to follow, possibly going over their work in the final stages.[97] This is certainly the way in which the *Hercules* for Ferrara (fig. 302) and the *giganti* for the Doge's Palace were made (fig. 307). Sansovino's accounts show that a small army of assistants worked on the *Mars* and *Neptune* for over eleven years.[98] After the models were approved by the clients, they would be copied to scale in gesso and then copied in stone by a pointing system. During these stages, apprentices would assist the more seasoned assistants and journeymen, thereby gaining training for their own careers. Sansovino's role would have been confined to advising and, perhaps, to providing some finishing touches. The same process must have been applied to the allegorical statues on the Venier tomb (figs. 289, 291) and the reliefs of the Podocataro tomb (figs. 297–98, 300). One can also see that these figures and reliefs are, in turn, based upon earlier models that were refurbished for the occasion.

There is no evidence to suggest that these practices were in any way exceptional, or that Sansovino's patrons objected to the extensive use of assistants any more than did Verrocchio's a century earlier or Bernini's a century later.[99] The idea of the sculptor as a solitary artist, producing works with his own hands, is a myth of the nineteenth and twentieth centuries which bears little relationship to sculptural practice of the Renaissance and Baroque periods. Then, most patrons were more interested in the speed of delivery and in the fame of the creator than in the extent to which he participated directly in its execution. If we can generalize from Sansovino's career, we can see a pattern roughly parallel to that of Raphael, Giulio Romano, Giambologna, or Bernini. The early years of the artist's career are spent in executing virtuoso works which prove his expertise; after that, fame and the pressure of steady employment force the artist to husband his resources and to produce works on an industrial scale by recourse to an efficient shop. This system worked well initially but ran into trouble as Sansovino grew older and took on more private work. Hence, the Sacristy door and the marble *Virgin and Child with Angels* took decades to complete and the *giganti* were in progress for over eleven years and the *Maiden Carilla* relief remained with Sansovino for twenty-seven years. The lawsuits between Francesco Sansovino and the procurators in the years after Jacopo's death were the inevitable result of an easy-going relationship between employer and servant which broke down when works were not delivered on time.

Beyond that, the surviving evidence shows that Sansovino's working procedure was both

sophisticated and shrewd in drawing upon the resources available to him in Venice. This is reflected in the number of successful bronzes he began to create after his arrival in Venice; his interest in bronze would have been stimulated by the presence of figures like Minio as well as professional bronze-casters connected with the Arsenal. Artists such as Minio and Vittoria were also available for stucco decorations, but, chiefly, it was the presence of a number of skilled assistants capable of working in his idiom that made possible the enormous extension of Sansovino's production after he arrived in Venice. Few, if any, contemporary sculptors were as successful as Sansovino in finding such a pool of talent to draw upon, and it was this that placed Sansovino in the tradition of Ghiberti and Donatello.

In the final decade of his life, Sansovino gradually withdrew from active practice. The Venier and Podocataro tombs were finished by the middle of the 1560s; the *giganti* were erected in 1567. His few remaining architectural commissions and the more arduous duties of *proto* to the procuracy *de supra* were being taken over by other men.[100] Of those sculptors who took part in Sansovino's last projects, several are known by name, thanks to the accounts for the *giganti*, but only two had significant careers of their own: Jacopo de' Medici and Domenico da Salò. Vasari reports that Jacopo Medici had only just left Sansovino for his native Brescia a short time before the publication of the *Vite* in 1568, which would make him one of the last disciples of Sansovino. His few surviving works do not place him among the best of Sansovino's followers, and the same can be said for Domenico da Salò.[101] Both were competent in the manner of Tommaso Lombardo and must have been employed by Sansovino in a similar fashion. Apart from the *giganti*, the works on which they may have been employed are the relief of the Virgin and Child in the Doge's Palace (fig. 330), the virtues of the Venier tomb (figs. 289–92), and the reliefs on the tomb of Livio Podocataro (figs. 297–98, 300).[102] They all derive from earlier compositions, and, with the exception of the *Charity* and *Hope* of the Venier tomb, they represent a falling off in quality from their prototypes. Sansovino's age meant that his control of the production of works was less secure than it had been; additionally, the process of stone carving was less susceptible to mechanical reproduction than bronze-casting and had unpredictable results.

Sansovino's last will, of 1568, sheds some additional light on his sculptural and architectural career.[103] In it, he expresses a wish to be buried in the Florentine chapel at the Frari, beneath his own *St John the Baptist* (fig. 93). He describes the *Baptist* as 'di mia propria mano', a phrase which not only attests to its autograph status among Sansovino's *oeuvre*, but also implies a comparative rarity of wholly autograph works by the sculptor. This would certainly fit the evidence concerning Sansovino's Venetian career where a high degree of collaboration is evident in all but a few cases. Moreover, the *Baptist* is a virtuoso piece, not unlike the earlier *Bacchus*, a work in which the sculptor advertised his abilities. It would have been a fitting monument to the sculptor's *virtù*.

If the phrase concerning the *Baptist* offers some proof that many of Sansovino's sculptures were not wholly autograph in the modern sense of the word, another passage from the same document draws attention to a second aspect of Sansovino's working methods, namely, the role of drawing and modelling in his sculpture and architecture. Sansovino makes a distinction between his drawings and his 'gessi antichi e moderni' in his testament: the former he leaves to one of his executors, Salvador *tagliapietra*, and the latter to Danese Cattaneo. As Salvador was a stonemason and exclusively concerned with architectural projects, it seems likely that any drawings he inherited would have been related only to his field of expertise. Why, then, were no drawings left to Sansovino's sculptural 'heir', Cattaneo? From a codicil to a lost will, we know that Sansovino once contemplated giving Cattaneo his drawings, but he obviously changed his mind.[104] The explanation for lack of mention of the drawings may lie with the intentions of Francesco Sansovino, for the will of 1568 allowed him first choice of the drawings with the remainder then going to Salvador. Francesco would probably have kept any drawings of artistic worth with a view towards publication.[105] Since virtually no

drawings by Sansovino appear to survive, the bulk of them may have disappeared with Francesco's sudden death in 1583.

The absence of substantial autograph drawings by Sansovino and the distinction between drawings and casts in the will of 1568 may also indicate a difference in the practice of sculptors and painters. This concerns the role of drawing in both arts. It is not a question of sculptors' drawings as opposed to painters' drawings—an overworked cliché in my opinion—but rather of the more limited function of drawing in sculpture.[106] Vasari reports on several occasions that many sculptors are competent in their field without knowing how to draw because they habitually think in terms of three-dimensional models.[107] Certainly few, if any, drawings exist for most of the major Renaissance sculptors, from Sansovino to the Lombardi to Giambologna. Those who left a large corpus of drawings, such as Michelangelo or Bandinelli, are exceptions to the rule, for they had idiosyncratic training that included time spent in painters' studios.[108] It was that training which led them to incorporate drawing into their working process to such a conspicuous degree.

It may be fair, then, to say that Sansovino employed drawings more for his architecture than for his sculpture in Venice, and surviving evidence tends to support this conclusion. It is especially clear with his tombs, where work was divided along craft lines, with stonemasons executing the architectural structure after drawings and sculptors making the reliefs and effigies after plastic models. Sansovino's reliance upon models for sculpture is also reflected in the elaboration of certain themes, particularly the Virgin and Child, which he developed in a number of works from the 1530s onwards; there is, too, a consistency in his figural types which underscores the importance of models as a touchstone and as an element in the evolution of his compositions. Thus the resemblance between the Nichesola *Madonna* and the *Charity* on the Venier tomb or the *Hercules* and the two *giganti* points to the presence of standard figural types in Jacopo's studio, types which he adapted to suit a given context. In this way, his practice was not dissimilar to that of his fellow Florentine Bandinelli or to Giambologna's.[109]

Sansovino's Venetian career traces a change in his working practice from carving to modelling. Several factors may have forced this change upon him, but it was chiefly a question of time and energy, as his letter to the Duke of Ferrara implies.[110] Carving marble was an occupation better suited to a young man, and Sansovino's age and his work as *proto* left him little scope for the sort of career he enjoyed in Florence and Rome. But his switch to modelling and supervising others in the carving and casting of his works was part of a trend in sculpture, already evident in the Renaissance but becoming predominant in subsequent centuries: that is, the cleavage between designer and technician.[111] The distinction is already present in the way in which Sansovino regarded himself in later life as someone who made a design and directed its execution by trained hands. Unlike many of his nineteenth-century successors, Sansovino had worked his way up through his profession and knew intimately the process of carving marble, but, like them, he came to see his role as that of an inventor of subjects in wax and clay. This change in Sansovino's working procedure had a definite impact upon the quality of sculpture issuing from his Venetian shop; it meant that he was at his most successful in bronze, where the method of reproduction was mechanized and straightforward, and on a small scale, where the transfer from the artist's own model to finished work was more easily controllable. It also meant that large statues tended to be less predictable in outcome because they were substantially executed by assistants.

Sansovino's Venetian career was highly successful by any standards. In it, patronage and collaborative effort can be seen as mutually reinforcing features. Sansovino was virtually groomed for his role in Venetian sculpture and architecture by a small group of patrons who were well placed and influential; his office and public commissions also made him conspicuous at a time when the local competition was at a low ebb. These elements attracted further commissions and enabled Sansovino to build the extended network of assistants and followers

which became essential to the execution of his projects. By training so many collaborators, Sansovino impressed himself upon Venetian sculpture much as Giambologna did upon Florentine sculpture a few decades later. A view of Sansovino as an impresario of sculpture may be less romantic than conventional notions of artistic creation as a solitary process, but it is undoubtedly closer to the way in which Sansovino and many of his fellow artists worked. Moreover, Sansovino's Venetian workshop opened up opportunities beyond those available in his earlier career.[112]

XI. Sansovino's School and his Legacy

SOME TIME IN the early 1560s, Sansovino sat to his friend Tintoretto. The resulting portrait, now in the Uffizi, conveys an image in keeping with Vasari's verbal account of the artist in his biography (frontispiece, Vol. I).[1] Handsome and self-assured, Sansovino gazes out proudly and holds in his right hand the tools of his trade, compasses and chalk, while behind his right elbow there appears to be the head of a sculptural model. Vasari describes Sansovino as imposing and as having been handsome in youth, and this is evident in the face staring out from the canvas.

The Sansovino of Tintoretto's painting and of Vasari's biography is very much the gentleman-artist, someone capable of moving easily between artistic and aristocratic circles. The preceding chapters have shown the scope which Venice and Venetian patrons gave to Sansovino's artistic powers in the decades following the Sack of Rome. He was deliberately promoted by a small band of powerful patrons, who brought major commissions his way; these commissions in turn allowed Sansovino to impose his own style on Venetian sculpture and architecture while enabling him to create a network of followers and assistants who served as his extra hands in most of his projects. The security and evident contentment that Sansovino found in Venice led him to turn down offers of employment in Ferrara, Rome, and his native Florence.[2] Both Aretino and his own son Francesco touched on the underlying reasons for Sansovino's happiness in Venice; the absence of court intrigue, the more liberal climate of opinion, and his acceptance as a gentleman were not inconsiderable factors in his decision to stay put.[3]

Though he remained remarkably robust in his old age, Sansovino's last years saw an inevitable decline in his activity. Over the years, he had moved away from active participation in his commissions to a role of designer, someone prized for his inventive ability. Even so, the volume of projects completed in the 1560s is remarkable and includes the tombs of Doge Venier and Archbishop Podocataro, the *giganti* for the Doge's Palace, the completion of San Geminiano, and the design of the church of the Incurabili. During this period, some criticisms within the procuracy *de supra* were voiced concerning Sansovino's keeping of accounts, and his autonomy was notably curtailed; he was also given an assistant to carry out some of the more onerous duties of his office. These complaints reflected a growing sense of concern about the finances of the procuracy, which finally led to a government investigation, and may have been the first signs of the dispute over Sansovino's conduct in office manifest in Francesco Sansovino's quarrels with the procuracy.[4]

Whatever disagreements may have coloured Sansovino's last years, he continued to exercise his office until some six weeks before his death. He also acquired the rights to a family vault in the chapel of the crucifixion in San Geminiano in June 1570, in return for which Sansovino promised to provide, among other things, a 'Christo nuovo'.[5] Sansovino's

plans for his mortuary chapel were curtailed by his death on 27 November 1570, following a short illness. He was eighty-six at the time of his death, but his son evidently believed his father to be ninety-three.[6] His funeral was held in his parish church of San Basso, the other side of the clock tower from Sansovino's apartments on the Piazza; burial followed in the chapel in San Geminiano which Sansovino and his son had only recently obtained for their family. This was a more prominent location than the previously intended burial site, the chapel of the Florentine community in the Frari. Unluckily for Sansovino, the church of San Geminiano, one of his most conspicuous achievements in Venice, was eventually to be swept away by Napoleon.[7]

The news of Sansovino's death was mentioned by Cosimo Bartoli in his dispatches to the Medicean court, and, more significantly, it was communicated to the Accademia del Disegno in Florence by Francesco Sansovino.[8] Though Jacopo was never a member, several of his friends and pupils had been elected academicians, and Francesco's letter encouraged the academy to honour his father's memory with some form of commemoration. A committee that included the sculptors Vincenzo Danti and Giambologna was established to consider an appropriate tribute; this eventually took the form of a portrait of Sansovino among the Florentine architects in Santi di Tito's fresco of the temple of Solomon in the chapel of the Accademia at Santissima Annunziata.[9]

Francesco Sansovino's intervention with the Florentine academy is indicative of his role as custodian of his father's reputation, a role that began long before Jacopo's death (fig. 436). Already in 1550 we find him acting as his father's secretary when he wrote and signed the letter to the Duke of Ferrara, and Francesco also purchased land in his father's name and drew up his father's tax return in 1565 (fig. 438).[10] He was probably the guiding force behind the attempts to settle payment for the *giganti* and the Sacristy door before his father's death, and he pursued these cases and others through the early 1570s.[11] Francesco Sansovino's motives were not wholly unselfish: as the sole heir to his father's estate, he stood to benefit materially from his legal actions. At the same time, he had a genuine grievance against the shabby behaviour of the procurators and a concern for his father's reputation. Francesco's celebration of his adopted city began in 1556 with the publication of *Tutte le cose notabili et belle che sono in Venetia*, printed under the pseudonym of Anselmo Guisconi.[12] Cast in the form of a dialogue between a Venetian and a stranger to Venice, this little book enjoyed numerous reprintings under Francesco Sansovino's own name from 1561 to the early seventeenth century. It reads like an early draft of Francesco's lengthier and more famous guidebook, *Venetia città nobilissima et singolare*, published in 1581. Sansovino's writings contain a generous mixture of propaganda and factual information, but they are of particular value for their wealth of art-historical notices, especially on the works of his own father. Francesco was particularly sensitive to the value of his father's urbanistic achievements, and his observations on the Loggetta, Library, and Public Mint remain fundamental to our understanding of these buildings.[13]

These were not the only places where Sansovino's praises were sung. As early as 1546 Francesco had pulished an account of the Loggetta's iconography in his *L'arte oratoria*, and four years later he announced an intention to publish his father's anatomical drawings in his *L'edificio del corpo humano*.[14] Among these incidental references to his father, none is more remarkable than the biographical sketch inserted into Cristoforo Landino's *Comento sopra la Comedia di Dante Alighieri*, which Francesco published in a de luxe edition of the *Divine Comedy* in 1564.[15] There, Fancesco brought up to date the list of famous artists enumerated by Landino in his defence of the city and included his father's chief contemporaries: Michelangelo, Torrigiano, Fra Bartolommeo, Sarto, Pontormo, among others. Where most of these were given only a sentence or two, Jacopo Sansovino received a lengthy account which, in its fullness, anticipates Giorgio Vasari's life of Jacopo in the 1568 edition of the *Vite*. More significantly, it also resembles an anonymous manuscript life of Jacopo formerly in Vasari's

possession. Many years ago Georg Gronau noted the existence of two pages of manscript notes on Jacopo Sansovino, apparently sent to Vasari for incorporation into the *Vite*; their significance was ignored until publication by Charles Davis a few years ago.[16] As Davis initially observed, the pages are by someone well versed in contemporary discussions of art, but not one of Vasari's normal correspondents. In fact, the lines appear to have been dashed off in the distinctive hand of Francesco Sansovino, a conclusion with which Davis now agrees.[17] They share many features in common with other specimens by Francesco, notably the ductus of the capital *S*, *P*, *M*, and *F*, as well as the final *e*'s, *h*'s, and double *z*'s; in addition, words like 'Et', 'Signoria', and 'Palazzo' can be matched exactly in other writings by Francesco (figs. 437–39). Clearly, it would make sense to suppose that Francesco was the unnamed correspondent, given his distinctive combination of interests in art and literature, as well as his intimate knowledge of his father's career; then, too, the manuscript notes are also consistent with Fancesco's published accounts of his father's achievements.

Francesco Sansovino was not one of Vasari's regular correspondents, but their acquaintance dated from 1540 when the painter visited Venice. Two years later Francesco wrote appreciatively of Vasari's decorations for *La Talanta* in his *Lettere . . . sopra le diece giornate del Decamerone*.[18] They also moved in overlapping artistic and intellectual circles, and both could number figures like Ammannati, Danese Cattaneo, and Benedetto Varchi among their acquaintance. Moreover, Francesco, though born in Rome and only briefly resident in Florence as a child, still felt himself Florentine by descent and maintained his Florentine contacts across his career.[19] As he would have known about Vasari's new edition of the *Vite*, it is not surprising that he should have forwarded notes for the biography of his father.

Francesco's notes provide a fairly linear account of Jacopo's working life, but they anticipate the format of Vasari's biography, even down to certain phrases. They are less concerned with and somewhat less well informed about Jacopo's pre-Venetian years, where Vasari writes more knowledgeably about early commissions and models in Florentine collections. The manuscript does, however, mention a lost *Christ* sent to the sister of the emperor and a bust of Alexander the Great for Francis I, which are unrecorded elsewhere, and the summons to the French court which Jacopo planned to accept after the Sack of Rome, something confirmed by Francesco Sansovino in a letter written in 1579.[20]

As one would expect, the manuscript notes grow more expansive on the Venetian career. Again they record Sansovino's appointment as architect of the Venetian fortifications prior to his appointment as *proto* of San Marco, an item not found in any other source.[21] The notes also demonstrate a greater sensitivity to Jacopo's architecture than found in Vasari's 1568 account, echoing passages in Francesco Sansovino's other writings on Venice.[22]

Not all of these observations found their way into Vasari's second edition of the *Vite*. Instead, Vasari seems to have relied upon his own recollections from his stay in Venice in 1540 and possibly from his brief visit in 1566. It is a very business-like account of Sansovino's career, underplaying the importance of his Venetian architecture and striking a balance between Sansovino's contribution to Venice and what he received from the city in return. But this is not the end of the story, for a second edition of the biography appeared shortly after the death of Sansovino (frontispiece, Vol. II). It is an extremely rare quarto volume of thirteen pages, bearing no date or place of publication. Reprinted by Morelli in 1789, the work is now perhaps best known in Milanesi's synthesis of the two versions for his standard edition of the *Vite*. This has meant, however, that important divergencies and shifts of emphasis have been obscured; when read in sequence, the later version reads very much like a second draft of the 1568 biography and seems to have been a collaborative effort between Vasari and Francesco Sansovino. Internal evidence including type face and orthography reveals that the text was published in Venice, not Florence, and almost certainly by the press run by Francesco Sansovino and his son Jacopo Sansovino il Giovane.[23]

The purpose of the edition may have been twofold: one motive may have been to create a

corrected and amplified version of Sansovino's life as part of the commemoration instigated by Francesco Sansovino with his letter to the Florentine academy; a second purpose could have been to vindicate Francesco's lawsuits against the procurators, which were under way in 1571, the probable date of publication.[24] In a sense, both aims fit the scope of the text, as it celebrates Sansovino through his unstinting service to his Venetian patrons.

The differences between the first and second texts of Vasari's biography deserve consideration and can be summarized briefly. The first part of the life reads as it did in the 1568 edition with the notable addition of information concerning the background of the Tatti family and its origins in Lucca.[25] This is coupled with a typical Vasarian embroidery on the artist's childhood that has Jacopo erroneously born on the same street as Michelangelo and manifesting an early inclination towards art. Apart from these interpolations, the passages on the Florentine and Roman careers remain as they were, although one new piece of information, a knighthood bestowed upon Sansovino by Pope Leo X, is now mentioned.[26]

More radical changes occur with Sansovino's arrival in Venice, and here one senses how much Francesco Sansovino must have contributed to the revision. These are lengthy additions concerning Sansovino's urban interventions in and around Piazza San Marco; these correspond to similar passages in Francesco Sansovino's writings and reflect his view of his father's work. Then, too, Sansovino's close alliance with Doge Gritti, Vettor Grimani, and Zuane da Lezze is stressed and his contribution to the procuracy's finances underscored. Mention is also made of Sansovino's service to the dukes of Mantua and Urbino.[27] More importantly, the list of Sansovino's works has been substantially augmented by the inclusion of the tomb of Doge Venier and the reconstruction of San Geminiano, San Giuliano, and Santo Spirito in Isola; the Villa Garzoni is described in terms reminiscent of Francesco Sansovino's manuscript notes.[28] Where the 1568 edition of the biography contained a passage on the benefits Sansovino derived from his employment in Venice, the new version omits any reference to this. Instead, there is a tart sentence about Sansovino's having spent his own money on his commissions without regard to his heirs. This observation is couched in terms sympathetic to Francesco Sansovino's point of view and again suggests a personal interpolation.[29]

Even more substantial rewriting comes towards the end of the biography. Three stucco models in Francesco Sansovino's collection are noted: a Laocoon, a standing Venus, and a Virgin surrounded by putti. There is also mention of sixty architectural drawings, which Francesco planned to publish together with illustrations of various of his father's commissions.[30] The biography concludes with a verbal sketch of Sansovino's physical appearance and his last days. In place of the cameo biographies of the 1568 *Vite*, we find only a list of names of Sansovino's disciples. Vasari prints as well the lengthy inscription which Francesco was to have placed over his father's tomb and refers to a marble self-portrait of Jacopo that stood in the chapel. As neither of these elements was ever brought to the chapel in San Geminiano, we can only infer that here again Vasari relied upon Francesco for his information.[31]

But the most remarkable new passage in the second version of the life comes in a final summation of Sansovino's artistic gifts. While Sansovino could not claim an equal footing with Michelangelo, Vasari states that he was held by 'experts' to be the older sculptor's superior in rendering drapery and the expressive nature of women and children. Vasari dwells upon the miraculous quality of his drapery folds, the naturalness of his children, and the unrivalled beauty of his female figures. Given Vasari's predisposition to view Michelangelo as the summit of artistic achievement, this is an unusually noteworthy passage. As with the famous lines on Raphael's more catholic approach to art, here, too, Vasari steps back from his Michelangelesque bias in order to appreciate an alternative approach.[32]

In more general terms, it remains to be asked what is meant by Sansovino's style as a sculptor and how was it interpreted by his followers. The preceeding chapters will have given a composite idea of Sansovino's sculptural activity, but it is always helpful to piece together

these various aspects into a more coherent picture. We are accustomed to think of style as a linear development and of an artist's works as markers regularly placed throughout a career. While this may hold for some artists, it certainly doesn't for the greatest, Sansovino included. True, his earlier career does follow a reasonably straightforward path from a training in the late Quattrocento manner of Andrea Sansovino through a widening of horizons by encounters with the art of Leonardo, Michelangelo, and the antique to the achievement of an individual voice with his first known works. The various strands of Sansovino's artist gifts were revealed in the *Bacchus* (fig. 35) and the Florentine *St James* (fig. 45). The *Bacchus* demonstrated Sansovino's mastery of classical forms—*de rigueur* for an aspiring artist by that date; the *St James* proved his equal familiarity with the great tradition of fifteenth-century Florentine sculpture. During the second decade, Sansovino consolidated his position as the leading Florentine sculptor after Michelangelo, evolving a weightier style which could be termed the plastic equivalent of the art of Fra Bartolommeo and Andrea del Sarto. Towards the end of the decade, Sansovino shifted his sights towards Rome, taking more seriously the challenge of Michelangelo and Raphael. His Martelli *Virgin and Child* (fig. 68) and the *St James* for Cardinal Serra (fig. 80) illustrate the degree to which Sansovino could accommodate himself to the distinctive world of the later Roman High Renaissance without compromising his individuality.

Had Sansovino done no more as a sculptor, these four works would have assured him fame, at least as a promising follower of Michelangelo. But much the most interesting aspect of Sansovino's Venetian career is how diverse it became by comparison with his Florentine and Roman years. Already, with his first verifiable works, the Nichesola monument in Verona (fig. 86) and the Arsenal *Madonna* in Venice (fig. 98), one encounters a volte-face, away from the pronounced Michelangelesque vocabulary of the Roman works towards a style that consciously exploits the sculptor's roots in the Quattrocento to fashion a new vocabulary of forms. In part, this would have been in reaction to the obvious affinities between Venetian art and Sansovino's own early training in a late Quattrocentesque workshop; in part, too, it would have been pressed upon him by the tastes or directives of his patrons. Evidently, it did not go against the grain of Sansovino's own inclinations, for the thread which runs through many of his best works in the latter part of his career, from the *Baptist* (fig. 93) to the Loggetta bronzes (figs. 210, 213, 217–18), is the appearance of an artistic development unruffled by the High Renaissance. Sansovino was led in this direction by a new medium, bronze, and by such tasks as the San Marco reliefs and Sacristy door which brought him back to his own heritage, to the works of Donatello and Ghiberti. Bronze gave Sansovino the freedom to express himself quickly and directly without the burden of carving; if he can be said to have had a 'late style' in the conventional sense of that phrase, then it occurred in the remarkable decade between 1536 and 1546.

Sansovino's Venetian career also shows that he did not have one *maniera* but several on which he drew according to the nature of his task. Thus he could enter into the spirit of Donatello when fashioning the Loggetta gods, creating bronzes which could almost be mistaken for fifteenth-century Florentine works. Their slender and effeminate forms also squared well with the imported central Italian *maniera* that younger colleagues like Vasari and the Salviati brought to Venice. With Sansovino, however, it was more of a parallel evolution, arriving at a comparable aesthetic through different means. Above all, Sansovino was capable of thinking along different lines and in diverse stylistic modes at the same time. This can be seen with a number of overlapping works of the 1540s and 1550s, and the virtues from the Venier monument are an instructive example. The statue of *Charity* (fig. 291) can be traced back to a lost prototype produced some twenty years earlier, while the *Hope* (fig. 289) evolved from the more recent caryatids of the Villa Garzoni (fig. 338) and was implicitly related to Vittoria's *feminoni* at the entrance to the Library (fig. 434). Though it had a more complex evolution, *Hope* demonstrates the same recourse to earlier designs, amplified or

modified to suit the sculptor's needs. Superficially, *Hope* may not appear to have much in common with the diminutive *Peace* from the Loggetta (fig. 218) or the caryatids from the Villa Garzoni, just as the *Maiden Carilla* relief (fig. 260) looks unlike the bronze reliefs in San Marco (figs. 134, 136, 138, 141–43). In the end, these differences have as much to do with scale, medium, and decorum as with the maturation of Sansovino's style.

An ability to choose lies at the very heart of Sansovino's sculptural and architectural work, and he had a gamut of styles which could be adapted to any given situation. He had literally grown up with a range of choices, from Andrea Sansovino and his Florentine predecessors to Michelangelo and the antique. He presented a similar range of choices to his Venetian followers. When trying to summarize his career, we should think in terms of two tracks of development, one in stone and the other in bronze. In stone, Sansovino recreated a style that had analogies with his earliest work and with Central Italian art at the beginning of the century, but in bronze, he had fewer precedents to guide him and could indulge his fantasy more. In both cases, a binding link was a return to the Quattrocento Florentine tradition, at times filtered through the alembic of Michelangelo. Sansovino breathed new life into Venetian sculpture, liberating it from the more rigid conventions of the Lombardo tradition and providing new prototypes for a host of decorative figures and for compositions of the Virgin and Child. Here and also in large-scale works like the *giganti*, Sansovino served as a conduit of Central Italian ideas for a younger generation of sculptors, and what they made of his example lies at the centre of Venetian sculpture for the rest of the century. What sort of School did Sansovino bequeath to Venice and who were its principal exponents towards the end of the sixteenth century? Here one can speak only of sculpture, for, although Sansovino's architecture is such a conspicuous feature of Venice, a Sansovinian school of architecture simply does not exist, and his work was eclipsed by Palladio's. Instead, one of the striking features of Vasari's biography of Sansovino is the stress on the 'sculptural seminary' which he established in Venice.[33] Indeed, Sansovino was unusual among his contemporaries for the large number of pupils and collaborators whom he had across his career, and his dominance of the sculptural scene was proven indirectly by the difficulties faced by the procurators of San Marco when searching for an unbiased expert to appraise the Sacristy door.[34]

Of the principal exponents of Sansovino's school, Bartolomeo Ammannati and Tiziano Minio are the most problematic to assess, the former through his partial adherence to Sansovino's style, the latter through the incomplete nature of his *oeuvre*. Both Vasari and Borghini describe Ammannati as a pupil of Sansovino's, and Borghini specifically mentions an early trip to Venice to study under the older sculptor.[35] It is tempting to see Ammannati as the young disciple of Michelangelo mentioned by Lotto as accompanying Sansovino to Venice in 1527; yet the evidence is inconclusive, and Ammannati may not have quit Florence then or until the middle of 1529.[36] When he reached Venice and how long he remained there are subject to speculation. He was back in Tuscany by 1535, and during the subsequent years Ammannati's sculpture bears a clear imprint of Sansovino's style. This can be seen in the figure of St Nazarius on the tomb of Jacopo Sannazaro in Naples, a work modelled upon Sansovino's Florentine *St James*. It is also evident in the *Victory* from the Nari monument which, despite a conceptual debt to Michelangelo, displays a morphology and drapery style closer to Sansovino.[37]

The Sansovinesque substratum of Ammannati's sculpture is clearest, however, in the surviving commissions from his Veneto sojourn of the 1540s. This is not surprising, given the close proximity of Ammannati to Sansovino in 1543–44 when the younger man was carving a statue of Neptune and some keystones for the Library.[38] By January 1545 he had removed himself to Padua where he embarked upon a series of commissions for a distinguished local patron, Marco Mantova Benavides. The degree of Ammannati's immersion in Sansovino's style is most obvious in his works there, particularly in the arch erected for Benavides's palace. The relief panels, now sadly corroded (fig. 445), once bore testimony to Ammannati's

study of Sansovino's bronze reliefs in San Marco, and the statues of *Apollo* (fig. 443) and *Jupiter* have an evident affinity with the Loggetta bronzes.[39] The *Apollo* is, but for a slight alteration to the left forearm, a close copy of Sansovino's *Apollo* (fig. 213). The *Jupiter*, too, conflates the poses of the Loggetta *Mercury* and *Apollo* in a manner that anticipates the later work of Alessandro Vittoria.[40] Both figures are more compact, more classical in form, and generally less etherial than Sansovino's, though recognizably derived from his models.

By comparison, the tomb of Benavides (fig. 442) in the Eremitani church seems superficially Michelangelesque; yet here again the guiding influence behind the statuary is Sansovino. The recourse to formulae culled from the antique, the slender proportions of the figures and their basic ponderation, the smooth surfaces and rather feline characterizations point to the sculptural decoration of the Loggetta and, indeed, the Library. As Kriegbaum once observed, a figure like the *Fame* from the Benavides tomb reflects the kind of high-waisted, bare-legged female type that recurs so frequently in the work of Sansovino and his Venetian followers, but here one could speak of a possible influence from Ammannati on Sansovino.[41]

As strong as the influence of Sansovino is in Ammannati's Paduan sculpture, it diminishes rapidly in his later career. It is just visible in the statues of *Religion* and *Justice* on the de' Monte monuments in San Pietro in Montorio in Rome, but it is scarcely discernible in his sculpture for the Medici court in Florence.[42] There Ammannati comes more to terms with the legacy of Michelangelo and influences from Vasari, and takes a closer look at the antique; the only traces of Sansovino in his later work are a certain softness and an intermittent Quattrocentesque character. His divergence from Sansovino's Venetian style suggests that the idiom, although dominant, was localized to the Veneto, and certainly the other main followers of Sansovino's style all practised in Venice or her territories.

Tiziano Minio's career is more indicative of the volte-face that Sansovino's arrival in Venice caused among local sculptors. Minio was the nickname of Tiziano Aspetti, the uncle of the late sixteenth-century sculptor of the same name.[43] He was born around 1511/12, the son of a bronze-caster called Guido Lizzaro. Minio undoubtedly acquired his training as a founder under his father and would have gained his entrée into artistic circles through him as well, since his father had been a sometime collaborator of Giovanni Maria Mosca.[44] His first documented appearance is as a *stuccatore* on the vault of the chapel of the Arca del Santo in 1533; there he worked under the architect Falconetto and alongside two members of Sansovino's circle, Silvio Cosini and Danese Cattaneo.[45] In 1535–36 he executed his first independent work, the large stucco altar of the Confraternity of San Rocco in Padua (figs. 239, 444).[46] Large and ungainly, the altar has the crude vigour often associated with provincial workmanship. At the same time, it already shows an awareness of Sansovino's style, particularly in the drapery and general features of the female saints. In addition, the altar's format seems to reflect the design of the Loggetta in its deployment of statues and relief sculpture, the putti calling to mind the Ionic frieze on the Library.

The altar of San Rocco testifies to Minio's access to Sansovinesque motifs, and the medium of his introduction would have been the Arca del Santo, for which Sansovino was also working. Mino collaborated with Sansovino on stucco decoration in San Marco in 1536 and helped to cast the first bronze reliefs for the choir of San Marco thereafter.[47] He was clearly valued by Sansovino for his skills in plasterwork and bronze-casting, and Minio found in Sansovino a source of new ideas and a new figural language. This can be seen in all of Minio's surviving work, most forcefully in his stucco decorations for the Odeo Cornaro in Padua and in the bronze reliefs for the baptismal font in San Marco.

The stucco desorations of the Odeo Cornaro were undertaken between 1539 and 1543 for Minio's great patron and protector, Alvise Cornaro.[48] For over a decade, Minio was a member of Cornaro's household, and his career was materially advanced by his master on several occasions. The stuccoed ceilings of the Odeo furnish the best index of Minio's abilities

in this field (fig. 416). Intermingled with direct quotations from the first series of Sansovino's bronze reliefs in San Marco are other figures of an obvious Central Italian stamp that Minio could have known only via Sansovino or his sometime collaborator Danese Cattaneo. They have a fluency and a sophistication of design far removed from the altar of San Rocco, testifying to the remarkable transformation Minio underwent in a matter of a few years. The figures show the tendency towards elongated forms that is such a hallmark of Sansovino's sculpture, particularly in bronze, during the 1540s.

Shortly after the stucco decorations of the Odeo Cornaro, Minio had an opportunity to demonstrate his mastery of this mode in his only other significant work to survive, the cover for the baptismal font in the baptistry of San Marco (fig. 423). This was a project very much in Sansovino's gift, as he had persuaded the procurators to use a large block of marble in their stores for its base and had drawn up the contract with Minio.[49] Although the contract was also signed by Desiderio da Firenze, an enigmatic protégé of Pietro Bembo, the bulk of the design reflects Minio's style as seen in the Odeo and must represent his own invention.[50] It consists of eight panels, four of the evangelists and four scenes from the life of John the Baptist. The evangelists are seated in an impasto of clouds reminiscent of Sansovino's Medici Tabernacle (fig. 168) and the *Resurrection* on the Sacristy door (fig. 160), and they themselves suggest variations of the formulae employed by Sansovino on the small panels of St Mark and his lion on the *pergoli* of San Marco, with a similar treatment of drapery and facial types (figs. 145, 149). The scenes from the life of the Baptist are similarly peopled with Sansovinesque types and quotations from Ghiberti and Donatello, all set against a rudimentary perspectival backdrop. Here there is a stronger sense of narrative line than was present in the ceiling of the Odeo Cornaro, but, like the earlier stucco figures, the bronze ones on the baptismal font favour the same elongated forms found in Sansovino's contemporaneous relief sculpture. Modelled with great subtlety and in very low relief, the panels have emerged from their recent cleaning as among the most outstanding bronze panels produced in sixteenth-century Venice, a testimonial to Minio's skill as a founder and as an artist. They are also far removed, both morphologically and artistically, from the sculpture of the Lombardo school in which Minio grew up. In this context, they serve as a reminder of the watershed created by Sansovino's settling in Venice after 1527.

In addition to these works, Vasari records Minio's collaboration on his decorations for the performance of Aretino's *La Talanta* in 1542 and also speaks of 'alcune figurette' carved by the sculptor for Sansovino's Loggetta.[51] The former were temporary decorations and do not survive; the role of Minio in the latter project has been the subject of some speculation though it was probably confined to a small scale intervention, much as Vasari says (see figs. 424–25). What would have been Minio's most ambitious work is likewise known only from Vasari and documentary references. This was a series of five bronze gates for the entrance arcade of the chapel of the Arca del Santo, a commission undertaken jointly with Sansovino's former pupil Danese Cattaneo.[52] Piecing together documentary references and hints from other works, we can guess that the gates would have contained a series of historiated panels like the baptismal font's cover, framed by decorative schemes reminiscent of the ceilings of the Odeo Cornaro. They remained incomplete at Minio's death in 1552, and their disappearance has robbed us of an important criterion for assessing Minio's and, to an extent, Cattaneo's career.

Minio's early death and the ephemeral nature of many of his creations poses problems in estimating his importance to Veneto sculpture. This is further compounded by the promiscuous attribution of small sculptures to him and to other followers of Sansovino by Planiscig.[53] Few of these works have any relation to the known works by Minio discussed above or others like the Contarini arms (fig. 446) or the figure of *Justice* on the façade of the Palazzo Comunale in Padua.[54] By concentrating on his securely documented works, we can see that Minio was an artist of high decorative abilities and capable of translating Sansovino's style into the media of stucco and bronze. His position in the circle of Alvise Cornaro and at

the Arca del Santo made him central to the diffusion of the Sansovinesque style in Padua, and his association with Agostino Zoppo and indirectly with his nephew Tiziano Aspetti fostered the continuation of that style into the latter part of the century.[55]

The last decade of Minio's life was spent in a loose partnership with Cattaneo on the gates for the Arca del Santo. The two men were almost exact contemporaries, Cattaneo having been born around 1509 in Colonnata in the mountains of Carrara.[56] Cattaneo was probably apprenticed to Sansovino in Rome and followed his master to Venice in 1527, establishing himself as an independent sculptor shortly thereafter. His earliest surviving work is the statuette of *St Jerome* for the Merceria portal at San Salvatore (fig. 410), which Cattaneo executed in competition with a *St Lawrence* by Jacopo Fantoni in 1530 (fig. 411).[57] If imitation is a sign of discipleship, then Cattaneo proclaims himself here as Sansovino's follower, and so he was to remain until his death in 1572.

Like Minio, Cattaneo spent his early years on a variety of projects, from the stucco decorations of the vault of the chapel of the Arca del Santo to the figural component of Serlio's now-destroyed high altar for the Madonna di Galliera in Bologna, on which he collaborated with Jacopo Fantoni.[58] In the 1540s he received three important commissions, which established his career. These were the statue of the sun god for the Public Mint in Venice, the bust of Pietro Bembo for his monument in the Santo in Padua, and the entrance gates for the chapel of the Arca del Santo, the creation of which he shared with Tiziano Minio and which was never completed. Both the *Sun God* and the bust of Bembo illustrate aspects of Cattaneo's peculiar gifts as a sculptor.

The *Sun God* was an important state commission, which Cattaneo probably obtained on the recommendation of Sansovino, who was the Mint's architect.[59] According to Vasari, Cattaneo proposed to the authorities that there should be three statues for the Mint, a *Sole* signifying gold, a *Luna* for silver, and a third, unspecified, work for copper.[60] As Vasari appears to have had his information direct from Cattaneo, there seems little reason to doubt the proposal, though, in the event, only one statue was ordered. The proposal also reveals Cattaneo's highly literary approach to his craft, something conditioned by his other main occupation, poetry, and this proved to be a recurrent theme of much of the sculptor's later work. The *Sun God*, formerly on the well-head at the Mint and now in Palazzo Pesaro, displays something of the poet's gift for imagery (figs. 417, 448). It is an unconventional piece of sculpture, with the sun god as a nude figure seated upon a globe supported by mounds of gold generated by the sun's rays.[61] The pose recalls Michelangelo's *Giuliano de' Medici*, but the form is less substantial and the effect more lyrical. The features, too, reflect the softer style of Sansovino and of Ammannati, whose presence in Venice and Padua in the middle of the 1540s had an evident impact upon Cattaneo.[62]

The bust of Pietro Bembo represents a different though no less important realm of Cattaneo's achievement in sculpture. The bust was executed in 1548, one year after Bembo's death, as the centrepiece of the distinctive monument in the Santo which has been recently attributed to Andrea Palladio.[63] Aretino wrote appreciatively, if somewhat conventionally, of the life-like qualities of the marble portrait, adding that Sansovino and Titian admired it.[64] With its incisive characterization of the sitter and bell-like treatment of the upper torso, the bust of Bembo helped to popularize the new type of *all'antica* portrait in the Veneto. Cattaneo continued this type in later works, such as the bust of Lazzaro Bonamico (fig. 447), which is, if anything, an even more vivid portrait than that of Bembo.[65] It was Cattaneo's ability to convey personality in a classicizing framework that laid the foundations for the type of portrait bust in which Vittoria excelled.

Despite his gifts, Cattaneo's output was meagre and his material success less conspicuous than that of his younger rival Vittoria. As he survived Sansovino by only two years, Cattaneo's career unfolded very much in the shadow of the older man's, and like those rivals of Bernini's a century later, he had to content himself with crumbs from the rich man's table.

Thus he spent some of his career at work on the decorative sculpture for the Library and Loggetta and in carving fireplaces under Sansovino's direction (figs. 338, 340–41, 430–31). [66] One reason for Cattaneo's restricted *oeuvre* lay in his decided literary ambitions, which distinguished him from his fellow artists. His efforts culminated with the appearance of his poem *L'amor di Marfisa* in 1562, but he also left behind a number of unpublished sonnets, plays, and other verse. [67] These interests drew him into the circle of Paduan intellectuals such as Bembo, Alvise Cornaro, and Bernardo and Torquato Tasso, the last of whom Cattaneo encouraged with his *Gerusalemme liberata*. Obviously, these pursuits took time away from sculpture; as early as 1545, Aretino shrewdly noted that, if Cattaneo could give his undivided attention to sculpture, he would surpass even his master Sansovino. [68]

In the last decade of his life, Cattaneo created two of his greatest achievements, the Fregoso altar in Verona and the monument to Doge Leonardo Loredan in Venice. Both were essentially tombs and showed a merging of his interests in sculpture and literature. In both instances, Cattaneo altered the conventional formulae for such memorials by his distinctive approach to art. With the Fregoso altar, he did this by combining what was effectively a tomb to a *condottiere* with an altar dedicated to the Redeemer. [69] Though the format of the tomb was not without precedents in Verona, it is highly unconventional and in marked contrast to the more traditional types of monuments produced by Sansovino. Cattaneo may have been encouraged to produce something out of the ordinary by Palladio, who may have collaborated with him on the architectural design of the monument, but in the main he was following the example of Ammannati's highly abstract symbolism in the Benavides monument of the 1540s. [70] Thus the triumphal arch contains statues of Giano Fregoso and Military Virtue and reliefs of Minerva and Victory, while on the attic level *Fame* and *Eternity* flank trophies and the crowning arms of the Fregoso family. All of this sits uncomfortably with the central tabernacle of Christ, and, if Tasso is to be believed, Cattaneo felt rather defensive about his creation. [71] Despite these departures in format, the figural language of the Fregoso monument remains that of Sansovino. This is most evident in the personifications of Fame and Eternity (fig. 450), which recall the sinuous, lyrical style of the Loggetta bronzes, particularly *Peace* (fig. 218), but it is also present in the figure of Christ, one of the most beautiful by Cattaneo (fig. 449). In the eloquence of gesture, in the mixture of nobility and pathos, the Christ stands out in Cattaneo's *oeuvre*; to find something comparable, we must go back to the works of Sansovino's youth, the two *St Jameses* in Florence and Rome (figs. 45, 80). The later *St James* in particular was a work Cattaneo knew from his early years in Rome, and it obviously conditioned his own approach to statuary.

With the Loredan monument (fig. 453), Cattaneo also returned to Sansovino for inspiration. This was the long-deferred memorial to the doge whose reign witnessed the great drama of the War of the League of Cambrai, a project which Cattaneo and the architect Girolamo Grapiglia inherited at some point in the 1560s. [72] As with the Fregoso altar, there is here the same tendency towards allegory, but the message is exclusively secular. Cattaneo draws upon the Loggetta for the basic formula of allegorical statues framed by Composite columns, and in one instance, the figure of *Peace*, the reference is exact. The centre of the monument, however, contains a tableau re-enacting the War of the League in which Doge Loredan sits enthroned between female personifications of the League and of the armed might of Venice. Only an artist with the imagination of Cattaneo could have drawn upon the allegorical mode of the Loggetta and married it to the format of funerary monuments. The introduction here of active figures recalls the great tombs of the late fifteenth century like that of Doge Pietro Mocenigo, while the seated figure of the doge introduces a new iconographic convention into such memorials. The Loredan monument is a pivotal creation in the history of ducal tombs, looking back to the Renaissance and forward to the Baroque at the same time. With it, Cattaneo left his most lasting mark on Venetian sculpture. [73]

Of all Sansovino's followers, Cattaneo was unquestionably the closest to his former master

and something of a spiritual heir. He was probably more intimate with Sansovino's household than any of the others, being on close terms with both Jacopo and his son Francesco. The two sculptors had a period of strained relations during the 1550s when Jacopo cut Danese out of his will, but in his final will of 1568 the older man speaks with genuine affection of his former pupil and leaves him his casts of ancient and modern sculpture.[74] Francesco Sansovino chose Cattaneo as his representative in the dispute over the Sacristy door and spoke of him as a second father in his first will.[75] For his part, Cattaneo's sculptures are the best advocates for his unique position among Sansovino's disciples.

While Cattaneo was engaged on the Loredan monument in 1569, the emperor Maximilian II made enquiries in Venice about sculptors and architects who might consider service at the imperial court. The reply of his agent, Viet von Dornberg, is noteworthy because it gives a well-informed assessment of the Venetian artistic scene just prior to Sansovino's death.[76] For architecture, Giovanni Antonio Rusconi and Palladio are recommended, von Dornberg adding that 'with the exception of Sansovino, an architect and sculptor hired long ago by the state for its own service, Palladio is held to have attained the first place by general consent'. The writer can be forgiven for assuming that Sansovino had been hired as sculptor and architect to the Republic, and clearly by that date his position and age made him *hors concours*. Among sculptors, von Dornberg confirms the imperial report that Alessandro Vittoria is held the best after Sansovino, with Danese Cattaneo trailing a poor second. While this is a bit hard on Cattaneo, it none the less underscores the preeminence that Vittoria enjoyed over his rivals even before Sansovino's death. Already in 1568 Vasari had published a warmly appreciative account of his career in the *Vite*, and Vittoria's bravura in portraiture, statuary, and plasterwork made him an indispensible fixture in Venice throughout a long and profitable career.[77]

Vittoria, born in 1525, was a generation younger than Cattaneo. As a boy, he may have gained some knowledge of sculpture from the Paduans Vincenzo and Girolamo de' Grandi, then active in his native Trent. He left Trent for Venice in 1543, armed with a recommendation from the Bishop-Prince Cristoforo Madruzzo, and entered the workshop of Jacopo Sansovino.[78] It was a fortunate moment for the young man's arrival; Sansovino was at the height of his powers and had in hand several of his most important commissions, including the second choir reliefs and the Sacristy door for San Marco, the Loggetta bronzes, and the decoration of the Library. These works, especially the bronzes, formed the basis of Vittoria's artistic style and the touchstone for his later career. By 1550 Vittoria was carving river gods for the spandrels of the Library arches and executing his first independent works in his master's style.[79] The little *St John the Baptist* in San Zaccaria (fig. 451) betrays an unmistakable debt to Sansovino's statuette in the Frari (figs. 94–95) for its physical type and pathos, for its treatment of drapery and for its extended right arm. At the same time, the elongated form and attenuated proportions of the figure point to the stimulus of more recent works like Sansovino's Sacristy door (fig. 152) and Medici Tabernacle (fig. 165). It is a virtuoso piece, carved with delicacy and obvious love, and the marble statuette served as an example of Vittoria's technical expertise, much as the Frari *Baptist* did for Sansovino.[80]

Shortly after the execution of the little *Baptist*, Vittoria quarrelled with Sansovino and removed to Vicenza where he established himself as a stuccoist under Palladio at Palazzo Thiene. He remained there between 1551 and 1553 and his ceilings in Palazzo Thiene mark the first of numerous decorative cycles associated with his name.[81] His principal collaborators were the stuccoist Bartolomeo Ridolfi and the painters Bernardo India and Anselmo Canera, all Veronese, and their orientation towards the work of Giulio Romano, Parmigianino, and the young Paolo Veronese widened Vittoria's frame of reference considerably. The coalescence of these elements can be seen in an early masterpiece, the ceiling of the octagonal *sala* on the ground floor of the palace: the river gods recall those on Sansovino's Library, and the smooth, attenuated figural canon draws upon Vittoria's experience of the Loggetta and the

Sacristy door; at the same time, the decorative scheme combines motifs from Mantua and Padua, while the fluidity of the narrative panels points to Parmigianino.[82] It was the example of Parmigianino, whose work Vittoria assiduously collected, that drew the young sculptor towards the inflected, etherial manner first seen here and subsequently a hallmark of his work. His reinterpretation of Sansovino's Venetian sculpture must be viewed against the background of the complementary work by artists like Tiziano Minio, Andrea Schiavone, and Veronese.

Vittoria's two most famous contributions to ceiling decoration occurred in Venice with the Scala d'Oro of the Doge's Palace (figs. 432, 435) and the Library staircase (fig. 421). Both were in hand at the end of the 1550s and reflect a collaboration between Vittoria and his former master, Sansovino.[83] In both cases, the basic decorative schemes stem from Sansovinesque designs which must have been approved by the leader artist even though they are more luxuriously embellished than in Sansovino's own work. Vittoria's figural style also breaks more decisively here with Sansovino's than was previously the case, betraying an unmistakable influence from Paolo Veronese's ceilings in San Sebastiano and the Sala del Consiglio dei Dieci.[84] His more convoluted and attenuated forms distinguish Vittoria from Sansovino and clearly align him with the younger generation of artists then making their début in the Sala d'Oro of the Library and in the Doge's Palace.

Vittoria brought much the same aesthetic creed to his statuary. His first major work in this field, the *feminoni* or caryatids at the entrance of the Library (fig. 434), paraphrases a Sansovinesque model much as Ammannati did with his allegorical figures on the Benavides monument a few years before (fig. 442). By the early 1560s, when Vittoria carved the *St Roch, St Anthony Abbot,* and *St Sebastian* in San Francesco della Vigna, though the figures are still much indebted to Sansovino, new influences are making themselves felt.[85] In particular, the *St Sebastian* looks beyond obvious models like the Loggetta bronzes to the *Laocoon* group, Parmigianino, and Michelangelo's *Slaves.* It strikes a balance between an exploitation of dynamic movement and a self-conscious presentation of beautiful forms, two features characteristic of the best of Vittoria's work. The *St Sebastian* also possesses the appearance of an enlarged statuette, and it is not surprising that the sculptor had his model preserved as a handsome small bronze, where its sinuosity can be even better appreciated (fig. 455).[86].

The style of the *St Sebastian* can be traced through many later works, but it was never more successfully embodied than in two small stone figures of the 1580s, the *Prophet Daniel* (fig. 456) and *St Catherine of Alexandria,* from the altar of the Mercers' guild in San Giuliano.[87] Again, the impression of a small-scale composition subsequently enlarged seems inescapable, but their gracefulness and formal dexterity would not shame Parmigianino. They bring to stone something of the malleability of bronze and show that, almost forty years after his apprenticeship, the impact of Sansovino's bronzes was still fresh in Vittoria's mind.

A Michelangelesque element has been noted in Vittoria's figures for San Giuliano, but its presence is even stronger in the sculptor's chief essays in the male nude, the *St Jeromes* in the Frari and Santi Giovanni e Paolo. That carved for the Zane altar of the Frari is the earlier and more imposing of the two (fig. 452).[88] Carved around 1570, it shows the saint in penance, turning sharply to the left as he strikes his chest with a stone. As Kauffmann observed, the basic pose depends upon Donatello's *St Jerome* in Faenza, a work which Veronese employed a few years earlier for a penitential Jerome on the organ case of San Sebastiano.[89] Both artists may have known Donatello's work through Sansovino's adaptations of it, as both were privy to his workshop in the 1550s. The Donatellesque kernel has, however, been overlaid with more monumental forms that are unmistakably Michelangelo's. This component of the *St Jerome* was noted by Temanza, and the forward thrust of the right arm and corresponding action of the left leg establish a *contrapposto* reminiscent of the *St Matthew* (fig. 52) or Sansovino's variations on it (figs. 160, 217). Of course, Sansovino had created similar figures on occasion, notably the old man on the left of the *Maiden Carilla* relief (fig. 263), and had

experimented with the juxtaposition of a saint and his emblematic lion (figs. 145, 149), but he was never fully at ease with the male nude or with the dynamic qualities of Michelangelo's later works. By contrast, Vittoria shows himself in command of both, just as Tintoretto did with his *Last Judgement* in the Madonna dell'Orto. The *St Jerome* is saved from an arid academicism by the naturalness of the saint's gesture and by the emotional quality with which the work is invested. Vittoria has here created a figural type that forms a bridge between the High Renaissance and the Baroque.[90]

The *St Jerome* in the Frari is unquestionably one of Vittoria's greatest statements in stone, and though he continued to produce statuary almost to the end of his career, he never again achieved such conspicuous results. All too often, as in his statue of Tommaso Rangone as St Thomas (fig. 283) or the stucco evangelists in San Giorgio Maggiore, a certain slackness pervades his work, perhaps indicative of an unease when working on a larger scale.[91]. But Vittoria's talents led him in another direction, to exploit a vacuum in the Venetian sculptural market, portraiture. It was an aspect of sculpture in which Sansovino evinced little interest, and his handing over of Rangone's statue may have been a recognition of Vittoria's promise in this area.[92] Vittoria's first ventures in portraiture, like the bust of Marc'antonio Grimani in San Sebastiano (fig. 454), are based on the *all'antica* style of Simone Bianco and, more especially, Danese Cattaneo.[93] Vittoria built upon the psychological perceptiveness and directness of Cattaneo's portraits, but his characterizations are more dramatic, his treatment of drapery in the aristocratic images is more imposing, than Cattaneo's or most contemporary portrait sculpture. At their best, his busts (fig. 281) have a vivacity unmatched by any other contemporary portraitist, and in his succession of doges and military heroes, Vittoria expressed that image of the Republic so carefully fostered in Venetian ceremonial.

Vittoria continued to play a major role in Venetian sculpture until his death in 1608, but if any one sculptor dominated the last two decades of the sixteenth century, it was not Vittoria but a younger rival named Girolamo Campagna. Born in Verona in 1549, Campagna was of a later generation than Vittoria and through his apprenticeship with Danese Cattaneo could be described as an artistic grandson of Jacopo Sansovino.[94] He had been a pupil of Cattaneo while the latter was at work upon the Fregoso altar in Verona and literally inherited several important commissions from his master, including the completion of the Loredan monument (fig. 453) and the last marble relief for the cycle in the Santo in Padua. His *Miracle of the Raising of the Youth at Lisbon* (fig. 267) presents Campagna as the continuator of Sansovino's narrative style as expressed in the *Maiden Carilla* relief (fig. 265); it is an accomplished work for a sculptor still in his twenties and demonstrates an easy command of the Sansovinesque vocabulary.[95]

The fame accruing from that commission meant that Campagna was immediately established among the major Venetian sculptors of his day, and this position was consolidated between 1580 and 1584 by his redesigning of the high altar of Sant'Antonio in Padua, which he turned into a proto-Baroque *macchina* with Donatello's bronze figures draped like so many Christmas ornaments. In the same decade Campagna also received commissions for statues for the Doge's Palace and for the crowning balustrade of the Library, again an indication of his growing prominence in this area.[96] Probably the most tangible evidence of Campagna's superiority over Vittoria as a carver of statuary came in 1583 when he won the right to execute six allegorical figures for the tomb of Doge Niccolò Da Ponte while Vittoria carved only the bust.[97] Campagna subsequently gained other commissions which ought to have gone to his better-established rival, such as the high altars of the Redentore and San Giorgio Maggiore, both dating from the early 1590s. In each case, Campagna was called upon to create a new kind of altar, quite without precedent in Venice, to meet the demands of Counter-Reformation church architecture.[98] This meant, essentially, an altar to be seen from all sides, by congregation and clerics alike, and Campagna showed himself sensitive to the nature of both sites. For the Capuchins of the Redentore, he created a variant on the medieval

meditation on the Crucifixion, with Sts Mark and Francis flanking the cross.[99] Though the impact of the original composition has been diluted by the rebuilding of the altar in the seventeenth century, it is still possible to appreciate the dynamic qualities of the individual figures. The *contrapposto* of the saints establishes a sense of three-dimensional movement which complements the articulation of Christ's body. While the *St Mark* (fig. 458) and *St Francis* invite comparison with works by Sansovino and Vittoria, the crucifix (fig. 459) points rather to Donatello's corresponding bronze figure for the Santo, a work which Campagna would have had ample time to study when he remodelled the high altar there. The *Christ* is one of Campagna's best-achieved works, marvellously modelled and with a surer sense of anatomy than would have been the case, in all probability, with Vittoria. Here Campagna obtained a perfect equilibrium between beauty of form and pathos unequalled in his later sculpture.

Timofiewitsch rightly compared the compositional form of the Redentore's high altar with works by Tintoretto, and certainly if Campagna had an affinity with a contemporary artist, it would be with that painter. For San Giorgio Maggiore, Campagna actually collaborated with a follower of Tintoretto, the painter Aliense, who furnished the design for the Benedictines' high altar and recommended Campagna for its execution.[100] Ridolfi, who was a pupil of Aliense, explained the resulting work as 'le tre Divine Persone, il Mondo e gli Evangelisti, promulgatori della Cattolica Fede'; as such, the idea was not unusual and could be traced back to the representations of the evangelists in the cupolas of San Marco.[101] What is unusual, however, is the form in which this is displayed. God the Father stands on a globe which bears the dove and before which stands a crucifix. The globe itself is supported by the evangelists, John and Mark in front and Luke and Matthew behind (fig. 457). The primary sense of the work would seem to be, as Ridolfi implies, the promulgation of the Catholic Faith through the divinely inspired text of the four apostles. In artistic terms, the *Evangelists* show an awareness of Michelangelo's *Slaves*, an interest which Campagna shared with his older contemporary Tintoretto. They are also possessed of a weight and dynamism unrivaled by any other Venetian sculptor of the period and are comparable only with the best work produced by the shop of Giambologna. In more traditional fields, such as the Virgin and Child or small bronzes, Campagna created a personal re-elaboration of the style of Sansovino and Cattaneo with some reminiscences of Veronese, as would be expected of someone who grew up in Verona. It was fortunate for Vittoria that the two areas in which Campagna did not excel were mythological compositions and portraiture.

The impact of Campagna's work can be seen in the sculpture of the Paduan Tiziano Aspetti, the Genoese Niccolò Roccatagliata, and the Veronese Giulio dal Moro. Aspetti came of a famous family of founders and formed his own style on that of his uncle, Tiziano Minio, as well as that of Campagna, with whom he may have worked. Certainly his earliest known works in Venice were executed in connection with Campagna and essentially approximate that sculptor's style.[102] Aspetti had, however, the good fortune to be taken up by the great Venetian art-patron and collector Giovanni Grimani, Patriarch of Aquileia, for whom he restored antiques and for whom he executed two large bronzes of *Moses* and *St Paul* for the façade of San Francesco della Vigna in 1592. The medium of bronze was particularly felicitous for Aspetti, and he earned great praise for the reliefs he made for the altar of St Daniel in the crypt of Padua Cathedral (fig. 463).[103] The two panels, which treat the martyrdom of the Paduan saint and experiment with the high relief style of Sansovino's works for San Marco, are among the most accomplished bronze reliefs of the late sixteenth century. Aspetti's figures display that exaggerated fluidity found in the work of his uncle Tiziano Minio, particularly the reliefs of the life of St John the Baptist on the baptismal font in San Marco (fig. 423), which would have been an obvious touchstone for a young sculptor. The success of the St Daniel reliefs led to another important commission in Padua, eleven statues and a pair of bronze gates for the shrine of St Anthony in the Santo, executed between 1593 and 1596.[104]

Graceful if bland, these saints, angels, and virtues come closer to the classicizing vein of Campagna than they do to Vittoria. However, Aspetti's few portrait busts not unexpectedly betray a self-conscious modelling on those of Vittoria.

Aspetti moved to Tuscany in 1599 but returned to the Veneto in 1602, when he made a number of silver statuettes for the Duchess of Mantua. He returned to Tuscany in 1604 with Antonio Grimani, the apostolic nuncio, and divided his time between Pisa and Massa Carrara. Before his death in 1606, Aspetti made a will in which he referred to ten statues, some finished, and a pair of bronzes, *Hercules and the Centaur* and *Hercules and Antaeus*. None of these works has been identified, but there is one relief that does survive from this period, the *Martyrdom of St Lawrence*, made for the Usimbardi chapel in Santa Trinità in Florence.[105] Though similar to the Paduan reliefs, the Florentine one reflects an awareness of Giambologna's reliefs, especially those for the Grimaldi chapel in Genoa.

Less is known of Aspetti's contemporary Niccolò Roccatagliata.[106] He trained as a goldsmith in his native Genoa before coming to Venice, probably in the 1580s, when tradition has it that he made models for Tintoretto. He is known to have worked for the Benedictines of San Giorgio Maggiore in the 1590s, and for them he created a number of sculptures in bronze. Figures like the *St Stephen* and *St George* or the recently identified *Virgin and Child*, now at Écouen (fig. 462), place Roccatagliata in the orbit of Campagna, who also made a marble *Virgin and Child* for San Giorgio at the same time.[107] The Genoese sculptor strikes a more fanciful and individualistic note in works like the *St George and the Dragon* or the large candelabra in the presbytery of San Giorgio, and the handful of securely autograph works are enough to assure Roccatagliata a distinguished place among the sculptors working in Venice at the end of the century. He disappeared from Venice around 1597 and apparently returned to Genoa, where he is known to have executed a number of works in the first part of the seventeenth century. In 1633 he signed the bronze altar frontal in the Sacristy of San Moisè in Venice, which he executed together with his son Sebastiano. He is last documented in 1636, when he received a contract for the figures of angels to flank Campagna's *Evangelists* on the high altar of San Giorgio. These figures were to have been made in collaboration with Pietro Boselli, but Boselli executed the angels in 1644, some time after Roccatagliata's death.[108]

The last of this trio, Giulio dal Moro, was a rare example of an artist who was painter, sculptor, and architect.[109] Born in Verona in 1555, dal Moro was the son of the painter Battista and the younger brother of Marco dal Moro. His family was active in painting and stucco work, and Giulio undoubtedly learned these trades under his father and older brother. In 1577 Giulio is recorded as working with Marco on paintings and stucco decorations for the Sala dell'Anticollegio in the Doge's Palace, and over the next three decades proved himself a highly accomplished stuccoist, sculptor, and painter in the refurbishment of the Doge's Palace after the fires of 1574 and 1577. He was at work alongside Campagna in the Sala delle Quattro Porte in 1589–90, where he executed three allegorical figures of Secrecy, Diligence, and Loyalty. Just how dal Moro learned to carve stone is a mystery, but the grace and sveltness of the figures point, at the very least, to a close study of analogous sculptures on the Fregoso altar in Verona, a monument by Cattaneo on which the young Campagna was employed (figs. 449–50). Though dal Moro was too young to have assisted in the making of that monument, he may well have gravitated to Campagna's workshop in the 1570s and 1580s. However that may be, dal Moro's statuary demonstrates an affinity with the work of both sculptors. Interestingly, his *Christ* on the Andrea Dolfin monument in San Salvatore (fig. 460), executed in 1603–04, appears to have been based not only on Cattaneo's analogous work on the Fregoso altar, but even more on Jacopo Fantoni's *Redeemer*, carved for the church of Santa Croce in Venice over half a century earlier.[110] Fantoni had been one of Sansovino's earliest followers in Venice and had worked in tandem with Cattaneo during the 1530s, at which time both sculptors evolved similar styles. So it is not surprising that Giulio dal Moro would have based his *Christ* on such a model. By the same token, the unusual format of the

Dolfin monument, with the figure of the Saviour in the middle, simply varies the formula of Cattaneo's 'mixed' altar and tomb for Gian Fregoso in Verona. Here the busts of Andrea Dolfin and his wife were carved by Campagna, though it was generally dal Moro who assumed Vittoria's mantle as official portraitist to the Venetian nobility in the early years of the seventeenth century. His most notable achievements in this field are the busts of the doges Tribuno Memmo and Sebastiano Ziani on the façade of San Giorgio Maggiore, the bust of Zuane da Lezze on the da Lezze monument in the Gesuiti (fig. 389), and that of Doge Marc'antonio Memmo in San Giorgio Maggiore.[111] It was in this field and in the medium of stucco decoration that dal Moro demonstrated his best abilities, whereas his statuary tends never to rise above a level of mere technical proficiency.

Vittoria, Campagna, Aspetti, and Roccatagliata have all been lumbered with a number of dubious attributions of firedogs and small bronzes. What is known of their careers and the little known about the production of popular bronzes suggest that most, if not all of these, were the creation of highly competent founders. For example, the two splendid well-heads in the courtyard of the Doge's Palace are the creation of two master founders of the Arsenal, Niccolò dei Conti and Alfonso Alberghetti; yet, if their names did not appear on the wells, the obvious solution would be to assign them to Vittoria.[112] Another example of this kind is the magnificent paschal candelabrum now in the Salute but made for the church of Santo Spirito, probably in the late 1560s.[113] It, too, would pass as a work by Vittoria were it not signed by his close friend Andrea di Alessandro da Brescia, who cast Vittoria's statuette of St Sebastian (fig. 455). Andrea is also documented as making any number of small bronzes as part of his stock in trade as a founder. Major sculptors like Sansovino or Vittoria or Campagna were not founders and had to rely upon trained professionals like Tiziano Minio or the Campanato and Alberghetti families. But their rapport with such men led to the diffusion of what can be seen as a Venetian style in the applied arts. Artisan-founders, thoroughly conversant with the idiom of the greater sculptors, imitated their works in the form of doorknockers, ink wells, and the like, and it is to them rather than their more distinguished contemporaries that the bulk of minor Venetian bronzes should be ascribed.[114]

The dawn of the seventeenth century found Venetian sculpture in a situation not unlike that of the 1520s, for the school founded by Sansovino and his followers was a dwindling phenomenon. Its condition was fairly assessed by the agent of the Duke of Urbino, who negotiated with Campagna for a statue of the first duke, Federico da Montefeltro, in 1604. Campagna, the agent wrote, could pick and choose among commissions on offer because he had no real competition, and he 'had to be handled with kid gloves because sculptors suffer from the same malady as poets and painters, Campagna no less than others'.[115] Death and migration cut away Sansovino's school: Segala died in 1592; Aspetti quit the Veneto definitively in 1604; Roccatagliata was absent from Venice between 1596 and 1633; Vittoria died in 1608; Giulio dal Moro in 1616. Campagna soldiered on until 1625, producing a number of statues of substantial if somewhat academic quality.

In retrospect, one can see that Venetian sculpture of the sixteenth century divides into two periods. The earlier, dominated by the Lombardo family, witnessed an opening towards Central Italian sculpture of the earlier fifteenth century and towards the antique. This latter strand in Venetian sculpture led to the development of a precociously classical style by the turn of the sixteenth century, but it was a style incapable of developing beyond the achievements of those first decades and literally passed away with its major proponent, Tullio Lombardo. It was replaced by a more versatile and cosmopolitan style, which Sansovino ushered into Venice in the years around 1530. While Sansovino's art paid token lipservice to the classical ideal, it had little in common with that of the Lombardo brothers, as a relief like the *Miracle of the Maiden Carilla* demonstrates (fig. 265). Then too, with its inclination towards a neo-Quattrocentesque manner based upon Ghiberti and Donatello, Sansovino's sculpture fitted more easily into the tradition of decorative sculpture espoused by Antonio Rizzo (fig.

295). Coupled with its fifteenth-century sense of grace, Sansovino's sculpture was also grounded in the achievements of Central Italian sculpture and painting at the turn of the century. The diffusion of Sansovino's style in Venice was assured by his position in that city and by the substantial number of associates and followers who were conversant with his idiom and able to reproduce it. Sansovino's school proved a resilient one, and in their hands his repertoire was widened to include elements from the later work of Michelangelo and other aspects of classical sculpture. Though it had run its course by the death of Girolamo Campagna, the Sansovinesque style continued to resurface in later generations, especially when sculptors were called upon to depict the tenderer emotions. Even a thoroughly Baroque sculptor like the Genoese Filippo Parodi fell under this spell when creating his *Pietà* in Santa Giustina, Padua, a work Temanza believed was based on a lost *Mater Dolorosa* by Sansovino (fig. 465).[116] Antonio Corradini also essayed a similar composition in his *Pietà* of 1723 (fig. 466), and we have seen how Giovanni Marchiori patterned his *David* in San Rocco (fig. 232) after Sansovino's *Apollo* (fig. 25).[117] Thus Sansovino remained a touchstone of elegance and expressiveness well into the eighteenth century, and it comes as no surprise to discover traces of his style in the juvenile works of Antonio Canova (fig. 467).[118]

Corpus of Documents

A note on the documents

I HAVE INCLUDED an appendix of documentary sources for two principal reasons. One is that the reader will be able to check my interpretation of events in Sansovino's career against the sources; the second is that such an assemblage of documents may prove useful for economic and social historians as well as art historians. It would be impossible to reprint here all documents concerning Sansovino, and I have included items dealing primarily with his sculptural career, together with a few concerning his architectural practice where they throw light on his career as a whole.

The following texts are not presented for the professional paleographer. A modicum of punctuation and standardized capitalization has been introduced; abbreviations have been expanded in the hope of making these pages more intelligible to readers unfamiliar with Italian notarial conventions. Where a source is a printed book, such·as the 1609 edition of Aretino's *Lettere*, I have reproduced it as printed. Those documents taken from printed sources or not consulted by me in the original are numbers: 28–29, 31–32, 34–56, 58–59, 61–67, 91–92, 103, 106, 110–11, 123–25, 137, 167, 175, 207, 242–45, 247–48, 253, 257, 304–05, 309. The vast majority of the documents printed here have been reread and freshly transcribed by me for the appendix. Those documents never before published or only summarily mentioned in earlier literature are numbers: 68, 82, 86, 93–102, 108–09, 113, 121, 141–43, 152, 154, 159, 168–69, 173–74, 177–92, 198–203, 205–17, 220–25, 240, 246, 251, 260, 306–08. Within documents, I have employed the following symbols:

[]	editorial emendations
. . .	omissions from the text
⟨ . . . ⟩	gaps in the text

1. Sansovino's birth
Domenica, adì 2 di luglio 1486. Jacopo Bastiano et Romolo d'Antonio di Jacopo popolo di Sam Piero Maggiore nacque adì 2, hore 8, battezzato adì 2.

(AOD, Libro de' battezzati, maschi, 1481–91, fol. 71r; Pittoni, 1909, p. 7)

2. Tax declaration by Sansovino's father, 1505
[in the left margin] Data la scritta di numero 233, Gonfalone Ruote, Santa Croce.
Quartiere di Santa Maria Novella, Gonfalone Lione Bianco
Anttonio di Iachopo di Giovanni, materasaio, trato del'estimo di chontado e del quartiere di Santa Maria Novella e popolo di Santo Lorenzo drento, numero 7, e meso a graveza in Firenze per gli uficiali del'estimo del'ano 1505, per loro partito e per virtù di legie.

Sustanzie

Una bottegia a uso di materasaio, posta nel popolo di Santo Andrea di Firenze, nela via de' Pelliciai, da primo via detta, secondo beni di Santo Branchazio, a 3° beni del Cepo, a 4° piaza di Santo Andrea. La quale bottegia tiene a livello da' fratti di Santa Croce di Firenze e pagane l'ano a detti fratti fiorini 14 di suggello e una ocha_____ fiorini 3 lire 6 larghi di grossi

Boche di maschi

Anttonio di Iachopo detto, d'anni	47
Iachopo di detto Anttonio, d'anni	18
Giovanni, suo figliuolo, d'anni	15
Piero, suo figliuolo, d'anni	12

femine

Mona Francesca, dona di detto, d'anni	37
Madalena, sua figliuóla, d'anni	10
Lessandra, sua figligliuola [*sic*], d'anni	7

Salda per me Pietro Pagolo Monti questo dì xvii di settembre

1505, per entrata di fiorini 3 soldi 6 denari 7: tochagli di decima soldi sei denari x oro, di fiorini larghi di grossi

fiorini____. 6. 10 larghi di grossi
Adì 26 di febbraio 1511 arogasi fiorini 1. 4 per beni di contadini, come nela scripta numero 71: monta fiorini 1. 9. 2.
Al' 32 in Iacopo d'Antonio di Iacopo, gonfalone Ruote, numero 233, per deima di fiorini 1. 9. 2____ fiorini 1. 9. 2

(ASF, Decima Repubblicana, filza 44, fol. 269r)

3. Contract for the *St James* in Florence Cathedral

Die xx Junii [1511]
Deliberatio pro figura appostoli fiendi in cathedrali ecclesie

Superdicti domini operarii omnes in concordia et servatis servandis ect., locaverunt Jacobo Antonii decto il Sansovino sculptori florentino ad faciendum pro opera unum Apostolum Sancti Jacobi pro mictendo in ecclesia cathedrali et quod eidem consignetur unum petium marmoris existentem super platea dicte opere pro faciendo statuam predictam cum pactis et condicionibus quod dictam statuam debeat perfecisse hinc ad unum annum proxime futurum, et quod mense quolibet debeat habere pro eius provisione Florenos tres auri largos in auro.

(AOD, Deliberazioni, 1507–15, fol. 72v; see Poggi, 1988, p. 147, no. 2160)

Payments and decisions relating to the *St James*

4. 1511 dicembre 19
Jacopo d'Antonio del Luchese sculptore di marmi, lire XXI piccoli per tanti se gli pagano per conto dello appostolo adì 19 detto lire 21

(AOD, II-4-23, Stanziamenti, quaderno del notaio, 1505–13, fol. 127v; see Poggi, 1988, p. 147, no. 2161)

5. 1511 febbraio 13 [=1512]
Jacopo d'Antonio di Luchese sculptore lire XXI piccoli per conto di sua provisione d'una statua d'apostolo di marmo fa per l'opera pagata [?] adì 13 detto lire 21 soldi____

(AOD, II-4-23, Stanziamenti, quaderno del notaio, 1505–13, fol. 130r; see Poggi, 1988, p. 147, no. 2161)

6. 1512 aprile 7/17
Jacopo d'Antonio del Luchese scultore lire XXI piccoli per tanti a-llui dati per sua provisione della statua dello appostolo fa per l'opera lire 21 soldi____

(AOD, II-4-23, Stanziamenti, quaderno del notaio, 1503–13, fol. 132r; see Poggi, 1988, p. 147, no. 2161)

7. 1512 agosto 6/14
Jacopo d'Antonio del Luchese sculptore lire XXI piccoli per sua provisione d'uno appostolo fa per l'opera lire 21 soldi____

(AOD, II-4-23, Stanziamenti, quaderno del notaio, 1503–13, fol. 139r; see Poggi, 1988, p. 147, no. 2161)

8. 1513 maggio 14
Jacopo d'Antonio scultore lire XXI piccoli per sua provisione del fare uno apostolo per conto della chiesa pagata [?] adì 14 decto
lire 21 soldi____

(AOD, II-4-23, Stanziamenti, quaderno del notaio, 1503–13, fol. 150v; see Poggi, 1988, p. 147, no. 2161)

9. 1513 giugno 21
Jacopo d'Antonio del Luchese sculptore lire XXI piccoli per sua provisione dello apostolo pagata [?] a dì XXI di giugno
lire 21 soldi____

(AOD, II-4-23, Stanziamenti, quaderno del notaio, 1505–13, fol. 152v; see Poggi, 1988, p. 147, no. 2161)

10. Die xvi maii MDXIIII
[In margin] Quod figura appostoli locata Jacobo sculptori reducatur ad operam
Superdicti Domini operari servatis servandis etc., deliberaverunt quod figura appostoli locata Jacobo Antonii Sculptori Florentino, que est in hospitale Sancti Honoforii prope portam Justitie reducatur ad Operam et similiter omnis materia laterum et tegulorum muratorum pro fiendo locum dicti appostoli ibidem existens reducatur ad Operam.

(AOD, Deliberazioni, 1507–15, fol. 166r; see Poggi, 1988, p. 149, no. 2168)

11. Die xviiii dicti mensis Aprilis MDXV
Quod Jacobus Antonii Sculptor possit perficere appostolum iam inceptum Item servatis servandis etc., prefati domini consules non obstante qualibet deliberatione incontrarium per eos facta circa perficiendo appostolos inceptos deliberaverunt quod Jacobus Antonii dictus il Sansovino sculptor florentinus possit et eidem liceat perficere appostolum per eum iamdiu inceptum cum sua provisione.

(AOD, Deliberazioni, 1507–15, fol. 196v; see Poggi, 1988, p. 150, no. 2173)

12. Die xviiii maii 1515
Jacobo Antonii sculptori libras XXI pro parte sue provisionis super lavorando unum appostolum ex marmore
lire 21 soldi____

(AOD, II-4-24, Stanziamenti, 1514–22, fol. 8v; see Weihrauch, 1935, p. 89)

13. Die xviiii Junii 1515
Jacobo Antonii sculptori libras XXI piccioli pro parte eius provisionis pro faciendo appostolum pro opera
lire 21 soldi____

(AOD, II-4-24, Stanziamenti, 1514–22, fol. 10v)

14. Die xxviii Julii 1515
Jacobo Antonii sculptori libras XXI piccoli pro eius provisione pro laborando appostolum ad rationem florenorum trium auri largorum in auro pro mense quolibet Lire 21 soldi____

(AOD, II-4-24, Stanziamenti, 1514–22, fol. 16v; see Weihrauch, 1935, p. 89)

15. Die xiii mensis augusti 1515
Jacobo Antonii sculptori libras XXI piccioli pro parte sue provisionis pro laborando appostolum facit pro opera
lire 21 soldi____

(AOD, II-4–24, Stanziamenti, 1514–22, fol. 17ʳ)

16. Die vii septembris 1515
Jacobo Antonii sculptori super laborando appostolum libras XXI piccioli pro provisione eiusdem lire 21 soldi____

(*Ibid.*, fol. 17ᵛ)

17. Die xviii octobris MDXV
Jacobo Antonii sculptori libras XXI piccioli pro sua provisione pro appostolo conficiendo lire 21 soldi____

(*Ibid.*, fol. 20ᵛ)

18. Die xxv decembre 1515[1]
Antonio Jacobi matarassario libras 14 piccioli pro parte fattura trium padiglionorum quos facit pro tribuna ecclesie
lire 14 soldi____

(*Ibid.*, fol. 23ʳ)

1. This must be a reference to Jacopo Sansovino's father, who probably obtained the commission for three baldachins through his son.

19. Die xxv Januarii 1515 [=1516]
Jacopo Antonii sculptori libras 21 piccioli pro provisione pro laborando appostolum lire 21 soldi____

(*Ibid.*, fol. 25ʳ)

20. Die vi martii 1515 [=1516]
Jacobo Antonii sculptori libras 21 piccioli pro parte sue provisionis lire 21 soldi____

(*Ibid.*, fol. 28ʳ)

21. 1516 agosto 20
Operarii deliberaverunt quod appostolus et figura appostoli que laboratur per Jacobum Antonii, sculptorem florentinum, extrahatur de mansione in qua est de presenti et mictatur in curia ubi laborant scalpellini dicte opere et in apoteca que facta fuit contemplatione magistri Andree de Ferruccis adeo quod ubi est ipsa figura possint poni lignamina dicte opere . . .

(AOD, Deliberzioni, 1515–19, fol. 14ᵛ; see Poggi, 1988, p. 151, no. 2176)

22. Die 23 septembris 1516
Jacobo Antonii sculptori super appostolum fiendum ex marmore libras 56 piccioli pro sue provisione duorum mensium videlicet, augusti et septembris. lire 56
Jacobo predicto libras XXXV pro eius provisione mensis septembris omnis predicti (?) lire 35 soldi____

(AOD, II-4–24, Stanziamenti, 1514–22, fol. 47ʳ; see Weihrauch, 1935, p. 89)

23. Die 5 decembris 1516
Jacobo Antonii sculptori libras XXXV pro eius provisione super laborando appostolum lire 35 soldi____

(AOD, II-4–24, Stanziamenti, 1514–22, fol. 48ᵛ)

24. Die Jovis octava Januarii 1516 [=1517]
Jacobo Antonii sculptori et super appostolo deputato libras XXXV piccioli pro parte et compositio sue provisionis ad rationem florenorum 3 largorum pro mense quolibet
lire 35 soldi____

(*Ibid.*, fol. 52ᵛ)

25. Die Sabati 4 martii 1516 [=1517]
Jacobo Antonii sculptori marmorum et deputato super appostolo conficiendo libras XXXV pro parte sue provisionis
lire 35 soldi____

(*Ibid.*, fol. 55ʳ)

26. Die martis xxii septembris 1517
A Jacopo d'Antonio sculptore decto Sansovino lire XXXXII per parte di factura d'uno apostolo di marmo fa per l'opera
lire 42 soldi____

(*Ibid.*, fol. 70ʳ)

27. Die quinta Januarii 1517 [=1518]
Item atendentes qualiter Jacobus Antonii sculptor florentinus perfecit figuram Sancti Jacobi de marmore ad usum optimi sculptoris et atendentes qualiter dictus Jacobus ex sua humanitate remisit pretium sibi debendum ex figura predicta in dominos operarios, ideo habito iudicio a pluribus practis etc., declaraverunt pretium dicti apostoli fuisse et esse debere florenos CXXXV dari debere persone proprie dicti Jacobi et florenos XXV dari debere eidem pro dispensando garzonibus quos ipse conduxit per tres menses pro perficiendo dictam figuram.

(AOD, Deliberazioni, 1515–19, fol. 33ᵛ; see Poggi 1988, p. 152, no. 2180)

28. 1517 gennaio 5 [=1518]
Jachopo d'Antonio ischultore che fa l'apostolo di San Jacopo di contro de'avere insino addì 5 di giennaio 1517/18 lire ML piccioli, facciamoli buoni per la valuta cioè sua fatcha e manifattura d'averci lavorato in ischultura una fighura di marmo biancho in uno santo Jachopo di nostri marmi consegniatoci nell'opera finito e tutto per deliberazione de' signori operai, roghato ser Filippo Cioni cancielliere sotto dì 5 di giennaio 1517.

(AOD, VII-1–52, Deb. e Cred. EE, 1517–19, fol. 14ʳ; see Poggi, 1988, p. 152, no. 2180)

29. 1517 gennaio 8 [=1518]
Richordo questo dì 8 di giennaio 1517 chome noi promettiamo a stanza di Jacopo d'Antonio del Tatta, vochato Sansovino, ischultore, a Giovanni di Taddeo Ghaddi proprio e per lui alle rede di Taddeo Ghaddi e conpagnia, banchieri di Firenze, fiorini LXVIII larghi d'oro innoro di paghar loro per da oggi a mesi tre prossimi a venire liberamente e sanza alchuna aciezione, la quale

promessa quando sara paghata s'aranno a mettere a conto di detto Jacopo sopra il credito suo dichiarato per signori operai della valuta dell'apostolo fattoci di marmo con santo Jacopo, come n'apare partito de' signori operai, roghato ser Filippo Cioni cancielliere sotto di 5 di giennaio 1517/18.

(AOD, Stanziamenti, 1517–19, fol. 22ᵛ; see Poggi, 1988, p. 152, no. 2181)

30. Die xviiii mensis augusti 1518
A Jacopo d'Antonio sculptore decto Sansovino fiorini sessantocto larghi d'oro in oro per tanti per lui pagati a Giovanni di Taddeo Gaddi per conto dello apostolo ha facto per conto della casa
 lire 476 soldi____

(AOD, II-4-24, Stanziamenti, 1514–22, fol. 82ʳ; see Weihrauch, 1935, p. 89)

31. The *Bacchus* for Giovanni Bartolini
Jachopo d'antonio detto el sansovino schultore... per fattura d'uno bacco di marmo con suo marmo fece a Giovanni Bartolini Jachopo d'antonio detto el sansovino schultore... per conto d'una fighura mi fa di marmo come dice una scripta di suo pugno detto libro verde carta 1.

(Ginori Lisci, 1953, p. 9; Archivio Bartolini Salimbeni, Florence)

32. The base of the *Bacchus* by Benedetto da Rovezzano
adì xxii di marzo (1519) fiorini soldi xv d'oro larghi, si fanno buoni a maestro benedetto da rovezzano in questo a 201 sono per costo del balustro e del piede di marmo bianco e marmo rosso e del mischio fatto e posto nella corte dellorto suvvi el baccho di marmo.

(Ginori Lisci, 1953, p. 9; Archivio Bartolini Salimbeni, Florence)

33. Payments to Andrea del Sarto, Sansovino, and others for work on temporary façade of the Duomo and for equestrian group, December 1515
Spese di ornamenti et archi facti nella città per honorare la santità di Nostro Signore fiorini cinque mila novanta larghi in oro, lire 26, soldi due, denari otto piccioli, cioè fiorini VIIIX largi in oro, a Piero da Sexto legnaiolo et altri sua compagni, per factura dell'arco della porta a San Piero Gattolini, dell'arco in sul ponte ad Sancta Trinita e per la aguglia; et fiorini CCCXX larghi in oro a Lorenzo scultore et compagni, per l'arco di San Filice; et fiorini CCCXV a Jacopo vocato Baia, per il theatro facto alla chiesa di Santa Trinita; et fiorini quattrocento septantuno a Bernardino da San Gallo, per l'arco di piaza; et fiorini CCCLXXᵗᵃ a Francesco Granacci et altri, per l'arco della Badia; et fiorini quattrocento otanta a Giovanbaptista vocato Rosso, per l'arco del canto de' Bischeri; et fiorini DXX a Andrea di Agnolo dipinctore et Iacopo da San Sovino, per lo ornamento della facciata di Santa Maria del Fiore, e il cavallo facto in sulla piaza di Santa Maria Novella; et fiorini mille cento sexantocto d'oro a Bartolomeo di Michelangnolo scultore et altri, per l'arco del canto de' Carnesecchi, l'ornamento della via della Scala, colomna di mercato nuovo, et gigante della loggia; et fiorini centoctanta d'oro a ser Giovanni Visoni prete, per l'ornamento della sala grande del Papa; et fiorini dugento cinquanta larghi in oro a Giuliano Bugiardini per dipinctura e abigliatura di huomini mesi in su decti archi; et fiorini cinquantasei a Piero di Cosimo dipinctore,

per decte cagioni; et fiorini cinquantasei larghi, in oro dati a' cantori che cantorno in su decti archi; et il resto a più persone, banderai et altri che hanno dato abigliamenti per decti archi et per accattature di più et più cose, come distinctamente et in assai partite ne appare conti a decto vostro quaderno, a carte 159 et 176; in tutto fiorini 5090 lire 26 soldi 2 denari 8 piccioli.

(ASF, Otto di pratica, Deliberazioni, partiti, condotte e stanziamenti, 11, fols. 89ᵛ–90ʳ; del Rosso, 1879, pp. 481–82)

34. Contract for the Martelli *Virgin and Child* in Sant' Agostino, Rome
+Addì XX di maggio 1516.
Sia noto a chi vedrà la presente scritta come Lodovico di Gino Capponi, come prochuratore delli heredi di Giovan Francesco Martelli per li qualli intende e vuole essere obligato, s'è convenuto con maestro Iacopo d'Antonio scultore fiorentino di fare un'opera di marmi nuovi in Santo Agostino di Roma, acanto alla porta di detta chiesa dove è la sepultura di detti Martelli: quale opera si debba fare secondo il disegno che detto maestro Iacopo ha mostro al decto Lodovico, cioè un tabernaculo con colonne, fregi e architravi e altri finimenti di sopra, col piè dell'altare tutto di marmo e detto piè ha essere di marmi vechi, drèntovi in detto tabernaculo una figura di Nostra Donna, alta braccia 3 in circha, con un puttino o dua secondo parrà meglio al decto maestro Iacopo, al quale detto Lodovico liberamente si rimette che facci più o mancho secondo che giudicherà stia meglio et più honorevole. Et per pagamento son convenuti e rimasti d'achordo che il decto Lodovico gli dia ducati dugento cinquanta d'oro di camera e più quel giudicherà Bindo Altoviti, non possendo il detto Bindo passare ducati trecento simili, in questo modo cioè: al presente ducati LXX simili, li quali dice per comperare detti marmi, li quali ha a ffar condurre a Roma a ssuo risigho e spesa, et poi ogni mese ducati otto dal dì che comincerà detta opera in Roma. Intendendosi che il decto maestro Iacopo habbi a ffare ogni cosa a ssua spese di lavorare et far lavorare detta opera, salvo che di metterlli su, che questo s'intenda a spese di decto Lodovico. Il qual li promette darlli una casetta in Roma, di dette rede, appresso di Santo Rocho, per lavorare detta opera. Et il detto maestro Iacopo s'obliga haver finito detta opera per da oggi a anni dua proximi, salvo iusto impedimento. Et per tanto observare, ciaschuna delle parte si soscriverrà qui appie di sua propria mano, questo dì e anno sudetto in Roma. E detto maestro Iacopo promette esser qui a settembre o ottobre proximo, per cominciare detta opera.

Io Lodovicho Capponi come prochuratore di detta rede per lle quali voglio essere ublighato, mi obligo e prometto observare quanto di sopra, et in fede mi sono sottoscritto di mia mano propria questo dì detto in Roma. Et sono contento che detti danari siano ducati d'oro in oro larghi, dove di sopra si dice ducati di camera.

Io Bindo d'Antonio Altoviti avendo visto la sopradetta opera e bene examinato, giudicho che detto Lodovico la debba paghare fino alla somma di ducati trecento d'oro larghi, e per fede mi sono sottoscripto di mia propria mano.

(Corti, 1971; Archivio Capponi, Florence)

Sansovino and the façade for San Lorenzo

35. Buonarroto Buonarroti in Florence to Michelangelo in Carrara, 13 January 1517
... E chosì vene a me uno Iachopo del Sansovino, cioè lo trovai:

domandòmi se volevo schriverti ieri, che dicie veniva chostà. Li disi non bisogniava. Altro m'ochore…

(Barocchi and Ristori, 1965–83, I, p. 241; AB, XXV, no. 27)

36. Domenico Buoninsegni in Rome to Michelangelo in Carrara, 2 February 1517

… E ogni chosa piacierebbe loro [i.e., Pope Leo X and Cardinal Giulio de'Medici], salvo che mi pare che si tenghino assai male satisfatti di voi circha le chose delli marmi di Pietrasanta; perché so sapete la ampla chomissione che ve ne dettono, e chome per l'opere loro, per chosa del mondo, non volevono delli marmi di Charrara, ma vogliono che si tiri inanzi le chose di Pietrasanta. E tanto più dipoi che ànno avuto relazione da Iacopo Salviati esservi a questi giorni stato insieme chon Iacopo del Sansovino e con delli altri, e ritraghono esservi li marmi di somma bontà e bellezza, e inoltre quantità infinita, e assai più facili a averli che non si pensava. E non sollecitono altro che el finire della strada…

(Barocchi and Ristori, 1965–83, I, p. 245; AB, VI, no. 100)

37. Domenico Buoninsegni in Rome to Michelangelo in Carrara, 3 February 1517

… [Pope Leo X and Cardinal de' Medici] Ànnomi detto aver nuove da Iacopo Salviati che le chose di Pietrasanta sono optime; benché anchora lui ne scrive a·mme, e dicie li marmi vi sono in abbundanzia grande, e di bellissima sorte e facili averli, e che a questi dì è venuto di là insieme con Iacopo del Sansovino…

(Barocchi and Ristori, 1965–83, I, p. 248; AB, VI, no. 101)

38. Jacopo Sansovino in Florence to Michelangelo in Carrara

+Addì 16 di febraio 1516 [=1517]

Honorando et maggior mio, salute et rechomandatione infinite. Sola questa sarà per intendere del vostro essere sano, ch'a Dio piacia, e per intendere se·lla pietra la quale voi mi prometesti l'avete tra·lle vostre pietre; che n'ò piaciere assai, inteso da Chucherello che sì. E per tanto, essendovi, vi priegho mi diate aviso a chausa che io possa darne notitia a Roma a pieno, come di già n'ò dato parte. Et così a maestro Domenico vi priegho li richordiate il restante a causa che io possa fare, da poi finita cotesta opera, servire voi di tutto quello che io saperò o potrò. E esendo prosuntuoso, aspetto da voi con prudentia ripremsione. È statone la causa la vostra buona conversazione verso di me, con tante oferte le quale a me supèrfuie. Non dirò altro, salvo Buonoaruoto dice di schrivervi. Se·llui la manderà, sarà in questa.

Circha a' casi dello modello, io non ho poi visto niente; benché Bacio mi dice volere essere insieme di chorto. Darovi aviso a pieno, come seguirà, del tutto. Ho hoperato da parte vostra per el Chucherello, con Bacio da Montelupo, come per me medesimo; et chosì farò in tutti é casi vostri e degli servitori vostri.

Iddio di male vi guardi e nella sua gratia vi conservi. Io sano, in Firenze.

Iachopo d'Antonio schultore.

Avisatemi del marmo, e io passerò di chostà a hora che noi torneremo di qua insieme.

Domino Michelagniolo Buonaruoti magior mio honorando, in Charrara, in sua propria mano.

(Barocchi and Ristori, 1965–83, I, p. 254; AB, XI, no. 689)

39. Jacopo Sansovino in Florence to Michelangelo in Carrara

+Addì 20 d'aprile 1517.

Carisimo et magiore, alla venuta vostra non potetti fare el debito mio verso di voi; hora so che da voi, chome prudente, sarò ripreso. Sopra del modello, io non lo avevo visto, chome v'avisai; e parmi non si farebe mai altrimenti che chome voi avete visto. E basta che io mi voglio venire a stare con esso voi un mese, per potere fare charichare e' marmi e' quali da voi mi sono promessi, e per torvi noia, che so n'avete tante da voi che aresti bisognio d'aiuto. E quando sarò costà parleremo in modo che io vi mostrerò che tutto quello che noi parlamo per la via, tornando in qua, è riuscito. E priegovi siate contento non abandonare la inpresa, come più volte v'ò pregato. E basta.

Io vi mando una lettera la quale la feci fare, per mandarvi aviso di certe lettere, da Domenicho Buoninsegni, ch'è in questa; e chosì io schrissi. E sono sopratenuto insino a ora, perché uno Bastiano, el quale è chostà, lo feci pregare fussi contento portarvi le lettere, e·llui promesse, e da poi si partì di qua sanza farmi motto; in modo non ci ho auto altro modo salvo hora. Altro non dicho. A voi mi rachomando, richordandovi, venendovi bene farmi abozare la mia pietra, la faciate. Se none, io sarò costà infra uno mese e farò el bisognio, coll'aiuto vostro. Pur che·lla non mi sia tolta da altri. E se voi volete paghi e danari qua a Buonaruoto, lo farò; se non, io li porterò con esso mecho alla venuta mia, che sono disideroso vedervi.

Iddio vi guardi di male. Per lo vostro

Iachopo vocato Sansovino, in Firenze.

Domino Michelagniolo Buonaruoti amicho honorando. In Carara.

(Barocchi and Ristori, 1965–83, I, p. 273; AB, XI, no. 690)

40. Ludovico Buonarroti in Florence to Michelangelo in Carrara, 6 May 1517

Carissimo figliuolo, questo dì per l' gharzone di Iacopo da Sansovino, ò avuto nuove a boccha di te; inteso chome stai bene, Iddio grazia, di che n'ò avuto grandissimo piacere. Sono maravigliato non ci abbi fatto dua versi; pure ringrazio Iddio che tu se' sano e stai bene…

(Barocchi and Ristori, 1965–83, I, p. 280; AB, XXIII, no. 5)

41. Jacopo Sansovino in Florence to Michelangelo in Carrara

+Addì xxx di giugnio 1517.

Non v'avendo possuto parlare inanzi la partita vostra, mi sono messo a farvi intendere lo animo mio verso di voi. Sapiate che da voi a me, di qua, fu pocha dotta. E parlai con Iachopo Salviati, e intesi come Bacino di Michelagniolo era così valente uomo, el meglio che ci fussi. Ma Iachopo Salviati vi rispose assai bene a proposito perché à conosciuto la natura vostra a punto. E per questo vostro lodarlo, Bacino fa stima d'averne la parte sua come uno altro. E più vi dico che el Papa, el Cardinale e Iachopo Salviati sono uomini che quando dicano uno sì è una carta e uno contratto; con ciò sia sono verili e non sono come voi dite. Ma voi misurate loro colla cana vostra, che non vale con esso voi né contratti né fede, e a ogni ora dite non si come vi venga bene e utile. E sapiate ch'el Papa mi promesse le storie, e Iachopo anchora; e sono uomini che me le manteranno. E ò fatto inverso di voi tanto quanto io ò potuto, di cosa vi sia utile e onore. E non mi ero avisto anchora che voi non faciesti mai bene a nessuno; e che, cominciando a me sarebe volere che·ll'aqua none inmollassi. E

massimo sapete siamo stati insieme a molti ragionamenti, e maladetta quella volta che voi dicessi mai bene di nessuno universalmente. Or sia con Dio. Non dirò altro. Sono stato raguagliato assai bene; el simile sarete voi alla vostra tornata. E basta. Iacopo Sansovini florentino.
Domino Michelagniolo Buonaruoti in Carara.

(Barocchi and Ristori, 1965–83, I, p. 291; AB, XI, no. 691)

42. Leonardo Sellaio in Rome to Michelangelo in Florence
+Dì 18 di dicembre 1518.
Sabato vi schrissi. El Chardinale è stato malato, e dipoi guarito à mandato per me e dettomi chome uno gran maestro l'è stato a vicitare e dettogli chome voi non lavorate e mai finirete el suo lavoro, e che io gl'ò dette le bugie. So donde viene: nollo schrivo . . .

(Barocchi and Ristori, 1965–83, II, p. 127; AB, IX, no. 412)

43. Leonardo Sellaio in Rome to Michelangelo in Florence
+Dì xxii di genaio 1518 [=1519].
Carisimo Michelagnolo, salute et cet. Ò ritrovato chi aveva indegnato el Chardinale, chome sapete. Questo era Iachopo da Sansovino, e per lui qualche grande uomo che mi intendete, che aveva detto che e' marmi nonn·erono mossi da l'Avenza, dove che el Palavisiono per questo diceva volere venire, più che per sua facende. Facemogli chapace, colle lettere vostre, esere la bugia, e chosì restò sodisfatto el Chardinale . . .

(Barocchi and Ristori, 1965–83, II, p. 146; AB, IX, no. 414)

44. Leonardo Sellaio in Rome to Michelangelo in Florence, 29 January 1520
. . . Sansovino, cioè Iachopo, finì la fighura; nolla chava fuora, ché si dice è delle vostre.[1] Quando la vedreno, schriverò el parere nostro . . .

(Barocchi and Ristori, 1965–83, II, p. 214; AB, IX, no. 420)

1. Probably a reference to the Roman *St James*; see Hirst (1972).

45. The chapel of Cardinal Giacomo Serra in San Giacomo degli Spagnoli, 3 February 15
Reverendissimus dominus Anthonius de Monte tituli Sancte Praxedis . . . Cardinalis et Exequtor Testamenti quondam Bonae memoriae Jacobi Episcopi Prenestinij Cardinalis Arborensii vulgariter dicti postmodum etiam finito anno exequutionis a jure prefixo per Sanctissimum dominum leonem papam X ad exequutionem dicti Testamentj et exactionum creditorum eiusdem in virj Brevis sue Sanctitatis sub data dicti II Martij Annj 1518 . . . deputatus sive confirmatus cum amplissima facultate quietandj prout in dicto Brevj In mei Notarij testumque praesentia dicto nomine pro constructione capelle et Sepulchri per dictum quondam Jacobum Cardinalem ut in ecclesia Sancti Jacobi hispanorum de Urbe construerentur in dicta sua ultima voluntate commisse et ordinate a Spectabilj domino Hieronymo Beltramio mercatore Valentino praesente . . . ducatos Mille aurj in auro de camera in tanto auro et numerata pecunia Qui Mille ducatj sunt pro solutione totidem quos alias de Anno 1515 de mense Octobris seu alio veriorj tempore dictus dominus Heironymus per cedulam suam.

(Davidson, 1970, p. 81, n. 10; ASR, Audituris Camere, J.J. Apocellus, vol. 406, fol. 188)

46. Francesco di Giovan Michele in Carrara to Michelangelo in Florence, 29 February 1520[1]
. . . faczo intenderve come le vostre lavorante, le quale havite costì, czioè el Bello di Torano et Leone et Quindiche, et le altre che deveno fare vostre marme, haveno guastata quella vostra fegura che era in lo Polvolaczo, per conducherla in Ruma a maistro Iacopo Sansavino; et più quella ch'e in la piaia de la marina de l'Avencza, ià son più giorne, come voe sapete, la voleno guastare et portarila a ditto maistro Iacopo. Unde per la presente ve fo intendere el tutto, a czio che potiate congnoscere che molto amo le cose vostre et che questa sia la verità: questo mese de decembre lo Bello, insieme con Leone, forno in Fiorencza per trovare de lavorare, et da poe andarno in Roma et ferno partito de vostre marme con ditto maistro Iacobo, et che più volte le havevo detto come le marme son vostre, non fanno bene a guastarle né a venderle ad altre; et loro decheno marme tutta via sanno fare. Chi porta denare, venderiano insino loro figlie . . .

(Barocchi and Ristori, 1965–83, II, p. 217; AB, VIII, no. 342)

1. See Thode (1902–13), I, p. 377. This episode has received little notice but is interesting on two counts. First, it offers another reference to Sansovino's continued residence in Rome during the period 1518 to 1521. Second, while making allowances for exaggeration in the telling, the account of Jacopo's purchase of Michelangelo's marble blocks is consonant with the image of the younger sculptor as a spoiler that is found in doc. no. 43.

San Giovanni dei Fiorentini

47. Die. xj. octobris. MDXX.
Congregatj in loco quo supra el signore consolo, consiglierj et operaj, et ricordandosj como altra volta del mese di febraro passato loro in casa della signoria del consolo messer Lodovico Bartholinj havevono ordinato el salario per lj ministrj della fabrica della loro chiesa et che no appariva nota in su quel loro libro, mj comessono et ordinorno che io ne facessi nota nello infrascripto modo che seguita et cosj chiarirono essere stata et essere deliberatione et voluntà come su uno foglio di mano d'uno di loro . . . scripto quale e appresso me notaio dello infrascripto tenore:

Ad maestro Iacopo da Sansovino ducatj cinque	duc. 5
Et finj el suo salario fatto la festa de San Giovanni Bartholomeo Marinarj soprastante ducati octo	duc. 8
Francesco fattore ducatj tre	duc. 3
Carlo Belforti proveditore questo mi dissono lasciassj in bianco che mj direbbono poj quello volevono che fussj duc.	
Pietro Epiphanio cancellierj ducati due	duc. 2
Maestro Bartholo della Barba messo per maestro Antonio da Sangallo julij quarantacinque el mese	duc. 4
Maestro Perino del Capitano ducati diecj	duc. 10
Sandro Pianetti ducatj sej	duc. 6
Franchino ducatj sej	duc. 6

E quali tuttj salarij sono a ducatj di camera 83 di Julii x. per ducato. Et declarorono che non volevano corressino a sopradetti salariatj se non per tutto el presente mese dj octobre 1520. Exceptuatj maestro Antonio da Sangallo e maestro Perino del Capitano: questi due habbino a stare ad salario secondo sara declarato per loro signorie. Et cosj el proveditore et el cancellierj habbino a stare per lj loro salarij ordinarij e qualj corrino loro senza altra nuova deliberatione. Tutti quantj gli altrj sopradettj ministrj habbino dj nuovo ad ricondursi secondo che parra et piacera allj prefatj signorj consolj, consiglierj et operaj, et cosi comissono ad me cancellierj ne facessi nota, presentibus messer Petro Filippo Ridolfi et Rafaello Rucellaj.

(Nava, 1936, pp. 350–51; Archivio di San Giovanni dei Fiorentini, Rome, vol. 708, fols. 18ᵛ–19ʳ)

48. 7 gennaio 1520 [=1521]¹

In dicta die in eodem loco tutti lj prefatj operay chongregati ut supra volendo saldare el chonto chon maestro Iachopo Sansovino alias loro architectore el quale asserivano avere preso più danarj che no aveva servit, dopo moltj parlamentj avutj chol prefato Sansovino lj periti chomessono tuutj unanimes a Lodovico Capponi e Giovan Francesco de Bardj che fussino chol prefato Sansovino et seccho chalchulassino a qualj chosì dettono viva voce tanta auctorità quanta anno tuttj loro insieme dj componere et stracciare et dare et acchomodare et fare tanto quanto parrà loro necessario et opportuno sopra la prefata chausa di detto Sansovino tanto per chonto di suo servito quanto dj modello o altro di che si fussi maj impacciato detto Sansovino.

(Nava, 1936, pp. 349–50; Archivio di San Giovanni dei Fiorentini, Rome, vol. 708, fol. 25ᵛ)

> 1. See Frommel (1973), II, p. 198, no. 6.

Completion of the Madonna in Sant'Agostino

49. Pietro Urbano in Rome to Michelangelo in Florence, 31 March 1521

... Ò visto la Nostra Donna di Iachopo: è mala chosa più che io no estimavo ...

(Barocchi and Ristori, 1965–83, II, p. 282; AB, X, no. 627)

Sansovino proposed as collaborator on tomb of Julius II

50. Giovan Francesco Fattucci in Rome to Michelangelo in Florence, 22 March 1524

... Io dissi et dico che Santi 4°¹ è·llui che vole scrivere a questi dua et dir loro che, se vogliono che la sepultura si faccia, che e' bisogna che dipositino otto milia ducati; et non dipositando, vole protestare a tut'a dua che detta sepultura non si può finire per non c'essere danari. Et poi mi disse che, volendo dipositare detti danari in luogo sicuro, et dipositandogli, Santi Quatro vole intendere da voi se vi piace o che e' v'aspettino tanto che voi abbiate servito Nostro Signiore, o che voi vi contentiate che la facia il Sansovino o altri: et conterannosi tutti vostri marmi e figure nove mila cinque cento ducati. Con questo, che e' vorebe che voi facessi ancora di vostra mano la Nostra Donna che vi va ...

(Barocchi and Ristori, 1965–83, III, p. 50; AB, VIII, no. 246)

> 1. Cardinal Lorenzo Pucci; see Eubel, III, p. 70, n. 4.

Projected tomb for the Duke of Sessa

51. Leonardo Sellaio in Rome to Michelangelo in Florence
+Dì 15 di genaio 1524 [=1525]

Conpare, egl'è istato a me Bastiano pitore, e mi dice el ducha di Sessa vuole fare una sipoltura per lui e per lla moglie, e àgli detto vorebe voi la facessi. Dise nonn·era posibile, perché sete ubrighato a Nostro Signore. Vorebe almeno per ogni modo vostro chonsiglio, e, posendo, un pocho di vostro schizzo, di spendere fino a 4000 duchati.

E perché Bacio di Michelagnolo vorebe quest'opera, e chosì quegli giovani di Rafaello da Urbino per non so che loro amicho, e Bastiano, perché sa quello che à fatto Bacio controvi, e chosì choloro chontro a lui, non vorebe manchare di vendicharssi cho loro in questo modo. À messo inanzi il Sansovino, e vorebe, se a voi paressi, voi ne dicessi vostro parere, chome lui servirà chome ogn'altro maestro; e questo lo avete a schrivere a Bastiano e nonne al Ducha, ché Bastiano non vorebe chostoro l'avesino a fare. E io,

per me, chredo che el Sansovino, cioè Iachopo, farebe bene: massime che Bastiano gli sarebe senpre a presso; e io l'arei charo per chominciare a paghagli de' debiti che ànno chon voi ...

(Barocchi and Ristori, 1965–83, III, p. 127; AB, IX, no. 452)

52. Jacopo Sansovino in Rome to Michelangelo in Florence
+Yesus. Addì 22 di febraio 1525.

Honorando et magior mio, per una vostra a Sebastiano pittore intendo el favore el quale m'avete fatto presso al ducha di Sesso, del quale vi ringratio quanto so et posso; et priegovi vi piacia comandarmi, schadendo, per voi, o per cosa la quale io sia atto a farla, che senpre saro pronto e parato a tutte vostre voglie. Altro non dirò, salvo del continovo mi rachomando. Iddio felicissimo vi conservi.

> Per lo vostro servitore, in Rome, Iacopo Sansovini.

(Barocchi and Ristori, 1965–83, III, p. 136; AB, XI, no. 692)

53. Sebastiano del Piombo in Rome to Michelangelo in Florence, 22 April 1525

... Ancora vi rengratio sumamente de la littera me scrivesti in favor de Iacopo del Sansovino; et fece bona hopera con el Ducca, ma pur non ebbe l'opera, ché 'l Ducca mi disse che bisognava atendere a le arme et non a' marmi, adeso ...

(Barocchi and Ristori, 1965–83, III, p. 148; AB, IX, no. 479)

Stucco *Laocoon* for the Marquis of Mantua

54. Francesco Gonzaga, ambassador in Rome, to Federico Gonzaga, Marquis of Mantua, February 1525

... Et me ha detto [Aretino] di voler mandar a Vostra Eccellenza un Lachoonte di giesso, retratto dal naturale de quello che ha Nostro Signore in Bel Vedere; qual dice satisfarà molto a quella, perche è fatto per mano d'un Maestro molto eccellente. Et anche me ha promisso di vedere d'haver qualche testa antiqua, per poterne compiacere a prefata Vostra Eccellenza, alla quale me ha instato che io dia ricordo de le camise et scuffie che per lui sono state promisse, aspectandole cum summo desiderio ...

(Baschet, 1866, p. 122, no. xvii)

55. Pietro Aretino to Federico Gonzaga, February (?) 1525

... Io ho fatto ritrarre di stucco Laocoonte antico de Belvedere, d'altezza forse d'un braccio; e a giuditio del papa e di tutti gli scultori de Roma, non fu mai la meglio cosa ritratta: et l'autore è un Iacopo Sansovino, che Messer Iulio vostro dipintore vi po dir chi egli è. E ci è stato tutto verno a ritrarlo; e Nostro Signore spesso a Belvedere è ito a vederlo lavorare. Et in somma, fra x giorni ve lo mando con molti altre novelle accompagnato ...

(*Ibid.*, p. 125, no. xxiv)

56. Girolamo Scledio to Federico Gonzaga, 30 July 1525

... El Laocoonte sarà presto in ordine, et in l'uno o l'altro modo che riusca di Messer Pietro capitara a mano de Vostra Eccellenza ...

(*Ibid.*, p. 128, no. xxvi)

57. Sansovino sells coloured marbles to the Opera del Duomo, Florence

Jacopo d'Antonio vochato el Sansovino, schultore, de' avere in dì 14 di settembre fiorini XLVI d'oro innoro larghi sono per la valuta di nove tondi di pietra fine mischiati di più cholori comprati da llui per detto pregio chome si vede al giornale segnato dua FF, carta 12

(AOD, Deb. e Cred., II, fol. 100; see Poggi, 1988, no. 2283)

58. Benvenuto Cellini to an unnamed correspondent, 2 June 1526

. . . io detti la chroniola[1] a Jachomo del Sansovino e anchora hopero nelle vostr anella e serviro vi bene vorei che facessi me fussi dato quella pierra che volete che io metto in nella anello da caro perche ho piacere fare chose che vi piaccano. A voi mi rachomando. Restate chon dio. el vostro Benvenuto horefice in Roma

(Brentano, 1959)

1. I.e., a cornelian.

59. Benvenuto Cellini to Giovanni Gaddi, 15 July 1526[1]

Masser Giovanni, io grandissimamente Vi ringratio dell'avermi Voi rachomandato a Chosimo Chasini che, si chome che lui mi scrive, mi pare che per Vostro amore sia molto afetionato all servirmi e per tanto somamente Vi sono ubrigato, et cetera [?]. Jachomo del Sansovino a aute de' Vostre dua anella e chon esse sara il chomto [?] de loro ch'io ho Vi misso e de' danari che da lui ho avuti per la mia fattura. Circha l'essere istato un pocho lungo al servirVi, abiatemi per questa volta ischuso, perche lecita chausa ho auto; non ò laverato né per Voi né per altri, e il primo servito sete istato Voi. Apresso ò auto la pietra da Iachomo e il vostro anello da Ciaro; l'avete presto, perche chontinuo carendo. Di nuovo vorei pregare Vostra Signo‹ria› fussi chontenta. Rachomandomi a Chosimo Chasini, perché chon questa sarà la prochura e potrà chomincare a dare [written as dore] fuocho alla girandola. Anchora Vi voria istremamente pregare che Voi chommettessi a uno de' vostri giovani che lo salutasi chon danari tanti quanto a Voi pare che lla sua faticha meriti. Di troppe chose V' afanno: abiate patienza, il mio chostume è fare chosi a quegli homini ai quali mi sottometto buon servitore. Non altro; restate chon Dio. A Voi mi rachomando. Il Vostro Benvenuto di Giovanni Cellini horefice. In Roma, adì 15 di luglio 1526.

(*Woodner*, 1971, no. 15; Pope-Hennessy, 1985, pl. 15)

1. Given the similarity in content between this letter and no. 58, it may be that both were addressed to Giovanni Gaddi and concerned the same commission, for which Sansovino acted as middleman.

60. Recipe for using stucco on wood as recorded by Benvenuto di Lorenzo della Volpaia[1]

da Jachopo di Sansovino
Stucho dal legname cioè dal lavore a uso di legname
Togli giesso volterrano macinato e farina stacciata per el quarto o meno del giesso e chimatura di quarnello tanta quanta farina e cholla, ne troppo dolcie ne troppo forte e stacciato e rimenalo bene chon uno scharpello e prima dar di cholla dolcie al legno dove lo vuoi applicare e mettine pocho per volta e chome secho mettine n'anche tanto che basti e tieni il detto stucho rinvolto in un panno lino molle e basta parechi di e puolo tignere di che cholore vuoi.

(BNM, MS Ital., Cl. 4, no. 41 = 5363, fol. 4r; see Pittoni, 1909, p. 360)

1. This recipe is undated in the manuscript but must come from Sansovino's pre-Venetian years, possibly from the time of Leo X's entry into Florence in 1515. It may be worth noting here that Benvenuto della Volpaia apparently lived with Sansovino in 1511; see Poggi, 1988, p. 147, no. 2161. A hydraulic device, invented by Sansovino and one Maestro Guglielmo degli Orivoli, is mentioned in the manuscript on fol. 8.

Sansovino's arrival in Venice

61. Lorenzo Lotto in Venice to the *deputati* of the Confraternity of the Misericordia in Bergamo, 5 August 1527

. . . hora si trova qui venuti a quietarsi in Venetia per qualche giorno etiam fino si rasseta alquanto le cose de Roma, perché hanno imprese lì et di Firenze si passa la furia e sospeto che al presente hanno. Questi, l'uno è giovine et molto valente, unico et solo discipulo di Michelagnolo, quale ha molto bene quelli andamenti del suo maestro.[1] L'altro, è homo più provecto in tute cose, de età de anni 40, che si adimanda Jacobo Sansovino che in Roma et Firenze è grande homo dopo Michelagnolo. Sichè penso che facilmente haresti da loro quello che desiderate et qualche bona condicione che non haresti altri tempi . . .

(Zampetti, 1969, pp. 275–76)

1. The identity of the younger man is not known, but Bartolomeo Ammannati has been suggested; see chap. iii, p. 37.

62. Lotto to the Confraternity of the Misericordia, 12 August 1527

. . . Item a 5 de lo instante avisai a Vostre Signorie qualiter erano capitati in Venetia molto quieta e bonaza dui excellentissimi sculptori che dal sacco e flagello di Roma e di le paure di Firenze hano dato loco alla furribonda fortuna. Io mi sono ricordato del bisogno de la vostra palla per i modeli de terra, che questa sarebbe la ventura de l'opera con qualche bona condicione che altri tempi, et presto, perchè non hanno cura de alcuna impresa, fino qui. Lo uno de loro e alevato di Michelagnolo et giovineto; l'altro è homo de 40 anni; questo ne le architecture et sculpture excellentissimo et phamoso si adimanda messer Jacopo de Sansovino, che al presente haveva in Roma de belle imprese et maxime la sepultura del nipote di papa Julio etiam quella del cardinale Grimano. Io non so quello havete concluso con maestro Bartolomio; non fazendo injuria a nisuno, ho fatto questo officio per debito mio con el loco de Santa Maria, come sempre son stato e serò prompto . . .

(*Ibid.*, pp. 276–77)

The 'Mantuan Venus'

63. Pietro Aretino in Venice to Federico Gonzaga, Marquis of Mantua, 6 (?) October 1527[1]

. . . Perchè io so; che vostra eccellenza vuole che quegli, ai quali ella dona, la ringratiano con il non ringratiarla; dirò solamente; che Mazzone mio servidore me ha dati i cinquanta scudi, et il giubbon' d'oro; che mi mandate. Dirò ancho; che teniate a mente la promessa fatta a Titiano; mercè del mio ritratto; che io in suo nome vi feci presentare. Credo che Messer Iacopo Sansovino rarissimo vi ornerà la camera d'una Venere sì vera e sì viva che empie di libidine il pensiero di ciascuno; che la mira . . .

(Aretino, 1609, I, p. 13v)

1. Though the printed date of this letter in the early editions of Aretino's *Lettere* is 6 August 1527, it must date from late September or early

October, as it was a reply to a letter from Gonzaga in September; see Luzio (1888), p. 74, and Flora (1960), p. 988, n. 7.

64. Lotto to the Confraternity of the Misericordia, 7 October 1527

... Lui [i.e., Sansovino] stassi qui alogiato con misser Gioane de Gaddi, homo di gran reputatione, rico e gran banchieri in Roma, fratello del cardinale, quale ha fatto a dito misser Jacopo el manegio de una opera e mercato in ducati setantacinque mile per el re de Ingeltera e sicurtà de certa parte de essi per il principio, ultra le altre importante imprese che ave in Roma. Non ha bisogno questui di comprar lavori medicatamente ... Al presente per fuzir ocio et per piacere fa una figura de una Venere per gitarla de metallo et uno modello di certo pallacio ch'è per un homo da ben rico, che importava da venti mille ducati o circha, qual ha veduto li prefati vostri excellentissimi ambasciatori, fino qualche di si vedera fornito ...[1]

(Zampetti, 1969, p. 284)

1. From the context of Lotto's letter, it would appear that neither the Venus nor the palace worth 20,000 ducats was designed for a specific patron but rather as an example of Sansovino's virtuosity. For an identification of the palace project with a drawing for a Grimani palace, see Foscari and Tafuri (1981).

65. Federico Gonzaga, Marquis of Mantua, to Pietro Aretino, 11 October 1527

... Et circa il Tucciano io non mancarò di fargli in brievi qualche dimostratione, di sorta che potrà cognoscere in quanto bon conto io lo tengo et quanto mi è grato. Se mi mandareti quella statua che mi haveti scritto che mi lavora di bronzo quel Maestro che mi fece il Laocoonte io l'haverò molto cara, perchè laudandomela voi come fate che seti persona di grandissimo ingegno et iuditio, son certissimo che la non mi potrà se non somamente piacere; et tanto più l'averò cara quanto ch'è cosa lavorata a nome mio sì come mi scriveti ...

(Luzio, 1888, pp. 73–74, no. viii)

66. Federico Gonzaga, Marquis of Mantua, to Pietro Aretino, 26 February 1528

... Aspettava con devotione la Venere, hora che intendo che l'è tanto laudata li quanto voi scrivete l'aspetto con maggior desiderio, sperando di havere una cosa eccellente e che meritamente mi habbia ad esser grata e cara ...[1]

(*Ibid.*, p. 79, no. xv)

1. Luzio (1888), p. 25, interprets this letter as a sign of Sansovino's statue having arrived in Mantua, but the sense of the words is that Gonzaga is still looking forward to seeing it. If the work had reached Mantua, it is strange that there is no record of it in the Mantuan archives nor a letter from Sansovino acknowledging a present from the marquis, much as Titian thanked him for the present he received for Aretino's portrait in March 1528; see Luzio, 1888, pp. 73–74, no. viii.

67. Isabella d'Este in Mantua to Francesco Gonzaga in Rome, 31 May 1529

... Quando maestro Raphaele volesse perxistere in la opinione soa che le figurine soe fussero antique potrete adurli per testimoni maestro Giacomo Sansuino sculptore, Zoan Baptista Colombe antiquario, et un Laurentio sculptore quali havendo viste dicte figurine le judicarono per moderne et sono homini de tal peritia in questa arte che al iuditio se può prestare ampla fede ...

(d'Arco, 1857–59, II, pp. 104–05, no. 134)

Tomb of Galesio Nichesola

68.
In Christi nomine Amen. Anno a nativitate eiusdem domini nostri Iesu Christi millesimo quingentesimo vigesimo septimo mensis Ianuarii die duodecima, indictione quinta decima. Venetiis in confino Sanctae Euphemiae a Iudaica presentibus testibus infrascriptis et in eo propria manu subscripti michi presbitero francisco blanco publico imperiali et venetiarum auctoritatae notario fuit presentatum infrascriptum testamentum per infrascriptum testatorem scriptum partim pro ut dixit manu sua quod partim aliena manu per ipsum testatorem lectum et sua propria manu subscriptum, in quo dixit contineri quod esse suam ultimam voluntatem ... Ideo ego Galesius Nichesola, Dei et appostolicae sedis gratia episcopus civitatis Belluni et eius diocesis, ilius quondam nobilis, et magnifici viri Domini Ludovici de nichesolis de verona, venetiis nunc morans, et domicilium trahens in confino sanctae euphemiae a Judaica venetiarum sanus mente, corpore, loquellaque optime dispositus, cupiens ultimam meam voluntatem, et ultimum testamentum disponere, et ordinare in his scriptis. prae ceteris omnibus antea factis, et ordinatis valiturum. Primo animam meam omnipotenti Deo, Trino, et uno, eiusque celesti curiae triumphanti, ac gloriosissimae vergini Mariae ac sanctis omnibus comendo, testamentum autem vulgari idiomate sic scribi, et subscribi, ac adimpleri de verbo ad verbum, modo et forma, ac tenore ut infra jubens videlicet: Volgio, ordino, et dispono, che quando piacerà alo omnipotente Dio de separare l'anima mia da questo corpo, lo cadaver mio sia trasferito, et portato a Verona et esser sepulto in la Ecclesia Cathedrale de Verona, in uno conveniente deposito messo et collocato in una capella della predicta Ecclesia. La qual capella volgio sia constructa et edificata deli mei propri beni sub vocabulo assumptionis beatissimae virginis Mariae in uno loco apresso el campanille, segondo la concessione ad mi facta dalo Reverendo Domino Calixto vicario del Reverendissimo Episcopo Veronese overo in altro più conveniente et più honesto loco, al juditio, et parere de lo prefato Reverendo vicario. et Reverendi Domino Nicolao de placentinis et Domino Francisco de gervasii cononici veronesi sarà ellecto, et deputato, la qual capella volgio, et ordino sia constructa, et edificata cum lo prefato deposito fra el termene de dui anni dal giorno de la morte mia, computando ala constructione et edificatione de la prefata capella sepulcro deposito et altri ornamenti sacerdotali ad la celebratione de li divini officii ad dicta capella necessarii, volgio et ordino sia speso de li mei beni ducati trecento, et più de li trecento, segondo lo arbitrio et parere de li infrascripti mei commissarii, et segondo la convenientia del loco sarà consignato. A la qual capella io li lasso per conto de dota li infrascripti beni, li quali habiano ad esser perpetua dota de dicta capella et subventione de quello sacerdote che in quella sarà instituito, et primo una mia casa vechia la qual io comprai da Domino Bernardino nuncupato balardin, le qual sono poste in Verona in la contrata de Sancto Pietro Incarnaro in lo confine de la citadella de Verona. Item li lasso ducati ducento sopra la possessione mia del Tormene in el territorio Veronese. Cum questo che le infrascripto mio herede universale sia tenuto et obligato ad dare et pagare per li dicti ducati ducento ogni anno al capellano de dicta capella ducati diese finche per dota de dicta capella haverà consegnato possessione, et fondi securi ala summa de li dicti ducati ducento cum questa tamen condicione et

reservatione, senza le qual per modo alguno saria per edificar, et dotar dicta capella che in perpetuo lo più antiquo, et più proximo mio de la casa de Nichesela maschio legitimo, et naturale habia et haver debia facultà, et auctorità de presentare ad dicta capella uno sacerdote idoneo da esser instituto per lo Reverendissimo ordinario del loco, et ad essi pleno iure specti et pertegna in perpetuo ius presentandi sacerdotem ad dictum altarem... Item volgio et ordino che sia speso ducati cento de li mei beni ala cellebratione, de le exequie mie et funerale, et translation del mio corpo ad Verona, et più de li cento alo arbitrio de li infrascripti mei commissarii, segondo che ad loro parerà esser expediente. Item volgio et ordino che per li infrascripti mei commissarii sia dato et consignato al Reverendo Capitulo de la prefata ecclesia de Verona lo mio pliviale alexandrino pavonazo figurato cum oro, cum lo suo capuzino per uso et servitio de dicta ecclesia... Item volgio et ordino et lasso, che per li infrascripti mei commissarii sia consegnato a Domino Francisco de Gervasiis mio familiare, tanti denari, che siano bastanti ad far dipenzer lo volto sopra lo altar mazore de la ecclesia del priorato de Sancto Silvestro de Nogara, segondo la convenientia del dicto volto; Item volgio et ordino che per li infrascripti mei commissarii sia etiam dato tanti danari che se possa far voltare la nave picola al opposito de l'altra, che al presente se ritrova voltata, cum quello medemo modo, et maniera; Item lasso ancora ducati vinticinque ala prefata ecclesia de Nogara da esser spesi in uno calice et patena, per lo servitio di essa ecclesia. Item lasso etiam sia datto per li infrascripti mei commissarii de li mei beni ala ecclesia de Sancta Maria da Sedego, diocese Bellunese, ducati diese, da esser spesi in uno vaso, over tabernaculo de argento per la conservation del sacratissimo corpo de Christo... Item volgio ordino et instituisco lo Reverendo vicario de lo Reverendissimo episcopo Veronese et lo Reverendo Domino Nicolo de Placentinis canonico Veronese, et Domino Francisco de Gervasiis mio familiare canonico Veronese et li magnifici et clarissimi Domino Lorentio fo del Serenissimo Loredano et Domino Petro Lando mei commissarii, et de questo mio testamento executori, li quali habiano ad mandar exeqution questa mia ultima voluntà, et maxime circa la constructione, et dotatione de la mia capella, et deposito, et satisfaction de li legati de li mei familiari. ali quali commissarii io do, et fazo piena, et ampla faculta de vender, et alienar tuti li mei beni mobeli per la edificatione, tumulatione, et remuneratione infrascripte, de quali beni mobeli volgio siano specialmente deputati ad dicta edificatione, et remuneratione... A tergo vero dicti testamenti, 1527, die 2 mense augusti indicatione quinta decima obiit prefatus testator, et die tertia instantis per me notarium infrascriptum apertum fuit testamentum ipsum, presentibus spettabile et clarissimo Domino Iacobo de Tebaldis orator dignissimo Duci Ferrarie et viri nobili Domino Ioane Lando filio magnifici Domini Petri, Domino Carlo Donato quondam Domini Iacobi, et Ser Francisco Zenucha ac pre Philippo eius filio, et aliis testibus vocatur et habitur...

(ASV, not. test., Bianco, F., busta 127, fols. 29r–32v; Brenzoni, 1957)

69. Die Veneris undecimo mesis martii 1530
6° [altare] Sancti Laurentii illorum de Cartulariis cui mandatum fuit non celebrari eo quo mandavit providere ut adimplectum obligationis emi duo candelabra ut aptare sepulcrum ante ipsum altare existens. Candelabra fuerunt reposita quia fuerunt ablata.

(Biblioteca Capitolare, Verona, Visitationes Ecclesiarum Veronae, III, fols. 3r, 108v; Eberhardt, 1971, pp. 222–23)

70. Die mercurii 27 novembris 1532
6° Altare Assumptionis, cuius rector don Nicolaus Beganus, erectum vigore testamenti Reverendi domini Galesii Nichesolae, cum obligatione celebrandi singulis diebus dominicis et duobus feriatis, quae celebrantur per dictum don Nicolau.
Mandatum fuit fieri cortinam viridem pro cohopertura altaris.

(Biblioteca Capitolare, Verona, Visitationes Ecclesiarum Veronae, III, fols. 3r, 108v; Eberhardt, 1971, pp. 222–23)

71. Sansovino's appointment as *proto* of San Marco, 7 April 1529
Magnifici et clarissimi Domini Leonardus Mocenigo, Aloysius Pascalico, Laurentius Lauretano, Jacobus Superatio, Andreas Leono, Joannes Pisacani [*sic*], et Victor Grimani, procuratores Sancti Marci de supra, absentibus aliis collegis, tanquam optime informati de sufficientia et bonitate magistri Jacobi Sansovini, architecti, ipsum assumpserant in prothum dictae sua procuratia, in locum quondam magistri Boni insuper defuncti, cum salario ducatorum octuaginta in anno, et ratione anni, valoris lirae 6 soldorum 4 pro singulo ducato, nec non cum domo pro sua habitatione. Incipiendo tempus sui salari die primo aprilis instantis, qui magister Jacobus facere et exercere debeat, et teneat officium suum praedictum diligenter, et accurate prout convenint eius debito.

(ASV, Proc. de supra, atti reg. 124, fol. 53r; Pittoni, 1909, pp. 151–52)

Projected tomb of Doge Antonio Grimani

72. Extract from will of Cardinal Domenico Grimani, 9 October 1520
Cadaver autem nostrum sepeliri volumus in ecclesia monasterii Sancti Antonii Venetiarum in aliqua capella separata more ecclesiastico e honesto prout commissariis nostris infrascriptis placuerit et eorum arbitrio visum fuerit. Volumus et ordinamus per la supra facta capella... quotidie una missa... Commissarios autem nostros e huius nostre ultime voluntatis exequutores instituimus et esse volumus nobiles viros Dominum Vincentium Grimani fratrem nostrum charissimum principaliter et pro maiore parte et simul cum eo Dominum Alovisium Grimani quondam Domini Bernardi quod tamen cum consilio magnifici et clarissimi Domini Antonii Grimani genitoris nostri et procuratoris Sancti Marci Venetiarum exequi et adimplere debeat quantum in hac nostra ultima voluntate continebit...

(ASV, Archivio di Sant'Antonio di Castello, catastico x, fol. 45^{r-v})

73. Extract from will of Cardinal Grimani, 16 August 1523
...Corpus autem meum relinquo terre et mando tradi ecclesiastica sepultura in ecclesia Sanctorum Johanis et Pauli de urbe fratrum Iesuatorum quorum summum percentuorum quibus pro ellimosina lego ducatos centum aurei de camera. Funeralia autem fiant sobria ad edificandam animorum nostrorum omnia superfluitate et pompa petitur abiecta et sepultura simplex pro ut videbit Domino Johani Staphileo, prefacto Domino Iacobo de Nordis, electo Urbinatem, et Domino Stephano Illigio... Item, reliquo iure institutionum Domino Vincentio Grimano fratre meo res et bona infrascripta in quibus heredem meum instituo cum pactis et conditionibus et modificationibus infrascriptis. Videlicet, in primis possessiones meas quas habeo in territorio vincentino

que est annui reditus 400 ducati ut circha cum hoc onere quod teneatur ex redditu dicte possessionis singulo quoque anno usquam ad totalem perfectionem operis dare et solvere cum effectu ducatos centum quinquaginta largos in contructionem sepulcri bone memoria serenissimi principis Venetiarum patris mei aptum secundum modellum iam factum prout bene novit Dominus Stephanus Illigius qui volo quod habeat omnimodo curam costruendi facere et perficere prefatum sepulcrum et eandem curam comitendi cuicumque voluerit...

(*Ibid.*, fols. 54ʳ–55ᵛ; see Dengel, 1913, pp. 33–37)

74. Canon Stefano Illigio deposits model for Doge Grimani's tomb with procuracy *de supra*

Die xxi mensis iulii 1530

Constitutus in procuratia de supra in presentia clarissimi Domini Victoris Grimani, procuratoris Sancti Marci Venetiarum, Dominus Stephanus Illigius, canonicus aquilegiensis, asserens alias per bonae memoriae Reverendissimum Dominum Dominicum cardinalem Grimani nuncupatum in suo ultimo testamento ordinatum fuisse modelum sepulchri fiendi pro bonae memoriae Serenissimo Principe Domino Domino Antonio Grimani, quem modelum ipse Dominus Stephanus fecit fieri de ordine prefati quondam Reverendissimi Domini Cardinalis et penes se habuit et habet de presenti et quem ipse Dominus Stephanus est reccessurus ab hac civitate Venetiarum et Romam profecturus, et ne modelum ipse caveat in sinistrum et potius conservetur et conservari possit, modelum ipsius actualiter exhibuit et presentavit et deposuit in procuratia nostra Sancti Marci, presente prefato clarissimo Domino Victore Grimani, quem modelum ipse Dominus Stephanus manu propria subscripsit, dicens et affirmans esse undem modelum quem alias ut dixit sibi dedit et assignavit prefatus quondam reverendissimus dominus cardinalis, qui ulterius substituit et posavit loco sui ad perficiendum opus dicti modeli Dominum Iacobum Sansovinum nunc prothum procuratiae Sancti Marci, patentem et acceptantem qui quidem modelus fuit locatus et positus in sanctuario dicte procuratie.

(ASV, Proc. de supra, atti reg. 124, fol. 76ʳ; Foscari and Tafuri, 1982, pp. 117–18)

75. Vettor Grimani deposits 500 ducats towards cost of Doge Grimani's tomb

Die dicto fuit die quinto mensis septembris 1541. In procuratia de supra.

Essendo constituto in procuratia el clarissimo messer Victor Grimani, procurator, disse che essendoge sta depositado questi anni passati ducati cinquecento in circa, depositadi in mano sua per la magnifica madona Isabetha Grimani, relicta del quondam clarissimo messer Vincenzo del Serenissimo Principe, per el costruir della sepultura della bona memoria del Serenissimo Principe suo avo da esser facta in Sancto Antonio de Venetia, iuxto el modello apresentato in dicta procuratia per il reverendissimo messer Stephano Eligeo, canonico de Aquilegia, et iuxta etiam el testamento del quondam reverendissimo cardinale Grimani, suo barba. Anchor che per sua magnificentia per questo tempo passato sia sta facto molta instantia per expedition de tanto laudabil opera impertio esso magnifico messer Victor ha depositato in dicta procuratia in questo giorno ducati cinquecento da lire 6 soldi 4 pro ducato, i quali denari siano dati con saputa et intervento de sua magnificentia a quello over quelli maestri che torano il carico di far essa sepoltura, iuxto l'ordine di

esso testamento de dicto reverendissimo cardinal et iuxta la forma del modello apresentato ut supra. Et se in termine de giorni quidese dal giorno soprascritto non se haverà facto effectualmente il mercado di essa sepoltura per quelli che ad ciò sono deputati con li maestri che si torano el carico de questo, esso magnifico messer Victor intende e vuol poter levar dicto deposito senza alchuno strepito de inditio et accetion propria. Et questo sua magnificencia fa per dar causa a quelli che hano il carico de meter fine a cussì bona ed laudabile opera.

(ASV, Proc. de supra, atti reg. 125, fol. 102ᵛ)

Die xiii mensis suprascripti [septembris], in curie palatii.

Ibique prefatus clarissimus Dominus Victor Grimanius, procurator, dixit mihi notario, presentibus infrascriptis testibus, quod se removebat et removet a clausula illa contenta in suprascripta scriptura depositi ubi dicit: E se in termine de giorni 15 dal giorno suprascripto non si haverà facto effectualmente il mercado di essa sepoltura per quelli che ad ciò sono deputati con li maestri che si trovano al carico di questo, esso magnifico messer Victor intende et vuol poter levar dicto deposito senza alchuno strepito de inditio et auctoritate propria, et ut in ea affare volens ex nunc ipse magnificus Dominus Victor quod dicti ducati 500 depositati ut supra remaneant in procuratia per il costruir della sepultura dicta, et sic notari voluit et iussit, presentibus reverendissimo Domino Angelo de Barcholio, archidiacono Venetiarum, et Domino Francisco Urseri, Domini Moysii, testibus rogatis.

(*Ibid.*, fol. 103ʳ)

76. Granting of façade of San Francesco della Vigna to Grimani family

Die iovis xx aprilis 1542

In monasterio infrascriptorum dominorum fratrum.

Cum alias bone memorie Reverendissimus Dominus Dominus Dominicus Grimanus, Sancte Romane Ecclesie cardinalis et patriarcha acquiliensis, reliquit per suum ultimum testamentum quod fieri debeat et fabricari ac construi sepultura bone memorie serenissimi principis et excellentissimi Domini Domini Antonii Grimani, inclyti Venetiarum ducis eius patris, iuxta formam modelli iam facti et dessignatum fuerit pro honorificentia tanti principis, et ad eius memoriam illam construi et fieri debere in facie nova ecclesie reverendorum dominorum fratrum monasterii Sancti Francisci a Vinea Venetiarum, ordinis Sancti Francisci de observantia, respiciente super campo versus ecclesiam Sancte Iustine. Et considerantes reverendi patres Dominus Frater Clemens, comissarius generalis, et Dominus Frater Hieronymus Contareno, provincialis minister dicti ordinis, et Dominus Frater Iustinus de Venetiis, guardianus dicti monasterii, rem gratam facere reverendissimo et illustrissimo Domino Domino Marino Grimano, eiusdem Sancte Romane Ecclesie cardinali patriarche aquiliensis, comissario relicto in dicto testamento, et clarissimo Domino Victori Grimano, procuratori Sancti Marci, fratribus et nepotibus eiusdem reverendissimi domini cardinalis defuncti, maxime cupientibus in memoriam tanti principis et honorem domus eorum hanc sepulturam fieri et expediri debere iuxta formam dicti testamenti. Et propterea constituti in presentia mei notarii et testium infrascriptorum, supranominati reverendi domini comissarius generalis, provincialis minister et guardianus, agentes nomine totius sui conventus et monasterii predictorum, sponte et libere concesserunt pro ut vigore presentis publici instrumenti concedunt totam faciem novam dicte ecclesie respicientem super illius campo, versus ecclesiam Sancte Iustine ut

supra dictum est, videlicet, totam, tam pro altitudine quam pro latitudine, in qua fieri, fabricari et construi debeat dicta sepultura, libere et absque ullo impedimento et sine aliqua expensa dicti monasterii iuxta ordinationem testamentariam prelibati reverendissimi domini cardinalis defuncti, promittentes prefacti domini commissarius, minister et guardianus ut supra stipulantes presentem concessionem ratificari et confirmari facere per eorum provinciale capitulum de proximo faciendum in civitate Verone pro illius validiori firmitate et non contrafacere huic concessioni aliquo tempore, ratione vel causa. Et iure, illam perpetuo habere gratam et firmam, super quibus rogatus fui ego notarius infrascriptus. Unum vel plura fieri instrumentum et instrumenta. Ego Ioannes Baptista Cygrignus, notarius publicus, rogatus fui et extrassi.[1]

(ASV, San Francesco della Vigna, busta 2, part I, pp. 437–40; Foscari and Tafuri, 1983, pp. 196–97)

 1. On 7 January 1542 Pope Paul III granted permission for the tomb to be built other than at Sant'Antonio di Castello; see Paschini (1943), p. 119.

77. Permission given to Vettor Grimani to build monuments on inside wall of San Francesco, 9 June 1542

. . . hinc est quod ad instantiam et requisitionem prefacti clarissimi Domini Victoris, prefactus reverendus Dominus Frater Hieronymus Contarenus, minister antedicte provincie Sancti Antonii, Dominus Frater Paulus de Bergamo, guardianus monasterii Sancti Francisci a Vinea, et Dominus Frater Raphael de Vincentia ac Dominus Frater Iustinus Venetus, difinitores eiusdem provincie, agentes vigore auctoritatis eis attribute, ut dixerunt a prefacto reverendo capitulo provinciali, celebrato in civitate Verone, in monasterio Sancti Bernardini, sub die vigesimo octavo mensis aprilis proxime preteriti, volentes ac intendentes honeste pieque requisitioni antedicti clarissimi Domini Victoris annuere. Ideo vigore presentis publici instrumenti concesserunt ac expresse concedunt licentiam et auctoritatem clarissimo eidem Domino Victori presenti, stipulanti et acceptanti pro se, heredibus et successoribus suis, quod possit et libere valeat ad sui libitum et propriis expensis sine interesse prefati monasterii Sancti Francisci a Vinea fabricari facere totam faciem muri interioris, quantum capit navis de medio ipsius ecclesie Sancti Francisci a Vinea a parte introytus suprascripte ianue magistre respicientis super iam dicto campo, simul cum ianua ipsa a fundamento usque ad tectum. In qua quidem facie muri interioris ut supra concessa prefactus clarissimus Dominus Victor ponere seu poni facere et fabricare possit unum sive plura sepulcra tumula vel monumentum ad nomen ipsius Domini Victoris, heredum et successorum suorum, et pro ut ei melius videbitur et placuerit iuxta velle suum et beneplacitum sine aliqua contradictione alicuius persone pro quibus observandis et validus attendendis dicte partes agentes ut supra obligarunt se et successores suos ac dictum provinciale capitulum cum omnibus et singulis suis bonis generis cuiuscumque presentibus et futuris . . .

(ASV, San Francesco della Vigna, busta 2, parte I, pp. 440–43; Foscari and Tafuri, 1983, pp. 198–99)

78. Agreement between Cardinal Marino Grimani and Vincenzo Grimani il giovane to build tomb at San Francesco

Die sabbati sexto mensis decembris 1544, in domo habitationis Reverendissimi Domini Barbadico, primicerii ecclesie Sancti Marci Venetiarum, de confino Sanctae Eufemie a Judaica Venetiarum.

Cum alias bone memorie Reverendissimus et Illustrissimus Dominus Dominus Dominicus Grimani, Sancte Romane Ecclesie cardinalis, per testamentum iure institutionis reliquerit clarissimo Domino Vincentio Grimano, quondam serenissimi principis, unam possessionem usquam impressentiarum vulgariter nuncupatum la possession della Spessa, sitam in territorio vincentino, cum onere tamen, ut ex eius reddictu construeretur, seu construi deberet sepulcrum bone memorie serenissimi principis Domini Domini Antonii Grimani secundum quoddam modellum prout dicebatur bene nosce Dominum Stephanum Illigium, canonicum aquilegiensem. Relictis etiam in prefato testamento exequutoribus et commissariis suis, ut in eo, ex quibus superest tantius Reverendissimus et Illustrissimus Dominus Dominus Marinus Grimanus, episcopus portuensis Sancte Romane Ecclesie cardinalis coram quo existens et personaliter constitutus nobilis vir Dominus Vincentius Grimanus Iunior, quondam magnifici Domini Antonii Iunioris quondam prelibati clarissimi Domini Vincentii quondam serenissimi principis Domini Antonii predicti, omnibus nominibus quibus intervenit et intervenire posset exposuit quod super dicta constructione sepulcri fuit aliquandiu hesitatum protestatum [similiter appears here but cancelled], et de modo et loco quo construi deberet dubitatum, et similiter de quantitate certa super inde exponenda cum in eodem testamento nullus locus certus, nulla certa summa habeatur. Et propterea supplicavit prefato Reverendissimo Domino Domino Marino, cardinali exequutorique et commissario superstiti prefati Reverendissimi et Illustrissimi Domini Domini Dominici cardinalis, quatenus dignaretur super quantitate impendenda in ipso sepulcro, certam proferre summam et assensum similiter prestare super ceptione ipsius sepulcri in faciata ecclesie Beati Francisci a Vinea, ubi iam iacta sunt fundamenta. Itaque prefatus Reverendissimus et Illustrissimus Dominus Dominus Marinus cardinalis et solus commissarius intendens et cupiens satisfacere requisitioni ipsius Domini Vincentii Iunioris ut consulere voluntati prefati Reverendissimi Domini Dominici cardinalis omni meliori modo, via, et forma, quibus melius et validius fieri potest assensum suum prestitit. Quod sepulcrum ipsum construatur et perficiatur in facia ipsius ecclesie Beati Francisci a Vinea ubi datum est principium, impensumque fuit de ducatis octingentis viginti duobus soldis treginta depositatis per antea in procuratia dicta de causa. Motus presertim tam reverentia religionis quam etiam que ibidem fuerit et sit antiquum sepulcrum ipsius familie Grimane, et quantum etiam ad summam in ipso sepulcro impendendum, intendes prefatus Reverendissimus Dominus Dominus Cardinalis et uti solus commissarius certam proferre summam et securum reddere ipsum Dominum Vincentium Iuniorem voluit quod ipse Dominus Vincentius Iunior quibus supra nominibus computatis ducatis octagentis vigenti duobus soldis triginta depositatis, et iam ceptis impendi ut supra exbursare etiam habeat usquam ad summam ducatorum trium millium quingentorum ad liras 6 soldos 4 pro ducato. Et quantum de presenti idem Dominus Vincentius Iunior dictis nominibus depositare debeat ad dictum computum in procuratia de supra ducatos ducentos quinquaginta impendendos ut supra. Residuum vero dictorum ducatorum trium millium quingentorum, idem magnificus Dominus Vincentius dicto nomine depositare debeat singulis annis in ratione ducatorum centum quinquaginta in anno in eadem procuratia impendendos ut supra. Incipiendo de mense novembris proximo anni millesimi quingentesimi quadragesimi quinti et successive de anno in annum usque ad integram satisfactionem. Et idem Dominus Vincentius Iunior dictis nominibus cautus et securus sit perinde ac si et locus ipsius sepulcri et summa denariorum in eo impendenda in ipso testamento prefati

Reverendissimi Domini Dominici cardinalis esset expressa. Pro qua summa de anno in annum depositanda dicta de causa remaneant specialiter obligati omnes fructus prefate possessionis della Spessa usque ad integram satisfactionem predictorum ducatorum trium millium quingentorum. Non debente ipso Domino Vincentio Iuniore operari in contrarium quominus singulis annis ipsi ducati centum quinquaginta depositentur dicta de causa ut supra sub pena etiam condictionis apposite per ipsum Reverendissimum et Illustrissimum Dominum Dominicum in dicto eius testamento ut supra. Et prefatus Dominus Vincentius Iunior dictis nominibus per se, heredes, et successores suos omni meliori modo quo potuit acceptavit et acceptat dictum assensum loci constructionis ipsius sepulcri et prolationem summe impendende sub obligatione ut supra presente ad predicta omnia et singula clarissimo Domino Victore Grimano, dignissimo procuratore Sancti Marci, et promittente super eius bonis quam dictus Dominus Vincentius Iunior adimplendo ut supra pro premissis et causa premissorum nullo modo seu ratione molestabitur ratione ipsius et remanebit perpetuo cautus et securus pro ut iustum et conveniens est de et super quibus omnibus et singulis promissis prelibatus Reverendissimus Dominus Cardinalis mandavit, et dicti clarissimi Dominus Victor et Vincentius respective rogaverunt me notarium publicum infrascriptum hoc presens publicum conficere instrumentum . . .

(ASV, Sant'Antonio di Castello, catastico x, fols. 58r–61r; Foscari and Tafuri, 1983, pp. 202–03)

79. Ex Libro Terminationum Curie
Die 28 marcii 1544
Coram dominis iudicibus curie procuratorum comparuit clarissimus Dominus Victor Grimanus, procurator Sancti Marci quondam clarissimi Domini Hieronimi quondam serenissimi principis, tamquam unus ex heredibus et de familia eiusdem serenissimi principis, narrans et exponens quodcum recolenda memoria Illustrissimius et Reverendissimus Dominus Dominus Dominicus Sancte Romane Ecclesie cardinalis Grimanus nuncupatus veniens ad mortem suum condiderit testamentum in quo inter cetera iure investitionis legavit clarissimo viro Domino Vincentio Grimani eius fratri unam eius possessionem in agro vicentino dictam la Spessa, annui redditus ducatorum 400 et ultra cum honeres solvendi et exborsandi singulo quoque anno ducatos centum quinquaginta largos in constitutionem sepulcri recolende memorie serenissimi principis ipsorum iubens sepoluturam predictam edificare et eius curam comitens Reverendissimo Domino Stephano Illigio, canonico aquiligiensi, et pro ut in ipso legato honorificentissimo cumque diversimode rebursatio dictarum pecuniarum sic legatarum distracta fuerit pro multos annos tam per dictum quondam clarissimum Dominum Vincentium quam per alios qui administrationem hereditatis sue habuerunt post eius mortem ita quod dictus opus costruiri non potuit, nec alia exbursata pecunia in hinc usque diem nisi circa summam ducatorum octingentorum expositorum pro edificatione dicti sepulcri in loco honorabili et iam dessignato per predictum Reverendissimum Dominum Stephanum Illigium, requisitione Reverendissimi et Illustrissimi Domini Domini Marini cardinalis Grimani comissarii prelibati reverendissimi cardinalis testatoris, silicet in facie ecclesie nove Beati Francisci a Vinea cum autem iterum cessatum sit iam multo tempore per heredes et comissarios prefati quondam clarissimi Domini Vincentii et subministrandi pecunias necessarias resterque opus imperfectum quod equidem indecorum est propterea volens prefatus clarissimus Dominus Victor providere quantum in se est

pro honore familie et decore civitatis ut dictum sepulcrum proficiatur per memoriam serenissimi principis, dignissimi eius avi, cumque propter absentiam prefati reverendissimi et illustrissimi domini cardinalis Grimani canonici aliis et maioribus occupare ut dictum est, defficiat persona que possit legitime que ordinata sunt ex testamento preditto circa confermationem sepulcri predicti adimplere idcirco petebat et requirebat per dominos iudices presentis curie dici, terminari ac terminando creari debere spectabiles ac prestantissimos viros Dominos Nicolaum Bernardum et socios procuratores ecclesie Sancti Marci de supra inadiuntos comissarios testamenti predicti ad proficiendum opus predictum et necessaria et opportuna facienda et exercenda hiusmodi de causa et audita responsione Domini Santi Barbadico, advocati spectabilium dominorum procuratorum citrari ut in processus respondent superinde ius fieri unde spectabiles et generosi Dominus Laurentius Aurio, Laurus Quirino et Angelus Maripetro, honorabiles iudices curie procuratorum, audita suprascripta requisitione et responsione iusta et equa et cum iusta permissione non est denigandus assensus per eorum terminationem vigore sui officii terminando dixerunt ac creaverunt infrascriptos clarissimos procuratores de supra in adiuntos comissarios suprascripti testamenti ad perficiendum opus predictum et omnia alia necessaria et opportuna faciendi et exercendi huiusmodi de causa et in omnibus et per omnia prout in suprascripta requisitione legitur et continetur causis et rationibus suprascriptis salvis iuribus.
Die 5 decembris 1544
Costitutus in officio clarissimus Dominus Victor Grimani, suprascriptis nominibus ex convenientibus causis et ius respectibus, in presenti rebus animum suum removentibus voluntarie cassat et annullat suprascriptam terminationem et ita annotari requisivit.
Aloysius Permarino curie procuratorum.

(ASV, Sant'Antonio di Castello, catastico x, fols. 62r–64r; Foscari and Tafuri, 1983, pp. 200–01)

80. Vettor and Vincenzo Grimani the Younger agree to pay for façade of Sant'Antonio, 1548
. . . el magnifico messer Vetor Grimani, el prior, el messer Vicentin Grimani, fo de messer Antonio, suo nepote, esser rimasti d'acordo con maestro Francesco Quatrino, taiapiera, el qual se obliga di far a tutte sue spexe di muraro come de piere vive e piere cotte, calcine, sabioni, et manifature e ogni altra cosa che andarà in ditta fabrica . . . eccetuando solamente li ferri et veri che andarano nel'ochio de dicta fabricha, le qual pietre vive siano de Rovigno, ben lavorate et comisse, iusta a quella grandezza e forma, secondo il desegno fato per mano de messer Jacomo Sansovino . . . la qual fabrica e il restante della facciata di Santo Antonio già principiata, et . . . se obligano de darli . . . ducati 185 per cadauno . . . et se la darà fornida del tuto avanti forniti li dui anni, et el ditto magnifico messer Vetor se obliga in sua specialità de darli al ditto maestro ducati 15 oltra li ducati 350 . . .

(ASV, Sant'Antonio di Castello, tomo ii, fol. 215r; Paoletti, 1893, p. 108)

81. Notification by Chapter of Sant'Antonio to Vettor and Vincenzo Grimani concerning façade, January 1549
. . . Havendo il quondam magnifico et reverendissimo messer Piero Grimani, fo del clarissimo messer Antonio il procurator, ordinato per il suo ultimo testamento fatto del 1516 adì 5 novembre, ad instantia de noi padri di Santo Antonio è sta

sententiato a legge sotto di 12 luglio prossimo passato. Inter cetera che nella faza esteriore della nostra giesia dovesse essere fabricata una archa honorifica marmorea sopra la porta maestra di essa giesa et una archa terrena in giesa, et di sopra essa archa marmorea da esser fatta sopra la porta ut sopra dovesse esser posta una statua marmorea del preditto clarissimo messer Antonio suo padre in arme bianche secundo che è solito poner li altri capetani generali maritimi et la statua sua marmorea in habito di cavalier hierosolimitano genibus flexis davanti la imagine della beatissima Vergine, apresso quella del clarissimo suo padre cum insegne et epitaphiis condecenti a cadaun de loro, sì come in esso testamento si legge. Et dovendosi in esecuzione di esso far in omnibus et per omnia quanto per così pia voluntà le ha parso di ordinar, par che voi clarissimo messer Vetor Grimani, il procurator, et voi il magnifico messer Vincenzo Grimani non faciate quanto per il preditto testator è sta ordinato ma faciate far certa fabrica (ne perdonerano Vostre Magnificientie) a modo loro et non secundo è sta deposito ut supra. Però, a parso a noi padri soprascritti per la antiqua osservanza et venerazione habbiamo alla famiglia grimana et precipue in particolar a Vostre Magnificientie, prima con la presente nostra scriptura over protesto pregar et esortar Vostre Magnificientie che poiché nihil est qui magis hominibus debeatur que ut supreme voluntatis iam qui aliud velle non possunt liber sit stillus, le siano contente far far la fabricha predita al modo, condition et forma che ha voluto il predetto testator, con le sue imagine, epitaphii et altre particularità nel suo predetto testamento dichiarate perché quando Vostre Magnificientie havesseno altra oppenion et non volessero far sì che la ultima volontà del predetto testator havesse la sua debita esecuzione, noi saremo sforciati con li mezzi ordinari proveder che un tal et tanto inconveniente non procedi più oltre anzi che si divenga hormai in capo de anni 30 et più alla espeditione della fabricha ordinata per il soprascritto testator. Et per tutto il presente mese di zenaro aspettamo in risposta del presente nostro la oppenione di Vostre Magnificientie in scrittura, la qual non vogliamo persuaderci che debbi esser se non conforme a quanto di sopra gli abbiamo narrato et rechiesto, et hoc dicimus omni meliori modo, etcetera, salvis etcetera.

(ASV, Sant'Antonio di Castello, tomo ii, fol. 216ʳ; Foscari and Tafuri, 1982, pp. 120–21)

82. The will of Daniel Giustinian
Die xiiiᵃ mensis Iulii 1534. Indictione 7ᵃ
Considerando mi Daniel Iustinian fo de messer Francesco del confin de San Panthaleon la fragilità di questa nostra misera vita, et che in questo mondo non habiamo cosa si certa come non poter fuzir la morte, ne manco certa dil tempo de essa morte. Perhò ho deliberado ordinar li fati mei et fin che ho il tempo et per la gratia dil mio Signore la mente sana far el mio testamento et ho fatto vegnir da mi Ser Nicolò Moravio piovan de la parochia nostra de San Panthaleon preditto nodaro de Venetia, et lui ho pregato presenti li sottoscritti testimonii ch'l ditto mio testimonio scrivesse, et da poi la mia morte compisse et roborasse secondo le leze de la patria nostra. In primo con ogni humilità quanto più posso riccomando l'anima mia al mio Creator Signor Idio, a la intercession de la sua gloriosa madre et a tutta la corte celeste. Casso et revoco ogni altro testamento fatto per mi fin questo zorno come se mai fatto non fusse. Instituisco mei fidelcomissarii messer Bernardo messer Marco e messer Piero mei fradeli honoratissimi madonna Andriana et madonna Helena mie sorele amantissime messer Francesco mio zenero et fiol Danielo et Bianchesina fiola dolcissima. Intendendo et volendo che da quella parte che sara ditto messer Bernardo quella si intenda esser la

mazor parte di essi commissarii voglio ch'l corpo mio sia sepulto in la chiesa di fra menori per mezo la pilla dil aqua santa secondo che sa ditto messer Bernardo. Et voglio sia fatta la pilla et larcha più presto che si potrà et in quel mezo el mio corpo sia messo in un deposito et fornido larcha sia messo in essa. Et in essa archa etiam siano messe le osse de la quondam charissima mia consorte Querina et de mia fiola Badia. Item lasso al capitolo de San Panthalon ducati doese per la mia sepoltura, al monastero di fra minori ducati diese per la mia sepoltura, ali fratini dil ditto convento ducati quatro, a la fabrica dil convento ducati cinquanta . . .

(ASV, not. test., Moravio, N., busta 675, no. 273)

83. Tax declaration by Jacopo and Piero de' Tatti, 1534
Quartiere di Santa Croce, Gonfalone Ruote[1]
Jacopo et Piero, frategli et figliuoli d'Antonio di Jacopo di Giovanni Tatti materasaio. Disse la decima l'anno 1505 al libro 5°, carta 269[2] in Antonio nostro padre, Quartiere Santa Maria Novella, Gonfalone Leone Biancho. Abitiano nel popolo di San Piero Maggiore e nella via di Santa Maria.
Sustanze
Una casa per nostro abitare posta nella via e popolo [sic], confini: a primo e secondo Mariotto di Giovanni sarto, terzo rede di Ser Lodovicho di Ser Bindo Chassi, et altri confini, per uso[3]
fiorini____
Una bottegha a uso di materassaio, posta nel popolo di Santo Andrea di Firenze e nella via di Pellicciai, a primo via detta, secondo beni di San Branchazio, terzo beni di Lippo, quarto piaza di Santo Andrea e altri confini, la quale bottegha tegniamo a livello da' frati di Santa Croce di Firenze, e pàghone l'anno a detti frati fiorini 14 di suggello e una ocha, per rendita di fiorini 3 soldi 6 denari 7 l'anno[4] fiorini 3 soldi 19 deanri 11
Bene aquistati et achonci
Uno pezzo di terra di staiora 14, luogho detto la Lama, posto nel popolo di Santo Moro, a primo Arno, secondo Bizenzio, terzo via, quarto Bartolo farinaiuolo, et altri confini, per entrata di fiorini 7 soldi 11[5]
Uno pezzo di terra di staiora 8, posto nel popolo di Santa Maria a Peretola, a primo beni di Santo Pagholo, secondo Arte de' Merchatanti, terzo chiesa di Peretola, quarto Giovanni di Lanzilao, et altri confini[6] fiorini 5 soldi 17
E quali beni pervenono a 'Ntonio nostro padre per via di donagione di mona Cosa, donna fu d'Arigho di Giovanni Chortigiani, rogato Ser Lorenzo Lioni addì 6 di genaio 1511, per uno aroto 1511, numero 71, Santa Maria Novella per decima di fiorini 17 soldi 7 denari 11
Beni aquistati e non achonci
Una casetta, con una presa di terra lavoratia, vite e ulivi e boschi di staiora 5 in circa, posta nel popolo di Santo Piero a Quinto, [luogo] detto le Palaie, confini: a primo via, secondo rede di Piero di Francesco et Bernardo Nusi et fossato. Comprai io Piero soprascritto da 'Ndrea d'Antonio di Francesco ischarpellino per fiorini 50 d'oro, di lire 7 per fiorino, rogato Ser Zanobi Rovai l'anno 1532 del mese di febraio fiorini 2 soldi 18
E sono al'estimo Santo Giovanni, numero 251, carta 320, per decima di fiorini IIII denari X larghi, estimo chome di sopra, carta 320, per decima di fiorini 4 denari 10.[7]
Una chasa posta alle Palaie, nel popolo di Santo Piero a Quintole, con staiora 5 di terra in circa, confini: a primo via, secondo io Piero sopradetto,[8] terzo fossato, quarto Lorenzo Ghualteroti et altri confini. Comprò Piero d'Andrea d'Antonio dalle Palaie, contadino da Patigniano, ischarpelino, comprò la linea di detto

Andrea e di dua sua figliuoli, et lui gli aveva condotti da' frati de' Servi per fiorini 6 d'oro, rogato Ser Zanobi Rovai sotti dì [blank] di febraio 1532, e io non ne pagho nulla ché gli ò liberi.

E sono detti beni all'estimo Santo Giovanni, numero 251, carta 232, sotto nome di Francesco di Piero di Bochino di Francesco dell'ordine de' Servi, con decima di fiorini 9 denari 10 larghi, et tutto s'à a levare e pore a mio conto, estimo Santo Giovanni, numero 251, carta 322, per fiorini 9 denari 10, fanno d'entrata fiorini 5 soldi 18, sotto nome di Filippo detto[9]

(ASF, Decima Granducale, no. 3594, Quartiere Santa Croce, Ruote F-L, fols. 409ᵛ–410ʳ; Garrard, 1970, pp. 417–18)

1. (In the margin) Numero 233
2. See doc. no. 2.
3. (In the margin) Et la detta casa non si trova perche l'ànno murata di nuovo. È per uso.
4. (In the margin) Dal'estimo 1505, carta 269, in Antonio di Jacopo materasaio per entrata di fiorini tre soldi vi denari 7 l'anno, e sbattuto è livello sono d'entrata fiorini tre soldi xviiii denari xi di suggello.
5. (In the margin) Novella 49 Dal'estimo Santa Maria Novella numero 49, carta 295 in Arigho di Giovanni del Magno, per entrata di fiorini sette soldi 11 di suggello, fiorini 7 soldi 11.
6. (In the margin) Novella, 18. Dal'estimo Santa Maria Novella, numero 18, carta 71, per uno aroto 1511, numero 71, per entrata di fiorini v soldi xvii denari.
7. (In the margin) Giovanni, 251. Da estimo Santo Giovanni, numero 251, carta 320, d'Andrea d'Antonio di Francesco, per entrata di fiorini dua soldi xviiii denari.
8. This and the reference in the preceding paragraph imply that the declaration was made solely by Piero in his own and his brother Jacopo's name.
9. (In the margin) Giovanni 251. Dal'estimo Santo Giovanni, numero 251, carta 322, sotto nome di fra Piero di Bochino, per entrata di fiorini 5 soldi 18.

The choir stalls for San Marco

84. 1535 adì 7 giugno
Io antonio de' grandi marangon et mastro Niholo zorzo marangon abiamo rezevuto da misser Lodoviho di Mafei duhati quaranta da lire sei e soldi quatro per duhato a bon conto di banhi ge noi Antonio et mastro Niholo soprascritti abiamo fatto marhado del horo de San Marho segondo el disego fatto de man de miser Zahomo Sansovin a duhati otto el paso a tuta nostra roba posti in opera.

(ASV, Proc. de supra, busta 77, proc. 180, fasc. 1, fol. 11ʳ; Ongania and Cecchetti, 1886, p. 34, no. 198)

85. Yhesus. addì x di giugno 1535
El si dichiara per la presente schritta come li clarissimi Signori Procuratori de supra aluogano a fare el choro della chiesa de Santo Marco colla sieda dello serenissimo principe con questi patti, coè sotto schitti. Ch'al mistro che farà ditta opera sia obrigato lavorare lo ditto choro bene e diligentemente a uso di buono maestro, coè ben commesso e ben lavorato e di buono ligiame di nogara, tutto conpito e posto in opera a tutte sue spese di tutti legniami così di nogara come dabete colla sedia del serenissimo principe. Intendendosi che ditto mistro non sia obrigato fare d'intaglio cosa nessuna ma sia obrigato che lui prepari tutti li legniami che anderano intagliati così le colone della sedia come li modiglioni sotto el sentare e così li fregi. E che ditto mistro sia obrigato fare ditto coro attorno tredici quadri e la sedia del serenissimo di più catorno sieno ventisette sentari tutti da alzare con bertavelle. Et fra l'uno e l'altro sia uno modiglione o si veramente una cartella dove

ditti sentari si posino, e sieno alti dal sentare in suso piedi cinque colla sua cornice, fregio e arhcitrave. E che atorno alli quadri sia uno intavolato col so fregio, e così li quadri sieno da incassare nelli telari di ditto choro. E così fra l'uno modiglione e l'altro de sotto allo sentare sia uno quadrato col suo fregio attorno. Et sia obrigato ditto mistro fare lo apogatoio overo oratorio secondo sarano li banchi con quello medesimo riquadrato, e tuto posto in opera a sua spesa per prezzo e valuta di lire [blank] el passo.

(ASV, Proc. de supra, busta 77, proc. 180, fasc. 1, fol. 12ʳ; Ongania and Cecchetti, 1886, p. 51, no. 247)

86. Adì 25 fevrer MDXXXVII [=1538]
per spese per la chiesa// a casa contadi a più maestri marangoni, intaiadori, doradori, legnami loro, etc., per el far di banchi in coro in chiesa di San Marco et sedia del serenissimo principe et in tutto lire 3301 soldi 25 de picoli, come per poliza del protho de dì 20 fevrer presente appare. Sono ducati 532 lire 12 picoli 30, et furono delli danari soprascritti tratti di sachi nostri——
Lire LIII soldi v denari——picoli 30

(ASV, Cassier Chiesa II, 1534–41)

87. Payments made by Sansovino for various projects, October 1536 to February 1537
MDXXXVI, vii ottobre
Lire 4 soldi 10 a Piero fachino per haver buttato giuso rovinazzo
L. 5. s. 18[1]
Lire 3 soldi 12 a Conzo manovale per haver lavorato L. 4. s. 18
Lire 4 soldi 10 a Borella manovale per haver lavorato L. 5. s. 18
Lire 18 soldi 12 a mistro Antonio delli piombi a buon conto delli piombi del colmo
Lire 3 soldi—— a Tiziano padovano per haver lavorato alli stuchi che vanno attorno al musaico dietro alla porta L. 2. s. 30
Lire 1 soldi 16 a Valerio fante per haver lavorato col sopradito
L. 2. s. 18
Lire 9 soldi—— a Tomaso schultore per haver lavorato a bozare la nostra Donna di marmo che va alla porta della chiesia L. 6. s. 3
Lire 5 soldi 8 a Cipriano manovale per haver cernito musaico e fatto più servirsi L. 6. s. 18

Yhs. 1536

Yhs. Adì 14 ottobrio 1536
Lire 9 soldi—— a mistro Battista muraro per haver lavorato
L. 6. s. 30
Lire 6 soldi—— a Tonio manovale per aver lavorato L. 6. s. 20
Lire 6 soldi—— a Bernardo manovale per haver lavorato
L. 6. s. 20
Lire 4 soldi 10 a Piero manovale per haver lavorato L. 6. s. 15
Lire 3 soldi 12 a Jacomo fachio [sic] per haver lavorato
L. 4. s. 18
Lire 3 soldi 12 a Bettino fachino per haver lavorato L. 4. s. 18
Lire 9 soldi—— a mistro Antonio marangone per haver lavorato
L. 6. s. 30
Lire 9 soldi—— a mistro Giuliano taglia piera per haver lavorato
L. 6. s. 30
Lire 18 soldi 12 a mistro Antonio delli piombi a buon conto delli piombi del coperto
Lire 36 soldi 16 a Jacomo burchiaro per haver portato via 46 burchielle di rovinazzo L. 46. s. 16
Lire 23 soldi—— a Piero fabro per libbre 154 di penole per serrare li volti
Lire 9 soldi—— a Thomaso scultore per haver lavorato in sula

nostra donna di marmo L. 6. s. 30
Lire 7 soldi 4 a Lucha taglia pietra per haver lavorato col
sopraditto L. 6. s. 24
Lire 4 soldi 10 a Titiano padovano per haver lavorato di stucho
attorno alli musaichi L. 3. s. 30
Lire 2 soldi 14 a Aurelio suo fante per haver lavorato col sopradito
 L. 3. s. 18

Yhs. Adì 21 otobrio 1536
Lire 7 soldi 10 a mistro Battista muraro per haver lavorato
 L. 5. s. 30
Lire 5 soldi____ a Antonio manovale per haver lavorato
 L. 5. s. 20
Lire 5 soldi____ a Bernardo manovale per haver lavorato
 L. 5. s. 20
Lire 3 soldi 15 a Francesco manovale per haver lavorato
 L. 5. s. 15
Lire 7 soldi 10 a mistro Antonio marangone per haver lavorato
 L. 5. s. 30
Lire 3 soldi____ a mistro Giuliano tagliapiera per haver lavorato
 L. 2. s. 30
Lire 12 soldi 15 a Piero fabro per libbre 85 di pomoli de ferro
Lire 12 soldi____ a mistro Battista muraro et la maestranza per
buona mano per haver serrato el volto
Lire 8 soldi____ alli fachini che hanno portato in magazeno 16
migliara di piombino
Lire 6 soldi____ a Titiano per haver lavorato alli stuchi intorno al
musaico L. 4. s. 30
Lire 7 soldi 10 a Thomaso scultore per haver lavorato alla nostra
donna di marmo L. 5. s. 30
Lire 6 soldi____ a Luca taglia piera per haver lavorato col
sopraditto L. 5. s. 24

Yhs. Adì 27 ottobrio 1536
Lire 7 soldi 10 a mistro Battista muraro per haver lavorato
 L. 5. s. 30
Lire 5 soldi____ a Tonio manovale per haver lavorato
 L. 5. s. 20
Lire 5 soldi____ a Bernardo manovale per haver lavorato
 L. 5. s. 20
Lire 3 soldi 15 a Giovane manovale per haver lavorato
 L. 5. s. 15
Lire 7 soldi 10 a mistro Antonio marangone per haver lavorato
 L. 5. s. 30
Lire 7 soldi 10 a Thomaso scultore per haver lavorato alla
madonna di marmo L. 5. s. 30
Lire 6 soldi____ a Luca taglia piera per haver lavorato col ditto
 L. 5. s. 24
Lire 4 soldi____ a Jerolimo da Chrisone per haver lavorato
Lire 4 soldi____ a Piero della torre per la guardia
Lire 18 soldi 12 a mistro Antonio dalli piombi a buon conto della
concara el colmo di chiesa

Yhs. Adì 4 novembre 1536
Lire 7 soldi 10 a mistro Battista muraro per haver lavorato
 L. 5. s. 30
Lire 5 soldi____ a Tonio manovale per haver lavorato
 L. 5. s. 20
Lire 5 soldi____ a Bernardo manovale per haver lavorato
 L. 5. s. 20
Lire 3 soldi 15 a Giovanni manovale per haver lavorato
 L. 5. s. 15
Lire 7 soldi 10 a mistro Antonio marangone per haver lavorato
 L. 5. s. 30
Lire 7 soldi 10 a Thomaso scultore per haver lavorato su la nostra
donna de marmo L. 5. s. 30

Lire 6 soldi____ a Luca taia piera haver lavorato col ditto
 L. 5. s. 24
Lire 4 soldi____ a mistro Zuane lustratore per haver siegato una
collonella del pergolo de marmo cel choro
Lire 12 soldi 8 a mistro Antonio delli piombi a buon conto del
conciero del colmo de chiesia

Yhs. Adì 10 novembre 1536
Lire 7 soldi 10 a mistro Battista muraro per haver lavorato
 L. 5. s. 30
Lire 7 soldi____ a Tonio manovale per haver lavorato
 L. 5. s. 20
Lire 5 soldi____ a Bernardo manovale per haver lavorato
 L. 5. s. 20
Lire 3 soldi 15 a Zune manovale per haver lavorato L. 5. s. 15
Lire 7 soldi 10 a mistro Antonio marangone per haver lavorato
 L. 5. s. 30
Lire 7 soldi 10 a Thomaso manovale per haver lavorato alla nostra
donna de marmo
Lire 6 soldi____ a Luca tagliapiera per haver lavorato col
sopraditto
Lire 20 soldi 11 a mistro Piero fabro per 105 libbre di penole per
serrare el volto e libbre 31 d'agùi da peso

Yhs. Adi 18 de novembre 1536
Lire 9 soldi____ a mistro Batista muraro per haver lavorato
 L. 6. s. 30
Lire 5 soldi 8 a Tonio manovale per haver lavorato L. 6. s. 18
Lire 7 soldi 10 a mistro Antonio marangone per haver lavorato
 L. 5. s. 30
Lire 7 soldi____ a mistro Giovanni Maria marangone per haver
lavorato L. 5. s. 20
Lire 6 soldi____ a Nicolò marangone per haver lavorato
 L. 5. s. 24
Lire 40 soldi____ a Francesco de Giustiniano per 100 tavole de
larese e una chiave de larese
Lire 1 soldi 12 a Benvenuto fachino per haver portato el sopraditto
larese
Lire 51 soldi 18 a Piero fabro per libbre 346 d'arpice e aguti da peso
Lire 15 soldi 15 a messer Gentile Conterini per diese mastella de
calcina a soldi 10 e per portatura
Lire 9 soldi____ a Thomaso scultore per haver lavorato alla
madonna de marmo L. 6. s. 30
Lire 7 soldi 4 a Luca taiapiera per haver lavorato col sopraditto

Yhs. Adì 24 di novembre 1536
Lire 7 soldi 10 a mistro Battista muraro per haver lavorato
 L. 5. s. 30
Lire 4 soldi 10 a Antonio manovale per haver lavorato
 L. 5. s. 18
Lire 2 soldi 10 a mistro Bertholomeo muraro per libre 50 de gesso
Lire 6 soldi____ a Luca tagliapiera per haver fatto più servirsi
Lire 12 soldi 4 a Jacomo burchiaro per 14 burchielle di rovinazzo
levate dalla chiesia
Lire 2 soldi 8 a messer Agostino bottonaro per 200 chiodi per li
piombi
Lire 12 soldi 8 a mistro Antonio dalli piombi a buon conto delli
piombi raconcio per el colmo
Lire 8 soldi____ a Francesco barcheruolo per 10 mastella de calcina
nera e 5 de bianca
Lire 7 soldi 10 a Tomaso scultore per haver fatto più servirsi per el
modello della madonna de marmo

Yhs. Adì 2 de decembre
Lire 7 soldi 10 a mistro Batista muraro per haver lavorato
 L. 5. s. 30

Lire 4 soldi——— a Tonio manovale per haver lavorato
L. 5. s. 18
Lire 4 soldi 10 a mistro Antonio marangon per haver lavorato
L. 5. s. 30
Lire 3 soldi 15 a mistro Andrea naparo per libbre 75 de gesso
Lire 7 soldi——— a Francesco di Spavento marangone per haver
lavorato L. 5. s. 28
Lire 11 soldi 8 a Gian Francesco quarantani per 2,200 agui da 25 e
29 mantovani
Lire 12 soldi 8 a mistro Antonio dalli piombi a buon conto delli
piombi raconza per el colmo
Lire 6 soldi——— a Luca tagliapiera per haver lavorato L. 5. s. 24
Lire 4 soldi——— a Girolamo da Chrisone per la guardia
Lire 4 soldi——— a Piero della Torre per la guardia
Lire 7 soldi 10 a Thomaso scultore per haver lavorato alla nostra
donna de marmo
Lire 9 soldi 1 a mistro Francisco del musaico per haverli spesi in
più spese in sponze carta conzar ferri
Lire 5 soldi 13 a mistro Vincenzio del musaico per haverli spesi in
più cose conzar ferri carta e sponze
Lire 6 soldi——— a mistro Jerolimo che fa li partimenti per haverli
spesi in più cose carboni carta e sponze

Yhs. Adì 9 di decembre 1536
Lire 6 soldi——— a mistro Batista muraro per haver lavorato
L. 4. s. 30
Lire 3 soldi 12 a Tonio manovale per haver lavorato L. 4. s. 18
Lire 2 soldi 19 a Piero fabro per 20 [sic] di ferro
Lire 4 soldi 16 a Luca tagliapiera per haver lavorato L. 4. s. 24
Lira 1 soldi 10 a mistro Andrea naparo per libbre 30 di gesso
Lire 18 soldi 12 a mistro Antonio stagnaro a buon conto delli
piombi del colmo
Lire 3 soldi 12 alli fachini che hanno portato el piombo sul colmo
libre 7000 / m
Lire 13 soldi——— a mistro Matthio finestraro per 60 vetri nuovi e
70 de vecchi e 4 pie de ferri e de teleri di rame e lire 2 soldi 4 in casa
messer Adriano in più vetri
Lire 6 soldi——— a Thomaso schultore per haver lavorato alla
madona de marmo
Yhs. Adì 16 decembre 1536
Lire 7 soldi 10 a mistro Batista muraro per haver lavorato
L. 5. s. 30
Lire 4 soldi 10 a Piero boldone per haver lavorato L. 5. s. 18
Lire 12 soldi 8 a mistro Antonio stagnaro a buon conto delli
piombi del colmo
Lire 6 soldi——— a Luca tagliapiera per haver lavorato L. 5. s. 24
Lire 9 soldi 12 a messer Antonio Tristano per 12 tavole di turlo e
10 di puglia e 2 cantinelle et per fattura per el conciero dello altare
Lire 7 soldi——— a Francesco di Spavento marangone per haver
lavorato al ditto conciero L. 5. 2. 28
Lire 7 soldi 10 a Thomaso scultore per haver lavorato alla nostra
donna de marmo L. 5. s. 30

Yhs. Adí 23 decembrio 1536
Lire 7 soldi 10 a mistro Batista muraro per haver lavorato
L. 5. s. 30
Lire 4 soldi 10 a Tonio manovale per haver lavorato L. 5. s. 18
Lire 6 soldi——— a Luca tagliapiera per haver lavorato L. 5. s. 24
Lire 3 soldi 7 a Piero fabro per libre 9 di penole e 58 punte
Lire 12 soldi 8 a mistro Antonio delli piombi a buon conto del
colmo
Lire 7 soldi 10 a Thomaso scultore per haver lavorato alla nostra
donna de marmo
Lire 7 soldi——— a Francesco di Spavento marangone per haver
lavorato al conciero de chiesia all'altare

Lire 4 soldi——— a mistro Steffano a San Gianni e Polo per 13 passa
di spaliera per l'altare grande e per terra
Lire 2 soldi 12 a Francesco de Giustiniano per 2 quarti di chiave per
una sibala

Yhs. Adì 30 decembre 1536
Lire 2 soldi 16 a Francesco di Spavento marangone per haver fatto
più servirsi
Lire 2 soldi 8 a Luca tagliapiera per haver fatto più servirsi
Lire 14 soldi——— a quelli del sale per dua morali d'abeto
Lire 2 soldi 6 a Francesco manovale per haverli spesi in più cose,
argano, lino e cantinelle
Lire 4 soldi 7 a mistro Alberto sabionaro per 3 burchietti di
sabione
Al borella per una corba de carbone
Lire 3 soldi——— a Thomaso scultore per haver lavorato alla nostra
donna de marmo
Lire 4 soldi——— a Piero della torre per la guardia
A Jerolamo da Chrigione per la guardia
Lire 39 soldi 10 a mistro Pizio tagliapiera per una finestra de piera
viva, per un santuario di piedi 21 a soldi 36 al pie e portatura
Lira 1 soldi 4 a Gianni Canatta per le scoppe

Yhs. 1536

Yhs. Adì di genaro 1536 [=1537]
Lire 5 soldi 12 a Francesco di Spavento marangone per haver
lavorato a più servirsi L. 4. s. 28
Lire 12 soldi 8 a mistro Antonio delli Piombi a buon conto del
colmo de chiesia
Lire 6 soldi——— a Tomaso scultor per haver lavorato in su la
nostra donna de marmo L. 4. s. 30
Lire 4 soldi 16 a Luca tagliapiera per haver lavorato col sopraditto
L. 4. s. 24
Lire 55 soldi 10 a Piero fabro per una finestra de ferro di peso di
libbre 370 per la finestra di santuario

Yhs. Adì 13 de genaio 1536 [=1537]
Lire 3 soldi——— a mistro Battista muraro per haver aconcio la
investigione de marmory de chiesia L. 2. s. 30
Lira 1 soldi 16 a Giuliano manovale per haver lavorato col
sopraditto L. 2. s. 18
Lire 5 soldi——— a mistro Giuliano taglipiera per haver lavorato
alla ditta investigione
Lire 4 soldi 4 a Francesco di Spavento marangone per haver
lavorato a disfare el conciero di natale L. 3. s. 28
Lire——— soldi 6 a mistro Andrea naparo per libbre 6 di gesso
Lire 9 soldi——— a Thomaso scultore per haver lavorato alla
madonna de marmo L. 6. s. 30
Lire 7 soldi 4 a Luca scultor per haver lavorato col sopraditto
L. 6. s. 24

Yhs. Adì 19 genaio 1536 [=1537]
Lire 4 soldi 10 a mistro Battista muraro per haver lavorato alle
investigione lui e Gianni da Zon L. 3. s. 30
Lire 2 soldi 14 a Giuliano manovale per haver lavorato con il
sopraditto L. 3. s. 18
Lire 3 soldi——— a mistro Giuliano tagliapiera per haver fatto più
servirsi alla investigione L. 2. s. 30
Lire 4 soldi 16 a Luca tagliapiera per haver fatto più servirsi in ditta
chiesia L. 4. s. 24
Lira 1 soldi 12 a Piero fabro per 16 piedi arpice per la investigione
Lira 1 soldi——— a mistro Andrea naparo per libbre 120 di giesso
Lire 5 soldi 8 a Bernardino e Martino fachino per haver portato
pietre vive dalla rovina delle hostarie sotto li volti et su la chiesia
Lire 6 soldi——— a Thomaso scultore per haver lavorato alla
madonna de marmo

Lire 12 soldi 8 a mistro Antonio dalli piombi a buon conto del colmo de chiesa

Yhs. 1536

Yhs. Adì 27 de genaio 1536 [=1537]
Lire 4 soldi____ a Jerolimo da Chrigione per la guardia
Lire 4 soldi____ a Piero della torre per la guardia
Lire 12 soldi____ a mistro Cipriano per haver lustrato tre collone del pergolo de marmo
Lire 6 soldi____ a Luca tagliapiera per haver fatto più servirsi e lavorato su la madona de marmo L. 5. s. 24
Lire 7 soldi 10 a Thomaso scultore per haver lavorato su la madonna di marmo L. 5. s. 30

Yhs. Adì 3 di febraio 1536 [=1537]
Lire 4 soldi____ a Piero della torre per la guardia
Lire 4 soldi____ a Jerolimo da Chrigione per la guardia
Lire 3 soldi____ a Luca tagliapiera per haver lavorato alla madona de marmo

Yhs. Adì 10 febraio 1536 [=1537]
Lire 2 soldi 16 a Francesco di Spavento marangone per haver fatto le serraglie sopra alla chiesa per li Clarissimi Signor Procuratori L. 2. s. 28
Lire 29 soldi 18 a mistro Antonio Tristano per 125 tavole di puglia et 20... e quattro morali, e 3 ponti, e per portatura
Lire 3 soldi 12 a Jannone manovale per haver lavorato a più servirsi L. 4. s. 18
Lire 3 soldi 10 a Jerolimo manovale per haver fatto più servirsi
Lire 4 soldi 15 a mistro Piero fabro per serrature 3 e bertovelle per la serraglia sopradita
Lire 7 soldi 10 a Thomaso scultore per haver lavorato su la nostra donna de marmo

Yhs. Adì 17 febraio 1536 [=1537]
Lire 7 soldi 10 a Thomaso scultore per haver lavorato su la nostra donna de marmo et in sul pergolo della chiesa
Lire 2 soldi 16 a Francesco di Spavento marangone per haver lavorato a più servirsi
Lire 4 soldi____ a Jerolimo manovale per haver lavorato a più servirsi

(ASV, Proc. de supra, busta 77, proc. 181, fasc. 2, fols. 4ʳ–11ᵛ; Ongania and Cecchetti, 1886, pp. 34–36, no. 199)

1. As Ongania and Cecchetti (1886) have observed in their transcription of these payments, the L. and s. signs on the right do not seem to represent the standard lire and soldi signs found on the left.

88. Bronze reliefs for first *pergolo* in San Marco

Adì xii decembrio 1537
per spese della chiesa di San Marcho// A ser Christophoro de Piero mazer che el promesse per noi de nostro ordine ducati dusento e quatrodese a mistro Jacopo Sansovino nostro protho per tanti spesi nelle sculture de bronzo del pergolo fatto novamente in essa giesa in choro, cioè a mistro Zuane Campanaro / et a Titiano per bronzo et loro fatiche ducati 78. A Thomaso scultore ducati 56, a Lucha scultor ducati 45, a Alvise et mistro Francesco et Diego ducati 36, come per poliza del ditto protho adì 10 ditto appar. I quali sono per la paga che chorre a carneval proximo del fitto della possessio de Santo Egidio de Fontanelle. Val Lire XXI soldi x denari____

(ASV, Proc. de supra, busta 77, proc. 181, fasc. 1, fol. 7ʳ; Ongania and Cecchetti, 1886, p. 42, no. 216)

89.
Copia di una partita posta in un libro di mio padre a carta 28, circa le spese del primo pergolo
1537. Li Clarissimi Signori Procuratori della procuratia de supra devono dare adì 12 di dicembre 1537 ducati 215 / come per una poliza di mia mano data loro appare: et pagati a più persone che hano lavorato alle 3 historie di bronzo del pergolo di San Marco, cioè nel primo un miracolo che San Marco caccia demoni, sana storpiati, et suscita morti, nel secondo quando strascinavano San Marco che vene quella grande pioggia, nel terzo quando San Marco battezza, et un San Marco per testa di detto. Val
 Lire 1333 soldi____

(ASV, Proc. de supra, busta 77, proc. 181, fasc. 1, fol. 8ʳ; Ongania and Cecchetti, 1886, p. 42, no. 217)

90. Bronze reliefs for second *pergolo* in San Marco

Copia de le spese fatte nel secondo pergolo
1541 primo marzo. I Clarissimi Signori Procuratori devono dare per libre 100 / di cera per fare le historie del pergolo rincontro a quello di coro fatto di bronzo nella chiesa di San Marco a soldi 10 la libra Lire 50
Et per fino a dì 15 settembre lire 132 per Tomaso scultore per haver lavorato alle ditte historie di cera Lire 132
E a dì 18 ditto a Julio scultore per haver lavorato col sopraditto alle ditte Lire 108
1542. E a dì 15 novembre lire 180 per libre di metallo per buttar le ditte historie Lire 180
E a dì 7 dicembre lire 93 pagati a mistro Girolamo Campanaro per haver buttato 3 historie, et una ributta et un San Marco
 Lire 93
1543. E a dì 14 luglio, a Giulio scultore per haver lavorato a rinettar le ditte istorie di bronzo Lire 160
E a dì 5 novembre a Francesco, a Gian Maria, et al Nera per haver lavorato a rinettar le ditte historie Lire 240
E devono dare a dì 14 febraio lire 4 / portò conti mistro Zuane Campanaro per haver buttato il San Marco Lire 4
1544. E devono dare in sino a dì 15 di luglio ducati 90 / per haver lavorato Alessandro e Nassimbene a rinettar le sopradite istorie
 Lire 248
 ‾‾‾‾‾‾‾‾
 Lire 1215

(ASV, Proc. de supra, busta 77, proc. 181, fasc. 1, fol. 10ʳ; Ongania and Cecchetti, 1886, p. 43, no. 223)

91. Pietro Aretino to Jacopo Sansovino, 20 November 1537

Hora si che l'essecuzione de l'opre uscite da l'altezza del vostro ingegno dan' compimento a la pompa de la cittade che noi, mercè de le sue bontà libere, ci haviamo eletta per patria; et è stata nostra ventura, poi che qui il buon' forestieri non solo si aguaglia al cittadino, ma si pareggia al gentil'huomo. Ecco dal male del sacco di Roma è pur'uscito il bene che in questo luogo di Dio fa la vostra scultura e la vostra architettura. A me non par' nuovo che il magnanimo Giovanni Gaddi chierico apostolico, co i cardinali e co i papi vi tormentino con le richieste de le lettere a ritornare in corte di riornarla di voi. Mi parebbe bene strano il vostro giudicio, se cercaste di snidarvi da la sicurezza per colcarvi nel pericolo, lasciando i Senatori Venetiani per i Prelati Cortigiani. Ma si dee perdonargli le spronate che per ciò vi danno, sendo voi atto a restaurargli i tempii. le statue, et i palazzi. Di gia essi non veggon mai la chiesa dei Fiorentini, che fondaste in sul Tevere, con istupor' di Raphaello da Urbino, d'Antonio da San Gallo, e da Baldassare da Siena; né mai si voltano a San Marcello, vostra operazione, né a le figure di marmo, né a la sepoltura di Aragona,

di Santa Croce, e di Aginense (i principii de le quali pochi sapranno fornire), che non sospirino l'assenzia Sansovina; come ancho se ne duol'Fiorenza, mentre vagheggia l'artificio che da il moto de lo spirito al Bacco locato ne gli orti Bartolini, con la somma di cotante altre maraviglie che avete scolpite e gittate. Ma eglino si staranno senza voi, perché in buon' luogo s'han' fatti i tabernacoli le vostre virtù savie. Di poi val più un saluto di queste maniche nobili che un presente di quelle mitere ignobili. Guardi la casa che habitate come degna prigione de l'arte vostra chi vuol' vedere in che grado sieno tenuti da così fatta Republica i vertuosi, atti a ridurla nelle maraviglie che tutto di partorite con le mani e con l'intelletto. Chi non lauda i ripari perpetui per cui sostiensi la chiesa do San Marco? Chi non si stupisce nella corinta machina de la Misericordia? Chi non rimane astratto nella fabrica rustica e dorica de la Zecca? Chi non si smarrisce vedendo l'opra di dorico intagliato che ha sopra il componimento ionico con gli ornamenti dovuti, cominciata al'incontro al Palazzo de la Signoria? Che bel vedere fara l'edificio di marmo e di pietre miste, ricco di gran' colonne, che dee murarsi apresso la detta? Egli havrà la forma composta di tutte le bellezze de l'architettura, servendo per loggia, nella quale spasseggiaranno i personaggi di cotanta nobiltade. Dove lascio io i fondamenti in cui debbon fermarsi i superbi tetti Cornari? Dove la Vigna? Dove la Nostra Donna de l'Arsenale? Dov'è quella mirabile Madre di Cristo che porge la corona al Protettore di questa unica patria? L'historia del quale fate vedere di bronzo con mirabile contesto di figure nel pergolo de la sua habitatione; onde merita te i premi, e gli honori dativi da le magnificenze del serenissimo animo de i suoi riguardati divoti. Hor' consenta Iddio, che i dì nostri sien' molti, acciò che voi duriate più a servirgli, et io più continui a lodargli.
Di Vinetia il xx di novembre M.D.XXXVII.

(Aretino, 1609, I, pp. 190ᵛ–191ᵛ)

92. Appraisal by Sansovino and others of Serlio's altar for the Madonna di Galliera in Bologna[1]

Architatori
Jacomo Sansavino, firentino, proto de San Marcho
Sebastiano di Serli da Bologna, sta da San Thomau
Angelo dal Cortina
Alessandro di Strozzi
Gabrielo Vendramino
Victore Fausto
Capi maestri che lavorano de sua mano
Martino dal Vitello che consulto l'opera del saracino
Guglielmino da San Cassano
Matheo da Santo Angelo
Zanetto da Santo Apolinario
Maestri da figura[2]
Jacomo de maestro Venturino, sta a San Barnabà
Danese suo compagnio
Silino da Pisa
Maestro de intaglii, che non tieno botecha
Nicola da Francesco de Chola, sta a Santa Malgarita
Precii delli desegni
Lo desegnio de Alfonso con la figura in tutu come dimostra facto, de marmi da Charara excepto lo bassamento quale se presupone de preda istriana da Roigno non ponendo lo altare in tuto
ducati 1450
Lo disegnio magiore de Sebastiano, facto de marmi da Charara com architravo friso et cornisa intagliata con li inchassi da basso de marmi machiato, zoè, in li pedistali corendo tuto l'ordine con lo bassamento de preda da Roignio della figura istoria de chapiteli intagliati secondo lo disegnio, presuponendo le colone quatro

volte quelle 2 de sopra tondo non ponendo lo altare in tuto
ducati 2500
Lo disegnio minore de Sebastiano, com figure nove tonde computato doe figure davanti alli pilastri de sopra et più uno dio padre in uno trono de anzoli nelo archo con doe victorie in li angoli com lo architravo friso et cornisa intagliato et sopra del nichio in la marcha uno festone intagliato com aquila hovero seraphino. Et in li piedistali li inchassi de marmi machiadi com li bassamenti de preda da Roignio intendendosi doe colone tonde adornate secondo lo designio non ponendo lo altare in tuto
ducati 2300
Volendo vedere la prospettiva da basso relivuo secondo che se dimostra in li quadri dove ha la madonna in li disegni de Sebastiano. Conviene andar alli servi in uno pilastro apresso lo altare grande a man destra. Item a San Francesco in uno pilastro allo incontro del pergolo. Item a San Proculo alla capela del corpo de Christo. Item parendo alli homini de volere atendere allo disegnio grande de Sebastiano et fare la istoria della asoncione converia observare lo nichio picolo e volendo fare lo archivolto secondo lo disegnio picolo converia observare deto desegnio, ma portare le colone fora della fenestra secondo che apare nelo desegnio grande ponendoli una figura sopra.
Lo disegnio de Sebastiano senza le ali fatto de marmi de Charara com figure cinque longhe piedi 3 l'una com uno dio padre nel archo come nel desegnio minore com architravo friso et cronise intagliato secondo lo desgnio grande com lo bassamento, de preda da Roignio non ponendo lo altare in tuto
ducati 1500
Li condutori chararini domandano in ultimo ducati 6½ del migliaro grosso de Venetia delli marmi da Charara posti in Bolognia non ponendo la gabella de Ferara, ma si pensa che lo dariano per li ducati 6 et li maestri fano conto che in lo desgnio grande de Sebastiano li andaria migliara 150. In quello de Alfonso migliara 50. In lo minore de Sebastiano migliara 140. In lo [sic] senza le ali del ditto, migliara 70. Intendendosi el dicto peso del tuto non [?]
Nota come 4 piedi quadri de marmo pesano generalmente uno migliaro grosso de Venecia che dano denari 250 per piede, el quale piede ha de Venecia che sono denari 11 de Bologna.
Volendo fare lo desegnio magiore de Sebastiano, parte de marmoro, zoè, le colone, basse, chapiteli et figure et lo resto de preda veronese nominata bronzo, li andaria intorno a migliara 80 le deta preda che costaria posta in Bolognia. [sic] Volendo fare lo desegnio minore del detto come desopra li andaria intorno a migliara 70 de deta preda che costaria posta in Bolognia. [sic]
Item se fa conto che volendo fare ciaschuno delli desegni una parte de preda viva li andaria intorno alla meta dela preda.
Item pigliando li marmi in Venecia costariano lo migliaro duchati 4½ de xpto [?] le colone quale volendole della longheza de piedi 6½ l'una et bellissimo costariano duchati 15 e de mancho alla
e volendola non così in tuta bellezza costariano duchati 10 de deta longheza de piedi 6½ ed de mancho alla
Per porto de marmi et prede da Venezia a Ferara b. 20[3] de marchitti per migliaro grosso.
Item Sebastiano offerise fare lo modello alto piedi 2½ de legname o saguma con lo disegnio della prospettiva e abrazare l'opera o di quela traverne bona chura e diligentia in tutto per ducati 25 computandoli li 3 avuti.
Item lo dacio delli marmi paghano in Venecia la mita del chosto niente di meno se fa conto che con lo megio de amici sendo per opera de ghiesia pagariano al mancho lo ¼.
Item lo dacio de Ferara delli marmi paghano al più bolognini 10 migliaro grosso.[4]

(ASB, Demaniale, Padri Filippini, 112/5995; Malaguzzi Valeri, 1893, pp. 46–47, no. xii)

1. This document is reproduced, not for the specific information concerning Sansovino but rather for its value concerning the division of labour on architectural and sculptural projects of the period. The presence of the Venetian collector Gabriele Vendramin and the Florentine Alessandro Strozzi should be noted among the architectural experts called upon to assess the cost of Serlio's design. For the background to the document, see Malaguzzi Valeri (1893).

2. The three *maestri da figura* are Jacopo Colonna, Danese Cattaneo, and probably Silvio Cosini.

3. Probably 'bolognini 20'; cf. the last item in the account.

4. The document as published by Malaguzzi Valeri is undated, but the context suggests 1538–39.

Rebuilding the Loggetta

93. MDXXXVII adì 27 agosto
per reparation del Campaniel de San Marco percosso dalla sieta adì 11 agosto presente ha hore do½ de notte// A cassa contadi a maestranza et altro

L 56 s 18 per poliza de 18 ditto
L 228 s 14 per poliza de 25 ditto

L 285 s 12 valuta L iiii s xii d i p 16

MDXXXVII adì 29 septembre
per reparation del Campaniel// A cassa contadi a maestranze et altro

L 48 s 13
L 54 s 7
L 34 s 4
L 45 s 10
L 55 s 18

L 238 s 12 valuta L iii s xvi d xi p 20

MDXXXVII adì 31 ditt [ottobrio]
per la reparation del Campaniel// A cassa contadi a maestranze et altro

L 22 s 16
L 39 s 19
L 56 s 10

L 118 s 15 L i s viii d iii p 21

(ASV, Proc. de supra, Cassier Chiesa, 1534–41)

94. Die xv. mense februarii 1537 [=1538]
Clarissimi Domini Iacobus Superantio, Franciscus de Priolis, Ioannes de Lege, Antonius Capello et Ioannes de Lege eques, absentibus aliis collegis suis, audito Ser Ioannes Mariae Cathena qui habet onus custodie sacristiae superioris ecclesiae Sancti Marci et lobia plathea Sancti Marci qua de novo fabricatur petente qui atento onere et obligatione maxima qui habet, cum modico salario, et utilitate sua . . . dignentur augere sibi salarium . . .

(ASV, Proc. de supra, Chiesa Actorum, reg. 125, 1536–44, fol. 29ʳ)

95. MDXXXVII adì 28 fevrer [=1538]
per fabricha della loza nuova apresso il Campaniel de San Marco// A cassa contadi a più maestranze, marmori, collone, et altre sorte de piere L 4808 s 18 e fo per mano de maestro Jacomo Sansovino nostro protho come per uno conto de sua mano appare sonno
 ducati 775. 15. 6
 L lxxvii s xi d iiii p 6

1538 adì 27 austo
per fabrica de la loza apresso el campaniel// A casa contadi per più spese de maistranze che altro fate per mano de mistro Jacopo Sansovino nostro proto L 299 s 9 per poliza de 27 lugio 1538
 L 4 s 16 d ii

1538 28 febraio [=1539]
per fabrica della loza// A cassa contadi a più maestranze et altro L 718 s 18 per mano de maestro Jacopo Sansovino nostro proto come per uno suo conto da dì 3 auosto passato fin questo di appar
 L xi s xi d xi p——

1539 31 marzo
per fabricha della loza// A caxa contadi a maestraer e valano

L 45 s 5 per poliza di primo ditto
L 54 s 6 per poliza di 8 ditto
L 52 s 16 per poliza di 15 ditto
L 73 s 5 per poliza di 22 ditto
L 69 s 15 per poliza di 29 ditto

L 297 s 7 valuta L iiii s xv d xi p——

1539 30 [aprile ?]
per fabricha della loza// a caxa contadi a maistranze ed altro

L 60 s 14 per poliza a 3 ditto
L 45 s 5 per poliza a 12 ditto
L 90 s 16 per poliza a 19 ditto
L 58 s 3 per poliza a 26 ditto

L 254 s 18 valuta L iiii s ii d i p 22

1539 adì 31 ditto [mazo]
per fabricha della loza// a caxa contadi a maistranza ed altro

L 57 s 18 per poliza a 2 ditto
L 99 s 6 per poliza a 19 ditto
L 188 s 9 per poliza a 17 ditto
L 149 s 28 per poliza a 24 ditto
L 91 s 16 per poliza a 31 ditto

L 587 s 7 valuta L viiii s viiii d v p 20

1539 30 zugno
per fabricha dela loza// Casa contadi a maistranze ed altri

L 104 s 5 per poliza de 7 ditto
L 157 s 4 per poliza de 14 ditto
L 149 s 14 per poliza de 21 ditto
L 129 s 13 per poliza de 28 ditto

L 540 s 16 valuta L viii s xiii d v p 12

1539 adì 31 luio
per fabricha de la loxa// a casa conttadi a maistranze ed altro

L 109 s 18 per poliza de 5 ditto
L 139 s 14 per poliza de 12 ditto
L 65 s per poliza de 19 ditto
L 74 s 6 per poliza de 26 ditto

L 388 s 18 L vi s v d v p 14

1539 adì 31 auosto
per fabriche dela loxa// a casa conttadi a maistranze ed alttro

L 124 s 2 per poliza de 2 ditto
L 117 s 17 per poliza de 9 ditto
L 109 s 11 per poliza de 14 ditto
L 132 s 17 per poliza de 23 ditto
L 76 s 13 per poliza de 30 ditto

L 561 s valuta L viiii s—— d xi p 20

1539 adì 27 settembrio
per la fabricha dela loxa// a casa conttadi a maistranze ed altro

L 124 s 13 per poliza de 6 ditto
L 130 s 3 per poliza de 13 ditto

L 86 s 6 per poliza de 20 ditto
L 104 s 1 per poliza de 27 ditto

L 445 s 3 valuta L vii s iii d vii p 5

1539 adì 31 ottobrio
per fabricha de la loxa// a cassa conttadi a maistranze ed altro
 L 59 s 4 per poliza de 4 ditto
 L 90 s 3 per poliza de 11 ditto
 L 122 s 7 per poliza de 18 ditto
 L 162 s per poliza de 25 ditto

summa L 431 s 14 valuta L vi s xviiii d iii p 3

1539 adì 29 novembrio
per fabricha dela loxa// A cassa conttadi a maistranze ed alttro
 L 120 s 4 per poliza de primo ditto
 L 193 s 15 per poliza de 8 ditto
 L 133 s 1 per poliza de 15 ditto
 L 233 s 12 per poliza de 22 ditto
 L 203 s 3 per poliza de 29 ditto

L 883 s 15 valuta L xiiii s v d 16 p___

(ASV. Proc. de supra, Cassier Chiesa, 1534–41)

96. Die quinto mensis decembris 1539
Clarissimus Dominus Ioannis [da Lezze] eques procurator Sancti Marci pro quanto ad suam magnificentiam spectat suspendit, ut dixit, fabricar et laboreria quae de presenti fiunt pro computo procuratiae nostrae de supra super plathea Sancti Marci, ne alterius prosequantur rationibus et causis allogatis per suam magnificentiam in presentia aliorum clarissimorum dominorum collegorum suorum.

(ASV, Proc. de supra, Chiesa Actorum, reg. 125, 1536–44, fol. 61ᵛ)

97. 1539 adì 30 desembrio
per la fabricha dela loxa// a casa conttadi a maistranze ed alttro
 L 353 s per poliza de 6 ditto
 L 264 s 1 per poliza de 13 ditto
 L 501 s 6 per poliza de 20 ditto
 L 386 s 15 per poliza de 24 ditto

L 1505 s 2 valuta L xxiiii s v d vi p 6

1539 adì 31 zener [=1540]
per fabricha de la loxa// a caxa contadi a maistranza ed alttro
 L 415 s 6 per poliza de 3 ditto
 L 353 s 19 per poliza de 10 ditto
 L 312 s 3 per poliza de 17 ditto
 L 362 s 6 per poliza de 24 ditto
 L 360 s 14

L 1804 s 8 valuta L xxviiii s ii d___ p 24

1539 adì 31 zener [=1540]
per fabricha dela loxa// a Ser Marco Anttonio Zustignan fu de Messer Jeronimo il procuratore per marmori avutti da lui miera 13 a ducati 5½ il mier monta L 443 s 6. E per do più per far do instorie, L 24 s 16 apar per poliza del proto de di 17 ditto summa
 L 468 s 2 valuta L vii s xi
Per fabricha ditta// a Ser Zuan Anttonio Zustignan per marmori autti da lui L 122 s 3 a ducati 4½ il mier monta ducati 55 danari 4 apar per poliza del proto de di 17 ditto valuta L v s x d iiii

Anno 1539 adì 28 fevrer [=1540]
per fabricha dela loza// a maestro piero favro per fero autto da lui per le cadene del volto dela detta loza, pezo libre 3463 a soldi 3 la libra monta L 51999 valuta L viii s vii d vi p___

1539 28 fevrer [=1540]
per fabricha dela loza// a caxa chonttadi a maistranze ed alttro
 L 157 s 2 per poliza a 7 ditto
 L 263 s 1 per poliza a 14 ditto
 L 223 s 11 per poliza a 21 ditto
 L 284 s 19 per poliza a 28 ditto

 L 928 s 13 valuta L xiiii s xviiii d vi p___

1539 28 fevrer [=1540]
per maistro Paulo tagliapiera da Verona// a caxa contadi a lui per mano de maistro Jacomo Sansovino nostro proto ducati 50. E fo fin 10 marzo 1539 a chonto de marmori rosi per la loza valuta
 L v s___
Per fabrica dela loza// per Marco Antonio Zustignan fo de messer Jeronimo procurator per marmori libre 3300 a ducati 5½ al mier, ducati 18 danari 3 per poliza del proto de questo di valuta
 L i s xvi d iii

(ASV, Proc. de supra, Cassier Chiesa, 1534–41)

98. Die octavio martii [1540]
[The procurators *de supra* vote to allow their treasurer, Giovanni da Lezze, to borrow 1500 ducats against the expected revenues of the procuracy in 1541] quod procuratia nostra reparetur gravatia pluribus debitis, sumptibus, et expensis.

(ASV, Proc. de supra, Chiesa Actorum, reg. 125, 1536–44, fol. 65ᵛ)

99. MDXXXX adì xxxi ditto [marzo]
per fabricha de la loza// a casa contadi a maistranze et altro
 L 37 s 4 per poliza de 6 ditto
 L 60 s 13 per poliza de 13 ditto
 L 34 s 2 per poliza de 20 ditto
 L 22 s 6 per poliza de 27 ditto

 L 154 s 5 L ii s viiii d viiii

1540 adì 20 novembrio
per maestro Paulo fenestrer// A casa contadi a lui ducati cinque uso adì 26 agosto passato al conto de veri a fenestri ch'el die far per la lozeta L___ s x d___

(ASV, Proc. de supra, Cassier Chiesa, 1534–41)

100. Die tertio mensis Decembris 1540
[Because of their debts on existing building projects, the procurators decree that no money could be spent on any new building project without] ad incantum fiendum in procuratiae precedente vocatione.

(ASV, Proc. de supra, Chiesa Actorum, reg. 125, 1536–44, fol. 85ʳ)

101. 1540 adì xi zener [=1541]
per Ser Agustin de Agustin murer al insegna de Santa Lena// a cassa contadi a lui ducati novanta quatro al conto de la montar de libra 6040 piombo tolto per coprir la lozeta apresso el campaniel zoè lire sei mille e quaranta ducati 15 2 /3 el mier valuta
 L viiii s viii d___
adì 15 ditto [zener 1541]
per Ser Agustin de Agustin murer sopraditto// A cassa contadi a

suo fiol grossi quindese per resto del sopraditto piombo cioè grossi nuove per le spese de fachini summa ducato uno et e per poliza del protho di questo di, nella qual e lo amontar de tutto el sopraditto piombo. L____ s ii d____

per fabricha della loza// A ser Agustin ditto se retraze le sopraditte due partide che summano ducati 95, et, e per tenir conto della loza separato valuta L viiii s x d____

per fabricha della loza// A cassa contadi a maestranze ed altro Lire tresento e sessantatre de piccoli per poliza del protho de questo di sono ducati cinquantaotto danari 13 piccoli 24 valuta

 L v s xvii d i p 24

per cassa// A maestro Paullo fenestraro se mette per contadi da (sic) lui ducati cinque et fo che ge li ditti per inanti a conto delli veri della loza ch'el doveva far et hozi ge li ho retenuti nella poliza del protho soprascripta valuta L____ s x d____

MDXXXX° adì 29 ditto [zener 1541]
per fabricha della loza// A cassa contadi a maestranze et altro
 L 47 s 4 per poliza del proto de 22 ditto
 L 216 s 13 per poliza del ditto de questo di

 L 263 s 17 sono ducati 42 danari 13. 12 L iiii s v d i. 12

MDXXXX adì 7 ditto [fevrer 1541]
per fabricha della loza// A cassa et sono per L 89 s 19 de piccoli fatti boni questo di a Ser Ludovico di maestri spitier in piaza per robe l'ha dato per ditta loza per poliza del protho de 28 fevrer 1539 (=1540). Sono ducati 14 grossi 12 piccoli 6. L i s viiii d____. 6
per fabricha della loza// A cassa contadi a maestranze et altro L 21 s 5 de piccoli per poliza del protho de 5 ditto sonno ducati 3 grossi 10 piccoli 8 L____ s vi d x p 8

MDXXXX adì 21 ditto [fevrer 1541]
per Ser Jacopo Sansovin nostro protho// A cassa contadi a lui ducati cinquanta per parte de una poliza de sua mano del 15 del presente de ducati dusento e sono al conto delle figure de bronzo el die far per la loza delli qual l'haveva a montar conto
 L v s____ d____

MDXXXX° adì 26 fevrer [1541]
per fabricha della loza// A cassa contadi a maestranze et altro
 L 19 s 1 per poliza del protho de 12 ditto
 L 20 s 16 per poliza de 19 ditto
 L 78 s 14 per poliza de 26 ditto

 L 118 s 10 sono ducati 19 soldi 2 piccoli 22
 L i s xviii d ii–22

adì 28 ditto [fevrer 1541]
per maestro polo da San Michiel taiapietra da Verona// A cassa contadi a lui ducati ottanta per parte de una poliza del protho de ducati cento de 15 del presente quel è a conto de piere rosse per conto della loza L viii s____ d____

MDXLI adì 5 ditto [marzo]
per mistro paulo tagiapiera da San Michiel da Verona// A cassa conttadi a lui lire setanta sei per poliza del proto de 3 del prexente che sonno per resto de miara 170 de pietr rose l'a dacto per la loza fin a questo di con ducati dodexe danari 6 piccoli 6
 L i s iiii d vi p 6

1541 adì 4 ditto [auosto]
per maestro paulo da San Michiel tagiapietra da Verona// A cassa conttadi a lui porto li de suo ordine Ser Piero F⟨ . . . ⟩co suo servitor ducati cinque per parte de una poliza del proto de 15 zenaro 1540 [=1541] valuta L____ s x d____

MDXXXXI adì 17 ditto [novembrio]
per maestro pollo talgiapietra da Verona// A cassa conttadi a lui ducati quindexe per resto de una poliza del proto de 15 zener 1540

[=1541] porto li del suo ordine Ser Piero F⟨ . . . ⟩co suo servitor valuta L i s x

MDXXXXI adì 11 fevrer [=1542]
per Ser Jacopo Sansovino proto// A cassa conttadi a lui e fo per in anti ducati vinti cinque per parte de una poliza de sua mano de le figure il fano [sic] per la loza la qual e de 15 febraro 1540 [=1541] valuta L ii s x

(ASV, Proc. de supra, Cassier Chiesa, 1534–41)

102. Diego Hurtado de Menoza's letter of introduction for Sansovino to Cosimo I de' Medici, 31 October 1540[1]

Messer Jacobo Sansovino que es aquy la persona que Vuestra Excelencia avra entendido y tan estimado desta Señoria como su rrara virtud lo mereçe juntamente con las otras partes de juizio y entendimyento que tiene. Va a Florençia y [sic] hazer rreverençia a Vestra Señoria y porque el es tan gran amigo mio y lo quiero tanto y aunque no tiene necessidad de rrecomendasion de ninguno no la e querido dejar de dar esta y con ella suplicar a Vuestra excelencia por mi rrespecto le haga parte del favor y merced que se que le hara porque la tendre como si a my se hiziesse a my señora la duquesa beso las manos. Guarde [?] nuestro senor la illustrissima y excelentisima persona de Vuestra Excelencia y su estado acreçiente en Venecia, a ultimo de otubre, las manos a Vuestra Excelencia besa . . .

(ASF, Mediceo, filza, 347, fol. 305ʳ)

1. Diego Hurtado de Mendoza (1503–1575) was a soldier, man of letters, and ambassador. He came to Italy with the Imperial army for the Battle of Pavia and remained there until his return to Spain in 1554. He was ambassador of Charles V in Venice from 1539 to 1547 and was subsequently ambassador in Rome. He sat to Titian in 1541, but the portrait is now lost. This document was first cited by Ciardi Dupré (1961), p. 27, n. 21. For the lost portrait by Titian, see Wethey (1971), pp. 199–200, L-19. Mr A. L. Garcia kindly furnished me with the transcription used here.

103. Pietro Aretino on a lost bronze St Catherine by Sansovino

Io vi mando il sonetto sopra la figura de la santa, che voi mi havete fatta, e donata. E caso che nei suoi versi troviate cosa buona, datene la colpa, non a lo ingegno, con cui vi par' ch'io l'habbia composto, ma al debito mio e al merito vostro; perchè l'una mi ha insegnato le rime e l'altro dato la materia da farle. Anzi lodatene la vergine de la quale si parla, che sì come ha infuso in voi gratia da poterla ritrarre, così ha largito in me dono da saperne scrivere. Di Vinetia il xiii di genaio MDXXXXI.

> Chi vol vedere quel real pensiero,
> Quel pudico voler, quel zel fervente,
> E quel'animo in Dio costante et ardente,
> Ch'offerse Catherina al martir fèro;
> Contempli il suo bel simulacro altero,
> Che posa e gira in atto sì vivente,
> Che discopre quel core e quella mente
> U' Christo le stampò la fede e 'l vero.
> Certo nel rimirarlo iscorger parmi
> Qual le virtù di lei note e secrete
> De le ruote ischernir gli horrori e l'armi.
> Immortal Sansovin, voi pur havete
> Mostrato al mondo come ai bronzi e i marmi
> Non men senso che moto dar sapete.

(Aretino, 1609, II, p. 191ʳ⁻ᵛ)

104. Contract for bronze cover of baptismal font in San Marco

MDXXXXV, xviii aprile

Fu promesso per li Signori procuratori de supra a Ticiano da Padoa et a Desiderio da Fiorenza, scultori, ducati dusento per il far de uno coperchio de bronzo sopra la pilla posta nella chiesa de San Marco nella capella de San Zuane come appar per scritto fatto sopra de ciò, qual è in mano de misser Jacomo Sansovino, protho, sotoscritto de mani del ditto Tician. Fu etiam dato per sue Signorie alli ditti scultori ducati otanta, lire 1 soldi 12, computa danari, cera, che lui ha hauto dalla chiesa, feramenti, che ha hauto da mistro Piero Fabro, et lire 93 di metallo, come appar per una poliza de mano de ditto messer Jacomo protho, la qual è apresso di me nodaro. Et perhò, non essendo sta fin hora fatta essa opera, sono devenuti con el ditto Tician che l'habi in termine de uno anno proximo a far et finir esso coperto, juxta la forma di esso scritto, prometendoli di darli ducati cento e disnove, lire quatro et soldi xii che è il restante delli dusento soprascritti. Et non dando in termine de anno uno proximo esso Ticiano esso coperto finito della qualità e modo che si contien in esso scritto, promete di restituir a sue Signorie quanto che per conto di esso coperchio sue Signorie havesseno exborsato e sì a lui come al dito Desiderio suo compagno; i quali denari hauti per esso Desiderio sono compresi nelli sopradetti ducati ottanta, come appar per la sopra scritta poliza. Et per observantia di quanto è soprascritto missier Alvise Corner, fo de messer Antonio,[1] promette e se obliga de satisfar esso danaro che fusse sta exborsato. Et etiam esso missier Alvise simelmente promette per il metalo che si li darà per far ditta opera; et in fede de ciò, io pre Alvise Bonsaver, piovan de San Symeon Propheta, nodaro della ditta procuratia de supra, ho scritto il presente scritto de volontà dele dette parte.

Copia delle sottoscrittion come nel scritto.

Io Ticiano schultore contento a quanto è sopra scritto.

Io Alvise Corner, fo de missier Antonio, prometto di observar quanto è soprascritto.

(ASV, Proc. de supra, busta 77, proc. 180, fasc. 1, fol. 13ʳ; Ongania and Cecchetti, 1886, p. 43, no. 222)

1. Alvise Cornaro (1484–1556), the great Paduan patron and amateur architect, stood surety for Tiziano Minio's work. Minio was very much a protégé of Cornaro's and of his son-in-law, Giovanni Cornaro.

105. Contract for bronze *St John the Baptist* on baptismal font

MDLXV, adì x april in Venetia

Dovendo li clarissimi signori procuratori de sopra far far una figura de bronzo di uno San Giovanni Battista di altezza di piedi quatro di tutto tondo da esser posta sopra il batisterio nella capella di San Giovanni Battista nella giesia de San Marco, sono rimasti d'acordo con Francesco Segalla padoano scultore nel modo infrascrito.

Che 'l detto maestro sii obligato di far essa figura a tutte sue spese dal metallo in fuori et darla finita da poter esser posta al loco suo in opera et metterla per tutto zener prossimo a da venir. Et per il far et amontar de ditta figura li clarissimi signori procuratori li diano ducati setanta da lire 6 soldi 4 per ducato, al presente ducati quaranta, et al getar della figura ducati trenta, talche siano ducati setanta; contentandosi esso maestro che quando sarà finita essa figura, sue signorie clarissime la facino giudicare acciò che se sarà estimata valer meno di essi ducati setanta lui debbi riffar tanto quanto sarà estimata di meno, e se sarà estimata ancho di più di essi ducati setanta si rimete alla buona volontà et buona gratia di sue signorie clarissime.

Che sue signorie clarissime li diano per detta figura tutto il metallo che li andarà per gittarla, ed il callo suo ordenario. Che manchando di darla nel tempo ha promesso, esso maestro è contento che la figura li sia pagata solum ducati cinquanta. Che detto maestro per maior cautione si obligha dar per piezo et principal in solidum il Danese Cathaneo, qual Danese affermerà quanto è soprascrito et si sottoscriverà.

Io Francesco Segalla ho scrito di mia mano propria la presente scritura et mi obligo ut supra.

Io Danese Cataneo sopradetto prometto per maestro Francesco detto quanto e scritto di sopra.

(ASV, Proc. de supra, busta 77, proc. 180, fasc. 1, fol. 19ʳ; Ongania and Cecchetti, 1886, p. 78, no. 307)

106. The interrogation of Sansovino over the collapse of the Library[1]

Die 22. Mensis Decembris: Indictione tertia.

Constitutus coram Clarissimis, et Magnificis, Dominis Nicolao Bernardo, Jacobo Superantio, Andrea Leono, Joanne de Lege qᵐ Clarissimi Domini Michaelis, Antonio Capello, Victore Grimano, Petro Grimano, et Domino Joanne de Lege Equite, Dignissimis Procuratoribus de supra, Ecclesie Sancti Marci, existentibus in offitio sue Procuratiae, Dominus Jacobus Sansovinus Prothus Procuratiae prefacte, et per suas Magnificentias interrogatus unde et ex qua causa processit ruina fabricae novae, Respondit: Clarissimi Signori, Io non posso pensar, che la ruina de tal fabrica sia processo da altro, se non dal giaccio, cioè che la sii giacciata, et da le artelarie, che ali giorni passati tirorno; perchè, ritrovandomi la matina, che vene la Galia de Baruto dentro, sopra la Fabrica, tirate che furono le artelarie, la fabrica si tremò, et resenti. Interrogatus: chel deba dechiarir la condition di questa fabrica e quanto era largo il volto; Respondit: il volto era largo piedi trentadò, et ogni piedi cinque li era una cadena di ferro a traverso tanto longa quanto era il volto largo, et le catene havevano le sue braghe di ferro. Interrogatus: sel volto facto dal murer era ben facto, et se l'havea la sua portion de volto, et compito; Respondit: Signori sì, che era ben facto, et era finito. Interrogatus: se mai d'alcun li fu dicto che quel volto pareva impossibile chel potesse star suzo, et de potersi mantegnir; Respondit: Signori non. Interrogatus: che havendo dicto che la ruina è causata dal ghiaccio, se mai l'ha dicto nè advertito tal cosa a niuno de sue Signorie, che in questi tempi de fredi vien i ghiacci, che metteno in pericolo le fabriche; Respondit: Signori, Io non ho dicto niente, perchè io non pensava, che venisse uno ghiaccio di quella qualità che è venuto, perchè pensava che la dovesse essere coperta avanti il ghiaccio. Interrogatus, sel piombo per coverzela era preparato, et i legnami da metter sotto il piombo: Respondit, ogni cosa era a l'ordine, ma la piogia, che è seguita, impedì che non si posse coverzer. Interrogatus di quanto damno puol esser sta questa ruina, et con quanti danari crede che la si possa refar; Respondit: Io credo, che con ottocento o mille ducati la si rifarà ne li termini che la era con quella roba che si ritrova, che era prima in opera. Interrogatus: quando la Procuratia vi desse li mille ducati, ve obligaressi de tuorla a far a tutte vostre spese, senza che la procuratia vi facesse altra refaction; Respondit: Signori sì, che dandomi Vostre Signorie li mille ducati io mi obligo di ritornar la dicta Fabricha in quello esser, che la si trovava avanti la ruinasse.

Quibus interrogationibus hactenus factis, Clarissimus D.us Jacobus Superantio Procurator prefactus recessit, et reliqui Clarissimi Domini Procuratores sequentes interrogationes; interrogatus: Quando vui fusti per rifar questa fabricha la refaresti in volto, opur in travadura; Respondit: la saria più sicura et de

mancho periculo a farla in travadura. Interrogatus: Ben Messer Jacomo se vui sapevi, che a farla in travadura lera più sicura, segondo chel Clarissimo Messer Antonio Capello vi lo arricordò, perchè non lo faceste? Respondit: Io l'ho voluta far far in volto per esser cosa più bella, et più perpetua, et più sicura da foco. Interrogatus: le cadene che havete posto nel volto, de che grosseza erano? Respondit: le erano di grosseza suffitiente, et condecente ala fabricha. Interrogatus: ben M.r Jacomo, dandovi la Procuratia li mille Ducati, in quanto tempo volè vu redur l'opera in el termine, che la era; Respondit: Io mi obligo di redurla per tutto April proximo.

Fuit sibi dictum: ben, quando se vi desse li Ducati mille per rifar essa fabricha, come è dicto, non daresti piezaria per il resto del danaro, che potesse entrar a ridur essa fabricha nel termene che la si trovava avanti la ruinasse. Respondit, Signori: Io mi offerro de dar bonissima piezaria de la spesa, che li potesse andar dali Ducati mille in suzo.

Rellectum per me notarium infrascriptum sibi Domino Jacobo, in presentia spectabilium Dominorum Gastaldiorum Procuratiae prefactae, quantum supra deposuit, confirmavit.

Ego Bonus Deo Marinus, quondam Ser Antonii, publicus imperiali et Venetiarum authoritatibus notarius, assumptus in hoc notarius a suprascriptis Clarissimis Dominis Procuratoribus, suprascriptum constitutum et depositionem fideliter scripsi, et de mandato ipsorum Clarissimorum Dominorum Procuratorum exemplavi, et in fidem subscripsi.

Scrittura intimata domino Jacopo Sansovino ut in ultra scripto accordio fit mensio

Et che li dicti ducati mille il dicto Ser Jacomo Sansovino habia a restituirli a ducati cento a l'anno: et che le figure, frisi, et altro che fussero rotte et spezzate il non possa metter quelle in opera, ma farle da novo del suo. Et che fra questo mezzo non li corra il salario, ma reducta poi dicta fabricha nel termine che la era, si deba venir ala Procuratia, et far circa la sua conducta quello che parerà ali Signori Procuratori con ballotte sei de sì; et de la piezaria chel dice de dar per redur dicta fabricha ut supra, quella sia data per lui de persona suffitiente, et idonea che non sia nobile di questa città, et sia ballottata per li Signori Procuratori, ne se intenda acceptata, se non la haverà ballotte sei de sì. Item che li ducati mille da esserli dati ut supra, li siano dati per zornada, segondo che l'anderà lavorando, essendo obligato esso Sansovino a sue spese far portar via li ruinazi. Et perchè potria occorrer, che li Procuratori restasseno in menor numero, over che fusseno absenti per causa publica, se dichiara, che circa la sua conducta, quanto si haverà a deliberar, si intenda preso: ogni volta che l'havera balotte do de non; Et havendone tre de non, non si intenda preso.

Die 30 Jannuarij 1545: mihi notario retulit Dominus Hieronimus de Rhenis Gastaldio legisse, et intimasse suprascriptam scripturam Ser Jacobo Sansovino suprascripto, mandato suprascriptorum Clarissimorum Dominorum Procuratorum, excepto Clarissimo Domino Joanne de Lege, q. Domini Michaelis, qui non fuit de opinione ipsi Ser Jacobo dari tempus ad respondendum, prout voluerunt alii Clarissimi Procuratores, quod pro die mercurij ipse Ser Jacobus respondeat presenti scripture: aliter ec.; nec non excepto Clarissimo Domino Victore Grimani, qui dicit velle ire ad Serenissimum Principem in collegio ad dicendum opinionem suam, et jussu Clarissimi Domini Antonij Capello Procuratoris consimilem copiam ipsi ser Jacobo dedi, sic referente mihi praedicto Domino Hieronimo de Rhenis Gastaldione, die 30 Jannuarij suprascripti, sed absente Clarissimo Domino Andrea Leono Procuratore eorum collega.

Die quinta Februarij 1545 [=1546]. Indictione 4.ta

Conciosia che ser Jacomo Sansovino Protho sia stato constituito per i Clarissimi Signori Procuratori, adi 22 Dicembrio proximo

passado, per occasion de la fabrica ruinata, et dapoi li è sta intimato una scriptura per nome de essi Clarissimi Signori Procuratori, si come in esso constituto et scriptura qui sopra registrati appar, et desiderando lui Sansovino esser obsequiente a sue Excellentie, et in niuna cosa voler a quelle contravenir; è devenuto a la infrascritta composition, obligation, et accordo con essi Clarissimi Signori Procuratori: Prima lui Sansovino accepta in omnibus et per omnia essa Scriptura intimatali del tenor infrascritto, et [si] contenta refar essa fabrica ruinata in travatura, et sarà più sicura, et di mancho periculo, si come dice haver dicto nel suo constituto, da esser registrato. Però li Clarissimi Messer Nicolò Bernardo, Jacopo Soranzo, Andrea Lion, Antonio Capello, Piero Grimani, Victor Grimani, et Zuan da Leze Chavalier, Procuratori de supra, de la Giesia de San Marco, absente il Clarissimo Messer Zuan da Leze Procurator, fu de Messer Michiel, voleno essa fabrica sia refacta per el dicto Sansovino in travatura con il volto di canna. Et alincontro li prometteno di attender a tanto, quanto si contien in essa sua scriptura a lui Sansovino intimata. Et per observation de la Scriptura predicta, intimatali per el presente instrumento, si obliga dar una idonea et suffitiente piezaria a beneplacito de le loro Magnificentie, iuxta la forma di essa scrittura, la qual sarà per quel più si expenderà in dicta fabricha: oltre li Ducati mille, promettendo attender in omnibus ut supra; et hoc presentibus Spectabili Domino Sancto Barbadico, Advocato Procuratiae de supra, et Ser Andrea a Balla rationatum Procuratiae praedictae, testibus adhibitis, et rogatis.

(ASV, Proc. de supra, busta 68, Libreria Pubblica, proc. 151, fasc. 3)

1. Based upon the version published by Barozzi (1855): The original is not available for consultation.

107. Settlement between Sansovino and the procurators for the Loggetta and second *pergolo* bronzes

MDXXXXV. die decima februarii [=1546]
Clarissimi Domini Nicolaus Bernardo, Jacobus Superantio, Joannes de Lege quondam magnifici domini Michaelis, Antonius Capello et Victor Grimani, dignissimi procuratores de supra ecclesie Sancti Marci, aliis suis collegis absentibus. Havendo domino Jacobo Sansuino protho de la procuratia senza alcuno acordo facto cum essi clarissimi signori procuratori facto quatro figure di metallo integre in piedi, zoè uno apolo, uno mercurio, la dea de la pace, et pallade, le quale vanno in la faza de la lozeta in piazza de San Marco; et tre quadri de altre figure, zoè la historia de missier San Marco in metallo ut supra che vano in coro alla giesia de San Marco per far uno novo pergolo alincontro del facto; et quelle reducte a compimento, presenta ad essi clarissimi signori procuratori, contentando lui Sansuino che Sue Excellentie li habbia a dar quel pagamento li par convenevole che di tanto quanto Sue Excellentie li darà, lui è contento. Onde viste esse tutte figure superius nominate per essi clarissimi signori procuratori hanno deliberato a bossoli et ballotte per tutti li suprascripti cinque sufragii de si, che li sia dato al ditto Domino Jacobo Sansuino per intero pagamento di quelle fino alla summa de ducati novecento a lire 6 soldi 4 cadaun ducato, videlicet ducati seicento per le quatro figure e ducati 300 per li quadri va al pergollo. Qua deliberatione intellecta per ipsum Dominum Jacobum Sansuinum, qui contentavit de precio predicto et ita contentat habere solutionem summe suprascriptarum figurarum tam logie quam ecclesie ut supra usque ad summam predictam ducatorum 900 in omnibus ut supra, presentibus spectabilibus dominis gastaldionibus procuratie nostre.

(ASV, Proc. de supra, atti reg. 126, 1541–52, fol. 9r; Ongania and Cecchetti, 1886, p. 51, no. 248)

108. Tratto del libro G. della chiesa, da carta 414. MDXLV 13 febraio. per ser Bortholomeo da Leze, affitual del priorado di San Egidio di Fontanele, per tanti che se li consegna, a bon conto delle figure 4 di bronzo fatte per la loza et de quadri 3 pur di bronzo fatti per far un'altro pergolo in chiesia, giuxta la terminazione fatta per li clarissimi nostri collega sotto x del presente, come appare per notta del libro del nodaro Cavaza a carta 9. Ducati 300 denari____
cioè, ducati tresento Lire 30 soldi____ denari____[1]
____detto per contadi a lui, a bon conto delle sopraditte figure ducati quindese denari____ val Lira 1 soldi 10 denari____
1546. 30 luio. per contadi a lui a bon conto delle ditte figure, appare in zornale Lire 3 soldi____ denari____
7 zenaio. per contadi a lui a bon conto del suo credito ducati vinti
 Lire 2 soldi____

(ASV, Proc. de supra, busta 77, proc. 180, fasc. 1, fol. 11v)

1. Lire of account; each lira equals 10 ducats.

109. Tratto del libro H. della chiesa, da carta 49.
MDXLVII Ser Jacomo Sansovino protto, die dar adì primo marzo per lui medesimo per resto tratto del libro G. ducati 452
 lire 89 soldi 15 denari 6
18 febraio. per contadi a lui ducati dui denari 6 per resto di figure de bronzo della loza, delle historie de bronzo della chiesia che montano ducati novecento denari____Val
 Lire____ soldi 4 denair 6

(*Ibid.*, fol. 13v)

110. Account of the Loggetta's iconography by Francesco Sansovino, 1546
In Vinegia intorno al Campanile di S. Marco su la publica piazza, vi ha nella parte incontro al Palazzo, la Loggietta, opera e composizione così di architettura come di scoltura di Messer Iacopo Sansovino fiorentino. Tra le quali Sculture, si come principali si vede una Minerva verso la parte del Canal Grande, appresso all'entrata un'Apollo, dall'altra parte a man destra un Mercurio, e nella fine la Pace. Queste diremo che sian come luoghi della memoria, perchè non si tosto l'huomo s'incontra con l'occhio in quella imagine di Minerva, che egli comprende per quel segno tutte le cose che da lei secondo i poeti furon trattate; oltra il significato, che ella ha, cioè che l'Ottimo Massimo Senato Venetiano è sapientissimo, e ne governi, e nelle attioni. Se noi medesimamente vediamo l'Apollo, tosto ci corre a memoria, ciò che di lui lasciarono gli antichi, il simile di Mercurio e de gli altri diremo, oltra il segno della musica e dell'eloquenza, nelle quai due cose i Signori Venetiani sommamente sono eccellenti, che della prima ne è dimostratore Apollo, della seconda Mercurio, ma perchè questa via de luoghi è da Cicerone, e dopo lui da Quintiliano trattata, e a nostri tempi da Ramondo Lullo, sopra il quale ampiamente si estende Cornelio Agrippa, e da Pietro da Ravenna acutissimo e breve scrittore, rimettendoci a sopradetti, potremo con facilità acquistarci per arte, quello, che la natura non ci ha voluto per se stessa concedere.

(Sansovino, 1546, fols. 52v–53r; Davis, 1985)

111. Francesco Sansovino on his father's anatomical drawings
…la onde volendo dell'anatomia ragionare, bisognava distintamente a parte per parte mostrarla non solamente in parole ma anco in disegno, il che per adesso non voglio, et quando che sia metteremo alla luce bellissime anatomie di mano di Messer Iacopo Sansovino, mio honoratissimo padre.

(Sansovino, 1550, p. 4r)

The Sacristy door

112. +Yhs. adì 9 febraro 1545 [=1546]
E Clarissimi Signori Procuratori della procuratia de supra deono dare per una porta di legno per la porta della sagrestia
 Lire 31 soldi____
E deono dare per la fattura di cera della istorie et figure per ditta porta ducati 50 / portolli Tomaso schultore qual lavorò su ditta porta di cera val Lire 310 soldi____
E deono dare adì 9 di aprile ducati 4 / per libre 50 di cera et trementina[1] vale Lire 24 soldi 16
E deono dare per libre 200 di gesso dal gessaro di Santo Apolonale per far le forme di detta porta, vale Lire 10 soldi____
E deono dare adì ditto ducati 15 / portò maestro Gasapro per far dette forme, cioè l'istorie, figure, putti, et teste
 Lire 92 soldi____
Et più ducati sei a maestro Andrea gessaro per haver buttato le figure di cera in ditte forme, vale Lire 37 soldi 4
Et più adì maggio 1546 a Alessandro et a Antonio scultori per havermi aiutato a nettare le ditte historie, et figure di cera ducati 20 vale Lire 124 soldi____
1562. Et più adì 15 luglio a maestro Piero Campanaro per libre 185 / di bronzo per li ornamenti attorno la ditta porta netti di calo, roba, et fonditura a soldi 30 / la libra d'accordo
 Lire 277 soldi 10
Et adì 15 di novembre a missier Bortolo di cavedoni, per haver buttato libre 251 / di fregi, broche[2] per detta porta netto di calo, a soldi 30 la libra vale Lire 316 soldi 4
1563. Et più alli 9 d'agosto a maestro Agostino Zotto scultore padoano per haver buttato tutte le figure, et teste, et quadri, et putti, di detta porta in tutto vale Lire 310 soldi____
Et più per libre 340 di metallo netto di calo, che sono state pesate dette figure, teste, quadri, et putti, a soldi 35 / la libra monta in tutto Lire 595 soldi____

1568. E deono dare adì 22 di novembre Lire 52 / portolli Menico intagliatore per haver intagliato li fregi delle soaggie[3] et camuffati[4] et a Battista scultore, vale Lire 52 soldi____
Et deono dare per contadi in più volte a maestro Benetto fabbro per haver intagliato le broche, aggiustato le cornice, fatte le vite di bronzo et messa insieme detta porta, Lire cento novantaquatro soldi 8 / vale Lire 194 soldi 8
E deono dare per contadi a maestro Stefano tagliapietra per haver nettato gli spochezzi, che erano intorno a detta porta in più giorni
 Lire 25 soldi 4
1569. E deono dare adì 9 di maggio per libre 91 oncie 8 di rame havuto da maestro Batista calderaro a San Salvadore per soppanare[5] la detta porta a soldi 18 la libra vale
 Lire 82 soldi 10
E deono dare per contadi a maestro Marcho fabro in cassellaria per 2 cerchii di ferro doppii, posti su la testa de la ditta porta, ducati sei, vale Lire 37 soldi 4
E deono dare per contadi a maestro Ambrogio fabro per 2 serrature per ditta porta ducati dieci, vale Lire 62 soldi____
E deono dare per contadi al ditto per dua billichi di ferro[6] per la

detta porta ducati due Lire 12 soldi 8
E deono dare per contadi al ditto per tampagni di bronzo[7] per la
ditta Lire 24 soldi 16

Io Jacopo Sansovino

 Lire 2619 soldi 4 / ducati 422
 lire 2 soldi 16

Ex tergo: Conto presentato per missier Giacomo Sansuin alli
Clarissimi Signori Procuratori, tutti 3 ridotti in procuratia, in
questo dì 22 febraio 1569 [=1570], di ducati 422 lire 2 soldi 16 per
lui spesi nella porta di metallo fatto per la sagrestia della chiesa di
San Marco.
Adì ditto, 22 febraio 1569. Fu menata la partita a credito del ditto
di ordine di tutti 3 li Clarissimi Signori Procuratori delli sopradetti
ducati 422 lire 2 soldi 16.

1571, 22 zugno
Presentata per Domino Francesco Sansovino, dottore, nella causa
contro la procuratia de supra.

1575 die 8 martii
Presentata per excellentissimum Dominum Aloysium Leonum,
intervenientem nomine Clarissimorum Dominorum
Procuratorum de supra, ad excellentissimum Consilium de XL
Civile Vetus in causa cum Domino Francisco Sansovino doctore.

Die 9 dicti
Intimata per Antonium Theupulum, famulum offitii Domino
Francisco Sansovino.

(ASV, Proc. de supra, busta 77, proc. 181, fasc. 1, fol. 12[r–v];
Ongania and Cecchetti, 1886, pp. 43–44, no. 224)

 1. I.e., turpentine mixed with the wax to make a firmer shell for the clay
core of the cast.
 2. The roses or projecting nails of the door frame.
 3. From *soazar*, a cornice or ornament of a panel.
 4. The chiselled borders of the panels.
 5. For lining the door with strips of copper.
 6. A type of pivot used in portage; see Baldinucci (1681), p. 22.
 7. Hinges.

113. Tratto del libro G della chiesa da carta 414
1546. 9 detto [=9 January 1547].[1] per contadi a lui ducati
cinquanta / per comprar bronzo per la porta della sagrestia
 Lire 5 soldi____
Tratto del libro G della chiesa da carta 452
25 febraio. per contadi ducati cinquanta / a bon conto per comprar
metallo disse per far la porta della sagrestia Lire 5 soldi____[2]
Tratto del libro H della chiesia da carta 111
detto fo 13 settembrio 1549. per contadi al ditto ducati ottanta
denari____ a bon conto del far della porta di bronzo alla sagrestia.
Li scritte il Rheni in banco Priuli Lire 8 soldi____denari____

(ASV, Proc. de supra, busta 77, proc. 181, fasc. 1, fols. 11[v], 12[v],
14[v])

 1. Lorenzetti (1909), p. 290, n. 2, refers to Cassier Chiesa 3 as showing
payments to Sansovino from 1545. That volume is not available for
consultation, but it could refer to 1545, more veneto (=1546).
 2. Probably a duplicate reference to the previous payment.

114. 1553 adì 9 auosto
Io Augustino scultor da Padova ho ricevuto adì soprascritto da
messier Jacomo Sansovino ducati vinti / a bon conto de buttar
l'historie e figure della porta della sagrestia di San Marco
 Lire 124 soldi____

Ricevi dal soprascritto adì 22 zennaio 1554 ducati diese
 Lire 62 soldi____
Ricevi dal soprascritto adì 22 mazo 1555 lire quaranta / una soldi
10
 Lire 41 soldi 10
Ricevi dal soprascritto adì 26 mazo 1556 scudi doe / dal Sol
 Lire 13 soldi 12
Ricevi dal soprascritto adì 4 febraio 1563 lire sessantaotto / soldi
18, et questi è per resto e compio pagamento di haver butado li
lavori, cioè, le figure della porta della soprascritta sagrestia
de San Marco Lire 68 soldi 18
Io Augustin sopraditto

(ASV, Proc. de supra, busta 77, proc. 181, fasc. 1, fol. 30[r];
Ongania and Cecchetti, 1886, p. 44, no. 225)

115. 1562 adì 15 lugio
Ricevi io Piero de Zuane Campanato da messier Jacomo
Sansovino per sei pezzi di fornimenti che vano intorno alla porta
della sagrestia di bronzo, et ditti ornamenti pesò libre cento
ottantacinque, cioè, libre 185 / de ottone netto di callo, fatto
mercado per avanti a soldi 30 la libra, cioè, soldi trenta / ottone et
fonditura monta lire dusento settantasette soldi 10, et così io Piero
soprascritto ho ricevuto dal soprascritto messier Jacomo le ditte
 Lire 277 soldi 10

(ASV, Proc. de supra, busta 77, proc. 181, fasc. 1, fol. 31[r];
Ongania and Cecchetti, 1886, p. 44, no. 226)

116. 1562 adì 15 novembre
Io Bortholamio di Zuanpiero di Chaveoni ho ricevuto da messier
Jacomo Sansovino ducati cinquantauno / da lire 6 soldi 4 per
ducato, per haverli datto lire dusento cinquantauna di cornise, et
broche di latone[1] per la porta della sagrestia, le quale lire dusento
cinquantauna sono nette di callo.
Io Bortholamio di Zuanpiero scrisse et sottoscrisse

(ASV, Proc. de supra, busta 77, proc. 181, fasc. 1, fol. 32[r];
Ongania and Cecchetti, 1886, p. 44, no. 227)

 1. A variant form of *ottone*, an alloy with a copper base.

117. 1563
Io Beneto favro ho ricevuto da messier Jacopo Sansovino in fina
questo di adì 15 zenaro in più volte scudi diese, li quali me li ha
dati per haver justato le cornise de metalo della porta della
sagrestia Lire 67 soldi____
Et più ho ricevuto a conto delle vide di ferro[1] con la testa di
metallo ducati doi Lire 12 soldi 8
Io Beneto soprascritto ho ricevuto, ogi questo dì ventuno di
agosto lire vintiquatro a bon conto delle vide della sopradita porta
 Lire 24 soldi____

Io Beneto soprascritto ho ricevuto adì 30 decembre dal
soprascritto messier Jacomo lire dodese per intagliar le broche
della porta Lire 12 soldi____
Et adì 23 aprile ho ricevuto a conto della porta Lire 15 soldi____
Et adì 21 mazo ho ricevuto a conto della porta Lire 17 soldi____
Et adì 6 agosto ho ricevuto lire quindese e meza a conto della ditta
porta Lire 15 soldi 10

(ASV, Proc. de supra, busta 77, proc. 181, fasc. 1, fol. 33[r];
Ongania and Cecchetti, 1886, pp. 44–45, no. 228)

 1. A type of screw.

118. MDLXIX adì xxii febbraro
Copia tratta del zornal della chiesia segnato K
Per chiesia di San Marco a ser Jacopo Sansuino ducati quatrocento vintido lire 2 soldi 16, se li da credito delli ditti di voler et ordine de tutti 3 noi procucratori, et sono per tanti per lui spesi nella porta di bronzo che ha fatto con molte figure per la sagrestia de ditta chiesia, compreso il bronzo posto nella ditta porta, come per suo conto presentado a noi procuratori et etiam per ricever de diversi posti insieme con il ditto conto in filza delle polize appar. Non compreso però nella presente partida la mercede sua di haver fatto ditta porta, la qual mercede si haverà poi a estimar per periti, consideratis considerandis, la qual porta li fu ordinato per li clarissimi procuratori fin del'anno 1546 et datoli a tal conto ducati cinquanta del ditto millessimo alli 9 zenaro et ducati ottanta alli 17 febraro 1550, sicome nelli libri della procuratia a conto del ditto ser Jacopo appar, val Lire 42 soldi 4 denari 11 picoli———

(ASV, Proc. de supra, busta 77, proc. 181, fasc. 1, fol. 35ʳ; Ongania and Cecchetti, 1886, p. 45, no. 231)

119. Tapestries for the Choir of San Marco
Die 20 octobre 1550, in Venetia, in procuratia de la giesia di San Marco. El se dechiara per la presente scrittura qualmente maistro Zuane de Zuane di rosto, fiamengo razzaro del Illustre Signor Duca de Firenza, e rimasto d'accordo con il Clarissimo missier Antonio Capello, procurator et cassier della giesia sopradetta: per il qual el ditto mistro promette et se obliga far quattro pezzi di spaliera della longezza et altezza et del dissegno che a lui sarà mandato per Domino Jacobo Sansuino, proto della procuratia predita, tutte di setta d'oro et d'argento, così l'ordito come il resto senza ponervi ponto di lana ne altra sorta di roba dentro. Et questo per lo adornamento del coro della giesia predita de San Marco, dechiarando che l'oro et l'argento et etiam la seda siano in tutta bontà si come richiede ad ogni opera grande et degna. Et essa opera non solum sia fatta iuxta il dissegno che se li ha a mandar, ma etiam meglio di esso dissegno. Per la qual opera el ditto Clarissimo missier Antonio Capello come cassier ut supra promette al ditto maistro Zuane ducati vinti da Lire 6 soldi 4 per ducato, per ogni brazzo quadro che sara ditta opera, mesurando a brazzo de seda de questa città de Venetia, dando de presenti ad esso maistro Zuane a bon conto scudi cento d'oro et promettendo de darli altri scudi dusento d'oro per tutto el mese de fevraro proximo, et come el portarà over manderà due de ditte spaliere finide con li sui dissegni che haverà havuto se li habbi a dar lo integral pagamento di essi doi pezzi, et scudi cento de piu a bon conto delli altri doi pezzi restanti et similiter in mesi quattro subsequenti altri duxento scudi d'oro, et el restante de lo amontar di essi doi secondi pezzi quando el portarà over manderà quelli con li sui dissegni come è ditto delli doi primi. El qual mistro Zuane promette dar ditti quattro pezzi de spaliere finidi integralmente da mo' per tutto il mese de decembre 1551. Et non lo dando in esso termine, e contento di perder et liberamente relaxar della summa, et amontar de tutto el mercato scudi cento d'oro senza alcuna contradiction et obstaculo; volendo et contentando per patto expresso el ditto mistro Zuane per observantia de quanto nel presente accordo se contien, poter esser astretto realmente et personalmente cussì in questa città come in cadauna parte et loco del mondo. Et per chiarezza de tutte le due sopradette parte, io Alvise Rizzo, nodaro della procuratia de supra, ho scripto de voluntà de l'una et l'altra presenti li infrascripti testimoni.
Testes Ser Valerius Zuchato quondam ser Sebastiani
 Ser Josepha recamator ad sanctum leonem quondam
 ser Constantini . . .

(ASV, Proc. de supra, atti reg. 126, 1542–52, fol. 136ʳ; Ongania and Cecchetti, 1886, pp. 52–53, no. 252)

120. Antonio Capello to Giovanni Rost
De dicta [18 Agosto 1551]
A maistro Giovanni di rosto arazzaro dello Reverendissimo Duca di Firenza
 Frater carissime: considerando io pel termine che tolessi di perfettamenta finire li quattro pezzi di spagliere che vi forno ordinate per tutto el mese di decembre prossimo che viene, come si contiene nel accordo per voi fatto fino alli 20 di ottobre del anno passato, ho tenuto fermo nel mio animo che alla mitta del tempo dovesse venir la metà di esso lavoro, che cussì ne da de mentione la forma di esso mercado. Per vedendo esser gionto apresso pel finir, et non solamente non haver riceputo li dui pezzi di esse spaliere per la forma di esso accordo a me pare che si dovrebono haver havuto, ma non haver havuto pur nova alcuna in qual termine si attrovino, mi ha parso farvi la presente. Ricordandovi che è di gran importantia il menar a longo tal opera essendo per ornamento de la giesia nostra di San Marco a voi come credo molto ben mota, e vi esorto a non mancare di far esso lavoro integralmente finito per el termine da voi volontariamente tolto, cussì per l'utile vostro come etiam per conservation del honor nostro perché dal canto nostro non si manchera de quanto vi è stato promesso. Antonio Capello procurator Sancti Marci

(ASV, Proc. de supra, reg. 193, fol. 44ʳ; Gallo, 1926, pp. 57–58)

The Four Evangelists
121. Tratto del Libro H della chiesia da carta 111.
MDXLVII 1550. 17 febraio. per contadi per il far di quattro evangelista di bronzo che hano da andar sopra il pozo[1] novamente fatto all'altar grando in chiesia, ducati cinquanta / appare in zornale sotto primo marzo 1491 Lire 5 soldi——denari——

1. *Pozo* comes from *appoggiatoio* and here means the enclosure of the high altar. The reference to 1491 may be to an earlier enclosure, and there is a payment for this in the Cassier Chiesa I, under 1 March 1492.

122. Tratto del Libro H della chiesia da carta 263
MDLII. ottobrio
12 detto. per contadi a lui ducati vinticinque / per il far delle figure di bronzo da porer sopra la seragia[1] che e davanti l'altare grando nella chiesia di San Marco, qual sono quattro evangelisti
 Lire 2 soldi 10 denari——
30 zenaio. per contadi a lui ducati cinquanta / a conto di 4 evangelisti davanti l'altare grando, et sono quelli fu dar ser Nicolo de Zuane Strazarno Lire 5 soldi——
——detto per contadi a lui ducati quaranta cinque / quali sono per resto e saldo dell'amontar delle 4 figure sopradette di bronzo poste nella chiesia di San Marco davanti l'altare grando
 Lire 4 soldi 10

MDLII
Ser Jacomo Sansuin, prottho, die haver adì 30 zenaio [=30 zenaio 1553] per chiesia di San Marco. Si fa creditor per l'amontar di 4 evangelisti di bronzo quali sono sta posti sopra la seragia delle colonne davanti l'altare grando della chiesia nostra, le quali si come appare per il conto assegnato di man sua al Rheni nostro gastaldo montano ducati cento settanta denari——
 Lire 17 soldi——denari——

(ASV, Proc. de supra, busta 77, proc. 181, fasc. 1, fols. 14v, 15v, 16r; see Cicogna, 1824–53, IV, p. 30)

1. From *serraglio*, an enclosure.

Pietro Aretino's relief by Sansovino

123. Francesco Marcolini to Pietro Aretino, 15 September 1551
Signor compare, Prima che io vedessi il gran quadro ed il sì bene ornato della nostra Donna con Cristo in braccio, che di sua mano avvi donato quel Messer Jacopo Sansovino, fino da Michelangelo lodato per singolare e mirabile, non avrei potuto credere che altre figure di sua mano arrivassero alla bellezza del Marte e della Minerva, che di lui tengo per miracoli in casa, donatimi dalla sua gran cortesia. Certo ieri, che venni per visitarvi e non vi eri, ché vidi tal cosa, restai stupido fuor di modo, e da senno, nel vedere come nel mirarsi fissi la Madre ed il suo Figlio, pare che si beono santissimamente l'un l'altro con gli occhi; in tanto quella purità e castità e vaghezza, che si può imaginare, che fosse nella Vergine, sendo in terra, si discerne in la sembianza di lei, viva e vera nel tutto . . .

(Bottari and Ticozzi, 1822–25, V, pp. 522–25)

124. Pietro Aretino to the Duchess of Urbino, January 1552
Per conoscere ciascuna stanza della casa, ch'io habito, indegna del grande et mirabil' quadro, dove di basso rilievo la mano del Sansovino (il quale per essere al Buonaruoti secondo, viene tenuto tra gli scultori il primo) sì bene ha ritratto con la imaginatione dell'ingegno alla Vergine in braccio il figliuolo che par' vivo. Lo consacro a quella real' camera, che all'eccellenza della Signora Vittoria illustrissima più piacera di sì santa et divota opra adornarla. Onde a lei e al Duca bascio con religioso affetto di sperito le mani. Di genaio in Venetia. MD.LII.

(Aretino, 1609, VI, p. 58^{r-v})

125. Pietro Aretino to Sansovino, March 1552
Il gran' quadro di bassorilievo e di marmorea durezza composto, per volerlo sollevare fino a cielo con la lode, basta a dire che dalla mano di Messer Iacopo ci venga; imperò che il nome che havete ne la scultura e sì degno che fino al Buonaruoti ne ammira. Pochi huomini nell'intelletto et nel grado sublimi sono restati di non venirlo a vedere in mia casa. Il Reverendisimo Monsignor Beccatello legato, che avanza se stesso d'ingegno, stupido rimase subito che l'hebbe considerato et veduto. Il mio Signor Duca d'Urbino tosto che lo rimirò disse è una mirabil' cosa tal'opra che più la Eccellenza della Illustrissima Vittoria Farnese, alla cui bontà somma ne ho fatto un' presente, mi scrive che nè in Roma nè altrove mai non se n'e visto un' sì bello. Il che devesi credere a Madama sì mirabile et magna. Perochè essendo lei suta nipote di quel' Papa Pauolo, che tanto seppe et valse, si può stimare che niuno magistero d'importanza restasse dietro ai suoi occhi. Ma che parole, quali effetti userò io in ricompensa di sì notabil dono et sì caro che anco a ogni gran' Principe metterebbe pensiero a remunerarlo? Io non so mostrarne altra gratitudine che il tacere. Avvenga che ne anco me proprio posso offerirmi, pero che mi vi diedi tutto, è gran tempo; se vi piace hora che niente di me stesso vi dia, e di necessità che ne lo prestate ad usura. La qual somma pagaravvi poi la buona volontà del mio animo. Di marzo in Venetia. M.D.LII.

(*Ibid.*, p. 72^{r-v})

Sansovino and the Arca del Santo in Padua

126. 28 and 31 January 1529
Messer Jacopo Sansovini, scultore excellentissimo et raro a questa nostra età, die haver per fattura de una figura de un Santo Sebastiano de marmo come appar per man de ser Sebastian Balzan, adì 28 zennaio 1529[1] Lire 620 soldi___
Messer Jacopo contrascripto die dar adì 31 zennaio 1529 per tanti el portò in haver per saldo de questo in libro comune a carta 115
Lire 620 soldi___

(ADA, Reg. 392, fols. 77v, 78r; Sartori, 1976, p. 206)

1. What may be the contract for the *St Sebastian* survives but is virtually illegible; Sartori (1976), p. 206, conjectures that it refers to the completion of Minello's relief instead.

127. 17 March and 26 April 1529
Adì dito [17 marzo 1529], per do letere mandate a messer Jacomo Sansovino e per la resposta per cose del archa Lire___soldi 6
Adì 26 dito [26 avril 1529] mandati a va a messer Piero Paulo scultore per venir a fornir el quadro dal goto, lire tredese soldi diese, sono mandati a messer Jacomo Sansovino,[1] val
Lire 13 soldi 10

(ADA, Reg. 394, fols. 81r, 82r)

1. These references must concern Mosca's quarrel with the Arca del Santo over his relief. On 2 April 1529 Mosca announced he was going to Venice to find a collaborator, hence the introduction of Paolo Stella; see Sartori (1976), p. 173.

128. 26 April 1529
Maestro Piero Paulo scultore die dar adì 26 avril [1529] per tanti li conto per mio nome messer Jacomo Sansovino quando lui venne a Padova a lavorare e fornire el quadro del goto Lire 13 soldi 10
[There follow weekly payments to Stella until 13 October of that year.] Maestro Piero Paulo scultor die haver per el fornir del quadro dal gotto, za comenzado per maestro Zuan Maria scultor, e così fatto lo acordo de voluntà deli masari, li quali remesero a messer Jacomo Sansovini quello che poteva dito maestro Paulo meritare, e lui per una sua letra del dì 25 settembre 1529, ne fese intende che se li dovesse dar lire dosento e quaranta otto, et così l'ho fatto creditore de dita suma, la qual è Lire 248 soldi 4

(*Ibid.*, fols. 63v, 64r)

129. Adì 30 dito [July 1529]. per spese in Venetia per el fator per condur da San Sovero a San Silvestro el quadro lavorava el quondam Ser Antonio Minelo, per piata e fachini, lire diese soldi dodese Lire 10 soldi 12
e adì dito a maestro Silvestro tagiapira in Venetia, fese condur el quadro da San Sovero el messe soto el quadro una soa asse de larise et fo rotta. fese dar Messer Jacopo Sansovino lire doe soldi otto.[1]

(*Ibid.*, fol. 86r)

1. Apparently the first reference to Sansovino's commission to finish Minello's relief.

130. 10 October 1529
[Maestro Zulian fiorentino receives 4 lire and sixteen soldi] . . . e sono per andar a va parlar a Messer Jacomo Sansovino e da questo dì indrio se paga per conto dela seconda prospetiva de parola de messer Jacomo contrascrito. Lire quatro soldi sedese
Maestro Zulian contrascrito. die haver per il far dela prospetiva

del quadro dal gotto, la qual lui ha fornita e posta al suo luogo in la capella del gloriose Santo Antonio.

(*Ibid.*, fols. 64ᵛ, 65ʳ; Sartori, 1976, p. 206).

131. 23 October (?) 1529

Messer Jacomo (?) Sansovini die haver per fornir el quadro comenzado dal quondam Ser Zuan [*sic*] de Menelo . . .

Messer Jacomo Sansovino die dar adì 23 ottobre per cinque arnasi per metter suo vin ali barcharoli, li portono lira una soldi sedese e per li fachini li portono dal portelo a casa mia lire una, monta in tutto lire do soldi sedese, val Lire 2 soldi 16

[There follow other payments in kind through the rest of 1529 and into the following year. They amount to 302 lire 8 soldi.]

(ADA, Reg. 394, fols. 63ʳ, 62ᵛ; Sartori, 1976, p. 206)

132. +Yhs addì 29 novembre 1529

Io Jacopo Sansovino schultore et architettore fiorentino ho risceuto dalli signori masari del Santo a Padova schudi dieci d'oro in oro de lire sei soldi quadri per ciaschuno schudo. E sono per parte della opera feci per la archa e per loro, da Bartolomeo padovano per tre littere, e per fede ho fatto questo a mia propria mano.

(ADA, busta 962, fasc. v, no. 39; Sartori, 1976, p. 206)

133. 21 decembrio 1529. Scritto per el quale Jacomo Sansovino scultore confessa haver ricevuto dal magnifico messer Piero da Lion massaro et per nome dell'Arca de Sant'Antonio alcuni dannari per finir il quadro de che lui havea termine a finir in quattro mesi, in coppia de esso messer Jacomo, et sottoscritto da messer Zuane Santuliana, con numero 352.

(ADA, Reg. 59, fol. 34ᵛ; Sartori, 1976, p. 206)

134. 1530

Messer Jacomo Sansovino sculptore die dar per tanti contadi a lui tra roba e dinari per il mio predecessore, come apar nel suo libro a carta 63, in partide numero desdoto. Lire 201 soldi 16

El contrascrito die haver per tanto che die esser posto, debba dar per el mio successor finche si farà li soi conti. Lire 201 soldi 16

(ADA, Reg. 395, fols. 72ᵛ, 73ʳ)

135. 1531

Messer Jacomo Sansovino scultore die dar per tanti, tutto del lire del mio predecessor, apar a carta 73 Lire 201 soldi 16

E die dar per tanti o li contati a messer Allisandro di Boni adì 14 zugno 1531, delli quali danari lui aveva dare al dito messer Jacomo per conto del quadro come apar per un suo scrito ho apreso de mi, fa Lire 100 soldi____

E die avere per tanto debia esser porto debitor per lo mio succesorio per fare se farà lui soi conti Lire 301 soldi 16

(ADA, Reg. 396, fols. 68ᵛ, 69ʳ; Sartori, 1976, p. 206¹)

1. This and the following reference are given by Sartori without the year.

136. 20 October 1531

[The stewards of the Arca del Santo choose Marco Cermisan as their representative] . . . ad se componendum et raccordandum cum magistro Ioanne [*sic*] Sansovino, protho Clarissimorum Dominorum Procuratorum, scultore, pro certo quadro facto seu faciendo pro ornamento capelle Sancti Antonii Paduae pro eo pretio et promissione prout melius ipso spectabili domino Marco Antonio Cermisano . . . placuerit.

(ASP, Atti, Saviolo, A., busta 5000, fol. 316; Sartori, 1976, p. 206)

137. 21 December 1531

Scritto per el quale messer Jacomo Sansovino scultore confessa haver ricevuto dal magnifico messer Piero da Lion massaro et per nome dell'Arca de Santo Antonio alcuni dannari per finir il quadro che lui havea termine a finir in quattro mesi.

(ADA, Reg. 59, fol. 34ᵛ; Sartori, 1976, p. 206¹)

1. I have relied upon Sartori's transcription.

138. 1532

Messer Jacomo Sansovino scultor die dar per tanti trati del libro de messer Zuan Antonio Zacharoto a carta 69, Lire 301 soldi 16

E die dar a di 4 mazo presente contadi a lui per partide del quadro lui ha a finir Lire 155 soldi____
 Lire 456 soldi 16

Messer Jacomo Sansovino scultore contrascrito die avere per tanto die esser porto deba dare per el mio sucessor per saldare la contrascrita finche fatto li sui conti Lire 456 soldi 16

(ADA, Reg. 397, fols. 68ᵛ, 69ʳ; Sartori, 1976, p. 207¹)

1. Partially transcribed by Sartori under 4 May 1532.

139. Yhesu, addì 21 de magio 1532.

Io Iacopo Sansovino schultore ho risevuto ogi, come de sopra detto dallo magnifico messer Pietro Dallio massaro et cassiero dell'Arca de Santo Antonio, ducati venti cinque da Lire 6 soldi 4 per ducati, e quali danari mi da per parte de finire il quadro el quale io ho da finire per le loro signorie in termine di quattro mesi prossimi a venire. Et così io Iacopo sopra ditto prometto a l'antedetto messer Pietro.

(ADA, Reg. 298, fol. 139;¹ Sartori, 1976, p. 207)

1. Gonzati (1852–53) reproduces this document in an unnumbered plate.

140. 27 December 1532

Dechiaro io Piero da Lion, massaro della gloriosa Arca de esser Santo Antonio . . . di ordine del reverendo padre guardian maestro Marcantonio Fontana et Fra Bartholomeo Anderlin massaro . . . habbiamo unamiter concesso el quadro qual alias fu dato a maestro Tulio Lombardo, qual al presente si trova nelle man de suoi heredi, al magnifico maestro Giacomo Sansovino fiorentino, scultor excellentissimo in Venetia, qual promettemo levar di man de detti heredi, e quello a spese della gloriosa Arca far condur alla sua habitation, con el quale al presente non è stato fatto mercato alcuno, ma riportandosi secondo sarà l'opera per lui fatta e per periti giudicata, e ad ogni sua richiesta per il futturo cassier li sarà dati ducati 50 dummodo lui habbia principato ditto quadro, e così successive di tempo in tempo secondo lui lavorerà, li sia dati danari a sufficientia, acciò non patisca, e possa con bon animo finir

ditta opera. Laus Deo. Con patto, però, che 'l sopradetto esser Giacomo habbia a sculpir in ditto quadro quel miracolo di Sant'Antonio, ch'era stato commesso a maestro Tulio soprascripto

(ADA, Reg. 273, fol. 189ᵛ; Sartori, 1976, p. 207)

141. 1533

Domino Jacomo Sansovino architeto et protho dela illustrissima Signoria [sic] die haver per fornir il quadro comenzato per il quondam messer Zuan de Minello, d'accordo con li masari come lui dice Lire 620 soldi____

Domino Jacomo Sansovino contrascrito die dar per tanti li contò messer Battista Bonfilio casiero in piu partite como in suo libro apare Lire 202 soldi 8

Item. die dar per tanti apar per dicto libro del Bonfilio haverli dati ma in fato non li ha habuti. Lire 100 soldi ____

Item. die dar per tanti li contò messer Piero da Lion casiero come per suo libro apare. Lire 155 soldi____

Nota che credo lui li non habi havuti de Lire 100 dal Bonfilio, non habi regreso contra l'archa per chè fra lui et il Bonfilio nascette scritura.

(ADA, Reg. 398, fols. 74ʳ, 73ᵛ)

142. 1534

Messer Jacomo Sansovino architetto et proto dela Illustrissima Signoria [sic] de Venetia die haver per esser portato credito et per il mio precessor messer Francesco Alvarotto in suo libro a carta 74 Lire 1240 soldi____

Messer Jacomo soprascrito die haver per saldo facto con lui adì 28 avosto 1534, anulando ogni altro saldo per manufacto [?], resto haver chalculada in [illegible] lui et come apar per un scripto a de lui de man de mi Iulio Zabarella et soto scripto de tre deli altri mei colega, val Lire 312 soldi 12

Il contrascrito die dar como in libro de messer Francesco Alvarotto per partidi qui chasieri in detto libro a carta
 4 Lire 954 soldi 1

et el mandò il fator a maestro Silvio [Cosini] scultore per suo conto Lire 33 soldi 15

et per contadi maestro Silvio per suo conto Lire 3 soldi 4

et che fu contade maestro Vicenzo per lavorar giorni 3 in la prostativa¹ adì 4 lugio Lire 4 soldi____

et che fu contadi al ditto per conto del ditto messer Jacomo per lavorar in la ditta Lire 16 soldi 16

(ADA, Reg. 399, fols. 52ʳ, 51ᵛ)

1. I have been unable to trace maestro Vicenzo, but the reference is to a perspective relief for the chapel of the Arca which was left unfinished by Giuliano Fiorentino; see ADA, Reg. 398, fol. 74ʳ.

143. 1535

Messer Jacomo Sansovin contrascrito die haver per saldo de messer Iulio Zabarella a carta 52 Lire 312 soldi 12

E die li avere per tanti da esser porto creditore per il mio sucessore per tuto 1535 Lire 162 soldi 12

Item. da sapere che messer Battista Bonfilio, olim cassiero de l'archa resto debitore de Lire 100 et el Sansovino soprascrito disse de scoderli et perché messer Iulio Zabarella non el porta debitor in libro, ne se sano se el Sansovino li habi scossi, però, ho voluto far

dita notta. Maestro Jacomo Sansovin contrascrito die dar adi ultimo mazo 1535 per tanti contadi Lire 100 soldi____

E die dar adì 17 zugno per tanti contadi a messer Zuan Sant'Uliana
 Lire 50 soldi____

(ADA, Reg. 400, fols. 51ʳ, 50ᵛ)

144. 1536–37

Messer Jachomo Sansoin, schultore exelentissimo, die haver per sui resti dal quadro et dela prospetiva li ha fato tanto dal libro de messer Lorenzo da Noale a carta 51 Lire 162 soldi 12¹

Messer Jachomo contrascrito die dare che lui contrascrito haver receputo da messer Basylo Bonfilio a dito conto adì settembre 1535, schudi 8 d'oro val Lire 33 soldi 15

adì 7 zugnio 1536 gie contai mi per suo resto in carta 105
 Lire 128 soldi 17

(ADA, Reg. 401, fols. 50ʳ, 49ᵛ; Sartori, 1976, p. 207)

1. This payment refers to the completion of the relief begun by Minello.

145.
Messer Iacopo Sansoin, fiorentino, schultore exelentissimo, sta in Venetia, die haver per fare un quadro de marmoro qual doveva fare el quondam Tulio Lombardo con el miracolo dela dona anegata con el Santo Antonio in aere, dandogie nui i marmori, et è obligato a meter el suo nome scholpito soto dito quadro, et questo per pregio de ducati tresento a Lire 6 soldi 4 per ducato et tanto più quanto parerà al magnifico Messer Iacomo Cornaro e al magnifico Messer Fedricho di Priuli se lui havese fato tal opera ch'el meritase . . . come apare per scrito fato per mano da ser Zuane di Zagi canzeliere del magnifico messer Iacomo Cornaro capitanio de Padoa, fato adì 3 zugnio 1536, val a montada
 Lire 1860 soldi____

(ADA, Reg. 401, fol. 70ʳ; Sartori, 1976, p. 207)

146.
Messer Iacomo Sansoin contra scrito de dare adì 7 setembre 1536 a conto del contrascrito quadro quali gie contie mi in Venetia, contò de sua man, apare apreso de mi, ducati cinquanta
 Lire 310 soldi____¹

(ADA, Reg. 401, fol. 69ᵛ; Sartori, 1976, p. 207)

1. This is the first payment for the *Maiden Carilla* relief and appears on the page opposite the abstract of the contract in this register.

147.
7 settembre per gondola per andare da li fioli de Tulio Lonbardo con messer Iacomo Sansoin per el quadro, pagò el dito. Adì 8 per dare a messer Iacomo Sansoin per fare portar el quadro de marmoro, era da Tulio Lonbardo, a San Marcho per barcha e fachini, gie contie mi.

(ADA, Reg. 401, fol. 86ʳ; Sartori, 1976, p. 207)

148.
Del haver maestro Silvio, contò el fatore, per meter l'aier ala prospetiva a conzar el quadro drio l'altaro de messer Sancto Antonio in più fiade, apar in questo ala partida de maestro Silvio, va a conto del ditto Iacomo, ut supra a carta 52
 Lire 36 soldi____pizoli____¹

(ADA, Reg. 401 fol. 86ʳ; Sartori, 1976, p. 207)

1. This payment, collected by Silvio Cosini, refers to the perspective above the relief begun by Minello and finished by Sansovino.

149. 1541
Dì 28 dito [settembre] per pagare due litere mandate al excelentissimo messer Iacomo Corner una e l'altra al Sansuin, a carta 67 Lire____ soldi 2

(ADA, Reg. 406, fol. 54ᵛ; Sartori, 1976, p. 207[1])

 1. Sartori (1976), p. 207, glosses this as two letters to Sansovino, which is incorrect.

150. 1542
Domino Jacomo Sansoin fiorentino die haver per resto de un quadro che lui fa nel modo contenuto in un scritto fato per messer Zuan del Zago da Castelfranco, fu canceliero del clarissimo messer Jacomo Corner, del quale appare nel libro de messer Bonzanelo da Vigonza a carta, et tratto del libro de messer Marco Orsato a carta 52 Lire 1514 soldi____
El contrascito die dare per casa contadi a lui per il fatore adì 29 mazo 1542 Lire 37 soldi 4 pizoli____
adì 18 avosto per casa contadi a lui
 Lire 155 soldi____ pizoli____
Et per tanti lui die esser posto debba haver per el mio successore
 Lire 1321 soldi 16 pizoli____

(ADA, Reg. 407, fols. 49ᵛ–50ʳ; Sartori, 1976, p. 207)

151. 1545
Domino Jacomo Sansuin fiorentino die haver per resto di uno quadro che lui debba far, denari lire mille trecento vintiuna soldi 16, tratto del libro de messer Francesco Inselmo a carta 54
 Lire 1321 soldi 16
al incontro die dar adì 10 marzo, contadi allui a bon conto in zornal a carta 3 Lire 62 soldi____
E per tanti die esser posti a die haver per suo resto dal mio sucessor, metter per saldo Lire 1259 soldi 16

(ADA, Reg. 410, fols. 56ʳ, 55ᵛ; Sartori, 1976, p. 207)

152. 1548
Messer Jacomo Sansaeino scultore fiorentino dè haver per resto de uno quadro che lui fa per la capella de Santo Antonio di Lire mille cento ottantaotto soldi sedese, tratto dal libro del' 47 a carta 62
 Lire 1188 soldi 16
Al incontro de dar per tanti da esser posser posti in havere per il mio successore Lire 1188 soldi 16[1]

(ADA, Reg. 412, fols. 62ʳ, 61ᵛ; Sartori, 1976, p. 207)

 1. A deduction of 71 lire seems to have occurred between 1545 and 1548, which is not recorded in Sansovino's accounts, printed here as doc. no. 157. This is the probable source of the disagreement over money that delayed delivery of the relief. Sartori's reference here is garbled.

153. 1549
Messer Jacomo Sansoyno scultor fiorentino die haver per resto de uno quadro che lui fa per la capella de Santo Antonio, danari Lire mille cento octanta otto soldi sedese, tratto dal libro de Messer Paullo Valdozotto 1548, a carta 62, dar Lire 1188 soldi 16
Messer Jacomo contrascrito die dar adì 28 marzo 1549 per tanti contadi a lui a bon conto a Venetia in zornale a carta 4
 Lire 62 soldi____

Adì 6 septembre per contadi a lui a bon conto in zornale a carta 18
 Lire 124 soldi____
porto creditor per el mio sucessor a carta 62 Lire 1002 soldi 16

(ADA, Reg. 413, fols. 62ʳ, 61ᵛ; Sartori, 1976, p. 207)

154. 1550
Messer Jacomo Sansuino scultor fiorentino die haver per resto de uno quadro che lui fa per la capella de Santo Antonio denarii Lire mille et due soldi sedese, tratto dal libro 1549 a carta 62
 Lire 1002 soldi 16

(ADA, Reg. 414, fol. 62ʳ)

155. 1551
Messer Jacomo Sansuino scultor fiorentino die haver per resto de uno quadro che lui fa per la capella di Santo Antonio, denarii Lire mille et dieci soldi 26 [sic], trato dal libro 1550 a carta 62
 Lire 1002 soldi 16
Al incontro die dar adì 19 avosto contadi allui per il tanti [?] a bon conto carta 92 Lire 150 soldi 4
E per tanti die esser posto et die haver per resto dal mio sucessor
 Lire 852 soldi 12

(ADA, Reg. 415, fols. 64ʳ, 63ᵛ; Sartori, 1976, p. 207)

156. 1554 Indicatione xii die veneris, 6 Julii in secritario sacrestiae conventus Sancti Antonii confessoris Paduae.
Congregati li infrascritti Reverendi Padri et Magnifici Deputati della Veneranda Arca del glorioso Santo Antonio per trattare et terminare molte cose utili e honorevoli a essa Veneranda Arca, tra le quali . . . Essendo stato dato di molti denari al Sansovino per finiere un quadro della capela del glorioso Santo Antonio, già tanto tempo, nè mai è stato ordine di venire ad alcun fine per il che hano preso parte de andar a Venetia et per via di ragioni astringerlo che s'habbi il quadro over li suo denari . . .

(ADA, Reg. 3, fol. 111ʳ; Sartori, 1976, p. 207)

157. Sansovino's statement of account
+Yhs 1536
addì 7 settembre ducati 50 avuti da Messer Buonzanelo da Vigonza
 Ducati 50
1542 addì 29 mazo ducati 6 avuti da Messer Giovanni Barisone
 Ducati 6
addì 20 agosto ducati 25 avuti da el ditto
 Ducati 25
1545 addì 27 marzo ducati 10 avuti da detto Barisone
 Ducati 10
addì 18 guglio ducati 10 avuti da Messer Giovanni Sant'Uliana
 Ducati 10
1549 addì 19 marzo ducati 10 avuti da Messer Buonzanello da Vigonza
 Ducati 10
addì 5 settembre ducati 20 avuti da Messer Buonzanello Vigonza
 Ducati 20
1551 addì 3 settembre Lire 150 Ducati 24 lire 5 soldi 4
1557 addì 18 aprile ducati 30 avuti da Messer Trapolino Trapolini
 Ducati 30 lire____
 Ducati 180 lire 1 soldi 4
[In another hand on the same sheet] Ducati 180 et libre 1 soldi 4, fano in tutto libre mille et cento et disesette soldi 4, cioè, libre 1117 soldi 4, non di meno per li libri dell'arca ha havuto libre 1184 soldi

4 che sono libre sessanta sette da piu di questo conto. [On the verso] Ducati cento et ottabta sborsati a messer Giacobo Sansovino per diversi cassieri et massari per conto dil quadro marmoreo ha da fare per l'arca di Santo Antonio.

(ADA, busta 962, fasc. iv, no. 67; Sartori, 1976, p. 208)

158. 15 decembre 1557. Per spexa dil quadro, a cassa per tanti contà al magnifico miser Zuanantonio da Orologio mio honorevol colega per andar a tuor il quadro dale man de miser Iacomo Sansevino firentino schultor, presente il magnifico miser Francesco Boromeo e il fattor, ducati numero 105 foresteri a Lire 6 soldi 14, sumano in tuti lire settecento e tre soldi dexe, val Lire 703 soldi 10.
Per cassa. Domino Zuan Antonio da Relogio per tanti mi restituì che riportò da Venecia per non haver podù levar il quadro de le man del Sansovino, lire settecento e tre soldi dexe.

(ADA, Reg. 542, fols. 21v–22r; Sartori, 1976, p. 208)

1557, indictione 15, die martis 14 mensis decembris.
Paduae in comuni pallatio ad officium sigilli. Ibique reverendus magister Natalis de Commitibus, honorandus guardianus Sancti Antonii conffessoris, necnon reverendus magister Vincentius de Padua, nobilis dominus Petrus de Leone, honorabilis capserius venerandae Arcae Sancti Antonii conffessoris, necnon nobilis dominus Franciscus Boromeus, agentes nominibus suis, necnon nobilis domini Bartholomaei de Zachis, omni meliori modo et forma quibus melius validius et efficatius facere potuerunt, per se et successores suos fecerunt constituerunt nobilem dominum Johannem Antonium ab Horologio eorum collegam ad eundum in inclita civitate Venetiarum ad accipiendum a domino Jacobo Saxobino [sic] quadrum constructum ad honorem cappellae venerandae Arcae Divi Antonii conffessoris. Ad agendum petendum accipiendum exbursandum quancunque pecuniarum quantitatem in ellevacione dicti quadri, Promittentest. Quae omnia. Sub obligatione etc.

(ASP, atti, Talamazzo, L., busta 5027, fol. 326; Sartori, 1976, p. 208)

159. 1558
Conto dal danaro sborsato in più fiate, come qui sotto appare, à messer Giacobo Sansovino scultore raro in [illegible] del quadro di marmoreo ha da scolpire con il miracolo; il qual danaro resta contado al prefatto messer Giacobo per diversi cassieri di tempo in tempo, et primamente per tanti che have dal magnifico messer Bonzanello Vigonza, cassiero adì 7 settembrio 1536, appare nel suo libro a carta 70, libre trecento et dieci de picoli, val
Libre 310 soldi____
Item. per tanti sborsati al detto per Domino Alovise Enselmo cassiero adì . . . 1537, appare nel libro di quello a carta 63, libre trentasei soldi____val Libre 36 soldi____
Item. per tanti sborsati al detto per Domino Zuan Barisone cassiero in due partite adì 29 marzo et 18 agosto 1542, libre cento et novantadue soldi 4, come appare nel libro di quello a carta 50, val Libre 192, soldi 4
Item. per tanti sborsati al detto per l'eccellentissimo messer Vicenzo Rosso cassiero adì 10 marzo 1546, libre sessantado soldi____, appare nel suo libro a carta 56, val Libre 62 soldi____
Item. per tanti sborsati al detto per Domino Galleazzo Mussato cassiero adì zugno 1547, libre sessantado soldi____, appare nel suo libro a carta 66 Libre 62 soldi____
Item. per tanti sborsati al detto per il soprascritto Domino

Bonzanello Vigonza cassiero in due fiate, videlicet, adì 28 marzo; et adì settembrio 1549, libre cento et ottantasei soldi____, appare nel suo libro a carta 62, val Libre 186 soldi____
Item. per tanti sborsati al detto per Domino Frigerino Cappodivacha cassiero adì 19 agosto 1551, libre cento et cinquanta soldi____, appare nel libro di quello a carta 64, val
Libre 150 soldi____
Item per tanti sborsati al detto per Domino Pietro da Lione cassiero adì 15 aprile 1557, libre cento et ottantasei, appare nel suo libro a carta 71 Libre 186 soldi

Libre 1184 soldi 4
Libre 675 soldi 16

Libre 1860 soldi____

Questa memoria descritta sì della conventione, come dal danaro sborsato a Messer Giacobo, si ha fatto per sollevare li cassieri successori dalla fatica; acciochè con facilità loro possano ritrovare ogni sborsatione da tempo in tempo fatta; et quello tanto resta haverà Messer Giacobo Sansovino.

(ADA, Reg. 422, fol. 108r)

160. 1558
Conventione fatta tra li agenti, over Magnifici Signori Massari della Veneranda Arca del glorioso Santo Antonio Confessore di Padova et il celebre scultore Messer Giacobo Sansovino, per conto del fare in scultura di marmo uno miracolo di esso glorioso Santo Antonio, tratta dal libro del Magnifico Messer Bonzanello Vigonza cassiero, l'anno 1536, a carta 70, ut infra.
Messer Giacobo Sansovino fiorentino, scultore eccellentissimo, sta in Venetia, die haver per far uno quadro di marmo, qual dovea far il quondam maestro Tulio Lombardo con il miracolo della donna annegata con il Santo Antonio in aere, dandoge noi i marmori, et, è obligato mettere il suo nome scolpito sotto a ditto quadro. Et questo per precio de ducati trecento a Lire soldi 4 per ducato; et tanto più quanto parersi al Magnifico Messer Giacobo Cornaro et Magnifico Messer Federigo di Priuli, se lui havesse fatta opra tal ch'el meritasse; et del soprascritto accordo fatto per il Reverendo Padre Maestro Antonio Canazza, Guardiano del Santo, et per il Padre Maestro Bernardino Massaro, et Eccellentia de Messer Francesco Papafava et Messer Nicolò Bonfio, et Messer Alessandro Dono, et io Bonzanello Vigonza, come appare per scritto fatto per mano de Sier Zuanne di Zaghi da Castelfrancho, cancelliere del magnifico messer Giacobo Cornaro, capitano di Padova, fatto adì 3 zugno 1536, val a moneda
·Lire 1860 soldi____
Battere Lire 1184 soldi 4
Resta Lire 675 soldi 16
Messer Giacobo suprascritto per il conto del danaro scosso per lui come all'incontro appare notato; va creditore la libre seicento et settantacinque soldi 16. Non di meno, essendo fatta nota per Domino Frigerino Cappodivacha, cassiero l'anno 1551 nel suo libro a carta 64, lo manda creddttore da Libre 852 soldi 12. Questo istesso lo nota Domino Piero da Lione, cassiero l'anno 1552 nel libro suo a carta 64, et contandogli per parte il prefatto Domino Pietro da Lione, cassiero l'anno 1557, Libre cento et ottantasei soldi____picoli due. Altri cassieri dall'anno 1552 fin 1557 non gli ha [sic] contado nulla, et detrazando Libre 186 soldi____ da Libre 852 soldi 12, veranno a restar Libre 666 soldi 12, che di tante solamente die andare credditore messer Giacobo, et non da Libre 675 soldi 16. Dove die proceda questo errore non lo so, ne ho possuto trovarlo.

(Ibid., fol. 197v; Sartori, 1976, p. 208)

161. Giovanni Sant'Uliana in Venice to the Arca del Santo in Padua, 2 March 1562

Molto Magnifici Signori Presidenti et Monsignori,

Si atrova maestro Giacomo Sansovino nel letto amalatto, onde fui così ieri a trovarlo et raggionamo del negotio del quadro, et dappoi ditte molte parolle si aquettò d'haver ducati 450, ma voria de prexente ducati cento et il resto al natalle susequente dell'anno venturo, et alliegga che il magnifico Messer Giovanni Antonio da Relogio, mio gienero, volse darli altre fiatte ducati cento alla mano et il resto poi quanto fusse estimatto certo tempo dappoi, et però che hora siatti contenti d'accomodarlo de questi ducati cento, aciò se ne possi anche lui prevalere, lassandovi maxime di molti ducati che lui sè certo, quando si extimase, li serriano adgiudicati, ma che per far appiacere et a Vostre Signorie et a mè, et perché [?] molto desidero che quomodolibet che si veda quest'opera di mano sua in quella città non vol guardar ad un pocho più, ad un pocho meno, et qui m'ha detto un mondo di belle parolle, del che l'ho ringratiatto quant'ho saputo. Vostra Signoria veda mo' di satisfarlo in darli questi cento ducati et non vogli guardar ad un pocho discomodo suo, non havendo questo guardato al molto. Sicché mi dice haver havuti ducati 380, tanto che al natal li avanzerà poi ducati 70. Di che non le dirò altro inportandomi di questo al caso verdico. Et prego Vostra Signoria perdonarmi s'io sono statto tardo ad exiquir questo negotio perché invero non ho potutto far più, con che facendo fine melli offro et dichiaro insieme con tutta la magnifica sua caxa.

Di Venetia, adì 2 marzo 1562. Par [?]; et Servitor di Vostra Signoria, Giovanni Sant'Uliana

(ASP, atti, Ottaviano, G.D., busta 2458, fol. 31ʳ; Sartori, 1976, p. 208)

162. Settlement with Sansovino is agreed by the Arca del Santo, 17 March 1562

... Inter caetera proposita fuit pars huiusmodi: quibus placet quod fiat mandatum procurae in personam Magnifici et excellentissimi iuris Doctoris Domini Iacobi de Leone, ac Magnifici Domini Ioannis S. Iuliana, nunc existentium Venetiis, pro expediendo et exequendo concordio facto, et concluso per ipsum Magnificum Comem Hieronimum de Capitibuslistae, medio eiusdem Magnifici Domini Ioannis de S. Iuliana, cum Domino Iacobo Sansovino, occasione quadri marmorei de quo fit mentio in litteris eiusdem Magnifici Domini Ioannis scriptis praedicto Magnifico Comiti Hieronimo, ea de causa secondo instantis, ac mihi notario per ipsum Comitem Hieronimum traditis in custodiam. Quod concordium sit hoc modo, videlicet, de dando ipsi Domino Iacobo ulta ducattos 280 iam per eum habittos, alios ducattos 170 pro resto, videlicet, quinquaginta de presenti, quinquaginta in mense maii proxime futturo, et 35 ad festa nattalicia proxime futura, et alios 35 ad festa paschalia resurectionis 1563, et in reliquis cum clausulis consuettis ponant votum suum in pixide rubea, quibus non in viridi, ipsaque parte abbalotata fuerunt pro VI—contra O. Et sic de omnibus capta remansit.

(ADA, Pars, busta 182, fol. 72ʳ; Sartori, 1976, p. 208)

163. 17 March 1562

Facultà datta alli Signori Giacomo Leoni et Giovanni Sant'Uliana per spendere et esequire il concordio fatto con il Signor Giacomo Sansovino scultor per far li quadri di marmo della capella del Santo.

(ADA, Reg. 182, fol. 16ᵛ; Sartori, 1976, p. 208)

164. Settlement of Sansovino's bonus, 17 March 1562

Cum sit quod alias conventum fuerit inter agentes Venerandae Arcae gloriosi Sancti Antonii confessoris de Padua ex una et dominum Iacobum Sansovinum sculptorem in inclita civitate Venetiarum ex alia, quod haberet facere quodam quadrum marmoreum pro percio ducatos 300 et pro eo pluri quod fuerit arbitratum per quodam Clarissimum Dominum Iacobum Cornelio et Federicum de Priolis, et hoc iam pluribus annis, et tandem quadrum ipsum Deo auxiliante reductum fuerit ad perfectionem adeo quod nil aliud restat nisi quod dictum quadrum accipiatur et Paduam conducatur, sed tamen quod satisffiat dicto Domino Iacobo de eo quod sit iustum et honestum, super quo precio cum difficultas oriretur tam propter id quod dictus Dominus Iacobus praetendebat longe plus ducatis 300, tam quia aestimatio seu arbitrium de valore dicti quadri amplius fieri non potest propter mortem dictorum Clarissimorum Dominorum Iacobi Cornelii et Federici de Priolis. Adeoque futura erat non modicalis [?] inter partes praedictas super valore dicti quadri, et desiderantes Reverendi et Magnifici Massarii eiusdem Venerandae Arcae ut hiusmodi differentia componeretur eum satisfactione utriusque partis onus dederunt Magnifico Comiti Hieronimo de Capitibuslistae uni ex ipsis deputatis et massariis praedictae Venerandae Arcae ut medio Magnifici Domini Ioannis S. Uliana Venetiis iam aliquibus diebus exactis concordium aliquod honestum pertractaret. Qui tandem de consensu ipsorum Reverendorum et Magnificorum Massariorum, bene prius viso et considerato ipso quadro simul cum Magnifico et excellente iuris Doctore Iacobo de Leone alio ex dictis Magnificis Deputatis nunc Venetiis existente, conclusit cum dicto Domino Iacobo quod sibi dari debeat in toto ducati quadringentiquinquaginta, et cum iam ad talem computum habuerit praedictus Dominus Iacobus ducatos ducentos octuaginta, residuum quod est de ducatis centum septuaginta sibi pro eodem debeat in his terminis, videlicet, ducatos quiquaginta de praesenti et ducatos quinquaginta per totum mensem maii proxime venturi, ducatos triginta quinqiue ad festa natalitia Domini Iesus Christi proxime futura et reliqui ducati trigintaquinque ad festa paschalia resurrectionis Domini Iesus Christi 1563.

Unde Reverendi et Magnifici infrascripti Massarii non valentes omnes se Venetias conferre pro accipiendo dicto quadro, sponte omni meliori modo fecerunt constituerunt et solemniter ordinaverunt suos veros et legiptimos nuncios comissarios et procurators praedictum excellentem Dominum Iacobum de Leone et Magnificum Dominum Iohannem de S. Uliana absentes ... ad faciendum instrumentum concordii iuxta tenorem suprascriptum et ad solvendum dictos ducatos quinquaginta de praesenti et promittendum, nomine dictae Venerandae Arcae, de solvendo residuo in terminis suprascriptis et ad accipiendum ipsum quadrum et illud conduci faciendum in hanc civitatem Paduae ut poniposit in loco deputato in capella eiusdem gloriosi sancti in ecclesia praedicta et circa praemissa ...

(ASP, atti, Ottaviano, G.D., busta 2458, fol. 32ʳ⁻ᵛ; Sartori, 1976, p. 209)

165. The Arca del Santo gives power of attorney to Jacobo de Leone and Giovanni Sant'Uliana, 17 March 1562

... nunc existentium Venetiis pro repediendo et exequendo concordio facto et concluso per ipsum Magnificum Comitem Hieronimum de Capitibuslistae, medio eiusdem Magnifici Domini Loannis S. Uliana, cum Domino Jacobo Sansovino occasione quadri marmore ... de dando ipsi Domino Jacobo ultra ducatos ducentum octuaginta iam per eum habitos, alios ducatos

centum septuaginta pro resto, videlicet, quinquaginta de praesenti, quinquaginta in mense maii proxime futuro, et trigintaquinque ad festa natalitia proxime futura, et alios xxxv ad festa paschalia resurectionis 1563, et in reliquis cum clausulis conclusis . . .

(ADA, Reg. 3, fol. 261; Sartori, 1976, p. 209)

166. The Arca del Santo confirms new power of attorney, 20 March 1562

. . . in personam Reverendi Sacrae Theologiae Doctoris Cornelii divi, ministri optime meriti provinciae Sancti Antonii, et hoc quia excellentissimus Iuris Doctor Dominus Jacobus de Leone suprascriptus ac Magnificus dominus Ioannes S. Uliana, in quibus factum fuerat ipsum mandatum procurae iuxta formam partis praedictae reversi sunt Paduam antequam sibi missum fuisset ipsum mandatum procurae. Qua parte, aballotata, fuerunt pro 6 contra 0, et sic capta remansit de omnibus suffragiis.

(ADA, Reg. 3, fols. 261–62; Sartori, 1976, p. 209)

167. The Arca del Santo makes final quittance with Sansovino, 16 May 1562

The Arca agrees to pay Sansovino 50 ducats immediately and a further 50 ducats during the same month, followed by 510 lire 18 soldi at Christmas and 510 lire 18 soldi at Easter.[1]

(ADA, busta 963, fol. 263; Sartori, 1976, p. 209)

1. My knowledge of this transaction comes from Sartori.

168. Sansovino gives relief to Antonio Correr in exchange for first instalment of his quittance

Die Sabbati xxiii mensis maii 1562 ad cancellum
Spectabilis Dominus Antonius Correrius, civis Paduae Venetiis commorans, tamquam prout, et cum nomine Magnificorum Massariorum et Praesidentium Venerandae Arcae gloriosi Sancti Antonii Confessoris de Padua, cum auctoritate speciali infrascripta peragendi quem ad modum constat instrumentum suae procurae Paduae cellebrato sub signo et nomine Spectabilis Ioannis Dominici Octaviani notarii publici dictae civitatis, sub die 16 maii instantis . . . per me notarium infrascriptum viso, et lecto, decto procurae [?] nomine, dixit ut confessus fuit habuisse et sibi consignatum fuisse per spectabilem Dominum Iacobum Sansovinum architectum quadrum marmoreum per ipsum confectum quod penes ipsum existebat et quod collocandum venit in capella ipsius Venerandae Arcae et quod Padua in manibus ipsorum Magnificorum Dominorum Massariorum iuxta eorum ordinem transcritere intendit. Et propterea decto viro Domino Iacobo fecit quietationem . . .

(ASV, atti, Maffei, V., busta 8132, fols. 251ʳ–252ʳ¹)

1. Sartori (1976), p. 209, gives a reference to Antonio Correr's power of attorney from the Paduan archives.

169. Yhs MDLXII

Messer Jacomo Sansuino scultore fiorentino die haver per resto de un quadro di marmo, et mercado fatto come del tuto appar nel libro 1558 a carta 108 lire sei cento setanta cinque soldi 16, trato del libro Lire 675 soldi 16
Al'incontro die dar adì 6 zugno contadi allui a bon conto a carta 84
 Lire 310 soldi ——

Adì 11 luglio per contadi a lui a bon conto a carta 85
 Lire 124 soldi ——
Adì 15 avosto allui a conto a carta 86 Lire 186 soldi ——

(ADA, Reg. 426, fols. 70ʳ, 69ᵛ)

170. Yhs MDLXIII

Messer Jacomo Sansuino scultore fiorentino die haver per resto del quadro facto per lui et mercado come del tuto apar nel libro 1558 a carta 108, lire cinquanta cinque soldi—— Apar in libro 1562 a carta 70 Lire 55 soldi 16
E per aquanto de sua merzede e resto per il quadro della dona anegada per parte pressa l'ano 1562 adì 17 marzo, conto e saldo apar instrumento de Messer Vetor di Mafei, nodaro Venetia, soto dì 23 mazo 1562, con presentia de Messer Antonio Coriero, comesso della Veneranda Arca, lire novecento sesanta sete soldi cinque Lire 967 soldi 5
 Lire 1023 soldo 1
Al'incontro di dar. Adì 29 zugnio have Messer Francesco Sansovino a carta 84
Adì 7 novembre conto a Messer Francesco suo fiolo a carta 84
 Lire 551 soldi 13
Adì 30 decembrio ave Messer Francesco ut supra a carta 86
 Lire 161 soldi 8
 Lire 1023 soldo 1

(ADA, Reg. 427, fols. 71ʳ, 70ᵛ; Sartori, 1976, p. 209¹)

1. Sartori has this under the wrong date, volume, and page.

171. Agostino Zoppo is paid for putting Sansovino's relief in place, 26 November 1563

Maestro Agustino Zoto scultore die haver per mazè fare per la presiol [?] et per matte suxo il quadro fato per il Sansuino nella capela de Santo Antonio lire cento e vinti cinque
 Lire 125 soldi——
Al'incontro die dar adì 26 novembre per contadi a lui a carta 85
 Lire 32 soldi——
Adì 30 decembre per contadi a lui a carta 86 Lire 93 soldi
 Lire 125

(ADA, Reg. 427, fols. 72ʳ, 71ᵛ; Sartori, 1976, p. 237)

172. Settlement between Arca del Santo and Zoppo, 8 January 1564

. . . Quoniam Magister Augustinus sculptor de contrada Sancti Prosdocimi instat sibi satisfieri de eius mercede industria et expensis qua usus est et quas fecit in extrahendo ex barcha et conducendo ex ponte Ponderoso usque in ecclesiam et capellam Sancti Antonii quadrum marmoreum habitum a Sansovino, praetenditque bonam quantitatem denariorum ut ibi dictum fuit, offerens tamen accipere ducatos duos minus eo quod per expertos terminatum foret sibi venire quam per ritum aestimationis procedere, et quoniam, habita matura consideratione inter eosdem Reverendos et Magnificos Dominos Massarios et informatione circa praedicta, visum est quod ducatorum quindecim de libris 6 soldis 4 pro ducato, solutio esset satisfactio honesta pro utraque parte, idcirco proposita fuit ibidem pars quibus placet quod est Magistro Augustino dentur ducati quindecim suprascripti pro integra satisfactione expensarum per se factarum in extractione quadri praedicti ex barcha conductione et collocatione illius in eadem capella et demum totius eius quod ipse Magister Augustinus quomodolibet praetendere ac petere posset occasione

quadri praedicti... Datis et receptis suffragiis in rubea fuere reperta pro VI contra O, et sic de omnibus capta remansit.

(ASP, atti, Ottaviano, G. D., busta 2458, fol. 67; Sartori, 1976, p. 210)

173. Extracts from will and codicil of Doge Francesco Venier

Io Francesco Venier, fo de messer Zuane, fatio el mio testamento et dechiarisco qui sotto la mia ultima volontà, cassando et annullando ogni altro testamento havesse fatto. Lasso mei commissarii messer Piero Venier, mio amantissimo et cordialissimo fratello, il qual voglio sia per la mazor parte, madonna Chiara Venier et madonna Cecilia Foscari, relicta del magnifico messer Federico mia cordialissima sorela, il clarissimo messer Zacharia Vendramin, mio cugnado et fratello charissimo, et madonna Isabetta Venier, mia carissima cugnada. Lasso che siano celebrate al tempo de la mia morte dove parerà alli mei commissarii mese / 300 / Voglio esser sepulto a San Francesco di la Vigna con pocca pompa etcetera, come parerà alli mei commissarii. Lasso alla Scuola de la Misericordia, oltra el suo consueto, ducati vinti da esser dispensati per messer lo guardian et deputati alla bancha a poveri fratelli come a loro conscientia parerà. Lasso siano dispensati nella contrà si troveremo habitare nel mese che Dio mi havrà chiamato da questa vita ducati quindese a persone miserabili. Lasso a San Francesco di la Vignia ducati quindese, oltra quello li aspettarà per el mio funeral... [1550]

Jesus Maria. 1555 alli 25 di settembre, in Venetia

Al nome del eterno Dio amen. Volendo nui Francesco Venier per la gratia di esso nostro Signor Dio dose di Venetia, etcetera, in qualche parte dove più necessità correzer et azonzer per adesso al testamento nostro, qual scritto di mano nostra propria havemo consegnato a Domino Antonio Marsilio nostro cancellier inferior et pregato, fu del anno 1550. Fatiamo el presente condicillo di nostra mano per el quale lassemo a Alvise, fiol del fedelissimo secretario nostro, Marc'antonio Saysa, et nostro balotin, oltra li ducati cento che per la promission nostra siano tenuto lassarli, et oltra li vestimenti lagubri che si sogliono fare alli balotini al tempo de la morte di principi, et oltra og'altra vestido over altro dono li havesamo fatto in vita, altri ducati cento / 100 / si che computa li superscritti che li siamo obligato lassare ⟨...⟩ ducati duecento /200 / et questo in segno del amor et benevolentia li havemo. Preterea, revochemo l'ordine che per el testamento preditto davemo di esser sepulto a San Francesco di la Vigna. Ittem, quelle parole dove dicemo, lasso a San Francesco di la Vigna ducati xv, oltra quello li spetterà per el mio funeral, et in loco de ditti legati, li lassemo ducati vinti / 20 / Et perché è conveniente che circa la nostra sepultura diamo quel ordine che se ne conviene, volemo quanto alle exequie che si siegui quello che alli altri predecessori nostri è sta solito farsi per li heredi dei altri principi più di quello che per el publico è costume di fare. Volemo esser seoulto nella giesa de San Salvatore nel locco che havemo ellecto, et che nui è sta concesso da li reverendi padri di quel monasteri per el far de la sepultura nostra come appar per instrumento pregado adì primo april proximo passato predicto a ser Marc'antonio di Cavanei, publico nodaro, il qual instrumento sii et quanto alla mansionsionaria et in tutto exeguito. Volemo che per el fare de la ditta nostra archa et adornamento nella faza del muro et nel salizado sia speso al meno ducati mille, et così etiam non più de ducati mille et cinquecento ad arbitrio de nostro fratello messer Piero, overo de suoi fioli, et del fare questa opera quando per nui in vita nostra non fusse sta fatta, li aggravamo molto la conscientia

che al meno in spatio di anni doi la sia fornida. Volemo ancora che'l nostro corpo sii posto nell'archa in terra che si farà, et non nel cassone nel muro, et questo per la humilità che dovemo havere, et vergonessimento de la miseria nostra, dando sempre laudo al Signor Dio de la exaltatione nostra, et de li innumerabili benefitii che si è degnato conferirmene. In reliquis conferemo et approbemo el soprascritto nostro testamento come el sta in tutto et per tutto...

(ASV, testamenti, Ziliol, C., busta 1207, no. 300; see ASV, testamenti, Marsilio, A., busta 1217, ix, fol. 64^{r-v})

174. The agreement between Francesco Venier and the church of San Salvatore

In Christi nomine amen. Anno nativitatis eiusdem millesimo quingentesimo quinquagesimo quinto, indicatione tertiadecima, die primo mensis aprilis. Volentes et intendentes Reverendi Patres Monasterii Sancti Salvatoris Venetiarum, ordini Sancti Augustini et congregationis Sancti Salvatoris, sattisfacere pio voto Serenissimi Domini Domini Francisci Venerio, Dei gratia Venetiarum Principis, qui cupit habere locum in ecclesia predicti Monasteri Sancti Salvatoris, pro facienda sive fabricanda una honorifica sepultura ad sepelendum cadaver, sive ossa sua, et heredum suorum. Ideo, constitutus in presentia mei notarii et testium infrascriptorum, Reverendus Pater Dominus Frater Jaonnes Paulus de Corniaris, visitator totius predictae congregationis, agens ut commissus supradicti monasterii Sancti Salvatoris, ut apparet instrumento procuarae hodie scriptae, et rogato per me notarium infrascriptum, sponte et libere dedit et concessit ac tenore presentis publici instrumenti datum, et concessus esse voluit et vult prelibato Serenissimo Principi ibidem presenti et acceptanti: faciem ipsius ecclesiae ex opposito organi et januae per quam eggreditur in Merzzanam, ac inter altaria e pillastris capellae Sanctae Mariae et Sancti Augustini. In quo loco predictus Serenissimus Princeps fieri et fabricari facere possit unam honoratam sepulturam cum suis ornamentis juxta eius voluntatem beneplacitur, et deposit ipsamque sepulturam fabricari facere tam in pariete eiusdem ecclesiae quam in terra sive pavimento, a primis contonis dictorum pillastrorum inclusive recta linea prout sibi videbitur. E contra vero supradictus Serenissimus Princeps promist scribi facere predictis Reverendis Patribus Monasterii Sancti Salvatoris ducatos quadringentos capitalis Montis Novissimi, sive subsidii ad ducatum pro ducato in ellectione ipsorum Reverendorum Patrum, quorum prodia sint eorundem Dominorum Patrium. Cum hoc, predictus Reverendus Dominus Visitator dicto nomine per se, suosque successores teneatur de tempore in tempus nominare et appresentare heredibus antedicti Serenissimi Principis unum ex suis fratribus Sancti Salvatoris in mansionarium, elligendum postea et acceptandum per dictos heredes de anno in annum; qui quidem mansionarius sic nominatus et ellectus celebrare habeat singulo die in perpetuum unam missam pro anima ipsius Serenissimi Principis, facendo de ea commemorationem...

(ASV, San Salvatore, busta 41 [=tomo 85], fols. 74v–75v)

175. Payments to Alessandro Vittoria for work on tomb of Doge Francesco Venier

ali 30 hotobrio 1557 [fol. 86v]

Lire 6 soldi 10 A Antonio di maestro Picio per avre lavorato cinque giornate sula Pietà dil clarissimo Venier fratelo dil Principe.

Val. Lire 6 soldi 10.

ali 13 novembrio 1557
Lire 3 soldi 18 A Antonio di maestro Picio per avere lavorato tre
giornate sul piedino dil fereto va posto in Santo Stefano

Lire 3 soldi 18

ali 9 decembrio 1557
Lire 2 soldi 16 A Antonio soprascritto per aver lavorato 2 giornate
sul
Dose di la dita Pietà Lire 2 soldi 12
ali 22 zenaro 1558
Lire 4 soldi 16 A Tomaso da Zara per aver polito la Madona dela
Santissima Pietà per saldo e resto del nostro mercato
ali 6 novembrio 1557 [fol. 87ʳ]
Ricevi dal magnifico Signor Giovanni Veniero a bon conto dela
Pietà va posta ala sepoltura dil Principe a Santo Salvadore ducati
numero 10
ali 27 novembrio 1557
Ricevi dal magnifico Signor Giovani Veniero a dito conto de la
Pietà ducati, numero 20
ali 23 decembrio 1557
Ricevi dal magnifico Signor Giovani Veniero a bon conto di la
Santissima Pietà ducati, numero 10
ali 23 zenaro 1557
Ricevi [ecc. come sopra] 20
ali 8 marzo 1558
Ricevi dal magnifico Signor Giovani Veniero per resto e saldo di
la sopradita Pietà ducati numero 10
ali 28 marzo 1558
Ricevi dal magnifico Signor Giovani Veniero a bon conto dil
serenissimo doge che va sul cassone morto ducati 10
ali 13 aprile 1558
Ricevi dal magnifico Signor Giovani soprascritto a bon conto dil
Serenissimo Principe ducati quatordese val duc. 14
ali 15 magio 1558
Ricevi dal magnifico Signor Giovani Veniero a bon conto di la
soprascritta figura ducati 15, cioè ducati 15
ali 30 magio 1558
Ricevi dal magnifico Signor Giovani Veniero per resto e saldo dila
figura soprascritta ducati 6 val ducati 6
ali 26 marzo 1558 [fol. 88]
Lire 6 soldi 10 A maestro Antonio di Picio per 5 giorni sula figura
dil principe morta
ali 2 aprile 1558
Lire 7 soldi 16 A Antonio di maestro Picio per 6 giorni sula figura
dil principe morto
ali 9 aprile 1558
Lire 6 soldi 10 A Antonio di maestro Picio per 5 giornate sula
figura dil principe morto
ali 16 aprile 1558
Lire 5 soldi 4 A Antonio di maestro Picio per 4 giornate sula figura
dil serenissimo
ali 23 aprile 1558
Lire 7 soldi 3 A Antonio di maestro Picio per 5 giorni e mezo.

(Predelli, 1908, pp. 185–88)

176. Sansovino makes his son-in-law proxy for a baptism in Florence[1]

1550 die lune, 6 octobris, ad cancellum. Excellentissimus sculptor
Dominus Jacobus Sansovinus de Florentia, Venetiis commorans,
omni meliori modo quo potuit constituit suum procuratorem et
commissum Dominum Clementem de Empoli, florentinum
generum suum, absentem tanquam presentem, specialiter et
expresse eius nomine tenere ad sacratissimum baptisma pro

civitate Florentie unum filium marem sive feminam Domini
Pancratii de Impoli florentium, et super inde quascumque
cerimonias necessarias et opportunas faciendum prout in similiter
fieri consuendum . . .

(ASV, arch. not., Pellestrina, A., busta 10646, fols. 628ᵛ–629ʳ;
Ludwig, 1911, p. 19)

1. Clemente da Empoli was the husband of Sansovino's daughter
Alessandra, who lived in Florence; see the genealogical tree in Vasari, VII,
p. 533. A Florentine jeweller named Tommaso Empoli is recorded in
Lorenzo Lotto's accounts in September 1541; see Zampetti (1969), p. 132.

177. Completion of the church of San Geminiano[1]

MDLVII Die xiiii martii in Collegio
Fatta la ballotatione delli signori procuratori della chiesa di San
Marco in esecution della parte dell'eccellentissimo Senato de xiii
del mese di marzo presente per deputarne doi alla fabrica della
chiesa de San Heminiano, rimasero
ser Antonio Capello, et
ser Vettor Grimani

(ASV, Collegio, notatorio reg. 31, fol. 3ᵛ)

1. Gallo (1957) first examined Tommaso Rangone's connection with the
façades of San Geminiano and San Giuliano, but his assertion that Rangone
agreed to pay for the façade of San Geminiano is supported only by the
presence of a design for the façade in Rangone's possession (see doc. no.
189). Contrary to Gallo (1957), p. 96, there is no mention of either
Rangone or the church in the Senate's deliberations for 1552; see Howard
(1975), p. 175, n. 83.

Die xxviiii martii in Collegio [1557]
Che 'l modello fatto far per li procuratori della chiesa di San
Marco della facciata della chiesa di San Geminiano in execution
della parte del Senato del 13 presente sia per auttorità di questo
Collegio approbato; al qual modello in luogo delli dui San Marchi
possino esser fatte ditte fenestre, over tondi corispondenti a quello
di mezo, sì come meglio parerà a prediti procuratori, non si
potendo nel resto in modo alcuno alterar ditto modello.
21–1–1

(Ibid., fol. 8ᵛ)

The façade of San Giuliano[1]

178. Serenissimo Principe, et Illustrissima Signoria
Havendo bisogno l'antiqua, et vetustissima chiesa di San
Giuliano, per la vetustà sua, molto mal condittionata, ruinata, et
mal ad ordine, di essere con assai spesa ristorata, sì dentro, come
di fuori, essendo massime situata in questa città, nel loco notabile
che ella si trova, nè potendosi quella per le debile entrate sue, da se
stessa ressarcire ma di continuo tenendo a maggiore ruina, hà
piacciuto alla somma bonta divina, per la gloria dil culto suo, et
honore di questa inclita città, favorire il pio desiderio di molti in
vedere a ristorare cossì antiqua, et honorata chiesa; onde, come
espettato nontio di tanto beneficio, è comparso lo eccellentissimo
Domino Thomaso da Ravenna, il quale si come havendo sempre il
pensiero suo volto alla virtù, et alle opere digne, hà in Padoa eretto
uno colleggio de scholari xxv da lui dotato, et fabricato con molta
sua spesa, cossì considerando con l'animo suo pio, quanto seria
grato a Dio si soccorresse alla detta povera chiesa.
Aggiongendossi etiam la riverente, et intiera affection che egli
porta a questa felicissima, et religiosissima Republica offerisse al
Reverendo Domino Francesco Gritti piovano presente, et al
capitolo della prefata chiesa stipulanti, et accettanti ducati mille
obligati subbito al presente per fare la fazzada davanti marmorea,
et altre cose, offerrendo poi etiam à beneplacito suo, et commodo

ressarcire, et accommodare tutta la predetta chiesia, cossì fori, come dentro, dummodo li sii concesso, et perpetuamente asservato da Vostra Serenità et Signoria Illustrissime et eccellentie ch'el possi mettere, et eternamente stare una sua figura dal vivo, et imagine di bronzo in piedi, over sedendo, come par a Vostra Serenità, fatta a spese sue, oltra li sopradetti ducati mille nella fazzada davanti essa chiesia, con sue arme, litere, et ogni altra cosa pertinente ad uno benefattore. Né che si possi mai pro tempo né conto alcuno rimovere dal ditto loco, cossì la detta figura, come le altre cose sopradette fatte dal predetto eccellentissimo Domino Thomaso benefattore de la anteditta chiesia in decoro, et ornamento di quella, et fabricate con il suo proprio danaro, et spese questo ciede cossì a commodo della volontà, et intentione del predetto eccellentissimo Domino Thomaso, come della chiesa prelibata. Però pro nome dello antedetto Reverendo Domino Piovano, et capitolo, insieme con esso eccellentissimo Domino Thomaso, si supplica Vostra Serenità et Signoria eccellentissime che quelle voglino essere contente fargli gratia di concederli questa licentia di far quanto di sopra si contiene, acciò la detta chiesia habbi questo beneficio, et esso eccellentissimo Domino Thomaso possi essere sicuro che non li sii interotto questo suo desiderio, et alla buona gratia sua humilmente si raccomandano.

(ASV, Senato-Terra, filza 18, settembre-febbraio, ad datum)

1. Many of the following documents were first noted by Gallo (1957).

179. 1553 prima septembre in Pregati

Che per auttorità di questo consiglio sia concesso al venerabile Piovano et Capitolo della chiesa di San Zuliano di questa nostra città et all'excellente Domino Thomaso da Ravenna medico, che sborsando il ditto exellente Domino Thomaso li preditti ducati mille, per far la fazzada marmorea della chiesa prefata et raconciando et accommodando essa chiesa cosi dentro come di fuori a beneplacito suo, iuxta la forma dell'accordo che l'ha fatto con il preditto venerabile Piovano et Capitolo; al qual accordo si habbia in omnibus relatione; el possi eriger nella prefata fazzada una statua over imagine sua di bronzo cavata dal vivo, in piedi over[1] sentata, a spese sue oltre li prediti ducati mille, con le sue arme, et inscrittione adherente alle conditione et qualita sue, la qual imagine, arme et inscritione habbino ad esser in perpetuo conservata, non dalla prefata fazzada in alcun caso over evento possino per alcuno esser rimosto, ma restino a perpetua sua memoria, con buon esempio alli posteri, et della virtù, et delle buone operation che da lui sono sta fatte degne di commendatione.

De parte 124
De non 35
Non synceri 8

(*Ibid.*)

1. *In piedi over* is crossed out in the decision of the Pregati.

180.

Marcus Antonius Trivisano Dei Gratia Dux Venetiarum universis et singulis magistratibus huius urbis nostrae Ventiarum, notum esse volumus, quod in consilio nostro Rogatorum capta fuit pars dia prima instantis di tenoris infrascripti videlicet.
Che per auttorità di questo consiglio sia concesso al venerabile Piovan et capitolo della Chiesa de San Zuliano di questa città nostra et all'eccellentissimo Domino Thomaso da Ravenna medico, che sborsando el detto eccellentissimo messer Thomaso de presenti ducati mille per far la fazzada marmorea della chiesa prefata, et raconciando, et accomodando essa Chiesa, così dentro,

come de fuori a beneplacito suo iuxta la forma dell'accordo, che l'ha fatto, con il prefatto Venerabile Piovano, et Capitulo al qual accordo, se habbi in omnibus relatione, et possi erigere nella prefatta fazzada una statua, over imagine sua di bronzo, cavata dal vivo, sentata, a spese sue, oltra li prefatti ducati mille, con la sua arma, et inscritione condecente alla conditione, et qualità sua, la qual imagine, arme, et inscritione habbino ad esser in perpetuo conservate, ne dalla prefatta fazada in alcun caso, over evento, possino per alcuno esser rimosse; ma restino a perpetua sua memoria con buon esempio alli posteri et della virtù et delle buone operationi, che da lui sono state fatte, degne di commendatione. Quare auctoritate prefatti consilii, mandamus vobis, ut suprascriptas partes observatis. Datum in nostro Ducali Palatio die quinto septembris indictione decima secunda millesimo quingentesimo quinquagesimo tertio . . .

(ACP, Chiesa San Giuliano, busta dal n.o 1 al 14, fasc. 5)

181. 1553 20 septembre In Nomine Domini nostri Iesus Christi amen.

Anno Nativitatis eiusdem Millesimo quingentesimo quinquagesimo tertio indictione undecima, Die Mercurii vigesimo mensis septembris. Convocato, et congregato Reverendo Capitulo ecclesiae Sancti Iuliani Venetiarum in sacrestia ipsius ecclesiae sono campanellae percusso, ut moris est, pro infrascriptis peragendis et pertractandis. In quoquidem capitulo interfuerunt et primo Reverendus Dominus Franciscus Gritti plebanus ipsius ecclesiae . . . ex una[1] et infrascriptus exellentissimus artium et medicinae doctor Dominus Thomas Ravennas ex altera in executione partis captae in Excellentissimo Consilio Rogatorum inferum registrati concordes tandem, et unanimus devenerunt atque deveniunt ad celebrationem et conclusionem presentis instrumenti, sub hac verborum forma tenoris, et continentiae infrascriptum, videlicet. Cum ecclesia Divi Iuliani Venetiarum tum ob eius antiquitatem nobilissima inter totius civitatis collegiatas ecclesias ecclesias, a quam plurimis annis citra opere pendeat interrupto si quidem indigeat constructione partis anterioris nobiliorisque, et aliarum partium, tam intus, quam extra, ob prospectum eiusdem in non modicum decus, et ornamentum merzariae in medio viae qua die quolibet pertransit universa civitas. Cui quidem constructioni, cum tam modernus, quam pro tempore predecessores antistites, et collegium eiusdem ecclesiae, obtenues introitus, et proventus ex eadem provenientes qui via ad sustentandum, retinendumque eorum gradum sufficiunt, occurrere nequiverint nequeatque de presenti, sperantes nihilominus divinum auxilium eis non defuturum eorum itaque tanto Deo grato pioque desiderio, et spi annuens rerum opiferum suae velut expectatus nuntius tanti benefitii recipiendi comparens exellentissimus artium, in medicinae doctor Dominus Thomas Philologus Ravena clarissimus phisicorum doctor deque re litteraria omnique virtutum genere benemeritus considerans pioque animo perpendens quantum Deo gratum opus erit, si ecclesiae ipsi tam indigenti succuratur. Ideo in remedium animae suae obtulit Reverendo domino Francisco Gritti ecclesiae prefatae moderno antistiti, nec non et collegio ipsius ecclesiae stipulantibus et acceptantibus vice et nomine supradictae eorum ecclesiae se de bonis a Deo collatis, propriis sumptibus et expensis mille ducatorum construi facere anteriorem faciem nobilioremque ecclesiae praedictae, ac alia, et omnia fieri, tam intus quam foris videns ad beneplacitum, et comodum prefati exellentissimi Domini Thomasii futuro postea tempore complecto prius supradictae ecclesiae frontispitio et apposita imagine aenea suis

insignibus armis, ut vulgo dicitur capsa, et inscriptionibus, vel ut infra dummodo sibi infrascripta concedantur, et firmiter perpetuis temporibus observentur videlicet. Quod idem exellentissimus Dominus Thomas ponatur, et ponere possit in parte ipsa anteriori dictae ecclesiae super portam magnam ecclesiae eiusdem versus dictam merzariam respicienten, capsam, seu archam lapideam et prout sibi placuerit decoratam collocare, et similiter in eodem frontispitio eam eiusdem Domini Thomae suprascripti imaginem, seu figuram collocare, cum harum litterarum inscriptione. Thomas Philologus Ravenas physicus et cetera honestis laboribus parto edes primum Paduae virtuti, post has senatus permissu pietati erigi fecit illas animi, has etiam corporis monumentum ac suo utrobique insignia armorum apponere, et in reliquis partibus, tam intus quam extra predictae ecclesiae figuras quascumque, tam eneas quam lapideas collocare armorum insignia litteras et quaecumque ipsi domino Thomae libuerit ponere pingere et describere valeat. Et intrinsicus a porta ipsa magna, et ante ipsam partem anteriorem presenti tempore vacuam archas pro se, et quibuscumque maluerit construi facere propriis sumptibus vel aliter quovismodo de dicto terreno disponere, et de quocumque ac quibusvis construi facere quocumque ipsi Domino Thomae libuerit propriis sumptibus vel aliter de dicto terreno et de quibuscumque disponere, dummodo sit in ornamentum ecclesiae praedictae pro ut sibi melius videbitur sine tamen aliaqua solutione, nunc vel pro tempore facienda ipsi ecclesiae, sed gratis pure et libere. Insuper declarantes ob hoc maximum munus ac urgentissimum benefitium tam presentem Reverendum antistitem tam successores suos omnes, seu vigerentes perpetuis temporibus gratis, absque solutione aliqua teneri, et obligatos esse associare, vel cum capitulo toto predictae ecclesiae recipere prefati domini Thomae successorum eius familiarum, servorum, ac servarum corpora restituentes indumenta, ornamenta et reliqua gratis pure, ac libere vel sicut ab ipsis fuerit dispositum solemnia nihilominus pro consuetudine, et pro personarum dignitate, vel gratis, pro eorum caritativa dispositione celebrantes addentes quod etiam perpetuis temporibus Reverendus Dominus prefatus antistes, et predictum capitulum predictae ecclesiae successores et vigerentes ac procuratores eiusdem ecclesiae seu fabricae ipsius ecclesiae teneantur elligere semper, et in perpetuum unum ex familia, seu posteritate prefati excellentissimi domini Thomae ecclesiae antedictae procuratorum atque pro benefactore seu sempiterna eius memoria par pari, vel consimile redigente proque gratiarum actionem, et signo amoris, acceptique beneficii memoria Reverendus predictus antistites successores vel gerentes et capitulum prefatum singulis annis perpetuisque temporibus. Die vigesimo nono mensis decembris in festo Sancti Thomae episcopi teneantur anniversarium cellebratae beneficium, et munificentiam hanc solemnia in ecclesia ab extra, foranias et rogationes celebrando divina commemorantes. Supplicationes Ihesu Christi nostro porrigant pro vita Thomae Ravena diuturna, felici ac sana et pro anima caelo felicius collocanda altius cantantes, et respondentes ora vel orate pro Thoma Ravena, fiendum gratis per infinita seculorum secula attendentes. Itaque prefatus et dominus Franciscus Gritti antistes, ceterique de capitulo ecclesiae prefatae, ad hoc capitulariter congregatae ut supra, una cum procuratoribus eiusdem ecclesiae vel fabricae ecclesiae superdictae, et munus hoc tamen dignum, et diu ut supra, nomine dictae eorum ecclesiae expectatum acceptantes pure libereque ac gratis concesserunt et expresse concedunt superdicto excellentissimo domino Thomae, omnia, ac singula, et quocumque ut supra nullo penitus omisso, et sine aliqua cognitione, aut solutione facienda temporali, vel perpetua ecclesiae predictae et e converso. Idem excellentissimus Dominus Thomas promisit ac promittit, et se obligat eidem Reverendo domino antisti, et capitulo pro remedio animae suae

vivens se omnia superius predicta, tam extra, quam foris, et intus ad eius beneplacitum et commodum suum ut supra fabricari facere ac construere obbligans se nunc et immediate mille ducatos ut supra expositum, imo et expenditurum et rogaturum pro conficiendis omnibus prefactis, et similiter idem Reverendus Dominus Franciscus Gritti antistes, et prefact de capitulo dictae ecclesiae, atque eisdem ecclesiae procuratores utrique, seu omnes, et reliqui pro se suisque successoribus promiserunt, ac expresse promitterunt attendere, perpetuisque temporibus observari tueri et manutenere, atque in eodem statu in eternum conservare omnia et quaecumque ac singula fuerint ab excellentissimo domino Thoma disposita facta, et fabricata sub obligatione omnium bonorum suorum presentium et futurorum. Et pro maiori robore promissorum partes ipsae manu factis scripturis iuraverunt ad sacra Dei evangelia praemissa omnia, et singula inviolabiter attendere, et observare, nec aliquo unquam tempore per se alium vel alios quamvis occasione, vel causa quam dici ellegari excogitari, vel immaginari posset tuam de iure quam de facto contravenire, nec non a iuramento prefato absolutionem non petere, et petita non uti, hoc tamen pacto, et conditione apposita quam presens instrumentum suum roboris firmitatem inviolabiliter obtineat, si, et quatenus Reverendissimus Venetiarum Patriarca caeteri, et quicumque quibus pertinet, et spectat suum in praemissis adhibuerint consensum et non aliter alias vel alio modo quo consentu Reverendissimi Patriarcae, et reliqui quibus pertinet non prestito presens instrumentum nullatenus ullam roboris formitatem obtineat, sed sit, et esse debeat ac si nunquam inter ipsas partes, actum, gestum, aut stipulatum non esset quoniam ita inter ipsas partes actum, conventum, et concordatum extitit. Rogantes ambe partes me notarium ut de predictis omnibus, et singulis publicum instrumentum ad perpetuam rei memoriam totiens ellevandum in publicam formam seu exemplum quotiens fuero requisitus. Tenor supradictae partis captae in prefacto excellentissimo consilio Rogatorum sequitur ut est talis . . .
[Here follows a copy of the decision taken by the Senate and printed as doc. no. 179, above, as well as the approval given by the vicar of the Patriarch of Venice.]

(ACP, Catastico Ecclesiae Sancti Iuliani, no. 9, ad datam)

1. The names of the priests, deacons, sub-deacons, and procurators of the church have been omitted.

182. Die dicta [27 agosto 1554] ad cancellum. L'excellente dil'arte, et medicina dottore messer Thomaso Ravenna da una parte, et messer Giulio Alberghetto fu de messer Alberghetto dall'altra parte, per li loro heredi et successori sonno convenuti et rimasti d'accordo nel modo infrascritto, cioè, che dovendo il prefatto excellente messer Thomaso far getar di bronzo la figura et immagine sua iuxta la forma et pronto di cerna fatto per il spettabile messer Giacomo Sansovino scultor et Architetto. Però il prefato messer Giulio promette, et si obliga a proprie spese sue, si di mettalo, come di qualunque altra cosa gettar di buon mettalo da esser approbato per il detto messer Giacomo Sansovino, detta figura qual sii netta in tutte sue parte, et non maculata ma ben gettada et nettada, Dechiarando che in caso che detta figura venise deffetiva in qualche sua parte che il prefatto messer Giulio sii obligato a tutta quella spese occorerà in far una simil forma, et figura, di cera. Rimanendoli però la cera della figura vechia per suo conto et ciò per patto expresso. Et al'incontro detto excellente messer Thomaso per pretio, et mercede tra loro cusi d'acordo per detta figura gettada promette a dar ad esso messer Giulio ducati cento diesi da lire 6 soldi 4 per ducato in questo modo cioè ducati

cinquanta al tempo che lui messer Giulio vorrà gettar detta figura, et li ducati sessantatre tanti alla consignatione de detta figura gettada et nettada, qual figura lui messer Giulio promette gettarla, et dar compiuta per spatio de uno mese dappoi, consegnatetli la figura di cera senza alcuna exceptione . . .

(ASV, arch. not., Maffei, V., busta 8105, fols. 632ᵛ–633ʳ)

183. 1554. Die vigesimo septimo mensis suprascripti in magazeno domini Jacobi Sansovini architecti in confino Sancti Geminiani. Contrascriptus excellens Thomas effectualiter consignavit statuam ceream et scripsit et illesam contrascripto domino Iulio Albergheto per eum inde asportandam et opere fusile proficiendam quam inde idem dominus Iulius statim secum asportavit, coram domino Jacopo Sansovino architetto et maistro Salvatore quondam Victoris lapicida, testibus rogatis.

(*Ibid.*, fol. 632ᵛ, in margin)

184. Die dicta [9 mensis Januarii 1555] ad cancellum.
Havendo messer Giulio Albergheto quondam messer Albergheto havuto il giorno presente dell'excellente messer Thomaso da Ravenna phisico la forma di zesso della figura de cera alias consignata per esso excellente messer Thomaso ad esso messer Giulio da esser getada di metalo iuxta il loro accordo, come appar nelli atti di me nodaro sotto li 27 settembrio proxime preterito, della qual intende valersi per il getto ha da fare de ditta figura iuxta il suo accordo prefato. De qui è che detto messer Giulio promette, et si obliga tal forma di zesso consignar illesa ad esso excellente messer Thomaso doppo gettada detta figura di bronzo in quello essere che la li è sta consignata et in caso che tal forma di zesso venisse a rompersi per diffetto di esso messer Giulio, lui messer Giulio promette di reffar ogni danno, interesse, et spesa che lui excellente messer Thomaso potesse patire per tal causa iuxta la depositione de messer Jacomo Sansovino architetto. Ita che lui messer Giulio sotto iacia alla spesa di una forma di zesso, quale però si come dicono, non si può fare se prima non viene formata una figura di terra qual representi il vivo, et similitudine di esso messer Thomaso come representava la figura di cera li fu consegnata come di sopra. Et percio lui messer Giulio si obliga real et personalmente, et qualunque suoi beni presenti et futuri, super quibus.

(*Ibid.*, busta 8107, fol. 30ᵛ)

185. Die eadem [octava mensis Iulii 1555]
. . . Fino sotto dì 27 agosto 1554, io Thomaso Philologo Ravena phisico stipulati instrumento con voi messer Giulio Alberghetto come nell'atti di messer Vettor di Maffei nodaro di Venetia appar, nel qual si leze che voi et io erimo restati d'accordo, et convenuti à gettar di bronzo la figura, et immagine mia iusta la forma, et pronto di cera fatto, ò da esser fatto per messer Giacomo Sansovino per pretio de ducati cento diese, con modi, forma, et condictione ut in detto instrumento, al qual in tutto si habbi relatione, et maxime havendovi fino sotto dì 27 settembre del soprascritto millesimo consegnato la detta figura, come era obligato ut in instrumento, l'obligo vostro era in termine de mese uno darmi la detta figura di bronzo gettada, et nettada et perfetta al giuditio del detto Sansovino, par mò che voi messer Giulio havendo guastà la detta figura, et io fatto refar la detta figura di cera al detto Sansovino con assai più parte de mia spesa, acciò poi adimpisti l'obligo vostro iuxta detto instrumento, voi puocho vi ne curate, havendovi si pregato come fatto pregar per tanti

clarissimi senatori che ben sapete chi sono oltra il non havervi mai mancato sì dell'opera mia in casi importanti come anchora satisfattovi in tutto iusta la forma del detto instrumento, e di più darvi ducati cinquanta come nelli atti del detto nodaro appar. Hora mò per non mancare in tutto ad officio conveniente da Cristiano, et amico vostro ho preso questa deliberatione di farvi intender, et exortarvi et anchora pregarvi siate contento fra termine di mese uno dal dì dell'intimatione della presente far, et operar con vero effetto che habbi detta figura gettada netta perfetta, come per l'instrumento sette obligato al juditio del Sansovino altrimente passato detto termine, et non havendo con vero effetto operato ut supra vi protesto de ogni spesa danno, et interesse mi potesse intervenire in far gettar detta figura ad altri netta, et perfetta al juditio del Sansovino, offerendomi pro consegnata detta figura ut supra darvi vostro resto come nell'instrumento. Et hoc facio omni meliori modo et cetera.
Et hic est finis dictae scripturae.

(*Ibid.*, busta 8108, fol. 414ʳ⁻ᵛ)

186. Die veneris vigesimo secundo mensis Novembris 1555 in domo habitationis infrascripti domini Julii de confinio Sancti Blasii Venetiarum
Constitutit in presentia mei notarii et testium infrascriptorum excellens artium et medicinae doctor Dominus Thomas Ravenna ex una, et Dominus Julius Alberghetus partibus ex altera, attenta infirmitate, et corporis indispositione ipsius Domini Julii non valentis ob causam humori adimplere contenta in concordio inter ipsas partes sequito manu mei notarii infrascripti sub die 7 Augusti 1554, sponte, et voluntarie dictum concordium cum omnibus in eo contentis cessarunt revocarunt er annullarunt. Itaque de cetero nullius roboris existat et sucessive idem excellens dominus Thomas confessus fuit sibi restitutam fuisse statuam ceream per se dicto domino Julio consignatam prout in dictis actis meis continetur. Et quia dicto excellenti domino Thomae per maestrum Antonium Calderarium fideiussorem ipsius domini Julii consignata fuere in pignus pro restitutione ducatorum quinquaginta exbursatorum per ipsum excellentem dominum Thomam ipsi domino Julio bona infrascripta, videlicet catenella una aurea, numismata quatuor aurea, moneta quatuor aurea de ducatis quatuor ungaris proqualibet, et alia quatuor monete de ducati duobus pro qualibet . . . Ideo idem excellens Dominus Thomas ex urbanitate contentus fuit infra mensem unum proximum venturum habere, et recipere ab eodem domino Julio ducatos quinquaginta praedictos, nec non expensam cartulinae elevate in officio iustitie veteris contra eundem magistrum Antonium Calderarium, quo quidem mense elapso, et non satisfactis ducatis quinquaginta, et expensis praedictis, voluitprout protestatur pro satisfactione eorumdem eadem pginora vendi, et de eorum tractu satisfieri posse. Postremo idem Dominus Julis promisit satisfacere magistro Andreae formatori id quo eidem debetur ratione reformationis imaginis ceree refacte per ipsum magistrum Andream. Itaque imago ipsa perveniat ad manus ipsius excellentis domini Thomae absque aliqua expensa, et e converso ipse excellens Dominus Thomas promisit dicto domino Julio consignari facere, et restitui omnia ferramenta per ipsum Dominum Julium dicto magistro Andreae data pro reformatione ipsius immaginis . . .

(*Ibid.*, fols. 686ᵛ–687ʳ)

187. Die dicta [secunda mensis Martii 1556] ad Cancellum
L'excellente dell'arte et medicina dottor messer Thomaso

Ravenna da una parte et maistro Thomaso dalle Sagome fondator et messer Giacomo di Conti fu de messer Francesco fondator di artegliarie, ambi due simul et insolidum dall'altra parte, per li loro heredi, et successori sono convenuti, et rimasti d'accordo nel modo infrascripto, videlicet, che intendendo detto excellente messer Thomaso far gettar la sua immagine de bronzo, quale va sopra la porta della fazzada della chiesa de San Juliano iuxta la forma di tal figura fatta per messer Alexandro da Trento, loro maistro Thomaso et maistro Jacomo insolidum ut supra promettono, et si obligano gettar tal figura di buon mettalo, iusta la forma di cera li serà consignata per detto excellente messer Thomaso netta, et non maculata in parte alcuna. Ponendo loro il mettalo del suo proprio, et facendo ogni spesa occorerà. La qual figura getada si debbi giudicare per dui periti dell'arte da esser eletti uno per parte, et ciò fra termine de mesi sei proxime venturi, principiando dal giorno della consignatione di detta forma di cera per lui messer Thomaso ad essi fondatori, dichiarando che quando per detti dui eletti fusse detto et dechiarito detta figura seu immagine gettada non esser conforme alla imagine seu forma di cera consegnateli, seu fusse trovata maculata, ò deffetiva, overo non essere di buon mettalo, che in tal caso detto excellente messer Thomaso non sia obligato à pagamento di sorte alcuna per conto di faticha ò spesa che detti fonditori havessero fatto per tal causa, immo per patto expresso siano tenuti, et obligati di ritornarli una figura di cera simile a quella li serà stata consignata à proprie spese de loro fondatori fra termine di uno mese all'hora immediate sequente. Se veramente detta immagine serà ritrovata esser giusta senza macula, et conforme a detta figura cerea, lui excellente messer Thomaso sia tenuto, et obligato, si come ex nunc promette così d'accordo con detti fondatori, per pretio solemnemente convenuto darli et exborsarli, ducati cento ottanta da lire 6 soldi 4 per ducato e ciò al tempo della consignatione di detta figura cerea, et ciò per patto expresso . . .

(*Ibid.*, busta 8109, fols. 202ᵛ–203ʳ)

188. Die eadem [decima septima mensis Martii 1556] ad Cancellum

Cum magister Andrea naparius de confino Sancti Luce Venetiarum ex concordio secuto cum domino Iulio Alberghetto confecerit formam imaginis excellentis artium et medicinae doctoris Domini Thome Ravenna, et ex mercato secuto cum dicto domino Iulio reperiatur creditor pro resto librarum sexdecim, soldorum trium parvorum. Cumque idem excellens Dominus Thomas recquisiverit dictum magistrum Andream ut formam huismodi per se factam sibi consignare vallet: offerens eidem dictum residuum mercedis et spectantis. Hinc est quod in presentia mei notarii et testium infrascriptorum idem excellens dominus Thomas affectualiter exbursavit dicto magistro Andree presenti, et recipienti easdem libras sexdecim, soldos tres parvaroum, de quibus idem magister Andreas eidem rogavit quietationem et successive confessus fuit sibi consignatam extitisse eandem forman ceream per eundem magistrum Andream cui fecit quietationem, et e converso idem magister Andreas cessit et transtulit eidem excellenti domino Thome omnes actiones que sibi quomodolibet, competebat, et competit contra personam et bona dicti domini Iulii occasione dectarum librarum sexdecim soldorum trium . . .

(*Ibid.*, fol. 268ʳ⁻ᵛ)

189. Die Iovis secundo mensis Iulii 1556 in domo habitationis notarii infrascripti posita in confino Sancti Geminiani Venetiarum

In presentia mei notarii, et testium infrascriptorum, excellens artium et medicine doctor Dominus Thomas Ravenna dedit, et effectualiter exbursavit, causa puri et grati mutui pecuniae: viro Thome dalle Sagome funditori presenti et recipienti ducatos decem ad liras 6 soldos 4 pro quolibet ducato in pecunia numerata. Quos namquam ducatos decem idem messer Thomas debitor promisit, et solemniter se obligavit dare, et restituere dicto excellenti Domino Thome creditori ad omnem ipsius excellentis domini Thome instantiam, et recognitionem omni obstaculo, et cavillatione remotis, et ad hoc obligavit sese heredes, et successores suos, ac omnia, et singula eius bona mobilia, et immobilia presentia, et futura ubique posita, et generis cuiusque super quibus.

Testes Magister Baptista quondam Philippi ab Ulmo strazzarolus, et Ser Blasius de Perlis quodam Francisci a Lignamine

(*Ibid.*, busta 8111, fol. 3ʳ)

190. Die dicta [prima mensis Febrarii 1557] in domo habitationis infrascripti domini Antonii Goretti de Confino Sancti Luce Venetiarum

Constitutus in presentia mei notarii, et testium infrascriptorum, excellens artium et medicinae doctor dominus Thomas Ravenna physicus dixit, et confessus fuit sibi actualiter et cum effectu consignatam fuisse, et esse eius Imaginem seu statuam ex aereo opere fusili factam per quodam magistrum Thomam a Sagomis funditorem, et dominum Jacobum de Comitibus, quondam domini Francisci, in statu et termini prout eam fundere tenebantur iuxta conventionem secum sequitam manu mei notarii sub die 2 Martii nuper decursi. Quam consignationem factam fuisse affirmavit per propriam manum dominus Jacobus. Et propterea dicto domino Jacobo presenti, nec non heredibus dicti quondam magistri Thome superscripti ab manibus me tamen notario publico eorum presente, et acceptante rogavit quietationem perpetuam. Et successit idem dominus Jacobus tam nomine suo proprio agens quam nomine et vice dictorum heredum pro quibus promisit de ratto in propriis bonis bonificavit et bonificat dicto excellenti domino Thome ad computum ducatorum 180 per se dominum Thomam promissorum pro dicta imagine: ducatos decem, pro totidem alias per eumdem excellentem dominum Thomam mutuo exbursatis dicto quondam magistro Thome prout constat in actis meis sub die [blank] Item bonificavit, ut supra eidem excellenti domino Thome alios ducatis quindecim pro totidem per dictum excellentem dominum Thomam exbursatis videlicet magistro Hieronymo lapicide ducatos undecim de consensu ipsius domini Jacobi, et quatuor restantes sibi domino Jacobo proquibus sic bonificatis eidem excellenti domino Thome rogavit quietationem. In super, Dominus Antonius Gorettii quondam alterius domini Antonii Calderarius ad signum Sancti Petri confessus fuit de consensu ipsius domini Jacobi presenti recepisse actualiter et cum effectu recepisse ab eodem excellente domino Thome ducatos centum cum dimidio, et ad hoc ad computum residui ducatorum centum octuaginta per conventionem, qui ducati 100½ sunt affirmarunt ipsi domini Jacobus et Antonius ad computum crediti quod ipse dominus Antonius habebat, et habet contra dictos quondam magistrum Thomam et dominum Jacobum pro quantitate mettali eis vendita pro fundenda imagine aerea suprascripta. Itaque excellens dominus Thomas presens pro residuo ducatorum 180 suprascriptorum remanet debitor ducatos quinquaginta quatuor cum dimidio, quos ducatos 54½ idem excellens dominus Thomas exbursare promisit (sic consentienti ipso domino Jacobo) dicto

domino Antonio ad omnem ipsius domini Antonii requisitionem et instantiam omni exceptione remota. Et propterea idem dominus Jacobus nomine suo, nec non heredum quondam magistri Thome suprascriptorum de suprascripto convento docatorum 180 suprascriptorum eidem excellenti domino Thome presenti, et stipulanti rogavit, et fecit quietationem perpetuam liberationem et absolutionem, cum pacto de aliquid aliud ei vel heredibus aut successoribus suis causa pretii suprascripti ulterius non petendo. Et successive suprascriptus dominus Antonius nec non idem dominus Jacobus insolidum se obligantes promiserunt perpetuo et omni tempore conservare indemnem, et illesum dictum excellentem dominum Thomam ab omni molestia, damna, expensa, et interesse quod, et qua sibi quomodocunque inferri posset suprascriptis heredibus dicti quondam magistri Thome occasione exbursationis et satisfactionis integre ducatorum 180 suprascriptorum, obligantes propterea se heredes et successores suos insolidum ut supra et eorum omnia bona mobilia et immobilia presentia et futura.

Testes Reverendus dominus Franciscus Gritti plebanus ecclesiae Sancti Juliani, et
 Dominus Mattheus Paganus librarius ad orgium fidei

(*Ibid.*, busta 8112, fol. 111^{r-v})

Die veneris quinto mensis Februarii 1557 ad cancellum Constitutus dominus Antonius Goretus confessus fuit actualiter Cum effectu recepisse a contrascriptio excellente domino Thoma in prompta pecunia contrascriptos docatos 54½. Renuntians proquibus sic receptis sic eidem excellenti domino Thome contrascripto, absenti me notario publico eius nomine presente et stipulante rogavit quietationem perpetuam cum pacto...

(*Ibid.*, fol. 111r, in margin)

191. Die dicta [8 Februarii 1558] in sacrestia ecclesiae Sancti Juliani Venetiarum

Cum alias excellens artium et medicinae doctor dominus Thomas Philologus Ravennas physicus pro devotionis affectu et in anime sue remedium specialiter motus videns tunc ecclesiam collegiatam Sanctum Julianum Venetiarum a li quali reparatione indigere, sponte Reverendis dominis Plebano et capitulo eiusdem ecclesie obtulerit, propriis impensis construi facturum anteriorem partem et nobiliorem tunc necessaria, etiam a fundamentis reedificatione indigentem, quam anteriorem partem postmodum (ut modo ad occulum conspicui potest) costrui et fabricari fecerit. Adhibitis insignibus, inscriptionibus et ornamentis eisdem excellenti domino Thome ex gratia et concessione illustrissimi et excellentissimi Senatus per dictos dominos Plebanum et capitulo concessis et prout de oblatione et concessione huiusmodi constat publico instrumento manu Ser Avidii Biancho notarii publici Venetiarum, sub die 20 septembris 1553 cumque postmodum fortuitu casu, ecclesia memorata Sancti Juliani in quadam alia sui parte converit et in dies (ut intueri potest) magis dilabi et corrui velle appareat. Ita ut non solum reparatione verum et totali a fundamentis necessaria reedificatione indigere videatur. Quod quidem intuens idem excellens dominus Thomas et summopere cupiens huic tam indigenti necessitati proviribus pie et benigne succurrere, sperans ab omnipotenti deo centuplum recipere. Propterea ad presentiam Reverendorum domini Plebani et capituli meique

notarii et testium inferiorum personaliter constitutus idem excellens dominus Thomas philologus Ravennas physicus, ab inceptis piis, Deoque gratis operibus non desistens, sed eis magis atque magis proposse intendens sponte et ex certa animi sui scientia, et non aliquo juris vel facti errore ductus aut aliqua sinistra machinatione circumventus obtuilt, et offert Reverendis dominis Plebano et capitulo eiusdem ecclesie collegiate Sancti Juliani Venetiarum in et pro reedificatione eiusdem ecclesie a fundamentis necessaria, et quam ecclesiam soprascripti dominus Plebanus et capitulus ac eiusdem ecclesie procuratores reedificare intendunt, quartam partem integram totius expensae exponende in reedificatione dicte ecclesie Sancti Juliani proportionabilis reedificande secundum formam partis anterioris soprascriptae iam constructe ac alias iuxta modellum spectabilis domini Jacobi Sansovini architecti que tamen quarta pars totius expense suprascriptae non excedat summam ducatorum nonigentorum ad liras 6 soldos 4 pro ducato sed abinde infra quantacumque fuerit, et quam quartam partem ipsius expensae idem excellens dominus Thomas obtulit expositurum et ad hoc teneri voluit pro rata cuiuscumque quantitatis pecuniarumque per ipsum dominum Plebanum et capitulum et fabrice ecclesie suprascripte procuratores vel quamcumque aliam personam dietim improptu exhiberetur... E converso [the Plebanus and chapter of San Giuliano]... in perpetuam libere et gratiose concesserunt dicto excellenti domino Thome ibidem sic ut premittu presenti et benigne, ac gratis acceptanti pro se heredibus et successoribus suis imperpetuam capellam maiorem eiusdem ecclesie omnibus expensis, et ex massa integra totius impense in reedificatione totius ecclesie exponentis construentis. Ita aut capella ipsa postquam constructa fuerit ad nomen ipsius excellentis domini Thome heredumque et successorum suorum perpetuo remaneat, nec alteri alicui personae in posterum dari obligaruit per dominum Plebanum et capitulum ac fabrice procuratores eiusdem ecclesie possit aut valeat. Et in quaquidem capella maiori reservatus sit locus pro constructione chori construendi (ita consentante et consentiente eodem excellente domino Thoma, secundumque dictis domino plebano, capitulo, et procuratoribus melius videbitur absque tamen aliqua impensa ipsius excellentis domini Thome). Ita etiam quod si idem excellens dominus Thomas ornamenta aliqua lapidea conveniens vel picturas ultra ordinariam illius fabricham facere voluerit hoc propriis impensis ultra quartem partem suprascriptam oblatam facere queat...

(*Ibid.*, busta 8116, fols. 146v–148v)

192. Die veneris xxiii mensis Junii 1559 in sacristia ecclesiae Sancti Juliani Venetiarum

...Poiché à laude de Iddio è sta finita la fazzada della chiesa de San Zulian per l'eccellentissimo messer Thomaso Philologo Ravenna phisico iuxta la contumatia della sua oblatione et promissione per la concessione et gratia dell'eccellentissimo Senato, et per l'instrumento sotto dì 20 settembre 1553, del qual fu rogado messer Avidio Biancho nodaro publico de Venetia al qual in omnibus se habbia relatione. Et sia hora bisogno ritornar in esser la parte de detta fazzada dalla parte interiore, nel suo essere, con l'organo et banchi quali erano inanti fossero remossi, et perché volendo ritornar il detto organo, et banchi vechi al modo che erano saria cosa che non corisponderia all'opera già fatta, et al restante della chiesa che se ha deliberato de far. Però dovendosi continuar ad augmentare tal operatione egli è remasto d'accordo

esso excellentissimo messer Thomaso di voler spender in far tal organo et restitution de banchi al modo conveniente come è già detto, mentre però li sia scomputa la spesa che per sua eccellentia sarà fatta nella quantita delli denari per lui promessi per construttion del corpo de essa chiesa che sono alla summa de ducati novecento come appare per instromento cellebrado per messer Vettor di Maphei nodaro sotto li 8 marzo 1558. Però così contentando il Piovano con el capitulo et procuratori di essa chiesa, detto eccellentissimo messer Thomaso si è contentato et così promette de presenti de far restituir detto organo, et in quanto sia bisogno far da novo tutte quelle parte de organo et banchi che serano opportuni, alla soprascritta parte interiore proportionalmente, et come meglio parerà a sua eccellentia spendendo quanto serà necessario per tal opera, dovendosi però excomputar et far boni et diffalcar dalla suprascritta summa delli ducati novecento quel tanto che haverà speso. Ita che al tempo della fabricha del corpo de ditta chiesa esso eccellentissimo messer Thomaso habbia a spender il restante tantum modo...

(*Ibid.*, busta 8121, fols. 833r–834r)

193. Agreement to rebuild the church of San Giuliano

Al nome di Christo amen. Nel'anno della sua natività 1566, indicatione ix, il dì di venere li 26 del mese de april, impresentia de mi nodaro publico e testamonii infrascritti. Convocati a son de campanela, come si costuma, et congregato il reverendo capitulo delli reverendi signori piovani e preti della chiesa de messer San Zulian de Venetia nella detta loro chiesa... per una parte, et l'eccellentissimo messer Tomaso Filologo Ravenna, dottor fissico et cavalier, come procurator di essa fabricha et benefator di essa giesa per l'altra, et volendo ambe esse parte cum il nome del spirito santo et ad honor del glorioso martire messer San Zulian, unanimi et concordi sono rimasti d'accordo de far da nobo la sudeta gesa de messer San Zulain, videlicet, il corpo che manca et farla in una nave secundo il disegnio et modello che darà l'eccellentissimo Jacomo Sansovino l'architetto. Che così getorna meglio, et farano mancho spesa...

(CMC, MS Cic. 1432, fols. 55–57; Wedigen, 1974, p. 63)

194. Order of items to be carried in Rangone's funeral

... 23. Catagrapha Sancti Juliani, Sancti Sepulcri porticus, et faciei Divi Geminiani super platea Divi Marci... 29. Architypus, vulgo moduli ecclesiae Sancti Juliani, a fornice Sansovini, ligneus magnus... 41. Sanctissima Virgo stuchea cum Christo Jesu Santo vivi manu... 65. Sanctissima Mater Dei Virgo Maria in maiestate, nucea aurata magna Sansovini...

(ASV, testamenti, Fiume, B., busta 421, no. 1172, fols. 5v–6r; Wedigen, 1974, p. 63)

195. Sculpture in Rangone's library

... magnum capsa ebani copertum Sanctissima Virgo Maria cum Yesu Christo nato, cuprea magna librarum... Sansovini opus quadringentorum ducatorum. Altera stuchea aureata tellario columnis nuceo in maiestati maiore. Altera stuchea alba magna priori similes... Facies ecclesiae Divi Juliani Venetiarum Merceriae realis, seu maioris, Jacobi Sansovini, sculptoris et architecti florentini excellentissimi, sagome eiusdem duplices, altera facies eiusdem Joannis Antonii Rusconi, volenti Bollanio ipso brixiensi, architecti prestantissimi. Cartagrapha portae maioris ecclesiae eiusdem Sansovini. Cartagrapha spherae solide

celestias media marmore ad planum sculptae super portam maiorem predictae ecclesiae, Josipi Foresti pictoris delineata, ad latitudinem almae venetorum urbis gradum 44, menutorum 30, Libro signo horoscopi fermae leoneque quasi coeli sumo. Cartagrapha faciei anterioris predictae ecclesiae illustris ampliatae ab Alexandro Victoria, sculptore, architetto, et proto ingeniosissimo, cum porticu...

(ASV, testamenti, Fiume, B., busta 421, no. 1172, fols. 18v–20r; Wedigen, 1974, pp. 63–64)

196. Extract from will of Livio Podocataro, 10 January 1556[1]

... Ordiniamo oltra ciò ch'el corpo nostro sii sepulto nella chiesa de frati di Santo Sebastiano di Venetia, a quali vogliamo sii dato, et così gli lasciamo per legato ducati cinquecento con obligo ingiontoli di cellebrar ogni giorno perpetuis temporibus una messa in detta lor chiesa per l'anima nostra, con questo etiam che siano obligati assignare un loco alli nostri commissarii in detta loro chiesia in loco nobile per fabricar la nostra sepoltura in loco alto nel muro, nella qual sepoltura nostra ordiniamo sii speso ducati settecento sino a mille sì come a nostro fratello herede infrascritto meglio parerà. Quanto al funeral nostro ordiniamo che tal funerale sii fatto honorevole come è il consueto, et come parerà ad essi clarissimi nostri commissarii, et herede. Item, ordiniamo che sii fatto uno paramento alla chiesa nostra di Santa Soffia di Nicosia, qual sii bello et honorevole, nel qual sii speso scudi cinquecento d'oro et sii fatto immediate et mandatoli...

(ASV, proc. di San Marco, Commissarie, Proc. de supra, busta 40, Podocataro, L., fasc. 2, fol. 2$^{r–v}$)

1. Portions of the wills of Livio and Cesare Podocataro were first printed by Cicogna, IV, pp. 143, 145, respectively.

197. Extract from will of Cesare Podocataro, brother and heir of Livio Podocataro, 16 November 1557

... Ordiniamo che 'l nostro corpo sii posto in deposito in chiesa di San Sebastiano in loco più honorevole si potrà, et vogliamo siino prestidi ducati cinquecento per uno mansionario, qual debbi cellebrare la sacratissima messa nella chiesa dove il corpo nostro serà sepuloto et che fabricata serà la sepoltura del reverendissimo nostro fratello bona memoria. In detta chiesa di San Sebastiano ordiniamo che'l corpo nostro inseime con quello del detto reverendissimo nostro fratello et del quondam magnifico nostro padre, le osse del qual si atrovano sepulte in chiesa di Santa Maria di Miracoli di Venetia in deposito, similmente le osse di domini nostri nepoti si attrovano in chiesa di San Sebastiano preditto, tutti cinque siamo posti in detta seppoltura... ordiniamo che per nostri comissarii et de beni della commissaria nostra, sii sodisfatto il maestro, quale fabrica la seppoltura del sudeto reverendissimo nostro fratello, et sii finito il paramento d'oro, et fatte le figure entrano in detta seppoltura, secondo serà d'accordo il clarissimo messer Matheo Dandolo, il cavaliere comissario del detto reverendissimo nostro fratello, et messer Giacomo Sansovino, architetto...

(ASV, Archivio San Sebastiano, busta 4, processo 22, Commissaria Podocataro, fasc. 2, fols. 9r–10r)

198. Contract for tomb of Livio Podocataro

Die veneris quinto mensis novembris 1557, in domo habitationis infrascripti reverendissimi Domini Cesaris Podocatari, electi nicosiensis, de confino Sancti Raphaelis.

Constituti in presentia mei notarii et testium inferiorum, reverendissimus in Christo pater Dominus Cesar Podocatarus, electus archiepiscopus nicosiensis et in hac parte solus heres ex testamento bonae memoriae reverendissimi domini Livii etiam Podocattari, olim archiepiscopi nicosiensis fratris sui, nec non clarissimus Dominus Mattheus Dandulo, eques tamquam commissarius superstes ex eodem testamento prelibati bonae memoriae reverendissimi Domini Livii, de quoquidem testamento rogatus fui ego notarius infrascriptus, sub die x mensis januarii 1555 [=1556] ad incarnatione, ex una, et magister Vicentius quondam Georgii de Venetiis, lapicida in confino Sancti Mauritii Venetiarum, agens tam nomine suo proprio quam nomine et vice magistri Joannis Petri de Zanchis, nec non et magistri Salvatoris quondam Victoris, lapicidarum eius consociorum, pro quibus et eorum quibusque insolidum; primis de ratto et ratti habitione in propriis bonis partibus et altera, exhibuerunt mihi notario infrascripto scripturam conventionis inter eos dictis nominibus seguente tenoris ut mea et me rogaverunt ut illam in actis meis registrare debeam et ex inde per me conficii publicum instrumentum. Dicentes et affirmantes inter sese convenisse et concordasse in omnibus et per omnia prout in eadem scriptura plenius legitime [?] et continetur, ac promittentes omnia et singula in eadem scriptura contenta annotataes descripta inviolabiter observare et adimplere, obligantes propria, videlicet, isdem reverendissimus dominus haeres dicte haereditatis ac clarissimus dominus commissarius dicte commissariae ipse vero magister Vincentius, sua et societatis suae omnia et singula bona mobilia et immobilia presentia ac futura. Et in super pro maiori cautione ipsius reverendissimi domini haeredis et clarissimi domini commissarii ibi presens et personaliter constitutus magister Joannes Paliaga quondam Stephani lapicida in confino Sancti Vitalis per se suosque haeredes et successores instantia et requisitione praefati magistri Vincenti ut supra intervenientis et secum principaliter et insolidum in parte et toto se obligando, constituit se fideiussorem penes eosdem Reverendissimum Dominum Cesarem et clarissimum Dominum Mattheum ut supra intervenientes pro omnibus denariis exbursandis et omnibus attendendis et observandis per eundem magistri Vincentii in omnibus et per omnia prout in infrascriptura conventionis continetur. Et ad hoc obligavit sese insolidum ut supra et eius omnia bona mobilia et immobilia presentia et futura super quibus.

Testes Reverendus Pater Dominus Joannes Trivisanus, abbas Sancti Cipri de Murano

Marcus dictus Fortunius Spira nobilis viterbiensis

Scripturae autem supplementum tenor fatis etcetera.

El se dechiara per questo presente scritto come el Reverendissimo Signor Cesaro Podocattaro, arcivescovo di Cipro, si è convenuto con il maestro che hora à fare la sepoltura per la buona memoria del Reverendissimo Livio Podocattaro, arcivescovo quondam de Cipro suo fratello, in questa forma che ditto maestro sia obligato a fare tutte le sottoposte cose — Et prima cavare tutte due le fenestre da basso e restuirle alli fratti, cioè, le pietre vive et li ferri et li vetri et così la cornice de sopra et l'architrave, cavarla e restituirla alli fratti a tutte sue spese de levarle dopara all'occhio ovato de sopra resti in opera.

Item, ditta opera sia fatta secondo el debisogno fatto per me Jacomo Sansovino e sottoscritto sarà dal maestro che farrà ditta opera, facendo detta opera larga piedi 27 et alta fino alla cornice piedi 23. Vel circa el frontone desopra che va in mezo sarà alto fino al cominciare del'occhio ovato che sarà piedi 4 in circa e nel mezo sarà fuora del muro piedi 3½ vel circa, cioè, dove vanno le due collone e cassone della sepoltura, et sarà larga ditto cassone e collone fuora dal dritto del muro piedi xi½ come per la piana si vedela qual sarà appresso al reverendissimo arcivescovo.

Et più sia obligatto ditto maestro far ditta opera come sta il disegno non mancando della sagoma e misura che da me Jacomo li sarà datti, fazzando ditta opera di pietra da Rovigno, salde et nette, et sia lavorata ditta opera bene a uso è solito di buon maestro, cioè, le ditte pietre siano battude da minuto, et obligandosi darla finita del tutto sì de pietra viva come pietre cotte, calcina, sabbinoe, ferramenta, fazzando due fenestre de ferro in mandorla come quella della chiesa de San Giuliano e ditti ferri siano mesti nelle pietre vive in luce facendo la fondamenta tanto quanto da me sarà ordinato non mancando cosa alcuna.

Et più sia obligatto darla finita del tutto eccettuato la figura, ma sia obligatto darle pietre per tutta la figura et in termine de uno anno sia posta in opera a tutte sue spese e non landando finita in ditto termine caschi alla pena de ducati 50 / li quali siano ratenuti dalli denari del suo mercado e per pretio de detta opera sono rimasti d'accordo in ducati cinquecento, cioè, ducati 500 da lire 6 soldi 4 per ducato, dando detto maestro buona securtà così del lavoro che lui farà come delli denarii e della pena. El reverendissimo arcivescovo promette darli al presente ducati 100 simili, el restante per giornata seconda lui lavorerà, etcetera. Io Vincenzo taiapiera et compagni a San Moritio me obbligo a quanto è oltrascritto di fare tanto quanto nel ditto scritto si contiene e pervede del vero ho sottoposto de mia propria mano questo adì 3 novembre 1557 in Venetia.

Et hic est finis dictae scripturae.

(ASV, arch. not., Maffei, V., busta 8115, fols. 395ʳ–396ʳ)

199. Record of disbursements for the tomb

1557 13 fevrer

dar			haver	
per investir ducati		15,000	conti alli Zustigniani	1,000
per la sepoltura	d.	700	ducati	
per il panno	d.	500	a quel de' Zudesi da	400
		16,200	conegia	
		−10,840	al tagiapietra per	100
		5,360	l'arca	
		− 3,400	conti in procuratia in	9,340
		1,960	due volte	
		− 600		ducati 10,840
		1,360		

ha dato in procuratia dopoi questo conto, cioè, dai 19 fevrer 1557 ducati 3400/ fu posti in scrigno⸺ ducati 3400/

Item, dal Badoer s'tt in banco ducati 600

per resto delli ducati 15,000 dieno dar

ducati	260			
per resto della sepoltura	600			
per il panno	500			
ducati	1,360			
(on the verso)				
ducati	260			
	600			
	500			
ducati	1,300			
Zustigniani ducati	1,000		per investir ducati	15,000
Conegia	400			−14,140
Contadi in segno	4,000		resto a dar ducati	860
In ditto	5,340		dal Badoer	− 600
In ditto	3,400		resto a dar ducati	260
ducati	14,140			

per sepultura ducati 700/— ha dato al tagiapiera
 − 100 ducati 100
 ducati 600
per il panno ducati 500

(ASV, Proc. di San Marco, Commissarie, Proc. de supra, busta
40, Podocataro, L., fasc. 3, loose folio)

200. Payment to Sansovino for work on the tomb

25 mazo 1565 consegno a Jacopo Sansovino protho ducati
vinticinque per haver in adoperato in far detta sepultura del detto
soprascritto Reverendo Domino Livio Podocataro in chiesia di
San Sabstian, qual fu posto in opera dalli sui commisarii della
detta commisaria avanti che provenise in ditta procuratia, ghe
sono sta dati in execution d'una termination de 23 ditta fatta con la
presente de messer Mathio Dandolo, kavalier procuratore,
commissario della ditta commisaria.
 Lire 2 soldi 10——
——ditto per esso medesimo porto avanti ducati 141
 Lire 15 soldi 14——6

(ASV, Proc. di San Marco, Commissarie, Proc. de supra, busta
40, Podocataro, L., fasc. 3, ad datam)

The statue of *Hercules* for the Duke of Ferrara[1]

201. Hieronimo Feruffino to Ercole II d'Este, 13 August 1550

. . . Alla quale sino qui non ho voluto far mentione della statua
d'Ercole, qual ha da far il Sansovino, perché pur haverei voluto
puoter scriver che havenda vista non solamente principiata, ma
anche in qualche buon termine; imperò quantumque, io l'habbia
tenuto dextramente solicitato, perché essendo molto fantastico, è
necessario cum lui proceder cum dextra mano, sino qui non ha
giovato et ancora non l'ha encomenzata per non haver la pietra de
rovigno a suo mano, che quella che egli in li principii faceva
condurre da Capo d'Istria si perse cum altre piere marmoree in
una barca che si affondò cum dano del mercante de 3,000 ducati in
circa che le facea condurre. Et perciò da questi signori li ne era
stato compiacciuto per far la detta statua d'um gran pezzo molto
bello, il qual in . . . non ha voluto porre in opra per haver trovato
che non saria in proposito per una vena e rottura che ha nel
mezzo, tuttavia m'assicura ch'l pezzo ch'egli ha ordinato che sia
condutto insieme cum quantità di piere per la fabrica delli
procuratori signori, non può tardar molto più ad arrivar, et che
havuto l'habbia non attenderà ad altro lavoro che ad essa statua et
che dipoi in breve mi la farà vedere . . .

(ASM, Cancelleria Ducale, Ambasciatori Venezia, busta 36;
Campori, 1872)

1. Campori (1872) published an account of this correspondence between
Venice and Ferrara over the statue of Hercules by Sansovino. The original
overture to Sansovino and the contract summarized by Campori appear to
be lost or are possibly among some of the pages rendered illegible by
dampness.

202. Hieronimo Feruffino to Ercole II d'Este, 10 September 1550

. . . Circa il Sansovino, non dubito ch'egli non habbi mandato per
la pietra la qual havuta che haverà terrò solicitato, et se Ella
desidera di havere la statua per mano soa [sic], e necessario cum lui
procedere destramente, perche é cervello bizaro et che ha modo,
et per puoco ritornaria li denari et saria per non farla, et per tanto

io medesimo lo solicito et solicitato facendoli sapere quanto
Vostra Eccellenza la desidera, per puoterla puorre sopra di quella
portà Herculea la qual dir egli che si fornisse de finire per non
haversi la detta statua. A Vostra Eccellenza bascio le mani in la
benigna gratia di la quale ben riverentemente mi racomando et
prego Iddio che la conservi come Ella istessa desidera . . .

(ASM, Cancelleria Ducale, Ambasciatori Venezia, busta 36;
Campori, 1872)

203. Feruffino to Sansovino

Signor Sansovino mio honorato,
. . . lo eccellentissimo Signor Duca mio signore da giorni in qua
mi tiene solicitato per la statua d'Hercole havendola da far porre
alla Porta Herculea della parte nuova di Modena, alla qual porta
non manca per esser finita se non la detta statua e per tanto dalla
eccellenza sua per tutte le lettere che mi vengon scritte mi è
ordinato a solicitarvi, parendole strano che anchora non habbia
aviso da me che la sij encomenzata. Per il che vi prego per il vostro
et mio honore a non differir più quest'opera tanto desiderata da
sua eccellenza. Et havero molto charo di saper se havete havuto la
pietra et se li havete dato principio. Et me vi offero et raccomando
di cuore. Di casa alli xi di septembre del 50 . . . [1]

(ASM, Cancelleria Ducale, Ambasciatori Venezia, busta 36;
Campori, 1872)

1. This is found inside a letter of 13 September 1550, but I have placed it
here for the sake of clarity.

204. Sansovino to the Duke of Ferrara

Allo Eccellentissimo et Illustrissimo Signor Duca di Ferrara mio
patrone, e Signore Osservatissimo Illustrissimo Signore,
 Già parecchi giorni sono passati, che havendomi il Signor
Ambasciator di Vostra Eccellentia richiesto ch'io dovessi far una
statua d'Hercole per un gentilhuomo ferrarese, mi accordai seco,
con animo di farla fare a qualche mio giovane, giudandolo, e
correggendol'io senza porvi le mani, com'io soglio far qua di
molte altre sculture, non havendo tempo per esser impedito ne le
fabriche de le quali ho carico, di sculpir di mia mano. Ma
essendomi stato detto poi doppo l'accordo, che per Vostra
Eccellenza, e non per altri si dee fare detta opera, mi parve, e
parmi ancora si grave peso a là debolezza de le mie spalle, che
temendo non poterlo sostenere, sono stato per ricusar l'impresa,
perché non consente il debito mio in servir sì honorato principe,
ch'io adopri altre mani che le mie proprie, e tempo e forza di
poterle adoprar non posso, se non con gran mio disconcio, e
difficilmente havere: pure il gran desiderio ch'è in me di
compiacere in quanto per me si può a l'Eccellentia Vostra mi ha
fatto deliberare di pormi a sì lodat'opera, com'è il servirlo, e già
harei di novo cominciato ad affattic'ar i ferri da me, già tanti dì
sono, lasciati in riposo, se la pietra che per tale statua havevo fatta
cavar in Istria, non si fusse com'è insieme con moltre altre pietre, e
col navilio stesso ove erano, sommerse nel mare mentre si
conduceva a Venetia, onde per tal caso serà molto difficile far
condurre una altra pietra de la grandezza ch'era quella, perché non
si trova chi voglia più torsi l'impresa, temendo che il disconcio
peso di sì gran pietra non faccia di novo affondar loro i navilii. E
però parendo a l'Eccellentia Vostra, sarebbe bene ch'ella facesse
scrivere al Clarissimo messer Vittor Grimani richiedendogli una
de le pietre sue per tal opera, perché Sua magnificentia ne fece gia
condurre alquanti pessi tra i quali ve ne sarebbe una atta al bisogno
mio, e io subito hauta la pietra darò principio, perché il desiderio
mio e si pronto, che se Dio mi da gratia ch'io possa seguitarlo con

le forze, spero che l'Eccellentia Vostra, a la qual con riverenza bascio le mani, si satisfera dell'opera mia. Di Venetia a dì 12 di settembre. M. D. L.

Di Vostra Eccellentia, Humilissimo Servitore,

Jacopo Sansovino[1]

(ASM, Archivio materie, belle arti, scultori, busta 17 / 1; Campori, 1872)

1. The letter is in the hand of Francesco Sansovino.

205. Feruffino to the Duke of Ferrara, 13 September 1550

. . . essendo io più volte andato da giorni in qua verso la parte di San Marco per ritrovar io medesimo il Sansovino ne havendo egli voluto lassarsi trovare da me, ne da mei per quante fiate habbia saputo mandar et da hora di poterlo ritrovar ho preso in fine per espediente de farli un scritto et fargliolo lassar in casa del qual mio scritto mando la copia qual inclusa per haver esso scritta una soa, a Vostra Eccellentia la qual mando qui alligata, è cosa diabolica d'haver a far cum un fantastico et tanto bizarro quanto questo. Io non so pensare quello ch'egli scrive se non qualche difficultà per taccagneria perché puoi non parlar seco. Haveva havuto aviso che la pietra d'istrania de ruvigno era stata cavata et ch'in brevi saria condutta cum quantità di marmori per la fabrica di S. Marco dippuoi mandato un mio per intender da lui se le pietre erano ancor arrivate, rispuose ch'era necessario di aspettar che fussino mandati in Histria li burchij della Scola della Misericordia che sono grandi et quali si acconzavano per mandar a levar marmori per la fabrica di essa scola per che li altri burchij, o come si voglian barche, non sono buone per condurre marmori sicuramente, etiam la cosa si tratta seco per un gentilhuomo di Ferrara in presentia del Beltrami et del Magnifico [?] Qualengo, et che dippuoi se concluse per 120 scudi senza alcuna executtione promisse di farla in otto mese dippuoi scursi molti et molti giorni per darline magior ansia et anche per ordine ch'o ne hebbi, li dissi che la statua era per il Conte Hercole de Contrarij, gentilhuomo de principali et molto virtuoso, et che ritrovandosi Vostra Eccellenza in Modena per quella fabrica et fortificatione di quella soa città che la quale al'hora soa signoria si trovava al governo che li venne detto parlandossi di statue et antiquitadi che sono in essa città che egli faceva far in Venetia dal Sansovino una statua d'Hercole destinata in un suo giardino, il che inteso per Vostra Eccellenza disse al predetto Conte, voi conte lassiate questa a me che la farò metter a questa mia porta nova. Et voi puoi ne puotrete far fare un'altro per il vostro giardino, di manera che la statua da un giardino era stata destinata ad una porta et che puoi che havea da esser per la Eccellenza Vostra pregavo a voler usar et diligenza et prontezza in fare che fuosse et ben lavorata et presto, et che havea egli promesso di far tutto questo a sodisfattione d'un conte che molto magiomente credevo che saria per farlo a satisfatione di Vostra Eccellenza Prencipe al qual egli doveva haver molto charo di dover servire. Il che tutto da lui fuo accettato molto bene et mi promesse largamente che puoi che l'opera havea da esser per quella che cum piu diligenza et studio la farebbe hora, questa [?] soa lettera senza haver fatto risposta al scritto mio fatto riservatamente come puotra veder mi fa star tutto suspeso, et per tanto staro aspettando che essa mi facce ordinar quello che vorra ch'io faccia cum lui che il caso suo parmi la istessa hydra . . .

(ASM, Cancelleria Ducale, Ambasciatori Venezia, busta 36; Campori, 1872)

206. The Duke of Ferrara to Feruffino, 14 October 1550

Hercules Dux Ferrarae, ecc.

Messer Girolamo: non essendo anchora mandata l'allegata ci è gionta la vostra del xi et visto quanto cortesemente il Clarissimo Signor Vettor Grimani ha voluto che quella pietra sia data senza pagamento per far quella nostra statua et di più con tante amorevoli parole ne restano molto obilgo a Sua Signoria. Così volemo che in nome nostro la rengratiate bene efficacemente da tanto grata demostratione che ella ha voluta farci del Suo aiuto [?], certificandola che lo haremo tanto caro che non potressimo dirlilo in poche parole ma che la pregamo all'incontro a voler persuadersi che sì per questo come per il valor de Sua Signoria et quello amore che già molto tempo le portamo semo dispostissimo . . . et farle ogni piacere et però ch'ella ci farà cosa gratissima a valersi di noi con tutta quella confidentia che può aspettar da suo bono amico come loe siamo et con questo ce li raccomandate assai, ringratiandola ancho del bono ufficio che le piacciuto fare col Sansovino, il quale sollicitarete come parrerà a voi per la espeditione della statua: state sano. Ferrarae 14 octobre 1550

(ASM, Archivio Seg. Estense, Carteggio restit., B. Prospero, busta 41)

207. The Duke of Ferrara to Feruffino, late October 1550 (?)

. . . Quanto al particolar della statua, noi havessimo ben le lettere del Sansovino mentre che eramo su le montagne di Carfignana, ma oltra le occupationi che li havessimo, parendoci ch'egli volesse più tosto ridurre la cosa in parole, che farcene vedere alcuno effetto, non curassimo farli risposta. Pero quando ci voglia servire et si possi haver la pietra dal Grimani haremo piacere che si dia principio al opera, et procuri di venirne al fine quanto più presto sia possibile, essendo pur strana cosa che la statua qual dovea esser finita a San Martino,[1] non sia pur anchor principiata et se la soprascripta petra non si potesse havere saremo contento, ognivolta che l'opera riesca in modo che non s'habbia a vedere le commissure, che la statua si faccia di due pezzi, et così voi sollicitarete che se ne venghi a fine . . .

(Campori, 1872[2])

1. The Feast of St Martin is on 11 November.
2. I have used the undated transcription in Campori (1872).

208. The Duke of Ferrara to Feruffino, 31 October 1550

. . . Circa la statua che fa il Sansovino non ve ne dicemo altro essendo sicuro, che non mancate di sollicitarla, acciò che si finita quanto più presto sia possibile . . .

(ASM, Archivio Seg. Estense, Carteggio restit., B. Prospero, busta 41)

209. Feruffino to the Duke of Ferrara, 2 November 1550

. . . Il Sansovino non solamente è solecitato da me ma anche importunato, cognoscendo io essere necessario di far così cum lui, imperò destramente. Così egli hoggi mi ha mandato a dire se voglio veder il modello della statua d'Hercole che non m'incresca d'andare sino a casa sua. Sono andato et l'ho veduto puosso dir quasi perfetto et per mio debol giudicio molto ben fatto et tra quattro o sei giorni finirà di polirlo. Dippuoi havendo egli sagiar cum ferri qual di le pietre grandi è la miglior et fatta ellettione di quella ch'esso vole da me veduta, a San Francesco della Vigna dove il Clarissimo Signor Vittor Grimani ha le dette

pietre farà la legerir et dippuoi condurre nel magazeno nel quale egli lavora et havrà da far detta statua, promettendomi ch' in termine de xv giorni mi la farà veder principiata, et che vedrò che non li perderà ponto di tempo, dicendo di finirla in cinque mesi et che al impossibile insino è tenuto et ancora hoggi si ben è domenica lavorava intorno al detto modello ...

(ASM, Cancelleria Ducale, Ambasciatori Venezia, busta 36; Campori, 1872)

210. Feruffino to the Duke of Ferrara, 6 December 1550

... Ritrovandomi non hieri altro a ragionar col Clarissimo Signor Vittor Grimani, mi parve de dir a Soa Signoria che mi era parso per debito mio di far saper a Vostra Eccellenza per mie della seconda soa molto amorevole demostratione verso di quella acciò ch'l Sansovino per mancamento di pietra non restasse di far la statua, la qual egli come appar per un suo scritto era et è obligato a far di pietra soa, et che sono certissimo che la Eccellenza Vostra le ne haverà tuttavia magior obligatione, così ella me ringratiò assai d'haver fatto questo officio quantunque per la soa devotissima servitú verso di Lei et per desiderare come desidera di puoterLe servir, questa demostratione esser minima et di cosa molto piccola cum altre parole humanissime et piene di molta affettione et devotione ch'essa porta a Vostra Eccellenza: la quale cum la benignità soa et cortese demostratione fatta a giorni passati in Ferrara e a Coparo al Magnifico et Clarissimo Messer Federico Prioli, cugino germano del predetto Signor Vittor. Se lo ha acquistato et fatto perpetuo servitor suo et di maniera che parlando meco Soa Magnificentia in presentia d'esso Signor Vittor non si puoteva satiar di parlar in laude di quella, dicendomi che così come più avanti ...

(ASM, Cancelleria Ducale, Ambasciatori Venezia, busta 36; Campori, 1872)

211. The Duke of Ferrara to Feruffino, 8 December 1550

... Volemo che rengratiate molto il Clarissimo Signor Messer Vittor Grimani della nova cortesia, la quale ci significate, che ha usato verso noi, non havendo rispetto a guastar qualche suo disegno per accommodar noi di quella pietra per far la statua, poi essendosi come dite fatto nostro sollecitatore col Sansovino, acciò che egli faccia tanto più presto la detta statua, et certificate Sua Signoria che ne teniremo grata memoria, misurando non tanto la qualità della cosa, quanto d'animo di essa ... Non essendo anco serrata questa ci è gionto la vostra di vi., ne intorno alla parte del Magnifico et Clarissimo Messer Vittor Grimani, vi replicaremo altro, havendo con questa sodisfatto a bastanza, ma quanto alla buona relatione fatta da noi del Clarissimo Messer Federico Priuli, rengratiate per nostra parte SuaSignoria infinitamente, dicendole che cele sentiamo obligato del buon animo che si dimostra, et offerendoci ad ogni suo piacer, col raccommandarci in fine a Sua Signoria bene efficacemente et in litteris ...

(ASM, Archivio Seg. Estense, Carteggio restit., busta 41; Campori, 1872)

212. Feruffino to the Duke of Ferrara, 14 March 1551

... Et perchè mi haveva certificato ch'ancore novamente il Clarissimo Signor Vittor Grimani, essendo di compagnia soa, ito à vedere la statua d'Hercole, haveva ordinato al Sansovino ché usi in essa tutta la diligentia che può si in fornirla come in farla bene et ché lassi tutto per attenderli. mi é parso havendo visto Sua

Signoria de certificarle che puol essere sicura ch'appresso le altre soe amorevoli demostrationi verso di la Eccellenza Vostra, ch'il detto officio ch'ultimamente ha fatto per soa molta cortesia col detto Sansovino — serà gratissimo a quella, alla quale esso mi ha pregato ch'io scrivi di novo come lei è buono et ben devoto servitore et che si rallegra cum lei che le cose di Parma habbiano preso quella strada et appoggio che hanno ...

(ASM, Cancelleria Ducale, Ambasciatori Venezia, busta 37; Campori 1872)

213. Feruffino to the Duke of Ferrara, 29 June 1551[1]

... Se ben è molto ch'io non ho scritto alcuna cosa della statua non resto però di vederla qualche volta et di farla vedere da li miei. Io l'ho vista, è puoco, et il Sansovino non manca di far quello che bisogna di sua mano, et li tiene tre suoi che la lavorano, et è quasi ridutta al suo segno. Dippuoi si metterano a polirla et per quanto a me ne pare, tengo che non serà perfetta più tosto che per tutto Agosto prossimo ...

(ASM, Cancelleria Ducale, Ambasciatori Venezia, busta 37; Campori, 1872)

1. Campori (1872) refers to a letter of 15 January 1551, concerning Sansovino's use of two *garzoni* and his own labour on the statue. Though there is no letter of this date extant, Campori may have been thinking of this letter.

214. Feruffino to the Duke of Ferrara, 26 August 1551

... Sono già ben sei giorni ch'l Sansovino mi prego di voler scrivere a Vostra Eccellenza, facendoLe sapere ch'egli continuamente tiene duoi et tre lavoranti pagati intorno alla statua, la qual pensa di finire per tutto settembre prossimo, et fra tanto esso vorria che li fuosseno mandati 25 scudi per puorer dare denari a detti lavoranti. Et puoco ch'io l'ho vista et e quasi ridutta a perfettione, ne altro bisognerà che di polirla ... Bisogno però di denari anch'io et sono certo molto più del Sansovino ...

(ASM, Cancelleria Ducale, Ambasciatori Venezia, busta 37; Campori, 1872)

215. Feruffino to the Duke of Ferrara, 10 September 1551

... Li sessanta scudi per me ne li 25 per il Sansovino che pensavo per il bisogno mio grandissimo di havere al giungnere di detto Francesco Corrier non ho havuto altramente ...

(ASM, Cancelleria Ducale, Ambasciatori Venezia, busta 37; Campori, 1872)

216. Feruffino to the Duke of Ferrara, 16 September 1551

... Al Sansovino si dettero hieri li 25 scudi co'l quale ho fatto l'ufficio ordinatomi per lettere di Avella. Et per quanto puosso comprendere egli lavora et fa lavorare in la statua cum diligentia, et al principio del mese venturo stimo serà perfetta ...

(ASM, Carcelleria Ducale, Ambasciatori Venezia, busta 37; Campori, 1872)

217. Feruffino to the Duke of Ferrara, 21 April 1552

... cum mie precedenti [lettere] hebbi damandare alla Eccellenza Vostra una di maestro Alessandro [Vittoria] sculptore Vicentino [sic], il qual mi disse che d'ordine di Lei haveva veduto la statua

d'Hercole fatta da questa testa di pietra durissima del Sansovino, et prima ch'egli mi habbi detto il parere suo d'essa statua, mi è parso di pervenir in dirli ch'ancora non sia mia professione perché non habbia cognitione de figure ch'imperò sono già da tre in quattro mese che ritrovandomi a vederla, dissi ad esso Sansovino che le gambe et le cosce non mi pareva correspondessino bene alla grandezza del corpo, tuttavia che per la molta oppinione che havevo di lui, il qual l'havesse fatta senza vitio et ben proportionata, non mi parve di farne mentione alcuna per mie [lettere] a Vostra Eccellenza per non essere moccato da Lei. Così egli hora mi ha certificato esser pur'troppo vera la detta desproportione, et che non solo son curte, ma troppo sotile con altri vitij che sono stati represi da huomini di giudicio et molto intelligenti, onde che per riverderla meglio, hoggi insieme cum il predetto maestro Alessandro, stato da xij anni cum detto Sansovino, et insieme cum maestro Isepo Vicentino pittore et uomo di giudtitio et di buon sentimento,[1] sono andato a casa sua. Tuttavia non ci ha giovato perché esso non ha voluto lasciarsi trovare, nè li suoi han voluto trovare le chiavi del magazeno nel quale si è fatta la statua. Imperò, havendo io preso ordine cum detti suoi domatina io insieme cum li periti per vederla, dicendo d'haverne commissione da Vostra Eccellenza di fargliela vedere, il buon Sansovino pazzo bestiale et impratticabile, mi ha stasera mandato a dire ch'egli non vuole ch'io la vegga cum li detti duoi, uno de quali è stato suo famiglio et che non sa se sia vivo, et che si meraviglia di me a voler far vedere questa figura da uno che niente sa et che ne scriverà alla Eccellenza Vostra cum dire che vole ch'l giudicio d'essa sia fatta da uno Bacchio qual'è in Fiorenza alli servitij di quel Signore et da un'altro qual se ritrova in Roma.[2] Hora, io, Signore, per quanto il sudetto maestro Isepo mi ha detto haver inteso da virtuosi et di questo mestiere in Padova che l'hanno veduta, è imperfettissima et di maniera ch'egli, per non perdere il credito, non doveria darla fuori in conto alcuno et massime a Vostra Eccellenza, ma più presto pensare di farne un'altra cum aggiunto di persone che meglio di lui intendere le figure nude, delle quali esso è detto che non ha mai hauto vera cognitione. Maestro Alessandro desiderava di andare cum lui per l'honore suo et per aggiutarlo a far ⟨ . . . ⟩ Tuttavia, vista la sua bestialitade, ha deliberato di farne un modello, il quale a giudicio degli ⟨ . . . ⟩ de' periti serà giudicato migliore assai di quello del Sansovino . . .

(ASM, Cancelleria Ducale, Dispacci da Venezia, busta 38; Campori, 1872)

1. Campori (1872) tentatively identifies this person as Giuseppe Scolari.
2. The two sculptors are Baccio Bandinelli and Ammannati, who had just executed the colossal *Hercules* in Padua prior to his departure for Rome.

218. Alessandro Vittoria to the Duke of Ferrara, 16 April 1552
Illustrissimo et Eccellentissimo Signore
L'Illustrissimo Signor Conte Ludovico di Thiene, essendo io l'altro giorno costí, mostrò a Vostra Eccellentia una mia medaglia del principe di Spagna, e puoco dopo per mio maggior favore, m'appresentò a quella alla qual havendomi dimandato s'io potessi far il suo ritratto ò di marmo, ò di bronzo, risposi, che più tosto, ch'io havessi fornite alcune mie opere serei ad ogni suo piacere e comodo, per ciò hora che libero son, Vostra Eccellentia liberamente mi commandi, poscia che ogni mio desiderio sia in tutto quel che so e posso servirla, alla cui buona gratia humilmente mi raccommando. Di Vicenza, alli xvi di aprile MDLII. Di Vostra

Illustrissima et Eccellentissima Signoria humilissimo servitore
Alessandro Vittoria scultore

(ASM, Archivio materie, belle arti, scultori, busta 17/1; Campori, 1872)

219. Vittoria to Feruffino, 30 May 1552
Illustrissimo Signor mio et patron honorando.
Feci il modello d'un Hercule in nome del eccellentissimo Signor Duca di Ferrara al paragone del Sansovino, qual spinto forse più per livore, che per giudicio, mostrava biasimare le cose mie, et perchè son tenero del mio honore, in gratia richiedo che quello vogli mettere a paragone del mio alcun suo et meco sottomettersi alla sententia, et censura de belli intelletti, over periti nell'arte, et da mo ⟨ . . . ⟩ volendo, che se depositi qualche honorato pretio, per me non resti, che se giudichi, qual di noi al altro in simil lavoro debba esser preferito che se non basta a Vostra Signoria di veder sol il modello, mi porrò al compimento del opra et verrò con quella a Venetia, in questo mezzo Vostra Signoria m'ami et favoreggi che il son servitore, et se mi vol dar risposta dirici sue lettere al palazzo del Magnifico Conte Marcantonio di Thiene, ove al presente mi ritrovo, et a Vostra Signoria infinitamente mi raccomando.
Di Vicenza alli xxx magio MDLII.
Di Vostra Signoria servitore
Alessandro Vittoria S.

(ASM, Archivio materie, belle arti, scultori, busta 17/1; Campori, 1872)

220. Feruffino to the Duke of Ferrara, 25 January 1553
. . . Di compagnia de Monsignore Rossetto fuoi non hier l'altro a veder la statua di Hercole, nella quale ritrovassimo il Sansovino medesimo che lavorava, et essa non dispiacque al predetto monsignore, et a me riesce meglio del solito, e in termine che per finirla et polirla sempre che li serà ordinato che la finischi, dice che in xx giorni la puotrà fornire, tuttavia vole aspettar che li sia ordinato perché haverà da corcarla et porla distessa in terra per polirla, che altramente non seria per muoverla, et per tanto la Eccellentia Vostra puotrà far scrivere quello che circa ciò le piacerà, ch'appresso puoi serà necessario de farli far una cassa del modo ch'el predetto Sansovino ordinarà . . .

(ASM, Cancelleria Ducale, Ambasciatori Venezia, busta 39; Campori, 1872)

221. Payment to Sansovino, 1553
[On 21 March 1553 Feruffino was paid 45 gold scudi to give] al spettabile maestro Jacopo Sansovino schultore in Venetia et questo per conto d'havere fatto la statua d'un Hercule quale se fatta fare de comissione di sua Excellentia per mandarla poi a Modena.

(ASM, Camera Ducale, Reg. 121; Campori 1872)

222. Feruffino to the Duke of Ferrara, 24 March 1553
. . . Al Sansovino ho fatto intender come io ho in mano mia li denari che se gli resteno pagar per la statua d'Hercole in la quale tuttavia lavora per ridurla ad honor suo più perfetta che puotrà. Et ancora ch'egli dica di finirla in xii o xv giorni; imperò da suor che li lavorini anco essi intorno, mi è ditto che non sera finita più presto che per tutto aprile prossimo et puoi che tanto l'ha tenuta

parmi che sia ben che la tenghi ancor' questi puochi giorni per farla venir meglio che puotra. Io lo tengo et tenuto solicitato et per darli magior ansia di lavorar el meglio et presto li ho ditto ch'haver meco li denari. Finita che serà per esso farò che serà ordinata la cassa et tutto quello che serà bisogno per mandarla ben sicura a Vostra Eccellentia in Ferrara. Io li ho in oltra parlato di qualche statua che fuosse da vender, onde che vedrà se si trovasse et ne uscerà buona diligenza . . .

(ASM, Cancelleria Ducale, Ambasciatori Venezia, busta 39; Campori, 1872)

223. Feruffino to the Duke of Ferrara, 29 July 1553

. . . in buon proposito fei ufficio in oltra tale come io scrivo al signor fattor Guarino per conto di la statua d'Hercole che subito ne hebbi espeditione autentica da puterla mandar senza alcuno impedimento come puotassi veder per la copia che ne mando . . . [1]

(ASM, Cancelleria Ducale, Ambasciatori Venezia, busta 39; Campori, 1872)

1. The paper mentioned here does not survive.

224. Feruffino to the Duke of Ferrara, 2 August 1553

. . . Ho mendato a parlar al Sansovino in la cassa, la qual avanti del ritmo mio qui fe far il sudetto mio figliuolo; imperò li fuo dir che come esso sia per farla serrar in detta cassa che vorrò trovarmeli circa che hoggi mi serà rispuosto da messer Andrea Mussio, il qual voluntieri s'affatica in le cose di la Eccellentia Vostra, et facendo detto Sansovino suo debito, puotrò farla imbarcar sabato prossimo 5 di questo, sopra d'un borchio delli Tressi qui che serà da luoco espedito per Ferrara . . .

(ASM, Cancelleria Ducale, Ambasciatori Venezia, busta 39; Campori, 1872)

225. Payment to Feruffino for shipping the Hercules, 25 August 1553

[Feruffino was paid 48 lire] per l'ammontare de la spesa de la cassa che s'è fatta per incassare la statua de marmo per mandarla a Modena ovvero a Bersello, la qual statua è un'Ercole grande de Sua Excellentia.

(ASM, Libro dei debitori, 1553; Campori, 1872)

The Mars and Neptune for the Doge's Palace

226. 1554 Adì 31 luglio in Venetia

Ritrovandosi in questa Città dui pezzi di marmoro de longhezza de piedi X incirca luno, fatti qui condur per quelli che hebbero il carico di far la stantia del palazzo che habita li serenissimi Principi, con animo di far fare in quelli due figure de ziganti da esser posti per adornamento di esso palazzo, dove meglio cascheranno, et ritrovandosi in questa città al presente Domino Jacomo Sansovino persona inteligientissima et famosissima di scoltura, perhò desiderando li Clarissimi messer Mafio Venier, messer Antonio Capello Procurator, et messer Julio Contarini Procuator dignissimi Proveditori sopra le fabriche del Palazzo non perderla occasione di un simil homo, ma che quello habbia a far ad honor di questa Città et di esso Palazzo, esse ditte due figure hanno trattato et concluso con esso ditto Domino Jacomo che quello habbia a far et perficer due figure de Ziganti quanto più bene et belle che alla espetatione di uno tal homo si puol aspetar de havere,

per fattura delle qual se li promete de dare ducati dusento cinquanta, et cossì lui come persona che ha dedicato ogni suo spirito et forza a grandezza di essa Città si contenta, et promette di fare, a conto de li quali si li ha da dare ducati qindese ogni mese principiano il proximo di agosto, et così successive fino che sarà compito di fare esse figure, et compite che le saranno li venga ad esser dato, quanto venisse a restar d'haver fino al supplimento di essi ducati 250 in tutto. Le qual figure sia obligato a far che le siano belle et ben finite in termine de uno anno proximo alla più longa. Et per fede de ciò detti Clarissimi Signori Proveditori et dito Domino Jacomo sottoscriveranno il presente scritto.

Antonio Capello Procurator

Julio Contarini Procurator

Io Jacomo Sansovino me obligo a quanto è sopra schritto rimettendomi sempre alla limitazione delli Clarissimi Signori sopra nominati di quel più e mancho che pararà alle Clarissime Signorie Vostre. E per fede vero o sotto scritto mano propria.

(ASV, Senato Terra, filza 86 (1582–83); Lorenzi 1868, p. 481, no. 939b)

227. Adì 8 Zener 1566 [=1567]

Lustrissimi Signori Chapi dil lustrissimo conseio di diexe di ordene di Clarissimi Signori provedadori alofficio dal sal quali meano comeso chio veda la spexa va in meter in opera li doi ziganti fati per maistro Jacomo Sansovin la qual spexa considerada per mi antonio dal ponte proto sono di ducati sesant a val

Ducati 60 denarii_____

Antonio dal ponte proto officio dal sal sotoscrito

1567. die vi martij in additione

Capita.

Che sia commesso al depositario dell'officio dell'officio [sic] del sal, che dar debba al collega suo deputato alla cassa picciola delle fabriche Lire 326 soldi 16[1] per spesi in metter in opera i dui giganti fatti per maestro Giacomo Sansovino. Item altri ducati 25 per fornir la ditta opera. Di li qual ducati 25 sia tenuto conto distinto et particolar.

——25[2]

—— 3

—— 2

(ASV, Consiglio dei X, Parti Comuni, filza 99, 1567, March–June; Lorenzi, 1868, pp. 342–43, no. 721)

1. 'Ducati sessanta de' is cancelled, and the sum in lire and soldi is added in the margin.
2. Voting figures of 28–1–1 are crossed through.

228. +adì 12 zenero 1567

Spexe fate per il meter suxo le do figure in cima la scala di marmoro.

Item per 4 pezi di piera viva per far i pedestali tolti da mistro Bernardin in chale di cerchieri sono miera 6 a Lire 3 soldi 10 il mier

L 33 s___

per piata e fachini conduse i diti cargo e descargo L 7 s___

mistro marcho taiapiera zorni 12 aparechiar dite piere con suo fio e chavar i buxi di arpexi e inpionbarli a soldi 40 al di L 24 s___

mistro Batista marangon zorni tre a far i cusinelli e chariege per dite figure L 4 s10

Zuane suo garzon zorni 3 a soldi 20 al di L 3 s___

mistro Zuan Antonio murer zorni 9 per ordenarse i ponti e proveder di Cartaje e argne a soldi 36 al di L 16 s4

mistro Zuane zorni 6 a far ponti a soldi 30 al di L 9 s___

mistro Orlando zorni 5 a soldi 30 al di L 7 s10
Batista manoal zorni 5 a soldi 21 al di L 5 s 5
Zuane manoal zorni a soldi 21 al di L 5 s 5
Mazalon e do compagni zorni un per omo a soldi 20 al di
 L 3 s___
per fachini porto i legnami di ponti innanti e indrio L 7 s___
per far concar le taie e tangagni L 3 s 2
per seo per onzer le taie e vaxi L___s 6
per piata porto alcuni pezi di legno tiolti al magazen L___s 8
spexi in gondola a portar il marmo dil cimier L___s 6
per pianta ando a tior i chai alarsenal e tornarli L 2 s 2
per fachini chargo i chai e i deschargo e tornarli in drio
 L 5 s 5
 L___s16
per mendo [sic] dil chai pagado al arsenal L 6 s 7
per arpexi di rame numero 18 pexa lire 34 a soldi 24 la lira
 L 40 s16
per una zagaja e un tridente fati per mistro Benato sta al ponte di
dai in chale di favri per meter in man ale dite figure L 31 s___
per farli dar biacha a oio L 1 s10
per piombo lire 146 a soldi 3½ la lira tolto da ser simon dal falcon in
chale di favri L 25 s11
per agui grandi per fichar i ponti e per cusineli pexa lire 82 a soldi 4
la lira L 16 s 8
li soto scriti bastasi ano fato le soto scrite zornade in far le chavrie
per calar dite figure e condurli e meterli in opera e despazar e
portar via le argane
Sete barbe zorni 6 a soldi 30 al di L 9 s___
Francesco zorni 6 a soldi 30 al di L 9 s___
Zane zorni 6 a soldi 30 al di L 9 s___
Zuan berlingier zorni 6 a soldi 30 al di L 9 s___
Zuan di Sadonei zorni 5 a soldi 30 al di L 7 s10
Martin zorni 5 a soldi 30 al di L 7 s10
Jacomo zorni 5 a soldi 30 al di L 7 s10
Domenego zorni 5 a soldi 30 al di L 7 s10
Isepo zorni 5 a soldi 30 al di L 7 s10
 L326 s16
Suma Lire trexento e vinti sie e soldi sedexe
Item per voler investir i quadriseli di malmori fra arpexi pionbo
manifature e malmori li anda di spexa ducati vinticinque zoè
 Ducati 25
 Antonio dal ponte proto officio dal sal sotoscrito

(ASV, Consiglio dei X, Parti Comuni, filza 99, 1567, March-
June; Lorenzi, 1868, p. 343, no. 721)

229. Questions posed by Francesco Sansovino for his father's collaborators on the *giganti*[1]

Interrogatorii sopra i quali si hanno da esaminar testimoni in
materia delli giganti fatti da Messer Jacopo Sansovino, et posti nel
palazzo della Signoria di Venezia
Quando fu messo li giganti in opera nel Palazzo.
Se esso sa chi vi ha lavorato sopra per ordine di Messer Jacopo
Sansovino.
Quanto tempo esso testimonio vi ha lavorato supra et per quanti
dannari al giorno.
Se è integramente stato satisfatto da Messer Jacopo sopraditto.
Se esso era solo a lavorar su li giganti o pur in compagnia d'altri
lavoranti.

(ASV, Senato Terra, filza 86; not in Lorenzi, 1868)

1. The handwriting on the sheet is Francesco Sansovino's.

230. Florentine government's reply to Salt Magistracy concerning Francesco il Toccio[1]

Multuum Magnificiis Dominis Vicariis ad Sale inclitae Civitatis
Venetiarum nostris ossequiosissimis, Vinetia
Magnifici Domini Ossequiosissimi,
In ferentione literarum Dominorum Vostrorum de 25 Februarii
preteriti ad Magistratus Fiorentiae destinatarum, et vigore deli-
berationis super predittis litteris factis per Magnificos Dominos
Locutenentem et Consiliarios Illustrissimi et Eccellentissimi
Domini Principis Florentiae et Senarum per nostri Actuarii
Coadiutorem examinari fecimus super interrogatoriis in
Dominorum Vostrorum litteris preditis inclusis quendam Fran-
ciscum detto il Toccio sculptorem de Septignano testem inductum
et productum ad instantiam Domini Jacobi Sansovini cuius
attestationem et examen predictum sigillatum et nemini panditum
et per dictum nostrum Coadiutorem publicatum in authentica
forma ad Dominos Vostros transmittimus, et bene valete.
Datum Florentiae ex Palatio nostrae solitae residentiae sub anno
Domini 1568 indictione xi, die prima Aprilis.
Uti frater, Petrus Monaldusis Praetor

(ASV, Senato Terra, filza 86; Lorenzi, 1868, p. 483, no. 939f)

1. The record of the actual interrogation appears to be lost.

Testimonies concerning execution of the *giganti*

231. 3 septembris 1572

Capitulum Domini Francisci Sansovini per ipsum productum
apud Magnificos Dominos Judices Examinatorum admissum die
3 septembris 1572, salvis oppositionibus et interrogatoriis ut
retulit ser Hieronimus de Grandis, Praeco et Ministerialis Palatii.
Havendo il quondam messer Jacopo Sansovino mio padre fatto far
li giganti che sono alla Scala di Palazzo con molta sua spese e
desiderando io che apparisca sempre così qui, come fuori et in
ogni tempo et occasione la ditta spesa, desiderio che siano
esaminati a perpetua memoria tutti coloro che vi hanno lavorato
suso a spese del ditto Messer Jacopo et sono li infrascritti
Domenico ditto il Magnifico Taiapiera
Domenico da Salò Scultore
Battista di Bernardin Scultore
Poletto Intaiador da Piera
Alessandro Vittoria Scultor.

232. Die 9 septembris 1572

Dominus Dominicus Salodii testis ut supra productus, citatus,
juratus, monitus et diligenter examinatus super antedicto capitulo,
Juramento suo dixit ut infra, videlicet:
Io ho lavorato intorno a questi dui Giganti nominati in questo
capitolo da circa anni 3 et ho avuto dal detto messer jacomo
Sansovino per premio et mercede di tal mio lavoro ducati 180. Et
questo è quanto ch'io so.
Super generalibus recte respondit. Relectum confirmavit.

233. Die dicta

Dominus Dominicus Bernardini dictus il Magnifico sculptor,
testis ut supra productus, citatus, juratus, monitus, et diligenter
examinatus super capitulo ut supra producto juramento suo dixit:
Io posso haver lavorato in due volte intorno a questi Giganti da
mesi otto in circa. Et haveva per causa del lavoro ch'io faceva
come ho detto, soldi 30 al giorno, che mi dava detto Sansovino.
Et questo è quanto io so del mio haver lavorato.
Super generalibus recte respondit. Relectum confirmavit.

234. Die 17 novembris 1572

Dominus Baptista quondam Bernardini Venetiarum sculptor, habitator in Contrata Sancti Thomasii, testis ut ante productus, citatus, monitus, juratus, et super capitulis antedictis diligenter examinatus, juramento suo dixit ut infra, videlicet:

Io credo per quello mi posso ricordar di haver lavorato continuamente intorno a questi doi Giganti che mi havete menzonati forse cinque anni in circa. Et per mercede di tal mio lavoro io haveva dal quondam messer Jacomo Sansovino nominato nel capitolo soldi 30 il giorno. Dicens. Il detto Messer Jacomo mi fece ritrovar ancor doi altri homeni appresso di me per lavorar intorno li detti doi Giganti, li quali pagava nello stesso modo che pagava me, a soldi 30 il giorno, li quali hanno nome Maistro Zuanne sta al Portego scuro a Sant'Apostolo, et uno Maistro Gasparo de Zorzi grando. Subdens. Il detto Messer Jacomo per quello ch'io credo ha speso assai centenara de ducati atorno a questi tali Giganti.

Et haec satis, super generalibus recte respondit. Relectum confirmavit.

235. Magnifici uti fratres honorabiles

Pro executione literarum Magnificentiarum Vestrarum diei 22 septembris preteriti per Cancellarium meum, examinari feci ser Antonium Gallinum nominatus in predictis litteris super capitulo mihi trasmisso ad instantiam Domini Francisci Sansovini cuius dictum nemini ponditum sub his meis et sigillo Magnificentiis Vestris transmitto, et illis me commendo.

Padue 6 octobris 1572.

Jacobus Aymo Potestas.

Die 28 septembris 1572

Ser Antonius Gallinus sculptor filius Dominici habitator Padue in contrata Sanctae Agathae testis nominatus in literis Magnificorum Dominorum Judicum Curiae Examinatoris diei 22 Septembris presentis citatus per Antonium da Tridento preconem juratus sub die externa monitus et examinatus super capitulo in dictis literis transmisso ad instantiam Domini Francisci Sansovini suo juramento respondit:

Io ho lavorato in più volte da uno anno in circa, mentre ch'io stava in casa del quondam Messer Jacomo Sansovino, a sue spese però: ch'io per imparare non haveva altro nel far delli Giganti che sono alla Scala del Palazzo in Corte della Serenissima Signoria. Et dopo finito il tempo con ditto quondam Messer Jacomo, li ho ancora lavorato da 6 mesi in circa, et mi dava soldi 34 al giorno pure a mie spese. Et nel tempo ch'io stava in casa come ho detto vi stava anco Messer Jacomo de Medici Bressano, quale hora è morto, et lavorava anco intorno a questi Giganti un Battista de Bernardin scultor et un Francesco Fiorentino, et tutti lavoravano a spese del ditto quondam Messer Jacomo Sansovino intorno ditti Giganti. Et vi è sta lavorato, dopo ch'io sono partito, che per quanto ho inteso, vi sono stati da anni 7 a finirli. Et credarò che vi sia andata della spesa assai, ma la quantità non la posso sapere. Ma pagando lui li homeni e forza che vi sia andata della spesa. È vero che non se li lavorava al continovo, et al tempo ch'io stava in casa del ditto quondam Messer Jacomo io vi lavorava così a buttade, tal volta un mese continovo et secondo li lavori che li venivano. Et quando fui fuori di casa per quelli 6 mesi che ho detto vi lavorai continovo come ho detto. Ma che spesa vi sia andata non ve lo so dire. Esso quondam Messer Jacomo tirava danari dall'Officio delli Clarissimi Signori al Sale per tale opera ne vi so dir la quantità.

Super generalibus recte respondit.

Antonius Bagno.

Magnificis ac Generosis Dominis Bertucio de Garzonibus et dignissimis Viris Collegii

Si cava dalli soprascritti testimoni che Messer Jacomo ha speso intorno alli detti Giganti in lavoranti salariati del suo proprio danaro di borsa ducati 1100 in circa in spatio di anni 12 et questo e quanto alle spese.

Resta poi la sua industria, artificio, et fattura di dette figure di sua inventione la qual mercede sua propria si dee stimare. Et nondimeno non ha havuto altro che 240 ducati in tutto come per la fede fatta all'Offitio dal Sal si vede.

(ASV, Senato Terra, filza 86; Lorenzi, 1868, pp. 482–83, no. 939e-g)

236. Francesco Sansovino's petition

Serenissima Signoria

Mostrerei diffidenza io Francesco Sansovino fedelissimo Servitor suo, quando non l'esponessi i miei giusti gravami intorno alla Scoltura delli giganti marmorei, fatti dalli quodam Clarissimi Signori Proveditori sopra la fabrica del Palazzo per ordine della Serenissima Signoria, al quodam Messer Jacomo mio padre, il quale havendo speso di sua borsa in artefici che hanno lavorato per lo spatio di 12 anni diversi danari alla somma de 800 et passa ducati[1] si come dalla loro dispositione fatta solennemente appare, et non havendo havuto altro che ducati 240 all'offitio dal Sale, sarebbe cosa non conveniente che non venisse reintegrato almeno di quanto ha esborsato per questa cagione. Però persuadendomi io Francesco predetto che la Signoria Vostra sempre giusta con suddi, et sempre benigna con gli oppressi non permetterà mai, ch'io di si giusto credito resti privo, la suplico, se non per le fedeli fatiche da lui per la Signoria Vostra et per le mie vigilie tutte indiritte a gloria di quella, almeno per quella giustitia che l'è sempre a core, che si degni tolte le debite informationi che sia verso quanto ho ditto, deliberare talmente in questo negotio, che io venga reintegrato del denaro speso, e della sua compiuta mercede, sì come ella è solita di fare sempre verso i suoi fedeli. Et alla sua buona gratia humilmente mi inchino: ——

1581 30 Genaro

Che alla soprascritta supplicatione rispondino li Proveditori al Sal, et ben informati delle cose in essa contenute. Visto, serrato, et considerato quanto si deve ne dieno l'opinion loro con giuramento et sottoscrittione di man propria secondo la forma delle Leggi

De parte	4
De non	1
Non sincere	1

Consiglieri

Ser Giacom Foscarini	Ser Alvise Loredan
Ser Giacomo Emo	Ser Zuan Corner
Ser Alvise Zorzi	

Vincenzo Ottobon secretario

(ASV, Senato Terra, filza 86; Lorenzi, 1868, pp. 480–81, no. 939)

1. 'alla somma de 800 et passa ducati' added in the margin.

237. Danari spesi del suo da Messer Jacomo Sanosivno in lavoranti per finir le due statue marmoree, poste alla scala del Palazzo. pro ut in processu.

Domenego da Salò, ha lavorato 3 anni a soldi 24 il giorno, et ha habudo in tutto ducati	ducati	180
Domenego de Bernardin taiapria mesi 8 a soldi 30	ducati	48
Battista Scultor anni 5 a soldi 30	ducati	360
Antonio Gallino da Padova mesi 6 a soldi 34	ducati	42
Francesci del Toccio Fiorentino anni 7 a soldi 29	ducati	500
	ducati	1130

(ASV, Senato Terra, filza 86; Lorenzi, 1868, p. 482, no. 939)

238. Serenissimo Prencipe Illustrissima Signoria
Noi Gerolamo Lion, Nicolò Querini, Zuanfrancesco Salomon et
Zuanmattio Pisani Proveditori al Sal, Habbiamo in obedientia del
mandato della Serenità vostra veduta, et bene considerata la
supplicatione di Messer Francesco Sansovino, et insieme il
Mercatto fatto l'anno 1554 31 luglio, per li Clarissimi all'hora
Proveditori alla Fabrica dell'opera et fatura delli doi giganti, fatti
dal quondam Messer Giacomo suo padre, che sono sta posti sopra
la scalla nova nella corte del pallazzo, il qual Mercato fu de ducati
ducento e cinquanta i quali lui ha havuto meritamente, non
dimeno si ha produto con essa supplicatione alcume esame de
testimonij fatte sopra capitoli che ad futurorum memoriam sono
sta esaminate, cosi in questa citta, come in Padova, et Fiorenza,
nel modo che sono sta esaminati. Per il detto di quali appar chel
quondam Messer Giacomo Sansovino habbia speso in detti doi
giganti oltra il Mercatto predetto buona summa da suoi denari, il
qual esame madamo alla Serenita vostra, affinche con la sua molta
prudenza la deliberi quello, che gli parerà in questo proposito.
Perché non ci remettiamo al prudentissimo giudizio di sua
Serenita et delle Signorie Vostre Eccellentissime. Il che
affermiamo con giuramento esser l'openion nostra. Grazie.
Dati il dì 30 zugno 1582
Ieronimo Leon proveditor al Sal
Nicolo Quirini proveditor al Sal
Zuan Francesco Salomon proveditor al Sal
Zuan Mattio Pisani proveditor al Sal

(ASV, Senato Terra, filza 86; Lorenzi, 1868, p. 481, no. 939)

239. Sansovino's petition is rejected
1582. 20. Novembre in Pregadi
Consiglieri, Capi de 40, Savi del Consiglio, Savi di Terraferma
Dalla supplicatione de Domino Francesco Sansovino Dottor si è
inteso che havendo el quondam Jacomo suo padre del 1554 tolto il
carico della scultura dei dui giganti di marmo, che hora sono à
queste scale, per quel più, e manco pretio di ducati 250, che fosse
parso conveniente, furono da lui per lo spatio di. 12. anni contenui
forniti spendendo del suo in artifeci ducati 800 in circa, oltra ducati
250, che ebbe a tal conto dall'officio del Sal. Il che constando per
prova di testimonii sopra ciò esaminati, come questo consiglio ha
inteso, si recerca alla giustizia et bendignita della Signoria Nostra
darli in ciò qualche honesta satisfatione.
Però
L'anderà parte, che al detto Domino Francesco Sansovino Dottor
siano concessi delli debitori dei Tre Savii sopra i conti, overo delli
Avogadori nostri fiscali ducati quattrocento per compito resto, et
saldo di ogni sua pretension circa la fattura, e spesa fatta dal
quondam suo padre in detti dui giganti.
De parte 52
De Non 91 et fu presa di no.
Non sincere 36
1582. 18 settembre In collegio
De parte 16
De non 1
Non sincere 3
rieletta a 15 Novembre

(ASV, Senato Terra, filza 86; Lorenzi, 1868, p. 480, no. 939)

Che attese le honeste cause contenute njella supplicatione di
Domino Francesco Sansovino Dottor, et le imposte, e scritte

sopra quella hora lette, siano a lui supplicante concessi delli
debitori dei tre savij sopra i conti, overo delli Avogadori Fiscali
ducati quattrocento per resto e saldo di tute le sue pretensioni circa
la fattura e spesa dei dui giganti marmorei fatti dal quondam
Jacomo suo padre.
1582. 25 Agosto in collegio

De parte	11	10
De non	1	2
Non sincere	5	5

(ASV, Senato Terra, filza 86; Lorenzi, 1868, p. 480, no. 939)

**240. Two documents concerning Sansovino and the Scuola
Grande della Misericordia**
Dies dicta [lune vigesimonono mensis maii 1553] in dome
habitationis infrascripti magnifici Domini Marci Antonii de
confinio Sancti Geminiani Venetiani
Intendendo il magnifico guardiano et signori deputadi sopra la
fabricha della Scuola della Misericordia dar compimento alla
fabricha de detta schuola, già principiada, de qui e che 'l magnifico
messer Marco Antonio Paseto, dignissimo guardiano, et li
spettabili messer Marco Gonella, messer Francesco della Vedova,
messer Zuane Battista Antelmi, et messer Labieno Veutello,
deputadi sopra la fabrica predicta, da una parte, et ser Domenego,
Francesco, et Hieronimo, fratelli et fioli del quondam ser
Simoneto da Rovigno, simul et insolidum dall'altra parte, per si,
loro heredi, et successori, sono convenuti et rimasti d'accordo ut
infra, videlicet: che li prefati fratelli promettono et si obligano
insolidum ut supra, dar et consignar carghi in navilio a tutte loro
spese, collone numero sedese et tutte altre pietre vive cavade del
sasso de Orsera, secondo le polize, misure, et sagome che di
tempo in tempo li serà date per messer Jacomo Sansovino, proto
de ditta fabrica, qual polize siino presentade al nodaro infrascritto
et le copie autentice di quelle li siano mandate; essendo ubligati
exeguir quanto si contenirà in ditte polize, qual collone et altre
pietre non siino basade, ne scantonade, ne con pelli dentro,, ma
nete, salde, et in sue teste quadre, essendo ubligati per tutto el
mese d'agosto proxime venturo, effetualmente haver consignato
collone quatro consuoi fornimenti et successivamente continuar a
lavorar sopra detta opera, ne impedirsi in altro lavoro per modo
alcuno, et mancando di continuar il lavoro predetto, sii in facultà
de loro magnifico garardian et deputadi di tuor da altrui tutte
pietre et collone predite ad ogni dano et interesse di loro fratelli.
Dechiarando che tutte pietre si laverano del sasso preditto che
serano di longezza di piedi [sic] sopradetti magnifici guardian et
deputadi siino obligati accetarle, ma quelle da piedi 12½ a basso
restino per conto de loro fratelli. Et all'incontro, loro magnifici
guardian et deputadi promette sic et si obligano per pretio et
mercado così tra loro d'acordo concluso, dar et pagar a detti
fratelli secondo cargherano in navilio per la suma carica a raggion
de soldi 40 de pizoli per miaro de pietre sopra dechiarite, et a conto
del presente mercado loro, magnifici guardian et deputadi alla
presentia del nodaro et testimonii infrascritti exbursano ad essi
fratelli ducati sessanta da lire 6 soldi 4 per ducato, qual ducati 60
loro fratelli debbino scontar da poi haverà fatto il carico per la
mittà di carico a ducati diese per collona formida, et ciò per patto
expresso. Pro quibus attendentibus et super quibus etcetera.
Dom. Petrus Fancescus Bruscus, quondam artium et medicinae
doctor Domini Laurentii, et
ser Cornelius Pellitia de Ioanmarie et
ser Peturs di Quadro quondam Francesco lapicida

(ASV, arch. not., Maffei, V., busta 8102, fols. 284ᵛ–285ʳ)

Die dicta [martis, xiii mensis junii 1553] ad cancellum.

Constitutus in presentia mei notari et testium infrascriptorum, spectabilis vir Dominus Iacobus Sansovinus, architectus, in executione condicionis apposite in infrascripta conventionis sic, et mercati secuti inter magnificum dominum guardianum et deputatos super frabrica Schole Beate Marie Misericordiarum, civitatis Venetiarum, ex una, et ser Dominicus, Francescus, et Hieronimus, fratres et filiosquondam ser Simoneti de Rubino, manu mei notari, sub die 29 mensis maii nuper decursi. Declaravit mensuram lapidum de quibus in instituto sub his verbis, videlicet: Le collone vogliono essere longe di piedi quatordese et quarta, neta l'una, et grosse piedi dui et once 4, neta. Li capitelli de ditte collone, alti piedi dui et quarta, et larghi di sotto et di sopra per quadro piedi tre et mezo. La bassa sotto dette collone larga piedi 3½ per quadro, alta piedi uno et quarta. La cimasa larga piedi cinque per quadro, alta piedi uno et quarta. El quadricello largo piedi tre et mezo per quadro, et alto piedi quatro et quarta. La sottobassa del quadricello larga piedi cinque per quadro et grossa piedi uno et quarta. Il zocholo largo piedi cinque per quadro, alto piedi dui et quarto.

Testes Dominus presbiter Gaspar de Dragis, ecclesie Sancti Petri de Castello, et ser Antonius de Calegarinis Domini Tiberii

(*Ibid.*, fol. 308^{r-v})

1. Because little is known of the building history of the Misericordia, these unpublished documents are of some interest. The purpose of the sixteen columns ordered here is not mentioned, but they may have been destined for the façade, as Palladio's design for the Misericordia has a complement of sixteen large columns; see Howard (1975), pp. 96–112, fig. 77.

241. Subcontracting work on the Fabbriche Nuove

Die eadam [secundo mensis maii 1556] ad cancellum.

Havendo maestro Salvador quondam Vettor, taiapiera in Contrà de San Mauritio, per nome suo et de compagni, tolto sopradesi il lavoro de quadro de campi dodese del primo ordine della fabrica, che si fabrica al presente in Rialto sopra il Canal Grando verso li Camarlenghi, sopra l'incanto de li clarissimi signori provveditori sopra le fabriche et ornamenti della città. De qui è che detto maestro Salvador per nome suo et de campagni da una parte, et maestro Pasqualin de Francesco Zago, taiapiera in Contrà de San Thoma, et maestro Piero de Zuane, taiapiera in Contrà de San Panthalon, ambidui insolidum dall'altra parte, sono convenuti et remasti d'accordo nel modo infrascritto, cioè, che detti maestro Pasqualin et Piero prometteno et si obligano lavorare di quadro dell'arte del taiapiera di dodese pillastri che entrano nelli campi dodese lavorati a bugne con li suoi dodesi volti et dodeci angule, con la sua fasia de sopra da un capo all'altro. Item, li dodese pillastri che serve dalla parte de dentro iuxta la forma, sagoma et misura che li serà data per messer Jacomo Sansovino, architetto, protto di essa fabrica, qual lavori siano obligati expedire et lavorar fra quel termine li serà assegnato per detta messer Jacomo. Et all'incontro el detto maestro Salvador promette, et si dar et pagar alli prediti maestro Pasqualin et Piero così d'accordo con loro ducati udese grossi da lire 6 soldi 4 per ducato per cadauno campo, intendendosi il campo come di sopra è expresso, essendo loro obligati poner detti lavori in opera, eccetto però che non siano obligati cavar le gripie. Qual pretio, seu denari sii tenuto lui maestro Salvador de tempo in tempo, si come serà bisogno pagar a detti maestro Pasqualin et Piero, ogni eccettione remota. Pro quibus attendendis, etcetera.

Testes Doninus Marcus Antonius Figolinus Domini Alberti et ser Antonius de' Callegarinis Domini Tiberii

(*Ibid.*, busta 8110, fol. 422^{r-v})

Negotiations between Brescia and Venice for the loan of Sansovino's services

242. Nuntio. In questa inserta haverete la lettera di clarissimi Signori Rettori al clarissimo Grimani, nella quale gli scrivono ad instantia nostra che sua clarissima signoria ne voglia accomodar col Sansuino per uno mese et forse meno pro causa della fabrica del Palazzo, che farà cosa grata a sua Magnificentie. Vi mandiamo scudi quindese acciò che venendo dicto Sansuino habbia Vosta Zignoria da spender nel viaggio quel gli potrete dar al suo, primo che de qua poi compiremo de sodisfar al debito nostro et per vostre ne aviserete del suo partir, videlicet, quando abbia da esser da noi almeno per quattro giorni avanti acciò se gli possa com parar l'alloggiamento.

Da Brixia addì 5 d'aprile del 1554

I Deputati Pubblici

(Boselli, 1959, pp. 110–11)

243. Magifici Patres. Per soddisfar al desiderio delle Magnificentie Vostre che 'l Sansuino venghi de lì acciò si dia principio alla fabrica del palatio nostro, io so stato dal clarissimo messer Vittor Grimani, procuratore, al quale sta il dar la libertà al detto Sansuino di trasferinse de lì. Sua clarissima sì intendendo il desiderio di quella magnifica città a l'opera che si ha da fare prontamente, mi ha risposto essere inclinatissimo che 'l detto Sansuino veghi; a quando finise il bisogno di sua signoria, saria venuto in persona per lo amor porta a quella città et che si raccomandava alle Magnificentie Vostre et mille altre belle parole. Io ringraziai sua signoria clarissima; il Sansuino adunque venirà, solo Magnificentie Vostre mandarano una bona cavalcatura et presto che altrimenti non vi sarà modo. Così m'a detto che non si facia come l'altra volta fu fatto, le Magnificentie Vostre provvederanno subito di quanto bisogno.

Da Venetia il 7 di aprile del 1554

Ludovico Borgognino

(*Ibid.*)

244. Magnifici Patres. Hieri scrissi alle Magnificentie Vostre che subito mandassino una cavalcatura che 'l Sansuino saria venuto; questa mattina poi il detto clarissimo Grimani con detto Sansuino mi han fatto intendere che si mandi un cochio et non cavallo a Padova circa la fine del presente mese che di certeza venirà alli serviggi delle Magnificentie Vostre. Mi rincresce di questo stentar et che hora si deve dire a un modo ora all'altro io non posso più che tanto e volendosi servir delli gentilhomini, bisogna comodarsene alloro. Et alla Magnificentie Vostre mi raccomando. Si escusano che bisogna dar ordini di non so ch'importante fabrica et che 'l Sansovino malamente può cavalcar per il male d'una gamba.

Da Venetia il otto di aprile 1554

Ludovico Borgognino

(*Ibid.*)

245. An altar for Santa Maria Maggiore designed by Sansovino

M. D. LVIII. adì vi marzo

El si dechiara per questo presente scritto come el clarissimo messer Antonio Longo fo del clarissimo messer Francesco è rimasto d'accordo con maestro Zuan Giacomo[1] fo de maestro Guielmo taggiapiera da San Cassan, che ditto maestro Zuan Giacomo li debba dar tutte le piere vive bianche che bisogneranno alla fabrica del altar e scalini che 'l fa far nella giesia di Santa Maria Mazor, secondo il dessegno ordenado per messer Giacomo Sansovino, proto dei signori procuratori de sopra. Le quali piere vive bianche debbano esser da Rovigno, salde e nette, e queste e tutte le altre piere rosse mandolade di Arbe che vanno in ditto altar secondo il dissegno fatto e secondo le mesure del altar vicino da Cà Marcello, debba far lavorar, batter de menudo, e rassar e redur a tutta quella perfettion che si convien per farle poi fregar e lustrar e finir a spese del ditto clarissimo messer Antonio per precio di ducati 150, come ha termenado il clarissimo messer Vettor Grimani, procurator, in questo soprascritto giorno, nel qual tutti doi si hanno compromesso, ritrovandossi ello presente al trattamento di questo mercato, et etiam presente il sopranominato messer Giacomo Sansovino, il qual si sottoscriverà e confermerà quanto è detto di sopra. Et il clarissimo messer Antonio sopradito contenta sborsar de presenti al ditto maestro Giacomo ducati 50 et il resto al finir del lavoro, et esso messer Giacomo all'incontro promette darli il tutto lavorado, finido, e condutto lì in giesia per tutto il mese di settembre proxime venturo per metter in opera, et ivi si obliga far star un tagiapiera valente che attendi al metter in opera della piere continuamente fin che le piere per lui lavorade sarano compidamente poste in lavoro nel altar soprascritto, e non attendendo a quanto è detto, è contento perder ducati 10 al mese fin che 'l differirà satisfar al presente obligo et le soprascritte parte si sottoscriveranno per fermezza del ditto patto.

Io Antonio Longo fo del clarissimo messer Francesco affermo a quanto e ditto di sopra.

Io Zanjacomo fu del maestro Vielmo fu protho al Sal afermo a quanto nel presente scritto se chontien e ho receuto a bon contto ducati cinquanta, val ducati 50

Io Jacopo Sansovino confermo a quanto e sopra scritto e fui presente.

Adì 23 decembre. Recepui io Zaniacomo soprascritto dal clarissimo magnifico messer Anttonio Longo a bon conto dell'altar ducati cinquanta, val ducati 50

1559 adì 15 marcio

Recepui io Zanjacomo soprascritto dal clarissimo magnifico messer Anttonio Longon ducati trenta, a bon chontto dell'altar, val ducati 30

Adì 8 luio

Recepui io Zanjacomo de Vielmo soprascritto dal clarissimo messer Anttonio Longo ducaati cinquanta qual suprascritti ducati venti al suplimento dil secondo scritto et ducati trenta a bon contto del fregar et lavor fatto di più di l'accordo, val ducati 50

Adì 20 settembre. Recepui io Zaniacomo soprascritto dal clarissimo messer Anttonio soprascritto ducati vintiun soldi cinque denari sie, val ducati 21 soldi 5 denari 6

Adì 24 novembre. Recepui io Zaniacomo soprascritto dal soprascritto a bon contto, ducati quatordexe soldo uno et denari dodexe, val ducati 14 soldo 1 denari 12

Adì 5 decembre. Recepui io Zaniacomo soprascritto dal ditto ducati sesanta lire do et denaro uno, val ducati 60 lire 2 denaro 1

Adì 15 ditto. Recepui io Zaniacomo ditto dal soprascritto ducati trentado, lire tre et denari sette, val

ducati 32 lire 3 denari 7, suma ducati 309——

1560 adì 5 fevrar

Recepui io Zaniacomo contrascritto dal clarissimo messer Anttonio Longo ducati disnove et denari sette de contadi et in banco pisani ducati dieci denari disisete, val in tutto ducati trenta, val ducati 30

1561 adì 15 marzo. Recepui io Zaniacomo soprascritto dal clarissimo messer Anttonio soprascritto ducati cinque a bon contto, val ducati 5

[parte cancellata]

1561 adì 27 marcio. Recepui io Zaniac de Vielmo dal clarissimo Anttonio Longo ducati quindexe a chonto della sentenzia arbitraria fatta da messer Jacopo Sansuin, protto di signor procurator de San Marcho et sotto 4 decembre 1559, apar nelli ati de messer Anzollo da Chanal, nodaro a San Marcho. Et in elli chonto avanti il giorno della partida di 5 fevraro soprascritto, ne la qual partida me scrisse per restto de questa sentenzia ducati diexe et denari disisete in banco de magnifico messer Vettor Pisani et del magnifico messer Geronimo Tiepollo, la qual sentenzia le ducati quatrocento et nonantadoe. Qualli confesso et notto de mia mano qui haver recevuto in piu volte dal soprascritto clarissimo messer Antonio et mi chiamo pagato satisfatto. Val

ducati quindexe,
zoè ducati 15

(Arslan, 1957)

1. Giangiacomo dei Grigi, the architect and son of Guglielmo Bergamasco.

246. Sansovino appraises a tomb by Pompeo da Salò

Die martis xx, mensis martii 1564, ad cancellum.

Io Giacomo Sansovino architetto, solo giudice et arbitrator, eletto dal Reverendon Monsignor Hieronimo Superchio et il magnifico messer Giovanni Francesco Agatone, secretario dell'Illustrissimo Signor Duca d'Urbino come intervenienti per la Signora Contessa de Monte l'Abbate per una parte, et per l'altra, per maestro Pompeo da maestro Piero scultore, a giudicare in quello fusse mancato a narrarsi nella scrittura di convention tra esse parte fatta della convention della fabrica de una sepultura, che detto maestro Pompeo si è obligato fare, overo fusse diffetto del detto maestro, et come per la scrittura di mano di messer Vincenzo Carzoli da Bresighella, sotto dì [blank] novembris 1562, et sottoscritta di mano delli padre Reverendo Monsignor Hieroimo Superchio et magnifico messer Giovanni Francesco Agattone, secretario. Havendo io veduto la detta scrittura di accordo, et dappoi l'opera della sepultura fatta compita per esse parte mostratemi, et l'una et l'altra parte udita, et il tutto ben considerato, dico et dichiaro che tale opera merita ducati ottanta otto da lire 6 soldi 4 per ducato, in tutto lassando per mittà tra esse parte. Super avileis [?].

Testes ser Antonius de Callegarini, ser Domini Tiberii et
 Dominus Jacobus Gentilis, quondam Domini
 Augustini

(ASV, arch. not., Maffei, V., busta 8139, fol. 172r)

247. The Duke of Urbino to Francesco Sansovino, 26 January 1562

Magnifico mio amatissimo, ho visto molto volontieri quello che mi havete scritto in nome di Messer Jacomo vostro padre, sopra la fatica ch'io l'ho ricercato a fare in la occorrenza de quella casa mia, e certo tutto e conforme alla confidenza che sempre ho havuto in l'amorevolezza sua, piacciarvi di ringraziarnelo da mia parte . . .

(Sansovino, 1564, p. 99v)

248. A biographical sketch of Jacopo Sansovino in his son's edition of Dante with Landino's commentary

Iacopo Tatti, chiamato Iacopo Sansovino, per esser stato allievo di Andrea, da Sansovino, fu scultore, per opinioni d'ogniuno, il secondo dopo Michelagnolo. Questi fece in Fiorenza, il Bacco de' Bartolini, tenuto hora dal Duca in Palazzo fra le sue cose notabili, e nell'Opera sculpì un San Iacopo a concorrenza di Michelagnolo. Ma andatosene nella sua gioventù a Roma, si diede all'architettura, nella quale servì Giulio Secondo, Leon Decimo, et Clemente Settimo in San Pietro. Ma dopo il Sacco dell'anno 1527 di Roma, andatosene a Venetia, fu da quella Signoria tolto al suo servitio con honorata provisione. Quivi fece di scultura molte cose degne di memoria, come si può vedere, et di marmo, et di bronzo. Ma tra l'altra è notabile un quadro di marmo posto in Padova, nella chiesa del Santo, dietro all'altare di detto Santo. Et in Venetia un San Giovanni Battista nella chiesa de' Frari, dirimpeto all'altare de' Pesari. Et nella età sua di 83 anni ridusse a fine due giganti di marmo, cioè un Nettuno, et un Marte, per ornamento della scala principale del Palazzo publico. Nell'architettura diede lume a Venetia, et mostrò a quegli huomini come si dovesse fabricare, et utilmente et ornatamente secondo le regole da gli antichi, et oltre molte chiese e palazzi per tutta la citta, fece la Scuola della Misericordia, opera veramente eterna per la sua qualità, la Zecca, et la Libraria rincontro al Palazzo su la piazza publica, et il Palazzo Regio de' Cornari sul Canal Grande a San Mauritio.

(Sansovino, 1564[1])

1. The entry comes in Landino's *Comento sopra la Comedia di Dante Alighieri*, which contains an apologia of Florence. There Francesco Sansovino brings up to date the categories of famous Florentines, including Michelangelo, Leonardo, Rustici, Torrigiano, Sarto, and other artists. Of these, only Michelangelo receives more than a brief mention, but his entry is dwarfed by Jacopo's.

249. Sansovino's tax return, 1565

Alli 15 di gennaio 1565
Io Jacopo Sansovino quondam sier Antonio, habitante su la Piazza de San Marco della contrada di San Basso, do li miei beni in nota. Et prima.
Mi trovo in borgo de San Trovaso una casa de statio[1] con un teren vacuo, paga di fitto ducati 40.
Per una camara sotto alla ditta paga di fitto ducati 8½.
Per un'altra camera sotto alla ditta paga di fitto ducati 7.
Per due case contigue alla ditta da statio, l'una paga ducati 25, habita al presente ser Venerio Badoer, avocato.
L'altra paga ducati 25, habita ser Marco de Cadore, mercadente.
Item, mi trovo a Origo in villa di Trissigoli, campi de terra numero 43, li lavora ser Lazaro de Donà. Li affitto stara vinitiani de formento numero 36, mastelli di vino numero 9. Paga di livello all'abate di San Gregorio et a Vicenzo Pizzoni in tutto ducati diese. 1565 adì 26 zener, Registrato per me Gasparo [illegible] alli X Savi.

Antonio Diedo alli X Savi

(ASV, Dieci Savi sopra le Decime, Reg. 126; Cadorin, 1884, p. 13)

1. See Howard (1984).

250. Payment for the portal of the altar of the Holy Sacrament and for the Loggetta *Madonna*

1565, adì 20 marzo
Li clarissimi er eccellentissimi missier Marchio Michiel, kavalier, et missier Zuanne da Leze, quondam il clarissimo missier Michiel, et missier Zuane da Leze, kavalier, dignissimi procuratori, udita la infrascrita supplicatione et havuta sopra di essa matura consideratione, gratiose et juste agendo, hanno a bossoli et ballote terminato che il debitto, il quale appar nel libro della chiesa sotto nome di reffatione di fabricca nova, del quale è debitore il Sansovino sia portato a nome di esso Jacobo Sansovino per la summa de ducati mile et all'incontro poi di detto debito le sia dato credito del salario, delle piere vive, et delle pietre cotte, legnami et delli danari per lui sborsati, nec non della portella aposta al loco del Sacramento in chiesa di San Marco, et della imagine de relievo della Madona aposta nella Lozeta per le summe contenute nella infrascritta sua supplicatione, ben viste et considerate dalle sue clarissime signorie et dal castaldo.
Illustrissimi et eccellenti Signori Procuratori, Signori et Patroni mei, osservantissimi, apparo io Jacopo Sansovino inter cetera già molti anni debitore de buona summa di danari della procuratia per causa della riffatione del pezzo della fabrica nova incontro al pallazzo, quale del 1545 rovinò et cascò a terra, per la qual rovina le clarissime Signorie Vostre con consenso de mi Jacobo predetto contentorno di esborsar a conto mio ducati mile per la riffattione della detta rovinata fabrica, et per la detta riffatione furno spesi li ducati mile, per il che il preditto debito sotto nome di riffatione di fabrica appar nei libri della procuratia; essendo per terminatione di Vostre Clarissime Signorie sotto dì [blank] datto a me obligo di pagar detto debito de ducati mile a rason de ducati 100 all'anno per la qual causa io Jacobo Sansovino sopradito comparo avanti le Signorie Vostre eccellentissime et humilmente le supplico che siano contente per giustitia et per sua inata bontà di contraponer al detto debito la mercede della servitù mie prestatali per mesi vintisei, cioè, da dì primo novembrio 1545 fino tutto decembrio 1547, nel qual tempo non ho havuto cosa alcuna non obstante che 'l quondam Domino Hieronimo di Rheni, castaldo, mi havesse fatto debitor nel libro delle paghe di havermi datto paghe 12, et principando novembrio et decembrio 1545 fino settembrio e ottobrio 1547 inclusive, le quale per non haverle io havute forno retrattate dal credito della sua casa, come nel Libro G della chiesa a charta 455, a conto di paghe in monte et in Libro H della detta a charta 76, a conto di paghe ditte appare per le qual paghe 12 mi resta debitor 480. Ittem, per novembrio et decembrio 1547, che non hebbi ut supra ducati 40, sono in tutto ducati 520. Ittem, supplico che si degnino a bonifficarmi a tal conto ducati 115 lire 2 soldi 8 per conto di pietre vive et pietre cotte, poste in detta fabrica, comprate delli mei danari oltre li ducati mille sopraditi che furno spesi tutti per mano di ministri di procuratia, et ditte pietre vive et pietre cotte comprate per me delli mei danari sono state poste in detta fabrica doppoi ditta riffattione et di tanto mi de esser datto credito, cioè, per pietre vive migliara 26 a lire 5 soldi 10 il migliaro, ducati 23 soldi 8, et per pietre cotte migliara 44 a ducati 2 il migliaro, sono ducati 88. Ittem, sabion et calcina, ducati 4 lire 2, fanno ditta summa de ducati 115 lire 2 soldi 8. Ittem, Le supplico che si degnino bonifficarmi a tal conto ducati 96 lire 6 soldi 3 per legnami de più sorte comprati per me ut supra. Ittem, ducati 12 lire 5 soldi 2 in paggar fachini condussero ditti legnami et altro. Ittem, ducati 15 lire 4 soldi 8 per feramenta entrata in detta fabrica ut supra doppoi la riffatione sopradita paggati per me della borsa mia, che tutta è la summa de ducati 125 lire 3 soldi 5 come il tutto ne appare per conti et riceveri antentichi ch'io dimostro a Vostre Signorie. Di più Le supplico di bonifficarmi a tal conto la imagine di nostra Donna per me fatta, posta nella lozeta, et la portella di

bronzo per me similmente fatta posta in chiesa di San Marco allo altare del Sagramento, le qual opere montano ducati 85 come ben sano Vostre Signorie eccellentissime, et questo per esser state fatte tutte ditte spese et oppere del denaro di borsa di me Jacobo sopraditto come è prediato, oltre li ducati mille sopraditti esborsati come si è detto per li sui ministri di procuratia a qualli erano fatte le polize et doppoi la riffatione sopradetta et alla bona gratia di Vostre Signorie eccellentissime, humilmente mi ricomando.

Summa summarum ducati 520
 ducati 115 lire 2 soldi 8
 ducati 125 lire 3 soldi 5
 ducati 85
Summa ducati 845 lire 5 soldi 13

(ASV, Proc. de supra, busta 77, proc. 181, fasc. 1, fol. 34^{r-v}; Ongania and Cecchetti, 1886, p. 45, nos. 229–30)

251. Two tax returns of Alvise Garzoni[1]

Condizion de ser Alvise et ser Jeronimo de Garzoni frateli quondam ser Nadal dixe aver una chaxa in la Contrà de San Stai, nela qual abitemio, stimada ale decime ducati 50 . . .
Item, una chaxa in Padova in la Contrà de San Daniel, tenimo per nostro uso, son ale decime ducati 10
Item, in la vila de Pontte Chaxale in padoana, sotto la vicharie de Conselve, una chaxa con el suo chortivo, la qual tenimo per simel le nostre intrade ett abitti fator, gastaldo, stimade ale decime ducati 10 . . .

(ASV, Dieci Savi sopra le decime, Redecime 1537, Santa Croce, reg. 366, no. 423)

Per obedir alle legge dell'illustrissimo Senato, eccellentissimi et clarissimi Signori Dieci Savii, io Alvise di Garzoni, fo de messer Nadal, do in notta a Vostre Eccellentissime Signorie tutti gli lochi et benni che mi attrovo havere, insieme col'entrade et paga.
Una casa da statio nella Contrà di San Stai, nella qual habbito, stimata alla decima ducati 50 . . .
Item, mi attrovo nella villa di Ponte Casale sotto la viccaria di Conselve in padoana, una casa con suo cortivo, teze, grannaro, caneva et bruolo, la qual tengo per serrar et governar l'entrade, et habbita tutto l'anno fattor, gastaldo, famegli da stalla, et altri per bisogno delle possessioni et ⟨ . . . ⟩ far governar quelle, et massime per la diffession dell'acque d'i fiumi, etiam li habbito nelli tempi delli aracolti . . . [1566]

(ASV, Dieci Savi sopra le decime, condizioni, busta 134, no. 1034)

 1. These two documents are printed here because they suggest an approximate *terminus ante quem* of the rebuilding of the villa at Ponte Casale by Sansovino. The second tax return of 1566 was noted by Rupprecht (1963–65), pp. 2–3, and it indicates that the large agricultural complex at Ponte Casale was already in existence. The earlier return of 1537 has previously escaped notice, but it shows that there already was an establishment at Ponte Casale, though not on the scale of the one recorded thirty years later. In the earlier return, the villa was taxed at 10 ducats while in the later one, no tax is given, which suggests that the property was to be revalued. This points to the rebuilding of the complex after 1537, and probably in the 1540s, as is conventionally believed.

252. Francesco Sansovino's notes for the biography of his father[1]

Jacopo Tatti discepolo nella scultura d'Andrea da Sansovino, dal quale prese poi il cognome facendo una nuova famiglia, nacque in Fiorenza di honesta famiglia, et nella sua prima fanciullezza s'applicò tutto alla scultura, nella quale, havendo fatto molte prove del suo attissimo ingegno ⟨ . . . ⟩ssione, se n'andò a Roma ⟨ . . . ⟩ scuola dell'arti nobili et belli. Quivi fu raccolto da Bramante architetto singularissimo, et favorito da lui fu messo in opera percioche fece il Lacoonte et altre figure che piacquero summamente agli intendenti. Onde venuto a notitia della corte, entrò in molte imprese importanti. Et perché sarebbe soverchio il ragionare a lungo delle cose fatte da lui a particulari in Roma et in Fiorenza in materia di figure così ignude come vestite, et così grandi come piccole, diremo solamente delle più rilevanti et che son di maggior importanza, perché si dee presuporre che un maestro eccellente che habbia 85 anni et che viva ancora robusto et gagliardo et non punto otioso, operando nella gioventù, nella virilità, et nella vecchiezza, habbia fatto diverse cose in publico et in privato et tuttavia faccia.

In Fiorenza adunque, oltre le figure che si trovano in diverse case di gentilhuomini, come in quella de' Ridolfi, de' Ruscellai, de' Gaddi, [line left blank] vi è un Bacco di marmo che fu posto negli horti de' Bartolini, il quale hoggi si trova nelle stanze dell'eccellentissimo Signor Duca di Fiorenza. Et nell'opera fece uno San Jacopo da esser posto in Santa Maria del Fiore. In Roma, poi, favorito da Messer Giovanni Gaddi vero mecenate de' virtuosi, di scultura fece un San Jacopo grande di marmo che e posto nella chiesa di San Jacopo degli Spagnuoli, et in Santo Agostino una Nostra Donna, e un Christo che fu mandato alla sorella dell'Imperadore, et un Laocoonte che si trova hoggi nelle stanze del Duca di Mantova. Hebbe parimente a fare la sepoltura del Cardinal d'Aragona la quale era di somma importanza, et di architettura condusse a fine la casa de' Gaddi posta in Banchi et fondò la chiesa de' Fiorentini, la quale ossò ottenere in concorrenza di Raffaello da Urbino et altri eccellenti maestri. Perché essendo venuto famoso et condotto a servitii di Giulio Secondo, di Leon Decimo, et di Clemente Settimo s'essercitava . . . momento quando sopravenne il sacco di Roma, dove havendo perduto ciò che egli vi havea guadagnato, se n'andò a Venetia per passare a Parigi dove il Re lo havea chiamato poco innanzi. Si trovava allora principe della Republica Vinitiana Andrea Gritti, amator grandissimo di tutti i virtuosi, il qual saputo che il Sansovino era in Venetia, gli diede l'impresa di restaurar la chiesa di San Marco, la quale andava in rovina, né s'era trovato mai chi vi havesse voluto por mano. Messosi adunque a quel negotio et ridottolo a fine honorato, fu fatto architetto sopra le fabbriche delle fortezze, prima, et poi delle fabriche di San Marco, et essendogli constituita una provisione honorata, et datogli da quel Senato una bella et buona casa su la piazza di San Marco in sua vita, il detto Sansovino si rimase in Venetia senz'andarsene altramente a Parigi, dove amato et honorato et carezzato molto, fece di tempo in tempo honore alla sua patria Fiorenza, perché egli soleva dire ch'era meglio che i Fiorentini virtuosi fossero sparsi pel mondo che tutti rinchiusi in Fiorenza.

Attento che a que ⟨ . . . ⟩ esaltavano la nation fiorentina per tutti i versi et ⟨ . . . ⟩ recavano credito et fama d'ingegni eccellenti. Ora in Venetia quanto alla scultura, introducendola di nuovo fra quegli huomini, gli sforzò a dilettarsene in qualche parte, et si dilettò d'insegnarla et di mostrarla altrui con l'allevar molti discepoli. Et di sua mano operò molte cose. Et prima ne' Frati Minori fece un San Giovanni Battista di marmo sopra una pila della famiglia Giustiniana, il quale fu tenuto bellissimo da tutti. Fece al Re Francesco Primo che lo richiese dell'opera sua una testa d'Alessandro Magno di marmo, la qual piacque tanto a quel Re che mandò al Sansovino il suo ritratto acciochè lo facesse di marmo secondo quell'altro. Et per la chiesa del Santo di Padova fece un quadro di marmo pieno di molte belle et gran figure et degno di molta stima. Et nella chiesa di San Marco sono 6 historie

di bronzo in due pergametti posti nel coro e quattro Vangelisti all'altar grande pur di bronzo tutto di sua mano et alla sagrestia di detta chiesa una porta di bronzo con molte bellissime figure. Di fuori su la piazza alla loggia fece molte figure fra le quali son notabili uno Apollo, una Pace, un Mercurio, et una Pallade. Fece parimente una Madonna dentro nella loggetta et un'altra di marmo per di sopra la porta di San Marco. Ma quel che importa molto di più dì tutte l'altre predette (ancora che molte altre cose facesse sparse per diversi luoghi della città) sono dui giganti di marmo d'altezza di X piedi l'uno, figurati per Nettuno et per Marte, per la scala publica del Palazzo della Signoria, opera illustre per ogni sua qualità. Quanto all'architettura, introdusse fra quella gente il vero modo del fabricare che prima non era conosciuto, et facendo gli · edifici con modi et ornati di ⟨ . . . ⟩ splendor a Venezia. Et oltre a una infinità di ⟨ . . . ⟩ zecca publica tutte di pietra viva senza che vi sia uno stecco di legno. Fece anco la libreria publica d'ordine dorico et ionico di grande ornamento alla piazza. Vi è di suo la loggetta. Et quel che supera tutte le fabriche di Venezia di fortezza et di machina immensa è la Scuola della Misericordia. Il Palazzo di Messer Giorgio Cornaro sul canal grande è notabilissimo, San Francesco della Vigna, la chiesa di San Martino, il palazzo de' Delfini a Rialto, a San Girolamo la machina di Messer Lionardo Moro, et di fuori a Ponte Casale il grandissimo et smisurato palazzo de' Garzoni.

(Biblioteca degli Uffizi, MS 60, vol. I, no. 23; see Davis, 1981, pp. 234-35, and 1984-III, pp. 40-41)

1. My reasons for ascribing this unsigned manuscript to Francesco Sansovino are discussed in chap. xi. I am indebted to Robert Williams for the new transcription of these pages.

253. Viet von Dornberg, Imperial Resident in Venice, to Maximilian II concerning sculptors and architects, 22 January 1569

In executionem commissionum Caesareae Maiestatis Vestrae alias per me acceptarum pro habenda fructum, seminum, hortorum et ornamentorum hortensium nec non architectorum et sculptorum excellentium informatione nunc humiliter habeo Caesareae Maiestati Vestrae significandum, quod imprimis nullum profecto in illis omnibus investigandis studium et opera omnisi, deinde quod iam forma et hortorum omnium effigies, qui prae caeteris Venetiis celebrea sunt, una cum grottis, fontibus et ornamentis quibuscumque in illis exiatentibus ad vivum depicta eminenter et rilevate conficitur, quae omnia, cum primum erunt absoluta, statim ad caesaream maiestatem perferrri curabo...

Quid autem de Jacometo illo Tagliapietra,[1] architecto, et Alexandro, sculptore, informationis habuerim nimierum est, quod Jacometus ille tamquam architectus non multae habetur existimacionis, licet palatium unum familiae Cucinae contruxerit, cuius forma et extrinsecum ornamentum a pluribus comprobatur; eius tamen intrinsecas partitiones necquaquam respondere dicitur mihique tandem affirmatum est, ipsum practicam potius certam quam architecturae scientiam possidere ac potius lapicidam optimum quam architectum haberi. Cognovi insuper nonnullos etiam architectos Venetiis invenire et praecipue quendam Joannem Antonium cognominatum Rusconum, quem a pluribus commendari sentio, uti qui, ultas ut dicunt, egregias fabricas Anconae, Pisauri, Ravennae in aliisque Italiae locis confecerit; nihil, tamen adhuc operis sui conspicere potui, quo ipsum Caesareae Maiestati Vestrae merito comprobare audeam.

Est et alius Vicentinus architectus, cognominatus Palladius, vir quidem magni nominis et qui fabricas quam plures eximii operis et a peritis haud mediocriter commendatas perfecit, fabricam scilicet monasterii Caritatis, Sancti Francisci a Vigna, capellam Sanctae Luciae[2] praeter multa palatia tam in urbe quam extra diligenter fabricata, nuncque templum Sancti Georgii extruit, quod nempe a singulis opus mirabile iudicatur, ita ut excepto Sansovino, architecto atque sculptore et ab isto senatu iam diu ad servicium suum conducto, inter caeteros ab universis locum primum obtinere affirmetur. Unum tamen est, quod Palladius iste ob multas, quibus Venetiis fruitur, commoditates et ob continuum et maximum, quod inde percipit, lucrum difficillime, ut arbitror, ad cuiusvis principis servitium se conferrendi causa ex hac urbe recederet. Mihi tamen persuadeo, quod per unum vel alterum mensem pro alicuius fabricae formam delineanda et compondenda isthuc ad Caesarem Maiestatem Vestram proficisceretur, cuius opera plurium, credo, sibi satisfactionis afferret.

Quod vero ad Alexandrum Victorium, sculptorem, spectat, cognovi tam ex multorum relatione quam ex figuris per eum eleganter factis et in foro Divi Marci existentibus, ipsum caeteris sculptoribus Sansovino tamen excepto merito praeferri. Est et alius sculptor cognominatus Danese, qui, licet, ut audio, aliquid operis probati confecerit, longe tamen Alexandro praedicto minime comparandus.

Ulterius autem Venetias appulit Joannes quidam Belgicus,[3] qui per alioquot annos fuit Romae et nunc Bononia commorantur, ipsum tam in sculptura quam in fundendis imaginibus plurimum excellere affirmatur isque a multis rei peritis et praesertim a reverendissimo electo Aquilegiensi patriarcha Barbaro, qui alias commentum super Victruvio exacte composuit et quitemporibus istis architecturae scientia praestantissimus omnium habetur, mihi summopere commendatus est, uti qui Romae figuras omnes et statuas elegantissimas summa cura metitus est earumque delineamenta et exempla accuratissime transumpsit, qui facile apud Caesaream Maiestatem Vestram operam atque servicium sunm praestare posset, cum ipse nec uxorem neque liberos habeat. Cuius quidem hominis informationem etiam uberiorem ex Bononia quam primum habere curabo...

(Voltelini, 1892, pp. xlix-1, no. 8812)

1. Among the architects mentioned are, in ascending order of merit, Giangiacomo de' Grigi, Giovanni Antonio Rusconi, and Palladio.
2. Von Dornberg's account of Palladio's buildings is noteworthy for this reference to the chapel of Santa Lucia, as this is the only contemporary document attributing its design to him; see Puppi (1973), pp. 361-62.
3. This is a reference to the Netherlandish sculptor Johann Gregor van der Schardt, who was commended to von Dornberg by Daniele Barbaro, Palladio's patron and patriarch-elect of Aquileia.

254. Concession of the chapel of the Crucifix in San Geminiano to Jacopo and Francesco Sansovino

Die lune, 12 mensis iunii 1570, in loco infrascripto
Convocato solemniter et congregato venerando capitulo collegiatae et parrochialis ecclesiae Sancti Giminiani Venetiarum, in sacristia ipsius ecclesiae loco solito congregari ad sonum campanulae ut est moris, pro infrascriptis specialiter peragendis commissione et mandato infrascripti Reverendi Domini Plebani et de lincentia Illustrissimi et Reverendissimi Domini Patriarchae, in quo quidem capitulo interfuereunt Reverendus Dominus Benedictus Manginus, plebanus, Dominus Baptista Sorbolus, Dominus Petrus Antonius Aloisii, presbiteri, Dominus Nicolaus Rubeus, diaconus, et Dominus Ioannes Libius, subdiaconus, omnes titulati ipsius ecclesiae habentes vocem in dicto capitulo et illud integrum rapresentantes cum non sint alii qui in ipso capitulo intervenire, aut interesse debeant, agentes nomine dicti capituli et

per se eorumque successores imperpetuum. Lecta et bene considerata petitione et instantia antea sepius dicto reverendo capitulo facta, et mano inscriptis reddata per magnificum Dominum Iacobum Sansovinum, scultorem et architectum, et excellentem virum iuris doctorem Dominum Franciscum Sansovinum, ipsius magnifici Iacobi filium, pro ut in ipsa scriptura plenius legitur et continetur, cuius tenor in continentia erat iste.

In nomine sanctissimae et individuae Trinitatis, totiusque curiae celestis. Amen. Essendo il Reverendo Benedetto Manzini, piovan de San Giminian, col suo venerando capitulo de ditta chiesa congregato nella dicta de more ad sonum campanelle per espedition de alcuni sui negotii, è comparso l'eccellente messer Iacomo Sansovino, scultore et architetto, insieme con l'eccellente dottor messer Francesco suo figliuolo alla presentia del prefacto piovano et capitulo, esponendo che essendo sempre stato affetionatissimo già molti anni verso la sudetta chiesa mai ha mancato alli bisogni di quella, come ad ogniuno è manifesto, et precipue nella moderna fabrica della predetta chiesa et compimento di quella gratis et amore; frequento etiam ditta chiesa con gran sua divotione, assiduo sempre alli divini officii, et finalmente sì come vivo così occorendo il caso d'esser chiamato dall'omnipotente Dio, desidera quietarsi nella detta chiesa. Però, con buona gratia del predetto capitulo et piovano richiede l'altar del crocifisso con tutto quel pavimento fino al balcon della Scolla di Santa Catherina verso la Frezzaria, con libertà de fare una spoltura honorata per lui, suo figlio, et suoi heredi et successori. Et perchè sopra ditto pavimento sono de impedimento un coperto di sepoltura et alcune arche spetante al vostro capitulo e a quelli della Scolla de Santa Catherina, il detto messer Iacomo si offerisse insolidar col predetto suo figliuolo a tutte sue spese tirar le ditte arche più in dietro verso la piazza et rifarle di novo che stiano bene et promette far di novo l'altar del Christo col suo parapeto et fare un Christo di novo bellissimo et metter uno cesendello conveniente al ditto loco et delli sui beni li sia dato al'anno uno miro d'oglio, over valuta di quello secundo li tempi in munerata pecunia al piovano, presente et successori, con obligatione che tutti li veneri et feste di tutto l'anno, il cesendello sii acceso avanti il crucifisso la matina fino al sarar della chiesa per il suddetto piovano et successori, così contentando l'eccellente suo figliolo messer Francesco et questo in perpetuo per l'anima sua et de suoi heredi, et breviter ornar tutto quel luogo per lui dimandato. Et essendo il detto messer Iacomo et suo figiolo gratificati di questa sua pia et honesta domanda dal prefato piovano et capitulo per ricognitione di detto terreno, s'obliga a far un donativo al detto piovano et capitulo per una volta tantum de ducati diese da lire 6 soldi 4 per ducato, la qual esborsation de detto denaro se obliga far da poi l'espeditione dell'instrumento et comprobation del Reverendissimo Patriarcha. Item, lassa al detto piovano et successori et capitulo così etiam contentante il prefato messer Francesco suo figliuolo per il suo anniversario et de tutti li suoi heredi et successori da esser celebrato ogni anno nel giorno del suo obito per il reverendo piovano et suo venerato capitulo, ducati tre da lire 6 soldi 4 per ducato, cioè, ducati tre inperpetuo, cioè, ducati dui al piovano et capitulo per sua elemosina et ducato uno al piovano presente et a tutti li altri che per tempora si troveranno, con questa obligation che il piovano metta li candelotti sopra l'altare che siano honorati per conto del suo anniversario, et sia etiam obligato alla solennità della santissima croce poner sopra l'altar li ditti candeloti per l'anima sua et suoi heredi, li quali candelotti numero quattro siano de tanto pretio che ascendino alla summa de ducati uno, et al tutto detto legato vuol sia perpetuo da esser scosso dal detto piovano over suo procuratore dal predetto messer Francesco overo sui heredi dui giorni avanti il giorno del

anniversario. Et per caution del predetto legato ut supra, lassando il predetto messer Iacomo così contentado il detto messer Francesco obliga tutti li suoi bene stabili et mobili presenti et futuri, la cui bona et pia volontà, intendendo il piovano et suo capitulo unamini et concordi attendendo all'obligo fatto per il detto messer Iacomo et suo figliuolo per conto della chiesa et legati, etcetera, a bossoli et ballote hanno concesso a essi domandanti quanto richiedono, sì del'altare del Christo et oglio per le lampade, come del pavimento et renovation delle arche sopradite con l'obligatione sopradette. Et acciochè questa scrittura sia rata et valida così le parte se hanno contentato sia autenticata per man de nodaro publico veneto insieme col beneplacito del Reverendissimo et Illustrissimo Patriarcha col suo solito sigillo in forma . . .

(ASV, arch. not., Maffei, V., busta 8163, fols. 314ᵛ–316ᵛ; Cicogna, 1824–53, VI-2, p. 816)

255. Holograph codicil to a lost will by Sansovino
1556. Indicatione 15 die 7 decembris
havendo piu' avanti io Jacomo Sansovino fiorentino, fatto de mia mano el mio testamento, el qual se ritrova nella cancelleria inferiore nella mano de Ser Antonio Marsilio, nel qual tra li altri legati io lassava a Danese scultore da Carara nelle alpe di Fiorenza ducati cento e cinquanta de denari contanti e ducati cinquanta in alcuna robe, et lo lassava anche mio comissario con alcuni mei dissegni, come nel ditto mio testamento appare. Al presente per diversi mei convenienti [illegibile] per questo mio codicillo, casso, revoco, et anullo tuto el ditto legato che lassava al prefato Danese, si de danari, roba, comissaria, et altro, talmente che del tuto io lo privo.
Io pre Vettor Moresini mansionario nella giesia de Santa Croce de Venetiis fui presente a quanto e soprascritto et fui iurato et progatto.
Io Francesco de P. ro, fo de Messer Allvise, fui testimone per quanto et iurado.

(ASV, atti test., busta 768, no. 219)

256. Holograph will by Sansovino, 10 September 1568
Considerando io Jacopo del condam Antonio Tatti fiorentino cognominato Sansovino quanto sia fragile questa nostra umana vita e che el vivere, el morire è nella volontà dello onipotente iddio e che cosa più certa non nanegiamo dal morire e incerta l'ora quando debia venire aparo qualunche li torva di mente e d'animo e d'intelletto sano, debia all'anima e alli beni sua provedere che da poi venuto al caso della morte non abia a nascere contraversa contra li sua posteri, e però ho posto in animo io Jacopo sopranominato mentre che per lo dio gratia mi trovo sano di mente e d'intelletto e di corpo scrivere di mia propria mano questo ultimo testamento e l'ultima mia volontà, anullando casando ogni altro testamento o scrittura che io avessi fatto, di mia mano o fatto fare de ordine messo [?] fino a questo giorno, presente voglio sieno di nessuno valore e così questa e l'ultima mia volontà per li quali beni ch'ello onipotente iddio a che in ispatio dovuto col mio sudore o aquistati, etiam li beni paterni mantener in dispor e cordinare che dapoi la morte mia non abia a seguire schandolo fralli mei parenti per causa delli mia beni. E però quando lo onipotente iddio piacerà a se chiamarmi, li racomando l'anima mia e alla groliosa [sic] vergine Maria madre di Christo onipotente, che per la sua santa passione mi perdoni li mia pechati. Item laso che

dapoi ch'ero morto voglio esser vestito di sacho e che el cataletto non sia ornato di pani nessuno perche veni in questo mondo nudo e non voglio essere ornato di questi ornamenti cadili e frali. Item lasso d'essere sepellito a frati minori a pie della capella della natione fiorentina acanto la porta di detta chiesa dove el Santo Giovanni di mia propria mano sulla pila de' Giustiniani. E perché l'anno /1533/ io feci fare una sepoltura di marmo, la quale non è finita, alla feci lavorare a maestro Silvio e al fratello figliuoli da Giovanni da Pogibonse nella bottega dove stava maestro Salvestro tagliapiera a Santo Silvestro sul Canale Grande, e ditta opera è nelle casse nel magazino della Madona e ditta opera non è finita, e così voglio che sia finita e posta in muro a causa ch'elli vertuosi atendino a studiare e lasare memoria dalle loro vertuose fatiche, e ditta opera voglio ch'ella sia finita e posta in opera in muro colla mia testa di marmo e in terra sia fatto una lapida sola con poche lettere. E voglio che in termine d'uno ano dapoi sarò morto sia finita e posta in opera, e sulla mia rede non la finirano e poranno in opera, ch'elli procuratori dello spedale da San Giovanni e Polo posino adimandare alle mia rede ducati venticinque et ogni anno che si perderà [?] a metterla in opera, tale che io voglio che ditta opera sia fatta per esto, e non vadino in lungo come sono stati molti che ano lasato si facia la memoria loro e mai è stata fatta. E li mia commesari voglio sieno questi: el Magnifico Messer Marc'antonio Giustiniani del Clarissimo Messer Girolamo el procuratore, el Magnifico Messer Lionardo Moro del Magnifico Messer Carlo conpar caro, e maestro Salvadore de maestro Vettorio tagliapiera, el maestro caro Danese Cattaneo schultor, mio alevato, li quali pregino lo onipotente idio che metta loro in cuore che facino seguire questa mia ultima volontà coll'aiuto di dio.

Item lasso che subito ch'a dio piacerà separare questa anima de questo corpo sia portato subito alli poveri dello spedale di San Giani e Polo ducati cinque et cosi allo spedale delli incurabile altri ducati cinque, allo spedale delli poveri nocenti della pietà altri cinque ducati, li quali pregino iddio abia misericordia della anima mia, perdonandomi tuti li mia pechati e per la sua infinita bontà e misericordia inuta etterna. E più lasso alla schuola delli tagliapiera ducati cinque da esser dati a una figliuola de tagliapiera per suo maritare, e sia figliuola di buona fama. Et così lasso alla schuola de murari altri cinque ducati da esser dati a una figliuola d'un muraro, ben nata e di buona fama. E più lasso alla Schuola de' marangon altri cinque ducati da esser dati a una figliuola de marangone, ben nata e di buona fama, pregandole ch'elle pregino idio per me. E più lasso la matina che io sarò portato in chiesia voglio sia dito quindici messe, pregando iddio che per la sua infinita bontà et misericordia mi perdoni li mia pechati et mi conduca in vita eterna. E più lasso che tutti li disegni che lo ho nel mio studio, tutti quanti che mio figluolo Francesco non li voglia, per lui li deba dare a maestro Salvadore tagliapiera, e così tutti li gessi antichi e moderni voglio siano dati al Danese mio allevato talmente che infra tutti e due Danese schultore e maestro Salvadore separiscono fra loro le mie cose dell'arte, e sia comodino infra loro.

Item lasso erede universale, al quale racomando l'anima mia, Messer Francesco mio figliuolo, sia o non sia mi figliuolo,[1] ditto Messer Francesco dottore in lege. E questo voglio sia mio erede di tutto il restante de mia beni stabili e mobili, li quali mia beni voglio sian sua liberi e de sua figliuoli nati ligittimi e naturali, e quando che lui morissi sanza erede che dio non voglia e che lui avessi disposto del stabile da Santo Trovaso in qualunche modo si voglia e che lui havessi alienato voglio che tuto el soprabondante della mia facultà, così mobeli e stabeli, siano divisi in questo modo: che di tutto el sopra abondante ne sia fatto due parte, una parte ne sia della Lesandra mia figliuola, sia o non sia mia figliuola,

la quale è dona di Chimenti da Enpoli, figliuolo di Girolamo da Enpoli, e l'altra metà di ditta mia faculta allo più povero parente e sia della casa mia.

E così voglio sia sagiuto questo ultimo mio testamento soprascritto, anullando, casando ogni altro testamento o schritto come ò detto, pregando idio che metta in cuore alli mia commesari che facino seguire questo testamento fatto di mia propria mano in Vinezia questo di 10 settembre 1568, intendendo che Francesco mio figliuolo, sia o non sia mio figliuolo, voglio che sia insieme connesario colli altri sopranominati.

[On the verso]

1568 die 16 septembris indicatione xii

Rogati in cancelleria inferiore, io Jacomo di Tatti fo di messer Antonio fiorentino cognominato Sansovino, sano per gratia d'Iddio della mente, intelletto, et corpo, ho presentato questo mio testamento a Cesare Ziliolo, cancelliere ducale, dicendo esser scritto di mia mano propria, nel quale si contiene la mia ultima volontà, cassando, revocando, et annullando qualunque altro testamento ò codicillo ch'io havessi fatto per avanti fino a questo dì, volendo questo prevaler a ciascun altro che io havessi fatto, pregando ditto cancelliere che in ogni caso lo vogli aprir, leggerlo, republicarlo, et levarlo in forma di autentico testamento con tutte le clausule solite, neanche [?] secondo le lezze di questa inclita città . . .

1570 9 februarii. Ellencatum in publicam formam per me Caesarem Zeliolum, Cancellarium Ducalem.

1570 die mensis obiit.

(ASV, atti testmaneti, Ziliol, C., busta 1258, no. 452;[2] Sapori, 1928, pp. 127–30)

1. A typical phrase to cover questions of legitimacy; cf. Battista Franco's will of 1555, published by Ludwig (1911), p. 99.

2. A fair copy of the will can be found in ASV, Ziliol, C., busta 1262, III, protocolus, fols. 74v–76r.

257. Sansovino's death notice

27 novembre 1570. San Basso. Messer Jacomo Sansovino proto de la giexia di San Marco de ani 91, da vecchiezza zà un mexe e mezzo.

(Temanza, 1778, p. 260; Magistrato della sanità, necrologio pubblico)

258. Cosimo Bartoli, Medici agent in Venice, sends word of Sansovino's death to Florence, 6 December 1570

Di qua non è altro di momento se non che Messer Jacopo Sansovini di 96 anni passò a miglior vita.

(ASF, Med., filza 2979, fol. 524r)

259. Zuane Soranzo, Venetian ambassador to Pius V, sends condolences to Francesco Sansovino on the death of his father, 11 January 1571

. . . Mi è doluta certo sommamente la morte del Signor vostro padre, sì perché era grande amico di casa nostra, et io l'amava molto, come perché era huomo rarissimo, et non si potrà così facilmente ritrovar un par suo . . .

(Sansovino, 1580, p. 165^{r-v})

260. The Accademia del Disegno in Florence decides to commemorate Sansovino's death

MDLXX [=1571]

Ricordo oggi questo dì 14 di gennaio come si è fatta la nostra solita tornata nel capitolo de' servi con il Signor lucgotenete Messer Jacopo Pitti dove fu presentata una lettera alla accademia mandata dall'erede di Jacopo del Sansovino schultore excellentissimo, la quale pregava l'accademia volessi co qualche modo di essequie onorare la felice memoria di tanto huomo. Dove che letta la lettera, fu parlato abastanza nella accademia sopra a tal conto e finalmente fu concluso che si doversi onorare detta memoria del Sansovino con statue, pietture, e altro, et elettono quattro huomini sopra acciò che dovessino determinare tutto quello che bisognava e che deliberetemente pensassino alla spesa che poteva ascendere tale commennzaione [sic] e così e detti quattro huomini fuino questi, cioè, dua schultori e dua pittori.

Messer Vincenzio Danti Perugino
Messer Giovanni Bologna
Pittori Messer Alessandro Allori
 Messer Tommaso da Sanfriano

Questi accettono la carica di ordinare il modo che si dovea tenere per dar' principio a tale essequie, e anno autorità di poter chiamare tutti quelli che parea loro aporposito per condurre tale opera e così fu finito per partito nella accademia di fare, nere diciasette e dua bianche.

(ASF, Accademia del Disegno, filza 24, fol. 29ᵛ)

261. Francesco Sansovino's settlement of his father's account with the Scuola Grande della Misericordia, 15 January 15

Il Magnifico messer Marco Angelo Bonrizzo, guardian grando della Scuola di Madonna Santa Maria delle Misericordie detta la Valverde, insieme col magnifico messer Daniel Bembo, suo avicario, et con la presentia e consenso delli magnifici deputati sopra la fabrica, vicelicet, il magnifico Anzolo Benedetti, il magnifico messer Camillo Falier, dottor, il magnifico messer Zuan Francesco della Neve, et il magnifico Zuanbattista Luchini, in esecuzione della parte presa in questo nostro albergo sotto li 6 zugno 1569 passato, dall'una, et l'excellente messer Francesco Tatti cognominato Sansovino, figliuolo et herede del quondam messer Giacomo suo padre, il testamento di mano sua propria sotto dì 16 settembre 1568, nella cancellaria inferior, dall'altra, per liberarsi ambe le parte delle contentioni litigiose de pallazo per conto della mercede, utilità et salario quemodocumque spettante al sopradicto quondam messer Giacomo suo padre, protto et inzegnero stipendiato già dalla scuola mostra; sono rimasti insieme tutti unanimi et d'accordo in questo modo: che per resto et saldo sia effettualmente datto ducati cinquanta al presente delli danari della scuola nostra a detto excellente messer Francesco et altri ducati ottanta in tempo di anno uno in doi ratte, ogni sei mesi la ratta, fano la la summa di ducati cento e trenta da lire 6 soldi 4, et rinunziando in tutto et per tutto il detto excellente messer Francesco ogni attione e ragione potesse dimandare et havere per nome del quondam suo padre circa il salario e sua mercede. Promette appresso nelli beni della heredità paterna e suoi propri di non mai contravegnir a questa compositione, ma sempre tenirla valida et ferma et in fede sottoscrivendosi di sua mano propria conferma.

adì 14 settembre 1570. Io Francesco Tatti Sansovino, dottor soprascritto, affermo et son contento de quanto e soprascritto.

(ASV, Scuola Grande della Misericordia, busta 167, fol. 56; Cadorin, 1884, p. 14)

Francesco Sansovino's dispute with the procurators over the Sacristy door

262. MDLXXI, xxiii martii

Extensio terminationis Domini Francisci Sansuini contra clarissimos dominos procuratores de supra presentatae die 23 martii 1571 in officio curiae procuratorum.

Coram judicio curiae procuratorum comparuit Dominus Franciscus Sansovino, filius et heres quondam domini Jacobi, narrans et exponens predictum quondam eius patrem superioribus annis de ordine clarissimorum dominorum procuratorum de supra fecisse portam eneam cum multis figuris pro sacristia ecclesiae Sancti Marci, qui clarissimi domini procuratores pro expenditis per ipsum quondam dominum Jacobum in dicta porta dederunt ei creditum de ducatis 422 denarii 11, non comprehensa eius mercede, quae per peritos deberet extimari. Cumque postea venerit ad mortem predictus quondam Dominus Jacobus nulla facta solutione, nec extimatione dictae eius mercedis, et cum iustum et conveniens sit, quod predictus exponens de predicta mercede debeat satisfieri ideo citatis clarissimis dominis procuratoribus de supra ut in praeceptis cum instantia petebat et requirebat per dominos iudices dici, terminari et terminando mandari debere predictis clarissimis dominis procuratoribus, quatenus in breviori termino statuendo debeam elegisse unum peritum idoneum et non suspectum, qui simil cum alio per ipsum exponentem eligendo servatis servandis habeant extimare cum iuramento quid et quantum ipse exponens dicto nomine habere debeat pro mercede predictae portae per predictum quondam eius patrem confectae prout in similibus fieri solet et prout iustum, et conveniens est.

(ASV, Proc. de supra, busta 77, proc. 181, fasc. 1, fol. 14ʳ; Ongania and Cecchetti, 1886, pp. 45–46, no. 232¹)

1. As many of the pages in this fascicle have been incorrectly numbered, I have simply put the given numbers, with a reference to the published version in Ongania and Cecchetti.

263. 1571 ultimo martii

Bernardinus Preco procuratie retulit ut infra.

Demandato delli Clarissimi Signori Procuratori de supra si inhibisse a Voi Magnifici Signor Giudici di Procurator che procieder non debbiate sopra la dimanda data nell'offitio di Vostre Eccelentissime Signorie per messier Francesco Sansovin, fiol et haerede del quondam messier Jacomo olim protho di detta procuratia, per occasion della porta fatta per la sagrestia della giesia de San Marco per aspettar tal causa a loro Clarissimi Signori Procuratori, rationibus verum.

Die dicta. Dominicus, famulus offitii Advocariae, mandato clarissimi Domini Octaviani Valerio inhibuit in omnibus ut supra stante altera.

Die 3 aprilis 1571

Marcus Preco officii procuratoris retulit ut infra.

Demandato delli Magnifici Signori Iudici de procurator se inhibisse a Voi Clarissimi Signori Procuratori de supra che non ve debiate aliquo modo ingerir sopra la domanda data nel nostro officio per messier Francesco Sansovino, fiol et herede del quondam messier Jacomo olim vostro protho, per occasion della porta fatta da lui per la sacrestia della chiesa de San Marco per aspettar la causa al nostro officio . . .

Die dicta. Dominicus, famulus officii Adovcariae, mandato clarissimi Domini Octaviani Valerio inhibuit in omnibus ut supra stante altera.

(ASV, Proc. de supra, busta 77, proc. 181, fasc. 1, fol. 16ʳ; Ongania and Cecchetti, 1886, p. 46, no. 233)

264. 1571 27 aprile
Li Clarissimi Signori Procuratori, tutti in numero ridduti in procuratia, considerata la partida menata a credito del Sansovino sotto dì 22 febraro 1569[1] de lire 42 soldi 4 picoli 11, che dice per spesi per lui nella porta de bronzo, refferrendosi a certo conto per lui presentato, et seguitando dice non compresa però in detta partida la mercede sua de haver fatto ditta porta, la qual mercede se haverà poi da stimar per periti, consideratis considerandis, et essendo che ditta partida per li ordeni della procuratia non po esser menata; però Sue Signorie, per observantia delli ordeni della procuratia et per levar li abusi et pregiudicii che a quella possono esser causati da ditto disordine, hano a bossolli et ballotte terminato con tutte cinque ballotte de sì quella dover esser retrattata et per la istessa terminatione hano deliberato che si refformi la partida a credito del detto quondam Sansovino per quanto appare per soi conti se habbi speso, sì come in altre tal occasioni si ha osservato senza però alcun pregiudicio delle raggion della procuratia così contra ditto conto come circa essa porta se eccedesse le debite misure et no si accomodasse alla porta della sagrestia.

(ASV, Prov. de supra, busta 77, proc. 181, fasc. 1, fol. 17[r]; Ongania and Cecchetti, 1886, p. 46, no. 234)

1. More veneto = 1570.

265. 1571 il dì ultimo di aprile
Sopra le mutue inhibitioni seguite fra li clarissimi Signori Procuratori della chiesa di San Marco sotto il dì ultimo del mese di marzo et li magnifici Signori Judici di procurator sotto li tre del mese di april prossimi passati per occasione della domanda data nell'offitio di essi Signori Judici per lo fedelissimo Francesco Sansovino per certa porta per la sacrestia di detta chiesa fabricata per lo quondam Domino Jacomo Sansovino suo padre: la Serenissima Signoria, havendo bene inteso le ragioni dette dall'avocato delli predetti clarissimi signori procuratori et da quello di esso Sansovino in contradittorio, così finalmente contentando et sue Signorie clarissime et esso fedelissimo Francesco ha la difficultà sopradetta delegata alli clarissimi Signori Diese Savi estratti dall'eccellentissimo Senato, li quali debbano, servatis servandis et secondo il rito del loro officio, potendo metter una o più parti amministrar sopra di essa quello che conosceranno honesto et conveniente.

Consiglieri Domino Andrea Sanudo Domino Nicolò Veniero
 Domino Piero Justiniano Domino Jacomo Gussoni
 Domino Alvise Balbi Domino Piero Foscari
Gaspar Vidua, ducalis notarius

(ASV, Proc. de supra, busta 77, proc. 181, fasc. 1, fol. 18[r]; Ongania and Cecchetti, 1886, p. 46, no. 235)

266. 1571 alli 22 de maggio in Pregadi
Che per auttorità di questo Consiglio la differentia vertente fra i procuratori della chiesa di San Marco et i giudici della corte di procurator per occasione della dimanda data nell'offitio di essi giudici de procurator per lo fedelissimo Francesco Sansovino per certa porta per la sacrista di detta chiesa, frabricata dal quondam ser Giacomo Sansovino suo padre, la quale fu per la Signoria nostra all'ultimo di april prossimamente passato ai X Savii estratti del corpo di questo Consiglio, sia delegata etiamdio ad altri X Savii di esso Consiglio, i quali vinti ridotti al numero di quindeci debbano citati, uditi, et servate quelle cose che si devono, potendo i presidenti di esso Collegio metter una o più parti far quello sopra di essa che li parera convenir alla giustitia. Franciscus Rubeus, ducalis notarius

(ASV, Proc. de supra, busta 77, proc. 181, fasc. 1, fol. 19[r]; Ongania and Cecchetti, 1886, p. 46, no. 236)

267. 1571 26 maggio
Faccio fede io, Cesare Ziliolo cancelliero del Serenissmo Principe nostro, come l'eccellente Dottor di legge Domino Francesco Sansovino, fo del spettabile Domino Giacomo, è stato instituito dal ditto suo padre comessario et herede de tutti li suoi beni mobeli et stabeli d'ogni ragion et condition et qualità, sì come appare per suo testamento scritto de sua mano et presentato a me Cesare soprascrito a 16 di settembre 1568, et per me levato in publica et autentica forma, come in esso si contiene, in fede del che ho fatto questa di mia mano hoggi che è il xxvi di maggio MDLXXI, la quale sarà sigilata del consueto sigillo di San Marco. Idem Cesar qui supra.

(ASV, Proc. de supra, busta 77, proc. 181, fasc. 1, fol. 21[r]; Ongania and Cecchetti, 1886, pp. 46–47, no. 237)

268. 1571 21 zugno
La dimanda dell'eccellente messer Francesco Sansovino come fiol et herede del quondam messer Giacomo data contra noi procuratori della gesia di San Marco non può in alcun modo esser essaudita, per essere lontana da ogni termine di giustitia et di honestà. Perché essendo il quondam suo padre salariato et pagato delli dinari et entrate della gesia di San Marco amplissimamente, si conveniva ancora che fosse in obligo di essercitarsi et metter ogni sua industria a far quanto occorreva et facea bisogno per ditta gesia. Li può ben bastare c'havendo assegnato certo tal qual conto di spese fatte per la porta, della qual nella sua dimanda, così in robba come in fatture diverse, li sia stata fatta la integra satisfattione di quanto si ha voluto apportar creditore. Però instamo et ricerchiamo noi antedetti dover esser liberati dalla preditta vessatione et molestia, così indebitamente dataci, salva ogni altra ragion della procuratia nostra in cadaun modo.
Produtta a dì 21 zugno 1571

(ASV, Proc. de supra, busta 77, proc. 181, fasc. 1, fol. 22[r]; Ongania and Cecchetti, 1886, p. 47, no. 238)

269. 1571 7 settembre
Die 7 septembris in Collegio Dominorum X Sapientum Ordinum Excellentissimi Senatus cum aliis xv adiunctis in executione partis ipsius Senatus diei xxii maii proxime preteriti.
Essendo stati uditi in contraditorio juditio con li loro advocati in virtù della delegation fatta per lo Eccellentissimo Senato sotto dì 22 maggio prossimamente passato, Domino Francesco Sansovino Dottor per una parte et li advocati et intervenienti per la procuratia della chiesa di San Marco per l'altra, in proposito di certa porta per la sacrestia della detta chiesa, fatta per il quondam Domino Giacomo Sansovino suo padre, et dovendossi diffinir la detta difficultà di quel modo che conviene alla justitia.
L'anderà parte che per auttorità di questo Collegio sia preso et deliberato che la mercede della sudetta porta sia pagata al predetto Sansovino, juxta la forma della partita fatta nella procuratia sopradetta sotto li 22 febraro 1569.
Datum Juramentum. +11 sì—3 no—1 non sinceri
ser Francesco Diedo ser Marco Marin
ser Bortolomio Gradenigo ser Alessandro Trivisan
ser Zorzi Zorzi ser Alvise Diedo
ser Daniel Barbarigo ser Gabriel Emo, quondam
 ser Hieronimo

ser Gabriel Emo, quondam ser Piero⸳ ser Francesco Valier
ser Nicolo Dandolo ser Iseppo Trivisan
ser Francesco Contarini ser Sebastian Badoer
 ser Sebastian Barbarigo

(ASV, Proc. de supra, busta 77, proc. 181, fasc. 1. fol. 1ʳ⁻ᵛ [sic];
Ongania and Cecchetti, 1886, p. 47, no. 239)

270. 1571 adì 17 settembre
Referì Baldissera Comandador haver intimado demandato a
messer Alvise Lion advocato et interveniente per la procuratia de
supra ad instantia de Domino Francesco Sansuin Dotto, fiol, et
herede del quondam missier Giacomo, che per tutto zuoba
prossimo venturo debbi haver nominato il suo perito per stimar la
porta de bronzo, insieme con il moninato per il detto missier
Francesco nel ditto tempo, et questo per essecution del spazzo del
detto Collegio de dì 7 dell'instante, aliter passato ditto termine et
non fatta detta monination, la faranno essi clarissimi pressidenti
per essecution del detto spazzo.

271. Adì 20 ditto
Constituido nel presente officio messer Alvise Lion, advocato et
interveniente per la procuratia de supra, respondendo al
comandamento fattoli sotto dì 17 dell'instante, disse li clarissimi
missier Marchio Michiel et messer Ferigo Contarini esser fora
della terra, per il che li altri doi clarissimi suoi collega non si
riducono alla procuratia per non poter far cosa alcuna, non
essendo la magior parte, et che ritornati si riduranno, essi
nominerà.

272. 1571 adì 17 ottobrio
Referì Baldissera Comandador haver replicato a missier Alvise
Lion, advocato et interveniente per la procuratia de supra, il
comandamento fattoli sotto dì 17 settembrio prossimo passato,
ch'el debbi nominar il perito, videlicet per tutto il giorno di 18
dell'instante, aliter et cetera. Et questo ad instantia di Domino
Francesco Sansuin, dottor.

(ASV, Proc. de supra, busta 77, proc. 181, fasc. 1, fols. 3ʳ⁻4ʳ;
Ongania and Cecchetti, 1886, p. 47, no. 240)

273. 1571 adì 23 ottobrio
Constitudo nel presente officio messer Alvise Lion, dottor,
advocato, et per nome delli clarissimi signori procuratori de
supra, et in essecution delli comandamenti a lui fatti, ha richiesto
esser notado che per perito per la parte di essi clarissimi
procuratori nella causa con Domino Francesco Sansuin, doctor,
nomina messer Francesco Segala, scultor, et medesimanente il
predettom Domino Francesco Sansuin nomina messer Danese
Cathaneo, scultor, per la parte sua.

274. 30 ditto
Li clarissimi signori pressedenti infrascripti, allegando Domino
Labieno Velutello, dottor advocato della procuratia de supra, non
dover esser admesso per perito missier Danese Cathaneo, scultor,
nominato per Domino Francesco Sansuin, dottor, a dover estimar
insieme con il nominato per parte di essa procuratia la prota tra
esse parte contentiosa. Et questo per esser stato allievo del
quondam missier Giacomo Sansuin suo padre, et contradicendo a
questo il predetto Domino Francesco Sansuin per molte ragion de

l'uno et l'altro di loro dette et allegate, hanno terminato che il
predetto missier Danese sia admesso et habbi da estimar la detta
porta ut supra, et così han commesso che si noti.
Dominus Zacharias Gabriel
Dominus Philippus Alberto pressidentes

(ASV, Proc. de supra, busta 77, proc. 181, fasc. 1, fols. 11ʳ⁻12ʳ;
Ongania and Cecchetti, 1886, p. 48, no. 240)

275. Adì 30 dicto
Referì Baldissera Comandador haver intimado demandato delli
clarissimi signori pressidenti a misser Alvise Lion, advocato et
interveniente per la procuratia de supra, che in termine de giorni
tre prossimi venturi habbia fatto redur il suo perito per estimar la
porta insieme con il nominato per Domino Francesco Sansuin,
dottor, aliter et cetera. Et questo ad instantia del soprascritto
Sansuin.

(ASV, Proc. de supra, busta 77, proc. 181, fasc. 1, fol. 4ʳ⁻ᵛ;
Ongania and Cecchetti, 1886, p. 47, no. 240)

276. 1571 8 novembre
Al nome di Giesu Cristo Signore e Dio nostro e del tutto in
Venetia, adì 8 di novembre 1571.
In esecutione del comandamento fatto dalli clarissimi signori
presidenti delli x Savii estratti del corpo di Pregadi a noi Francesco
Segalla, padovano, e Danese Cataneo, carrarese, scultori, che per
nostra consienza e con giuramento dobbiamo stimare e giudicare
la fattura della porta di bronzo della sacrestia di San Marco,
scolpita et intagliata di varie figure, et di molti ornamenti dallo
eccellentissimo scultore missier Jacomo Sansuino di buona
memoria per ordine delli clarissimi signori procuratori de supra;
poi che con ogni debita acuratezza e diligenza habbiamo veduto et
considerato il raro artificio di sì nobel opera, invocando prima lo
spirito santo che ci illumini a far retto juditio, stimiamo et
apreciamo la fatura di tal porta mille seicento et cinquanta scudi
d'oro di lire sette l'uno, i quali debbiano esser pagati dalli clarisimi
signori procuratori detti allo eccellente missier Francesco
Sansuino, dottor di legge, per giusta mercede delle longhe fatiche
fatte in tal opera da messer Jacobo sopradetto suo padre, et questi
schudi mille seicento cinquanta d'oro debbia haver netti oltra li
422 ducati, lire due, soldi 16 dati et fatti boni a suo padre per spese
di tal porta a dì 22 di febraro del 1569. E per fede della verità, io
Danese detto ho fatta la presente scrittura per dechiaratione di tal
nostro giuditio con volontà di mistro Francesco Segalla detto, il
quale si sottoscriverà anche esso di sua man propria, affermando et
confermando con giuramento quanto in lei si contiene.
Io Danese Cataneo sopraditto scrissi di mia man propria.
Io Francesco Segalla sopraditto affermo con giuramento quanto
qui sopra si contiene et in fede mi ho sottoscritto di propria mano.
1571 adì 13 novembris, publicata de mandato delli clarissimi
misser Carlo Ruzini, misser Felippo Alberto, et misser Zaccharia
Gabriel, degnissimi presidenti del Collegio delli X Savii
dell'Illustrissimo Senato, upresente le parti.
Joannes Thura, ducalis notarius auscultavit.

(ASV, Proc. de supra, busta 77, proc. 181, fasc. 1, fol. 5ʳ⁻ᵛ [sic];
Ongania and Cecchetti, 1886, p. 49, no. 241)

277. Adì 12 novembrio
Referì Baldissera Comandador haver citato Domino Alvise Lion,
commesso et interveniente per li signori procuratori de supra, per

questa mattina a veder, zurar, et publicar la stima fatta per li periti della porta de bronzo ad instantia de missier Francesco Sansovino dottor.[1]

(ASV, Proc. de supra, busta 77, proc. 181, fasc. 1, fol. 4v–7r; Ongania and Cecchetti, 1886, p. 47, no. 240)

1. An idential petition, lodged with the procurators' attorney on 13 November, has been omitted.

278. 1571 20 novembrio
Li clarissimi missier Philippo Alberto, missier Zacharia Gabriel, honorandi pressidenti, non essistente in opinion il clarissimo missier Carlo Ruzini loro terzo collega, aldido Domino Alvise Lion, dottor, advocato et interveniente per li clarissimi signori procuratori de supra, dimandante per sue signorie clarissime dover esser ordinato che sii fatto una nova stima per doi periti dell'arte non suspetti, della porta de bronzo già estimata, da una parte, et Domino Francesco Sansuin, dottor, dall'altra, opponendossi a tal dimanda, allegando non potersi ne doversi far tal stima per più ragioni per cadauna di esse parti dette et allegate; hanno terminato et dechiarito che sii fatta un'altra stima, iuxta la dimanda del sopraditto Domino Alvise Lion. Et così han commesso che si noti.
Dominus Philippus Albertus
Dominus Zacharias Gabriel pressidentes
Johannes Thura, ducalis notarius auscultavit.

(ASV, Proc. de supra, busta 77, proc. 181, fasc. 1 fol. 29r; Ongania and Cecchetti, 1886, p. 48, no. 240)

279. Adì 22 novembre et fu adì 20 ditto
Referi il ditto[1] haver intimato a Domino Alvise Lion, interveniente per la procuratia de supra, che per tutto mercore prossimo debbi haver dato in nota il suo perito per estimar la porta de bronzo. Et questo ad instantia de messer Francesco Sansuin, dottor.[2]

(ASV, Proc. de supra, busta 77, proc. 181, fasc. 1, fol. 7^{r-v}; Ongania and Cecchetti, 1886, p. 48, no. 240)

1. Baldissera Comandador.
2. A similar petition, dated 23 November, has been omitted.

280. 1571 adì 27 novembrio
Constituido nel presente officio Domino Alvise Lion, dottor, advocato, et per nome delli clarissimi signori procuratori de supra, et in essecution delli comandamenti a lui fatti, ha richiesto esser nottado che per perito per la parte di essi clarissimi signori procuratori per la nova stima della porta con Domino Francesco Sansuin, dottor, nomina ser Benetto d'i Alchieri.

281. Adì 29 dicto
Li clarissimi signori pressidenti infrascriti aldidi Domino Francesco Sansuin, dottor, dimandando per sue signorie clarissime dover esser terminato che gli intervenienti et advocati della procuratia de supra debbino in luogo de mistro Benetto Alchieri per loro nominato per perito nella stima della porta de bronzo, et questo atteso che la profession sua è de favro et non de scultor, da una parte, et dall'altra, Domino Labieno Velutello, dottor, et Alvise Lion, advocati et intervenienti per la detta procuratia, opponendossi a tal dimanda allegando il sopraditto mistro Benetto esser perito et dover esser admesso a tal stima;

hanno terminato che li suddetti intervenienti per la procuratia debbino nominar un altro che sia perito nella profession de scultura et il sudetto Sansovino similmente un altro. Et così han commesso che si noti.
Dominus Carolus Ruzini
Dominus Philippus Alberto pressidentes
Dominus Zacharias Gabriel

282. Adì 3 decembre
Constituido nel presente officio Domino Francesco Sansovin, dottor, et in essecution della termination delli clarissimi signori pressidenti che debba esser reestimata la porta de bronzo fatta per il quondam Domino Giacomo suo padre, ha richiesto esser nottado che nomina per il suo perito mistro Hieronimo Campagna da Verona, scultor habitante in Venetia, et similmente Domino Alvise Lion, dottor, advocato, et interveniente per la procuratia de supra, ha nominato per la parte sua missier Giacomo Sicilian, scultor.[1]

(ASV, Proc. de supra, busta 77, proc. 181, fasc. 1, fols. 13r–14v; Ongania and Cecchetti, 1886, pp. 48–49, no. 240)

1. A reference to Giacomo del Duca (c.1520-after 1601), the Sicilian sculptor and architect.

283. 1571, adi 17 decembrio
Referì Baldissera Comandador haver de mandato delli clarissimi signori pressidenti intimado a Domino Alvise Lion, advocato et interveniente per la procuratia de supra, che per il primo giorno doppo le feste di nadal prossimo debbi haver fatto venir missier Giacomo Sicilian per lui nominato nato come scultor a dover reestimar la porta de bronzo insieme con l'altro nominato per domino Francesco Sansuin, altramente passato el detto giorno, sue signorie clarissime daranno essecution alla prima stima, et questo ad instantia del suddetto Domino Francesco Sansuin.

284. Adì 7 zener 1571 [=1572]
Referì il ditto haver citado Domino Alvise Lion, dottor interveniente per la procuratia de supra, per mercore da matina prossimo davanti li clarissimi signori pressidenti ad instantia de Domino Francesco Sansuin, dottor.

(ASV, Proc. de supra, busta 77, proc. 181, fasc. 1, fols. 7v–8r; Ongania and Cecchetti, 1886, p. 48, no. 240)

285. Adì 23 zener et fu adì 21 dell'instante
Li clarissimi signori president infrascritti instando Domino Francesco Sansovino che per sue signorie clarissime fosse posto fine alla stima in essecution della deliberation di questo Collegio et termination di essi clarissimi signori da esser fatta della porta di bronzo; attento che per parte delli clarissimi signori procuratori de supra era sta nominato uno che dicono esser in Roma et non si sa per che vogli venir altrimenti, et all'incontro opponendossi a questo Domino Alvise Lion, dottor, advocato, et interveniente per la suddetta procuratia, et rechiedendo tempo congruo da poter venir da Roma il perito nominato, mostrando lettere da Roma che dicono che'l predetto vol venir; hanno assignato termine a detto Domino Alvise per nome ut supra di far venir il predetto nominato per tutto un mese prossimo venturo, finirà a 20 febraro, che fra tanto nel termine de giorni otto prossimi detto Domino Alvise habbi nominato un altro perito, il quale passato il ditto mese et non essendo venuto quello da Roma, habbi ad estimar

immediate la ditta porta, insieme con il nominato dal sopraditto Sansovino, et così hanno commesso che si noti.
Dominus Zacharias Gabriel
Dominus Philippus Alberto pressidentes

(ASV, Proc. de supra, busta 77, proc. 181, fasc. 1, fols. 14ᵛ–15ᵛ; Ongania and Cecchetti, 1886, p. 49, no. 240)

286. 1571, adì 21 fevrer [=1572]
Referì il ditto[1] haver intimado a missier Alvise Lion, interveniente per la procuratia de supra, che per tutto hozi debba haver dato in nota il suo perito per estimar la porta de bronzo, aliter, et questo de mandato et ad instantia de Domino Francesco Sansuin, dottor.[2]

(ASV, Proc. de supra, busta 77, proc. 181, fasc. 1, fol. 8ᵛ; Ongania and Cecchetti, 1886, p. 48, no. 240)

1. Baldissera Comandador.
2. A similar petition, dated 23 February, has been omitted.

287. 23 febraro
Constituido nell'officio Domino Alvise Lion, dottor, advocato, et interveniente per la procuratia de supra, in essecution delli comandamenti a lui fatti, ha richiesto esser notato che per perito ad estimar la porta della qual nella soprascritta termination, nomina mistro Nicolo d'i Conti. Joannes Thura, ducalis notarius auscultavit.

(ASV, Proc. de supra, busta 77, proc. 181, fasc. 1, fol. 15ᵛ; Ongania and Cecchetti, 1886, p. 49, no. 240)

288. Ultimo ditto et fu a li 27 [fevrer 1572]
Referì il ditto[1] haver intimado de mandato delli clarissimi signori pressidenti a Domino Alvise Lion, dottor, advocato, et interveniente per la procuratia de supra, che in termine de giorni otto prossimi venturi debbi haver fatta estimar la porta de bronzo altre volte estimata nella causa con Domino Francesco Sansuin, dottor, aliter. Et questo ad instantia del ditto Sansuin.

1. Baldissera Comandador.

289. 1572, adi 13 mazo
Referì il ditto haver fatto comandamento a missier Nicolò d'i Conti et a missier Hieronimo Campagna, stimadori overo periti eletti per le parte a dover reestimar la porta de bronzo, qual messer Nicolò rispose dite ali Vostri Signori che non semo d'accordo fra noi et che bisogna eleger il terzo, che perhò Sue Signorie debbano dechiarir se le parte o noi o noi stimadori overo Sue Signorie Clarissime hanno da far election di esso terzo, et questo ad instantia de Domino Francesco Sansovino, dottor, et de mandato. Joannes Thura, ducalis notarius auscultavit.

(ASV, Proc. de supra, busta 77, proc. 181, fasc. 1, fol. 9ʳ⁻ᵛ; Ongania and Cecchetti, 1886, p. 48, no. 240)

290. 1572, xx mazo
Li clarissimi signori presidenti infrascritti aldidi in contradritorio giuditio per una parte Domino Alvise Lion, dottor, interveniente per la procuratia de supra con Domino Labieno Velutello, dottor advocato di essa procuratia, dimandanti esser terminato che mistro Hieronimo Campagna, veronese scultor eletto per Domino Francesco Sansuin, dottor, sotto dì 3 decembre prossimo

passato, per suo perito a dover reestimar la porta di bronzo, et cetera, per le raggioni et causa in una sua scrittura, vista et letta, non debbi esser admesso a tal stima; et per l'altra il prediteto Domino Francesco Sansuino opponendosi a questo et richiedendo che non essendo li doi periti d'accordo per la detta stima, si debba elezer il terzo per più sue raggioni dette et allegate; hanno terminato che le sopradette parti fra il termine di giorni xv prossimi venturi debbano haver eletto d'accordo fra loro il terzo perito per la stima sopradtta, altramente passato esso termine sue signorie clarissime lo elegerano, e cosi han commesso che si noti, non admettendo la scrittura di opposizione soprascritta.
Dominus Daniel Fuscareno
Dominus Daniel Barbadico Presidentes
Dominus Alexander Trivisano

(ASV, Proc. de supra, busta 77, proc. 181, fasc. 1, fol. 17ʳ⁻ᵛ; Ongania and Cecchetti, 1886, pp. 49–50, no. 242)

291. 1572, 20 maggio
Essendo venuto a notitia di noi procuratori de supra della gesia de San Marco che ser Hieronimo Champagna, dato in nota et elletto dall'eccellente messer Francesco Sansuino per suo perito a restimar la porta di bronzo già fatta per il quondam missier Giacomo suo padre et protho della detta procuratia, che fu prima stimata da missier Danese Cataneo et missier Francesco Segalla scultori, non solamente è stato et è garzon et lavorante del detto missier Danese, già eletto per ditto eccellente missier Francesco, ma che sta in casa con esso missier Danese a suo pane et vino, ne parendoci cosa conveniente che il detto garzon, il quale oltra per la poca sua età che non crediamo passi 20 anni, però [sic] haver pochissima cognitione di tal opera per il rispetto che havera sempre a detto giuditio, per la presente nostra scrittura, opponendoli dicemo a Vostre Signorie Clarissime, Clarissimi Signori Presidenti, che non deveno permetter che egli debbia giudicare, ma terminare che il detto Sansovino debbia ellegerne un altro ideoneo et non suspetto, così ricercando ogni termine di raggione et honestà, non essendo alcuna cosa più dura che l'esser giudicato da giudice suspetto et non libero, offerendoci quando all'adversario ci sia negato, che non crediamo che ardirà di fare, giustificar quanto habbiamo sopradetto et hoc omni meliori modo.

1572, 20 mazo
Visto per li clarissimi signori presidenti infrascritti le oppositioni sopradette, et admesse partibus auditis.
Dominus Daniel Fuscareno
Dominus Daniel Barbadico presidentes
Dominus Alexander Trivisano
Joannes Thura, ducalis notarius auscultavit.

(ASV, Proc. de supra, busta 77, proc. 181, fasc. 1, fol. 19ʳ⁻ᵛ; Ongania and Cecchetti, 1886, p. 50, no. 243)

292. MDLXXI, x giugno
Facio fede io Bastiam Saraceni chome ser Ieronimo Champagna veronexe è statto alquamtto tempo per garzon chon mistro Danexe Chatanio scholltor, e di poi sono alquanti mexi le stta chon lui per lavoramtte e stta im chaxa del ditto mistro Danexe. E al prexemtte, zouè, il lune delle presemte, choste amdò a Padova com ditto mistro Danexe e per quanto me dise amdava per lavoramtte a lavorar al Santo. E questo so perchè ditto mistro Danese aveua da mi la mitta della chaxa dove abitto in chontra de Sampamtalom ad afitto, et per fede ho schritto questa.
Adì sopra dito, fazo fede io Venturin de Alberti, cimador,

qualmente el ditto Ieronemo e stato garzon et in casa col dito mistro Danese, et è andato a Padova con lui come di sopra et pò esser de anni 20 in cercha. Io Zuane fiol de mistro Venturin sopraditto afermo esser vero quanto è soprachritto . . .

(ASV, Proc. de supra, busta 77, proc. 181, fasc. 1, fol. 20ʳ; Ongania and Cecchetti, 1886, p. 50, no. 244)[1]

1. Two postscripts to this affidavit, dated 8 and 9 March 1575, have been omitted.

293. 1572 die mercurii vigesimo augusti, ad cancellum
Il clarissimo Signor Federico Contarini, dignissimo procurator e cassier della procuratia de supra, facendo per nome suo et delli altri clarissimi signori procuratori, collega suoi, in vertù et essecution della libertà a Sua Signoria concessa per la terminatione sopra di ciò fatta per detti clarissimi signori procuratori sotti dì [blank] nelli atti della procuratia da una parte . . . et l'eccellente messer Francesco Sansovino, dottor, come fiol et herede del quondam spettabil messer Giacomo dall'altra, sono concordevolmente devenuti all'infrascritta composition et accordo sopra tutte et cadaune difficultà vertenti et che per qualsivoglia modo vertir potessero tra detta clarissima procuratia et la heredità del sopra detto quondam messer Giacomo, overo detto messer Francesco per nome, come di sopra per occasion della porta di bronzo fatta per esso quondam Sansovino per doversi poner alla porta della sagrestia della chiesa de messer San Marco, altre volte ordinata al detto Sansovino per li clarissimi signori procuratori di detta procuratia et pagatoli il metalo et altre spese come nelli libri d'essa procuratia appar. Sopra la qual difficultà sono nasciuti giuditii per li eccellentissimi Signori X Savii et adiunti del corpo del Senato, delegati per Sua Serenità giudici sopra questa materia contra la detta clarissima procuratia et a favor di detto Sansovino et anco stime de periti che hanno giudicato l'opera di detto quondam Sansovino meritar scudi mille seicento et cinquanta d'oro, che fano ducati correnti da lire 6 soldi 4 per ducato, mille ottocento sesantatre in circa. Et di più si era devenuto alla seconda mano de stimadori che dovessero de novo restimar detta opera, ma il sopradetto clarissimo signor procurator et cassier, come è detto facendo per nome suo et de voler et ordine et con scientia assenso et voluntà come dice delli clarissimi signori procuratori suoi collega da una parte, et detto messer Francesco Sansovino, fiol et come herede di detto quondam messer Giacomo dall'altra, volendo sparagnar alle spese de lite et quello che se convien de ragion far voluntariamente senza strepiti di giuditio, sono con il nome di messer Jesu Christo devenuti all'infrascripta compositione, accordo, et conventione che renuntiando voluntariamente l'una et l'altra parte all'estimation soprascritta fatta per li primi periti sopradetti et similmente ad ogni altra pronuntia che potesse esser fatta in tal materia di nove stime sopra l'opera a qualsivoglia via, modo, et forma presentada per il detto quondam messer Giacomo Sansovino nella construction della sopradetta porta de bronzo, così quanto alle figure spettante alla scultura come quanto ad ogni altra sua parte spettante a qualsivoglia altra professione et maestria ma d'ogni action et pretension che a qual si voglia via per causa di detta porta li potessi competer o al detto paresse che li potesse competer, niuna esclusa over eccettuata, ma il tutto incluso et posto a conto; li sopradetti clarissimo signor procurator et cassier et l'eccellente missier Francesco, per li nomi come de sopra, hanno d'accordo insieme amichevolmente et voluntariamente reddutto il pretio et ammontar sopradetto in ducati mille tresento cinquanta da lire 6 soldi 4 l'uno, et così insieme hano concluso che detta summa de ducati mille tresento cinquanta debba esser et sia

l'integra satisfattione del opera sopradetta d'essa porta, renuntiando come è detto a tutte le altre cose sopradette a quella concernente. Imperò, il sopradetto clarissimo signor procurator et cassier facendo per nome come de sopra ha promesso et promette al sopradetto missier Francesco de darli li sopradetti ducati mille tresento cinquanta per resto, saldo, et finito pagamento della detta opera et d'ogni pretension per causa di quella nel modo infrascritto, cioè, detrazer prima da questa summa ducati cento vinti che detto missier Francesco deve alla clarissima procuratia per fitto della casa dove habita per anni doi che finirano adì 18 zener prossimo venturo et a conto del restante che saranno ducati mille dusento et trenta assegnati alla camera d'imprestidi al sussidio et novissimo sopra settembre presente et marzo prossimo 1573, li pro·della chiesa de San Marco che importano in tutto ducati settecento nonantadoi in circa et il restante che vien ad esser ducati quattrocento trentaotto in circa promette sua signoria clarissima che li saranno dati nel detto tempo de marzo prossimo senza dilation alcuna, et così in essa libera esatione mantener esso eccellente messer Francesco sotto obligatione di tutti li altri beni d'essa procuratia. De et super omnibus et singulis rogavere me notarium, etcetera . . .

(ASV, arch. not., Figolin, G., busta 5617, fols. 77ʳ–78ᵛ; Ongania and Cecchetti, 1886, pp. 50–51, no. 245)

294. Adì detto 1573, 27 martii
Li oltrascritti clarissimi signori procuratori hano ordinato che la sententia arbitraia over compositione et accordo fatto tra la procuratia et domino Francesco Sansovino, quondam Domino Jacomo, in materia della porta de bronzo posta alla porta della sacrestia della chiesa de San Marco, pregata nei atti de ser Zuane Figolino, nodaro, sotto dì [blank] come in quella, la qual fu fatta de voler et consenso de sue signorie clarissime, sia registrata nel catastico della procuratia ad futurorum memoriam.

(ASV, Proc. de supra, atti reg. 132, fol. 79ʳ; Ongania and Cecchetti, 1886, p. 51, no. 246)

The dispute between Francesco Sansovino and the procurators over the 'Madonna di marmo'

295. 1575, die 8 martii
Presentata per Excellentissimum Dominum Aloysium Lionum infrascriptum, nomine clarissimorum dominorum procuratorum de supra ad Excellentissimum Consilium de XL. Civile Vetus, in causa cum Domino Francisco Sansovino doctore, nomine quo intervenit.
Die dicta
Intimata per Antonium Theupulum famulum offitii, Domino Francisco doctori.

MDLXXIII, xv ottobris
Petitio ser Francisci Sansovini contra clarissimos dominos procuratores de supra, presentata in officio curie procuratorum die 15 octobris 1573. Il quondam missier Jacomo Sansovino quando viveva fece una imagine della Beata Vergine Maria con alcuni anzeletti et puttini di marmo di ordene et consentimento delli clarissimi segnori procuratori de supra, per mettersi nella chiesa di San Marco, et perché essendo statti pagati i merzenarii per disgrossar et sbozzar quella, esso missier Jacomo non ha mai conseguitto la debita sua mercede per tale opera et fattura. La onde, havendo io Francesco Sansovino suo figliuollo et herede con ogni modestia più volte ricercato che voglino essi clarissimi signori procuratori pagar tal giusto et conveniente credito. Et essendo trattenutto di hoggi in demane, sonno statto astretto,

nomine quo supra, a comparir davanti alla giusticia di Vostre Signorie Clarissimi Signori Judici di Procurator, et legittime citato messer Alvise Lion, dottor et avocatto di essi clarissimi signori procuratori, ut in praeceptis et con la presente mia dimanda richiedo che sue clarissime signorie siano sententiati in ducatti 100 per parte et a bon conto della mercede spettante a me Francesco Sansovino, nomine quo supra, per la sopradetta opera fatta per il quondam mio padre, offerendomi sopra ciò stare alla depositione con juramnnto di periti idonei et sofficienti nella scoltura, et questo per le raggioni et cause sopradette, et siano condannati nelle spese salvo jure addendi et offerens probari necessaria, etc.

(ASV, Proc. de supra, busta 77, proc. 181, fasc. 2, fols. 1r–2r)

296. 1573, die 26 octobris
De mandato delli clarissimi signori procuratori de supra se inhibisse a Voi Magnifici Signori Giudici de Procurator che procieder non debbiate sopra la dimanda data nell'officio di Vostre Signorie Eccellentissime per missier Francesco Sansovino, fiolo et herede del quondam missier Giacomo olim protho di detta procurathia, per occasion della statua di marmo fatta per la chiesa di San Marco della Beata Vergine Santa Maria, per aspettar tal causa a loro signori procuratori, rationibus verum.

(*Ibid.*, fol. 3r)

297. 1573, die 27 dicti [=octobris]
Demandato delli Magnific Signori Giudici de Procurator se inhibisse a Voi Clarissimi Signori Procuratori de supra, che non ve debbiate aliquo modo ingerir sopra la dimanda data nel nostro officio per missier Fancesco Sansovino, fiol et herede del quondam Giacomo Sansovino olim protho, per occasion della statua di marmo della Beata Vergine fatta per la chiesa di San Marco, per aspettar tal causa al nostro officio, verum etc.

(*Ibid.*)

298. 1573, adì 27 genaro [=1574]
In Collegio. Uditi per la Serenissima Signoria li clarissimi procuratori de supra dimandanti la confirmatione della inhibition loro fatta alla Corte del Procurator, a xxvi del mese di ottobrio passato in proposito della dimanda del fedel Francesco Sansovino, figliolo et herede del quondam Giacomo fu protho di quella procuratia, per occasione di una imagine della Beata Vergine da una parte, et dall'altra udito il sudetto Sansovino dicente dover essa inhibitione esser revocata, et conseguentemente tenuta ferma quella di giudici di procurator ad essi clarissimi procuratori nell'istesso proposito fatta. Et bene inteso quanto gli avocati più volte hanno voluto per favor dell'una et l'altra parte dire, dedurre, et allegare. Ha essa Serenissima Signoria il tutto ben considerato; posto il bossolo bianchco, che la sopraditta inhibitione dei clarissimi procuratori sia tenuta ferma e rivocata quella dei giudici di Procurator; il verde che quella di giudici prefati di Procurator sia tenuta ferma et rivocata quella di Procuratori sopraditti; et il rosso non sincier, et fu preso che sia confirmata la inhibition dei Procuratori et rivocata quella di giudici di Procurator.
Consiglieri
ser Zuane Bondumier ser Francesco Duodo
ser Marco Grimani ser Marco Antonio Bembo,
ser Vincenzo Querini capo di Quaranta, vice consiglier

(*Ibid.*, fols. 3v–4r)

299. MDLXXIII, 5 februarii [=1574]
Sa Dio, Clarissimi et Eccellentissimi Signori Avogadori, che io Francesco Sansovino, figliolo et herede del quondam missier Giacomo, con grandissimo ramarico dell'animo mio mi conduco a dimandar intromission della termination fatta dalli Illustrissimi Signori Consiglieri, sotto dì 27 di genaro prossimo passato, a favor delli clarissimi signori procuratori di San Marco de supra et contra di me, per la quale è stato terminato che la causa mia la quale io ho con le sue signorie clarissime per occasione della madonna di marmo fatta dal quondam mio padre con infinita sua spesa, tempo, et diligenza, sia da sue signorie clarissime giudicata et questo per molti miei convenienti rispetti; ma vedendo che per detta terminatione sue signorie clarissime sono fatti giudici, havendosi lassato intender che a me non vogliono dar cosa alcuna, non mi par giusto che in una eccellentissima et ben regolata Republica sia permesso che debba esser giudicato per questa strada. Onde attese le predette, et molte mie raggioni benchè senz'alcuna scrittura dovrei esser sicurissimo di ottener da Vostre Signorie Clarissime larga intromissione della detta terminatione et in conseguenza larghissimo taglio nelli eccellentissimi et illustrissimi consegli, stabilissimi fondamenti di questa eccellentissima Republica, essendo a me già altre volte sopra il credito de altre mercedi dattimi altri giudici. Ma per dimostrar che l'intentione mia è stata sempre di voler non solamente quello che è giusto, ma anco di restar sempre inferiore nella ragioni quali mi competiscono (il che faccio per modestia et per cavarmi di lite) con la presente scrittura, faccio intendere ad essi clarissimi signori procuratori che per l'intromissione et taglio che seguirà a favor mio nelli eccellentissimi consigli, mi contento che sia in libertà di essi clarissimi signori procuratori di accettare un di questi due parti, cioè che volendo così detti clarissimi signori procuratori siano eletti dui periti, li più pratici, sofficienti, et intelligenti di scoltura che siano in questa città, come è stato fatto in similibus. Dalli quali tal statua sia stimata con suo giuramento, et secondo la stima di detti periti mi sia pagata, et io per urbanità mia mi contento di relassar ducati cento dalla stima che sarà fatta delle mercedi del quondam mio padre, le quali sono state lassate per particolar patrimonio per sostenar la mia povera famigliuola; overo quando non para a detti clarissimi signori procuratori di volersi servir della detta statua, et che in scrittura si lassino intender di lassarla a me liberamente, ita che come pattron libero d'essa possa disponer a piacer mio, mi contento di accettarla, et di non proseguir più oltre, et da me rinontio ogni raggion et action quomodocunque sia a favor mio per tal causa. Ma in caso che detti clarissimi procuratori non voglino accettar ne il primo ne il secondo partito, si comprenderà che voglino a torto farmi far lite della mia povertà, et con questa pomando la intromission predetta et il taglio della terminatione dell'Illustrissimo Collegio secuto etiam juditio a favor mio in excellentissimi consiliis, con questo che habbiano sue signorie clarissime in termine de giorni sei, tam ante quam post, a dire in scrittura il loro volere, overo quel piu che a Vostre Signorie Clarissime parerà. Presentata adì 5 febraro 1573 [=1574].

(*Ibid.*, fols. 4r–6r)

300. 1574, 13 januarii[1] [=1575]
Desiderosi noi procuratori de supra de venir a un fine con voi Domino Francesco Sansovino Dottor nel fatto della imagine della nostra donna sopra il che tanto ingiustamente travagliate et noi et li ministri nostri, vi dicemo che se ben conoscemo apertamente che voi trattate di far civanzo con la procuratia nostra et che vi pare far sachrificio il tentar di appropriarvi li dinari di rason della chiesa del glorioso San Marco, possendo esser certo che essendo

sta il quondam vostro padre per tanti anni nostro salariato et havendo fatto acquisto con la procuratia et di reputatione et di grossa summa di danari, non può convenirsi et meno piacere alla giustizia ch'havendo il detto quondam vostro padre da se voluto fare tale immagine et metter mano nelli marmi di raggion di detta chiesa, che possiamo noi procuratori esser in alcun obligo di farli alcun pagamento, et come dissegnate voi a stima di periti, persuadendovi vi debba reuscir con tali vostri periti d'haver miara di ducati come vi havete fatto riuscire nel fatto della porta della sagrestia.[2] Però più tosto che passar tanti disturbi per le vexation continue voi ne date, ex nunc contentiamo che pagando voi alla procuratia il marmo dal quondam vostro padre per propria sua authorità messo in opera, che era di rason di detta chiesa, o assignando un altro pezzo di marmo simile come era quello all'hora et non altramente, di detta immagine ne disponiate ad ogni vostra satisfatione et andate poi dissegnando di vostri miara de ducati con chi vi pare et piace. Il che sia sempre detto senza alcun pur minimo pregiuditio di alcuna nostra ragione et principalmente circa la giuridicione dalle leze et dalli giudici a noi adgiudicata.

(*Ibid.*, fol. 13^{r-v})

1. A protest by the procurators, dated 4 January 1575, has been omitted (fol. 11^{r-v}).
2. On the dispute over the Sacristy door, see doc. nos. 262–94.

301. 1574, 18 januarii [=1575]

Credeva io Francesco Sansovino, et tenevo per fermo con tutti coloro che hanno conosciuto il quondam missier Jacomo mio padre, che li clarissimi signori procuratori de supra vedendo i molti et molti meriti non punto volgari del detto quondam mio padre fatti sì nella predetta chiesa di San Marco, la qual stata per 30 anni su pontili fu conservata et salvata da lui, et come anco nelle cose della procuratia, dovessero pagarmi la mercede ben meritata, doppo molti anni et doppo molte fatiche fatte atorno all'imagine di nostra dona di marmo, della qual si contende, et ciò senza niuna altra contesa, perchè queste cossì fatte cause di mercede tanto favoribili non doverebbono esser tirate all'infinito per far che io fra tanto povero fiolo et herede con la mia famiglia insieme, manchi nel bisogno et necessità mia, non potendo conseguir del poco patrimonio di mio padre, il quale in gran parte consiste nella suddetta mercede per la scultura et per lo eccellentissimo artificio posto in ditta statua di marmo come altre volte si è detto in scrittura; ma io con tutti coloro che hanno notitia di questo fatto vegiamo per le scritture presentate per nome di essi clarissimi signori procuratori che succede tutto il contrario, perché mi vien tratenuto il mio contra giustizia, et del mio vien fatta litte e litte di sorte che Dio ne guardi ogni uno, atentochè essi clarissimi procuratori vogliono esser giudici et parte, il che non comportò ne comporterà giamai la giustitia di questa Serenissma et veramente Christiana Republica. Ma quel che più mi preme fin nell'interno dell'anima et che in ricompenso della longa, assidua, importante, et fidelissima servitù fatta dal detto mio padre per lo spatio di 47 anni et più, in cambio de' suoi infiniti et segnalati meriti, essi clarissimi signori faciano dir in scrittura, doppo la morte sua, che mio padre da se ha voluto far tal imagine et da se habbia messo mano nelli marmi di detta chiesa, cosa tanto contraria alla verità (et sia detto con ogni rispetto) quanto è il lucidissimo giorno alle oscurissime tenebre della notte. Ne so ne se ne possa imaginarmi per qual causa detti signori clarissimi facino adesso diseminar così fatta zizania, essendo il fatto in contrario che dal 1536, che fu cominciata l'opera, fino al 1574 alli 13 del corrente mese, tal vanità non è mai più stata, né in voce né in carta publicata, perché non solamente

non ha del vero ma ne anco del verissimile che mio padre riputato da tutta la città per homo giudicioso et di notabile integrità (or sia detto senza invidia) havesse come scultore posto mano per suo capricio nella roba di altri, et che sudasse 30 et più anni a far opera così nobile et eccellente per esser poi ripreso di temerario, et di arrogante, et di troppo licenzioso a intrometersi dove non li tocava, essendo certo che a un tempo stesso harebbe perduto, sì come si dice in proverbio, l'opera et l'olio. Et poi qual prudente giudice può credere che li clarissimi procuratori di quel tempo non solo illustrissimi per l'opere nobilissime fatte sotto di loro, ma illustrissimi per la grandezza dei loro animi heroici, havessero comportato che ne loro magazeni si lavorasse tanto tempo et si mettessero in opera i marmi della chiesa senza loro ordine et volontà. Certo che oltra che questo non è credibile; risulta anco in biasmo di quei clarissimi senatori perciochè pareria che non procurando, ma serando gli ochi havessero lassato in abbandono le cose della lor chiesa, il che è sacrilegio a dire. Perché essi che furono senatori honoratissimi in quei tempi procurarono sempre con ogni spirito la grandezza, la degnità, et l'ornamento di quella chiesa nella quale si vedono i pergoletti di rilievo delle historie di San Marco, li quatro evangelisti di metallo all'altar grande, la porta di bronzo alla sagrestia, et la portella dorata all'altar del Sacramento, tutte opere del quondam mio padre et degne di quel Tempio, il quale è il più ricco et il più celebre, et meraviglioso che sia nell'Europa, et nel qual Tempio doveva esser collocata l'imagine sopradetta, sicome i clarissimi procuratori hanno con la propria voce detto et testificato quando si tratò di acomodar di sopra nelle sale del Collegio ne mesi passati alcune belissime colone tolte a Puola di luogo sacro,[1] et come anco è manifesto a tutto il mondo che detta statua si faceva per detta chiesa, et si procurava sotto diversi cassieri, et spetialmente sotto il clarissimo missier Zuane da Lege quando era cassiero, il finimento dell'opera per collocarla in detta chiesa, le quai tutte cose mi offerisco di giustificare in caso che tal fatto mi sia negato in scrittua, altramente voglio che si habbia per comprobato. Non può star adunque che mio padre da se metesse mano ai marmi della chiesa, la qual verità si scuopre anco per altra strada perché per le polize[2] fatte per mio padre dal 36, che fu cominciata l'opera, il mese d'ottobre, fin al sussequente febraro, che sono in gran numero et comprendono cossì le fature fatte atorno la statua per disgrossarla, come in molte et varie cose, pertinenti a detta chiesa, appar che la procuratia a bossoli et ballotte ha pagato il tutto. Il libro di mio padre insieme con molti anni [*sic*] che sono riscontri delle polize poste in procuratia è in essere et è produtto. Facino li clarissimi procuratori trovar le polizze in filza, et scontrando troverano che io dico la verità. Ne possono scusarsi che tal partite non si trovino perché saria troppo gran cosa che tante et tante polizze, le qual contengono centenara de ducati, fossero smarite, ma più che queste sole dove si vedono i pagamenti dei lavoranti che hanno sbozzato la detta statua non si trovino et l'altre de altre qualità siano in essere. Però si conclude per le raggion suddette che mio padre di ordine delli clarissimi procuratori facesse detta imagine, et cossì di tempo in tempo furono pagati per la summa di 30 in 40 ducati coloro che sbozzarono il marmo, riducendolo a tal termine che mio padre poi con la propria mano, usando per molti anni faticosissima diligentia, diede con artificio mirabile quasi il sentimento et lo spirito alla detta imagine di marmo. Della qual opera singolarissima per universal giudizio d'ogn'uno, non solamente mi è tenuta la mercede, ma è calumniato a torto il quondam mio padre per suo fidelissimo et benemerito servitore. Ne voglio anco tacere questa contrarietà delle scritture presentate per nome di essi clarissimi signori procuratori che alli 4 del corrente vien detto che mi udiranno con ogni sincerità et al sicuro satisfaranno a quanto porta l'obbligo della conscienzia di loro

signorie a bossoli et ballote, le quai parole se bene sono generali pure concludono di voler satisfar, la qual satisfatione presupone l'obligo che hanno di satisfarmi della mia mercede, altramente la ditta scrittura sarebbe di vento et con questa scrittura si scancellano quel che essi dicevano, cioè che mio padre, non haveva ordine da loro di far tal opera. Ma se questo è vero, come è vero che fosse ordinata, come possono voltar dicendo che mi daranno la statua purché io paghi loro il marmo, volendo per questa strada farmi condescendere che ad arbitrio loro si termini a bossoli et ballote la mia mercede, et che poi tal giudizio sia innapellabile: cosa absurda et di troppo pregiudicio per non dire altro. Et queste scritture et partite loro sonno messi a campo, doppo che uno intero anno intero mi hanno tratenutto con bone parole di pagarmela, havendo intanto mutata la statua di luogo a luogo sotto diverse chiavi et postala nella più occulta parte della libraria di San Marco, togliendomi l'occasione di poterla mostrare et contratar per prevalermi del mio, volendo che io mi contenti di una mica. Però sebene il termine della mia causa è facile, cioè che contra le leggi, contra l'honesto, et contra le cose giudicate in tal materia, non conviene che detti clarissimi procuratori siano giudici et parte come è stato disputato. Però dico, respondendo alli loro partiti, che il dover vuole che la mercede mia sia stimata per periti sicome in similibus si è sempre osservato, et si osserva. Et perché voglio uscir di travaglio, dico che della stima che sarà fatta son contento di lasciar loro ducati non solamente cento ma 150 ancora. Et con la presente domando intromissione et taglio della terminatione fatta sotto dì 27 di gennaro proximo passato.

Die 18 Januarii 1574 [=1575]
Presens scriptura presentata fuit per excellentem dominum Franciscus [sic] Sansovinum doctorem, in causa quam habet cum clarissimis dominis procuratoribus de supra.
Die dicta
Aloysius Calucius famulus officii retulit intimasse presentem scripturam Domino Aloysio Leoneo advocato et intervenienti pro suprascriptis clarissimis dominis procuratoribus ad instantiam ut supra.
Marcus Franchinus officii advocarie notarius subscripsit.

(*Ibid.*, fols. 15ʳ–24ʳ)

1. This is a reference to the twenty-two antique columns removed from the church of Santa Maria del Canneto at Pula, in Istria, which was effected by Sansovino at the behest of the procurators, who held the *ius patronatum* of the church. See Gallo (1926), pp. 12–16.

2. See doc. no. 87.

302. MDLXXIIII, xxii januarii [=1575]
Vorebbe al presente ritirarsi l'eccellente missier Francesco Sansovino dalla proposta fatta per la precedente sua scrittura per la quale ha detto di tener per suo conto l'immagine contentiosa, et vorria pur redur noi procuratori de supra a tuorla, con offerir stando a giudicio di periti di relaxar ducati 150 ove prima offeriva ducati 100, sapendo ben lui quanto li torneria a commodo il farsela pagar a giudicio di periti, et di quanto si avantaggierebbe, ma che bisogna più versar in tali partiti, et meno che vogliamo esser giudici, ut in ea se gli havemo ditto chiaramente in scrittura che se la tenga per suo conto dandone almeno tanto marmo ò satisfacendo quello per il pretio che vale, che non si partiamo già in questo dal ragionevole, havendo da se stesso il detto suo padre posto mani in la robba della chiesa et vanamente dissemina et contra ogni verità anchora che dalla procuratia gli siano stati dati denari per pagar li mercenari hanno lavorato tal immagine perche, usata ogni possibile diligenza, non si è trovata cosa alcuna, et se così fosse, che però non è, saria tanto più avantaggiato et quando

anco potesse esser, che non si crede, che gli fosse stato datto da qualsivoglia procurator a parte parola alcuna, questo non obliga la procuratia ne la chiesa, ma tutte sono disseminatoni piene di artificio et lontane dalla nostra conclusione. La somma è che non vogliamo tal sua immagine ne sapiamo che farse ne; però pagato il marmo o datone simil altro pezzo ne idsponga a modo suo, ne più mai si prendi gioco di travagliar noi et li ministri nostri.

1575 die 8 martii
Presentata ad Clarissimum Consilium de XL Civile Vetus per eccellentem Dominum Aloysium Lionum intervenientem nomine clarissorum dominorum procuratorum de supra in causa cum Domino Francisco Sansovino doctore nomine quo intervenit.

Die 9 dicti
Intimata per Antonium Theupulum famulus officii Domino Francisco Sansovino doctori[1]

(*Ibid.*, fol. 25ʳ⁻ʳ)

1. Several similar statements and intimations have been omitted here (fols. 27ʳ–32ʳ).

303. MDLXXV die vii mensis aprilis
. . . Si è accettata per noi Procuratori de supra la oblatione fatta per voi Domino Francesco Sansovino dottor a l'Officio de l'Avogaria, non a fine di voler usar quella all'Eccellentissimo Consiglio de XL Civil Vecchio ove ne fatte citar, fingendo sagacemente di così credere, ma a fine solamente di ressecar tutte le putride cavilationi da voi introdute a metter fine a ogni vostro garbuglio et non habbiate in preda (come dissegnate troppo accortamente) li beni della giesia del glorioso San Marco; però debito nostro è di metter fine a tanti stratii e tuorvi la vostra immagine, la qual sta a voi di venirvela a tuore sempre, che vi pare et piace, che vi serà prontamente data et ve ne valerete come vi pare, non essendo quella a niun modo a proposito, ne di alcun bisogno per essa gesia, il che vi si è voluto dire per assicurarvi che non è più alcun bisogno di altra litte ne di alcuna nostra comparitione in alcun loco, protestandovi in ciò per ogni meglior modo, et sii sempre senza alcun pregiudicio di essa giesia, etcetera, salvis etc.
Franciscus Rheinus venetus notarius manu propria subscripsit.[1]

(*Ibid.*, fol. 33ʳ; Ongania and Cecchetti, 1886, pp. 37–41, nos. 200–14)

1. Some documents which do not contribute materially to the conclusion of the case have been left out; a few of these can be consulted in Ongania and Cecchetii (1886), pp. 37–41, nos. 200–14.

304. Albrecht V, Duke of Bavaria, to Francesco Sansovino, 29 May 1574
Habbiamo veduto la prontezza dell'animo vostro nel nostro servitio, e ne saremo sempre ricordevoli. Quanto alla historia nella quale illustrate le cose di casa nostra, vi riconosceremo come ben si conviene, et per più sicurezza, farete capo a Francesco Braccherio nostro agente. Quanto alla statua della Vergine, potrete mostrarla al detto Braccherio, al quale diremo la volutà nostra.[1] Di Starimbergo, alli 29 di maggio 1574.

(Sansovino, 1580, pp. 169ᵛ–170ʳ)

1. This letter may concern an attempt by Francesco Sansovino to sell the *Madonna di marmo*, which he obtained from the procurators after a lengthy legal struggle; see Lorenzetti (1929), p. 128. There is, however, a problem concerning the date of the letter. Since Francesco Sansovino only took possession of the statue in May 1575, he wouldn't have been in a position

to offer it to the Duke of Bavaria in May 1574; consequently, the printed date may be a mistake for 1575. Cicogna 1824–25, IV, p. 74, no. 71, refers to the same letter in the 1625 edition of the *Secretario* as dating from 1572, which must also be a typographical error. The publication referred to by the duke was published by Sansovino in honour of the marriage of Giovanna d'Austria with Francesco de' Medici in 1565.

305. An autobiographical sketch by Francesco Sansovino

The following lines were written to Gian Filippo Magnanini, secretary of Cornelio Bentivoglio on 15 December 1579. In the introductory passages, Sansovino says that they both are Florentine by blood but have ended up in foreign places, Magnanini in Ferrara, Sansovino in Venice. He then goes on:

. . . Nacqui adunque (come ho detto) in Roma sotto il felicissimo pontificato di Papa Leone Decimo, l'anno 1521. Mi trovai nel sacco memorando di quella Città, et vidi finalmente la Republica di Fiorenza risolversi in Principato. Di quindi trasferitomi a Venetia, dove mio padre buonae memoriae s'era salvato dal sacco, con honorata procisione da questo Serenissimo Dominio per suo ingeginero. Giunto in porto di salute, fui posto allo studio delle prime lettere sotto Stefano Plazone et Iovitta Rapicio, huomini chiari, et eccellenti nella loro professione. Gustai parimente la lingua greca sotto Antonio Francino da Monte Varchi, ma impedito dalla troppa frettolosa voglia di mio padre, posto alle leggi in Padova prima, et poi in Bologna, consumai il tempo assai vanamente et non essendo io punto inclinato alle leggi . . . me ne tornai a Roma, in tempo che Giovanni Maria de' Monti, fu fatto papa et chiamato Giulio Terzo. Et da lui lietamente raccolto (percioché in privata fortuna mi haveva l'anno 1521 tenuto a battesimo in Santo Eustachio) non è da domandare quanto la speranza (che è veramente la quinta essentia dell'huomo) mi aviluppasse ne suoi indissolubili intrighi. Ma ella non seppe farsi, che parte chiaritomi tosto di quegli andamenti non punto a proposito mio, et parte trafitto di continuo da acerbissime lettere del mio vecchio, et di diversi altri gravissimi Senatori suoi padroni et amici, piantata la corte, io non ritornassi si nuovo a Venetia . . . [Here follows an account of his career as a writer, then some concluding lines on Venice.] So bene io questo, che sopra tutte l'altre cose mi piacque la libertà. Et però terrò sempre obligo eterno a mio padre, che dopo il sacco, dovendo andare a Parigi, chiamato dal Re Francesco Primo, et giunto in Venetia, non solamente si fermò per i predetti giorni, ma ci visse 47. anni, et finalmente ci si morì, con quella honorevolezza che sa tutto il mondo, et che si legge nella sua vita scritta da Giorgio Vasari Aretino ne suoi tre volumi . . .

(Sansovino, 1580, pp. 219r–221v)

Zuane di Primao da Lezze and his family monument

306. Testament, 3 September 1550

. . . circa la mia sepoltura voglio che il prefato chiarissimo padre et commissario habbia a far far uno deposito in giezia di chrosechieri, o altrove dove a sua magnificentia parera al modo et con quella spesa in questo et circa le altre cose della mia xequie in tutto et per tutto come li piacera, nel qual deposito over archa del deposito non voglio che siano posti altri corpi che a quel di sua magnificentia et il mio.

(ASV, not. test., Bianco, co., busta 79, no. 496, fol. 1v)

307. Codicil, 2 March 1561

. . . voglio che sia fatto un deposito nella giesia di frati de

Crosechieri nella qual l'ossa dil quondam chiarisimo mio padre siano con il mio cadavere acompagnato nel qual deposito siano per il manto spesi ducati quatrocento . . .

(*Ibid.*)

308. Testament, 26 July 1576

. . . Et prima quando piacerà al Signor Dio chiamarmi à se prego humilmente la sua infinita misericordia, che si degni haver pietà de le mie colpe. Lasso che li mei comissarii habbino cura di sepelire il corpo mio nello emolumento alli Crosechieri con quello modo, che à loro parerà: et non essendo finito per sorte esso emolumento debbano con ogni diligentia farlo finire secondo la forma, patto, e condicion, che e dechiarito nello scritto fatto con maestro Cristopholo de Zorzi posto nelo mio catastico a karta 290. Commissarii et et esequutori della mia voluntà voglio che siano li mei cari fioli, et heredi . . .

(ASV, not. test., Secco, G., busta 1194, IV, fol. 85v)

The statue of St Anthony of Padua in San Petronio

309. Cappella dedicata a S. Antonio di Padova appartiene al signor Conte Cavaliere Ottavio Prospero Ranuzzi Cospi—La statua marmorea di S. Antonio è opera di Giacomo Sansovini. (undated)[1]

(Archivio di San Petronio, Misc. IIa, raccolta di recapiti riguardanti la nuova chiesa di S. Petronio, no. 5, mazzo 21; cited by Pittoni, 1909, p. 36)

 1. The transcription of this document is taken from Pittoni.

310. Ferdinando Cospi in Bologna to Cardinal Leopoldo de' Medici in Florence

Serenissimo et Reverendissimo Signor et Patrono Colmissimo, io ho una cappella povera nella Collegiale di San Petronio in questa città dedicata a Santo Antonio di Padova, ove è gran concorso per la devotione al Santo, ch' è una statua di mano del Sansovino, et io ho speso qualch' migliaia di scudi per renderla conspicua con molti ornamenti di pittur' e pur anco in seguitando come farò fin ché vivo per ridurla una delle più belle et prezziose [?] in Piazza et in chiesa, con principali, oltre li cittadini, tutta la foresteria di continuo sono a venerarla, havendosi anco reliquia del Santo ornata di gioie ch' è quasi unica. Mi manca solo una indulgenza fuori del ordinario che certo sarà ben impiegata et in benefitio della pietà cristiana . . .

(ASF, Archivio Mediceo Principato, Cardinale Leopoldo, filza 5533, no. 36, letter 8; Pittoni, 1909, pp. 39–40)

311. 15 December 1509

Jacopo Sansovino buys marble from Bello di Jacopo de Vanello and Leone di Jacopo de Puglia, both from 'Torano villa del Carrese': 'Peciam unam figure de marmore alto saldo et netto' 4½ × 1¾ × 1½ braccia fiorentina, for 26 ducats. 'duas alias figuras' each 3¼ × 1⅓ × 1 braccia and 'duas alias figuras' each 2½ × 1 × ¾ braccia, at 2 ducats per carratta, for a total of 36 ducats. These were carried to 'la spiagia de la Veccha [Zecca ?] Romana', on 7 May 1520. Nic. Perottus not.

(Biblioteca Casanatense, MS 4056, Spoglie di G. Amati, fol. 61^1)

 1. John Shearman kindly furnished me with the transcription of this document.

Notes to the Text

Notes to Chapter I

1. See doc. no. 1, printed in the appendix. The most comprehensive, early source of information on Sansovino is Giorgio Vasari's biography which was first published in the 1568 edition of the *Vite* and then reprinted in an amended version after Sansovino's death in 1570. Citations from Vasari's *Vite* will be from Milanesi's edition; for Sansovino, see Vasari, VII, pp. 485–533. For a recent, extensive account of Sansovino's early years and career up to 1527, see Garrard (1970). Among the earlier literature, see especially Lorenzetti (1910-I) and (1913); Weihrauch (1935); and Pope-Hennessy (1970), pp. 350–53.

2. Vasari, VII, pp. 485–86; and here doc. no. 2.

3. On the Florentine building trade and its overlapping guilds, see Goldthwaite (1980), pp. 242–86. A notable example of a bridal chamber decorated with paintings and marquetry was commissioned by Pierfrancesco Borgherini and coordinated by Baccio d'Agnolo for the Borgherini Palace; see recently Braham (1979). The document concerning the baldachins is no. 18.

4. See the detailed account given by Pope-Hennessy (1970) and (1971); and also Seymour (1966), pp. 15–19, 29–53. For Carrara and its quarries, see Klapisch-Zuber (1969).

5. Michelangelo's remark is reported by Condivi (1976), pp. 6–7.

6. Vasari, VII, p. 486, n. 2. Michelangelo was born some distance from Florence, at Caprese in the Casentino, where his father was *podestà* or mayor; see Barocchi (1962), II, pp. 57–58, n. 42.

7. Jacopo entertained high hopes for his son's career; see Francesco Sansovino's autobiographical letter, partially reprinted here as doc. no. 305.

8. On Andrea Sansovino, see Huntley (1935) and Pope-Hennessy (1970), pp. 344–50, with further references.

9. Andrea's correct name and approximate date of birth were established by Girolami (1941), pp. 6–9.

10. It would be more correct to say *displayed*, since the Baptist's arm had already been replaced in 1937. The right arm of Christ was damaged by a hail storm in 1975. For their recent restoration, see the note by Giusti in Forlani Tempesti et al. (1986), pp. 55–58.

11. The morphology of Andrea Sansovino's figures suggests a strong influence from Verrocchio, though Perugino's fresco in the Sistine Chapel has also been suggested; see Carmignani in Forlani Tempesti et al. (1986), pp. 53–54. Keutner (1977) proposed that Vincenzo Danti, who completed the pair, carved the Christ after Sarto's analogous fresco in the Chiostro degli Scalzi.

This seems less likely than the alternative, namely that Sarto's fresco was inspired by Andrea Sansovino's group; see Shearman (1965), I, pp. 61–62.

12. The connection with Ghiberti's relief of the same subject on the north door of the Baptistry was first made by Burckhardt in *Der Cicerone*; see Burckhardt (1929–34), IV, p. 51. The pose and profile of the Baptist can be compared with Ghiberti's *St John the Baptist* on Or San Michele; see Krautheimer (1970), II, pls. 4, 9a.

13. Huntley (1935), pp. 49–52, figs. 32–33; and Pope-Hennessy (1970), p. 345.

14. Huntley (1935), pp. 57–64; and Pope-Hennessy (1970), pp. 346–47.

15. On this subject and the cartoon now in the National Gallery, London, see esp. Kemp (1981), pp. 213–27; and Clark (1988), pp. 162–69.

16. For the political background to this period, see Rubinstein (1960) and Stephens (1983); on the decoration of the hall of the Great Council, see Wilde (1944).

17. See the comments in the biographies of Sarto and Bandinelli in Vasari, V, pp. 7–8, and VI, p. 137, respectively.

18. Workshop practice is discussed more extensively in chap. x, but see the remarks by Caplow (1974) and Wackernagel (1981), pp. 308–37.

19. On Sansovino's use of the *St George*, see chaps. v and ix.

20. See here p. 17, and chap. ii, p. 34. Sarto also employed the same figure in one of his San Filippo Benizzi frescoes at Santi Annunziata; see Shearman (1965), I, p. 25, pl. 8b.

21. See below p. 19, and chap. iv, p. 62. Reminiscences from the *Isaac* panel on the Gates of Paradise can also be found in Sarto's San Gallo *Annunciation*, reproduced here as fig. 61.

22. Vasari, IV, pp. 510–11; see Huntley (1935), pp. 8–12, fig. 2. On Lucca della Robbia's use of glazed terracotta, see Pope-Hennessy (1980), pp. 33–41. It is worth noting here that Sarto painted portraits of Andrea della Robbia and his sons in the San Filippo Benizzi frescoes, according to Vasari, V, p. 13.

23. See chap. vii, pp. 100–01; and Pope-Hennessy (1980-I), pp. 60–66.

24. See now the comments by Gentilini in Paolucci (1980), pp. 67–88. On small models and *bozzetti*, see also Schlosser (1913); Keller and Ress in RDK, II, cols. 1081–90; Lavin (1967); and Dent Weil (1978), pp. 113–34.

25. Pope-Hennessy (1964), I, pp. 191–96, and II, pp. 406–09, with further references.

26. Venturi, X-1, p. 72, n. 1, described it as 'interamente

dominato dal principio pittorico leonardesco'; see here cat. no. 2 and the following note.

27. Bode (1902), pp. 1–4; and Gentilini in Paolucci (1980), pp. 97–98, no. 28.

28. See cat. no. 1.

29. Vasari, VII, p. 488; see Fabriczy (1902), p. 10.

30. Bruschi (1977), pp. 163–67.

31. Jacopo's friendship with Bramante and Pinturicchio is mentioned by Vasari, VII, pp. 489–90.

32. The head of *Hope* is based on the *Apollo Belvedere* while its basic morphology and drapery recall paintings like *Hope* and *Faith* by the Pollaiuolo brothers for the Mercanzia in Florence; see Ettlinger (1978), pp. 142–45, no. 12. A similar combination of classical and 'modern' features can be found in the Virgins by both Sansovinos in Sant'Agostino in Rome (figs. 66, 72) and in Jacopo's Loggetta gods, for which, see chap. v.

33. Uffizi 1760A, measuring 28.4 by 21.5 cm, drawn in pen over lines incised with a compass. On the back is written in pencil: 'la scrittura è del Sansovino e corrisponde alla lettera reprodotta dal Pini Milanesi 1876, 2° vol., n. 180'. See also cat. no. 132.

34. According to his will of 1568, Sansovino's drawings, other than those retained by his son Francesco, were to go to a builder named Salvador quondam Vettor; see doc. no. 256, and chap. x, pp. 156–57.

35. On Sangallo's professionalism as an architect, see Frommel et al. (1984), pp. 241–306; see also the articles by Bonelli and de Fiore in Spagnesi (1986), pp. 407–21.

36. See the comments by Burns (1975), pp. 84–85.

37. Vasari, VII, pp. 488–89. On the sculpture collection in the Belvedere, see especially Brummer (1970).

38. Bernini's remark comes in his address to the French Academy; see Chantelou (1985), p. 167. On the *Apollo Belvedere*, see Brummer (1970), pp. 44–71.

39. Bober and Rubinstein (1986), p. 109, no. 74; see also here chap. iii, pp. 47–48.

40. Bober and Rubinstein (1986), pp. 54–56, nos. 6, 8. Sansovino employed a modified version of the apron-like folds of the *Juno Cesi*'s himation on his Nichesola *Madonna* (fig. 112) and in some of the female spectators in his *Maiden Carilla* relief (fig. 260).

41. See pp. 13–14.

42. See doc. no. 256, and also chap. x, pp. 156–57.

43. See chap. iv, p. 59, and chap. ix, p. 133.

44. See doc. no. 67.

45. Vasari, VII, p. 489; see cat. nos. 4, 83.

46. Shearman (1977), pp. 136–40; and Garrard (1970), pp. 99–100. Garrard hypothesized a date in the first half of 1508, but Shearman noted that Raphael was documented in Florence in April 1508, apparently remaining there for several months. In any event, the competition had to take place prior to Berruguete's departure for Florence in July 1508, as both Garrard and Shearman agree,.

47. Vasari, VII, p. 489.

48. See Perry (1978), pp. 221–22, 242.

49. Conti (1893), pp. 174–75.

50. Fabriczy (1896), pp. 159–60; see here cat. no. 4, for a discussion of the three versions.

51. Uffizi 14535F, measuring 33.5 by 22 cm, undersketch in black chalk, drawn over in red; see also cat. no. 129.

52. See Shearman (1965), I, pp. 24–25, and pl. 16 a, b, c.

53. I am grateful to Michael Hirst for suggesting the comparison with Michelangelo's black chalk studies; see Tolnay (1975–80), I, pls. 50^{r-v}, 51. Vasari mentions Sansovino's study of

the *Cascina* cartoon in his life of Bandinelli; see Vasari, VI, p. 137.

54. The drawings are Louvre 2712 and 2732, respectively; and see cat. nos. 130–31

55. This would indicate a date around 1510 for the drawing, following the completion of Raphael's fresco; see Dussler (1971), pp. 73–74.

56. See cat. no. 5.

57. Vasari, VII, p. 490; and Canuti (1931), I, pp. 194–97. Garrard (1970), p. 70, argues for a date closer to 1510, but this would contradict the circumstantial evidence of Vasari's account. Despite its accomplished style, I see no reason to place the *Descent* later than 1508.

58. Middeldorf (1936), p. 252. Vasari, III, pp. 586–87, reports the criticism levelled against Perugino's figures.

59. Compare the definition of *rilievo* given by Baldinucci (1681), pp. 135–36: 'E si dice anche rilievo a figura di cera o gesso, della quale si servono i pittori per immitare quando fanno i lor disegni e pitture.' Middeldorf (1936), p. 256, also draws attention to the peculiar nature of the work: 'il Sansovino non dette alla sua Deposizione di croce nè la forma di un vero e proprio rilievo nè quella di un vero e proprio gruppo statuario, e raggruppò invece le sue figure in un insieme panottico, ciò avvene senza dubbio per riguardo al pittore'.

60. Canuti (1931), I, pp. 185–90; Hamburgh (1978), II, pp. 363–71; and Scarpellini (1984), p. 114, no. 144.

61. Zucker (1984), pp. 104–05, with further references. Garrard (1970), pp. 79–85, draws attention to the Mantegnesque engraving but believes that Dürer's woodcut of the same subject in the *Small Passion* of 1509 was a stronger influence. My own view is that the similarities are not close enough to ascribe a role to Dürer's print in the genesis of Sansovino's *Descent*.

62. Middeldorf (1936), p. 258.

63. See Bober and Rubinstein (1986), pp. 146–47, nos. 117–18.

64. Grayson (1972), pp. 74–75: 'to represent the limbs of a body entirely at rest is as much a sign of an excellent artist as to render them all alive and in action' (*De pictura*, II, 37). Raphael's *Entombment* was painted for Perugia in 1507, but Shearman (1977), p. 133, sees Roman influences in its general composition.

65. Vasari, VII, pp. 490–91.

66. Quoted by Freedberg (1961), p. 192; for this period in Florentine art, see (1961), pp. 91–258, and (1971), pp. 49–64. For the historical background, see Stephens (1983).

67. Vasari, VII, p. 491. The date must remain approximate since so little is known of the whereabouts of Bandinelli and the other competitors. In addition, Vasari jumbles up incidents from before and after Jacopo's first Roman period as in the case of the *St Nicholas of Tolentino*, on which, see p. 17. See also cat. no. 8.

68. See cat. no. 8.

69. Sansovino was supposed to have carved crucifixes for Giovanni Bartolini and for the church of San Marcello in Rome as well as assisted Nanni Unghero on the *St Nicholas* in Santo Spirito; see Vasari, VII, pp. 488, 494, 497; and here cat. nos. 65–66.

70. On the serpentine figure, see Shearman (1967), pp. 81–88; and Summers (1972), esp. p. 282.

71. Vasari, IV, p. 223; see also Freedberg (1961), I, pp. 199–201; and Borgo (1976), pp. 100–12, 318–25, no. I-20. I am grateful to Michael Hirst for drawing my attention to the significance of Albertinelli's painting for Sansovino.

72. For his career, see Berti (1963).

73. See Ginori Lisci (1953) and (1972), I, pp. 317–22; and De Juliis et al. (1978). See also cat. no. 6.

74. See esp. Hirst (1981-I), pp. 590–93, appendix c.

75. Cf. Cellini's opinion that a statue had eight principal viewpoints, expressed in his letter to Benedetto Varchi and reprinted by Barocchi (1960–62), I, p. 80. Weihrauch (1935), p. 13, already observed that the relationship between Michelangelo's and Sansovino's *Bacchus* was not so much one of dependence as opposition.

76. See cat. no. 6 for these quotations and other critical comment.

77. Mansuelli (1958–61), I, pp. 133–34, no. 98. The statue's original height is 1.4 m, and its restored height is 1.85 m. On Renaissance sketches after it, see Bober and Rubinstein (1986), p. 108, no. 73. Alternative classical sources for the *Bacchus* are discussed in cat. no. 6.

78. Furtwängler (1912–13), I, pp. 190–212.

79. Even closer to the *Bacchus* are two satyrs with a Farnese provenance, now in the Museo Archeologico of Naples. They show a satyr with its right arm raised, its left holding a cup, and the left leg drawn back to suggest movement (fig. 43); see Ruesch (1911), p. 84, nos. 266 (6631) and 264 (6332). The original part of the statues are the torsos and upper legs, but it is not known when they were restored nor can one dismiss the possibility that their restoration was influenced by Sansovino's work.

80. The observation of Gorri (1731–62), III, p. 57, is typical: 'cum antiquis Graecorum, & Romanorum Statuis coniungendum est, quod eorum gloriam, studium, atque artificium non aemulatur solum, verum etiam facile exaquet'.

81. See Gallo (1986). For Sansovino and Giambologna's early bronze *Bacchus*, see esp. Holderbaum (1983), pp. 34–36, 72–77.

82. See cat. no. 7.

83. On the apostles, see the brief history given by Paatz (1940–54), III, p. 373, nn. 270, 272; and also Barocchi (1962), II, pp. 225–28, n. 183. On Michelangelo's *St Matthew*, see esp. Pope-Hennessy (1970), pp. 310–11.

84. Poggi (1988), no. 2276; the decision concerning the pavement is found in ASF, Arte della Lana, Riformazioni, LV, fol. 40ʳ⁻ᵛ.

85. Doc. nos. 3–30.

86. Andrea Sansovino's contract for the two statues of Sts Thadeus and Matthew is dated 28 June 1512 while Rovezzano's for St John is 28 September and Ferrucci's for St Andrew is 13 October of that year. Thus the new commissions for statues fell either side of the change of regime without any change of policy. On the events of 1512, see Stephens (1983), pp. 56–123.

87. In 1514 Ferrucci had been given a commission to carve a second statue of St Peter, but this was given to Bandinelli in January of the following year; see Vasari, IV, p. 479, n. 2, and VI, p. 141; as well as Poggi (1988), no. 2172.

88. Shearman (1965), I, pp. 229–30, pl. 46a.

89. The observation comes in his *Randglossen zur Skulptur der Renaissance*, printed in Burckhardt (1929–34), XIII, p. 274.

90. 'Nolo, quod pulchrum illi ducunt, pugilem aut ludionem scaenicum gestiat; sed ex vultu totaque corporis facie gratiam et maiestatem deo dignam . . . Huiusmodi in templis ponendas statuas, reliquas vero theatris et profanis aedificationibus demandandas statuo' (*De re aedificatoria*, VII, cap. xvii; cited here in the edition of Orlandi and Portoghesi, 1966, II, p. 663). The significance of this observation for Renaissance sculpture was noted by Burckhardt (1929–34), XIII, pp. 274–75, 330. On Alberti and sculpture, see also Riess (1979).

91. Vasari, VI, p. 136; see also Holderbaum (1967) and Weil-Garris (1981).

92. The highly mannered pairing of the middle fingers of the *St James's* left hand apparently originated in Florentine art of the middle of the previous century. It can be seen in the [...] the altarpiece by the Pollaiuolo brothers for the ch[...] Cardinal of Portugal at San Miniato and in Rossellino['s] the Virgin and Child for the same chapel; see Ettlinger ([...] 18; and Pope-Hennessy (1971), pl. 55. On the hand and g[...] in Renaissance painting and poetry, see Mirollo (1984), pp.[...] 59.

93. See Rossi (1974), pp. 105–06; and Davis (1981), [...] 292–93; see also here chap. xi, p. 159.

94. Middeldorf (1929), p. 490.

95. De la Moureyre-Gavoty (1975), no. 136; and here cat. no. 9.

96. Weihrauch (1935), pp. 18–20; and Middeldorf (1936).

97. They are mentioned in passing by Fornaciai (1903), p. 73. Middeldorf (1936), p. 248, suggested they might be by Nanni Unghero or someone close to Jacopo, around 1511, but they were probably carved by Andrea Ferrucci; see cat. no. 62.

98. Between 1506 and 1513 the chapel of San Giovanni Gualberto at the abbey of Pasignano was rebuilt, and Benedetto da Rovezzano was entrusted with the tomb for the saint; see Luporini (1964), pp. 128–31, no. 14. Benedetto also executed a fireplace for Bindo Altoviti after a design by Sansovino; see Vasari, VII, pp. 492–93; and Luporini (1964), pp. 157–58, nos. 31–32.

99. Shearman (1965), I, p. 19, has shown that Nanni was Baccio's assistant at Santissima Annunziata from 1506 and supplied scaffolding for Sarto's San Filippo Benizzi frescoes. He also worked at Gualfonda and on the Bartolini Palace under Baccio, later becoming an architect and engineer in Pistoia, Pisa, and Lucca. See Thieme–Becker, XIV, pp. 102–03; Gurrieri (1976); Bartolini Salimbeni (1978); and Gianneschi and Sodini (1979).

100. Parronchi (1971); and here cat. no. 60.

101. On Franciabigio's role, see Vasari, V, p. 191; McKillop (1974), pp. 147–50, no. 21; and Skubiszewska (1975). On Franciabigio's authorship of the Louvre drawing for this altar, see here cat. no. 144.

102. Krautheimer (1970), pp. 95–110.

103. Shearman (1965), I, pp. 2–3; also Cecchi in Chiarini et al. (1986), p. 47.

104. Vasari, VI, pp. 609, 618; also, for Rustici Pope-Hennessy (1970), pp. 340–42. On Gaddi and Sansovino, see Cecchi in Chiarini et al. (1986), pp. 48–50, with further references.

105. Shearman (1965), I, p. 2. For Bandinelli's brief period of study under the obscure painter Girolamo da Buda, see Vasari, VI, p. 135; and Hirst (1963).

106. Vasari, VII, pp. 492–93; and here chap. ii, p. 25.

107. Vasari, IV, p. 531. The context suggests 1512, and Vasari speaks of a fireplace and a sink or basin. For the drawing of the fireplace, see Stix and Fröhlich-Bum (1932), p. 20, no. 137ᵛ; it was first discussed by Shearman (1961), p. 230, n. 31.

108. Garrard (1970), pp. 275–76, and 302, n. 9, misinterprets the passage in Vasari and believes that fireplace and putti were removed to form a fountain. The Albertina drawing shows the fireplace as it was in the Altoviti palace and not as part of a fountain; see Shearman (1961), p. 230, n. 31; and here cat. no. 82.

109. Vasari, VII, pp. 488, 493, and VI, p. 58. The palace of Giovan Francesco Ridolfi was built around 1520, possibly by Baccio d'Agnolo; see Ginori Lisci (1972), II, pp. 711–16. See also cat. no. 89.

110. Vasari, VII, p. 512. For the Master of the Unruly Children, see here note 25. I do not accept the attribution of a lost

...ctions of Mantua and Charles

...n (1965), I, pp. 30–31; Garrard

...no. 120.

...29–30; and Garrard (1970), pp.

...s (1933), pp. 25–27, 83–87;

...off (1967).

...and here cat. no. 65.

...8, 497; see also here cat. no. 66.

...(1970), p. 114, n. 28; see also Balogh

... 142. Garrard (1970), pp. 287–91,

...rperia crucifix but reserved judgement on

...n; see here cat. nos. 96–97.

...i, VII, p. 492; see also here cat. nos. 88, 90–91.

...asari, VII, p. 492.

...6. Garrard (1970), pp. 279–80, assumes Vasari's phrase,
...putto di stoppa ed un cecero bellissimo quanto si può di
marmo', refers to one work made of tow (*stoppa*), but the sense of
the passage implies two works in two different media. That is
how it was interpreted by de Vere (1912–15), IX, p. 191; and by
Gottschewski and Gronau (1904–27), VII-2, p. 179.

119. Middeldorf (1929), pp. 503–06. The reference to
Sansovino's terracotta models comes in Agostino del Riccio's
manuscript, *Istoria delle pietre*, cited here as del Riccio (1979), fol.
18ʳ.

120. See chap. iv, pp. 57–58.

121. See chap. vi, pp. 97–98.

122. Shearman (1965), II, pp. 198–202, 209–10. See also
Padovani in Chiarini et al. (1986), pp. 94–96.

123. McKillop (1974), pp. 39–42, cites Ghiberti as a forma-
tive influence on Franciabigio's fresco.

124. On this, see Hirst (1981-II), esp. pp. 41–89.

125. Shearman (1961); see here cat. no. 72.

126. Vasari, VII, p. 488. See also Shearman (1965), I,
p. 68, and II, pp. 236–37; and Natali in Chiarini et al. (1986),
pp. 112–14, no. xii.

127. Garrard (1970), pp. 265–68; see here cat. no. 73.

128. On Fra Bartolommeo's development during this period,
see Freedberg (1961), I, pp. 193–206, and (1971), pp. 49–54; and
also Fischer (1986).

129. Cox Rearick (1974), pp. 349–50.

130. See Gabelentz (1922), II, pp. 38–39, no. 51, and p. 55,
no. 98; also Fischer (1986), pp. 119–22, nos. 68–69. For other
illustrations, see Venturi, IX-1, p. 292, figs. 205–07.

131. On these paintings, see the entry in Mancinelli et al.
(1984), p. 271, nos. 100–01; and Fischer (1986), pp. 126–29,
nos. 73–76.

132. See Shearman (1965), I, pp. 52–74, and II, 294–307;
and also Pope-Hennessy (1980), pp. 327–28. There was a break
in the cycle from 1517 to 1522 and it was completed by 1526.
Vasari, V, p. 45, saw the influence of Michelangelo on the last of
the frescoes, but his remark should be interpreted broadly, as
Shearman (1965), II, p. 306, observed.

133. This has already been noted by Shearman (1961),
p. 225.

134. For recent discussions see Lotz (1963); Garrard (1970),
pp. 329–37; Shearman (1975); and Söding (1980); and here cat.
no. 74.

135. Shearman (1975), p. 140.

136. Doc. no. 33; see Vasari, v, pp. 24–25, VII, pp. 494–95,
and VIII, pp. 140–45.

137. Shearman (1965), II, pp. 318–19; and here cat. no. 81.

138. Pope-Hennessy (1959) and Bush (1976), p. 131, assumed
that the subject was the *Dioscuri*, but one spectator, Francesco

Chiericati, described it as 'un homo armato dorato caduto da epso
[i.e., the horse]'; see Shearman (1975), p. 150, n. 42. On
the Trivulzio monument, see Clark and Pedretti (1968–69), I,
pp. xxxviii-xli.

139. Vasari, V, pp. 25, 208, and VI, p. 602; see also Shearman
(1965), II, p. 317.

140. Lotz (1963).

141. Utz (1973), esp. pp. 211–14.

142. Here I would include the relief published by Pope-
Hennessy (1959) and (1964), II, pp. 419–21; see here cat. no. 94.

143. As early as the contract for the Florentine *St James*, the
sculptor is referred to as 'Jacobo Antonii decto il Sansovino'; see
doc. no. 3.

Notes to Chapter II

1. The best survey of Medicean Rome remains that in Pastor
(1958–64), IV-1, esp. pp. 341–528; on Leo's promotion of
Florentines and Tuscans in general, see pp. 351–56. For more
recent surveys of this period, see Partner (1976) and Chastel
(1983).

2. For the Martelli altar, see pp. 26–28. On the façade com-
petition for San Lorenzo, see Vasari, VII, pp. 188, 496, in which
two somewhat divergent accounts are given. Detailed reviews of
the subject can be found in Barocchi (1962), II, pp. 662–86,
nn. 444–49; Ackerman (1964), II, pp. 3–7; Tafuri in Frommel
et al. (1984), pp. 165–70; and Hirst (1986). The late fifteenth-
century plan of San Lorenzo, published by Burns (1979), has been
ascribed to Sansovino by Foscari and Tafuri (1983), pp. 118–19,
n. 180, but neither the date nor the caligraphy of the drawing is
right for such an attribution.

3. See doc. nos. 35–41.

4. Jacopo Salviati was the brother-in-law of Leo X and
presented Sansovino to the pope in Florence in November 1515.
His son Piero, who died in 1523, was given the benefice of prior
of Rome for the Order of the Kights of St John of Jerusalem by
Leo; Sansovino gave him the model of his *Virgin and Child*
in Sant'Agostino. See Vasari, VII, pp. 495–96; and Hurtubise
(1985), pp. 152, 499, and here cat. no. 67.

5. Doc. no. 41.

6. Doc. no. 34; see also cat. no. 10.

7. See Litta (1819–99), X, disp. 165, table xvii. On his siding
with Sansovino at San Giovanni dei Fiorentini, see doc. no. 48.
He later became Pontormo's patron at Santa Felicita, for which,
see Shearman (1971), pp. 3–4.

8. See Stella (1960). In addition to the model of the *St James*,
Sansovino designed a fireplace for Altoviti which was executed by
Benedetto da Rovezzano; see Vasari, VII, pp. 491–492; and here
cat. no. 82.

9. Sansovino's Florentine connections in the Rome of Leo X
have been stressed by Tafuri in Spagnesi (1986), p. 80, *à propos* the
competition for San Giovanni. Similarly, Raphael owed his
position at the court of Julius II to that pontiff's familial ties with
Urbino; see Pastor (1958–64), III, p. 957, n. 2. A comparable
situation existed in the seventeenth century, on which, see Haskell
(1980), pp. 28, 34.

10. Hirst (1972), pp. 162–63; and Garrard (1975), pp. 333–
34. Sansovino was mentioned twice in the accounts of the
Florentine Opera del Duomo in 1518, once in January when the
finished statue was appraised and again in August when a
payment of 68 gold florins was recorded; see doc. nos. 28–30.
The first reference to his presence in Rome comes in a letter of 18
December of that year, partially reprinted here as doc. no. 42.

11. The name *Madonna del Parto* arose from the altar's inscription, VIRGO TVA GLORIA PARTVS, and reflected a veneration acquired by the sculpture from the eighteenth century onwards See Cretoni (1870), pp. 32–39; and also Caniglia in Cassanelli and Rossi (1983), pp. 92–94, no. 2.3.

12. The comparison with Agrippina and the young Nero appears in an anonymous pamphlet, *La Madonna di Santo Agostino sotto l'aspetto della religione e del genio artistico* . . . , Rome, 1858. The same idea is mentioned in passing by Pittoni (1909), p. 113; Weihrauch (1935), p. 21; and Pope-Hennessy (1970), p. 351. The identification stems from a vague similarity with statues of the seated *Agrippina* in the Capitoline Museum or the seated woman and child, formerly known as Agrippina and Nero; see Haskell and Penny (1981), pp. 133–34; and Jones (1912), pp. 131–32, no. 56.

13. The observation was first made by Garrard (1975); on the Sassi *Apollo*, now in Naples, see also Bober (1957), p. 71.

14. Garrard (1975), p. 337, pl. 52a; and Vasari, VII, p. 492. See also Bober and Rubinstein (1986), pp. 233–34, no. 200.

15. On the goldfinch, see Friedmann (1946), pp. 1–10, 62–73. Andrea Sansovino's Christ Child also holds a goldfinch; see fig. 81.

16. On Andrea's group, see the recent studies by Bonito (1980) and (1982); also Caniglia in Cassanelli and Rossi (1983), pp. 90–91, no. 2.2 The difference between Andrea's and Jacopo's sculpture in Sant'Agostino has been stressed by Weihrauch (1935), p. 23.

17. On the *Moses*, see Pope-Hennessy (1970), p. 322, with further references. The most probable way in which Jacopo could have seen the statue or sketches relating to it would have been in 1517, during the period of the San Lorenzo project. On Donatello's *St John*, see Janson (1963), pp. 12–16. Pls. 4–5.

18. See Jones and Penny (1983), pp. 89–92.

19. For Raphael's artistic development in his last years, see esp. Oberhuber (1972), pp. 50–55.

20. Buddensieg (1968), esp. pp. 63–67. It is worth recalling here that when Parmigianino appeared at the court of Clement VII, he was hailed as a second Raphael; see Shearman (1967), pp. 64–65; and also Cropper (1976).

21. Hirst (1981-II), pp. 86–87, pl. 130.

22. Shearman (1965), I, pp. 41–42, and II, pp. 310–11. Shearman makes the tantalizing suggestion that the Borghese *Madonna* was painted for Giovanni Gaddi.

23. Shearman (1965), I, p. 90. The possibility of Sansovino's group having served as a model for the Porta Pinti *Madonna* was raised in passing by Balogh (1937–39), p. 65, n. 153, but was rejected by Shearman (1965), II, p. 249. For a more recent discussion of Sarto's fresco, see Mattaeoli (1970–71).

24. Doc. no. 34. The phrase reads: 'una figura di Nostra Donna . . . con un puttino o dua secondo parrà meglio al decto maestro Iacopo'.

25. Shearman (1965), I, p. 86, n. 3.

26. See the observations by Hartt (1975). A similar effect can be seen in the Loggetta bronzes; see here chap. v, pp. 79–80.

27. For the Chigi chapel, see Shearman (1961); and Jones and Penny (1983), pp. 105–13.

28. Uffizi, Coll. Santarelli 619, 28 by 29 cm. Pittoni (1909), p. 114, saw the drawing as reflecting a design by Sansovino, which seems the most probable explanation. Sapori (1928), pl. 5, identified it as by Sansovino, but this was rightly rejected by Weihrauch (1935), p. 33. See also Vasari, V, p. 148, for the episode in Polidoro's life.

29. Cretoni (1870), p. 23; and Schiavo (1974). A sixteenth-century plan of Sant'Agostino, showing the original area of the

Martelli altar, has been published by Nesselrath in Fr[ommel] (1984), p. 441, no. 3.5.8.

30. See the entry on baldachin in RDK, I, cols. 1[], and the observations by Berliner (1958), esp. pp. 91–93[].

31. Eubel, II, p. 25, no. 25; see also Pastor (1958–64[]), p. 15.

32. Sanudo, XXIV, cols. 57, 104, reports his death at the[] of ninety-six. See also Davidson (1970); and here doc. no. 45; [] cat. no. ll.

33. Eubel, III, p. 12, no. 20; and Pastor (1958–64), IV-2, pp. 154–55, 351, 551–52; on the Ciocchi de' Monte family, see Pastor (1958–64), VI, pp. 34–36.

34. Tafuri (1986) has rightly demonstrated that the two men did not collaborate on either church, but the Serra chapel must have been collaborative in terms of the division of labour.

35. The villa is mentioned by Vasari, VII, p. 497. Although doubt has been cast upon this statement by Falk (1971), pp. 103–04, both Coffin (1979), pp. 150–55, and Nova (1982), pp. 58–61, argue convincingly that an earlier structure by Sansovino may be immured within the existing Villa Giulia. The site was purchased by Cardinal de' Monte and his nephew Balduino in 1519, and building probably began soon after. The cardinal became protector of the Servite Order in 1516; see Eubel, III, p. 12, n. 14.

36. See Sansovino (1580), p. 219^{r-v}, partially reprinted here as doc. no. 305.

37. Davidson (1970).

38. For the Cappella Gondi, see Marchini (1942), pl. XVa. On the Serra chapel, see Giovannoni (1959), I, pp. 242–45; see also the comments by Burns (1975), pp. 266–67, no. 493.

39. Blunt identified the architecture of *Confirmation* as loosely based on that of the Roman church Sant'Atanasio dei Greci, which is broadly correct, though the central chapel with tabernacle surmounted by a window is more closely based on the Serra chapel; see Blunt (1967), p. 189, fig. 153, pl. 130.

40. San Giacomo degli Spagnoli was closed in 1808 and heavily restored thereafter. In 1876 Sansovino's statue was moved to the new Spanish church of Santa Maria di Monserrato; see Pittoni (1909), p. 118.

41. Doc. no. 44, and Hirst (1972) and (1986).

42. Giovannoni (1959), pp. 243–44, identifies Uffizi 909A as a detailed study of the tabernacle's mouldings by Battista da Sangallo.

43. Planiscig (1921), p. 357, noted the connection with the *Apollo Belvedere*. On Michelangelo's *Christ*, see especially Lotz (1965) and de Tolnay (1967). Because the first version was begun as early as 1514, Sansovino would have had occasion to see Michelangelo's work before its completion.

44. Pittoni (1909), p. 122. Sansovino's statue stands in relation to Buzio's as Duquesnoy's *St Andrew* in St Peter's stands to early eighteenth-century paraphrases of it like Rusconi's *St Andrew* and *St John the Evangelist* in St John Lateran; see Enggass (1976), I, pp. 36–40.

45. See most recently, Tafuri (1973) (1984) and (1986).

46. Vasari, VII, pp. 497–98; and Serlio (1619), II, fol 24r. Tafuri (1986) has argued persuasively in support of Vasari's identification of the plan. It would have been a more modest version of the kind of project by Peruzzi for St Peter's that Serlio reproduces in III, fol. 65v.

47. The measurement given by Vasari is 15 *canne*, which would be approximately 43.5 m; see Martini (1883), p. 206.

48. Tafuri (1986), p. 81; and here doc. nos. 47–48.

49. For a useful résumé of the church's history, see Gigli (1977), esp. pp. 22–26, 41–43.

della Rovere was buried in Santa Maria Maggiore, of which he had been archpriest, but no inscription survives.

73. The inscriptions on the monument record its erection by Jacopo Orso, brother of Antonio, after the latter's death in 1511; see Giuriato (1884) and Bullo (1900).

74. Uffizi 142A, 40.2 by 60 cm, pen and brown wash; see cat. no. 146.

75. Supino (1938), pp. 208–15; and here doc. nos; 309–10; see also cat. no. 36.

76. Masini (1666), I, p. 111: 'Vedesi ancora di Giacomo Sansovino fatta di bianco marmo la statua di S. Antonio di Padova nella cappella de' Saraceni, dipinta a chiaro e scuro, con miracoli del medesimo S. Antonio, per opera di Girolamo Trevisi.' Masini subsequently lists Sansovino among artists working in Bologna and gives a date of 1515, but this is at best an approximation and some ten years before the date of the chapel (*ibid.*, p. 623).

77. Pittoni (1909), pp. 39–40; and here doc. no. 310.

78. Weihrauch (1935), p. 7.

79. Lorenzetti (1913), p. 101.

80. See chap. iii, pp. 44–47.

81. Garrard (1970), pp. 60–62.

82. Tribolo is documented in Bologna and working at San Petronio from the middle of 1525 through 1527 while Solosmeno acted as his *compagno* or collaborator in 1525–26; see Supino (1914), pp. 37, 52–53, 103–05.

83. Vasari, VII, p. 497.

84. On the question of Francesco Sansovino's legitimacy, see Temanza (1778), p. 211, n. b, and p. 239; see also Cicogna, IV, pp. 32–33, n. 1; and here chap. xi, pp. 160–61.

85. Doc. no. 305.

86. See Knecht (1982), pp. 264–70.

87. Partner (1976), pp. 25–33; and Hale (1977), esp. pp. 100–27. Pastor (1958–64), IV-1, pp. 502–20, and IV-2, pp. 512–26, gives a good survey of the arts under Leo and Clement, drawing attention to the small number of sculptures created in Rome in this period.

88. See Pirri (1931 and 1932), esp. pp. 232–36; and also Weil-Garris (1977), for a discussion of all aspects of the Loreto project.

89. Luzio (1886), pp. 73–74; and here cat. no. 84. The work is also mentioned by Francesco Sansovino in his biographical sketch of his father; see doc. no. 252.

90. On Aretino's friendship with Sebastiano, see Hirst (1981-II), pp. 41, 105. On Aretino's early assistance to Sansovino in Venice, see chap. iii.

91. Vasari, IV, p. 134; 'bene si può dire che e' la mutasse quasi a ciò ch'e' faceva'; see also Freedberg (1961), I, pp. 72–75, 212–14.

Notes to Chapter III

1. Zampetti (1969), pp. 275–76; and here doc. no. 61. The arrival probably took place after 22 July but before 5 August, those being the successive dates of Lotto's letters before and after the first mention of Sansovino. Both Condivi and Ammannati have been suggested as the unnamed younger sculptor; the former is certainly incorrect, though the latter is a possibility. On this see, Davis (1977), p. 69, n. 10.

2. See chap. ii, p. 35. Francesco Sansovino also mentions his father's intention to enter the service of Francis I in a letter of 1579; see doc. no. 305.

3. Zampetti (1969), pp. 276–77; and here doc. no. 62; see also cat. nos. 78, 112.

2.
8.
–22, and II, pp. 198–206; and

of the palaces by Pagliara in
216.

pecially Pastor (1958–64), IV-2,
Chastel (1983), pp. 136–39.

7.

a trip could only have taken place
20 May 1523 and the death of
of the same year. This particular piece
not occur in Francesco Sansovino's notes
areer, but later scholars have tended to accept
ment. On this, see Temanza (1778), p. 213; Weihrauch
p. 33; and the more extended discussion in Howard
), pp. 20–22. More recently, an extremely hypothetical
link between Cardinal Grimani and Sansovino *via* 'Catholic
evangelism' has been proposed by Foscari and Tafuri (1983),
pp. 36–42. On Sansovino's relationship with the Grimani, see
also chap. iii.

57. Doc. no. 252. Francesco Sansovino does not identify the sister, but in view of her seniority and Portuguese connection, Eleonore (1498–1558) seems a more likely candidate than Isabella (1501–1526), Mary (1505–1558), or Catalina (1507–1578). See cat. no. 64.

58. Vasari, VI, pp. 58–59; and here cat. no. 77.

59. Pastor (1958–64), IV-2, p. 159. Michelangelo's hopes, expressed in a letter of 25 November 1523, may have been typical: 'Arete inteso chome Medici è facto papa, di che mi pare si sia rallegrato tucto el mondo; ond'io stimo che qua, circha l'arte, si farà molte chose'; see Barocchi and Ristori (1965–83), III, p. 1.

60. Doc. no. 50. It is possible, however, that the Sansovino mentioned here was Andrea, who had previously raised with Michelangelo the question of collaboration on the New Sacristy in San Lorenzo; see Barocchi and Ristori (1965–83), III, pp. 16–17, 38, 118.

61. Doc. nos. 51–53; on Sebastiano's dealings with the Duke of Sessa, see Hirst (1981-II), pp. 80–81.

62. In 1531 Sebastiano wrote Pietro Aretino in Venice, adding a friendly message to Sansovino: 'e dite al Sansovino, che a Roma si pecsa offici, piombi, cappelli ed altre cose, come voi sapete, ma a Venezia si pesca anguille e menole e masenette . . . io non dico per dir male della patria, ma arricordare le cose di Roma al nostro Sansovino'; see Bottari-Ticozzi (1822–25), I, pp. 521–22.

63. Vasari, VII, p. 499.

64. See cat. no. 75. On Francesco Sansovino's comment, see doc. no. 252; his mention of it confirms Vasari's statement that it was interrupted.

65. Pittoni (1909), p. 102; see also here cat. no. 111.

66. Foscari and Tafuri (1981), p. 82, n. 28.

67. The identification of Agiense with Canea on Crete was made by Giuriato (1884), p. 125; see Eubel, II, p. 82. It might also be pointed out here that both Vasari and Aretino spell the cardinal's titular name Aginense; see here doc. no. 91.

68. Chacon (1677), III, col. 255; Eubel, III, p. 10.

69. See Barocchi and Ristori (1965–83), II, pp. 73, 99, 125–26, 160, 250, 252.

70. Doc. nos. 42–43; see also Frey (1899), pp. 128, 135.

71. Doc. no. 62. Sanudo, XXIX, col. 258, also referred to the cardinal as 'il reverendissimo Cardinal Aginense, nepote di papa Julio', when reporting his death.

72. Chacon (1677), III, col. 255, states that Cardinal Grosso

4. Zampetti (1969), p. 284; and here doc. no. 64. Foscari and Tafuri (1981) have tried to connect the plan in the Museo Correr (Disegni, Cl. III, 6038) with Lotto's remark about a palace for a rich man, but the Grimani did not acquire the property on the Grand Canal until the end of March 1528. Thus it is unlikely that the plan mentioned by Lotto would have been connected with the Grimani and their subsequent purchase of land. In addition, both the calligraphy and the style of the drawing endorse Olivato's proposal of Serlio as the author of the Correr plan; see Puppi (1980), p. 175, no. 174.

5. On the project for a tomb of Henry VIII, see Mitchell (1971), pp. 189–90, and here cat. no. 76.

6. Doc. no. 63. Though the date given in the early editions of the letters is 6 August, the letter replies to one from Gonzaga sent in early October. On this, see Luzio (1888), pp. 73–74, n. 2; and also Flora (1960), p. 988, n. 7.

7. On the putative Venus. see cat. no. 126.

8. Doc. no. 252, and also cat. no. 80.

9. Vasari, VII, p. 489; and here cat. no. 83.

10. Vasari, VII, pp. 499–500; and also here chap. ii, p. 32. For Francesco Sansovino's comments, see doc. no. 252.

11. I know of no other reference to this period as architect of the Venetian fortresses, but it could have preceded Sanmicheli's appointment as 'ingegner sopra i bastioni e fabbriche dello Stato' on 31 December 1528; see Bertoldi (1874), pp. 3–4.

12. Foscari and Tafuri (1982), pp. 110–14, following Da Mosto (1960), p. 234. See here cat. no. 112.

13. Vasari, VII, p. 508, states that Sansovino knew Giustinian in Rome. On Giustinian, see Howard (1975), p. 68; and Kolb Lewis (1977), pp. 17, 19, and the genealogical table opposite p. 288.

14. Giustinian and Grimani are both mentioned in a letter from the Venetian ambassador in Rome dated 20 May 1527; see Sanudo, XLV, cols. 216–17; and Hook (1972), p. 171. Giustinian was named in Sansovino's will, printed here as doc. no. 256.

15. Doc. no. 71. Lotz (1963), p. 3, n. 2, suggests that the phrase 'optime informati de sufficientia et bonitate magistri Jacobi Sansovini, architecti,' in Sansovino's contract of 1529 may refer to earlier work undertaken on behalf of the procurators. Howard (1972), pp. 19–20, found payments for the repair of the cupolas of San Marco voted by the procurators in August 1527 as well as references to work under way in 1528, although Sansovino's name is not mentioned.

16. This is discussed in detail by Howard (1972), pp. 31–33. Jacopo's salary began at 80 ducats per annum, and he was also given apartments adjacent to the Torre dell'Orologio. His salary was raised twice in 1530 and reached the sum of 180 ducats. In 1531 he was given the workshop and mezzanine floor below his own lodgings. In 1539 his salary was increased by 40 ducats per annum, and in January 1545 he was given a further increase of 20 ducats per annum for as long as he was taxed by the Republic, a position comparable to that enjoyed by his friend Titian. This gave Sansovino some 240 ducats per annum, not counting the benefit of his lodgings. His only subsequent increment came in 1559 when he was granted a further 11 ducats as compensation for the loss of part of his living quarters. Sansovino was comparatively well off by the standards of Venetian wages; see Braudel (1972–73), I, p. 458. On Sansovino's housing, see Schulz (1982), pp. 89–92.

17. Vasari, VII, p. 508. Gritti had been elected procurator de supra in 1509 and held the post until his election as doge in 1523. On da Lezze and Giustinian, see here notes 30, 74.

18. For this period, see esp. Pullan (1963–64); Gilbert (1973); and Finlay (1980).

19. See here Gilmore (1973); Lane (1973), pp. 250–73; and Muir (1981), pp. 185–263.

20. See esp. Finlay (1980), pp. 81–96, 158–61.

21. This is quoted in Bertelli (1978), p. 1.

22. Foscari and Tafuri (1983), p. 134.

23. For a survey of the office, see Manfredi (1602); Molmenti (1892), pp. 57–81; Howard (1972), pp. 23–30, and (1975), pp. 8–10; and Hirthe (1986-I), pp. 133–41. For their financial responsibilities, see Mueller (1971), esp. pp. 105–47.

24. Manfredi (1602), p. 10, and Howard (1975), p. 9, for their salaries.

25. Finlay (1980), pp. 163–81.

26. Mueller (1971), p. 122; and Finlay (1980), pp. 180–81; see also Sanudo, XXII, cols. 169–70, 219–21, 227–28, 236–38, 259–64, 266–67.

27. Finlay (1980), pp. 249–50.

28. Sanudo, XXXV, cols. 37–38.

29. *Ibid.*, XXXIII, col. 371: 'il far tanti Procuratori è vergogna di la procuratia, ch'è la prima dignità di questo stado'.

30. *Ibid.*, col. 372. This Zuane da Lezze di Michiel should not be confused with Sansovino's friend Cavaliere Zuane da Lezze di Priamo, who was elected procurator de supra in 1537 for 14,000 ducats; see Capellari-Vivaro, II, fol. 207ᵛ. Sanudo, XXXIII, col. 294, mentions in passing that part of the money which Vettor Grimani needed to purchase the office of procurator had been promised him by his father-in-law, Hieronimo Giustinian, who was procurator de ultra; see also here note 44.

31. For a survey of Gritti's career and patronage, see Da Mosto (1960), pp. 235–46; Howard (1975), *passim*; Olivieri (1978); Foscari and Tafuri (1983), esp. pp. 24–48; and Tafuri (1984), pp. 9–55.

32. Serlio (1537), p. iii; see also Howard (1975), p. 4.

33. Vasari, VII, p. 501.

34. Examples of Gritti's direct intervention in his chapel are recorded in ASV, Proc. di San Marco, Commissarie, Proc. de supra, busta 4 (Amministrazione propria), fasc. 1, fols. 8ʳ–9ᵛ. Dating from 1529 to 1535, they cover plural benefices, the standard of candidate for deacon and subdeacon, salaries, the quality of the choir, and so forth. Howard (1972), pp. 30–31, draws attention to Gritti's role in the appointment of Willaert and also his recommendation of the composer for a rise in salary in 1529.

35. Howard (1975), p. 39.

36. For Gritti and the Ducal Palace, see Foscari (1981), pp. 25–29, 31–33. On the *finestrone*, see chap. x, pp. 152–53.

37. Gritti has been erroneously credited with underwriting the reconstruction of San Francesco by Olivieri (1978), pp. 58–59, while Lewis (1972) and (1981) sees the whole project as essentially sponsored by Vettor Grimani, but as Foscari and Tafuri (1983) have shown, the story of San Francesco's rebuilding is much more complex than that and involved a number of significant figures, not least of all Francesco Zorzi.

38. Sansovino (1561), pp. 21ᵛ–22ʳ. See also Howard (1975), p. 34.

39. On Grimani, see esp. Howard (1975), *passim*; and Foscari and Tafuri (1983), pp. 134–38. His birthdate is not known, but Lewis (1979), p. 39, has suggested 1495.

40. Sanudo, XXXIII, col. 111. Marco Grimani stood for election as procurator de supra and de ultra earlier that same month, raising his bid each time; *ibid.*, cols. 91, 97.

41. The resolution allowing sons and grandsons of the Doge to be elected procurator was passed by the Maggior Consiglio on 26 March 1522, just before the first election; see Sanudo, XXXIII, col. 90. Lorenzo Loredan, son of Doge Leonardo, was elected

procurator *de supra* with a loan of 10,000 ducats; *ibid.*, XXII, cols. 259–62.

42. *Sanudo*, XXXIII, col. 589.

43. *Ibid.*

44. *Ibid.*, XXXV, cols. 324–25, 335, 355, 358. Hieronimo Giustinian was elected procurator *de ultra* with a loan of 12,000 ducats; see *ibid.*, XXII, cols. 266–67.

45. *Sanudo*, XXXIV, col. 116.

46. *Ibid.*, cols. 371,387.

47. *Ibid.*, XLVI, cols. 597, 601, 612. For the plague and famine that afflicted northern Italy in 1527–29, see Pullan (1963–64), esp. pp. 145–76. Sanudo, XLVI, col. 580, reports that Marino Grimani purchased his cardinalate with a gift of more than 12,000 ducats.

48. *Sanudo*, XLVI, col. 170.

49. The Grimani were not unique in this respect, as the analysis in Finlay (1980) demonstrates.

50. His career has been well documented by Colasanti (1975).

51. *Ibid.*, p. 748.

52. Sanudo, XXXVIII, cols. 48–49.

53. On the treasury, see Gallo (1967), p. 45; and Foscari (1981), pp. 22–25. Foscari considers Vettor Grimani the crucial figure behind the renovation of this part of San Marco, but Capello is given credit for it by Sanudo, LIV, col. 315. For Capello's role in the Library, see Colasanti (1975), p. 750; and Zorzi (1987), p. 130.

54. Sansovino (1561), p. 21ᵛ: 'questa loggia fu proposta e procurata dal Clarissimo messer Antonio Capello Procurator illustre e prestantissimo della chiesa, & che si diletta assai d'adornar tutta la Città'. On the tapestries, see Boucher (1976); and here chap. x. p. 151, and cat. no. 110.

55. Colasanti (1975), p. 750; and Howard (1975), pp. 54–55). Capello served as *provveditore* from January 1551 to November 1554 with Tommaso Contarini and Vettor Grimani and again from October 1555 to October 1556 with Matteo Bembo and Gianbattista Grimani.

56. See chap. ix.

57. See chap. viii, p. 118.

58. In his later years, Capello held many high appointments of a technical nature concerning fortifications. He was also a member of the Council of Ten's *zonta* or co-opted members in the 1550s and early 1560s. He also served on embassies and may have been made a count palatine by Charles V; see Colasanti (1975), pp. 749–50. His support for Sansovino finds a parallel in the next generation in Daniele and Marc'antonio Barbaro's support for Palladio, on which, see Burns (1975), pp. 157–58.

59. See note 14.

60. See cat. no. 112.

61. Foscari (1983), pp. 61–62.

62. On the Grimani palace, see Perry (1981).

63. Howard (1975), pp. 18–19; Foscari (1981), pp. 25–29; Hirthe (1986-I); and Zorzi (1987), esp. pp. 121–58.

64. Howard (1975), pp. 20, 41.

65. *Ibid.*, pp. 82, 114, respectively.

66. See note 55.

67. Foscari and Tafuri (1983), pp. 135–37, 196–201; and here doc. nos. 76–79.

68. Two years before his death, Grimani was ballotted for doge; see Da Mosto (1960), p. 263.

69. See chap. ix, and doc. nos. 204–07.

70. This happened in 1554; see Boselli (1950), p. 111; and here doc. nos. 242–44.

71. Podocataro is mentioned by Sanudo in the retinue of Marino Grimani upon his presentation to Doge Gritti as a cardinal; see Sanudo, XLVI, cols. 601, 612. For his tomb in San Sebastiano, see chap. viii.

72. Francesco Priuli was elected a procurator *de supra* in July 1522 for 10,000 ducats; see Sanudo, XXXIII, col. 381. Kolb (1969) shows that the villa at Treville was in existence by 1533 and that Federico Priuli actually paid for it. She has tentatively identified Serlio as the architect although noting that it is not mentioned in his published works. Two pieces of evidence point instead to Sansovino as the architect. One is a passing reference to it by Vasari, who promised to return to it in his biography of Sansovino. The second is the reconstruction of the façade published by Lewis (1981), which shows a striking resemblence to Sansovino's Villa Garzoni. For these points, see Vasari, VII, p. 45; and Lewis (1981), p. 361, figs. 14.5, 14.6.

73. For the *Maiden Carilla* relief, see chap. vi. Priuli and Jacomo Cornaro are described as commissioning the relief in Lewis (1981), p. 358, whereas they witnessed the contract and promised a bonus upon completion; see doc. no. 145. On the relief of *Christ in Glory* and Priuli's copy, see chap. iv, and cat. no. 24.

74. They are mentioned among Sansovino's strongest supporters by Vasari, VII, p. 508. Francesco Sansovino singles out Zuane da Lezze in his attempt to prove that the procurators commissioned the marble *Virgin and Child* from his father; see Ongania and Cecchetti (1886), p. 39, no. 207, partly reprinted here as doc. no. 301. Capellari-Vivaro, II, fol. 207ʳ, states that da Lezze 'abellì la chiesa di San Marco di pitture mosaiche, dando inoltre principio alla fabrica magnifica in cui si conserva la Publica Libreria'. The attribution of the da Lezze monument in the Gesuiti to Sansovino has recently been championed by Lewis (1979), p. 39, and Foscari and Tafuri (1983), p. 86; on the grounds of chronology, documents, and style this does not seem acceptable. See here cat. no. 113. The one significant act of patronage which can be attributed to Marc'antonio Giustinian is the completion of the Badoer-Giustinian chapel in San Francesco della Vigna. Though the marble reliefs are by the Lombardo family, the high altar was probably designed by Sansovino, as has been suggested by Foscari and Tafuri (1983), pp. 83–85, 95, n. 19. It is worth mentioning here that Giustinian was related by marriage to two procurators, Vettor Grimani and Zuane da Lezze di Michel; see Kolb Lewis (1977), p. 288. Lewis (1983) has ascribed three busts, tentatively identified as Marc'antonio Giustinian and his parents, to Sansovino, but neither do they bear any resemblance to Sansovino's sculptures nor do they fit comfortably into the proposed date of 1542–43. See here cat. no. 114.

75. See esp. Howard (1972), *passim*, and (1975), pp. 9–10.

76. The most detailed treatment of the collapse of the Library can be found in Lorenzetti (1928–29 and 1929–30). See also Howard (1975), pp. 8–37; and Zorzi (1987), pp. 121–58, esp. p. 132.

77. See doc. no. 106, for the interrogation. On Aretino's letters, see Aretino (1609). III. pp. 328ᵛ, 329ᵛ, 336ʳ, 359ᵛ.

78. Doc. no. 107. The Library vault was rebuilt with traditional cane vaulting, as had been recommended by Antonio Capello; see Temanza (1778), p. 240.

79. Lorenzetti (1928–29), p. 93; and Howard (1975), p. 21, n. 68.

80. Doc. nos. 91, 305. On the later disputes between the procurators and Francesco Sansovino, see chaps. iv and ix.

81. Dürer's reference to his acceptance as a gentleman in Venice comes in a letter to his friend Pirckheimer; see Panofsky (1955), p. 108. On Sansovino's offers from other courts, see Vasari, VII, p. 511.

82. See chap. vi.

83. For the portal of San Salvatore, the altar of Santa Maria Mater Domini, and the tomb of Alvise Malipiero, see chap. x; the other works are discussed in this chapter.

84. See cat. no. 12.

85. On the Nichesola family, see A. Torresani, *Elogiarum historicarum: 1656. Sectio secunda, Viventi* (ASVer, Fondo Lando, no. 26), fol. 144. On Galesio Nichesola's career, see Eubel, III, p. 13; for his death, Sanudo, XLV, col. 559.

86. Doc. no. 68; and Brenzoni (1957), p. 339.

87. On Giberti, see Prosperi (1969); for his activities in the cathedral, see Brugnoli (1955), pp. 70–72.

88. Boucher (1980).

89. An inscription in the pavement before the chapel records its erection by Antonio Cartolari in 1470.

90. Doc. nos. 69–70. Hope (1980), p. 70, dates Titian's *Assumption* to ca. 1530–32.

91. Two earlier examples can be seen in the high altar of San Rocco, executed by Venturino Fantoni between 1517 and 1521, and the Priuli chapel's altar in San Salvatore, designed by Guglielmo dei Grigi in 1524. On both see Paoletti (1893), pp. 243–44, 281.

92. Compare the analogous use of a central bracket on the windows of the Palazzo Delfin, as reproduced in Tafuri (1972), p. 47, or that on the doorway of San Martino, in Howard (1975), p. 79.

93. See Zava Boccazzi (1965), pp. 180–84, with further references; and Schulz (1985). On Venetian Renaissance tombs, see the extensive account in Sheard (1971), pp. 228–49; and Pope-Hennessy (1971), pp. 89–92.

94. For other examples of tombs with *putti*, compare Tullio Lombardo's monument for Matteo Bellati in Fletre Cathedral, reproduced in Paoletti (1893), p. 235, fig. 168; Peruzzi's tomb of Hadrian VI (here fig. 202); and Montorsoli's tomb of Mario Maffei in Volterra Cathedral, which is in Venturi, X-2, p. 120.

95. Sartori (1956), p. 28, states that the tomb was finished by 1524 and gives it generically to the Lombardo brothers, which seems plausible. See also Rosand (1982), p. 58, n. 22.

96. I owe this suggestion to Michael Hirst. On the 1516 design for Julius's tomb, see Wilde (1978), pp. 98–110, fig. 88. Michelangelo was in Venice during October and November of 1529; see Barocchi and Ristori (1965–83), III, pp. 280–85. It is also possible that the tomb may reflect the earlier project for the Duke of Sessa, on which, see chap. ii, p. 32.

97. On the statue by Francesco di Giorgio, see Carli (1949); Maltesi (1966); and Strom (1980), p. 246.

98. Sansovino used this type for the head of his bronze *St Matthew* (fig. 185), and for the old man on the left in the *Maiden Carilla relief* (fig. 263). On the bust of Aristotle, see esp. Richter (1965–72), II, pp. 172–75.

99. On the *St Sebastian*, see Weinberger and Middeldorf (1928), pp. 99–100; and Pope-Hennessy (1971), pp. 32–33. Its influence on Michelangelo is mentioned by von Einem (1973), p. 81.

100. On the pose of Arnolfo's saints, see Goffen (1979), p. 213, fig. 14.

101. See especially Burns (1975), p. 115.

102. On this aspect of Bandinelli, see Hirst (1963) and Weil-Garris (1981). The sculpture of Cosini has been aptly characterized as *neoquattrocentesco* by Federico Zeri; see Dalli Regoli (1984), p. 20, n. 15. On Tribolo, see Holderbaum (1957).

103. See cat. no. 13; for Sansovino's will of 1568, see doc. no. 256.

104. For Giustinian, see Capellari-Vivaro, II, fol. 147ᵛ. He married Querina, daughter of Giovanni Battista Morosini, and had by her two daughters and a son.

105. Doc. no. 82.

106. Doc. no. 256.

107. On Sansovino's planned tomb in the context of artists' monuments, see Lavin (1977–78); and Schütz-Rautenberg (1978), pp. 265–71.

108. Doc. no. 252. On Francesco Sansovino's authorship of these notes, see chap. xi, pp. 160–62.

109. For this subject, see Lavin (1955), with further references.

110. See chap. i, pp. 6–7, and cat. no. 2.

111. Mansuelli (1958–61), I, pp. 137–38, no. 102. The *Daphnis* is 1.29 m high and was described in the della Valle inventory as 'uno faunetto a sedere che suona, la testa moderna, il resto antico con tutte le sue membre'. The head of the Baptist is even closer to a bust of an adolescent of the *Spinario* type now in the Villa Doria Pamphili; see Calza (1977), p. 46, no. 15, pl. xii.

112. Quoted by Lavin (1955), p. 94. Whether or not Sansovino knew this text, he would have known the legends surrounding the saint's youth through representations such as Lippi's Baptist cycle in Prato Cathedral or in miracle-plays. On the former, see Borsook (1975), pp. 29–32; for the latter, see Luzio and Renier (1893), pp. 45–46.

113. Vasari, VII, pp. 511–12: 'Dicono gli intendenti, che quantunque cedesse a Michelagnolo, però fu suo superiore in alcune cose; perciocchè nel fare de' panni, e ne' putti, e nell'arie delle donne, Iacopo non ebbe alcun pari.' On this topic, see also chap. vii.

114. This resume of the history of the Florentine chapel in the fifteenth century is taken from ASV, Santa Maria Gloriosa dei Frari, reg. 7 (1436–1730), fols. 1ʳ–16ʳ. Kauffmann (1936), p. 150, gives the area of the chapel as only the first bay of the north aisle, but the register cited here states that the chapel extended to the north entrance by the present Pesaro chapel (fol. 4ᵛ).

115. In 1437 the Florentine confraternity in Venice solicited funds from Cosimo and Lorenzo de' Medici for their chapel in the Frari, and this may, in my opinion, have been the impetus for the commissioning of Donatello's statue, which bears the date 1438. See here Fraser Jenkins (1970), p. 164; and Wolters (1974).

116. Sansovino (1581), p. 66ʳ: 'Di dentro nella cappella dei Fiorentini, il San Giovanni Battista di legno indorato, fu scolpito dal famosissimo Donatello che fece in Padova il cavallo di Gatta Melata. Di rincontro alla predetta cappella, il San Giovanni Battista di marmo posto sopra la pila de' Giustiniani, fu opera di Jacomo Sansovino.' On the changes to the Frari's chapels in the nineteenth century, see Sartori (1956), p. 35.

117. Lorenzetti (1913), p. 129; see also cat. no. 14.

118. On the history of the Arsenal, see Casoni (1847); Lane (1965), esp. pp. 123–64; and Bellavitis (1983).

119. On the role of the *patroni*, see da Mosto (1937–40), I, pp. 160–61. For Contarini, Calbo, and Zane, see respectively, Barbaro, II, fol. 505ʳ; Capellari-Vivaro, I, fol. 214ᵛ, and IV, fol. 207ʳ. Calbo subsequently became a senator and elector of Doge Francesco Venier in 1554; Zane became a *savio del consiglio* and procurator *de citra* in 1568. On Contarini, who is not to be confused with his famous namesake, see Cicogna (1824–53), II, p. 227, n. 1. Details of their election as *patroni* of the Arsenal can be found in ASV, Segretario alle voci, elezioni del Maggior Consiglio, reg. I (1529–40), fols. 7ᵛ–8ʳ.

120. On Marian devotion in Venice, see esp. Tramontin (1965), pp. 241–74.

121. The only detailed account of this miraculous image by the Arsenal is in CMC, MS Gradenigo Dolfin, no. 193, vol. II,

fols. 150ʳ–152ᵛ. A chapel, which was built on the site and contained a statue by Girolamo Campagna, was destroyed in 1809; it is discussed by Casoni (1847), p. 63; Zorzi (1972), II, p. 305; and Bellavitis (1983), pp. 121–26.

122. Timofiewitsch (1972), pp. 226–27. On the *Theotokos*, see Cecchelli (1946–54), I, pp. 145–47, 172–73; and also Warner (1976), pp. 65–67, 287. Timofiewitsch (1972), pp. 226–27, suggests the second inscription might be a devotional formula to request the same spirit and will as demonstrated by Mary for the supplicant, but the sense of the inscription must logically refer to the Virgin herself.

123. Timofiewitsch (1972), p. 226, n. 17.

124. On Christ's orb, see Aurenhammer (1959–67), I, pp. 171–76, esp. p. 173. On the *sedes sapientiae*, see Schiller (1971–72), I, pp. 23–25, 28.

125. Goffen (1975), esp. p. 490.

126. Vasari, II, p. 412; and also Kauffmann (1936), p. 122.

127. Weihrauch (1935), p. 46; also Janson (1963), pp. 183–85.

128. On the Quattrocentesque nature of the Bruges *Madonna*, see von Einem (1973), pp. 26–27. For Raphael's paintings, see Dussler (1971), pp. 20, 22. Though Michelangelo's Christ Child has been recognized as the source for Raphael's Child in the *Madonna del Cardellino*, the same source was also used by the painter for the infant Baptist in the *Belle Jardinière*; see Pope-Hennessy (1970-II), p. 200.

129. Paoletti (1893), pp. 188–89, 268, attributes the Virgin of the clocktower to Leopardi, but this suggestion has not been taken up by subsequent writers. For the *Madonna della Scarpa*. see most recently Jestaz (1986).

130. See cat. no. 17.

131. For the Merceria portal of San Salvatore and the Malipiero tomb, see chap. x.

132. Doc. no. 91; see also cat. no. 16.

133. On Quignones, see Chacon (1677), III, cols. 496–500.

134. See especially Ortolani (1969), pp. 22–24.

135. See cat. no. 15; for a recent survey of this medium, see Gentilini in Paolucchi (1980), pp. 67–88.

136. Compare, for example, the Loggetta gods and the youth to the right in the relief of the *Maiden Carilla* in Padua, discussed here in chaps. v and vi, respectively.

137. This was confirmed by John Larson, chief of sculpture conservation at the Victoria and Albert Museum, who examined both the Thyssen *Annunciation* and the *cartapesta* relief after Sansovino now in the Kimbell Art Museum. The same technique is present on the Virgin's robe in the *cartapesta* relief of the same type now in the Kress Collection. This is not identified in the discussion of the Kress version, but see Middeldorf (1976), pp. 74–76; and here chap. vii, and cat. no. 51.

138. Kauffmann (1936), pp. 79–82; and Janson (1963), pp. 103–08, pls. 43–46.

139. Janson (1963), pp. 65–75, pls. 30a, 31a, and pp. 198–205, pl. 97a, respectively.

140. Wethey (1969), pp. 70–71, nos. 9–10.

141. Aretino (1609), I, p. 180ʳ⁻ᵛ; also Wilde (1974), p. 160.

142. Stott (1982), esp. pp. 382–86.

143. Moschini Marconi (1962), pp. 259–60, no. 452, with detailed bibliography. A dating in the fifth decade of the century has been accepted by Pallucchini (1969), I, p. 281, and by Wethey (1969), pp. 136–37, no. 109. Meyer (1937) and Hope (1980), pp. 69–70, have argued for 1530–32, which seems more probable to my mind. Valcanover has placed it in the late 1530s; see Pallucchini (1981), pp. 100–01.

144. Tietze (1936), I, p. 198, first suggested the relationship with Sansovino's sculpture of ca. 1518–20, presumably thinking

of figures like the Roman *St James*. Wilde (1974), pp. 168–69, proposed Michelangelo's *Christ* in Santa Maria sopra Minerva as an influence, Meller (1977) suggested that Titian had recourse to a model by Ammannati, although this seems highly unlikely, especially if a dating to the 1530s is accepted for the painting.

145. See cat. no. 63.

146. Paoletti (1893), pp. 112, 249, 293–94; and Meneghin (1962), I, p. 336, n. 109–10. Giambattista da Carona was probably related to Tullio Lombardo, whose family originated in Carona and whose will was witnessed by Giambattista in 1532.

Notes to Chapter IV

1. See chap. iii, pp. 38–44.

2. See esp. Howard (1972), pp. 33–34; and also Foscari (1981). On the transformation of the Piazza, see Lotz (1966); Howard (1975), pp. 10–16; and Hirthe (1986-II).

3. These works have previously been discussed in Boucher (1976) and (1979).

4. San Marco did not become the cathedral of Venice until after the fall of the Republic in 1807. On the importance of St Mark for Venice, see Demus (1960), pp. 30–60; Tramontin (1965), pp. 43–73; Sinding-Larsen (1974), pp. 156–219, 276–84; and Boucher (1976).

5. Sansovino (1561), p. 25ʳ: 'si spende in questa Chiesa fra provisionati, Preti, cere, et cose altre necessarie, meglio di dieci milia ducati l'anno'.

6. The liturgy for the feast of St Mark, as celebrated in the ducal chapel, was first published by Stringa (1602). It stressed the independent tradition of apostolic succession of the church in Venice, passing from Peter to Mark: 'Beatissimus Marcus discipul [us] et interpres Petri Apostoli: Secundum quod ab eo audierat, rogatus a fratribus Christi scripsit Evangelium . . . Quod videns Petrus probavit, et ecclesiae sua auctoritate tradet legendum' (p. 17); or, again, Mark is seen as a second Peter: 'unum cor, una in duobus anima corporibus habitasse videretur' (p. 19). See also Tramontin (1965), pp. 43–73.

7. The most informative account of the doge's *jus patronatum* is that by Lonego (1865); but see also Molmenti (1892), pp. 39–56.

8. As early as 1453–54, repairs were being undertaken on the cupolas and external walls of the Basilica; see ASV, Proc. de supra, busta 77, proc. 180, fasc. 1, fols. 4ʳ–5ʳ. Concern was expressed thereafter by the *proto* Antonio Zerlaga in 1470, as mentioned in Demus (1960), p. 194.

9. This is reported by Vasari, VII, pp. 449–500, and elaborated upon by Temanza (1778), pp. 213–19. For the restoration of the sanctuary, see Gallo (1967), p. 43.

10. The Maggior Consiglio's resolution of May 1531 argued that the removal of obstructions from the Piazza 'è cosa laudabile et di gran ornamento de la città nostra' (ASV, Maggior Cons., Diana, fol. 64ʳ). Vasari, VII, p. 501, attributed the removal of the stalls from the Piazzetta to a recommendation by Sansovino to Doge Gritti; the same point is made by Jacopo's son, Francesco (1581), p. 116ᵛ. See also Howard (1975), pp. 10–16.

11. The following description of the choir and its liturgical functions as Sansovino knew it, draws heavily upon the second edition of Francesco Sansovino's *Venetia*, published by Stringa (1604), pp. 32ᵛ–36ʳ. Stringa was master of ceremonies in San Marco, and his account of the ducal chapel is remarkable for its wealth of detail. For a more extended account of Sansovino's intervention in the choir of San Marco, see Boucher (1976) and (1979).

12. St Theodore's role as a patron saint of Venice is discussed by Tramontin (1965), pp. 92–95.

13. On the attribution of these tapestries to Schiavone, see cat. no. 110.

14. *Pergolo* derives from *pergamo* or pulpit and was commonly used in Venetian to mean any kind of balcony; see Galicciolli (1795). III, pp. 33–34, and I, p. 297; and Boerio (1867), p. 492. Francesco Sansovino explains that they were used for singing the epistle and gospel; see Sansovino (1561), p. 26.

15. Sanudo, XIII, cols. 130–43, gives an account of the choir of San Marco in 1511, which corresponds to Stringa's description of 1604 in terms of furnishings and general disposition.

16. The ducal throne must have been removed by 1815, as Moschini (1815), I, p. 283, does not mention it. The lateral stalls were still in place twenty years later when described by Francesco Zanotto in Cicognara (1838), p. 16. By the end of the nineteenth century, only the panels of the virtues survived; see Urbani de Gheltof (1888).

17. This is mentioned by Forlati (1955), pp. 241–42, and (1962), pp. 213–16. Two compartments of Faith and Fortitude remain in the ex-church of San Basso and measure 1.03 by 1.41 m. The remaining six passed into private hands and were sold in the Ruspoli Talleyrand Sale in Florence in 1969 (as lots 656–58). The design of these panels has recently been attributed to Sansovino, but on rather unconvincing grounds, by Davis (1980), p. 584.

18. Forlati (1965), pp. 197–99, reconstructs the original appearance of the medieval tribune.

19. Doc. no. 84. The wish to change the choir's furnishings had been expressed as early as 1523 when the procurators made an agreement with Fra Vincenzo da Verona to complete the inlay of the sacristy cupboards and to create perspectival inlays for the choir. In the event, his work did not suit the procurators, who dismissed him in 1524. See Ongania and Cechetti (1886), pp. 27–28, nos. 162–63.

20. The reference comes in the contract between the stonemason Antonio Buora and the confraternity of the Blessed Virgin, dated 25 August 1536. The confraternity's altar was to be built 'cum suis columniis et post ipsas columnas—cum duobus pilastris cum suis capitellis dupliciter intaleatarum eo modo quo sunt illi qui sunt in ecclesia S [an] cti Marci in cathedra Ser (enissi) mi principis novissime in choro fabricata. Et cum suis cornicibus prout stant apud ipsum d[ominum] Iac[obum].' See Paoletti (1893), p. 116, no. 108; and here chap. x.

21. Doc. no. 86. Moschini (1815), I, p. 283, saw the year 1536 inscribed in one of the decorative panels in the choir. Urbani de Gheltof (1888), pp. 441–12, claimed that an additional payment was made on 10 February 1540 (=1541), but I have not found any record of it.

22. Doc. nos. 87–89.

23. Three ducal tombs within San Marco follow the general format of the tomb of St Isidore: those of Andrea Dandalo and Giovanni Soranzo in the baptistry and that of Bartolomeo Gradenigo in the atrium. On the tomb of St Isidore, see Demus (1960), p. 208. The same model was employed by Venturino Fantoni for the sarcophagus of St Roch on the high altar of San Rocco, which is documented to 1517–21 by Paoletti (1893), p. 281. A more elaborate variation on this same model was employed by Andrea Riccio for the della Torre monument in San Fermo Maggiore, Verona; see Planiscig (1927), pp. 371–400, figs. 471–98.

24. Doc. no. 89; see cat. no. 22.

25. On the cycle for the Scuola Grande di San Marco, see especially Brown (1988), pp. 33–37, 196–209, 291–95; for the façade, see Sheard (1984).

26. See chap. i, p. 22, and cat. no. 74.

27. Chap. i, p. 19, and cat. no. 61.

28. Cat. no. 28.

29. See chap. x.

30. See Jestaz (1986), for a full discussion of this project.

31. See especially Jestaz (1982).

32. Cat. no. 21.

33. On Donatello's reliefs, see the observations by Middeldorf (1936), pp. 582–84; and Janson (1963), pp. 181–87. On the reliefs of the chapel of St Anthony, see here chap. vi; and also Wilk (1984).

34. On Raphael's tapestry cartoons, see Shearman (1972), esp. pp. 55–57; see also the discussion here in cat. no. 22.

35. See Brown (1988), pp. 196–209.

36. On Trajan's Column, see the important study by Agosti and Farinella (1984), esp. pp. 410–13.

37. Doc. no. 88. The function of Sansovino's workshop is discussed here in chap. x.

38. Campanaro belonged to a Venetian family of founders, who also cast the bronzes for the Zen chapel; see Thieme–Becker, V, pp. 454–55; and Jestaz (1986). On Minio's career, see Rigoni (1970), pp. 201–15; his relationship with Alvise Cornaro and his son-in-law Giovanni are examined by Sambin (1964) and (1966).

39. Doc. no. 90.

40. The significance of the central panel is explained by Stringa (1610), pp. 83ᵛ–84ᵛ. The legend concerns a woman of Murano who lay paralysed for four years and then had a vision of St Mark, who instructed her to be carried into his church. During mass, the woman made the sign of the cross and then could stand up. She returned home walking. An abbreviated version is reported in the *Acta Sanctorum*, Antwerp, 1675, III-3, p. 356. For an alternative interpretation, see here cat. no. 22.

41. Weihrauch (1935), p. 62; and here doc. no. 90.

42. Aretino (1609), II, p. 184ʳ; see also Shearman (1967), p. 86. Aretino's letter is dated 15 December 1540, probably a few months before Sansovino would have begun designing the second series of reliefs.

43. On Giuseppe Salviati's Venetian career, see McTavish (1981). On Vasari in Venice, see Schulz (1961); McTavish (1976); and the discussion of the Loggetta bronzes here in chap. v. Montini and Averini (1957) discuss Giovanni da Udine's work for the Grimani, as does Perry (1981). A useful survey of exchanges between Central Italy and Venice during the early sixteenth century is provided by Roskill (1968), pp, 75–82.

44. Krautheimer (1970), pp. 122–24, places the *Nativity* and *Annunciation* among the first reliefs done for the north door and still very much in the International Style.

45. See chap. xi, pp. 170–71.

46. On Minio's adaptations of Sansovino's bronze reliefs, see Wolters (1963). The baptismal font is discussed in chap. x, p. 151. The contract between Minio, Cattaneo, and the Arca del Santo for the gates is transcribed by Sartori (1976), pp. 70, 164.

47. For Cellini's visits to Venice and his projected pulpits and door, see Bacci (1901), pp. 150–51, 342; also Morselli (1979), pp. 136–51, no. 15; and Pope-Hennessy (1985), p. 172.

48. For Campagnola's drawing, see Boucher (1983-II).

49. On Tintoretto's painting, see Pallucchini (1950), pp. 111–15; Moschini Marconi (1962), pp. 221–23, no. 394; and Rosand (1982), pp. 186–90.

50. Aretino (1609), I, p. 191ᵛ.

51. Doc. nos. 121–22, and cat. no. 26.

52. In 1608 the procurators decided to add the lateral balustrades that now separate the two parts of the choir. The record of their decision noted that the stone for its construction

should some from their own stores and cost 'poco più della fattura di farli pozzi et colonelle' (ASV, Proc. de supra, Atti, reg. 17, fol. 31ʳ). The railings were complete by April 1609 (*ibid.*, fol. 46ʳ). This is also recorded by Stringa (1610), p. 22ᵛ.

53. See Tramontin (1965), pp. 78–80, for the significance of the Annunication in Venice.

54. The changes to the high altar are summarized by Forlati (1962), pp. 213–16. The figures by Paliari were commissioned in 1608 and finished by 1614 (see Ongania and Cecchetti (1886), p. 218, nos. 906–07). The identification of Paliari as the author of the *Doctors* is made by Stringa (1610), pp. 22ᵛ–23ʳ. Lorenzetti (1926), pp. 813–14, gaves the statuettes to Gabriele Orlandi and Battista Nicolini, but this arises from a misreading of the documents published in Ongania and Cecchetti; Orlandi and Nicolini were employed to cast the figures, not to make the models.

55. The Visentini engraving was published by Zatta (1761), pl. ix. The three drawings by Pellanda are in the archives of the Ufficio Tecnico of San Marco and have been published by Forlati (1962). They were made some thirty years after the rebuilding of the high altar and give only an approximate idea of the previous structure.

56. For a discussion of the Ascension and Pentacost cupolas, see Demus (1935), pp. 18–19, 24–28; see also Bettini (1946), pls. iv-vi, xvi. On the *pala d'oro* and the medallions of the evangelists, see Hahnloser (1965), pp. 12–17.

57. Demus (1960), pp. 165–67, 183–84, drew attention to a stylistic relationship between the thirteenth-century *Evangelists* on the ciborium and the ciborium's reliefs. The original location of the statuettes is not known but may have been part of an earlier enclosure for the high altar, subsequently replaced by Sansovino's. The figure of the Redeemer on the rear of the ciborium was added in 1751 by Pietro Monacco; see Lorenzetti (1926), p. 193.

58. For the Miracoli, see Paoletti (1893), pp. 205–16. An altar railing of similar format still survives in the mid-fifteenth-century altars of Sts James and Paul in the transept of San Marco. Both altars have lateral balustrades and figures of angels bearing candle holders but lack railings across the front. On the development of altars, see Braun (1924), II, pp. 648, 660–61.

59. A detailed account of the ducal investiture is given in Bartolomeo Bonifacio's *Caerimoniale rituum sacrorum ecclesiae S(ancti) Marci Venetiarum* (1564), now in the Biblioteca Nazionale Marciana, Venice, MS Lat. Cl. III, Cod. 172 (=2276), fol. 70ʳ⁻ᵛ; see also Sinding-Larsen (1974), pp. 159–66.

60. Stringa (1602), p. 16, for the vision of Ezekiel in the office of the Feast of St Mark. Stringa (1604), p. 28ʳ, specifically connects the vision with the Emmanuel cupola. For an account of the evangelists as *logos*, see *LCI*, I, cols. 704–06; and also Sinding-Larsen (1974), p. 186.

61. See, however, Timofiewitsch (1972); and here cat. no. 26.

62. Stringa (1604), p. 25ʳ⁻ᵛ, identifies the evangelists to the left and right of Christ as Mark and John respectively, but this cannot be corroborated by the figures themselves, their being identical in pose and devoid of any sign or symbol. I am grateful to Don Gastone Vio for confirmation of this. The *pala d'oro* has Mark to the right of Christ and John to the left.

63. On the distinction between Matthew and John as original followers of Christ, and Mark and Luke as disciples of Peter, see St Augustine's *De consensu evangelistarum*, cap. ii; also *LCI*, I, cols. 696–97, and *RDK*, VI, cols, 448–517. The special esteem enjoyed by St John in Venice is discussed by Tramontin (1965), pp. 140–41.

64. Burckhardt (1929–34), IV, p. 63, drew attention to the similarity with Michelangelo's *Moses*, here fig. 76.

65. See Wilde (1953), pp. 58–60, no. 29ʳ.

66. See Boucher (1989). Sarto's altarpieces are reproduced in Shearman (1965), pls. 137, 159b.

67. Cat. no. 25.

68. See Janson (1963), pp. 12–16, pls. 4–5. Sansovino's *St John* may also reflect Brunelleschi's vigorously modelled prophets on the altar of San Jacopo in Pistoia, and similar features were used by Ghiberti for his *St John the Baptist* on Or San Michele; see Krautheimer (1970), pp. 71–85, 90.

69. The purpose behind Donatello's elongation of the *St John* was explained by Vasari, II, p. 401; see also Seymour (1966), pp. 56–57.

70. On physiognomy as related to character in Renaissance art, see Meller (1963) and Fehl (1973).

71. See Wethey (1969), p. 143, no. 119. On the mosaic of St Mark in the atrium of San Marco, see Stringa (1604), p. 15ʳ⁻ᵛ; and Sinding-Larsen (1974), p. 192. The design for the mosaic has generally been accepted as by Lotto; see Banti (1953), p. 91, no. 127.

72. See Sinding-Larsen (1974), p. 192.

73. See cat. nos. 23, 38.

74. For the history of the commission, see cat. no. 23.

75. Peruzzi's drawing is discussed by Frommel (1968), pp. 139–40, who dates the project to 1528. Serlio explains how to make a bronze door in book IV, p. 191 (edition of 1619).

76. Aretino (1609), I, pp. 231ʳ–235ᵛ. The letter was addressed to the representative of the Duke of Urbino in Venice, Giangiacomo Lionardi, and concerns a vision of Paradise in which Aretino saw Sansovino 'poneva suso la porta di bronzo al tempio, dove erano intagliati i quattro milia fanti e gli ottocento cavalli, con cui la sua Eccellenza [i.e., the Duke of Urbino] trascorse Italia' (p. 233ᵛ).

77. On this commission, see Paoletti (1929), pp. 62–64. The agreement between the Scuola and the founder, Jacomo dei Conti, does not name the designer of the door, nor does it suggest that the door would have relief panels; see ASV, Scuola Grande di San Marco, atti diversi, busta 202.

78. For aspects of the critical reception of Ghiberti's work in the fifteenth and sixteenth centuries, see Martucci (1978), pp. 345–48. Vincenzo Danti had recourse to Ghibertian formulae when he designed the bronze *sportello* for Cosimo I; see Summers (1979), pp. 88–103. The examples of the later bronze doors for Loreto and Pisa are well known; see Venturi, X-2, pp. 715–19, and X-3, pp. 772–80.

79. A drawing after the *St John* is in the National Gallery of Scotland; see cat. no. 131.

80. See the discussion in cat. no. 23.

81. On Ghiberti's and his son's portraits, see Vasari, II, p. 238; and Krautheimer (1970), II, pl. 135a–b.

82. On this, see Krautheimer (1970), pp. 137–55; and Stott (1982).

83. See the discussion in cat. no. 23.

84. Janson (1963), pp. 95–101, 209–18, pl. 42a. The seated mourner was taken by Donatello from the lid of the Dionysis sarcophagus, now in the Museo Diocesano di Cortona; see Matz (1968–73), II, pp. 426–28, no. 237, pl. 258. There are a number of sixteenth-century drawings after Donatello's pulpit relief reproduced by Degenhart and Schmitt (1968), II, pp. 343–66. The influence of Donatello's pulpits on Florentine artists around 1515 is discussed by Shearman (1966), p. 158.

85. See, however, the recent article by Stott (1982), p. 381, n. 32.

86. See chap. vi.

87. Pope-Hennessy (1964), II, pp. 417–19, no. 442.

88. The two works are particularly close in the diagonal perspective of the tomb and in the pose and placement of the Magdalen. As Sansovino's *Entombment* was cast by the middle of the 1550s, it would have been known to Titian before he painted the *Entombment* for Philip II. On Titian's painting, see Wethey (1969), pp. 90–91, no. 37.

89. The drawings, in the Musée Bonnat of Bayonne, the Ashmolean Museum, Oxford, and elsewhere, have been connected with an unexecuted altarpiece for the Chigi chapel in Santa Maria della Pace; see Hirst (1961), and Oberhuber (1972). The innovative nature of Raphael's *Resurrection* has also been analysed by Schrade (1932), pp. 262–63.

90. On this, see Monbeig-Goguel (1978).

91. The Cappella del Crocifisso and the drawing formerly in the Ellesmere Collection are discussed by Hartt (1958), pp. 273–74, 304; and by Monbeig-Goguel (1978), pp. 14–15. The engraving by G.B. Ghisi is only recorded in Bartsch, XV, p. 378, no. 5.

92. Titian's paintings at Santo Spirito and his borrowings from Giulio are discussed by Schulz (1968), pp. 17–18; and Hope (1980), pp. 99–103. The 1540s marked the cresting of Giulio's popularity in the Veneto and also witnessed what Schulz termed 'the high point of Titian's mannerist phase'. Obviously Sansovino's interest in mannerism during the same years would have complemented that of his close friend.

93. See cat. no. 24.

94. See Krautheimer (1970), pl. 89.

95. Davis (1984-III), pp. 36–37, has argued that the various parts of the Medici Tabernacle were made at different times and that the wooden frame was created after the work's arrival in Florence in 1664; for a more detailed discussion of these points, see here cat. no. 24.

96. See chap. vii, and cat. no. 19.

97. Vasari, V, p. 148, implies that Polidoro's fresco and Sansovino's altar for the Martelli family were contemporaneous projects. Garrard (1970), p. 369, saw Polidoro's work as 'a later, unrelated addition to the wall', which seems unlikely to have been the case. For the drawing, see here chap. ii, note 28.

98. The idea was suggested to me by Manfred Leithe-Jasper of the Kunsthistorisches Museum, Vienna. The putti of the Medici Tabernacle anticipate those created by Vittoria for the Sala delle Notte of Palazzo Thiene in Vicenza, on which, see Wolters (1968), pl. xxxiii, no. 59. For Vittoria in Sansovino's shop, see here chap. x.

99. The dependence was first noted by Weihrauch (1935), p. 67, no. 164. The altar forms part of the chapel of Girolamo Priuli, who died in 1546; some years earlier he commissioned the adjacent portal, which opens on to the Merceria, from Sansovino's shop. For these projects, see here chap. x.

100. Vasari, VII, p. 511, connects Cosimo's offer of service with the project for the Fortezza de Basso. According to Cicogna, IV, p. 31, the Cronaca Gradenigo also mentions the tabernacle as having been made for the Medici.

101. Lorenzetti (1909), p. 293; and here cat. no. 24.

102. Zampetti (1969), p. 243.

103. Kunsthistorisches Museum (1960), p. 73, no. 580.

104. See chap. iii, notes 72–73.

105. Calì (1983), p. 45, dismisses the idea of a *paragone* in this context, but she misconstrues Aretino's letter. On the competition with Titian, see Gronau (1905) and, more recently, Stott (1982).

106. On Eucharistic imagery in general, see the article, 'Eucharistie,' *RDK*, VI, cols. 154–254, esp. 200–04; and also 'Engel,' *RDK*, V, cols. 341–555, esp. 429, 480–88. Among numerous publications on related subjects, like the Man of Sorrows, see Panofsky (1927); Caspari (1965); Schiller (1971–72), II, pp. 229–33; and Eisler (1969).

107. See I Tim. 3:16: 'Et manifeste magnum est pietatis sacramentum, quod manifestatum est in carne, justificatum est in spiritu, apparuit Angelis, praedicatum est gentibus, creditum est in mundo, assumptum est in gloria.' See also Dibelius (1931), p. 39.

108. Frizzoni (1911–12), fig. 1. The early photograph prior to cleaning corresponds to Lotto's description of the panel in his *Libro*; see cat. no. 24.

109. Braham (1978), pp. 11–16. The panel by Bellini was copied by Carpaccio for an altarpiece now in the Museo Civico of Udine; see Lauts (1962), pp. 29, 249, no. 74.

110. Cope (1979), pp. 76–77.

111. Rigoni (1970), pp. 279–87.

112. See Feurstein (1930), p. 51; and Koch (1959), pp. 234–35.

113. See chap. viii. and doc. no. 256.

114. Cat. no. 38.

115. Ongania and Cecchetti (1886), p. 27, no. 160; see also Paoletti (1893), pp. 216, 274–75, n. 3. For sacramental tabernacles in the Veneto, see Cope (1979).

116. Cat. no. 39.

117. A similar case can be seen in the two versions of the reliefs on St Daniel's martyrdom, which were produced by Tiziano Aspetti at the end of the century in Padua; see Boucher and Radcliffe (1983), pp. 358–59, nos. S1–2.

118. Mrozinska (1958), p. 25, no. 7.

119. Christie's, 2 December 1969, lot 31. The medium is pen, brown ink and wash, heightened with white. It measures 20.5 by 17.1 cm and passed through the collections of Resta, Somers (Lugt no. 1981), the elder Richardson, the Earls of Pembroke, and Baron de Lancy. An inscription, in Richardson's hand, reads: '[M]erola, seguaci dil parmeggiano, fece una stanza nel casino di Parma. P[adre] Re[sta].' The drawing is very close in style to a sketch of the vision of St John the Evangelist by Bedoli, now in the Uffizi and reproduced by di Giampaolo (1971), p. 29, no. 7.

120. See Bartsch, XVI, p. 9, no. 6.

121. See doc. nos. 112, 118. A similar condition can be found in the contract for the *Madonna and Child* in Sant'Agostino in Rome; see Corti (1971). On contracts and the settling of disputes in fifteenth century Venice, see Connell (1976), pp. 185–221.

122. Doc. no. 276. Segala and Cattaneo had previously executed the bronze *St John the Baptist* for the baptismal font in San Marco in 1566; see chap. x.

123. Doc. no. 282. He is referred to as 'Giacomo Sicilian' who was then in Rome. This could only mean del Duca, who practised as sculptor and architect and had recently finished the large Farnese Tabernacle, now in Naples; see Benetti (1972–73), pp. 61–76.

124. These were the apartments given to Jacopo with his post as *proto* of San Marco; see chap. iii, p. 38; and also Schulz (1982).

125. On 7 June 1556, the Maggior Consiglio passed by an overwhelming majority a motion that no new structure could be built in the church of San Marco without the approval of the doge, the councillors, the *capi di quaranta*, and the procurators, on a two-thirds' majority of all the above-mentioned. The motion was extended to include: 'l'istesso che è detto della chiesa, se debba etiam osservar di qualunque fabrica, che di novo si volesse far nella Piazza di San Marco'; see ASV, Maggior Consiglio, Deliberazione 28—Rocca, fols. 45ᵛ–46ʳ.

Notes to Chapter V

1. The most comprehensive study of the Loggetta remains that by Lorenzetti (1910-11). Among more recent studies, those by Tafuri (1972), pp. 72–80; Howard (1972), pp. 259–97, and (1975), pp. 28–35; and Hirthe (1986-I) merit particular attention.

2. On Leopardi's standard bases, see Jestaz (1982); and here pp. 82–83. For the building of the Procuratie Vecchie, see Paoletti (1893), pp. 277–79; Angelini (1961), pp. 15, 29–32; and Foscari (1983).

3. On 14 July 1536 the procurators commissioned a model of houses for the south side of the Piazza, 'ubi ad presens existunt domus veterus inhabitatae per clarissimos Dominos procuratores cum tota facie anteriori incipiendo ab ecclesia sancti geminiani' (ASV, Proc. de supra, Atti, reg. 125, fol. 2ᵛ). See also Howard (1975), p. 19.

4. This was first noted by Lotz (1966 and 1968); see Howard (1975), pp. 10–16.

5. The procurators decided to house the collection of manuscripts bequeathed to the Republic by Cardinal Bessarion in the newly begun building opposite the Doge's Palace on 6 March 1537. Their deliberation reads in part: 'fieri debeat libreria pro collocandis et gubernandis libris graecis et latinis bonae memoriae quondam excellentissimi domini Cardinalis Niceni super loco fabricae noviter incohatae ubi erant appotheca panatariae ... super plathea sancti Marci' (ASV, Proc. de supra, Atti, reg. 125, fol. 12ʳ⁻ᵛ). The gist of the deliberation was first published in a posthumous collection of notes by Clark (1911), pp. 308–09, n. 4; see also Howard (1975), p. 19. It should be mentioned here that the basic design of the Library would be better seen in the tradition of Veneto public palaces like those of Brescia and Verona as opposed to descriptions of ancient libraries. The procurators intended the structure to fulfill several functions: offices for the three *procuracies*, a public reading room, and shops. It was thus a multipurpose structure whose subsequent name reflects only one of its original functions; on this, see esp. Hirthe (1986-I).

6. The damage to the old loggia is mentioned by Sansovino (1581), p. 111ʳ. Reference to a restoration after an earthquake in 1511 comes in Sanudo, XII, col. 80; for the restoration to the Campanile in August 1537, see here doc. no. 93. Mention is made of Sansovino's project for a new loggia in a letter by Aretino (1609), I, pp. 190ᵛ–191ᵛ, here printed as doc, no. 91.

7. For the building history of the Loggetta, see the detailed account in cat. no. 27.

8. On the fall of the Campanile, see Vendrasco (1902) and Cantalamessa (1902). A more detailed account can be found in the pages of *The Times*, 15 July 1902, p. 5d; 18 July, pp. 3c, 8b; 19 July, p. 7c. According to these reports, the Campanile had been leaning for years, and unspecified though unsatisfactory repairs were carried out in the 1890s. After the collapse, some of the bronzes were found intact. On the restoration, see Fradeletto (1912), pp. 131–250; the design showing the proportion and placement of new and old marbles on the façade, printed here as fig. 194, is taken from p. 244 of the book edited by Fradaletto.

9. A stimulating discussion of the Loggetta in the context of Renaissance architectural theory is found in Onians (1968), pp. 28–35; see also Onians (1988), pp. 287–94.

10. See Lotz (1963).

11. Sansovino (1581), p. 112ᵛ, remarks of the Library: 'Parendo adunque al Senato, che all'incontro del palazzo publico dovesse apparir qualche edifitio honorato ... commesso a procuratori de supra l'anno 1536 questo carico, si fece la presente fabrica singolare sul modello del Sansovino.'

12. For this episode, see Howard (1975), pp. 19–20.

13. Serlio (1537). pp. 183ʳ–185ᵛ. Because the Composite order was itself composed of elements from other orders, Serlio felt that architects could use their imagination in applying it to modern buildings: 'Di quest'opera Composita non se ne vede molti edificij, eccetto che archi trionfali, & ancora la maggior parte di quelli son fatti di spoglie d'altri edificij: nondimeno & havendone data una regola generale, non faro altre inventioni di edificij di tal spetie: impero che il prudente Architetto, secondo gli accidenti si potra servire delle passate inventioni, trasmutandole nell'opera composita' (p. 185ᵛ).

14. Doc. no. 91; see also Onians (1968), pp. 61–69, and (1988), pp. 292–93.

15. The Composite order of the Lateran Baptistry and Santa Costanza are given by Palladio (1570), IV, pp. 63, 87. For the Arch of Titus, see Pfanner (1983), Beilage 2, no. 3.

16. See Zanotto (1858), pl. 54. The smaller Ionic order of the Library has an Ionic base after Vitruvius.

17. See Weihrauch (1935), pp. 54–55; and, more particularly, Lotz (1963).

18. For the Malipiero tomb, see chap. x, p. 149. On Minio's altar, see chap. xi, p. 165; and Grossato (1957).

19. See cat. no. 16.

20. Much useful information on the trade in coloured marbles can be found in Connell (1976), pp. 109–52; see also Gnoli (1971).

21. See Wolters (1976), I, pp. 173–78, no. 48, pp. 220–21, no. 143, and pp. 242–48, no. 175; for the Doge's Palace in particular, see Wolters (1983).

22. For the Colleoni monument, see Pope-Hennessy (1971), pp. 298–99. On the Zen chapel, see Paoletti (1893), pp. 244–47, 268–69; and Jestaz (1986).

23. See Frommel (1967–68), pp. 119–21, no. 86. The tomb was designed in 1523, shortly after the death of the pope, and was finished by 1529. There may have been some link between this tomb and the orchestration of coloured marbles by Raphael in the Chigi chapel in Santa Maria del Popolo, for which see Shearman (1961). Ligorio's monument to Paul IV is reproduced in Venturi, X-III, pp. 568–69. On the chapel of Sixtus V, see Schwager (1961).

24. The point was made in a public lecture in the Courtauld Institute in 1972; see also Howard (1975), p. 46. For the painting by Peruzzi, see Frommel (1967–68), p. 125, no. 89; and Virno in Cassanelli and Rossi (1983), pp. 142–44.

25. The assistance of Tribolo is mentioned by Vasari in his life of Michelangelo da Siena (V, p. 93).

26. Rosci (1966), pp. 44–45, draws attention to the similarity between the design for a choir screen in Serlio's seventh book, the Santa Casa in Loreto, and the Loggetta. Sansovino and Serlio were on good terms with Titian and Aretino and occasionally helped each other. Serlio signed the memorandum drawn up by Francesco Zorzi on San Francesco della Vigna in 1535, and Sansovino appraised Serlio's altarpiece for the Madonna di Galliera in Bologna in 1539. For these episodes, see Howard (1975), pp. 66–67; Tafuri and Foscari (1983); and Malaguzzi Valeri (1893). As late as 1550, Aretino mentions 'il Sansovino tutto vostro' in a letter to Serlio in France; see Aretino (1609), VI, p. 34ʳ⁻ᵛ.

27. Compare the elevation of the Arco Foscari published by Hubala (1965), p. 642. Similar mouldings occur on Tullio Lombardo's tomb of Doge Giovanni Mocenigo in Santi Giovanni e Paolo (here fig. 287).

28. See Janson (1963), pl. 99. Andrea Sansovino applied the same framing device to the predella of the terracotta altar of St Lawrence in the church of Santa Chiara in Monte Sansavino; see

Huntley (1935), pp. 28–31, figs. 18, 20.

29. On the stucco *Apollo*, see Favaretto (1972), p. 84: 'vi è la Statua di Gesso dell'Apollo dell'inclito famoso Scultore Giacomo Sansovino che di bronzo ha fatto con molt'Altre belissime Statue per Ornamento della Loggia nella Maestosa gran Piazza di S. Marco in Venetia'. As Favaretto observed, this figure was subsequently lost. On the *Minerva* and *Mars* in Marcolini's possession, see cat. no. 86. Some of the following observations have previously been treated in Boucher (1984).

30. Aretino (1609), II, p. 199^{r-v}, dated 13 January 1541. The poem ends with these lines:

Immortal' Sansovin' voi pur' havete
Mostrato al mondo, come ai bronzi, e i marmi
Non men' senso, che moti dar' sapete.

Aretino sent the bronze to the Marchese del Vasto; see cat. no. 71.

31. On these artists, see chaps. iv and x.

32. On the lost-wax method of casting, see Baudry and Bozo (1978), pp. 248–54; and the important study by Stone (1981).

33. This argument was advanced by Lányi, in an unpublished lecture given at the Warburg Institute; see Janson (1963), p. 84. The theory has been developed since by Pope-Hennessy (1984).

34. Janson (1963), pp. 23–29, with a synopsis of critical comments on the *St George* from the fifteenth and sixteenth centuries. Of these, the appreciation most in keeping with what Sansovino would have felt about the statue comes from Vasari: 'E certo, nelle figure moderne non s'è veduta ancora tanta vivacità, ne tanto spirito in marmo, quanto la natura e l'arte opero con la mano di Donato in questa' (II, p. 403). The late sixteenth-century treatise on the statue by Francesco Bocchi went so far as to elevate the *St George* to the level of antique sculpture; for this, see Barocchi (1960–62), III, pp. 127–94.

35. The feminine characterization of the nude body invites comparison with Donatello's *David*, while the general pose of the figure in its niche is reminiscent of Andrea Sansovino's *St Matthew* on the Corbinelli altarpiece (fig. 3).

36. For the engraving by Marc'antonio Raimondi after Raphael's *Apollo*, see Bartsch (1854–70), XIV, p. 251, no. 334. The sinuous nature of Raphael's *Apollo* is even more accentuated in a drawing of the *Apollo Citharoedus* by Girolamo Mazzola Bedoli; see di Giampaolo (1971), p. 70, no 63 (Chatsworth inv. no. 208).

37. On Firenzuola's *Dialogo della bellezza delle donne*, see Cropper (1976). Dolce's discussion of the 'gratiosa bellezza' of Titian's Adonis comes in a letter addressed to Alessandro Contarini, for which, see Roskill (1968), pp. 212–17. Weihrauch (1935), p. 57, drew attention to Dolce's letter and also compared Sansovino's *Apollo* with classical figures of Venus. See also here note 118.

38. Bartsch, XV, p. 78, no. 36.

39. Compare the torso of the *kore* now in the Museo Archeologico, Venice, published by Pincus (1981-I), figs. 8–9.

40. See the letter to Aretino in Vasari, VIII, pp. 254–60; and also Chastel (1960).

41. The correct identification and purpose of the drawing, Albertina inv. no. 462, was established by McTavish (1976).

42. The last example of a strong influence of Michelangelo upon Sansovino's work came with the *St James* for San Giacomo degli Spagnoli; see Hirst (1972); and here chap. ii, pp. 28–30.

43. Aretino's friendship with Vasari was fundamental for his introduction to Venice in 1541 and to figures like Sansovino and Titian. Significantly, Vasari was sending samples of his work to Aretino as early as 1536, asking his friend to show his drawings to Sansovino and Titian; see Frey (1923–30), II, pp. 46–48, no. xvi.

Aretino may have recommended Vasari's services to Sansovino for the ceiling paintings of Santo Spirito in Isola, on which, see Howard (1975), p. 76. It is not inconceivable that Sansovino may even have vetted Vasari's designs for *La talenta*; be doubtless knew them.

44. On the *Calumny of Apelles*, see Lightbown (1978), II, pp. 87–92, no. 79. Botticelli's use of Donatellesque figures in the *Calumny* has been noted by Hartt (1975); see also here note 100.

45. On this *topos*, see Monk (1944), esp. pp. 138–39; as well as Cropper (1976); and Roskill (1968), pp. 18–25.

46. McMahon (1956), II, p. 114r (no. 382): 'se tu voi fare figura che dimostra in se leggiadria, debbi fare membra gentili e distese, senza dimostrazione di troppi muscoli, e que' pochi ch'al proposito farai dimostrare, fagli dolci, cioè di poca evidenzia . . . e le membra, massimamente le braccia disnodate'.

47. Pliny, *Historia naturalis*, xxxiv, 65: 'Statuariae arti plurimum traditur contulisse capillum exprimendo, capita minora faciendo quam antiqui, corpora graciliora siccioraque, per quae proceritas signorum maior videretur.'

48. See the discussion of the orders given in Vitruvius, *Decem libri*, IV, i.

49. 'Gli antichi, oltre alla proporzione, attendevano alla gratia per satisfare allo aspetto et però facevano corpi alquanto grandi le teste piccole, le cosce lunghe; nel che era posta la sveltezza'; see Barbaro (1556), p. 63. See also the remarks by Chastel and Kelin in Gauricus (1969), pp. 75–113.

50. For these statues, see especially Haskell and Penny (1981), pp. 148–51, 227–32, 240–41, 311–14. As late as the eighteenth century, Schiller invoked the example of the *Juno Ludovisi* as the basis for his theory of ideal beauty as the reconciliation of male and female elements; see Wilkinson and Willoughby (1967), nos. xv, xvi.

51. Serlio's fourth book paraphrased Vitruvius's remarks on the orders; see Serlio (1537), pp. 158v, 169r (chaps. vii–viii). For Dolce's knowledge of ancient and modern writers on art, see Roskill (1968), pp. 7–32. Francesco Sansovino's literary connections are discussed by Cicogna (1824–53), IV, pp. 31–91; and Grendler (1969), pp. 65–68, with further references.

52. The translation comes from Roskill (1968), pp. 142–43.

53. *Ibid*. See also Firenzuola (1802), I, pp. 24–25. In support of his argument concerning beauty as a mixture of male and female qualities, Firenzuola cites Aristophanes' discourse on the origins of the sexes in Plato's *Symposium* (190b–191c). This may also be the ultimate source for the more ambitious analyses of beauty by Schiller and Wilhelm von Humboldt; see Wilkinson and Willoughby (1967); and von Humboldt (1960–81), I, pp. 296–336.

54. Onians (1968) and (1988), *passim*.

55. Vitruvius gives two different canons for the human figure, one of ten faces and another of eight heads (III, i, 2); his discussion of caryatids and persians as substitutes for columns comes in I, i, 5 and 6. The caryatids of Pontecasale are 183.5 cm high, from base to entablature, while the figure itself is 155.5 cm high, with a face of 15 cm. On these caryatids and the fireplaces designed by Sansovino for the Doge's Palace, see here chap. x.

56. See the remarks of Serlio on substituting caryatids for columns on the Corinthian fireplace: 'Et perche . . . la maniera Corinthia hebbe origine da una vergine Corinthia; ho voluto imitarla, ponendola per colonna' (1537, p. 182r).

57. See Hartt (1975).

58. For the Porta della Carta, see Schulz (1978). On Paolo Savin, see Jestaz (1986), pp. 143–58, esp. 153–55.

59. Sansovino employed a modified version of the *serpentinata* as early as his Florentine *St James*, for which, see chap. i,

pp. 15–16. See also cat. no. 7.

60. The quotation given here is taken from the guidebook of 1556, which was published under the name of Anselmo Guisconi and subsequently reprinted under Sansovino's name in 1561 and afterwards. Guisconi was probably a pseudonym for Sansovino, as Cicogna and Soranzo have suggested. See Guisconi (1556), p. 11; and also Cicogna (1847), p. 597, no. 4460; and Soranzo (1885), p. 601, no. 7407. Davis (1985) first drew attention to the brief account of the Loggetta published by Francesco Sansovino in a short treatise on rhetoric in 1546 (printed here as doc. no. 110).

61. The best discussion of the Loggetta's antecedents remains that by Lotz (1963). An exhaustive account of gates of honour and triumphal arches is given by von Erfa in *RDK*, IV, cols. 1443–1504.

62. The subject is vast and in need of a general treatment in terms of painting, sculpture, and architecture. Among earlier works dealing with the subject, see Borinski (1914–23), I, pp. 176–80; and Labowsky (1934). On the relationship between rhetorical *genera* and Vitruvius's distinction of the orders, see Onians (1968), pp. 166–71, and (1988), pp. 36–40, 152–57, 271–77. For the use of decorum by Alberti, see Grayson (1972), pp. 74–79 (*De pictura*, II, 37–40); and also Orlandi and Portoghesi (1966), I, pp. 64–75, II, pp. 632–41, pp. 778–87 (*De re aedificatoria*, I, ix-x; VII, xiv; IX, i). Alberti's ideas are reflected in Leonardo's *Trattato*; see McMahon (1956), I, pp. 147–48, nos. 387–89. See also Vasari, I, pp. 173–74, and Lomazzo's *Trattato*, for which see Ciardi (1973–74), II, pp. 294–306 (libro VI, xxii–xxviii).

63. Quintillian, *Institutio oratoris*, II, xiii, 9–11; see Summers (1972) for a discussion of this *topos* with respect to Renaissance art.

64. Vitruvius, *Decem libri*, I, ii, 5, and VI, iii, 6, treats *decor* as the equivalent of the Greek concept *to prepon*, that which is appropriate (the same word was employed by Aristotle in his discussion of plot in the *Poetics*). For Vitruvius's comparison of the order to human types, see IV, i; and here pp. 78–79.

65. Onians (1968), pp. 245–96 and (1988), pp. 147–57; and here note 62.

66. McMahon (1956), I, pp. 147–48, nos. 387–89. On Serlio and the orders, see Onians (1968) and (1988), pp. 263–86.

67. See Chartrou (1928) for a general survey and Ginori Conti (1936) and Chastel (1960) for specifically Italian examples from the sixteenth century.

68. Vasari described the *apparato* for *La Talanta* in his life of Cristoforo Gherardi and in a letter to Ottaviano de' Medici dated 1542; see Vasari, VI, pp. 223–24, and VIII, pp. 283–87, respectively. Vasari's abstract of the contract for these decorations is published by Frey (1923–30), II, p. 859. The most extensive discussion of Vasari's trip to Venice is that by Schulz (1961), but see also McTavish (1976).

69. As there are minor discrepancies in the several accounts of the decorations, the one followed here is that in the life of Gherardi; see Vasari, VI, pp. 223–24. On Minio's collaboration on the decorations, see Vasari, VII, p. 516.

70. *Vasari*, VI, p. 648. On the Orion Fountain, see Gombrich (1972), pp. 7–11; and Mösender (1974), pp. 54–80. Mösender compares the Orion Fountain to cars produced for *trionfi*.

71. Ginori Conti (1936).

72. Armenini (1971), pp. 148–51 (book iii). See also Ciardi (1973–74), pp. 294–306 (*Trattato*, libro VI, xxii–xxviii).

73. Battistella (1918), esp. pp. 23–27; also Lane (1973), pp. 23–29, 57.

74. Hill and Pollard (1967), p. 77, no. 416, for the medal by Spinelli.

75. Among the major surveys of this topic, see Chabod

(1958); Fasoli (1958); Gaeta (1961); Robey and Law (1975); and Muir (1981).

76. On Contarini and the *Argoa voluptas*, see Cicogna (1847), p. 258, no. 1808; and Foscarini (1854), p. 342, nos. 1–2. The only recent discussion of the poem is found in a pamphlet by Sardo (1908). The Latin edition of the poem, dedicated to Doge Pietro Lando (1539–45), was published in 1541, with a translation into Italian following in 1542. Contarini died in 1543. The references here come from the two editions in the Biblioteca Nazionale Marciana, 124.D.147 (Latin) and 138.D.235 (Italian version, called *Argo vulgar*).

77. For example, Glaucos and Scylla are mentioned in Ovid's *metamorphoses*, xiii, 900ff, and xiv, 1ff, as well as in Virgil's *Ecolgues*, VI, 74. Phorcos and Cymothoe are mentioned, along with Palaemon, Triton, Thetis, and others, in Virgil's description of Neptune's train in *Aeneid*, V, 816–26. It may be that Contarini wove his account of the standard bases from such passages in Virgil or others, such as Pliny's description of a group of the passing of Achilles to the Isles of the Blessed by the Greek sculptor Skopas in *Historia naturalis*, xxxvi, 26. Jestaz (1982), pp. 31–32, cites several examples of festival cars with decorations analogous to those on Leopardi's standard bases, the most striking being those for the carnival of 1533, in which Pallas, Justice, Concord, Victory, Peace, and Abundance were driven round Piazza San Marco. Jestaz sees the standard base reliefs as résumés of this type of popular personification of Venetian virtues.

78. Sansovino (1581), p. 105ᵛ. A slightly different explanation of the iconography of the bases is given by Cicognara et al. (1838–40), I, p. 48.

79. Contarini (1541), p. 17ʳ⁻ᵛ.

80. Guisconi (1556), p. 11. The allusion is to Lactantius's *De falsa religione*, I, xi: 'Sepulcrum ejus est in Creta et in oppido Cnosso, et dicitur Vesta hanc urbem creavisse; inque sepulcro ejus est inscriptum antiquis litteris graecis, ZANKRONOY, id est latine, Jupiter Saturni'. On the euhermeristic tradition, see Seznec (1961), pp. 3–36.

81. Secchi (1966); see also Cicogna (1824–53), III, pp. 318–23, 502–03. Cicogna reports that Bembo had an inscription carved into a stone tomb, identifying it as the tomb of Venus. He may have been inspired to do so by the passage in Lactantius.

82. On the painting by Titian, see Wittkower (1938–39), pp. 202–03; also Wethey (1969), pp. 152–53. On Venus and Venice, see Medin (1904), p. 7. The following verses by Doglioni (1613), fol. iiiᵛ, are characteristic:

Aut Venus a Venetis sibi fecit amabile nomen
 Aut Veneti Veneris nomen, & omen habent.
Orta maris spunta fertur Venus, & Venetorum
 Si videas urbem, creditur orta mari.
Iuppiter est illi genitor, sed Mars pater huic est
 Mulciberi coniunx illa, sed ista maris.
Complet amore sui Venus omnia; que Venetam urbem
 Non amat, hunc nunquam debet amare Venus.

For the canzone 'Ecco Vinegia bella' and a valuable discussion of musical aspects of this theme, see Rosand (1977), esp. p. 500, n. 49.

83. See Gaeta (1961), p. 61.

84. Cozzi (1963–64), esp. p. 230.

85. Hill (1948), III, pp. 830–36. For a recent survey of Venice and the Ottoman Empire, see Preto (1975).

86. Medin (1904), pp. 17–18, quotes an early sixteenth-century sonnet on the lion of St Mark as a symbol of peace and war.

87. Guisconi (1556), p. 11.

88. Wolters (1976), I, pp. 46–47, and 178–79, no. 49, dates

the relief on the Doge's Palace to ca. 1355; see also Wolters (1983), pp. 236–46.

89. On Jacobello's painting, formerly in the Magistrato del proprio of the Doge's Palace, see Moschini Marconi (1955), pp. 28–29; and Wolters (1983), pp. 238–39. The relationship between Venice and the Virgin Mary was underscored by the legendary foundation of the city on the Feast of the Annunciation; see Tramontin (1965), pp. 78–80; and Sinding Larsen (1974), pp. 45–56.

90. For the medals, see Hill and Pollard (1967), p. 29, no. 136, and p. 129, no. 137. On the Mint reliefs, see Boucher (1977).

91. Seznec (1961), *passim.*

92. Contarini (1541), p. 18ʳ.

93. Both *canzoni* were published by Donato (1558), pp. 25–26. See Rosand (1977), pp. 528–29. Medin (1904), p. 49, also quotes from an anonymous writer of the sixteenth century who described Venice as having received from heaven seven gifts that vouchsafed her an immortal kingdom: concord, peace, faith, piety, justice, solicitude, and charity.

94. Petrarca (1955), pp. 1076–78: 'Augustissima Venetorum urbs, que una hodie libertatis ac pacis iustitiae domus est, unum bonorum refugium, unus portus quem bene vivere cupientium tyranneis undique ac bellicis tempestatibus quasse rates petant; urbs auri dives sed ditior fame, potens opibus sed virtute potentior, solidis fundata marmoribus sed solidiore etiam fundamento civilis concordie stabilita, salsis cinta fluctibus sed salsioribus tuta consiliis.' The passage comes in a letter to Pietro da Bologna, dated 10 August 1364. The theme of Venice as a political refuge is elaborated in a treatise dedicated to Doge Gritti and written for the council of Ten by the Greek refugee Thomas Dipovatatius, *Tractatus de Venetae urbis libertate et ejusdem imperii dignitate et privilegiis*, now in the Biblioteca Nazionale Marciana, MS Lat. Cl. XIV, cod. lxxvii (=2991), esp. fols. 13ᵛ–17ᵛ. I am grateful to Giorgio Ferrari for bringing this manuscript to my attention.

95. See Boccaccio (1532), p. 146 (lib. V, cap. xlviii); and Jacopo da Bergamo (1485), p. 15ʳ (lib. III).

96. Boccaccio (1532), p. 145; the reference comes from Cicero.

97. Wolters (1965–66), pp. 315–16.

98. On the flaying of Marsyas, see Ovid, *Metamorphoses*, VI, 382–400. Cicero discusses the link between *sol* and *solus* in *De natura deorum*, II, xxvii, 68: 'Cum sol dictus sit vel quia solus ex omnibus sideribus est tantus vel quia cum est exortus obscuratis omnibus solus apparet.'

99. Sansovino (1581), p. 111ᵛ; see also Spitzer (1963), pp. 11–19. On the *Somnium Scipionis*, see Boyance (1936), pp. 57–119.

100. See Bodin (1576), p. 751, quoted by Rosand (1977), p. 513, n. 5. On Bodin and the myth of the 'mixed' constitution, see Gilmore (1973).

101. Ovid, *Metamorphoses*, I, 622–712.

102. The prose commentary by Giovanni Bonsignore was frequently published at the turn of the sixteenth century, and his account of the slaying of Argus reads in part: 'Argo in greco sona a dir in latino prudentia & avedimento . . . el quale è ingannato da Mercurio idio de la eloquentia. Imperhò che nullo è tanto savio che da lo ornato & polito parlare non sia ingagnato & tolto.' See Bonsignore (1519), pp. 7ᵛ–8ʳ (lib. I, cap. xliiii).

103. Cicero, *De natura deorum*, iii, 56, cited by Lactantius in his *De falsa religione*, I, vi. See also Boccaccio (1532), p. 312 (lib. xii, cap. lxii).

104. For the medal of Tasso, see the example by an anonymous medalist in the British Museum, Department of Coins and Medals (no. 599.14.3.5). For the reverse with Mercury

and Argus, see Weber (1975), p. 249, no. 503. On the relief cycle of the Library, see Ivanoff (1968). A small marble relief of Mercury playing to Argus was formerly in the Donà dalle Rose collection, with an attribution to Antonio Lombardo; see Lorenzetti and Planiscig (1934). p. 40, no. 207.

105. Seznec (1961), pp. 210–11.

106. Erizzo (1559), part 2, p. 130, publishes the reverse of such a medal from the reign of Vespasian.

107. For the medal of Leo X, see Hill (1930), p. 226, no. 872 bis; for that of Alessandro de' Medici, see Hill and Pollard (1967), p. 60, no. 317. Cellini's medal for Pope Clement VII is reproduced in Plon (1883–84), p. 198, pl. xi, fig. 4.

108. See Romanin (1853–61), I, p. 155.

109. Jacopo da Bergamo pays an extensive tribute to the peaceful traditions of Venice in his account of the city: 'Quae res a deo civiles discordias et populares seditiones omnio avertit ut huic dum taxat civitati per hominum memoriam sine factionibus et intestinis contentionbus tam immensum tamque diuturnum genere licuerit imperium ut autem in bellis inferendis semper tardissimi extitere veneti' (1485, p. 204ᵛ).

110. Cozzi (1963–64), p. 230.

111. In 1542 the French ambassador wrote of the Venetian policy of peace: 'Ils avoyent advise, pour le bien et consideration de leur estat, estre meilleur de ne s'empescher en matière de guerre aveques aucum, ains chaircher et entretenir la paix aveques ung chacun.' See Chabod (1958), p. 43, n. 50.

112. See Henkel and Schöne (1967), cols. 1489–90.

113. Wolters (1965–66), pp. 315–16.

114. During the progress of Charles V and his son Prince Philip through the Netherlands in 1549, there was a representation of Phrixus and the ram at Mons. The following inscription accompanied the tableau: QVAERITIS, AVSTRIADAE, CIVES QVID IMAGINE PHRYXI, / SIGNIFICENT, FVLVA QVI MARE TRANAT OVE. / SILICET, HI FAVSTO PORTENDVNT OMINE QVONDAM, / CESSARVM NOBIS AEQVORIS IMPERIVM. AVREA, QVAE COLLO GESTATIS, VELLERA PONTVS / AVRORAE NOSCET, NOVIT VT HESPERIAE. See Calvete de Estrella (1552), p. 211ʳ.

115. Selvatico (1847), p. 310, glosses the reliefs as 'mitlogiche allegorie forse riferibili ai pericoli che i Veneziani incontravano spesso guerreggiando coi barbari dominatori nei Dardanelli, forse ai fruttuosi commercii che per la via dell'Ellesponto essi mantenevano nell'Oriente. Le due a sinistra esprimono fatti relativi a Venere per meglio richiamare al pensiero quel regno di Cipro cui Venezia poneva tanta dilezione.' If the reliefs do refer to Venus, then one would expect them to have been placed beneath the relief of Venus in the attic.

116. For the role of Sansovino's shop in the execution of the *finestrone*, see chap. x, p. 152.

117. On this topic, see chap. xi, pp. 169–70.

118. See Burns (1975), pp. 124–26, 154–55, for these projects.

119. On the Loredan monument, see chap. xi, p. 168.

120. On the decoration of the Villa Godi, see Zorzi (1968), pp. 26–27, fig. 36. For the Villa Emo, see Bordignon Favero (1970), esp. pp. 35–51.

121. For Veronese's philosophers in the Library and for his frescoes at Maser, see Pignatti (1976), I, p. 117, nos. 94–95, and p. 118, respectively. On the decoration of the Sala Dorata of the Library, see von Hadeln (1911.)

122. On the early decorative cycles in the Doge's Palace, see Wickhoff (1883); Wolters (1965–66); and more recently Wolters (1983). On the ceilings by Veronese and his followers, see also von Hadeln (1911-II); and Schulz (1968), pp. 96–101.

123. Given that Francesco Sansovino was consulted for the

programme of the newly restored rooms in the Doge's Palace after the fire of 1577, it is not surprising that there should be a strong similarity between the iconography of the Loggetta and rooms like the *antipregadi*.

124. See Wittkower (1973), p. 300.

Notes to Chapter VI

1. On the life and miracles of St Anthony, see especially Kleinschmidt (1931); Felder (1933); and, with particular respect to the church of the Santo, Stepan (1982).

2. The first comprehensive history of the Santo is that by Gonzati (1852–53), but see also the more recent discussions by Dellwing (1975) and Puppi (1975), I, pp. 169–98.

3. Gonzati (1852–53), I, pp. 36–39, 75–83; new documents concerning the chapel have been published by Sartori (1976) and have been used in an excellent revised history of the chapel and its decoration by Wilk (1984).

4. The information on Stefano da Ferrara comes in an account of the chapel by Marc'antonio Michiel, for which, see Morelli (1884), p. 18; and Wilk (1984), pp. 110–12.

5. Gonzati (1852–53), I, p. 75, doc. li. Gonzati claims that a model for a new chapel was commissioned from Bartolomeo da Ponte, but the document he quotes is equivocal. In the event, only a new entablature was built at a cost of 1,041 lire.

6. *Ibid.*, p. 76, doc. lii.

7. *Ibid.*, doc. liii; see also Wilk (1984), pp. 111–14.

8. Gonzati (1852–53), I, p. 77, doc. liv.

9. *Ibid.*, pp. 77–78, docs. lv, lxxxix; and Wilk (1984), p. 157, figs. 210–13.

10. For the contract with the Lombardo brothers, see Sartori (1976), p. 137. A recent discussion of Tullio's career can be found in Wilk (1978).

11. Gonzati (1852–53), I, pp. 156–57, doc. lxxxv. The attribution to Riccio has been accepted by later writers such as Planiscig (1927), pp. 169–71; Cessi (1965), p. 28; and Pope-Hennessy (1971), p. 95. While Riccio could have had some role in the chapel's design it does seem strange that a trained goldsmith and bronze-caster would create a chapel in which there was no scope for his own handiwork.

12. Rigoni (1970), pp. 255–58; and Stepan (1982), pp. 17–20.

13. On Michiel's credibility, see Fletcher (1981), pp. 604–05.

14. This is confirmed in a statement by Pietro Lombardo in 1467; see Rigoni (1970), pp. 126, 134–35, no. viii.

15. For the Scuola di San Marco, see Paoletti (1929) and Sohm (1982). Wilk (1984) and Sheard (1984) arrived independently at conclusions similar to those expressed here. Sansovino (1581), p. 102ʳ, identifies Tullio as the author of the reliefs on the façade of the Scuola.

16. The engraving is by D. Valesi and based upon a drawing by F. Battaglioli; see Biblioteca Civica, Padua, RIP xxxi / 2736; and Mariacher (1981), p. 399, no. 275.

17. On Donatello's high altar reliefs, see Janson (1963), pp. 185–87; and White (1967-II), pp. 148–69. Tullio Lombardo's request for drawings and plaster copies of Donatello's *Miracle of the Eucharist* in 1528 is published by Sartori (1976), p. 140. Copies of Donatello's reliefs were still in circulation at the end of the sixteenth century; see Sartori (1963), pp. 357–58, no. viii. Four copies of reliefs by Donatello and five by Sansovino were in the estate of the Paduan sculptor Agostino Zoppo in 1572 as reported by Rigoni (1970), p. 305.

18. For the Bellini drawing of Christ among the doctors, see Goloubew (1908–12), II, pl. xii. A painting of the same subject by Bellini may have been in the Scuola Grande di San Giovanni Evangelista, according to Ridolfi (1914–24), I, p. 53.

19. See Gauricus (1969), pp. 15–17, 254–55.

20. 'Sarà una memoria sempiterna, como vostra nobeltà pol giudicare perché la pittura è cosa caduca et . . . la scoltura è molto più senza comparatione, et non dá paragonare con pittura per niun modo, perché de antiqui si ritrova sino alli nostri tempi de le sue scolture, con pittura veramente nulla si pol vedere.' See Puppi (1972), p. 103. This was a standard argument in the contemporary debate over the supremacy of painting versus sculpture, on which, see Mendelsohn (1982), with further references.

21. Vasari, I, pp. 156–57. In the absence of a comprehensive study of Renaissance relief sculpture, see Lehner (1969). *Mezzo rilievo* was the term commonly employed to describe the panels in the Santo from the sixteenth to the eighteenth century, but it had been replaced by *basso rilievo* by the early nineteenth century, as in Moschini (1817), p. 24.

22. Sartori (1976), pp. 137–38; and Wilk (1984), pp. 121–22, 125–27.

23. Sartori (1976), pp. 28–29, 137–38, 156; see also Wilk (1984), pp. 122–25.

24. Pen, brown ink, and wash, 245 by 295 mm, private collection, London; see Stock (1980), p. 24, no. 3. The drawing was attributed to Giovanni Bellini by Berenson and is called Bellini or assistant by Stock; yet the obvious connection with the Santo reliefs would argue for an attribution to the Lombardo brothers or their circle as stated above. See also Wilk (1984), p. 123.

25. Gonzati (1852–53), I, pp. 79, 82, doc. lix; see also Gilbert (1980).

26. Sartori (1976), p. 160; Wilk (1984), pp. 128–29.

27. Comparisons of the payments given to the various sculptors show that Tullio Lombardo received 400 ducats and Antonio received 324 ducats for the first two reliefs in 1505; see Sartori (1976), p. 139. Giovanni Battista Bregno contracted to furnish his relief for 150 ducats in 1502 and his brother Lorenzo agreed to a basic fee of 250 ducats in 1516; Sartori (1976), pp. 28–29. Antonio Minello's payment of 60 ducats is mentioned in his settlement of 1517; *ibid.*, p. 160. In 1520 Tullio's basic fee for his second relief was 250 ducats and Minello's was 240; *ibid.*, pp. 139–40, 161, respectively. Mosca initially agreed to a fee of 198 ducats in May 1520; *ibid.*, p. 172.

28. *Ibid.*, pp. 28–29.

29. On the cycle of paintings in the Scuola, see Sartori (1955); and Wethey (1969), pp. 128–29, no. 95.

30. See the references in note 27; and Wilk (1984), pp. 129–36. Mosca and Stella have been considered by Schulz (1985).

31. Rigoni (1970), pp. 239–53. Rubino, also called Dentone, was a pupil of Cristoforo Solari, il Gobbo, and was employed by Alvise Cornaro on the decoration of the façade of the Odeo Cornaro while at work on the relief for the Santo. Rubino died before finishing his relief, and its completion was entrusted to Sansovino's collaborator Silvio Cosini.

32. For the contract between Tullio and the *massari* in 1528, see Sartori (1976), p. 140.

33. Wilk (1984), pp. 130–33.

34. Janson (1963), p. 187, pl. 88.

35. Stepan (1982), pp. 59–63, 178–83; Wilk (1984), pp. 134–36; and Schulz (1985).

36. Rigoni (1970), pp. 239–53; Sartori (1976), pp. 76–77, 205; and Wilk (1984), pp. 139–41.

37. See especially Stepan (1982), pp. 53–55, 308; and Wilk

(1984), pp. 138–39. Sartori (1976), p. 161, mistakenly refers to Minello's model as finished in 1520, but the chronology was corrected by Stepan.

38. Doc. nos. 126–28. In all probability, the statue was not carved.

39. Doc. nos. 129–44; see cat. no. 29.

40. In this *De pictura*, Alberti advised against having more than ten figures in a scene; see Grayson (1972), pp. 78–79 (II, 40).

41. Stepan (1982), pp. 187–88, underlined the importance of Tranzapani's fresco for Minello. See also Sartori (1955), p. 67.

42. For the memorandum of 1532, see Sartori (1976), p. 207, and here doc. no. 140. A *précis* of the contract of 1536 is given in doc. no. 145; see also cat. no. 30.

43. See Stepan (1982), pp. 195–204, 365; and Wilk (1984), pp. 141–44.

44. Cornaro's family commissioned the vast Palazzo Cornaro at San Maurizio from Sansovino; see Howard (1975), pp. 136–38. On Priuli, see chap. iii, p. 43.

45. See especially chaps. iv and v.

46. This is discussed in more detail in cat. no. 30.

47. Doc. nos. 146, 150–57.

48. This is specifically stated in the decision to award Tullio Lombardo's third relief panel to Sansovino: 'li sara dati ducati 50 dum modo lui habbia principiato ditto quadro, e cosi successive di tempo in tempo secondo lui lavorerà, li sia dati danari a sufficientia, acciò non patisca, e possa con buon animo finir ditta opera'; see Sartori (1976), p. 207. The same condition had been imposed in Tullio Lombardo's contract of 1520; see *ibid.*, pp. 139–40.

49. See chaps. iv and v for a discussion of Sansovino's bronzes from this period.

50. See McMahon (1956), I, p. 145, no. 382; see also Boucher (1984), and here chap. v.

51. The statue was executed for the mortuary chapel of Hieronimo Priuli, who died in 1547. Priuli had commissioned the adjacent doorway from Sansovino's workshop in 1530, and the statue of St Jerome was probably another such project, delegated to Tommaso; on Tommaso Lombardo, see chap. x.

52. Bartsch, XIV, p. 43, no. 37.

53. The most explicit definition of geometric formulae as employed by painters comes in Lomazzo's *Trattato* (vi, cap. 2); see Ciardi (1973–74), II, pp. 246–47. The ideas, however, go back to Leonardo and his contemporaries; see Summers (1972), esp. 295–96; and Wittkower (1962), pp. 13–19.

54. The wooden sculpture, Bargello inv. no. 1, was replaced by Francesco da Sangallo's marble group. On the tradition of these figures, se *LCI*, V, cols. 185–90.

55. '. . . la propoporzione propriamente, secondo il parer mio, non è altro che un modo di comporre le cose in guisa che l'una con l'altra convenga, e parimente il tutto di loro insieme con quelle, in alcuna misurata quantità . . . secondo il fine a che la cosa si compone. E questa comisurazione può essere con la parità e similmente con la disparità. Ma la proporzione delle cose ineguali sarà sempre più artifiziosa e causerà maggior bellezza che non farà quella delle cose eguali'; see Barocchi (1960–62), I, p. 234. See also Summers (1972). Cf. the outsized figure of St Mark in the first series of reliefs in the choir of San Marco (figs. 134, 136, 138).

56. 'Sunt quidem cognatae artes eodemque ingenio pictura et sculptura nutritae' (*De pictura*, II, 27); see Grayson (1972), pp. 10, 64. See also Baxandall (1971), pp. 121–39, for a discussion of the second book of the *De pictura*, and also the observations of Hetzer (1957).

57. On the San Marco reliefs, see Boucher (1976); and here chap. iv. The relationship between Sansovino's and Sarto's style during the second decade of the century is discussed by Shearman (1965), pp. 62–64; and here in chap. ii.

58. Grayson (1972), pp. 72–86 (II.35–45); also Baxandall (1971), pp. 121–39.

59. McMahon (1956), I, pp. 110–11 (nos. 268–71). Leonardo's knowledge of the *De pictura* is discussed by Heydenreich, in McMahon (1956), pp. xxiv–xxv.

60. On this topic Leonardo wrote: 'It is an extreme error of some masters to repeat the same motions in the same compositions, one alongside the other, and likewise the beauty in the faces is always the same, though this is never found repeated in nature . . . Beauty and ugliness seem more effective through one another'; see McMahon (1956), I, p. 112 (nos. 274, 277). Leonardo employed such studies in contrast in his own works, and the idea found favour with younger Florentine artists like Bandinelli, who introduced contrasting studies of youth and old age in his *Martyrdom of St Lawrence*, for which, see Davidson (1961). For the more general acceptance of Leonardo's ideas at mid-century, see Summers (1977).

61. Rigoni (1970), pp. 239–53.

62. On the bust of Aristotle, see chap. iii, p. 46.

63. According to Francesco Sansovino, and Cicogna (1824–53), IV, pp. 76–77, no. 77, Jacopo had prepared 'bellissime anatomie' for publication, although this never happened. See also doc. no. 111.

64. The *Christ* is reproduced by Pope-Hennessy (1970), pl. 23.

65. Shearman (1967), pp. 54–56. For the popularity of the *Christ* in the 1540s and afterwards, see Hirst (1967).

66. Grayson (1972), p. 78: 'Sed hanc copiam velim cum varietate quadam esse ornatum, tum dignitate et vericundia gravem atque moderatum' (*De pictura*, II.40).

67. What the *massari* of the Arca thought of the relief is not recorded, though they did concede Sansovino's bonus after a lengthy dispute from 1557 to 1562; see cat no. 30.

68. See Timofiewitsch (1972), pp. 213–214, 233–35; and Wilk (1984), pp. 145–48.

69. Salò's relief is signed and dated 1571; on him, see Thieme–Becker, XXIX, p. 353; and here chap. ix, p. 138.

70. Cicognara (1823–24), V, p. 272; see also the discussion here in cat no. 30.

Notes to Chapter VII

1. Vasari, VII, pp. 511–12. See also Barocchi (1962), IV, p. 1934, no. 712; and also Davis (1981), p. 295.

2. See, *inter alia*, Jameson (1891); Lassreff (1938); Cecchelli (1946–54); Grabar (1968), pp. 36–37, 77; and Ringbom (1984).

3. Dominici (1861), pp. 131–32; see also Ringbom (1984), pp. 59–60.

4. Burckhardt (1929–34), XII, p. 269: Wackernagel (1981), pp. 103, 173–76; Pope-Hennessy (1976) and (1980-I), pp. 60–66. Kecks (1988) provides a useful survey of Florentine reliefs.

5. For the relief by Donatello, see Pope-Hennessy (1964), I, pp. 77–78, no. 64. For Luca's Genoa *Madonna*, see Pope-Hennessy (1980), pp. 255–56, no. 41.

6. On the *Madonna Tempi*, see Dussler (1971), pp. 21–22; and Pope-Hennessy (1970-II), p. 184.

7. On Andrea and his *atelier*, see Marquand (1922); and also Gentilini (1983).

8. For the *Madonna of the Architects* and the *Madonna of the Cushion*, see Marquand (1922), I, pp. 18–21, and II, pp. 65–66; see also Gentilini (1983), pp. 12–16, and 22, respectively.

9. See chap. i, p. 6; and cat. no. 2.

10. See chap. i, p. 12; and chap. ii, pp. 26–28. See also cat. nos. 8, 10.

11. See chap. iii, pp. 46–52; and cat. nos. 12, 14, 17.

12. See especially Goffen (1975).

13. On the Venetian tradition, see Bettini (1933); and also Goffen (1975), with a comprehensive bibliography. In his treatise of 1586, the painter Giovanni Battista Armenini complained about the old, blackened Byzantine images which were found all over northern Italy and stated that they were disgraceful and not apt to encourage devotion. See Ringbom (1984), pp. 34–35.

14. See Planiscig (1921), p. 382; Lorenzetti (1929), p. 35; and Venturi, X-2, pp. 637–40. See also cat. nos. 18–19.

15. See doc. nos. 295–303.

16. Doc. no. 91.

17. Vasari, VII, p. 506. In this, Vasari was following the biographical sketch of his father by Francesco Sansovino, printed here as doc. no. 252. There Francesco Sansovino refers to the marble group as 'per di sopra la porta di San Marco', i.e., *intended for*, but this fine point escaped Vasari's attention.

18. On this see chap. iv, pp. 71–72; and doc. nos. 262–94.

19. Weihrauch (1935), pp. 83–88.

20. *Ibid.*, p. 85. Weihrauch's questioning of the authorship of the statue follows an anonymous review of the volume of documents published by Ongania and Cecchetti (1886), in which the sculpture had been assigned to the workshop; see *Repertorium für Kunstwissenschaft*, X, 1887, pp. 338–39.

21. See Demus (1960), p. 15, n. 48.

22. See Davis (1980), p. 582; and also here cat. no. 19.

23. The detail is reproduced by Bagarotto, Savio, and Boucher (1980), p. 26, fig. 37.

24. This was, in essence, the case against Jacopo which the procurators made in 1574, but there must have been a verbal contract; see Boucher (1980-II), p. 585; and here chap. x, p. 145.

25. See chaps. iv, p. 60, and x, pp. 145–48.

26. Pietrogrande (1942–54), p. 132, dates the statues to the late 1560s even though they are not mentioned by Segala in an autobiographical letter of 1573. A more plausible date would be around 1580, just after the stucco figures of Charity that Segala made for Mantua; see Pietrogrande (1955), p. 110, esp. fig. 3 on p. 105.

27. Cat. no. 18.

28. Weihrauch (1935), p. 86, drew attention to the influence of Donatello's Santo *Madonna* here; as for the capitals, they are singular in Sansovino's *oeuvre* and may have been inspired by Donatello's use of similar motifs in the architectural surround of his San Lorenzo pulpit reliefs, on which see, Janson (1963), pl. 109. The type of capital is, in fact, a late antique invention; see Mercklin (1962), p. 165, no. 393; and also Chiarlo (1979).

29. Weihrauch (1935), p. 88, dated the *Giovannino* to the 1550s by comparison with the *St John the Baptist* in the Frari, but this work must also have been conceived ca. 1534. See here chap. iii, pp. 47–49.

30. Shearman (1965), I, pp. 63–64; see Pallucchini (1950), pp. 75–78; and Pallucchini and Rossi (1982), I, p. 133, nos. 12–15.

31. On the Bendict *Madonna*, see Pallucchini and Rossi (1982), I, p. 240, no. A 8.

32. Vasari, VII, p. 520; see also Cicogna (1824–53), IV, pp. 139–41, nos. 4–5. Lewis (1982), p. 170, gives 1557 as the chapel's date, but this must be a slip for 1547. On Tommaso, see here chap. x, p. 148.

33. Sansovino (1581), p. 92v.

34. The Virgin and Child were reconstructed, but the *Giovan-*

nino could not be; see Lorenzetti (1910-II), p. 124, figs. 8–9. On the collapse of the Campanile, see here chap. v, p. 74.

35. Shearman (1965), I, p. 64.

36. Shearman (1965), II, pp. 251–53.

37. *Ibid.*, I, p. 62; see also here chap. i, p. 12.

38. Shearman (1965), II, p. 290, no. 4.

39. See chap. ii, pp. 25–28.

40. Pope-Hennessy (1971), pp. 296–97, fig. 57.

41. See chap. viii, pp. 123–25.

42. Pignatti (1976), I, p. 112, no. 54. The painting was originally made for a sister convent of San Sebastiano's in Padua and is generally dated to the late 1550s; see also Boucher (1990).

43. See Pignatti (1976), I, p. 104, no. 5, and p. 126, no. 130, respectively.

44. On Campagna's works, see Timofiewitsch (1972-II), pls. 34, 72. On the Roccatagliata in the Metropolitan, see Weihrauch (1967), p. 165, fig. 200; a terracotta of similar design is discussed by Schottmüller (1933), p. 189, no. 2616.

45. Cat. no. 45.

46. See Bagarotto, Savio, and Boucher (1980); and also Davis (1980); as well as Boucher (1980-II).

47. Lorenzetti (1926), p. 723; see also here cat. no. 42.

48. Doc. no. 195; see also Weddigen (1974), pp. 44–45, 53–54.

49. The phrase comes from Meiss (1966), pp. 360–62; see also Firestone (1942), pp. 45–48.

50. These are discussed and illustrated by Beguin (1979).

51. Doc. no. 123; see also cat. no. 70.

52. Aretino (1609), VI, pp. 58^{r-v}, 72^{r-v}, partly reprinted here as doc. no. 124. For Vasari's observation, see here note 1.

53. Cicogna (1824–53), IV, p. 24, n. 2; see also here cat. no. 55.

54. Bode (1886), pp. 34–35. An account of Bode's article was published in French by Pigeon (1887).

55. See cat. nos. 44–45.

56. Pittoni (1909), pp. 359–60; see also here cat. no. 28.

57. Lorenzetti (1910-I), pp. 334–36, and (1929), pp. 87–89.

58. Doc. no. 145.

59. This is discussed in detail in cat. no. 28.

60. I am grateful to Elisa Avagnina of the Soprintendenza per i Beni Artistici e Ambientali del Veneto for sharing this information with me. See also cat. no. 28.

61. Aretino (1609), VI, p. 58^{r-v}; and here cat. no. 70.

62. Rupprecht (1963–65), p. 2; see also Vasari, VII, p. 503. On the sculpture of the Villa Garzoni, see chap. here x, p. 153.

63. See cat. nos. 46–56.

64. See the definition given in Baldinucci (1681), p. 29. A survey of the subject would be welcome, but see the scattered references in Middeldorf (1955) and (1978); Pope-Hennessy (1974), (1976) and (1980-I); Wackernagel (1981), p. 103; Boucher (1981), p. 23, nn. 1–2; and Strom (1982).

65. Vasari, II, pp. 110–11.

66. See cat. no. 74. Ammannati made a series of fourteen *cartapesta* statues of the apostles and two allegorical figures for the Florentine Baptistry in 1514; see Settesoldi (1975). For a surviving series of such statues from the eighteenth century, see Rizzo (1981).

67. Pope-Hennessy (1980), p. 330, has underlined the absence of Venetian prototypes for Sansovino's *cartapesta* reliefs and has seen an influence on them from Titian's paintings.

68. On this, see esp. Avery and Radcliffe (1978).

69. I owe these observations to the good offices of Elisa Avagnina of the Soprintendenza per i Beni Artistici e Ambientali del Veneto and to John Larson, chief of sculpture conservation at

the Victoria and Albert Museum. A well-illustrated report on the Vittorio Veneto relief has been published by Avagnina and Pianca (1989); see here cat. nos. 51, 55.

70. The example in the Kress Collection was catalogued as *cartapesta* and stucco by Middeldorf (1976), pp. 74–75, but there is no mention of the gold leaf and red glaze, which is visible to the naked eye. See here cat. no. 56.

71. See cat. no. 15.

72. Lorenzetti (1929), pp. 87–89; and here cat. no. 20.

73. Weihrauch (1935), p. 71, n. 179, and p. 88. For other critical comment, see here cat. no. 40.

74. See chap. iv, pp. 71–72. For a sketch of Contarini, see Cozzi (1961).

75. Zanotto (1853–61), I, p. 33, pl. xii; and here cat. no. 43.

76. Lorenzetti (1910–I), p. 336, and (1929), p. 70. Lewis (1982), pp. 163–66, has accepted it as autograph, linking it with the marble relief now in the Cà d'Oro.

Notes to Chapter VIII

1. For a discussion of these projects, see chaps. ix and x; on the Fabbriche Nuove, see Howard (1975), pp. 47–61.

2. A discussion on Primaticcio's role at the French court is given by Blunt (1971), pp. 31–34; for Giambologna and his shop, see Avery and Radcliffe (1978), pp. 37–38.

3. Giraldus (1539), p. 68, quoted by Hiesinger (1976), p. 284. Hiesinger's conclusions, however, misinterpret the meaning of Giraldus's text.

4. Sansovino (1581), pp. 146ᵛ–148ᵛ, writes of dress and rank in Venice by stating: 'Negli anni andati, s'osservava nel vestirsi un'ordine, quasi come per grado.' See also the observations of Chambers (1970), pp. 144–45.

5. On burial customs in Venice, see Sansovino (1581), pp. 150ʳ–151ʳ, 191ʳ–192ᵛ; Gallicciolli (1795), III, pp. 282–98; Cecchetti (1887), pp. 265–84; Molmenti (1905–08), II, pp. 560–84; and Bistort (1912), pp. 292–95.

6. Sansovino (1581), p. 150ᵛ, estimates the average cost of a funeral as 300 or 400 ducats, and in 1551 Hieronimo Benallo of Bergamo petitioned the Venetian Senate to curb the size and expense of funerals in his native town; see ASV, Senato Terra, filza 16 (September 1552–February 1553), under the date 27 July 1551.

7. Cecchetti (1887), pp. 277–78.

8. Weddigen (1974), pp. 7–76, offers a comprehensive survey of Rangone's career and artistic patronage, together with a full bibliography. Among the earlier accounts of Rangone's life, that by Astegiano (1925), pp. 49–70, 236–60, is also worth re-reading, although his interpretations of source material is sometimes unreliable.

9. As the inscription on the façade of San Giuliano and on the base of his bronze statue bear witness, Rangone was known as Filologo da Ravenna in the 1550s. He adopted the aristocratic name of Rangone only in later years; see Weddigen (1974), pp. 21–23, 65–66, n. 65.

10. Weddigen (1974), p. 26. Rangone is recorded as living in one of the houses near San Geminiano from May 1532.

11. The foundation of San Geminiano dated from the sixth century but had been wholly rebuilt when the area of the Piazza was enlarged to its present length in 1156. Cristoforo da Legname began a new church on the quincunx plan in 1505; this was substantially complete by 1518 when money was being solicited for the façade. There matters stood until the 1550s. On San Geminiano, see Cicogna (1824–53), IV, pp. 5–123; and more

recently Gallo (1957), pp. 81–84. On the destruction of the church, see Zorzi (1972), II, pp. 332–37.

12. Gallo (1957), p. 99, n. 77, gives as the source for Rangone's petition of 1552, Senato-Terra, filza 57, but the reference is incorrect, as Howard (1975), p. 81, n. 83, first observed. I have found no mention of San Geminiano in the *filze* of the Senate for 1552 (i.e., nos. 15–16), nor did I come across any discussion of the project in the *registri* of the Senate between 1550 and 1552 (ASV, Collegio, reg. 37–38). Thus, whatever Gallo's source may have been, it has not yet come to light.

13. Doc. no. 177. The short span of time between the appointment of the two procurators and the approval of Sansovino's design would imply that Sansovino prepared his design well before its final acceptance.

14. Doc. no. 178. The only surviving copy of the agreement is in the parish archives, now in the Archivio patriarcale, Venice. See also cat. no. 31.

15. The connection between San Giuliano and the Balbi family is mentioned by Sansovino (1581), p. 49ᵛ; see also Paoletti (1837–40), II, pp. 162–64. For a view of the pre-Sansovino church, see Franzoi and di Stefano (1976), p. 363, fig. 537. The quotation is taken from doc. no. 178.

16. Weddigen (1974), p. 62.

17. Doc. no. 179.

18. For the Tiepolo monuments, see da Mosto (1960), pp. 84–85.

19. On Vettor Capello's monument, see Munman (1971), Zorzi (1972), I, p. 126, discusses the now destroyed memorial to Pietro Grimani, but see also Foscari and Tafuri (1982); and here cat. no. 112.

20. On Rangone's service under Capello in 1534, see Weddigen (1974), p. 26.

21. Pavanello (1921), p. 3, refers to documents in the archive of Santa Maria Formosa that give the date of the façade as 1542, but they are not traceable. Capello died in August 1541, and in a codicil to his will, dated 25 March 1540, he expressed the wish to be buried in San Pietro Martire, Murano, or Santa Maria Formosa, leaving the final choice to his son Vincenzo (see ASV, atti testamenti, Marsilio, A., b. 1214, no. 1020, fol. 3ʳ). The statue on the façade was identified as by Domenico da Salò on the basis of a signature on the pedestal. Domenico was the son of Pietro da Salò, one of Sansovino's pupils, and he helped with the carving of the *giganti* in the 1550s. His only datable work is the altar of 1571 in San Giuseppe di Castello (fig. 268).

22. Capello became a procurator *de supra* in 1539. For his biography, see *DBI*, XVIII, pp. 827–30.

23. Benedetto Pesaro's will of 1503 expressly requested the kind of monument he eventually received, as was noted by Cecchetti (1887), p. 280, but it may only have been completed around 1537. On this, see Meyer zur Capellen (1980), p. 152, n. 48.

24. Sansovino (1581), p. 8ᵛ; and also Wolters (1976), I, p. 204, no. 118, and II, fig. 334. On the significance of the standing figure in the Renaissance, see Burckhardt (1929–34), XIII, pp. 306–09; and Keutner (1956).

25. Other examples, subsequent to Vettor Pisani, are: Jacopo Marcello, the general who died at Gallipoli in 1484, by Pietro Lombardo; Benedetto Pesaro, capitano da mar, by Lorenzo Bregno; Doge Niccolò Tron, by Antonio Rizzo—all three in the Frari; Dionigi Naldo da Brisighella by Lorenzo Bregno and Doge Pietro Mocenigo by Pietro Lombardo—both in Santi Giovanni e Paolo; Pelegrino Baselli by Bartolomeo Bon in the church of San Rocco; and Giovanni Emo by Rizzo, formerly in Santa Maria dei Servi.

26. The medal is discussed and dated by Weddigen (1974),

pp. 45–50; and by Gorini (1976), p. 70. Previous attributions of some of Rangone's medals to Sansovino can be discounted in light of the identification of the medalists in Rangone's will of 1577.

27. See doc. nos. 182–183, 191.

28. Temanza (1778), pp. 251, 480–81. Temanza's opinion is echoed by Selvatico (1847), pp. 299–300. Lorenzetti (1926), p. 350, gives the façade to Sansovino, as does Howard (1975), p. 86. Hubula (1965), p. 861, supports the idea of co-authorship for the façade, a position to which Howard (1977) has turned.

29. These decorative cartouches, uncommon in Sansovino's works and probably designed by Vittoria, contain Greek and Hebrew inscriptions. According to the translations published by Moschini (1815), I, pp. 532–33, the Hebrew reads: 'Thomas Philologus of Ravenna, who wrote many books in various fields of learning and found the means of extending human life beyond 120 years, erected this fabric in the year of creation 5315'; the Greek reads: 'Thomas Philologus of Ravenna, who with his erudition rendered illustrious the universities of Bologna, Rome and Padua, inspired this [project] in the year 7062 from the creation of the world.'

30. This was first noted by Howard (1975), p. 86, and corroborated by Mason Rinaldi (1975), p. 199, with a document of 1564, referring to the resiting of the altar of the Scuola dei marzeri 'a costo al muro in driedo *al volto di mezzo* et fra le due colonne' (my italics). This indicates an intention to build a basilical church as late as 1564. The adoption of a simpler interior may have been indirectly related to the collapse of the roof of the old church when the new façade was begun in 1554; see Temanza (1778), p. 251, n. b.

31. See doc. no. 195, and Weddigen (1974), p. 63–64. On Rusconi's career, see Zorzi (1965), pp. 130–46; for Bollani's interest in architecture, see Burns (1975), pp. 246–47, no. 436.

32. On the altar of the mercers or *marzeri*, see Mason Rinaldi (1975). The attribution of the façade of the Scuola di San Fantin to Vittoria has recently been sustained by Zampetti (1973), p. 11.

33. For these churches, see Howard (1975), pp. 64–77, and (1977).

34. Gallo (1957), pp. 101–04; this is discussed here in more detail in cat. no. 31.

35. On Vittoria as Sansovino's collaborator, see chap. x.

36. Doc. no. 204, and see also chap. ix.

37. In addition to various medals by Vittoria, Rangone also commissioned a statue of himself as St Thomas from the sculptor at some point before 1566. Vittoria refers to the statue in his will of 1566, in which he makes Rangone one of his executors; see Gerola (1924–25), pp. 343–45. By the end of the 1560s, Vittoria is acknowledged as the best sculptor in Venice after Sansovino; for this, see Voltelini (1892), pp. xlix–l, no. 8812, printed here as doc. no. 253.

38. On the bust, originally placed in San Geminiano ca. 1572, see Weddigen (1974), pp. 67–68. A recent examination of the statue during its conservation (September 1990) confirms the head as a work by Vittoria; its modelling is extremely close to that of the bust in the Ateneo Veneto.

39. Mentioned by Vasari, VII, p. 520. It was probably executed to commemorate the completion of the church in the early 1560s; see Cessi (1961), I, p. 30.

40. These portrait heads are discussed in chap. iv.

41. They were executed between 1551 and 1553; see chap. iv.

42. See note 37.

43. Pope-Hennessy (1970), pp. 97–98, discusses Sansovino and Vittoria as great portraitists, but his judgement is coloured by the attribution of the bronze of Rangone to Sansovino. Cessi (1961), I, pp. 27–44, discusses Vittoria's portraits in relation to his other sculpture.

44. From 1566 Sansovino rented the *bottega* beneath his apartments in the Piazza, and from April of that same year Jacomo Spavento was made his assistant as *proto*. By March 1569 Sansovino was also ordered to stop issuing *polizze* for the procurators. On this, see Howard (1972), pp. 53–55. On Vittoria and Rangone, see here note 37.

45. The case of the Scuola di San Marco is a good example of the employment of several architects in succession: see Paoletti (1929); and the more recent comments in Heydenreich-Lotz (1974), pp. 91–93, 316–17; and Sohm (1978). On the rebuilding of the Doge's Palace and San Giuliano, see Burns (1975), pp. 158–60.

46. Vittoria is described as *proto* in Rangone's will of 1577, both for San Giuliano and for the portal of the convent of San Sepulcro: see doc. no. 195.

47. The tradition of scholar's monuments in the context of seated and standing tomb effigies is analysed by Bauch (1975), pp. 161–85, esp. pp. 174–75.

48. The Dante monument was proposed by Weddigen (1974), pp. 65–67, as a source for Rangone's monument. Similar monuments to academics which may also have been known to Rangone and Sansovino are the tombs of Antonio Galeazzo Bentivoglio and Niccolò Fava, both attributed to Giacopo della Quercia and in San Giacomo Maggiore, Bologna; the monument to Cino di Sinibaldi and Filippo Lazzari by Antonio Rossellino in Pistoia; and the Trombetta and de Rossi monuments by the de Grandi brothers in Sant'Antonio, Padua.

49. See Supino (1938), pp. 368–69, for this monument. According to Thieme–Becker, XXXVI, p. 373, a contract for the monument was drawn up in October 1549 with a stipulation for completion within three years. Giovanni Zacchi, the designer of the tomb, was the son of Zaccaria Zacchi, an associate of Baccio da Montelupo and one of Sansovino's competitors in the famous Laocoon competition as reported by Vasari, VII, p. 489.

50. The Venetian influence on the Gozzadini monument was first noted by Ricci (1893), p. 17. Giovanni Zacchi had been in Venice in 1536 when he made a medal of Andrea Gritti, on which, see Hill (1914), pp. 335–41.

51. Here one must disagree with the conclusions proposed by Bialostocki (1973), pp. 7–32, esp. pp. 25–26, on the construction of tombs round doorways. In Rangone's monument and in Gozzadini's, the door is not an integral part of the composition but rather ignored. Hence, it is unlikely that the gate of death is being referred to.

52. The principal inscription reads as follows: THOMAS PHYLLOGVS RAVENNAS / PHYSICVS AERE HONESTIS LABORIBVS / PARTO AEDES ORIMVM PADVE / VIRTVTI POST HAS SENATVS / PERMISSV PIETATI ERIGI / FECIT: ILLAS ANIMI HAS ETIAM / CORPORIS MONVMENTVM. In the lunettes: ANNO MVNDI / VI DCCLIIII / NONIS OCTO / BRIS. IESV CHRISTI / MDLIIII / VRBIS / MC / XXX / IIII. For the Greek and Hebrew inscriptions, see note 29.

53. Astrology and herbology were part of a doctor's education, and references to them figured in medical portraits, as in the woodcut of Girolamo Fracastoro which was published in his *Homocendrica* (Venice, 1538) and shows the physician with an armillary sphere and a branch, possibly of guiac. Astegiano (1925), p. 238, identifies the branch in Rangone's hand as *Huysan beata radice* and cites a letter by G.B. Morgagni (1763), p. 11, in support. Morgagni's letter does allude to such a plant but in a synopsis of one of Rangone's works, *not* in the context of the façade of San Giuliano. I have not been able to identify the plant in Rangone's hand, but it must have some medical significance.

54. One of the medals Vittoria made for Rangone bears the

inscription LEO IMPERAT SOL ET APOLLO; see Weddigen (1974), pp. 47–48, who dates it ca. 1556–58. The dragon inside the three circles may have some value as a talisman against sickness, but this is not clear from the context. On the dragon in art, see the entry in RDK, IV, cols. 342–66. Weddigen (1974), p. 65, conjectures that the dragon may refer to the college of doctors, of which Rangone was a patron.

55. This was first noted by Pope-Hennessy (1970), p. 410. For a traditional, full-length monument of this type, see that of the Latinist Giovanni Calfurnio in the second cloister of the Santo in Padua, reproduced in Gauricus (1969), fig. 4. Rangone himself had been depicted in a manner similar to his own monument in the frontispiece to a pamphlet entitled *Ad clarissimos iustissimae Urbis Venetiarum praesides Dominum Laurentium Larentanum, Dominum Ioannem Cornelium, et Dominem Andream Taurisanum de repentinis, mortiferis, et, ut ita dicam, miraculosis nostri temporis aegritudinibus* (Venice, 1535). The pamphlet is recorded by Tiraboschi (1778), VI-2, pp. 58–61. Tiraboschi had never seen the work but knew of it through a description given him by Ireneo Affò, librarian of the Palatine Library in Parma. No copy of this rare work by Rangone can be traced in Parma or any other major European library.

56. Rangone died on 18 September 1577 at the age of eighty-four. According to his will (ASV, testamenti, b. 421, no. 1172, fols. 1–25, esp. 4v–7r), Rangone expected some one thousand persons to attend his funeral. The procession was to make its way from his house on the Piazza to San Geminiano, then through the Piazza to San Giuliano, with the greater part of his collection of coins, medals, paintings, drawings, models, and sculpture being carried in the procession.

57. For the life of Venier, see da Mosto (1960), pp. 259–62. The major stages in his career had been: *luogotenente* in Udine and member of the Council of Ten (1534); Podestà of Padua and ambassador to Paul III (1537); Podestà of Verona (1551). He was elected doge on 11 June 1554 (see Capellari-Vivaro, IV, fol. 163v). See also here cat. no. 32.

58. Venier's membership of the Misericordia, of which Sansovino was architect, is mentioned in his will; on his acquaintanceship with Manutio, see Manutio (1556), pp. 60v–61r.

59. Venier knew Capello at least as early as 1546 when he witnessed a power-of-attorney drawn up for Capello; see ASV, atti, Maffei, V., busta 8092, fol. 48r. For the *giganti*, see here chap. ix; for the Scala d'Oro, see chap. x. On the Fabbriche Nuove, see Howard (1975), pp. 47–61; and here doc. no. 241.

60. The history of the tomb is given by Lorenzetti (1929), p. 72; and Weihrauch (1935), pp. 78–79. See also here cat. no. 32.

61. Other than the works cited in notes 3 and 5, see the valuable discussion given in da Mosto (1960), pp. I–LVI.

62. The last doge to be buried in San Marco was Andrea Dandolo, whose tomb is in the Baptistry; see Wolters (1976), I, pp. 52–53, and II, fig. 311.

63. Cecchetti (1887), p. 278.

64. A useful survey of earlier ducal tombs is given in Meyer (1889), pp. 79–102.

65. The concept of the tomb as a memorial to the *casata* is explicitly stated in the will of Andrea Vendramin, drawn up in 1472; see Sheard (1978), pp. 120–25. On the Barbarigo tombs, see especially Markham Schulz (1981). The Mocenigo tombs are discussed by Zava Bocazzi (1965), pp. 117–23, 139–44.

66. Marc'antonio Trevisan is buried in the nave of San Francesco della Vigna and has only a tablet with a relief of himself and the lion of St Mark above the portal on the right-hand side of the transept; see da Mosto (1960), pp. 254–59.

67. Doc. no. 173.

68. 'Et perche è conveniente che circa la nostra sepultura diamo quel ordine che se ne conviene, volemo quanto alle exequie che si siegui quello che alli altri predecessori nostri è sta solito farsi per li heredi dei altri principi piu di quello che per el publico e costume di fare'; see doc. no. 173. For a different interpretation of Venier's will, see Hiesinger (1976), p. 287, but see also the discussion here in cat. no. 32.

69. Doc. no. 174.

70. Sansovino (1581), p. 273r. See also Da Mosto (1960), pp. 259–62, 571.

71. Vasari, VII, p. 505; Sansovino (1581), p. 48r.

72. This was observed by Temanza (1778), p. 254; see Selvatico (1847), pp. 300–01; and Hubala (1965), pp. 932–33.

73. See Wolters (1976), I, pp. 226–27, and II, fig. 475.

74. On this, see chap. v.

75. The attribution of the altar of the Annunciation to Sansovino goes back to Moschini (1815), I, p. 545, citing a passage in an abstract of the monastery's archives; it is illustrated by Mariacher (1962), p. 152. While plausible as a work by Sansovino, no architect's name occurs in the act of donation of the chapel to the della Vecchia family on 24 October 1560; see ASV, San Salvatore, busta 48 (=tomo 99), fols. 20r–24r. On the Palazzo Delfin, see Tafuri (1972), pp. 42–43.

76. According to Tassini (1895), pp. 13–14, no. 9, the inscription was composed by Giovanni Donà; for it, see here cat. no. 32.

77. Doc. no. 175; first published by Predelli (1908), pp. 185–88.

78. Vasari, VII, pp. 518–19; see Leithe-Jasper (1963), pp. 77–78.

79. On the recumbent effigy in general, see s'Jacob (1954), pp. 9–44. Girolamo Campagna used the semi-recumbent twice on monuments to Pasquale Cicogna, now in the Gesuiti, and Marino Grimani in San Giuseppe de Castello; for these tombs, see Timofiewitsch (1972), pp. 208, 267–73, nos. 20–21. Although Timofiewitsch sees these figures as archaic, they did represent a novelty for Venetian tombs.

80. Both statues are signed on the base: IACOBVS SANSOVINVS SCVLPTOR ET ARCHITECTVS FLORENTINVS F[ACIEBAT]. The same signature appears on the *Maiden Carilla* relief, and a similar signature is found on the Loggetta gods and the *Evangelists* in San Marco.

81. Weihrauch puts the Venier statues, the *giganti*, and parts of the *Maiden Carilla* relief together as examples of the sculptor's late style (1935), pp. 74–79.

82. On the bronze in the Beit collection, see Bagarotto, Savio, and Boucher (1980), p. 26, n. 17. On Minio's altar, now in the Museo Civico of Padua, see Grossato (1957), pp. 108–09, with further references.

83. Compare Vasari, VII, p. 487: 'si vedeva nondimeno, in quello che faceva, facilità, dolcezza, grazia, ed un certo che di leggiadro, molto grato agli occhi degli artefici; intanto che ogni suo schizzo, o segno, o bozza ha sempre avuto una movezza a fierezza, che a pochi scultori suole porgere la natura'.

84. For the *giganti*, see chap. ix.

85. Vasari, VII, p. 520, states that the altar by Tommaso Lombardo was made after his departure from Sansovino's shop (*partito dal Sansovino*). The altar was ceded to Melio Cortona on 29 November 1546 and bears the date 1547; see ASV, atti, Cavanis, M., busta 3250, fol. 419^{r-v}; and Cicogna (1824–53), IV, pp. 139–41, nos. 4–5.

86. The only earlier figure of Charity with children that I know on a Venetian tomb is on the tomb of Antonio Venier, which shows a woman suckling a child at either breast; see

Wolters (1976), II, fig. 468.

87. On the iconography of Charity, see the entry in RDK, III, cols. 343–56. For charity's importance to the policy of the Venetian state, see Pullan (1971), esp. pp. 7–8, 214–16. Giovanni Morlaiter (1699–1781) carved a statue of a woman with a child at her feet and a flaming heart in her right hand for the confraternity of the Carità in Venice. On the base is an inscription, partly legible, which begins DILIGES PROXIMVM . . .

88. Pittoni (1909), p. 334; and Weihrauch (1935), pp. 78–79.

89. See the discussion in cat. no. 32.

90. Burckhardt (1929–34), IV, p. 62. Lorenzetti (1926), p. 381, refers to it as *Speranza* but subsequently calls it *Fede*; see Lorenzetti (1929), p. 72. Weihrauch (1935), pp. 78–79, left open the question of its identity, while Hubala (1965), p. 933, refers to it as *Faith*.

91. On Faith and Hope, see *LCI*, II, cols. 31–34, and IV, cols. 376–77. The type of Hope depicted by Sansovino is called *speranza divina* by Ripa (1593), p. 471. Earlier examples of this type are the *Faith* by Donatello on the baptismal font in Siena, Agostino di Duccio's relief of Faith in the chapel of St Sigismund in the Tempio Malatestiano in Rimini, and the relief on the tomb of Alessandro Tartagni da Imola by Francesco Ferrucci in San Domenico, Bologna.

92. This engraving, one of a series of the virtues triumphant over vice, is recorded by Passavant (1860–65), VI, p. 87, nos. 95–105 (2). For the history of the Tron monument, see Pope-Hennessy (1971), p. 336; and Markham Schulz (1983), pp. 44–64. Pincus (1969) and (1981) attempts a new reading of the Tron monument's iconography.

93. Vasari, VII, pp. 511–12.

94. On the Villa Garzoni, see Rupprecht (1963), pp. 1–32, esp. p. 24; and Puppi (1969) and (1974).

95. Predelli (1908), pp. 176–77; Cessi (1961), p. 21. The relationship between Vittoria and Sansovino is discussed in chap. x.

96. See the tribute paid to him by Temanza (1778), p. 254; also Zanotto (1853–61), I, p. 114; Lorenzetti (1926), p. 381.

97. Burckhardt (1929–34), IV, p. 62.

98. On the Podocataro family, see Cicogna (1824–53), IV, pp. 142–47, no. 7. See also here cat. no. 33.

99. For their respective careers, see Eubel, III, p. 25, no. 29, and p. 275. Livio resigned the see of Nicosia in favour of his brother Cesare in 1552. Podocataro's Roman house contained some notable sculpture and was mentioned by Aldrovandi; see Hübner (1912), I, p. 110. On the letting of Podocataro's house to Gualter, see Bembo (1729), III, pp. 178–79.

100. On Spira and his circle, see the extensive discussion in Cicogna (1824–53), III, pp. 307–10, no. 25. For Zorzi's memorandum, see Howard (1975), pp. 66–67; and esp. Foscari and Tafuri (1983), pp. 48–70.

101. See Bentivoglio and Valtieri (1976), p. 48, n. 67, for the tomb of Lodovico Podocataro.

102. The panels were cast in 1553 by Agostino Zoppo; see chap. iv and doc. no. 114.

103. For this and other related compositions, see chap. vii.

104. They ultimately derive from the victories on the Arch of Titus in Rome.

105. Sansovino (1581), p. 92ᵛ, calls the whole tomb marble.

106. Doc. no. 196.

107. His funeral is mentioned in B. Bonifacio, 'Caeremoniale rituum sacrorum ecclesia sancti Marci Venetarum', 1564 (Biblioteca Nazionale Marciana, MS Lat. Cl. III, Cod. clxxii = 2276), fol. 83ᵛ.

108. Doc. no. 197.

109. The present windows are identical to those on the upper

floor of San Giuliano, minus the pediments; see doc. no. 198.

110. See Cicogna (1824–53), IV, p. 182, no. 24. The windows to either side of the high altar were rebuilt according to Veronese's design and are copies of those on the Podocataro tomb. The contract specifically refers to the Podocataro tomb as 'principiata nella medesima chiesa di san Bastian'. See also Puppi (1980-II), p. 75; and Boucher (1990).

111. Doc. no. 200. Whether payments for Sansovino's original drawings are included here is a moot point. The estimate for the breakdown of expenditure incurred is based on the analogous expenses recorded by Vittoria for the Venier monument; see doc. no. 175.

112. The contract is in ASV, arch. not., Maffei, V., busta 8098, fols. 21ᵛ–22ʳ, and busta 8106, fol. 742ʳ⁻ᵛ.

113. The contract for the Fabbriche Nuove is here transcribed as document no. 241.

114. See doc. no. 183.

115. On this, see note 110.

116. For Sansovino's will, see doc. no. 256.

117. See chapter iii, pp. 47–49; and cat. no. 13.

118. On Sansovino's tomb in the context of artists' tombs, see Schütz-Rautenberg (1978), pp. 265–71. In his will of 1568, Sansovino gives the date of Cosini's work as 1533; see doc. no. 256.

119. The phrase reads 'a causa chelli vertuosi atendino a studiare e lasare memoria delle loro vertuose fatiche'.

120. On these tombs, see Schütz-Rautenberg (1978), pp. 64–68, 78–135.

121. The Minerbetti tomb is discussed in chap. x.

122. Sansovino refers to himself as a Florentine not only in his will, but also on the base of the Loggetta bronzes, the *Evangelists* in San Marco, and the relief of the *Maiden Carilla*. The inscription OPVS IACOBI SANSOVINI, found on the *giganti* and the terracotta inside the Loggetta, was added after Sansovino's death.

123. Sansovino (1581), p. 44ʳ; see here cat. no. 79.

124. Doc. no. 254. The agreement was first published by Cicogna (1824–53), VI, p. 816, as a note to IV, p. 25. See also Gallo (1957), p. 100; and Howard (1972), pp. 104–05; and (1975), p. 82.

125. The inscription on the slab covering Sansovino's vault read: IACOBO PATRI OPT[IMO] FLORENTIAE / FILIAE DVLCISS[IMAE] SIBI SVISQ[VE] FRAN / CISVS SANSOVINVS P[OSVIT]. MDLXX. The more extensive wall inscription is given by Vasari. VII, p. 513; and Sansovino (1581), p. 44ʳ.

126. See cat. no. 79.

127. On these monuments, see Schütz-Rautenberg (1978), pp. 269–70.

128. For Palladio's tombs, see especially Burns (1979); on Contin, see Thieme–Becker, VII, pp. 339–40; and Bassi (1962), pp. 63–74. Cattaneo's tombs are discussed here in chap. xi.

129. The Grimani memorial is discussed in chap. xi, but see here cat. no. 112. Although the da Lezze monument is conventionally given to Sansovino, a stronger case can be made for Vittoria as its designer; see cat. no. 113.

130. For the Dolfin monument by Giulio dal Moro, see Timofiewitsch (1972), pp. 273–76, no. 22.

Notes to Chapter IX

1. Vasari, VII, p. 506; and Bodmer (1939), p. 117. Bodmer thought Carracci was referring to Jacopo Colonna's work, but the remark must relate to Vasari's passage on the *giganti*, on the same

page of the 1568 edition of the *Vite*. On the identification of Annibale Carracci as the author of these notes, see the summary of the recent debate in Posner (1982).

2. The following discussion of colossal sculpture is much indebted to the work of Bush (1976); for additional bibliographic information on this subject, see also Davis (1976–II).

3. 'Opera la più difficile e la mirabile di tutte le passate'; see Cellini (1857), p. 202. Cf. the remarks of Doni (1549), p. 34v: 'colossi, spettacoli veramente sopra tutte l'altre opere humane maravigliosi: tal che un solo è degno d'adornare et honorare magnificamente ogni gran provincia, non che gli spatiosi prati; che per essere opera di gran lunga rara sopra l'altre, spande tanta fama, che infinito concorso di continuo osserva, come sia bastato l'ingegno humano a fare si maraviglioso spettacolo'.

4. Pliny, *Natural History*, xxxiv, 39–47; and Pauly–Wissowa, IV, cols. 589–90, *s.v.* colossus.

5. See Siebenhüner (1954), p. 79; Ackerman (1961), I, pp. 60, 66; and also Bush (1976), pp. 73–124.

6. Pliny refers to this in xxxvi, 4; see also Bush (1976), pp. 23–29. Something of the eagerness with which most sculptors rose to the challenge of colossal sculpture can be felt in the letter from Vincenzo de' Rossi to Cosimo I de' Medici, asking to be considered for the task of carving the Neptune for the Piazza della Signoria in 1560: 'Per sapere io che la eccellenza vostra vole far fare uno Gigante di marmo, e desideroso di essere anche io nel numero di quelli che la servano, la prego che la si voglia degnare, poichè di mio nome non è opere in firenze'; see Gaye (1839–40), III, p. 24, no. xxviii.

7. Grayson (1972), pp. 100–01 (*De pictura*, III. 57). Alberti was, of course, referring here to life-size figures as opposed to smaller scale ones.

8. Vasari, VII, p. 144: '[Bandinelli] sempre fu vago di far giganti'. For the Perseus, see Pope-Hennessy (1985), pp. 163–214; and on Ammannati, Davis (1976–II).

9. Vasari, I, pp. 148–68; see also the notes of Baldwin Brown (1907), pp. 179–202; and Cellini (1857), pp. 202–12. For a more recent account of the same material, see the useful discussion and illustrations in Carradori (1802), esp. pp. xiv–xv, xxi–xxvii.

10. See Lavin (1967) and Weil (1978), pp. 113–34, on the subject of *bozzetti* in Renaissance sculpture.

11. Cellini (1857), pp. 205–12; see Bush (1976), pp. 43–45, where the distinction between the mechanical practice of Cellini and the more subjective approach of Michelangelo and his followers is underscored. By the seventeenth century, there is some evidence that large models on the same scale as the marble block had become a rarity. Thus Orfeo Boselli wrote: 'del continuo si trova, o il Modello maggiore del Marmo, o il Marmo maggiore del Modello; et di rado si trovano l'uno, et l'altro di equale proportione'; see Dent Weil (1978); MS Corsini, fol. 14v. See also Honour (1972), pp. 148–49, on the practice in Canova's day.

12. Barocchi (1961–62), III, p. 129; and Baldwin Brown (1907), p. 195.

13. On the *Hercules and Cacus*, see the article by Bush (1980), which reproduces the putative wax model, now in the Bode Museum, Berlin. The observation concerning Ammannati's *Neptune* was made by Borghini (1584), p. 593: 'Ma perchè il marmo gli riuscì stretto nelle spalle, non potè egli, siccome desiderava, far mostrare alla sua figura attitudine con le braccie alzate; ma fu costretto à farla con gran difficultà, come hoggi si vede'; see Pope-Hennessey (1970), pp. 374–76.

14. Bottari and Ticozzi (1822–25), I, pp. 70–73. The passage is quoted here in chap. x, note 3.

15. Shearman (1965), pp. 317–18, and (1975); see also Garrard (1970), pp. 330–37; and here cat. no. 81.

16. see Janson (1963), pp. 12–16. The height of the seated *St John* is 210 cm.

17. Pope-Hennessy (1959) and Bush (1976), p. 131, suggest that Sansovino's work was a copy of the *Dioscuri*, but new evidence advanced by Shearman (1975), p. 150, n. 42, makes clear that the figure was prone beneath the horse, perhaps as an allegory of *superbia*. Comparisons of the group with the *Dioscuri* or the *Marcus Aurelius* were probably references to its large scale.

18. Holderbaum (1967).

19. See doc. no. 217.

20. A *ricordo* of Lorenzo Lotto places Ammannati in Venice by January 1543; see Zampetti (1969), pp. 132–33; and Davis (1977), p. 87, n. 73.

21. Davis (1977), pp. 93–94, n. 75, wishes to see a reflection of Ammannati's lost *Neptune* in a small bronze of the type reproduced by Wiehrauch (1967), pp. 330–31. In my opinion, this work has nothing to do with the circle of Sansovino and is, rather, a copy of Leonardo's sketch for a Neptune, on which, see Gould (1952).

22. Davis (1976–II) provides a detailed account of the work.

23. *Ibid.*, pp. 45–46, for the texts of these letters; the reference to Palladio is one of the earliest to place the architect in such notable company.

24. Campori (1872) first published the correspondence over the *Hercules*. Some of the letters were later cited in extract by Pittoni (1909), pp. 291–99; see here cat. no. 34.

25. As a symbol of good government Hercules had been employed on the seal of the Florentine commune and later by the Medici. For this, see Rubinstein (1967); Forster (1971), pp. 78–80; and Ettlinger (1972).

26. Gauricus (1969), pp. 38–41.

27. The medal is attributed to Alfonso Ruspagiari; see Armand (1883–87), I, p. 218, no. 14. An example in the British Museum is reproduced by Jones (1979), p. 63, fig. 146. Erizzo (1559), p. 306, glosses the meaning of Hercules on ancient coins: 'gli antichi per Ercole intesero una perfetta idea di tutte le virtù, si dell'animo, come del corpo'.

28. Campori (1872), p. 502, n. 1, for the reference to Begarelli's work in July 1549. Apparently he did not carve in stone.

29. Vasari, VII, p. 511.

30. Campori (1872), p. 503; and here doc. nos. 201–04. The contract and the earlier part of this correspondence appear to have been lost.

31. Campori (1872), p. 505; see here doc. no. 204. The letter is not in Jacopo's hand but in that of his son Francesco, by comparison with autograph letters of both men. Francesco also wrote out his father's tax return in 1565, reproduced here as fig. 397.

32. A contract in the Venetian State Archives shows that more stone for the Misericordia was being ordered from Istria in 1553; see doc. no. 240.

33. See the duke's reply to Feruffino, printed here as doc. no. 207.

34. On Raphael's shop, see the observations of Shearman (1965) and Oberhuber (1972), pp. 25–50. This theme is discussed extensively in chap. x.

35. Francesco Sansovino writes warmly of the properties of Istrian stone in his guide to Venice, reflecting, perhaps, the enthusiasm of his father: 'Ma bella et mirabil cosa è la materia delle pietre vive, che sono condotte da Rovigno et da Brioni, castella in riviera della Dalmatia, sono di color bianco et simili al marmo: ma salde et forti di maniera che durano per lunghissimo tempo ai ghiacci et al Sole: onde ne fanno statue: le quali polite col feltro a

guisa del marmo, poiche sono pomiciate, hanno sembianza di marmo. Et di queste così fatte si incrostano le faccie intere delle Chiese et dei palazzi, con colonne alte, grosse, et lunghe di un pezzo quanto si vuole'; see Sansovino (1581) pp. 140^v–141^r.

36. On this, see the note in Barocchi (1962), II, p. 424, with further references.

37. Doc. no. 207. A letter referring to a favour by Ercole to Grimani's sister can be found in ASM, autografie varie, under Grimani.

38. Doc. no. 209.

39. The stones were probably assembled for the execution of the façade of San Francesco della Vigna, the rights to which were purchased by the Grimani, probably after the death of Doge Andrea Gritti; see Howard (1975), pp. 68–70; Lewis (1972); Foscari and Tafuri (1983); and here cat. no 112.

40. Doc. no. 213.

41. Doc. nos. 214–16.

42. This information is found in Feruffino's letter of 21 April 1552; see doc. no. 217.

43. Leithe-Jasper (1963), pp. 14–18, places the break around 1550.

44. Campori (1872), p. 510, identifies the painter as Giuseppe Scolari.

45. This is how I would interpret the phrase in Feruffino's letter, 'da un'altro qual se ritrova in Roma' (doc. no. 217). This would refer to Ammannati, who had recently gone to Rome for work on the del Monte chapel and the Villa Giulia; see Davis (1976-I).

46. Doc. no. 217; and Campori (1872), p. 511. The passage is quoted here in note 60.

47. Leithe-Jasper (1963), pp. 24–43; and Puppi (1973), pp. 215–54.

48. Doc. no. 218.

49. Mentioned by Vittoria in his ricordi for that date; see Predelli (1908), pp. 176–77; and Cessi (1960–62), I, p. 21.

50. Doc. nos. 220–25.

51. Campori (1872), p. 513.

52. Ibid., pp. 27–29. The local people call the statue 'Pasquin'. It was moved into the local town hall in the mid-1980s.

53. Brummer (1970), pp. 132–37.

54. The base is of a piece with the statue, and its narrow proportions suggest correspondingly narrow proportions for the original block of Istrian stone. See cat. no. 34.

55. Haskell and Penny (1981), pp. 291–96, with further bibliographic references.

56. See, however, Bush (1976), p. 138, and (1980), p. 188, for a different interpretation.

57. On this, see Holderbaum (1967), esp. p. 95.

58. Janson (1963), pp. 12–16. Vasari, II, pp. 400–01, observed that Donatello's sculptures were made to look well in their intended site and not necessarily when seen in the studio. This may have been the case with Sansovino's Hercules, which had been begun to decorate a city gate rather than to be seen from close at hand.

59. See chap. vi.

60. Doc. no. 217. The relevant passage is worth quoting here: 'per quanto il suddetto maestro Iseppo m'ha detto haver inteso da virtuosi et di questo mestiere in Padova che l'hanno veduta [i.e., Sansovino's statue], è imperfettissima et di maniera che egli per non perder il credito non doveria darla fuori in conto alcuno . . . ma più presto pensar di farne un'altra cum aggiunto di persone che meglio di lui intendono le figure nude delle quali esso, è detto che non ha mai havuto vera cognitione'.

61. The only subsequent mention of Sansovino's statue comes in a letter from Feruffino's successor, Girolamo Falletti, to the duke on 8 August 1554; in it, Falletti reports that a young Ferrarese sculptor then resident in Venice offered to make a Hercules better than the one by Sansovino, which was a 'cosa non troppo bene intesa'. See Campori (1872), pp. 511–12, where the young sculptor is tentatively identified as Lodovico Ranzi.

62. See here the interesting comments in Venturi, X-2, pp. 211–13, where Bandinelli's small bronze Hercules and Cleopatra are compared with Adam and Eve.

63. The poem begins: 'Corpo di vecchio e gambe di fanciulla / Ha il nuovo Perseo, e tutto insieme / Ci può bello parer, ma non val nulla'; it is printed in Heikamp (1957), p. 160. For a comparison of the small bronze and finished versions of Cellini's statue, see Pope-Hennessy (1985), pp. 169–70, pls. 86, 89–90.

64. For Raphael's letter, see Golzio (1963), pp. 30–31. The most explicit statement of this approach to art comes in the proemio to the third part of Vasari's Vite: 'La maniera venne poi la più bella dall'avere messo in uso il frequente ritrarre le cose più belle, e da quel più bello o mani teste o corpi o gambe aggiugnerle insieme, e far una figura di tutte quelle bellezze . . . e metterla in uso in ogni opera per tutte le figure'; see Vasari, IV, p. 8. On this theme, see also Panofsky (1968), pp. 59–63.

65. Cecchi (1985), p. 279. On the academic tradition in general, see Pevsner (1940), esp. pp. 39–92.

66. See Bernini's remarks on this subject as reported by Baldinucci (1966), p. 77.

67. See cat. no. 35.

68. Doc. no. 226. The accounts by Lorenzetti (1913), p. 125, Pope-Hennessy (1970), p. 408, and Bush (1976), pp. 139–42, contain a few factual errors which should be noted, as they have a bearing upon our interpretation of the episode. The documents show that Sansovino contracted to carve both giganti for 250 ducats in toto, plus a bonus. Sansovino received only 240 ducats for his work, and the petition to reimburse Francesco Sansovino for 400 ducats of his father's expenses on the commission was rejected by a vote of 52 to 91 against, with 36 abstentions.

69. Martini (1883), p. 817, gives the Venetian foot as equal to 0.347735 m. The height of ten feet must have been an underestimation, as the finished statues are approximately 4.4 m high.

70. On the Fabbriche Nuove, see Howard (1975), pp. 53–55. On the tomb of Francesco Venier, see here chap. viii, and see chap. x for the Scala d'Oro.

71. see chap. viii, p. 118, and note 59.

72. Sansovino (1561), p. 21^v. Rambaldi (1910), p. 109, n. 2, drew attention to the fact that this information is absent from the 1555 edition of Tutte le cose notabili. Vasari's account of the giganti, cited at the beginning of this chapter, also states the location as at the entrance to the stairs of the palace.

73. See Goloubew (1908–12), II, pl. xi. McAndrew (1980), p. 91, fig. 7.5, also reproduces the Bellini drawing in the British Museum (49) as possibly related to the staircase in the Doge's Palace.

74. Lorenzi (1868), pp. 97–98, no. 208; and Muraro (1961), p. 351.

75. On these Central Italian staircases, see White (1966), pp. 36–37, 176–78. On the difficulty of interpreting the iconographic programme of the staircase, see Muraro (1961).

76. Venturi, VI, pp. 1089–90, fig. 743, proposed that there would have been small statues on the staircase which were replaced by Sansovino's; he also suggested that statues found in the depot of the Doge's Palace may have been the original ones. Venturi's ideas have been decisively refuted by Rambaldi (1910), p. 107, n. 1; and Muraro (1961), p. 370, n. 81.

77. Sansovino (1561), p. 21^v. Sansovino (1581), p. 119^r,

gives a better definition of the statues as 'significative amendue lo stato di terra, e di mare di questa Republica'.

78. See the discussion in chap. v.

79. See chap. viii for the Pesaro monument; for the standard bases and the Loggetta, see chap. v; and chap. x, pp. 152–53, for the *finestrone*.

80. On the Capitoline *Mars*, see Helbig (1963–72), II, pp. 46–48, no. 1198.

81. For the *Neptune with Triton*, see Hülsen and Egger (1913–16), II, p. 58, fig. 3; also, Cavalieri (1593), pl. 27. On the *Marforio*, which was sometimes considered a figure of Neptune, see Helbig (1963–72), II, pp. 41–42, no. 1193.

82. See Janson (1963), pp. 24–25, for contemporary appreciations of the *St George*. On the *Minerva*, see here chap. v.

83. As in the young man on the left of the *Maiden Carilla* (fig. 263) or the young man in the centre of *St Mark rescuing the Servant* (fig. 141) in the second series of reliefs for the choir of San Marco.

84. On the *Agrippa*, see Traversari (1968), pp. 29–31, no. 13.

85. *Ibid.* Traversari identified the dolphin, tree trunk, altar, and plinth as modern restorations, and they have been removed from the statue since it was photographed by Anderson (here fig. 316). While Traversari does not speculate on the date of the modern restoration, the most likely period would have been the second half of the sixteenth century when Tiziano Aspetti was charged with restoring a number of Grimani pieces. On this, see Gallo (1952), p. 56, n. 1.

86. Janson (1963), pp. 248–49, pl. 128. Though deleted from recent studies of authentic works by Donatello, the *St Jerome* was accepted by Vasari, II, p. 413, and employed by Sarto for St Onophrius in his Gambassi *Madonna*, as noted by Kauffmann (1936), p. 155; see Shearman (1965), p. 137; and also Boucher (1989).

87. This was noted by Meller (1963), p. 67.

88. See Schulz (1968), pp. 104–07, pl. 74.

89. On the *Dioscuri*, see Haskell and Penny (1981), pp. 136–41. Michelangelo's study of them is discussed by Bush (1976), pp. 110–12.

90. Doc. no. 256; see also chap. x, p. 156. The Mars and Minerva which the printer Marcolini mentions as gifts from Sansovino, may have been sketches or models related to the *giganti* and the Loggetta projects, respectively; see doc. no. 123 and cat. no. 86. Interestingly enough, Jacopo Strada had for sale a clay model of a Neptune in 1567, which he described as 'von dem weitberühmten Jac. Sansovino gemacht'; see Stockbauer (1874), p. 44; and here cat. no. 87.

91. Doc. nos. 227–39. These were first published by Lorenzi (1868), pp. 480–83, no. 939; see also Rambaldi (1910).

92. On this subject, see chap. xi, pp. 160–62.

93. The reply of the Florentine officials charged with interrogating Francesco il Toccio mentions that the procedure was undertaken 'ad instantiam Domini Jacobi Sansovini'; see doc. no. 230.

94. Doc. nos. 229, 231–35. These wages compare with those of stonemasons working for the Scuola di San Rocco as given by Pullan (1968), p. 158.

95. Antonio Gallino states that he worked for one year on the *giganti*, and this coincided with Francesco il Toccio's period in Sansovino's service. Gallino records that work continued for seven years after his time, but he does not mention the presence of Domenico da Salò, who collaborated on the statues for three years. Adding these two periods together would bring the total time to eleven years, which is close enough to Francesco's reference to twelve years on his petition to the Senate of 1582, here doc. no. 236.

96. This is borne out by the affadavits of the sculptors, in which no more than three or four sculptors are named as working on the project at any one time.

97. See doc. no. 87, and chap. x.

98. Doc. nos. 227–28.

99. Sandi (1882); and also Rambaldi (1910), pp. 208–17.

100. Rambaldi (1910), pp. 221, 229. The signature of Sansovino's name is, of course, false as is that on the *Madonna* of the Loggetta.

101. See, for example, the comments of Lorenzetti (1929), p. 69; Muraro (1961), pp. 369–70, Rambaldi (1910), pp. 117–19, offers a more sympathetic account of the problems faced by the location of the *giganti*.

102. Sandi (1882); the passage from his account is also cited by Rambaldi (1910), p. 213.

103. Burckhardt (1929–34), IV, pp. 63–64; 'Ihre unschöne Stellung, zumal beim Anblick von vorn, fällt schneller in die Augen als ihre guten Eigenschaften, welche erst demjenigen ganz klar werden, welcher sie in Gedanken mit den gleichzeitigen Trivialitäten eines Bandinelli vergleicht. Sie sind vor allem noch anspruchslos und mit Überzeugung geschaffen, ohne gewaltsame Motive und erborgte Muskulatur; es sind noch echte, unmittelbare Werke der Renaissance, einige, wenn auch nicht vollkommene Idealtypen eines schöpfungsfähigen Künstlers, der selbst mangelhafte Motive durch grossartige Behandlung zu heben wusste.' See also Rambaldi (1910), pp. 111–12.

104. Rambaldi (1910), p. 115: 'Le quali cose [i.e., the rejection of Francesco's petition] sono per certo segni di malcontento, di disapprovazione dell'opera.'

105. On these cases, see chaps. iv and x, respectively.

106. Bottari and Ticozzi (1822–25), I, pp. 70–73. The passage is quoted here in chap. x, note 3.

107. This is how I interpret the presence of certain names, such as Zuanne and Gasparo de Zorzi grando (see doc. no. 234), who appear to have worked casually on the project, or Poletto Intaiador (doc. no. 231), who may have been called in for non-figurative decorative carving. Such a practice would have been complementary to Sansovino's recourse to specialists for different aspects of his bronzes; on this, see chap. iv.

108. Gaye (1839–40), III, p. 24, no. xxviii; also noted by Bush (1976), p. 36.

109. Borghini (1967), p. 551: 'fece grande studio sopra le statue rappresentanti Marte e Nettuno di Jacopo Sansovino; e poscia si prese per principal maestro i' opere del divino Michelagnolo, non riguardando a spese alcuna per aver formate le sue figure della sagrestia di San Lorenzo'. On Tintoretto's drawings, see Rossi (1975), pp. 3–4. Rossi believes that Tintoretto could not have known the *giganti* before 1567, the date of their installation, but it is probable that Tintoretto and Veronese would have seen them in Sansovino's workshop. In any case, no drawings after the *Mars* and *Neptune* can be ascribed to Tintoretto.

110. Schulz (1968), pp. 104–11, nos. 41 and 42, respectively.

111. Weihrauch (1935), esp. pp. 74–76.

Notes to Chapter X

1. See, for example, Pittoni (1909); Planiscig (1921); and in different ways, Weihrauch (1935) and (1967).

2. See chaps. i and ii. Interesting light has been cast on Michelangelo's use of assistants in architectural projects by Wallace (1989).

3. '... una lunga isperienza dell'arte mi ha fatto domandare aiuto di due garzoni, che sono niente a quello che bisognerebbe; e a V. eccellenza, n'ho dato vero esempio della Porta di S. Giovanni, raccordandomi, che alcuni che stettero con Donato mi dissero, che sempre aveva nella sua bottega diciotto o venti garzoni, altrimenti non avrebbe mai fornito un altare di santo Antonio da Padua, con altre opere. E in Roma le colonne istoriate, che ciascheduna è l'età di venti maestri, dovesi vede chiaro che il disegno e la invenzione ... viene da un solo ingegno; nientedimeno le figure, per essere infinita quantità, sono lavorate di molte maniere, e tutte buone e belle, perchè un valente disegnatore guidò tutti quelli maestri.'; the full text is published in Bottari and Ticozzi (1822–25), I, pp. 70–73.

4. On workshops in general, see Thomas (1976) and Wackernagel (1981), pp. 308–37. Less attention has been given to sculptors' workshops and practice, but see Seymour (1966), pp. 10–12; Caplow (1974), with extensive bibliography; and also Honour (1972), on Canova's period. On Sansovino's relations with Andrea della Robbia, see chap. vii, pp. 100–01. Perugino rented the old Ghiberti workshop from around 1498 and would have been active there when Jacopo was a pupil of Andrea Sansovino; see Canuti (1931), I, p. 270, and II, p. 303, no. 540. On Raphael's Roman workshop, see the observations in Shearman (1965-II); Marabottini (1968); and Oberhuber (1972), pp. 25–50.

5. Vasari, VI, pp. 57–58, and VII, pp. 513, 522. On the probability of Cattaneo's having studied with Sansovino in Rome, see Temanza (1778), pp. 269–70. Jacopo's master, Andrea Sansovino, probably kept a small shop, at least before he went to Loreto. Vasari, IV, p. 523, mentions only five disciples of Andrea, including Jacopo Sansovino.

6. For a survey of the situation in Venice, see Seymour (1966), pp. 188–201; also Lieberman (1982); and Huse and Wolters (1986), pp. 146–52.

7. Luzio and Renier (1888), pp. 433–34.

8. Vasari, VII, p. 510: 'Amò fuor di modo l'arte della scultura, e l'amò tanto, che, acciò ch'ella largamente si potesse in più parti diffondere, allevò molti discepoli, facendo quasi un seminario in Italia di quell'arte.' Exactly how many members of his workshop there were at any given time cannot be said, although surviving documents suggest there was usually a core of three to four assistants, with casual labour from others. This seems to be the case in the accounts kept by Sansovino during 1536–37, and in the records of payments for work on the two tribunes in San Marco, and later for the *giganti*; see doc. nos. 87–89, 226–39.

9. These observations are based upon the register or *mariegola* of the Venetian guild of stonemasons; see CMC, Mariegola della Scuola di tagliapietra, MS 150. Portions of the *mariegola* have been published by Sagredo (1856), pp. 281–310; for the comparable case of the painters' guild, see Favaro (1975), esp. pp. 55–77.

10. Luzzato (1961), pp. 117–19.

11. Predelli (1908), pp. 35–36, gives an analysis of the *garzoni* in Vittoria's *bottega* from 1555 to 1591.

12. CMC Mariegola..., MS 150, fols. 32ᵛ, 47ᵛ, 49ʳ⁻ᵛ.

13. Vasari, VII, p. 522, states that Cattaneo left his master at the age of 19, which would have been in 1528. For his career, see Campori (1873). On the possibility of Ammannati's having studied under Sansovino in Venice, see Davis (1977), p. 69. Ammannati could have arrived as early as 1527 or in the latter part of 1529, but it is difficult to determine what he did or how long he stayed. In any case, Ammannati must have remained long enough to become a good friend of Francesco Sansovino; see the letter addressed to Ammannati in Sansovino (1542), p. 60ᵛ. On

Ammannati's artistic relationship to Sansovino, see here chap. xi.

14. See chap. iii.

15. The entry on Giuliano da Firenze in Thieme–Becker, XIV, p. 210, places him in Padua from 1520 to 1529, whereas his presence is only documented from 1529 to 1531; see here doc. no. 130.

16. See Fulin (1881), p. 144; and Tassini (1895), p. 16, no. 12. The portal is also reproduced in Mariacher (1962), p. 51.

17. Sansovino (1581), pp. 13ʳ, 47ᵛ, 90ᵛ. Vasari, VII, pp. 514–15, also gives a full list of Colonna's works, including a Minerva, Venus, and Diana, all larger than life and made for Alvise Cornaro. He is mentioned in passing by Planiscig (1921), pp. 417–18; and a résumé of his career is given by Bossaglia (1978), pp. 74–75.

18. On this point, see the observations made by Caplow (1974) and Honour (1972).

19. For the role and development of the sketch model, see Vasari, I, pp. 152–55; and also Baldwin Brown (1907), pp. 148–53, with notes. Among more recent studies, see Schlosser (1913); Lànyi (1930); Lavin (1967); Honour (1972), pp. 148–49; Dent Weil (1978); and Avery (1978) and (1984), with reference to the practice of Giambologna.

20. Carradori (1802), pp. xiv–xv, xxi–xxv, gives an extended account of this process; see also Baldwin Brown (1907), pp. 147, 190–92; and here chap. ix.

21. This is the sense in which Vittoria employed the term: 'adi 6 marzo 1581 L 5 contai a maestro Isepo squadratore furlan [i.e., friulano] per aver lavorato giorni dua a pontar [i.e., spuntare] su la figura dil Cristo che va sopra la porta grande di la chiesa de fra minori'; see Predelli (1908), pp. 33–35.

22. Sansovino's letter was first published by Campori (1873-I); see here chap. vii and doc. no. 204. On Vittoria's practice, as given in his *ricordi*, see Predelli (1908), pp. 33–35.

23. Bennett and Wilkins (1984), pp. 49–52. They note that the *Habakkuk*, finished by 1436, was 'probably the last figure in marble that Donatello ever completed' and that only after his arrival in Padua did Donatello begin to work 'almost exclusively' in bronze. However, they do not relate this change of media to the sculptor's age.

24. On *cire perdue* casting, see Baldwin Brown (1907), pp. 199–201; and Stone (1981).

25. Doc. no. 87; see also chaps. iv and vii.

26. On Luca Lancia, see the entry in Thieme–Becker, XXII, p. 285. He is probably the same sculptor as the Luc Lange employed at Fontainebleau from 1541 to 1547 and from 1549 until his death in 1553 at the chateau of Binche by Mary of Hungary; see Duverger (1972), p. 722 n. 44.

27. Doc. nos. 295–303. the point of contention was whether Sansovino had been commissioned to execute the statue or not; on this dispute, see chap. vii, pp. 102–04, and cat. no. 19.

28. On Tommaso Lombardo, see Vasari, VII, p. 520; Thieme–Becker, XXIII, pp. 347–48; Planiscig (1921), pp. 392–93; and Venturi, X–3, pp. 58–63. His name occurs here in doc. nos. 87–88, 90, 112.

29. See, for example, the tables of wages paid to workmen engaged on the building of the Scuola di San Rocco at mid-century, compiled by Pullan (1968); see also Predelli (1908), pp. 32–33.

30. Doc. no. 87.

31. See chap. iv, pp. 57–61.

32. On Minio, see the biographical information in Rigoni (1970), pp. 201–15; see also here chap. xi, pp. 165–67. Zuane Campanaro came of a local family of founders who cast the bronzes for the Zen chapel. Zuane's son Pietro would later cast the frame of Sansovino's Sacristy door; see Thieme–Becker, V,

pp. 454–55; and also Jestaz (1986).

33. For example, Lorenzetti (1913), pp. 126–27; Weihrauch (1935), pp. 51–52; Venturi, X–3, pp. 37–38; and Ivanoff (1968), p. 53.

34. In addition to the bronzes for San Marco, the seated figure of Tommaso Rangone on the façade of San Giuliano was subcontracted to a professional founder; see chap. viii and doc. nos. 182–90. On Donatello's use of professional founders, see Bearzi (1966). On Vittoria and Andrea Bresciano, who cast his *St Sebastian* in 1566, see Predelli (1908), pp. 33, 78; and Davis (1976-III).

35. Doc. no. 90; see also cat. no. 22.

36. Vittoria recorded his arrival in Venice in July 1543; see Predelli (1908), p. 165.

37. Doc. nos. 112–18, and chap. iv, pp. 65–67.

38. Doc. no. 112. Similar payments to professional casters in plaster can be found in the accounts of Rysbrack and Canova; see Webb (1954), p. 199, no. ix; and Honour (1972), p. 154.

39. See cat. no. 25.

40. Doc. no. 101, under 21 February 1541 and 11 February 1542.

41. Favaretto (1972), p. 84, no. 66. A gesso model of the figure of Tommaso Rangone is mentioned among the documents concerning the casting of the bronze likeness for San Giuliano; see doc. no. 184.

42. Doc. no. 107.

43. The bonus is anticipated in the contracts for the *Maiden Carilla* relief and for the *giganti*; see doc. nos. 145 and 226, and chaps. vi and ix. respectively.

44. Vasari, VII, p. 520: 'partito dal Sansovin, ha fatto da sè una Nostra Donna col Fanciullo in braccio e à piedi San Giovannino'. On the chapel and its dating, see Cicogna, IV, pp. 139–41, nos. 4–5.

45. Sansovino (1581), p. 92ᵛ.

46. See Planiscig (1921), pp. 509–11; and Venturi, X–3, p. 63.

47. Tassini (1895), p. 16, no. 12, prints the epitaph with the date of death as 7 July 1547.

48. See the observations by Tietze (1939); for Dente, see also Fisher (1977), pp. 31–42.

49. On Cattaneo's falling out with Sansovino, see note 93. Vittoria was out of favour from the latter part of 1551 to 1553; see Leithe-Jasper (1963), pp. 17–18, and here chap. ix, pp. 132–33. On Domenico da Salò and other more minor figures who assisted Sansovino on the *giganti*, see doc. nos. 231–35, and chap. ix, pp. 137–38.

50. Cattaneo and Minio were employed on stuccoing the ceiling of the chapel of St Anthony in 1533, and Fantoni made two statues for its façade; see Gonzati (1852–53), I, p. 162; and Wilk (1984), pp. 159–64. For Cornaro's rapport with Minio and Cattaneo, see Sambin (1966), pp. 328–29, 332–33.

51. These documents were first published by Malaguzzi Valeri (1893), pp. 44–47, nos. viii–xii. Document number xii, the valuation of the work, is the most interesting for our purposes and is partially reprinted here as doc. no. 92. It lists Sansovino, Serlio, and the Venetian nobleman and collector Gabriele Vendramin among the 'architatori', and Jacomo Fantoni, Danese 'suo campagnio', and Silino da Pisa among the 'maestri da figura'. Danese must be Cattaneo, and Silino da Pisa may in fact refer to Silvio Cosini.

52. See especially Rigoni (1970), pp. 239–53, 279–87; and here chap. vi, p. 94, and chap. viii, pp. 125–26.

53. Cat. no. 37 with further references.

54. On the Minervetti tomb in relation to Cosini's work for Michelangelo, see Weinberger (1967), pp. 297–98; and Hirst (1969).

55. Barocchi (1964), pp. 106–07, no. 350.

56. See Davis (1977), p. 71, n. 13. On the altar of the Holy Martyrs, see Supino (1893), pp. 422–26 and 454–55, no. 8; and also Papini (1912), I, pp. 55–56, no. 8.

57. The contract is printed in Paoletti (1893), p. 116, no. 108; see also Tramontin (1962), p. 38. The only printed reference to the statue known to me comes in Lorenzetti (1929), p. 85, but he does not attribute it to Sansovino.

58. See Wolters (1963) and (1968), p. 55; see here chap. xi, p. 165.

59. On Ammannati's brief period with Sansovino in 1543–44, see Davis (1977), pp. 75 and 87, n. 73. By January 1545 Ammannati was already resident in Padua; see Sartori (1976), p. 4.

60. On their building histories, see Howard (1975), pp. 17–37; Hirthe (1986-I) and (1986-II); and Zorzi (1987), pp. 121–58. On the analogous case of the decoration of the Mint, see Boucher (1977).

61. This was a Neptune, destroyed in an accident in the middle of the eighteenth century; see Temanza (1778), p. 222, n. a; and Davis (1977), pp. 87–88.

62. In 1556 a protégé of Sansovino's named Salvador quondam Vettor contracted to erect twelve bays of the Fabbriche Nuove. At the same time, he made an agreement with other stonemasons to carve the pilasters and vaults needed for the said bays. The document indicates that direct involvement by Sansovio ended with supplying the detailed drawings for the mouldings; see here doc. no. 241. Two similar cases occurred with the designs for the tomb of Livio Podocataro, also executed by the *bottega* of Salvador, and the Longo altar for Santa Maria Maggiore, executed by Giangiacomo dei Grigi; see doc. nos. 198 and 245, respectively. These instances convey the impression that Sansovino commonly turned to trusted collaborators like Salvador or Giangiacomo dei Grigi for the execution of architectural projects after his own designs.

63. Sansovino (1581), p. 113ᵛ: 'Ne gli angoli dei volti, le figure dei vecchi con vasi versanti acqua, sono significative di fiumi. Et nelle chiavi che serrano i volti nel mezzo, sono teste di huomini, di donne, & di lioni interzate, le quali tutte furono scolpite dal Danese Cattaneo, da Pietro da Salò, da Bartolomeo Ammannati, & da diversi altri nobili & laudati Scultori.' Vasari, VII, pp. 514, 520, 523, mentions only Girolamo Lombardi, Tommaso Lombardo, and Danese Cattaneo as working on the Library.

64. Predelli (1908), p. 122. Vittoria received 20 ducats against a total debt of 50.

65. See Dacos (1977), for a comprehensive treatment of the Logge.

66. Ivanoff (1968). Previously Sanpaolesi (1952) attributed the river gods and victories on the Campanile side of the Library to Ammannati, but this is not plausible, since the first bay bears the date 1538, five years before the arrival of Ammannati in Venice; see Davis (1977), p. 93, n. 74. For a different interpretation of the hands involved on the Piazzetta side, see Leithe-Jasper (1963), pp. 9–11.

67. For example, the relief of Jupiter with his eagle on the fourth bay facing the Piazzetta side is based upon the relief of the same subject on the soffit of the Arch of Titus. The relief of the Milky Way on the sixth bay of the Piazzetta side refers to Michelangelo's *Creation of Adam* on the Sistine ceiling. A similar derivation from a drawing by Michelangelo of Tityus has been noted by Hirst (1978), p. 260, n. 25; this occurs on the twelfth bay of the Piazzetta side. In two cases, reliefs repeat the same scenes

from the small panels above the bronze gods of the Loggetta, namely, Mercury killing Argus (twelfth bay) and the death of the giant Pallas (fourteenth bay).

68. See the definition given by Boerio (1867), pp. 347–48: 'quello che intaglia o in pietra o in legno fogliami, cornici o simili, ma non figure, perchè quello che intaglia figure di rilievo, dicesi scultore'. In 1551 the Venetian Scuola dei Tagliapietra decided to exempt *intagliatori* from the customary trial of skill if they refrained from carving figures; see CMC Mariegola..., MS 150, fols. 53ᵛ–54ʳ. One documented use of an *intagliatore* by Sansovino occurs in the accounts of the carving of the *giganti*, on which, see here chap. ix, n. 107. See also Predelli (1908), pp. 124–25.

69. In the three surviving contracts for the *tondi* in the ceiling of the Sala d'Oro, the painters agreed to execute their canvases 'nel modo et forma che si contiene in uno schizzo fatto per el ditto pittore esistente appresso ditto Sansovino'; see ASV, Proc. de supra, busta 68, proc. 151, fasc. 2, fols. 6, 8, 10. The gist of the document has been printed previously by Howard (1972), pp. 219–23, and (1975), pp. 24–25. On the decoration of the Library's staircase by Vittoria, see here note 88.

70. Doc. no. 119. The reference to Sansovino states simply that he would send the tapestry design to Rost but does not imply his authorship of the design; see cat. no. 110.

71. Doc. no. 104. As in the case of the tapestry cartoons, this document also gives Sansovino an editorial control over the design for the font's cover; so, at any rate, I interpret the phrase: 'per il far da uno coperchio di bronzo sopra la pilla posta nella chiesa di San Marco nella cappella di San Zuane come appar per scritto fatto sopra de ciò qual è in mano de messir Jacomo Sansovino proto sotoscritto de mani del ditto Tician'. The role of Alvise Cornaro as guarantor of the work has not been noted elsewhere, to my knowledge.

72. See Sambin (1966), pp. 328–29. On Segala, in general, see Pietrogrande (1942–54; 1955; 1961).

73. Vasari, VII, pp. 514, 515, and 523, for Girolamo Lombardo, Tiziano, Minio, and Danese Cattaneo, respectively. Francesco Sansovino does not identify any of the sculptors who worked with his father on the Loggetta in his guide (1581), p. 111ᵛ.

74. See here cat. no. 27.

75. On the history of Scrutinio, see Lorenzi (1868), pp. 194–95, 210, 213, 218, 221, 234, 237. The room's history and remodelling in the 1530s had previously been discussed by Zanotto (1853–61), I, pp. 100–12, 200–01; he attributed the remodelling of that period and the sculpture of the *finestrone* to Sansovino and his followers. On the ceiling paintings by Pordenone, see Schulz (1968), pp. 139–41, no. 89. On the project as a whole, see the recent study by Foscari (1981), pp. 25–29.

76. See Lorenzi (1868), pp. 215, 227, nos. 454, 479. As the payments were for only 10 ducats each, they must have been for small-scale ornamental work rather than a statue. The Council of Ten set aside 400 ducats 'per compir el pergolo et li frisi' of the chamber in 1542, and this may mark the beginning of work on the statues; *ibid.*, p. 237, no. 508.

77. Wolters (1976), I, pp. 220–21, no. 143, fig. 493.

78. Vasari, VII, p. 517: '[Salò made] la statua d'un Marte, maggiore del naturale, che è nella facciata del palazzo publico; la quale statua è in compagnia di tre altre di mano di buoni artefici.' *Ibid.* p. 519: '[Vittoria] fece un Mercurio al pergamo di palazzo di San Marco, che risponde sopra la piazza, tenuto buona figura.' Vasari does not mention Cattaneo in this context though he paired him with Salò in mentioning the fireplaces for the Sala della Bussola and the Stanza dei Tre Capi, on which, see here note 79, The earliest attribution of the *Jupiter* and *Neptune* to Cattaneo

comes with the guide by Lorenzetti (1926), p. 231; followed by Da Mosto (1960), p. 245. The minor sculptures of the putti with Gritti's arms and the victories in the spandrels appear to be by Salò.

79. The figure of Mars was given to Baccio da Montelupo by Sansovino (1581), p. 66ʳ⁻ᵛ; see also Paoletti (1893), pp. 273–74. The attribution was rightly rejected by Kriegbaum in favour of the companion figure of Neptune; see Thieme–Becker, XXV, p. 86.

80. Lorenzi (1868), pp. 226–27.

81. Schulz (1968), pp. 99–101, nos. 36–37, with further bibliography.

82. See Serlio, IV, pp. 167ᵛ, 182ᵛ, 186ʳ; and here chap. v, p. 79.

83. On Sansovino's apartments, see Schulz (1982), p. 89, n. 55, and here cat. no. 93. The most detailed discussion of the Villa Garzoni comes in Rupprecht (1963–65); see also cat. no. 57.

84. The documents for the Scala d'Oro are published by Lorenzi (1868), pp. 286–88, 297–99, 308–09. Sansovino (1581), p. 274ᵛ, placed the construction and decoration of the staircase in the reign of Lorenzo Priuli (1556–59). The date 1559 is carved on the second flight of stairs by the *atrio quadrato*.

85. Leithe-Jasper (1963), pp. 79–80. The stuccoing was probably complete by November 1561 when the gilding and painting were under way; see Lorenzi (1868), pp. 308–09, no. 660.

86. Wolters (1968), p. 35, figs. 38–39.

87. Leithe-Jasper (1963), p. 81.

88. Vittoria's contract states that he would work 'iuxta il principio ci mostra per esso maestro Vittoria sin'hora fatto'. His work, perhaps a trial field on the staircase's vault, was seen and approved by Sansovino and the procurators; the signature of Sansovino on the contract would imply as much. See Leithe-Jasper (1963), pp. 87–93; and Howard (1975), p. 166, n. 86. For a different interpretation of the dating of the Library's stuccoing, see Ivanoff (1961).

89. On his break with Sansovino and his subsequent departure to Vicenza, see Leithe-Jasper (1963), pp. 17–18. For the stucco work in Palazzo Thiene, see Maganato (1966), pp. 63–76; and here chap.xi.

90. This episode is discussed in chap. ix.

91. See chap. viii, pp. 116–17, and cat. no. 31.

92. Predelli (1908), pp. 35–36; 164: 'Ricordo come questo dì soprascritto ho scritto ieronimo mio garzone ala iusticia vechia, per ani cinque e comincia il giorno soprascritto e per suo salario gli darò ducati venti a tute sue spese—e suo fratello è stato suo piego—D. 20 ducati, e di tuto il tempo che perderà, e questo scritto è fatto con messer Iacomo sansovino.' Predelli interpreted this to mean that Ieronimo was shared by Sansovino and Vittoria. A subsequent payment to Cristoforo di Zanchi of two ducats on behalf of Ieronimo again refers to 'a chonto di lachordo fato chon messer Iacomo sansovino', but, in the event, the boy never finished his apprenticeship.

93. Doc. no. 255. Cattaneo was reinstated in Sansovino's favour in his last will, of 1568, printed here as doc. no. 256.

94. Doc. nos. 197–98, and chap. viii, and cat. no. 33.

95. Doc. no. 175, and cat. no. 32.

96. Predelli (1908), pp. 126–27, records payments to Vittoria by the heirs of Contarini. The general design of the monument is given to Sanmicheli by Vasari and subsequent writers; see Gazzola (1960), pp. 164–65, no. 37; Puppi (1971), p. 130; and Leithe-Jasper (1975).

97. Doc. no. 204, and chap. ix. pp. 131–34.

98. Doc. nos. 229–35, and chap. ix, pp. 137–38. Vittoria's

ricordi show that he employed six assistants for the *feminoni* at the entrance to the Library (fig. 392) and four on the over-life-sized angel carved for the bishop of Verona in 1556–57; see Predelli (1908), pp. 122–24 and 124–25, respectively.

99. For a medieval example of specialization in a collaborative project, see White (1959), esp. pp. 286–91. On Verrocchio's use of collaborators, see Passavant (1969), pp. 23–31, 44–45. Bernini's use of large numbers of assistants is well known, but see Weil (1974), pp. 37–49; and Wittkower (1981), pp. 259–61, no. 77, with special reference to the tomb of Alexander VII. For a more general survey of Bernini's period, see the valuable account in Montagu (1989), esp. pp. 99–150.

100. See chap. xi, note 4.

101. Vasari, VII, p. 520. On Jacopo Medici in Brescia, see Treccani degli Alfieri (1963–64), II, pp. 833–34. The little that is known about Domenico da Salò can be found in Thieme–Becker, XXIX, p. 353, but see also Bettiolo (1913) and Pavanello (1921), p. 3. He is mentioned here in chap. vi, p. 99, and chap. ix, p. 138.

102. For these works, see chaps. vii, viii, and ix, respectively.

103. Doc. no. 256; see also chap. iii, pp. 47–49, and chap viii, pp. 125–26.

104. Doc. no. 255. The codicil, dated 1556, revoked an earlier bequest of money and drawings to Cattaneo.

105. As early as 1550 Francesco Sansovino spoke of plans to publish anatomical drawings by his father; see doc. no. 111. Vasari, VII, p. 507, mentions sixty plans of temples and churches by Sansovino in his son's collection, but neither these nor the anatomical studies have come to light.

106. On sculptors' drawings, see the general survey by Keller, 'Bildhauerzeichnungen', *RDK*, II, cols. 625–39, and the more tendentious observations by Eisler (1981).

107. The classic formulation of this opinion comes in Vasari's introductory remarks on *disegno* in the *Vite*: 'E perchè alcuni scultori talvolta non hanno molta pratica nelle linee e ne' dintorni, onde non possono disengare in carta: eglino, in quel cambio, con bella proporzione e misura facendo con terra o cera uomini, animali ed altre cose di rilievo, fanno il medesimo che fa colui, il quale perfettamente disegna in carta o in su altri piani' (I, p. 169). See also his letter to Benedetto Varchi, reprinted in Barocchi (1960–62), I, p. 62; as well as his biography of Andrea Ferrucci in Vasari, IV, p. 475.

108. Michelangelo's training under Ghirlandaio is reflected in his early drawings, as was noted by Berenson (1938), I, pp. 186–87. Bandinelli first trained under an obscure painter called Girolamo da Buda and, briefly, with Sarto around 1512; see Hirst (1963). On Bandinelli's regard for his own drawings, see Colasanti (1905), pp. 433–34. The difference between his approach to composition and that of a more conventionally trained sculptor, Andrea Sansovino, emerges in a remark by the latter to Bandinelli as reported by Vasari, VI, p. 143: 'L'opere si fanno con le mani, non con la lingua, e che 'l buon disegno non sta nelle carte, ma nella perfezione dell'opera finita nel sasso.'

109. On Bandinelli's reusing of drawings, see Ward (1981), pp. 7–8, n. 21. On the recycling of ideas in Giambologna's work, see Avery and Radcliffe (1978).

110. Doc. no. 204, and chap. ix, p. 131.

111. Wittkower (1974), p. 11: 'So, in the middle of the sixteenth century a process set in, in the course of which the modeller (the artist who handled the wax and clay) became the sculptor and the original sculptor (the one who worked the stone) was eventually turned into a mere craftsman or technician. A gulf opened between invention and execution.' This was, as Wittkower goes on to observe, a long process which happened over the seventeenth and eighteenth centuries. The extensive use of the trained carver, *praticien* as he was called in France, was common by the early nineteenth century when the following definition of working by points was given by Boutard (1838), pp. 528–29: 'Les ouvriers de cette espèce sont désignés dans l'atelier du sculpteur sous le titre de praticiens. Les plus habiles portent leur travail jusque la qu'il ne rest au maître qu'à donner les dernières finesses.' On the reaction against this separation of sculptors from carving in the early twentieth century, see Zilczer (1981).

112. See Tietze (1939), p. 45, for similar observations on painters' workshops in Venice: '[They] increased the painters' scope, augmented their effectiveness and afforded opportunities for trying out on a larger scale artistic principles which in reality were their personal property. The workshop operated under the master's responsibility; it was an instrument to enlarge his scope. Sometimes . . . a creation vastly indebted to assistants may bear a more convincing evidence of the master's genius than one in which no hand other than his has touched.'

Notes to Chapter XI

1. See the full discussion of Tintoretto's portrait in Davis (1981), pp. 292–93, with further references. On the conventional dating around 1566, which may be slightly too late, see Rossi (1974), pp. 105–06; for Vasari's verbal portrait of Sansovino, see Howard (1975), p. 1. Cellini's account of his meeting with Sansovino in 1535 presents a less attractive side of Sansovino; see Pope-Hennessy (1985), p. 72.

2. Vasari, VII, p. 511. This is corroborated, as far as Rome is concerned, by Aretino's letter to Sansovino in November 1537, reprinted here as doc. no. 91.

3. This is glossed in Aretino's letter of 1537 where he states of Venice: 'qui il buon' forestieri non solo si aguaglia al cittadino, ma si pareggia al gentil'huomo'; see doc. no. 91. A similar sentiment can be found in a letter by Francesco Sansovino, partially reprinted here as doc. no. 305.

4. See Howard (1972), pp. 52–57, and (1975), pp. 90–91. Jacopo Spavento became Sansovino's deputy at the procuracy *de supra* in 1556.

5. The concession is published here as doc. no. 254. Howard (1975), p. 82, implies that Jacopo asked for burial here in his last will, but that document, published here as no. 256, expresses a wish for burial in the Florentine chapel of the Frari. The first statement of a change in intention comes with the concession of the chapel in San Geminiano in June 1570.

6. Sansovino's death notice, reprinted here as doc. no. 257, the inscription in Vasari, VII, p. 513, and in Sansovino (1581), p. 44ʳ, all agree on the date of death as 27 November 1570. The date of 2 November 1570, found in Vasari's text (VII, p. 512) and picked up by Davis (1981), p. 293, must be a typographical error for 27 November. On Sansovino's exact age, there was disagreement even before his death. Francesco Sansovino's manuscript notes of circa 1566 give his father's age as 85 while the Giuntina edition of Vasari's *Vite* records him as 78 (see Vasari, 1568, III, p. 831). In addition, the death notice reads 91, Francesco's inscription, 93, and Cosimo Bartoli's report has Sansovino dying at 96 (see doc. no. 258). Such confusion was not uncommon and can be compared with the various figures given for Titian's age at the end of his life; on this, see Hope (1980), p. 11.

7. On the destruction of San Geminiano, see Zorzi (1972), II, pp. 332–37. Sansovino's remains were removed to the church of

San Maurizio in 1807 and then to the oratory of the Seminario Patriarcale, together with a terracotta bust believed to be of Sansovino by Vittoria (in fact, the bust was of the Venetian nobleman Girolamo Grimani and is reproduced by Venturi, X-3, p. 155, fig. 120). Eventually, Sansovino's remains were carried in solemn procession to San Marco and interred in its baptistry in 1929. On these movements, see Cicogna (1824–53), IV, pp. 26–29; and Lorenzetti (1929), pp. 9–14.

8. See doc. nos. 258, 260.

9. See Spalding (1982), pp. 272–74, fig. 29. Payments to Santi di Tito began in March and continued through June 1571; see ASF, Accademia del Disegno, filza 24, libro 'E', flos. 61ʳ–62ᵛ, 64ᵛ.

10. For the letter to the Duke of Ferrara and the tax return, see doc. nos. 204, 249. The purchase by Francesco Sansovino on behalf of his father is recorded in ASV, atti, Figolin, G., busta 5595, fols. 234ʳ–235ᵛ (18 April 1562); I am grateful to Gigi Corazzol for this reference.

11. For these subjects, see chaps. iv and vii.

12. On Francesco Sansovino's probable authorship, see Cicogna (1824–53), IV, pp. 70–71, no. 65; and Soranzo (1885), p. 601.

13. See Sansovino (1581), pp. 111ʳ–116ʳ⁻ᵛ. On Sansovino as a historian, see Grendler (1969); a study of Francesco's writings about his father has been promised by Davis (1984-II), p. 50, n. 3.

14. Sansovino (1546), pp. 52ʳ–53ʳ, and (1550), p. 4ʳ; in view of their significance, these passages have been reprinted here as doc. nos. 110–11. The passage on the Loggetta's iconography is the subject of an article by Davis (1985).

15. Sansovino (1564), unpaginated; and here doc. no. 248. Davis (1984-II), p. 50, n. 3, promises to discuss it in a future article.

16. The pages are now in the Biblioteca degli Uffizi, MS 60, Misc. Manoscritti I, no. 23. On it, see Gronau (1906) and Davis (1981), pp. 234–35, and (1984-II), pp. 40–41.

17. In his earlier publication of 1981, Davis did not recognize the hand as Francesco Sansovino's but subsequently arrived independently at the same conclusion as I. He also promises a full discussion of the manuscript notes at a later date. I am grateful to Dr Robert Williams of Princeton University for discussing the manuscript with me and for furnishing me with the transcription printed here as doc. no. 252.

18. Sansovino (1542), pp. 42ᵛ–43ʳ; to my knowledge, this letter has not been noticed before.

19. As early as 1538 in a rare volume called Stanze, he signed himself 'Francesco Sansovino Fiorentino'; see Cicogna (1824–53), IV, p. 84, and V, p. 544. The same signature appears on the 1564 edition of Dante and is inscribed on the portrait of Sansovino reproduced here from the 1565 edition of Del secretario in the Biblioteca Nazionale Marciana (fig. 436). Sansovino's contacts with the Medici court in Florence are attested by letters from Cosimo I, dated 1561 and 1571, and by a letter from Sansovino to the duke in praise of Benedetto Varchi; see Sansovino (1580), pp. 170ʳ and 88ʳ⁻ᵛ, respectively.

20. See Sansovino (1580), pp. 219ʳ–222ʳ; partially reprinted here as doc. no. 305. See also cat. nos. 64, 80.

21. I have been unable to trace any documentary confirmation of Sansovino's appointment as architect of the Venetian fortifications.

22. In particular, both the notes and Francesco Sansovino's Venetia of 1581 remark on the Public Mint's having been built without wood; see Sansovino (1581), p. 115ʳ⁻ᵛ. The same point is also made earlier in Guisconi (1556), p. 19, which as we have seen in note 12 above, is probably by Francesco Sansovino.

23. On the second version, see Morelli (1789), pp. 3–5; Moreni (1805), II, p. 432; Cicogna (1824–53), IV, pp. 29–30; and esp. Davis (1981), pp. 293–95.

24. Davis (1981), p. 294.

25. One can compare the original and emended versions of Vasari's biography in Della Pergola et al. (1962–66), VII, pp. 357–410, and in the English translation by de Vere (1912–15), IX, pp. 187–225. On the origins of Sansovino's family, see the notes by Milanesi in Vasari, VII, pp. 485–86.

26. Vasari, VII, p. 499.

27. Ibid., p. 508. The service to the Duke of Mantua may refer to the stucco Laocoon which Aretino commissioned from Sansovino in 1525; see here cat. no. 84. The reference to the Duke of Urbino probably deals with Sansovino's restoration of the duke's palace in Venice in 1560; see Temanza (1778), p. 255, and also here doc. no. 247.

28. Vasari, VII, p. 503. The text conveys the dimensions of the Villa Garzoni by stating that it exceeds the Fondaco de' Tedeschi by thirteen paces on each side. In the manuscript notes, Francesco Sansovino calls it 'il grandissimo et smisurato Palazzo del Garzoni'; see doc. no. 252.

29. For the excised passage on Jacopo's benefits from Venice, see Della Pergola et al. (1962–66), VII, p. 377; and de Vere (1912–15), IX, pp. 201–02; see also the comments of Davis (1981), p. 294.

30. Vasari, VII, p. 507. None of these objects has survived; see cat. nos. 68, 85, 92.

31. Vasari, VII, p. 513; see Sansovino (1581), p. 44ʳ. Temanza (1778), p. 259, recorded that there was only a small floor marker with a scarcely legible inscription. The floor marker was restored in 1785 by Giuseppe Farsetti, but no trace of the wall monument was ever found, leading Pietro Bettio and Cicogna to conjecture that it was never installed; see Cicogna (1824–53), IV, p. 26.

32. Vasari, VII, pp. 511–12: 'Dicono gli intendenti, che quantunque cedesse a Michelangelo, però fu suo superiore in alcune cose; perciochè nel fare de' panni, e ne' putti, e nell'arie delle donne, Iacopo non ebbe alcun pari.' On the singularity of this point, see Barocchi (1962), IV, p. 1934; and Davis (1981), p. 295.

33. Vasari, VII, p. 510. I shall not be discussing here figures like Tommaso Lombardo, Pietro da Salò, or Jacopo de' Medici, but reference is made to them in the account of Sansovino's workshop in chap. x. I have not included Tribolo here because his career falls outside the scope of this book, but see the references in Pope-Hennessy (1970), pp. 358–60; and Aschoff (1967).

34. See chap. iv, pp. 71–72.

35. Vasari, VII, pp. 521–22; and Borghini (1584), p. 590. Borghini has Ammannati as the pupil of Bandinelli first and then of Sansovino in Venice, but for Ammannati's early career, see esp. Davis (1977).

36. See chap. iii, p. 37; and Davis (1977), pp. 67–71.

37. Davis, (1977), p. 82.

38. See chap. x, pp. 150–51.

39. On these works, see Kriegbaum (1929), pp. 90–91. They are reproduced by Venturi, X-2, pp. 360–70, and the reliefs on the arch are illustrated and discussed by Kinney (1976), pp. 153–65, figs. 250–60.

40. Compare, for example, the bronze Jupiter from the workshop of Vittoria, which is reproduced in Planiscig (1921), p. 475, and discussed in Burns (1975), pp. 60–61, no. 110.

41. See here Kriegbaum (1929), p. 91. For the Benavides monument, see the observations in Davis (1976-II).

42. Kriegbaum (1929), pp. 91–99. On the de' Monte monu-

ments, see also Pope-Hennessy (1970), pp. 60, 376–77.

43. There is no definitive study of Minio, but a useful outline of his career is furnished by Thieme–Becker, XXIV, pp. 578–79. New biographical information has been published by Rigoni (1970), pp. 201–15; and Sartori (1976), pp. 164–65. The revised birthdate of 1511/12 was suggested by Rigoni.

44. See Frizzoni (1884), pp. 74–75; and Fiocco (1965-I).

45. Gonzati (1852–53), I, pp. xcvii–xcviii, no. lxxxix.

46. See Fiocco (1930–31) and Grossato (1957), pp. 108–09, with further references. The relationship between the altar of San Rocco and Sansovino's work has been analysed by Fiocco (1930–31) and Schottmüller (1933), p. 181, no. 286.

47. See chaps. iv and x, for Minio's early association with Sansovino.

48. See Wolters (1963) and (1968), p. 55. Minio was a member of Cornaro's household from 1538 to 1548, and this put him in the centre of a group of artists and scholars, including Bembo, Ruzzante, Trissino, Barbaro, Cattaneo, Palladio, and Aretino, See Sambin (1964), p. 229, and (1966), pp. 332–33; for a more general account of Cornaro's circle, see Fiocco (1965-II) and Puppi et al. (1980).

49. The contract for the cover is printed here as doc. no. 104.

50. For Desiderio, see Radcliffe in Boucher and Radcliffe (1983), p. 362. Wolters (1963) established a clear link between the bronze reliefs and stucco decorations in the Odeo Cornaro; this would indicate that Minio's would have been the dominant artistic role in the collaboration with Desiderio. The reliefs have lost their original setting, and it may be that Desiderio's contribution disappeared then. All eight of the panels are reproduced in Venturi, X–3, pp. 49–53.

51. Vasari, VII, pp. 515–16. On the question of his intervention in the Loggetta, see here chap. x, pp. 151–52.

52. Some documents concerning this project have been published by Sartori (1976), pp. 164–65; but see also Rigoni (1970), pp. 208–09. The contract between the Arca, Minio, and Cattaneo was signed in 1543; by 1548 portions of the gates were already cast. The project was suspended for financial reasons the year before Minio's death, and the cast portions were melted down. Some wax figures possibly connected with this project were given to Francesco Segala by the Arca del Santo in 1564; see Sartori (1976), pp. 215–16.

53. Planiscig (1921), pp. 389–408. The photographic survey in Venturi, X–3, pp. 36–57, is much more reliable.

54. Illustrated in Venturi, X–3, pp. 47 and 55, respectively.

55. On Zoppo, see Rigoni (1970), pp. 303–17; and Leithe-Jasper (1975). Zoppo learnt the trade of bronze-casting from Minio's father and became one of Sansovino's founders after Minio's death; see here cat. no. 23. On Tiziano Aspetti, see Boucher and Radcliffe (1983), pp. 358–59; and here pp. 172–73.

56. On Cattaneo, see the full biographical and bibliographical account by Macchioni and Gangeni (1979). Among the older literature, Temanza (1778), pp. 269–83, and Campori (1873), pp. 56–76, provide good extended accounts. Again, the pictorial survey in Venturi, X–3, pp. 1–35, is more reliable than Planiscig (1921), pp. 411–32.

57. See chap. x, p. 144.

58. See doc. no. 92.

59. See chap. x, p. 150.

60. Vasari, VII, p. 526; cf. the similar account in Sansovino (1581), p. 115ᵛ. The most likely source for Vasari's elaborate description of the *Sun god* and the Fregoso altar would have been Cattaneo himself; see Davis (1981), pp. 133–34, 227–30, 295–96.

61. The statue has lost its crown of rays and the sceptre has been broken from the right hand. The object in the left hand looks more like pipes than a wand, though presumably it, too, is now in an incomplete state.

62. Compare, for example, Ammannati's *Victory* from the Nari monument, which has a similar cast of features; it is discussed in Davis (1977). A work like the Benavides monument in Padua, with its unconventional symbolism, would have had an undoubted appeal for an artist like Cattaneo, and it does anticipate features of Cattaneo's later tombs.

63. Burns (1979), pp. 19–20, fig. 16.

64. Aretino (1609) IV, p. 205ʳ⁻ᵛ.

65. See Boucher and Radcliffe (1983), pp. 361–62, for a discussion of this bust.

66. See chap. x, pp. 150–52.

67. Cattaneo's *L'amor di Marfisa* was published in Venice by de' Franceschi, with a dedication to Alberico Cybo Malaspina, Marquis of Carrara. Cattaneo's unpublished poems were gathered in a manuscript volume by his grandson Nicolò, possibly intended for publication; the volume is in the Vatican Library, Biblioteca Chigiana, Manoscritti, Segnatura l. vi. 238. On his literary career, see Campori (1873) and especially Macchioni and Gangeni (1979), pp. 452–55.

68. Aretino (1609), III, pp. 112ʳ–113ʳ: 'Se ne la scultura, di che sete professore, voi tale foste qual' vi dimostrate essere nella poesia, di cui non fate professione, ardirei dire con lo iscarico della conscientia, che fino al Sansovino, Messer Jacopo, precettor' vostro (che non può da veruno avanzarsi), superareste nei marmi.'

69. See Hiesinger (1976) and the corrective to her arguments provided by Burns (1980).

70. The statement comes in Torquato Tasso's dialogue, *Il Cattaneo overo de le conclusioni*, quoted by Hiesinger (1976), pp. 288–91.

71. A precedent for the triumphal arch solution on the Fregoso altar is the Saraina altar in San Fermo Maggiore, Verona, ascribed to Sanmichele; see Gazzola (1960), pp. 199–200, fig. 230. On the Benavides monument, see Kriegbaum (1929), pp. 90–91; and Davis (1976-II).

72. See Da Mosto (1960), pp. 225–25; Zava Boccazzi (1965), pp. 263–68; and Pope-Hennessy (1970), pp. 410–11.

73. Temanza (1778), p. 280, refers to the personification of the League of Cambrai as male, but it is in fact female. Pope-Hennessy (1970), p. 411, notes that the iconography of the monument seems to have inspired the votive painting of Doge Loredan by Palma Giovane in the Sala dei Pregadi of the Doge's Palace; the painting has been dated ca. 1593 on stylistic grounds by Mason Rinaldi (1984), p. 142, no. 535, fig. 203. The tomb was unfinished at Cattaneo's death in 1572, but from his will one learns that he had completed three of the allegorical figures and brought a fourth to Padua from Venice; see Rigoni (1970), p. 223. The work was brought to an end by Campagna, who carved the statue of Doge Loredan after 1604; see Timofiewitsch (1978).

74. Doc. nos. 255–56.

75. See chap. iv, p. 71, on the dispute over the Sacristy door. Francesco Sansovino referred to Cattaneo in his will of 1572 as 'Messer Danese Cataneo scultore quale reputo un'altro mio padre'; see ASV, testamenti, Figolin, G., busta 442, no. 807, fol. 1ᵛ.

76. The correspondence was first published by Voltelini (1892), pp. xlix–l, no. 8812; it is partially reprinted here as doc. no. 253.

77. Vasari, VII, pp. 518–20. On Vittoria's relations with Vasari and his circle, see Davis et al. (1981), pp. 133–34, 261–62, 295–96. In the absence of a detailed published account of his career, see Planiscig (1921), pp. 435–524; Thieme–Becker, XXXIV, pp. 438–40; Venturi, X–3, pp. 64–179; Pope-Hennessy

(1970), pp. 415–16; and Boucher and Radcliffe (1983), pp 387–91. The small volumes by Cessi (1960–62) are useful mainly for their illustrations.

78. The best account of Vittoria's early years and stylistic development remains that by Leithe-Jasper (1963).

79. Predelli (1908), p. 177; and Leithe-Jasper (1963), pp. 8–14.

80. Vittoria sold it in 1550, bought it back in 1565, and bequeathed it to the nuns of San Zaccaria, where he was buried, in 1608. See Predelli (1908), pp. 132, 177; and Leithe-Jasper (1963), pp. 11–14. On Vittoria's monument in San Zaccaria in relation to Sansovino's intended monument, see Schütz-Rautenberg (1978), pp. 260–65.

81. Leithe-Jasper (1963), pp. 24–40; and Wolters (1968), pp. 33–34, 38–39, 41–49.

82. A generous photographic survey of these stucco decorations can be found in Maganato (1966), pp. 63–76.

83. See chap. x, pp. 153–54.

84. Compare the illustrations in Wolters (1968), figs. 24–26.

85. Pope-Hennessy (1970), p. 417, pl. 216. Leithe-Jasper (1963), pp. 112–18, has shown that the altar was designed independently by Francesco Tagliapietra in 1557, while the statues were commissioned from Vittoria in 1561 and finished in 1564.

86. Boucher and Radcliffe (1983), p. 388, with bibliography.

87. Leithe-Jasper (1963), pp. 185–92; and Mason-Rinaldi (1975). The altar was executed between 1579 and 1584.

88. Pope-Hennessy (1970), pp. 417–18, pls. 128–29. Leithe-Jasper (1963), pp. 127–36, 203–05, dates the Frari version around 1570 on documentary grounds and the later version to 1585 on stylistic grounds. For the altar in Santi Giovanni e Paolo, see Zava Boccazzi (1965), pp. 230–33.

89. Kauffmann (1936), pp. 154–55; see also Boucher (1989), fig. 9.

90. Compare the similarly proto-Baroque treatment of Vittoria's *Virgin of Sorrows*, now in Santi Giovanni e Paolo, discussed in Boucher and Radcliffe (1983), pp. 389–90.

91. Leithe-Jasper (1963), pp. 125, 139–40. The *Evangelists* are reproduced by Cessi (1961), pls. 42–45.

92. See chap viii, pp. 115–18.

93. On Simone Bianco, see Meller (1977). The bust of Marc'antonio Grimani was executed between 1558 and 1564; see Cicogna (1824–53), IV, p. 157; and Leithe-Jasper (1963), p. 123.

94. See Timofiewitsch (1972) and (1974).

95. Timofiewitsch (1972), pp. 233–35; and Wilk (1984), pp. 145–48. The relief was executed between 1574 and 1577.

96. Timofiewitsch (1972-II), pp. 19–22, with further references. Campagna was particularly helped in his early career by Palladio's patron Marc'antonio Barbaro.

97. See Barbieri (1952), p. 129; and Timofiewitsch (1972-II), p. 21. Of the tomb, only Vittoria's bust now survives; it is reproduced in Venturi, X–3, p. 173.

98. Timofiewitsch (1972-II), esp. pp. 58–60, 71–73, 141–42.

99. Timofiewitsch (1972-II), pp. 46–73.

100. Pope-Hennessy (1970), p. 82; and Timofiewitsch (1972-II), pp. 134–68. For Aliense's role, see McTavish (1980).

101. Ridolfi (1914–24), II, pp. 212–13; see also Timofiewitsch (1972-II), p. 258. On representations of the evangelists in San Marco, see here chap. iv, p. 63, and notes 56–60.

102. See Boucher and Radcliffe (1983), p. 358, with bibliography.

103. See Raggio (1982) and Boucher and Radcliffe (1983), pp. 358–59.

104. They are illustrated in Venturi, X–3, pp. 296–301; see also Pope-Hennessy (1970), p. 419, pl. 132.

105. It is reproduced in Venturi, X–3, p. 304, fig. 239.

106. Boucher and Radcliffe (1983), pp. 380–81.

107. The *Virgin and Child* were first published as Roccatagliata by Weihrauch (1967), p. 161. On Campagna's *Virgin and Child*, see Timofiewitsch (1972-II), pp. 123–33, pls. 71–74.

108. See Venturi, X–3, pp. 392–97, figs. 317–19. The relief probably represents more of Roccataliata's son's work than his own.

109. Dal Moro has recently been the subject of an exhaustive *tesi di laurea* by Comastri (1986–87); see also Comastri (1988).

110. See Moschini Marconi (1962), p. 295, no. 507; also Bossaglia (1978), pp. 74–75.

111. Comastri (1988).

112. They are illustrated in Pettorelli (1926), pl. 82, figs. 151–52.

113. See the informative article by Davis (1976-III).

114. For a more conventional view of small Venetian bronzes, see Planiscig (1921); Mariacher (1971); and Weihrauch (1967), pp. 138–68.

115. Timofiewitsch (1972-II), p. 27, no. 109.

116. Temanza (1778), p. 265. The model was in the collection of a Signor Caotorta in Padua. On the sculpture by Parodi, see Rotondi Briasco (1962), pp. 48–50, figs. 32–33.

117. Semenzato (1966), p. 44.

118. On Canova's *Apollo*, see Pavanello (1978), p. 60, no. 77.

Abbreviations

AB	Archivio Buonarroti, Florence
ACP	Archivio della Curia Patriarcale, Venice
ADA	Archivio della Veneranda Arca di Sant'Antonio, Padua
AOD	Archivio Opera del Duomo, Florence
ASB	Archivio di Stato di Bologna
ASF	Archivio di Stato di Firenze
ASM	Archivio di Stato di Modena
ASP	Archivio di Stato di Padova
ASR	Archivio di Stato di Roma
ASV	Archivio di Stato di Venezia
ASVER	Archivio di Stato di Verona
Barbaro	Barbaro, M., *'Arbori de' patritii veneti'*, ASV, Mis. Cod.
Bartsch	Bartsch, A., *Le Peintre-Graveur*, Leipzig, 1854–70, 21 vols.
BNM	Biblioteca Nazionale Marciana, Venice
Capellari-Vivaro	Capellari-Vivaro, G. A., 'Il Campidoglio veneto', BNM, MSS It. Cl. VII, Nos. 15–18 (=8304–07), 4 vols.
CMC	Civico Museo Correr, Venice
DBI	*Dizionario biografico degli Italiani*, Rome, 1960– .
Eubel	Eubel, C., et al., eds., *Hierarchia Catholica*, Münster and Padua, 1901– .
LCI	*Lexikon der christlichen Ikonographie*, ed. E. Kirschbaum, et al., Rome and Freiburg, 1968–72, 4 vols.
Pauly–Wissowa	*Paulys Realencyclopädie der klassischen Altertumswissenschaft*, ed. G. Wissowa, W. Kroll, et al., Stuttgart, 1894– .
Proc. de supra	Procuratori di San Marco de supra
RDK	*Reallexikon zur deutschen Kunstgeschichte*, ed. O. Schmitt, et al., Stuttgart, 1937– .
Thieme–Becker	Thieme, U., and Becker, F., *Allgemeines Künstlerlexikon*, Leipzig, 1907–50, 37 vols.
Vasari	Vasari, G. *Le vite de' più eccellenti pittori, scultori, e architettori (1568)*, ed. G. Milanesi, Florence, 1878–85.
Venturi	Venturi, A., *Storia dell'arte italiana*, Milan, 1901–40, 11 vols.

Bibliography

Ackerman, J. S., *The Architecture of Michelangelo*, London, 1964, 2 vols.

Agosti, G., and Farinella, V., 'Un monumento: la Colonna di Traiano . . .', in *Memoria dell'antico nell'arte italiana*, ed. S. Settis, vol. II, Turin, 1984, pp. 390–427.

Amelung, W., *Die Skulpturen des vaticanischen Museums*, Berlin, 1903–08, 2 vols.

Andrews, K., *National Gallery of Scotland: Catalogue of Italian Drawings*, Cambridge, 1968, 2 vols.

Angeli, D., *Le chiese di Roma*, Rome, n.d.

Angelini, L., *Bartolomeo Bon, Guglielmo d'Alzana*, Bergamo, 1961.

Angelucci, P. G., *Memorie storico-artistico-religiose della chiese di S. Marcello in Roma*, Rome, 1923.

Aretino, P., *Lettere*, Paris, 1609, 5 vols.

Armand, A., *Les Médailleurs italiens des XV^e et XVI^e siècles*, Paris, 1883–87.

Armenini, G. B., *De' veri precetti della pittura*, Ravenna, 1587 (reprinted Hildesheim, New York, 1971).

Arslan, E., 'Un documento sul Sansovino e Giangiacomo de' Grigi', in *Studi in onore di Carlo Castiglioni*, Milan, 1957, pp. 27–30.

Aschoff, W., 'Studien zu Niccolò Tribolo', Ph. D., Univ. of Frankfurt, 1967.

Astegiano, G., 'Su la vita e le opere di Tommaso da Ravenna', *Bollettino del Museo Civico di Padova*, n.s., I (XVIII), 1925, pp. 49–70, 236–60.

Aurenhammer, H., *Lexikon der christlichen Ikonographie*, Vienna, 1959–67, vol. I.

Avagnina, M. E., and Pianca, V., eds., *Jacopo Sansovino a Vittorio Veneto* (exh. cat.), Vittorio Veneto, 1989.

Avery, C. *Florentine Renaissance Sculpture*, London, 1970.

_____, 'Giambologna's Sketch-Models and his Sculptural Technique', *Connoisseur*, CIC, Sept. 1978, pp. 3–11.

_____, 'La cera sempre aspetta: Wax Sketch-Models for Sculpture', *Apollo*, CXIX, 1984, pp. 166–76.

_____ and Radcliffe, A., eds., *Giambologna, Sculptor to the Medici*, London, 1978.

Bacci, O., ed., *Vita di Benvenuto Cellini*, Florence, 1901.

Bagarotto, R., Savio, L., and Boucher, B., 'The Madonna delle Muneghette: A New Work by Jacopo Sansovino', *Burlington Magazine*, CXXII, 1980, pp. 22–29.

Baldinucci, F., *Vocabolario toscano dell'arte del disegno*, Florence, 1681.

_____, *Vita del Cavaliere Giovanni Lorenzo Bernino . . .*, trs. C. Engass, University Park, Pa., 1966.

Baldwin Brown, G., ed., *Vasari on Technique*, New York, 1907.

Ballarin, A., 'Jacopo Bassano e lo studio di Raffaello e dei Salviati', *Arte Veneta*, XXI, 1967, pp. 77–101.

Balogh, J., 'Nanni Unghero', *Az Országos Magyar Szépmüvészeti Múzeum: Évkönyvei*, IV, 1924–26, pp. 91–115.

_____, 'Studien in der alten Skulptursammlung des Museums der bildenden Künste', *Az Országos Magyar Szépmüvészeti Múzeum: Évkönyvei*, IX, 1937–39, pp. 45–75.

_____, 'Studi sulla collezione di sculture del Museo di Belle Arti', *Acta Historiae Artium Academiae Scientiarum Hungaricae*, XI, fasc. 1–2, 1965, pp. 1–67.

_____, *Katalog der ausländischen Bildwerke des Museums der bildenden Künste in Budapest, IV.–XVIII. Jahrhundert*, Budapest, 1975.

Barbaro, D., *I dieci libri dell'architettura . . .*, Venice, 1556.

Barbieri, F., *Vincenzo Scamozzi*, Vicenza, 1952.

Barioli, G., 'L'attività del Museo Civico di Vicenza', *Arte Veneta*, XXI, 1967, p. 294.

Barocchi, P., ed., *Trattati d'arte del Cinquecento*, Bari, 1960–62, 3 vols.

_____, *Giorgio Vasari: la vita di Michelàngelo nella redazioni del 1550 e del 1568*, Milan and Naples, 1962, 5 vols.

_____ and Ristori, R., eds., *Il carteggio di Michelangelo, edizione postuma di Giovanni Poggi*, Florence, 1965–83, 5 vols.

Barozzi, N., et al., *A Giuseppe co. Michiel e Antonio Baffo . . .*, Venice, 1855.

Bartoli, A., *I monumenti antichi di Roma nei disegni degli Uffizi di Firenze*, Rome, 1914–22, 6 vols.

Bartolini Salimbeni, L., 'Una "fabbrica" fiorentina di Baccio d'Agnolo', *Palladio*, XXVII, fasc. 2, 1978, pp. 7–28.

Baschet, A., 'Documents concernant la personne de Messer Pietro Aretino', *Archivio storico italiano*, ser. 3, III-2, 1886, pp. 107–30.

Bassi, E., *Architecture del Sei e Settecento a Venezia*, Naples, 1962.

Battistella, A., 'Il Domino del Golfo', *Nuovo Archivio Veneto*, n.s., XXXV, 1918, pp. 5–102.

Bauch, K., *Das mittelalterliche Grabmalbild*, Berlin and New York, 1975.

Baudry, M.-T., and Bozo, D., eds., *La Sculpture, méthode et vocabulaire*, Paris, 1978.

Baxandall, M., *Giotto and the Orators*, Oxford, 1971.

Bearzi, B., 'La tecnica fusoria di Donatello', *Donatello e il suo tempo: atti dell'VIII Convegno internazionale di Studi sul Rinascimento*, Florence, 1966, pp. 97–105.

Beckerath, A. v., 'Über einige Zeichnungen florentinischer

Maler . . . ', *Repertorium für Kunstwissenschaft*, XXVIII, 1905, pp. 104–26.

Beguin, S., 'Thème et Dérivations', in *La Madonne de Lorette* (Les Dossiers du Département des Peintures, No. 9), Paris, 1979, pp. 38–47.

Bellavitis, G., *L'Arsenale di Venezia*, Venice, 1983.

Bellesi, S., 'Precisazioni sulla vita e sull'attività dello scultore fiorentino Andrea di Michelangelo Ferrucci', *Antichità viva*, XXVIII, no. 1, 1989, pp. 49–55.

Bembo, P., *Opere . . . tutte in un corpo unite*, Venice, 1729, 4 vols.

Benedetti, S., *Giacomo del Duca e l'architettura del Cinquecento*, Rome, 1972–73.

Bennett, B., and Wilkins, D., *Donatello*, Oxford, 1984.

Bentivoglio, E., and Valtieri, S., *S. Maria del Popolo*, Rome, 1976.

Berenson, B., *The Drawings of the Florentine Painters*, Chicago, 1938, 3 vols.

Berliner, R., 'Raphaels Sixtinische Madonna als religiöses Kunstwerk', *Das Münster*, XI, 1958, pp. 85–104.

Bertelli, S., *Il potere oligarchico nello stato-città medievale*, Florence, 1978.

Berti, L., 'Bartolomeo Baglioni, detto Baccio d'Agnolo', *DBI*, V, 1963, pp. 202–05.

Bertoldi, A., *Michele Sanmicheli al servizio della Repubblica Veneta: documenti*, Verona, 1874.

Besozzi, R., *La storia della Basilica di Santa Croce in Gerusalemme*, Rome, 1750.

Bettini, S., *La pittura di icone cretese-veneziana e i madonneri*, Padua, 1933.

Bettiolo, G., 'Un altare votivo per la vittoria di Lepanto nella chiesa di S. Giuseppe a Venezia', *Arte Cristiana*, I, 1913, pp. 310–14.

Bialostocki, J., 'The Door of Death', *Jahrbuch der Hamburger Kunstsammlungen*, XVIII, 1973, pp. 7–32.

_____, *The Art of the Renaissance in Eastern Europe*, Oxford, 1976.

Biscaro, G., 'Pietro Lombardo e la cattedrale di Treviso', *Archivio storico dell' arte*, ser. 2, III, 1897, pp. 142–57.

Bistort, G., *Il Magistrato alle pompe nella Repubblica di Venezia*, Venice, 1912.

Blanc, C., *Collection d'objets d'art de M. Thiers léguée au Musée du Louvre*, Paris, 1884.

Bloch, P., *Madonnen Bilder* (exh. cat.), Berlin-Dahlem, 1969.

Blunt, A., *Nicholas Poussin*, New York, 1967.

_____, *Art and Architecture in France, 1500–1700*, Harmondsworth, 1971.

Bober, P. P., *Drawings after the Antique by Amico Aspertini . . .*, London, 1957.

_____ and Rubinstein, R., *Renaissance Artists and Antique Sculpture*, London, 1986.

Boccaccio, G., *Genealogia deorum*, Basel, 1532.

Bocchi, F., and Cinelli, F., *Le bellezze della città di Firenze*, Florence, 1677.

Bode, W., 'Die Ausstellung von Gemälden älterer Meister im Berliner Privatbesitz', *Jahrbuch der Königlichen Preussischen Kunstsammlungen*, IV, 1883, pp. 119–51.

_____, 'Die italienischen Skulpturen der Renaissance in der Königlichen Museen zu Berlin, VII. Jacopo Sansovino', *Jahrbuch der Königlichen Preussischen Kunstsammlungen*, VII, 1886, pp. 33–39.

_____, 'Italienische Bildwerke des XV. und XVI. Jahrhunderts: Statuetten, Büsten, Geräthschaften in Bronze', *Ausstellung von Kunstwerken des Mittelalters und der Renaissance aus Berliner Privatbesitz . . .*, Berlin, 1899, pp. 58–101.

_____, 'Two Venetian Bronze Busts in the Widener Collection . . . ', *Burlington Magazine*, XII, 1907, pp. 86–91.

Bode, W., *Die italienische Bronzestatuetten der Renaissance*, Berlin, 1907–12, 3 vols.

_____, *Die Sammlung Oscar Huldschinsky*, Frankfurt, 1909.

_____, *Staatliche Museen zu Berlin: die italienischen Bildwerke der Renaissance und des Barock, II. Bronzestatuetten . . .*, Berlin, 1930.

_____ and Tschudi, H. v., *Königliche Museen zu Berlin: Beschreibung der Bildwerke der christlichen Epoche*, Berlin, 1888.

Bodin, J., *Les Six Livres de la République*, Paris, 1576.

Bodmer, H., 'Le note marginali di Agostino Carracci nell' edizione del Vasari del 1568', *Il Vasari*, X, 1939, pp. 89–127.

Boerio, G., *Dizionario del dialetto veneziano*, Venice, 1867.

Bonito, V., 'The St Anne Altar in Sant'Agostino in Rome . . . ', *Burlington Magazine*, CXXII, 1980, pp. 805–12.

_____, 'The St Anne Altar in Sant'Agostino . . . ', *Burlington Magazine*, CXXIV, 1982, pp. 268–76.

Bordignon Favero, G., *La Villa Emo di Fanzolo*, Vicenza, 1970.

Borghini, R., *Il riposo*, Florence, 1584 (reprinted Milan, 1967), 2 vols.

Borgo, L., *The Works of Mariotto Albertinelli* (Outstanding Dissertations in the Fine Arts), New York and London, 1976.

Borinski, K., *Die Antike in Poetik und Kunsttheorie*, Leipzig, 1914–23, 2 vols.

Borsi, S., *Giuliano da Sangallo: i disegni di architettura e dell'antico*, Rome, 1985.

Borsook, E., 'Fra Filippo Lippi and the Murals for Prato Cathedral', *Mitteilungen des Kunsthistorischen Institutes in Florenz*, XIX, 1975, pp. 1–148.

Boschini, M., *La carta del navegar pitoresco*, ed. A. Pallucchini, Venice and Rome, 1966.

Boselli, C., 'Palladiana: notizia spiccioli di storia dell'architecture nell'archivio comunale di Brescia', *Commentari dell'Ateneo di Brescia*, CXLIX, 1950, pp. 109–20.

Bosignore, G. P., *P. Ovidio Metamorphoseos, vulgare*, Milan, 1519.

Bossaglia, R., ed., *I Fantoni: quattro secoli di bottega di sculture*, Vicenza, 1978.

Bottari, G., *Le vite . . . di Giorgio Vasari*, Rome, 1759–60, 3 vols.

Bottari, S., and Ticozzi, S., *Raccolta di lettere . . .*, Milan, 1822–25, 8 vols.

Boucher, B., 'Jacopo Sansovino and the Choir of St Mark's', *Burlington Magazine*, CXVIII, 1976, pp. 552–66.

_____, 'Opere ignote sansovinesche alla Biblioteca Marciana', *Arte Veneta*, XXXI, 1977, pp. 190–92.

_____, 'Jacopo Sansovino and the Choir of St Mark's: The Evangelists, the Sacristy Door and the Altar of the Sacrament', *Burlington Magazine*, CXXI, 1979, pp. 155–68.

_____, 'Il Sepolcro di Galesio Nichesola nel Duomo di Verona', *Palladio e Verona* (exh. cat.), ed. P. Marini and L. Magagnato, Verona, 1980, pp. 160–62 (=1980-I).

_____, 'Jacopo Sansovino?', *Burlington Magazine*, CXXII, 1980, pp. 584–86 (=1980-II).

_____, 'Leone Leoni and Primaticcio's Moulds of Antique Sculpture', *Burlington Magazine*, CXXIII, 1981, pp. 23–26.

_____, 'Sansovino's Medici Tabernacle and Lotto's Sacramental Allegory: New Evidence on their Relationship', *Apollo*, CXVIII, 1981, pp. 156–61.

_____, 'An Annunciation by Jacopo Sansovino', *Apollo*, CXVIII, 1983, pp. 22–27.

_____, 'St Mark healing the Demoniac', in *The Genius of Venice, 1500–1600*, ed. J. Martineau and C. Hope, London, 1983, p. 250, D8 (=1983-II).

_____, 'Jacopo Sansovino e la scultura veneziana del manierismo', *Cultura e società nel rinascimento tra riforme e manierismi*, ed. V. Branca and C. Ossola, Florence, 1984, pp. 335–50.

Boucher, B., 'Il Sansovino e i procuratori di San Marco', *Atti dell'Ateneo Veneto*, CLXXIII, 1986, pp. 59–74.

———, *Jacopo Sansovino: l'altarolo mediceo* (Lo specchio del Bargello, no. 33), Florence, 1987.

———, 'The St Jerome in Faenza: A Case for Restitution', *Donatello-Studien* (Kunsthistorisches Institut in Florenz: Italienische Forschungen, 3. F., XVI), Munich, 1989, pp. 186–93.

———, 'Sansovino e Veronese', in *Nuovi studi su Paolo Veronese*, ed. M. Gemin, Venice, 1990, pp. 53–62.

——— and Radcliffe, A., 'Sculpture', in *The Genius of Venice, 1500–1600*, ed. J. Martineau and C. Hope, London, 1983, pp. 355–91.

Boutard, J. B., *Dictionnaire des arts du dessin . . .* , Paris, 1838.

Boyance, P., *Études sur le Songe de Scipion*, Bordeaux and Paris, 1936, pp. 57–119.

Braham, A., et al., 'Bellini's "The Blood of the Redeemer"', *National Gallery Technical Bulletin* (London), II, 1978, pp. 11–24.

———, 'The Bed of Pierfrancesco Borgherini', *Burlington Magazine*, CXXI, 1979, pp. 754–65.

Brandolese, P., *Le cose più notabili di Padova*, Padua, 1791.

Braudel, F., *The Mediterranean and the Mediterranean World in the Age of Philip II*, London, 1972–73, 2 vols.

Braun, J., *Der christliche Altar in seiner geschichtlichen Entwicklung*, Munich, 1924, 2 vols.

Brentano, C. W., 'A 1526 Cellini Letter', *Art Bulletin*, XLI, 1959, p. 269.

Brenzoni, R., 'L' Altare dell'Assunta e l'urna sepolcrale del vescovo Galesio Nichesola nella Cattedrale di Verona', *Bollettino d'arte*, XLII, 1957, pp. 338–41.

Brinckmann, A. E., *Barock-Bozzetti*, Frankfurt, 1923–25, 4 vols.

Brown, P. F., *Venetian Narrative Painting in the Age of Carpaccio*, New Haven and London, 1988.

Brugnoli, M. V., 'Problemi di scultura cinquecentesca', in *La Basilica di San Petronio in Bologna*, Bologna, 1983–84, vol. II, pp. 103–16.

Brugnoli, P. P., *La Cattedrale* (Collana 'Le guide'), Verona, 1955.

Brummer, H. H., *The Statue Court in the Vatican Belvedere* (Stockholm Studies in History of Art, no. 20), Stockholm, 1970.

Bruschi, A., *Bramante*, London, 1977.

Buddensieg, T., 'Raphaels Grab', in *Munuscula Discipulorum: Kunsthistorische Studien, Hans Kauffmann zum 70. Geburtstag 1966*, Berlin, 1968, pp. 45–70.

Bullo, C., 'Di tre illustri prelati clodiensi segretari di pontefici', *Nuovo Archivio Veneto*, XX, 1900, pp. 245–85.

Burckhardt, J., *Gesamtausgabe*, ed. F. Stahelin and H. Wölfflin, Stuttgart, 1929–34, 14 vols.

Burns, H., 'Le opere minori del Palladio', *Bollettino del Centro internazionale di studi di architettura Andrea Palladio*, XXI, 1979, pp. 9–34 (=1979-I).

———, 'San Lorenzo in Florence before the Building of the New Sacristy', *Mitteilungen des Kunsthistorischen Institutes in Florenz*, XXIII, 1979, pp. 145–54 (=1979-II).

———, 'Altare Fregoso', in *Palladio e Verona* (exh. cat.), ed. P. Marini and L. Magagnato, Verona, 1980, pp. 165–166.

———, et al., *Andrea Palladio, 1508–1580* (exh. cat.), London, 1975.

Bury, J., 'The Loggetta in 1540', *Burlington Magazine*, CXXII, 1980, pp. 631–35.

Bush, V., *Colossal Sculpture of the Cinquecento . . .* (Outstanding Dissertations in the Fine Arts), New York, 1976.

———, 'Bandinelli's *Hercules and Cacus* and Florentine Traditions', in *Studies in Italian Art and Architecture, Fifteenth through Eighteenth Century*, ed. H. Millon, Rome, 1980, pp. 163–206.

Cadorin, G. B., *Testamento di Jacopo Sansovino . . .* , Venice, 1884.

Calì, M., 'Ancora sulla "religione" di Lorenzo Lotto', *Ricerche di storia dell'arte*, XIX, 1983, pp. 37–60.

Callegari, A., 'Il Palazzo Garzoni a Ponte Casale', *Dedelo*, VI, 1926, pp. 569–98.

Calvete de Estrella, I. C., *El felicissimo viaie del muy alto y muy poderoso Principe Don Phelippe . . .* , Antwerp, 1552.

Calza, R., *Antichità di Villa Doria Pamphilj*, Rome, 1977.

Campori, G., 'Una Statua di Jacopo Sansovino', *Atti e memorie delle Reali Deputazioni di storia patria per le provincie modenesi e parmensi*, VI, 1872, pp. 501–12.

———, 'Danese Cattaneo', in *Memorie biografiche degli scultori, architetti, pittori . . . nativi di Carrara*, Modena, 1873, pp. 56–76.

Cantalamessa, G., 'La Loggetta', *Rassegna d'Arte*, II, 1902, pp. 153–54.

Canuti, F., *Il Perugino*, Siena, 1931, 2 vols.

Caplow, H., 'Sculptors' Partnerships in Michelozzo's Florence', *Studies in the Renaissance*, XXI, 1974, pp. 145–75.

Cappelli, A., *Cronologia, cronografia e calendario perpetuo*, Milan, 1878.

Carli, E., 'A Rediscovered Francesco di Giorgio', *Burlington Magazine*, XLI, 1949, pp. 33–39.

Carocci, G., *La famiglia Ridolfi di Piazza*, Florence, 1889.

Carradori, F., *Istruzione elementare per gli studiosi della scultura*, Florence, 1802.

Casoni, G., *Breve storia dell'Arsenale*, Venice, 1847.

Caspari, H., 'Das Sakramentstabernakel in Italien bis zum Konzil von Trient . . .' , Ph.D., Univ. of Munich, 1965.

Cassanelli, L., and Rossi, S., eds., *I luoghi di Raffaello a Roma* (exh. cat.), Rome, 1983.

Cassirer, P., and Helbing, H., *Die Sammlung Oscar Huldschinsky* (sale cat.), Berlin, 10–11 May 1928.

Cavalieri, G. B., *Antiquarum statuarum urbis Romae . . .* , Rome, 1593.

Cecchelli, C., *Mater Christi*, Rome, 1946–54, 4 vols.

Cecchetti, B., 'Funerali e sepolture dei Veneziani antichi: Note', *Archivio Veneto*, XXXIV, 1887, pp. 265–84.

Cecchi, A., 'Nuove ricerche sulla Casa del Vasari a Firenze', in *Giorgio Vasari tra decorazione ambientale e storiografia artistica*, ed. G. C. Garfagnini, Florence, 1985, pp. 273–83.

Cellini, B., *I trattati dell'oreficeria e della scultura*, ed. C. Milanesi, Florence, 1857.

Ceresole, V., 'La Porte de Bronze, sacristie de Saint-Marc à Venise', *L'Art*, VI, no. 1, 1880, pp. 249–56, 273–76.

Cessi, F., *Alessandro Vittoria* (Collana artisti trentini), Trent, 1960–62, 5 vols.

———, *Andrea Briosco detto il Riccio* (Collana artisti trentini), Trent, 1965.

———, *Vincenzo e Gian Gerolamo Grandi* (Collana artisti trentini), Trent, 1967.

Chabod, F., 'Venezia nella politica italiana ed europea del Cinquecento', in *La civiltà veneziana del rinascimento*, Florence, 1958, pp. 29–55.

Chacon, A., *Vitae et Res Gestae Pontificum Romanorum et S.R.E. Cardinalium*, Rome, 1677, 4 vols.

Chambers, D., *The Imperial Age of Venice*, London, 1970.

——— and Martineau, J., eds., *Splendours of the Gonzaga* (exh. cat.), London, 1981.

Chantelou, P. Fréart de, *Diary of the Cavaliere Bernini's Visit to France*, ed. A. Blunt, Princeton, 1985.

Chartrou, J., *Les Entrées solennelles et triomphales à la Renaissance*, Paris, 1928.

Chastel, A., 'Les Entrées de Charles Quint en Italie', *Les Fêtes de la Renaissance, II. Fêtes et cérémonies au temps de Charles Quint*, ed. J. Jacquot, Paris, 1960, pp. 197–206.

———, *The Sack of Rome*, Princeton, 1983.

———, *Le Cardinal Louis d'Aragon: un voyager princier de la Renaissance*, Paris, 1986.

——— and Klein, R., eds., *Pomponius Gauricus: De sculptura (1504)*, Geneva, 1969.

Chiarini, M., et al., *Andrea del Sarto, 1486–1530: dipinti e disegni a Firenze* (exh. cat), Florence, 1986.

Chiarlo, C. R., 'Capitello tardoantico in Sant'Alessandro a Lucca', *Prospettiva*, no. 16, 1979, pp. 31–34.

Ciardo, R. P., ed., *Gian Paolo Lomazzo: scritti sulle arti*, Florence, 1973–74, 2 vols.

Ciardi Dupré, M. G., 'La prima attività dell'Ammannati scultore', *Paragone Arte*, 1961, fasc. 135, pp. 3–28.

———, 'Bronzi di Bartolomeo Ammannati', *Paragone Arte*, 1962, fasc. 151, pp. 57–59.

———, 'Sull'attività italiana di Alonso Berruguete scultore', *Commentari*, n.s., XIX, 1968, fasc. 1–2, pp. 111–36.

———, 'J. Balogh, *Katalog der ausländischen Bildwerke . . .* ', *Prospettiva*, no. 8, 1977, pp. 63–67.

Cicogna, E. A., *Delle iscrizioni veneziane*, Venice, 1824–53, 6 vols.

———, *Saggio di bibliografia veneziana*, Venice, 1847.

Cicognara, L., *Storia della scultura*, Prato, 1823–24, 7 vols.

———, Diedo, A., and Selva, G., *Le fabbriche e i monumenti cospicui di Venezia*, Venice, 1838–40, 2 vols.

Clark, J. W., 'On the Library of S. Mark, Venice', *Proceedings of the Cambridge Antiquarian Society*, XV, 1911, pp. 300–14.

Clark, K., *Leonardo da Vinci*, Harmondsworth, 1988.

——— and Pedretti, C., *The Drawings of Leonardo da Vinci in the Collection of Her Majesty the Queen at Windsor Castle*, London, 1968–69, 3 vols.

Clausse, G., *Les San Gallo*, Paris, 1900–02, 3 vols.

Cochin, C. N., *Voyage d'Italie*, Lausanne, 1773, 3 vols.

Colasanti, A., 'Il Memoriale di Baccio Bandinelli', *Repertorium für Kunstwissenschaft*, XXVII, 1905, pp. 406–43.

Colasanti, F., 'Antonio Cappello', in DBI, XVIII, 1975, pp. 748–51.

Comastri, E., 'Giulio dal Moro', Diss., Univ. of Venice, 1986–87.

———, 'Profilo di Giulio dal Moro', *Arte Veneta*, XLII, 1988, pp. 87–97.

Condivi, A., *The Life of Michelangelo*, trs. A. Sedgwick Wohl, ed. H. Wohl, Oxford, 1976.

Connell, S. M., 'The Employment of Sculptors and Stone-Masons in Venice in the Fifteenth Century', Ph.D., Univ. of London, 1976.

Contarini, P., *Argoa voluptas*, Venice, 1541.

———, *Argo vulgar*, Venice, n.d.

Conti, C., *La prima reggia di Cosimo I de' Medici*, Florence, 1893.

Cope, M., *The Venetian Chapel of the Sacrament in the Sixteenth Century* (Outstanding Dissertations in the Fine Arts), New York and London, 1979.

Corradi, A., *Annali delle epedemie occurse in Italie . . .*, Bologna, 1865–94, 5 vols.

Corti, G., 'Jacopo Sansovino's Contract for the Madonna in Sant'Agostino, Rome', *Burlington Magazine*, CXIII, 1971, pp. 395–96.

Cox Rearick, J., *The Drawings of Pontormo*, Cambridge, Mass., 1964, 2 vols.

Cox Rearick, J., 'Fra Bartolomeo's St Mark Evangelist and St Sebastian with an Angel', *Mitteilungen des Kunsthistorischen Institutes in Florenz*, XVIII, 1974, pp. 329–54.

Cozzi, G., 'Federico Contarini: un antiquario veneziano tra rinascimento e controriforma', *Bollettino dell'Istituto di storia della Società e dello Stato Veneziano*, III, 1961, pp. 190–220.

———, 'Paolo Paruta, Paolo Scarpi e la questione della Sovranità su Ceneda', *Bollettino dell'Istituto di Storia della Società e dello Stato Veneziano*, IV, 1962, pp. 176–237.

———, 'Cultura, politica e religione nella "Pubblica Storiografia" veneziana del'500', *Bollettino dell'Istituto di Storia della Società e dello Stato Veneziano*, V–VI, 1963–64, pp. 215–94.

Cretoni, A., *Cenni storici della Madonna di S. Agostino*, Rome, 1870.

Cropper, E., 'On Beautiful Women, Parmigianino, Petrarchismo, and the Vernacular Style', *Art Bulletin*, LVIII, 1976, pp. 374–94.

Dacos, N., *Le Logge di Raffaello: maestro e bottega di fronte all'antico*, Rome, 1977.

——— and Furlan, C., *Giovanni da Udine, 1487–1561*, Udine, 1987.

Dalli Regoli, G., 'Due angeli di marmo, "Opus Silvi", per cento scudi d'oro di sole', *Antologia di Belle Arti*, nos. 21–22, 1984, pp. 15–20.

Da Mosto, A., *L'Archivio di Stato di Venezia*, Rome, 1937–40, 2 vols.

———, *I Dogi di Venezia nella vita pubblica e privata*, Milan, 1960.

da Persico, G. B., *Descrizione di Verona e della sua provincia*, Verona, 1820.

Darcel, A., and Basilewsky, A., *Le Collection Basilewsky: catalogue raisonné*, Paris, 1874.

d'Arco, C., *Delle arti e artifici di Mantova*, Mantua, 1857–59, 2 vols.

Davidson, B., 'Marcantonio's Martyrdom of San Lorenzo', *Bulletin of the Rhode Island School of Design*, XLVII, no. 3, 1961, pp. 1–6.

———, 'Pellegrino da Modena', *Burlington Magazine*, CXII, 1970, pp. 78–86.

Davies, G. S., *Renascence: The Sculptured Tombs of the Fifteenth Century in Rome*, London, 1910.

Davis, C., 'Ammannati, Michelangelo and the Tomb of Francesco del Nero', *Burlington Magazine*, CXVIII, 1976, pp. 472–84 (=1976-I).

———, '"Colossum facere ausus est": l'apoteosi d'Ercole e il colosso padovano dell'Ammannati', *Psicon*, III, no. 6, 1976, pp. 32–47 (=1976-II).

———, 'Alari from the Shop of "Andrea dai bronzi": A Notice for Andrea Bresciano', *Arte Veneta*, XXX, 1976, pp. 163–67 (=1976-III).

———, 'The Tomb of Mario Nari for the SS. Annunziata in Florence . . .', *Mitteilungen des Kunsthistorischen Institutes in Florenz*, XXI, 1977, pp. 69–94.

———, 'Jacopo Sansovino?', *Burlington Magazine*, CXXII, 1980, pp. 582–84.

———, 'The Genius of Venice, 1500–1600: Ausstellung in der Royal Academy of Arts', *Kunstchronik*, XXXVII, 1984, pp. 81–88 (=1984-I).

———, 'La Grande "Venezia" a Londra', *Antichità viva*, XXIII, no. 2, 1984, pp. 45–52 (=1984-II).

———, 'La Grande "Venezia" a Londra', *Antichità viva*, XXIII, no. 6, 1984, pp. 32–44 (1984=III).

———, 'Jacopo Sansovino's "Loggetta di San Marco" and Two Problems of Iconography', *Mitteilungen des Kunsthistorischen Institutes in Florenz*, XXIX, 1985, pp. 396–400.

Davis, C., et al., *Georgio Vasari* (exh. cat.), Florence, 1981.

Degenhart, B., and Schmitt, A., eds., *Corpus der italienischen Zeichnungen*, Berlin, 1968– .

De Juliis, G., d'Arienzo, M., and Castiglia, N., 'Il Palazzo di Valfonda', *Granducato*, III, no. 11–12, 1978, pp. 65–72.

Dellwing, H., 'Der Santo in Pauda: Eine baugeschichtliche Untersuchung', *Mitteilungen des Kunsthistorischen Institutes in Florenz*, XIX, 1975, pp. 197–240.

Demus, O., *The Church of San Marco in Venice*, Washington, D.C., 1960.

Dengel, P., *Palast und Basilika San Marco in Rom*, Rome, 1913.

De Ricci, S., 'L' Art du Moyen Âge et de la Renaissance a l'Hôtel de Sagan', *Gazette des Beaux-Arts*, LV, 1913, pp. 68–76.

De Vecchi, P., 'Invenzioni sceniche e iconografia del miracolo nella pittura di Jacopo Tintoretto', *L'arte*, n.s., V, no. 17, 1972, pp. 101–32.

Dibelius, M., *Handbuch zum neuen Testament: 13. Die Pastoralbriefe*, Tübigen, 1931.

Di Giampaolo, M., *Disegni di Girolamo Bedoli* (exh, cat.), Viadana, 1971.

Dimier, L., 'Le "Tireur d'épine" du Louvre . . . ," *La Chronique des Artes et de la Curiosité* (Supplement to the Gazette des Beaux-Arts), Paris, 1899, pp. 71–72.

Doglioni, G., *Venetia trionfante et sempre libera*, Venice, 1613.

Dominici, G., *Regola del governo di cura familiare*, Florence, 1860.

Donato, B., *Il primo libro di canzon villanesche alla napolitana a quattro voci*, Venice, 1558.

Doni, A. F., *Disegno*, Venice, 1549.

———, *Tre libri di lettere . . .* , Venice, 1552.

Draper, J. D., 'A Bronze *Spinario* ascribed to Antonello Gagini', *Burlington Magazine*, CXIV, 1972, pp. 55–58.

———, ed., *The Italian Bronze Statuettes of the Renaissance by Wilhelm Bode*, New York, 1980.

Dussler, L., *Raphael: A Critical Catalogue . . .* , London, 1971.

Duveen Sculpture in Public Collections of America, New York, 1944.

Duverger, J., 'Marie de Hongrie', *Actes du XXIIᵉ Congrès international d'histoire de l'art*, Budapest, 1969 (1972), I, pp. 716–26.

Eberhardt, H.-J., 'Das Testament des Liberale da Verona', *Mitteilungen des Kunsthistorischen Institutes in Florenz*, XV, 1971, pp. 219–25.

Einem, H. v., *Michelangelo*, London, 1973.

Eisler, C., 'The Golden Christ of Cortona and the Man of Sorrows in Italy', *Art Bulletin*, LI, 1969, pp. 107–18, 233–46.

———, *Sculptors' Drawings over Six Centuries, 1400–1950* (exh. cat.), New York, 1981.

Engass, R., *Early Eighteenth Century Sculpture in Rome*, University Park, Pa., and London, 1976, 2 vols.

Erizzo, S., *Discorso sopra le medaglie degli antichi*, Venice, 1559.

Ettlinger, L., 'Hercules Florentinus', *Mitteilungen des Kunsthistorischen Institutes in Florenz*, XVI, 1972, pp. 119–42.

———, *Antonio and Piero Pollaiuolo*, Oxford, 1978.

Fabriczy, C. v., 'Litteraturbreicht: E. Müntz, Les Collections de Cosme Iᵉʳ de Medicis . . .', *Repertorium für Kunstwissenschaft*, XIX, 1896, pp. 157–65:

———, 'Giuliano da Sangallo', *Jahrbuch der Königlichen Preussischen Kunstsammlungen*, XXIII, 1902, Beiheft, pp. 1–42.

———, 'Ein unbekanntes Jugendwerk Andrea Sansovinos', *Jahrbuch der Königlichen Preussischen Kunstsammlungen*, XXVII, 1906, pp. 79–105.

Fabriczy, C. v., 'Die Bildhauerfamilie Ferrucci aus Fiesole', *Jahrbuch der Königlichen Preussischen Kunstsammlungen*, XXIX, 1908, Beiheft, pp. 1–28.

———, 'Kritisches Verzeichnis toskanischer Holz- und Tonstatuen bis zum Beginn des Cinquecento', *Jahrbuch der Königlichen Preussischen Kunstsammlungen*, XXX, 1909, pp. 1–88.

Fader, M. A., 'Sculpture in the Piazza della Signoria as Emblem of the Florentine Republic, Ph.D., Univ. of Michigan, 1977 (Univ. Microfilms).

Faison, S. L., *A Guide to the Art Museums of New England*, New York, 1958.

Falk, T., 'Studien zur Topographie und Geschichte der Villa Giulia in Rom', *Römisches Jahrbuch für Kunstgeschichte*, XIII, 1971, pp. 101–78.

Fasoli, G., 'Nascità di un mito', *Studi storici in onore di Gioacchino Volpe*, Florence, 1958, I, pp. 447–79.

Favaro, E., *L'arte dei pittori in Venezia e i suoi statuti*, Florence, 1975.

Faveretto, I., 'Andrea Mantova Benavides: inventario delle antichità di casa Mantova Benavides, 1695', *Bollettino del Museo Civico di Padova*, LXI, nos. 1–2, 1972, pp. 35–164.

Fehl, P., 'On the Representation of Character in Renaissance Sculpture', *Journal of Aesthetics and Art Criticism*, XXXI, no. 3, 1973, pp. 291–307.

Ferri, P. N., *Indice geografico-analitico dei disegni di architettura civile e militare esistenti nella R. Galleria degli Uffizi*, Rome, 1885.

Feulner, A., *Stiftung Sammlung Schloss Rohoncz: III. Teil, Plastik und Kunsthandwerk*, Lugano Castagnola, 1941.

Feurstein, H., *Matthias Grünewald*, Bonn, 1930.

Finlay, R., *Politics in Renaissance Venice*, London, 1980.

Fiocco, G., 'La prima opera di Tiziano Minio', *Dedalo*, XI–1, 1931, pp. 600–10.

———, 'Un capolavoro ignorato di Jacopo Sansovino a Venezia', *Mitteilungen des Kunsthistorischen Institutes in Florenz*, XI, 1963–65, pp. 111–15.

———, 'Il Mosca a Padova', *Venezia e la Polonia nei secoli dal XVII al XXIX*, Venice and Rome, 1965, pp. 43–52 (=1965-I).

———, *Alvise Cornaro, il suo tempo e le sue opere*, Vicenza, 1965 (=1965-II).

Firenzuola, A., 'Dialogo della bellezza delle donne', *Opere*, Milan, 1802, I, pp. 13–97.

Firestone, G., 'The Sleeping Christ-Child in Italian Renaissance Representations of the Madonna', *Marsyas*, II, 1942, pp. 43–62.

Fischer, C., *Disegni di Fra Bartolommeo* (exh. cat.), Florence, 1986.

Fisher, M. R., *Titian's Assistants during the Later Years* (Outstanding Dissertations in the Fine Arts), New York and London, 1977.

Fletcher, J. M., 'Marco Boschini and Paolo del Serra: Collectors and Connoisseurs of Venice', *Apollo*, CX, 1979, pp. 416–24.

———, 'Marcantonio Michiel . . .', *Burlington Magazine*, CXXIII, 1981, pp. 453–67, 602–08.

Flora, F., ed., *Tutte le opere di Pietro Aretino: lettere, il primo e secondo libro*, Milan, 1960.

Förster, R., 'Laokoon im Mittelalter und in der Renaissance', *Jahrbuch der Königlichen Preussischen Kunstsammlungen*, XXVII, 1906, pp. 149–78.

Forcella, V., *Iscrizioni delle chiese e d'altri edifici di Roma dal secolo XI fino ai giorni nostri*, Rome, 1869–84, 16 vols.

Forlani Tempesti, A., et al., *Capolavori e restauri* (exh. cat.), Florence, 1986.

Forlati, F., 'Lavori a San Marco', *Arte Veneta*, IX, 1955, pp. 241–42.

Forlati, F., 'Lavori di adattamento della cappella ducale di San Marco . . . ', *Arte Veneta*, XVI, 1962, pp. 213–16.

———, 'Lavori a San Marco', *Arte Veneta*, XIX, 1965, pp. 197–98.

Fornaciai, G., *La Badia di Passignano*, Florence, 1903.

Forneron, H., *Les Ducs de Guise et leur époque*, Paris, 1877, 2 vols.

Forster, K., 'Metaphors of Rule . . . ', *Mitteilungen des Kunsthistorischen Institutes in Florenz*, XV, 1971, pp. 65–104.

Foscari, A., 'Schede veneziane su Jacopo Sansovino', *Notizie da Palazzo Albani*, X, 1981, pp. 22–34.

———, 'Il cantiere delle "Procuratie Vecchie" e Jacopo Sansovino', *Ricerche di storia dell'arte*, XIX, 1983, pp. 61–76.

———, 'Appunti di lavoro su Jacopo Sansovino', *Notizie da Palazzo Albani*, XIII, no. 2, 1984, pp. 35–56.

———, 'Sebastiano da Lugano, i Grimani e Jacopo Sansovino: artisti e committenti nella chiesa di Sant'Antonio di Castello', *Arte Veneta*, XXXVI, 1982, pp. 100–23.

———, *L'armonia e i conflitti: la chiesa di San Franceso della Vigna nella Venezia del'500*, Turin, 1983.

——— and Tafuri, M., 'Un progetto del Sansovino per il palazzo di Vettor Grimani a S. Samuel', *Ricerche di storia dell'arte*, XV, 1981, pp. 69–82.

Foscarini, M., *Della letteratura veneziana*, Venice, 1854.

Fradeletto, A., ed., *Il campanile di San Marco riedificato*, Venice, 1912.

Fraenckel, I., *Andrea del Sarto: Gemälde und Zeichnungen*, Strasbourg, 1935.

Franzoi, U., and di Stefano, D., *Le chiese di Venezia*, Venice, 1976, 2 vols.

Fraschetti, S., *Il Bernini*, Milan, 1900.

Fraser Jenkins, A., 'Cosimo de' Medici's Patronage of Architecture and the Theory of Magnificence', *Journal of the Warburg and Courtauld Institutes*, XXXIII, 1970, pp. 162–70.

Freedberg, S. J., *Painting of the High Renaissance in Rome and Florence*, Cambridge, 1961, 2 vols.

———, *Andrea del Sarto*, Cambridge, Mass., 1963, 2 vols.

Frey, K., *Sammlung ausgewählter Briefe an Michelagniolo Buonarroti*, Berlin, 1899.

———, *Der literarische Nachlass Giorgio Vasaris*, Munich, 1923–30, 2 vols.

Friedmann, H., *The Symbolic Goldfinch*, Washington, D.C., 1946.

Frizzoni, G., ed., *Notizia d'opere di disegno pubblicata e illustrate da D. Jacopo Morelli*, Bologna, 1884.

———, 'Ein bisher nicht bekanntes Werk Lorenzo Lottos', *Jahrbuch der Kunstsammlungen des allerhöchsten Kaiserhauses*, XXX, 1911–12, pp. 49–57.

Frommel, C. L., *Baldassare Peruzzi als Maler und Zeichner*, Rome, 1967–68.

———, *Der römische Palastbau der Hochrenaissance*, Tübingen, 1973, 3 vols.

———, et al., *Raffaello architetto*, Milan, 1984.

——— and Winner, M., 'Raphael und Antonio da Sangallo der Jüngere', *Raffaello a Roma: il convegno del 1983*, Rome, 1986, pp. 261–304.

Fulin, R., 'Girolamo Priuli e i suoi diari', *Archivio Veneto*, XXII–1, 1881, pp. 137–54.

Furtwängler, A., 'Der Satyr aus Pergamon . . . ', *Kleine Schriften*, ed. J. Sieveking et al., Munich, 1912–13, Vol. I, pp. 190–212.

Gabelentz, H. von der, *Fra Bartolommeo und die florentiner Renaissance*, Leipzig, 1922, 2 vols.

Gaddi, J., *Trattato istorico della famiglia di Gaddi*, Padua, 1642.

Gaeta, F., 'Alcune considerazioni sul mito di Venezia', *Bibliothèque d'Humanisme et Renaissance*, XXIII, 1961, pp. 58–75.

Gallicciolli, G., *Delle memorie venete antiche profane ed ecclesiastiche . . . *, Venice, 1795, 8 vols.

Gallo, D., *Jacopo Sansovino: il Bacco e la sua fortuna* (exh. cat., Museo Nazionale del Bargello), Florence, 1984.

Gallo, R., 'Il tesoro di San Marco: gli arazzi', *Rivista mensile della Città di Venezia*, V, 1926, pp. 9–82.

———, 'Le donazioni alla Serenissima di Domenico e Giovanni Grimani', *Archivio Veneto*, ser. 5, L–LI, 1952, pp. 34–77.

———, 'Contributi su Jacopo Sansovino', *Saggi e memorie di storia dell'arte*, I, 1957, pp. 83–105.

———, *Il tesoro di San Marco e la sua storia*, Venice and Rome, 1967.

Gamba, C., *Il Museo Horne a Firenze*, Florence, 1961.

Gardani, D. L., *La chiesa di S. Maria della Presentazione (delle Zitelle) in Venezia*, Venice, 1961.

Gardin, A., 'Il testamento di Jacopo Sansovino', *Arte e Storia*, III, 1884, pp. 323–25.

Garrard, M., 'The Early Sculpture of Jacopo Sansovino: Florence and Rome', Ph.D., Johns Hopkins University, 1970.

———, 'Jacopo Sansovino's Madonna in Sant'Agostino: An Antique Source Rediscovered', *Journal of the Warburg and Courtauld Institutes*, XXXVIII, 1975, pp. 333–38.

Gauricus, P., *De sculptura (1504)*, ed. A. Chastel and R. Klein, Geneva, 1969.

Gaye, G., *Carteggio inedito d'artisti . . . *, Florence, 1839–40, 3 vols.

Gazzola, P., ed., *Michele Sanmicheli* (exh. cat.), Venice, 1960.

Gentili, T., *Le vite . . . di Giorgio Vasari*, Livorno and Florence, 1767–72, 7 vols.

Gentilini, G., *Andrea della Robbia: I. Madonne* (Lo specchio del Bargello), Florence, 1983.

———, *Andrea e Giovanni Della Robbia: nuove sale* (Lo specchio del Bargello), Florence, 1984.

——— and Morandotti, A., 'The Sculptures of the Nymphaeum at Lainate: The Origins of the Mellon *Venus* and *Bacchus*', *Studies in the History of Art*, XXIV, 1990, pp. 135–71.

——— and Sisi, C., *Collezione Chigi Saracini: la scultura, bozzetti in terracotta, piccoli marmi . . . dal XIV al XX secolo*, Siena, 1989, 2 vols.

Gianneschi, M., and Sodini, C., 'Urbanistica e politica durante il principato di Alessandro de' Medici, 1532–37', *Storia della città*, X, 1979, pp. 5–34.

Gigli, L., *San Marcello al Corso* (Le chiese di Roma illustrate, no. 131), Rome, 1977.

Gilbert, C., 'Some Findings on Early Works of Titian', *Art Bulletin*, LXII, 1980, pp. 36–75.

Gilbert, F., 'Venice in the Crisis of the League of Cambrai', in *Renaissance Venice*, ed. J. R. Hale, London, 1973, pp. 274–92.

Gilmore, M. P., 'Myth and Reality in Venetian Political Theory', in *Renaissance Venice*, ed. J. R. Hale, London, 1973, pp. 431–44.

Ginori Conti, P., *L'apparato per le nozze di Francesco de' Medici e di Giovanna d'Austria*, Florence, 1936.

Ginori Lisci, L., *Gualfonda: un antico palazzo ed un giardino scomparso*, Florence, 1953.

———, *I palazzi di Firenze . . . *, Florence, 1972, 2 vols.

Giovannoni, G., 'Un' opera sconosciuta di Jacopo Sansovino in Roma', *Bollettino d'arte*, XI, 1917, pp. 64–81.

Giovannoni, G. *Antonio San Gallo il Giovane*, Rome, 1959, 2 vols.

Giraldus, L., *De sepulchris et vario sepeliendi ritu, libellus*, Basel, 1539.

Girolami, C., 'In Margine ad una monografia su Andrea Sansovino', *Atti e memorie della Reale Accademia Petrarca di lettere, arti e scienze*, n. s., XXX–XXXI, 1941, pp. 107–18.

Giuriato, G., 'Memorie venete nei monumenti di Roma', *Archivio Veneto*, XXVII, 1884, pp. 106–30.

Glasser, H., *Artists' Contracts of the Early Renaissance* (Outstanding Dissertations in the Fine Arts), New York and London, 1977.

Gnoli, R., *Marmora romana*, Rome, 1971.

Goffen, R., 'Icon and Vision: Giovanni Bellini's Half-Length Madonnas', *Art Bulletin*, LVII, 1975, pp. 487–518.

———, 'Nostra Conversatio in Coelis Est: Observations on the Sacra Conversazione', *Art Bulletin*, LXI, 1979, pp. 198–222.

Goldschmidt, F., *Königliche Museen zu Berlin: II. Die italienischen Bronzen der Renaissance und des Barock*, Berlin, 1914.

Goldthwaite, R. A., *The Building of Renaissance Florence...*, Baltimore, 1980.

Goloubew, V., *Les Dessins de Jacopo Bellini au Louvre et au British Museum*, Brussels, 1908–09, 2 vols.

Golzio, V., *Raffaello nei documenti...*, Vatican City, 1936.

Gombrich, E.H., 'The Aims and Limits of Iconology', in *Symbolic Images*, London, 1972, pp. 1–25.

———, 'The Leaven of Criticism in Renaissance Art: Texts and Episodes', in *The Heritage of Apelles*, Oxford, 1976, pp. 111–31.

Gonzati, B., *La Basilica di S. Antonio in Padova*, Padua, 1852–53, 2 vols.

Gorini, G., Review of Weddigen (1974), *Medaglia*, VI, no. 11, 1976, p. 70.

Gorri, A. F., *Museum Florentinum*, Florence, 1731–62, 10 vols.

Gottschewski, A., and Gronau, G., *Die Lebenbeschreibungen ... des Giorgio Vasari*, Strasbourg, 1906–27, 7 vols.

Gould, C., 'Leonardo's "Neptune" Drawing', *Burlington Magazine*, XCIV, 1952, pp. 289–94.

Grabar, A., *Christian Iconography: A Study of its Origins*, Princeton, 1968.

Gradmann, E., *Bildhauer-Zeichnungen*, Basel, 1943.

Grayson, C., ed., *Leon Battista Alberti: On Painting and On Sculpture*, London, 1972.

Grendler, P., *Critics and the Italian World, 1530–1560...*, London, 1969.

Gronau, G., 'Literaturbericht: U. Scoti-Bertinelli, Giorgio Vasari, scrittore', *Repertorium für Kunstwissenschaft*, XXIX, 1906, pp. 173–82.

Grossato, L., *Il Museo Civico di Padova*, Venice, 1957.

Gsell-Fels, T., *Rom und Mittel-Italien: II, Rom*, Hildburghausen, 1872.

Gualdo, G., *1650: il giardino di Chà Gualdo*, ed. L. Puppi, Florence, 1972.

Guida, W., 'The Samuel H. Kress Collection', *Philadelphia Museum Bulletin*, XLVI, no. 227, 1950, pp. 5–22.

Guisconi, A. (=Francesco Sansovino?), *Tutte le cose notabili et belle che sono in Vinetia*, Venice, 1556.

Günther, H., 'Werke Bramantes im Spiegel einer Gruppe von Zeichnungen der Uffizien in Florenz', *Münchner Jahrbuch der bildenden Kunst*, 3rd ser., XXXIII, 1982, pp. 77–108.

———, *Das Studium der antiken Architektur in den Zeichnungen der Hochrenaissance*, Tübingen, 1988.

Gurrieri, F., 'La fortezza rinascimentale di S. Barbara a Pistoia: una conferma per Nanni Unghero', *Bollettino d'arte*, LXI, 1976, pp. 12–20.

Hadeln, D. v., 'Beiträge zur Tintorettoforschung', *Jahrbuch der Königlichen Preussischen Kunstsammlungen*, XXXII, 1911, pp. 25–58 (=1911-I).

———, 'Beitrage zur Geschichte des Dogenpalastes', *Jahrbuch der Königlichen Preussischen Kunstsammlungen*, XXXII, 1911, Beiheft, pp. 1–33 (=1911-II).

Hahnloser, H., ed., *Il tesoro di San Marco*, Florence, 1971.

Hale, J. R., *Florence and the Medici: The Pattern of Control*, London, 1977.

Hamburgh, H. E., 'Aspects of the Descent from the Cross from Lippi to Cigoli', Ph.D., Univ. of Iowa, 1978, 2 vols.

Harth, J., 'Zu Andrea del Sartos "Opfer Abrahams"', *Mitteilungen des Kunsthistorischen Institutes in Florenz*, VIII, 1959, pp. 167–73.

Hartt, F., Giulio Romano, New Haven, 1958, 2 vols.

———, *History of Italian Renaissance Art*, London, 1969.

———, 'Thoughts on the Statue and the Niche', in *Art Studies for an Editor: 25 Essays in Memory of M. S. Fox*, New York, 1975, pp. 99–106.

Haskell, F., *Patrons and Painters...*, New Haven and London, 1980 (rev. ed.).

——— and Penny, N., *Taste and the Antique: The Lure of Classical Sculpture, 1500–1900*, New Haven and London, 1981.

Heikamp, D., 'Rapporti fra accademici ed artisti nella Firenze del'500', *Il Vasari*, n. s., I, XV, 1957, pp. 139–63.

———, 'Ein Madonnenrelief von Francesco da Sangallo', *Berliner Museen: Berichte...*, n. s., VIII, no. 2, 1958, pp. 34–40.

———, 'Die Bildwerke des Clemente Bandinelli', *Mitteilungen des Kunsthistorischen Institutes in Florenz*, IX, 1960, pp. 130–36.

Helbig, W., *Führer durch die öffentlichen Sammlungen klassischer Altertümer in Rom*, Tübingen, 1963–72, 4 vols.

Helbing, H. (auction house), *Sammlung... Max von Heyl...*, Munich, 1930, 2 vols.

Henkel, A., and Schöne, A., *Emblemata: Handbuch zur Sinnbildkunst des XVI. und XVII. Jahrhunderts*, Stuttgart, 1967.

Hetzer, T., 'Vom Plastischen in der Malerei', *Aufsätze und Vorträge*, Leipzig, 1957, Vol. II, pp. 131–69.

Heydenreich, L. H., and Lotz, W., *Architecture in Italy, 1400–1600*, Harmondsworth, 1974.

Hibbard, H., *Michelangelo*, London, 1975.

Hiesinger, K., 'The Fregoso Monument: A Study in Sixteenth Century Tomb Monuments and Catholic Reform', *Burlington Magazine*, CXVIII, 1976, pp. 283–93.

Hill, G. F., 'Eight Italian Medals', *Burlington Magazine*, XIV, 1908–09, pp. 214–16.

———, 'Notes on Italian Medals—XVII', *Burlington Magazine*, XXV, 1914, pp. 335–41.

———, *A Corpus of Italian Medals of the Renaissance before Cellini*, London, 1930.

———, *A History of Cyprus*, Cambridge, 1948, 4 vols.

——— and Pollard, G., *Renaissance Medals from the Samuel H. Kress Collection...*, London, 1967.

Hirst, M., 'Baccio Bandinelli', in *DBI*, V, 1963, pp. 688–92.

———, 'Salviati's Two Apostles in the Oratorio of S. Giovanni Decollato', *Studies in Renaissance and Baroque Art presented to Anthony Blunt*, London, 1967, pp. 34–36.

———, 'Michelangelo the Sculptor by M. Weinberger', *Burlington Magazine*, CXI, 1969, pp. 762–64.

———, 'Addenda Sansoviniana', *Burlington Magazine*, CXIV, 1972, pp. 162–65.

Hirst, M., 'A Drawing of the Rape of Ganymede by Michelangelo', *Essays presented to Myron P. Gilmore*, ed. S. Bertelli, et al., Florence, 1978, II, pp. 253–60.

———, 'Michelangelo in Rome: An Altar-Piece and the "Bacchus"', *Burlington Magazine*, CXXIII, 1981, pp. 581–93 (=1981-I).

———, *Sebastiano del Piombo*, Oxford, 1981 (=1981-II).

———, 'A Note on Michelangelo and the San Lorenzo Façade', *Art Bulletin*, LXVIII, 1986, pp. 323–26.

Hirthe, T., 'Die Libreria des Jacopo Sansovino: Studien zu Architektur und Ausstattung eines öffentlichen Gebäudes in Vendig', *Münchner Jahrbuch der bildenden Kunst*, 3rd ser., XXXVII, 1986, pp. 131–76 (=1986-I).

———, 'Il "foro all'antica" di Venezia: la transformazione di Piazza San Marco nel Cinquecento', *Centro Tedesco di Studi Veneziani: Quaderni*, no. 35, 1986 (=1986-II).

Holderbaum, J., 'Notes on Tribolo', *Burlington Magazine*, XCIX, 1957, pp. 336–43, 364–72.

———, 'The Birth Date and a Destroyed Early Work of Baccio Bandinelli', *Essays . . . presented to Rudolf Wittkower*, London, 1967, pp. 93–97.

———, *The Sculptor Giovanni Bologna* (Outstanding Dissertations in the Fine Arts), New York and London, 1983.

Honour, H., 'Canova's Studio Practice . . .', *Burlington Magazine*, CXIV, 1972, pp. 146–59, 214–29.

Hook, J., *The Sack of Rome*, London, 1972.

Hope, C., *Titian*, London, 1980.

Horster, M., 'Antike Vorstufen zum florentiner Renaissance-Bacchus', *Festschrift Ulrich Middeldorf*, Berlin, 1968, Vol. I, pp. 218–24.

Howard, D., 'Studies in Jacopo Sansovino's Venetian Architecture', Ph.D., Univ. of London, 1972.

———, *Jacopo Sansovino: Architecture and Patronage in Renaissance Venice*, New Haven and London, 1975.

———, 'Le chiese di Jacopo Sansovino a Venezia', *Bollettino del Centro internazionale di studi di architettura Andrea Palladio*, XIX, 1977, pp. 49–67.

———, 'Jacopo Sansovino's House at San Trovaso', *Interpretazioni veneziane*, ed. D. Rosand, Venice, 1984, pp. 241–55.

Hubala, E., 'Venedig', *Reclams Kunstführer, Oberitalien Ost*, ed. E. Egg, et al., Stuttgart, 1965, pp. 606–1006.

Hübner, P., *Le statue di Roma*, Leipzig, 1912.

Hülsen, C., *Das Septizonium des Septimius Severus*, Berlin, 1886.

——— and Egger, H., *Die römischen Skizzenbücher von Martin van Heemskerck*, Berlin, 1913–16, 2 vols.

Humboldt, W. v., 'Über die männliche und weibliche Form', *Werke*, Darmstadt, 1960–81, I, pp. 296–336.

Huntley, G. H., *Andrea Sansovino*, Cambridge, Mass., 1935.

Hurtubise, P., *Une Famille—Temoin: Les Salviati*, Vatican City, 1985.

Huse, N., and Wolters, W., *Venedig: die Kunst der Renaissance*, Munich, 1986.

Ildefonso di San Luigi, *Delizie degi eruditi toscani*, Florence, 1750–86, 25 vols.

Italian Bronze Statuettes (exh. cat., Victoria and Albert Museum), London, 1961.

Ivanoff, N., 'Il ciclo allegorico della Libreria Sansoviniana', *Arte antica e moderna*, XIII–XVI, 1961, pp. 248–58.

———, 'La Scala d'oro del Palazzo Ducale di Venezia', *Critica d'arte*, VII, 1961, fasc. 47, pp. 27–41.

———, 'Il mito di Prometeo nell'arte veneziana del Cinquecento', *Emporium*, LXIX, no. 2, 1963, pp. 51–58.

Ivanoff, N., 'Il coronamento statuario della Marciana', *Ateneo Veneto*, n.s., II, 1964, pp. 403–09.

———, 'La Libreria Marciana: Arte e iconologia', *Saggi e memorie di storia dell'arte*, VI, 1968, pp. 35–78.

Jacopo da Bergamo, *Supplementum chronicarum*, Venice, 1485.

s'Jakob, H., *Idealism and Realism: A Study in Sepulchral Symbolism*, Leiden, 1954.

Jameson, A., *Legends of the Madonna*, London, 1891.

Janson, H. W., *The Sculpture of Donatello*, Princeton, 1963.

Jestaz, B., 'Requiem pour Alessandro Leopardi', *Revue de l'art*, LV, 1982, pp. 23–34.

———, *La Chapelle Zen à Saint-Marc de Venise*, Stuttgart, 1986.

Jones, H. S., ed., *A Catalogue of the Ancient Sculptures preserved in the Municipal Collections of Rome: The Sculptures of the Museo Capitolino*, Oxford, 1912, 2 vols.

———, *A Catalogue of the Ancient Sculptures preserved in the Municipal Collections of Rome: The Sculptures of the Palazzo dei Conservatori*, Oxford, 1926, 2 vols.

Jones, M., *The Art of the Medal*, London, 1979.

Jones, R., and Penny, N., *Raphael*, New Haven and London, 1983.

Joost-Gaugier, C. L., 'Jacopo Bellini's Interest in Perspective and its Iconographical Significance', *Zeitschrift für Kunstgeschichte*, XXXVIII, 1975, pp. 1–28.

Jungmann, J., *The Mass of the Roman Rite . . .*, New York, 1955, 2 vols.

Justi, C., *Michelangelo . . .*, Leipzig, 1900.

Kaufmann, H., *Donatello*, Berlin, 1936 (2nd ed.).

Kecks, R. G., *Madonna und Kind: das häusliche Andachtsbild im Florenz des 15. Jahrhunderts*, Berlin, 1988.

Keith, W. G., 'A Bust attributed to Alessandro Vittoria', *Bulletin of the Rhode Island School of Design*, XII, no. 3, 1955, pp. 2–6.

Kemp. M., *Leonardo da Vinci: The Marvellous Works of Nature and Man*, London, 1981.

Keutner, H., 'Über die Entstehung und die Formen des Standbildes im Cinquecento', *Münchner Jahrbuch der bildenden Kunst*, 3rd ser., VII, 1956, pp. 138–68.

———, 'Andrea Sansovino e Vincenzo Danti: Il gruppo del Battesimo di Cristo sopra la Porta del Paradiso', *Scritti di storia dell'arte in onore di Ugo Procacci*, Florence, 1977, pp. 370–80.

Kinney, P., *The Early Sculpture of Bartolomeo Ammanati* (Outstanding Dissertations in the Fine Arts), New York and London, 1976.

Klapisch-Zuber, C., *Les Maîtres du marbre: Carrare, 1300–1600*, Paris, 1969.

Knecht, R. J., *Francis I*, Cambridge, 1982.

Koch, C., et al., *Hans Baldung Grien* (exh. cat.), Karlsruhe, 1959.

Kolb, C., 'Portfolio for the Villa Priuli . . .', *Bollettino del Centro internazionale di studi di architettura Andrea Palladio*, XII, 1969, pp. 353–69.

Krahn, V., et al., *Italienische Renaissancekunst im Kaiser Wilhelm Museum*, Krefeld, 1987.

Krautheimer, R., *Lorenzo Ghiberti*, Princeton, 1970, 2 vols.

Kriegbaum, F., 'Ein verschollenes Brunnenwerk des Bartolomeo Ammannati', *Mitteilungen des Kunsthistorischen Institutes in Florenz*, III, 1929, pp. 71–103.

Kunsthistorisches Museum, Wien: Katalog der Gemäldegalerie, I. Teil, Italiener, Spanier, Franzosen, Engländer, Vienna, 1960.

Kurz, O., 'Giorgio Vasari's "Libro de' Disegni"', *Old Master Drawings*, XII, 1937, pp. 1–15, 32–44.

Labowsky, L., *Die Ethik des Panaitios: Untersuchung zur Geschichte des Decorum bei Cicero und Horaz*, Leipzig, 1934.

Landucci, L., *Diario fiorentino* . . . , ed. I. del Badia, Florence, 1883.

Lane, F. C., *Navires et constructeurs à Venise pendant la Renaissance*, Paris, 1965.

———, *Venice, a Maritime Republic*, Baltimore, Md., 1973.

Lányi, J., 'Quercia Studien', *Jahrbuch für Kunstwissenschaft*, VII, 1930.

Lapini, A., *Diario fiorentino*, ed. G. O. Gorazzini, Florence, 1900.

Laskin, M., 'Franciabigio's Altar-piece of St Nicholas of Tolentino in Santo Spirito . . .', in *Festschrift Ulrich Middeldorf*, ed. A. Kosegarten and P. Tigler, Berlin, 1968, pp. 276–78.

Lassareff, V., 'Studies in the Iconography of the Virgin', *Art Bulletin*, XX, 1938, pp. 26–65.

Lauts, J., *Carpaccio*, London, 1962.

Lavin, I., 'The Sources of Donatello's Pulpits in San Lorenzo . . .', *Art Bulletin*, XLI, 1959, pp. 19–38.

———, 'Bozzetti and Modelli . . .', *Stil und Überlieferung im Kunst des Abendlandes*, Berlin, 1967, III, pp. 93–104.

———, 'The Sculptor's "Last Will and Testament"', *Allen Memorial Art Museum Bulletin*, XXXV, 1977–78, pp. 4–39.

Lavin, M., 'Giovannino Battista: A Study in Renaissance Religious Symbolism', *Art Bulletin*, XXXVII, 1955, pp. 85–101.

Lehner, M.-E., 'Die Entwicklung des Reliefstils in Florenz nach den Jungendwerken des Michelangelo', Ph.D., Ludwig-Maximilian Univ., Munich, 1969.

Leithe-Jasper, M., 'Alessandro Vittoria: Beiträge zu einer Analyse des Stils seiner figürlichen Plastiken . . .', Ph.D., Univ. of Vienna, 1963.

———, 'Beiträge zum Werk des Agostino Zoppo', *Jahrbuch des Stiftes Klosterneuburg*, IX, 1975, pp. 109–38.

———, *Renaissance Master Bronzes from the Collection of the Kunsthistorisches Museum Vienna* (exh. cat.), Washington, D.C., 1986.

Lepke, R., *Nachlass Adolf von Beckerath* (sale cat.), Berlin, 1916.

Levi, G., and Venturi, A., 'Il libro dei conti di Lorenzo Lotto', *Gallerie Nazionali Italiane*, I, 1895, pp. 115–224.

Lewis, C. K., *The Villa Giustinian at Roncade* (Outstanding Dissertations in the Fine Arts), New York and London, 1977.

Lewis, D., 'Un Disegno autografo del Sanmicheli e la notizia del committente del Sansovino per S. Francesco della Vigna', *Bollettino dei Musei Civici Veneziani*, XVII, nos. 3–4, 1972, pp. 7–36.

———, 'Sansovino and Venetian Architecture', *Burlington Magazine*, CXXI, 1979, pp. 38–41.

———, 'Patterns of Preference: Patronage of Sixteenth-Century Architects by the Venetian Patriciate', in *Patronage in the Renaissance*, ed. G. F. Lytle, et al., Princeton, 1981, pp. 354–80.

———, 'Jacopo Sansovino, Sculptor of Venice', in *Titian: His World and his Legacy*, ed. D. Rosand, New York, 1982, pp. 133–90.

———, 'The Sculptures in the Chapel of the Villa Giustinian at Roncade . . .', *Mitteilungen des Kunsthistorischen Institutes in Florenz*, XXVII, 1983, pp. 307–52.

Lieberman, R., *Renaissance Architecture in Venice, 1450–1540*, New York, 1982.

Lightbown, R., *Sandro Botticelli*, London, 1978, 2 vols.

Liphart, E. de, 'Deux maquettes en bronze de la Renaissance Italienne', *Gazette des beaux-arts*, 5th ser., LXIV, 1922, pp. 339–47.

Liruti, G. G., *Notizie delle vite ed opere scritte da letterati del Friuli*, Venice, 1760–80, 4 vols.

Lisner, M., 'Ein florentiner Holzkruzifix des frühen Manierismus: Ein Werk des Jacopo Sansovino (?)', *Mitteilungen des Kunsthistorischen Institutes in Florenz*, IX, 1959–60, pp. 13–24.

———, 'Eine unbekannte Terrakottamadonna des frühen Cinquecento: Ein Jungendwerk des Jacopo Sansovino?', *Pantheon*, XX, 1962, pp. 97–104.

———, *Holzkruzifixe in Florenz und in der Toskana*, Munich, 1970.

Litta, P., *Famiglie celebri italiane*, Milan and Turin, 1819–99, 11 vols.

Lomazzo, G. P., *Scritti sull'arte*, ed. R. P. Ciardi, Florence, 1973–74, 2 vols.

Lonigo, G., *Sul patronato del Doge di Venezia sulla chiesa di San Marco* . . . , Venice, 1865.

Lorenzetti, G., 'Di alcuni basso-rilievi attribuiti a Jacopo Sansovino', *L'arte*, XII, 1909, pp. 288–301.

———, '"Jacop Sansovino scultore," note ed appunti', *Nuovo Archivio Veneto*, XX, 1910, pp. 314–40 (=1910-I).

———, 'La Loggetta al campanile di San Marco', *L'arte*, XII, 1910, pp. 108–33 (=1910-II).

———, ed., *Vita di Jacopo Tatti detto il Sansovino di Giorgio Vasari*, Florence, 1913.

———, *Venezia e il suo estuario*, Venice, 1926 (?).

———, *Itinerario sansoviniano a Venezia*, Venice, 1929.

———, 'La Libreria sansoviniana di Venezia', *Accademie e Biblioteche d'Italia*, II, 1928–29, fasc. vi, pp. 78–98; III, 1929–30, fasc. i, pp. 22–36.

———, *Venezia e il suo estuario*, Venice, 1956 (2nd ed.).

——— and Planiscig, L., *La collezione dei conti Donà dalle Rose a Venezia*, Venice, 1934.

Lorenzi, G. B., *Documenti per servire alla storia del Palazzo Ducale di Venezia*, Venice, 1868.

Lorenzoni, G., 'Dopo Donatello: da Bartolomeo Bellano ad Andrea Riccio', *Le Sculture del Santo di Padova*, Vicenza, 1984, pp. 95–107.

Lotz, W., 'The Roman Legacy in Sansovino's Venetian Buildings', *Journal of the Society of Architectural Historians*, XXII, 1963, pp. 3–12.

———, 'Zu Michelangelos Christus in S. Maria sopra Minerva', *Festschrift für Herbert von Einem*, ed. G. von der Osten and G. Kauffmann, Berlin, 1965, pp. 143–50.

———, 'La Trasformazione sansoviniana di Piazza San Marco e l'urbanistica del Cinquecento', *Bollettino del Centro internazionale di studi di architettura Andrea Palladio*, VIII–2, 1966, pp. 114–22.

———, 'Italienische Plätze des 16. Jahrhunderts', *Jahrbuch der Max-Planck-Gesellschaft* . . . , 1968, pp. 41–60.

Ludwig, G., *Archivalische Beiträge zur Geschichte der venezianischen Kunst* . . . (*Italienische Forschungen, hrsg. vom Kunsthistorischen Institut Florenz IV*), Berlin, 1911.

Luporini, E., *Benedetto da Rovezzano: scultura e decorazione a Firenze tra il 1490 e il 1520*, Milan, 1964.

Luzio, A., *Pietro Aretino nei primi suoi anni a Venezia e la corte dei Gonzaga*, Turin, 1888.

———, *Mantova e Urbino: Isabella d'Este ed Elisabetta Gonzaga nelle relazioni famigliari* . . . , Turin and Rome, 1893.

———, *La Galleria de' Gonzaga venduta all'Inghilterra nel 1627–28*, Milan, 1913.

——— and Renier, R., 'Di Pietro Lombardo architetto e scultore veneziano', *Archivio storico dell'arte*, I, 1888, pp. 433–38.

Luzzatto, G., *Storia economica di Venezia dell'XI al XVI secolo*, Venice, 1961.

McAndrew, J., *Venetian Architecture of the Early Renaissance*, Cambridge, Mass., and London, 1980.

McKillop, S. R., *Franciabigio*, Berkeley, 1974.

McMahon, A. P., ed., *Treatise on Painting . . . by Leonardo da Vinci*, Princeton, 1956, 2 vols.

McTavish, D., 'Speculations on Two Drawings attributed to Giorgio Vasari', *Bulletin: The National Gallery of Canada*, XXVIII, 1976, pp. 16–28.

———, 'A Drawing by Girolama Campagna for the High Altar of San Giorgio Maggiore', *Arte Veneta*, XXXIV, 1980, pp. 165–68.

———, *Giuseppe Porta called Giuseppe Salviati* (Outstanding Dissertations in the Fine Arts), New York and London, 1981.

Macchioni, S., and Gangeni, G., 'Danese Cattaneo', *DBI*, XXII, 1979, pp. 449–56.

La Madonna di Santo Agostino sotto l'aspetto della religione e del genio artistico, Rome, 1858.

Magagnato, L., *Palazzo Thiene*, Vicenza, 1966.

Malaguzzi Valeri, F., 'La chiesa della Madonna di Galliera in Bologna', *Archivio storico dell'arte*, VI, 1893, pp. 32–48.

Maltesi, C., *Francesco di Giorgio* (I maestri della scultura), Milan, 1966.

Malvasia, C. C., *Le pitture di Bologna*, Bologna, 1686.

Mancinelli, F., et al., *Raffaello in Vaticano* (exh. cat.), Milan, 1984.

Manfredi, F., *Degnità procuratoria di S. Marco di Venezia*, Venice, 1602.

Mann, J. G., *Wallace Collection Catalogues: Sculpture*, London, 1931 (2nd ed., 1981).

Mannini, M. P., ed., *Il Museo Civico di Prato: le collezioni d'arte*, Prato, 1990.

Mansuelli, G., *Gallerie degli Uffizi: le sculture*, Rome, 1958–61, 2 vols.

Manutio, P., *Tre libri di lettere volgari*, Venice, 1556.

Marabottini, A., 'I collaboratori', in *Raffaello: le opere, le fonti, la fortuna*, Novara, 1968, pp. 199–302.

Marchini, G., *Giuliano da Sangallo*, Florence, 1942.

———, 'Il ballatoio della cupola di Santa Maria del Fiore', *Antichità viva*, XVI, no. 6, 1977, pp. 36–48.

Mariacher, G., *Il Sansovino*, Milan, 1962.

———, *Bronzetti veneti del rinascimento*, Vicenza, 1971 (=1971-II).

———, ed., *Arte e Venezia* (exh. cat.), Venice, 1971.

———, et al., *S. Antonio, 1231–1981: il suo tempo, il suo culto e la sua citta* (exh. cat.), Padua, 1981.

Marini, P., and Magagnato, L., eds., *Palladio e Verona* (exh. cat.), Verona, 1980.

Marquand, A., *Andrea della Robbia and his Atelier*, Princeton, 1922, 2 vols.

Martini, A., *Manuale di metrologia*, Turin, 1883.

Martinioni, G., *Venetia città nobilissima et singolare, con aggiunte . . .*, Venice, 1663.

Martucci, A., 'La Porta del Paradiso: fortuna critica di Lorenzo Ghiberti nel '400 e '500', *Lorenzo Ghiberti: materia e raggionamenti* (exh. cat.), Florence, 1978, pp. 345–42.

Masini, A. P., *Bologna perlustrata*, Bologna, 1666 (3rd ed.).

Mason Rinaldi, S., 'Tre momenti documentati dell'attività di Palma il Giovane', *Arte Veneta*, XXIX, 1975, pp. 197–204.

———, *Palma il Giovane: l'opera completa*, Milan, 1984.

Matteoli, A., 'Sull'affresco perduto di Andrea del Sarto al tabernacolo di Porta Pinti', *Bollettino dell'Academia degli Euteleti*, XXXIII, 1970–71, pp. 154–63.

Matz, F., *Die Dionysischen Sarkophage*, Berlin, 1968–75, 4 vols.

Mayer, A. L., 'Two Pictures by Titian in the Escorial', *Burlington Magazine*, LXXI, 1937, pp. 178–83.

Medin, A., *La storia della Repubblica di Venezia nella poesia*, Milan, 1904.

Meiss, M., 'Sleep in Venice . . .', *Proceedings of the American Philosophical Society*, CX, no. 5, 1966, pp. 348–82.

Meller, P., 'Physiognomical Theory in Renaissance Heroic Portraits', *The Renaissance and Mannerism: Studies in Western Art* (Acts of the 20th International Congress of the History of Art), Princeton, 1963, pp. 53–69.

———, 'Tiziano e la scultura', *Tiziano nel quarto centenario della sua morte, 1576–1976*, ed. G. La Monaca, Venice, 1977, pp. 123–56.

———, 'Marmi e bronzi di Simone Bianco', *Mitteilungen des Kunsthistorischen Institutes in Florenz*, XXI, 1977, pp. 199–210.

Mellini, G. L., *Altichiero e Jacopo Avanzi*, Milan, 1965.

Mendelsohn, L., *Paragoni: Benedetto Varchi's Due Lezzioni and Cinquecento Art Theory*, Ann Arbor, 1982.

Meneghin, V., *San Michele in Isola*, Venice, 1962, 2 vols.

Meneghini, M., 'Un bassorilievo della "Loggetta del Sansovino" ritornato a Venezia', *Bollettino d'arte*, XXVIII, ser. iii, 1934, p. 467.

Mercklin, E. V., *Antike Figuralkapitelle*, Berlin, 1962.

Metz, P. *Bildwerke der christlichen Epochen von der Spätantike bis zum Klassizismus aus den Beständen der Skulpturenabteilung . . . Berlin-Dahlem*, Munich, 1966.

———, et al., *Europäische Bildwerke . . . aus den Beständen der Skulpturenabteilung der Ehem. Staatlichen Museen Berlin-Dahlem* (exh. cat., Villa Hugel, Essen), Munich, 1957.

Meyer, A. G., 'Das venezianische Wandgrabmal der Frührenaissance', Ph.D., Berlin, 1889.

Meyer zur Capellen, J., 'Beobachtungen zu Jacopo Pesaros Exvoto in Antwerpen', *Pantheon*, XXXVIII, 1980, pp. 144–52.

Michel, A., 'Les Acquisitions du Département de la Sculpture . . . au Musée du Louvre', *Gazette des beaux-arts*, per. 3, LXII, 1903, pp. 369–90.

Middeldorf, U., 'Giovanni Bandini detto Giovanni dell'Opera', *Rivista d'arte*, XI, 1929, pp. 481–518.

———, 'Unknown Drawings by the Two Sansovinos', *Burlington Magazine*, LX, 1932, pp. 236–45.

———, 'Sull' attività della bottega di Jacopo Sansovino', *Rivista d'arte*, XVIII, 1936, pp. 245–63. (=1936-I).

———, 'Donatello by H. Kauffmann', *Art Bulletin*, XVIII, 1936, pp. 570–85 (=1936-II).

———, 'Frieda Schottmüller: *Bildwerke . . .*', *Rivista d'arte*, XX, 1938, pp. 94–104.

———, 'A Florentine Madonna Relief', *Register of the Museum of Art of the University of Kansas*, V, 1955, pp. 4–7.

———, *Sculptures from the Samuel H. Kress Collection: European Schools, XIV–XIX Century*, London, 1976.

———, 'Some Florentine Painted Madonna Reliefs', in *Collaboration in Italian Renaissance Art*, ed. J. T. Paoletti and W. S. Sheard, New Haven and London, 1978, pp. 77–84.

———, 'In the Wake of Guglielmo della Porta', *Connoisseur*, CXIVC, 1977, pp. 75–84.

Mirollo, J. V., *Mannerism and Renaissance Poetry: Concept, Mode, Inner Design*, New Haven and London, 1984.

Mitchell, M., 'Works of Art from Rome for Henry VIII: A Study in Anglo-Papal Relations . . .', *Journal of the Warburg and Courtauld Institutes*, XXXIV, 1971, pp. 178–203.

Molmenti, P., 'Giuspatronato del doge', *Studi e ricerche di storia d'arte*, Turin and Rome, 1892, pp. 39–56.

———, 'I procuratori di San Marco', *Studi e ricerche di storia d'arte*, Turin and Rome, 1892, pp. 57–81.

———, *Storia di Venezia nella vita privata*, Bergamo, 1905–08, 3 vols.

Monbeig-Goguel, C., 'Francesco Salviati e il tema della resurrezione di Cristo', *Prospettiva*, XIII, 1978, pp. 7–23.

Monk, S. H., 'A Grace beyond the Reach of Art', *Journal of the History of Ideas*, V, 1944, pp. 131–50.

Montagu, J., *Roman Baroque Sculpture: The Industry of Art*, New Haven and London, 1989.

Morandotti, A., 'Nuove Tracce per il tardo rinascimento italiano: Il Ninfeo-Museo della Villa Borromeo . . .', *Annali della Scuola Normale Superiore di Pisa*, XV, 1985, pp. 129–85.

Morelli, J., *Vita di M. Iacopo Sansovino scultore e architetto della Repubblica di Venezia . . . seconda edizione*, Venice, 1789.

———, *Notizie d'opere di disegno*, ed. G. Frizzoni, Bologna, 1884.

Moreni, D., *Bibliografia storico-ragionata della Toscana*, Florence, 1805, 2 vols.

Morgagni, G. B., *Opusculorum Miscellaneorum, pars altera*, Naples, 1763.

Morselli, P., 'Corpus of Tuscan Pulpits, 1400–1550', Ph.D., Univ. of Pittsburgh, 1979.

Moschini, G. A., *Guida per la città di Venezia . . .*, Venice, 1815, 2 vols.

———, *Guida per la città di Padova*, Venice, 1817.

Moschini, V., *La R. Galleria Giorgio Franchetti alla Cà d'Oro, guida-catalogo*, Venice, 1929.

Moschini Marconi, S., *Gallerie dell'Accademia di Venezia: opere d'arte dei secoli XIV e XV*, Rome, 1955.

———, *Gallerie dell'Accademia di Venezia: opere d'arte del secolo XVI*, Rome, 1962.

Mösender, K., 'Die Brunnen des G. A. Montorsoli', Ph.D., Univ. of Salzburg, 1974.

Mostra dell'antica arte senese (exh. cat.), Siena, 1904.

Mothes, O., *Geschichte der Baukunst und Bildhauerei Venedigs*, Leipzig, 1859–60, 2 vols.

de la Moureyre-Gavoty, F., *Sculpture Italienne, Musée Jacquemart-André*, Paris, 1975.

Mueller, R. C., 'The Procurators of San Marco in the Thirteenth and Fourteenth Centuries . . .', *Studi Veneziani*, XIII, 1971, pp. 105–220.

Müntz, E., *Les Collections de Cosme I er de Medicis (1574)*, Paris, 1895.

Muir, E., *Civic Ritual in Renaissance Venice*, Princeton, 1981.

Munman, R., 'The Monument to Vittore Cappello of Antonio Rizzo', *Burlington Magazine*, CXIII, 1971, pp. 138–45.

Munoz Gasparini, L., *S. Marcello al Corso* (Le chiese di Roma illustrate, no. 161), Rome, 1925.

Muraro, M., 'La Scala senza giganti', in *De Artibus Opuscula XL: Essays in Honor of Erwin Panofsky*, ed. M. Meiss, New York, 1961, I, pp. 350–70.

Musée Jacquemart-André: Catalogue itineraire, Paris, 1933.

Nava, A., 'La storia della chiesa di S. Giovanni dei Fiorentini nei documenti del suo archivio', *Archivio della R. Deputazione romana di storia patria*, n.s., LIX, 1936, pp. 337–62.

de Nicola, G., 'Notes on the Museo Nazionale of Florence—II', *Burlington Magazine*, XXIX, 1916, pp. 363–73.

Nobis, N. W., 'Lorenzetto als Bildhauer', Ph.D., Univ. of Bonn, 1979.

Norton, P. F., 'The Lost Sleeping Cupid of Michelangelo', *Art Bulletin*, XXXIX, 1957, pp. 251–57.

Nova, A. F., 'The Artistic Patronage of Pope Julius III (1550–55): Profane Imagery and Buildings for the De' Monte Family in Rome', Ph.D., Univ. of London, 1982.

Oberhuber, K., *Raphaels Zeichnungen, Abteilung IX*, Berlin, 1972.

Olivieri, A., 'Capitale mercantile e committenza nella Venezia del Sansovino', *Critica storica*, XV, no. 4, 1978, pp. 44–77.

Ongania, F., ed., *La Basilica di San Marco in Venezia illustrata nella storia e nell'arte da scrittori veneziani . . .*, Venice, 1888.

——— and Cecchetti, B., eds., *Documenti per la storia dell'augusta ducale basilica di San Marco in Venezia . . .*, Venice, 1886.

Onians, J., 'Style and Decorum in Sixteenth-Century Italian Architecture', Ph.D., Univ. of London, 1968.

———, *Bearers of Meaning: The Classical Orders . . .*, Princeton, 1988.

Orlandi, G., and Portoghesi, P., eds., *Leon Battista Alberti: L'architettura (De re aedificatoria)*, Milan, 1966, 2 vols.

Ortolani, S., *S. Croce in Gerusalemme* (Le chiese di Roma illustrate, no. 106), Rome, 1969.

Paatz, W., and Paatz, E., *Die Kirchen von Florenz*, Frankfurt, 1940–54, 6 vols.

Padovani, S., 'Andrea del Sarto: ipotesi per gli inizi', *Arte cristiana*, LXXVI, 1988, pp. 197–216.

Palladio, A., *I quattro libri dell'architettura*, Venice, 1570 (reprinted Milan, 1970).

Pallucchini, R., ed., *I capolavori dei Musei Veneti*, Venice, 1946.

———, *La giovinezza del Tintoretto*, Milan, 1950.

———, *Tiziano*, Florence, 1969, 2 vols.

———, ed., *Da Tiziano a El Greco: per la storia del manierismo a Venezia* (exh. cat.), Venice, 1981.

——— and Rossi, P., *Tintoretto: le opere sacre e profane*, Milan, 1982, 2 vols.

Palumbo Fossati, I., 'L'interno della casa dell'artigiano e dell'artista nella Venezia del Cinquecento', *Studi Veneziani*, n.s., VIII, 1984, pp. 109–53.

Panofsky, E., '"Imago Pietatis": Ein Beitrag zur Typengeschichte des "Schmerzensmannes" und der "Maria Mediatrix"', in *Festschrift für Max J. Friedländer zum 60. Geburtstag*, Leipzig, 1927, pp. 261–308.

———, *The Life and Art of Albrecht Dürer*, Princeton, 1955.

———, *Idea: A Concept in Art Theory*, New York, 1968.

Paoletti, E., *Il fior di Venezia*, Venice, 1837–40, 5 vols.

Paoletti, P., *L'architettura e la scultura del rinascimento in Venezia*, Venice, 1893, 3 vols.

Paolucci, A., ed., *La civiltà del cotto: arte della terracotta nell'area fiorentina dal XV al XX secolo* (exh. cat.), Impruneta, 1980.

Papadopouli, N., *Le monete di Venezia*, Venice, 1893–1919, 3 vols.

Papini, R., ed., *Catalogo delle cose d'arte e di antichità d'Italia: Pisa*, Rome, 1912, 2 vols.

Parronchi, A., 'L'altare di San Nicola da Tolentino del Franciabigio', *Commentari*, XXII, 1971, pp. 24–35 (=1971-I).

———, 'Premesse toscane di Jacopo Sansovino', *Arte Veneta*, XXV, 1971, pp. 44–52 (=1971-II).

———, 'Une Madonne donatellienne de Jacopo Sansovino', *Revue de l'Art*, 21, 1973, pp. 40–43.

Partner, P., *Renaissance Rome, 1500–1559*, Berkeley, 1976.

Paschini, P., *Domenico Grimani: Cardinale di San Marco (+1523)*, Rome, 1943.

Passavant, G., *Verrochio: Sculpture, Paintings and Drawings*, London, 1969.

Passavant, J. D., *Le Peintre-Graveur*, Leipzig, 1860–65, 6 vols.

Passerini, L., *Genealogia della famiglia Altoviti*, Florence, 1871.

Passini, A., *Il tesoro di San Marco in Venezia*, Venice, 1887.

Pastor, L. v., ed., *Die Reise des Kardinals Luigi d'Aragona . . .*, Freiburg im Breisgau, 1905.

———, *Storia dei papi*, Roma, 1958–64, 17 vols.

Pavanello, G., *La chiesa di S. Maria Formosa nella VI sua ricostruzione (639–1921)*, Venice, 1921.

Pavanello, G., et al., *Venezia nell'età di Canova* (exh. cat.), Venice, 1978.

Pedretti, C., ed., *The Literary Works of Leonardo da Vinci . . .*, Oxford, 1977, 2 vols.

Pelli, G., *Saggio istorico della Real Galleria di Firenze*, Florence, 1779, 2 vols.

Pergola, P. della, et al., *Giorgio Vasari: le vite . . .*, Novara, 1962–66, 9 vols.

Perkins, C., *Historical Handbook of Italian Sculpture*, London, 1883.

Perry, M., 'Cardinal Domenico Grimani's Legacy of Ancient Art to Venice', *Journal of the Warburg and Courtauld Institutes*, XLI, 1978, pp. 215–44.

———, 'A Renaissance Showplace of Art: The Palazzo Grimani at Santa Maria Formosa, Venice', *Apollo*, CXIII, 1981, pp. 215–21.

Petrarca, F., *Prose*, ed. G. Martellotti, et al., Milan and Naples, 1955.

Petrasch, E., *Badisches Landesmuseum: Neuerwerbungen 1952–1965 . . .*, Karlsruhe, 1966.

Pettorelli, A., *Il bronzo e il rame nell'arte decorativa italiana*, Milan, 1926.

Pevsner, N., *Academies of Art Past and Present*, Cambridge, 1940.

Pfanner, M. *Der Titusbogen*, Mainz am Rhein, 1983.

Pietrangeli, C., *Guide rionali di Roma: Rione IX—Pigna, parte iii*, Rome, 1977.

Pietrogrande, L., 'Francesco Segala', *Bollettino del Museo Civico di Padova*, XXXI–XLIII, 1942–54, pp. 111–36; XLIV, 1955, pp. 99–119; L, 1961, pp. 29–58.

Pigeon, A., 'Le Mouvement des Arts en Allemagne', *Gazette des beaux-arts*, 2nd ser., XXXVI, 1887, pp. 76–81.

Pignatti, T., *Veronese: l'opera completa*, Venice, 1976, 2 vols.

Pincus, D., 'A Hand by Antonia Rizzo and the Double Caritas Scheme of the Tron Tomb', *Art Bulletin*, LI, 1969, pp. 247–56.

———, 'An Antique Fragment as a Workshop Model . . .', *Burlington Magazine*, CXXIII, 1981, pp. 342–46 (=1981-I).

———, 'The Tomb of Doge Nicolò Tron and Venetian Renaissance Ruler Imagery', in *Art the Ape of Nature: Studies in Honor of H. W. Janson*, ed. L. F. Sadler, et al., New York, 1981, pp. 127–50 (=1981-II).

Pini, C., and Milanesi, G., *La scrittura di artisti italiani . . .*, Florence, 1876.

Pirri, P., 'Andrea Sansovino a Loreto', *Civiltà catolica*, IV, 1931, pp. 415–29, and I, 1932, pp. 15–29, 223–36.

Pittoni, L., *Jacopo Sansovino scultore*, Venice, 1909.

Planiscig, L., *Die Estensische Kunstsammlung: I. Skulpturen und Plastiken des Mittelalters und der Renaissance*, Vienna, 1919.

———, *Venezianische Bildhauer der Renaissance*, Vienna, 1921.

———, *Andrea Riccio*, Vienna, 1927.

Plon, E., *Benvenuto Cellini*, Paris, 1883–84.

Poggi, G., *Il Duomo di Firenze*, ed. M. Haines, Florence, 1988, vol. II.

Polidoro, V., *Le religiose memorie . . .*, Venice, 1590.

Pope-Hennessy, J., 'A Relief by Sansovino', *Burlington Magazine*, CI, 1959, pp. 4–10.

———, *Catalogue of Italian Sculpture in the Victoria and Albert Museum*, London, 1964, 3 vols.

———, 'Portrait Sculptures by Ridolfo Siringatti', *Victoria and Albert Museum Bulletin*, I, no. 2, 1965, pp. 33–36.

———, 'An Exhibition of Italian Bronze Statuettes', in *Essays on Italian Sculpture*, London, 1968, pp. 172–98.

Pope-Hennessy, J., *Italian High Renaissance and Baroque Sculpture*, London, 1970 (=1970-I).

———, *Raphael*, London, 1970 (=1970-II).

———, *Italian Renaissance Sculpture*, London, 1971.

———, 'The Forging of Italian Renaissance Sculpture', *Apollo*, XCIX, 1974, pp. 242–67 (=1974-I).

———, *Fra Angelico*, London, 1974 (=1974-II).

———, 'The Madonna Reliefs of Donatello', *Apollo*, CIII, 1976, pp. 172–91.

———, *Luca della Robbia*, Oxford, 1980 (=1980-I).

———, 'The Relations between Florentine and Venetian Sculpture in the Sixteenth Century', *Florence and Venice: Comparisons and Relations: II. Cinquecento*, ed. S. Bertelli, et al., Florence, 1980, pp. 323–35 (=1980-II).

———, 'Donatello's Bronze David', *Scritti di storia dell'arte in onore di Federico Zeri*, ed. M. Natale, Milan, 1984, I, pp. 122–27.

———, *Cellini*, London, 1985.

Portogruaro, D., 'Il Tempio e il convento del Redentore', *Rivista mensile della città di Venezia*, IX, 1930, pp. 141–224.

The Portrait Bust: Renaissance to Enlightenment (exh. cat.), Rhode Island School of Design, Providence, 1969.

Posner, D., 'Marginal Notes by Annibale Carracci', *Burlington Magazine*, CXXIV, 1982, p. 239.

Posner, K. W.-G., 'Notes on S. Maria dell'Anima', *Storia dell'arte*, VI, 1970, pp. 121–38.

Pozzo, B. dal, *Le vite de' pittori, degli scultori et architetti veronesi*, Verona, 1718.

Predelli, P., *Venezia e i turchi*, Florence, 1975.

Preto, R., *Le memorie e le carte di Alessandro Vittoria*, Trent, 1908.

Prosperi, A., *Tra evangelismo e controriforma, G. M. Giberti (1495–1543)*, Rome, 1969.

Pullan, B., 'The Famine in Venice and the New Poor Law, 1527–1529', *Bollettino dell'Istituto di storia della società e dello stato veneziano*, V–VI, 1963–64, pp. 141–202.

———, 'Wage-Earners and the Venetian Economy', in *Crisis and Change in the Venetian Economy*, London, 1968, pp. 146–74.

Puppi, L., 'La Villa Garzoni a Pontecasale di Jacopo Sansovino', *Bollettino del Centre internazionale di studi di architettura Andrea Palladio*, XI, 1969, pp. 98–101.

———, *Michele San Micheli, architetto di Verona*, Padua, 1971.

———, 'Un'opera sconosciuta di Andrea da Valle', in *Scritti in onore di Roberto Pane*, Naples, 1972, pp. 315–33.

———, 'Per Tullio Lombardo', *Arte Lombarda*, XVII-1, 1972, pp. 100–03.

———, *Andrea Palladio*, Milan, 1973, 2 vols.

———, 'Minuzia archivistica per villa Garzoni di Jacopo Sansovino', *Antichità viva*, XIII, no. 5, 1974, pp. 63–64.

———, ed., *Architettura e utopia nella Venezia del Cinquecento* (exh. cat.), Milan, 1980.

———, 'Per Paolo Veronese architetto', *Palladio*, 3rd ser., III, fasc. 1–4, 1980, pp. 53–76 (=1980-II).

——— and Olivato Puppi, L., *Mauro Codussi*, Milan, 1974.

Raggio, O., 'Tiziano Aspetti's Reliefs of the Martyrdom of St Daniel of Padua', *Metropolitan Museum Journal*, 1982, pp. 131–46.

———, 'Bernini and the Collection of Cardinal Flavio Chigi', *Apollo*, CXVII, 1983, pp. 368–79.

Rambaldi, P., 'La scala dei giganti nel Palazzo Ducale di Venezia', *L'Ateneo Veneto*, XXXIII, 1910, pp. 87–121, 193–239.

Real Museo Borbonico, Naples, 1824–57, 16 vols.

Rearick, W. R., 'Observations on the Venetian Cinquecento in the Light of the Royal Academy Exhibition', *Artibus et historiae*, IX, 1984, pp. 59–75.

Réau, L., *Iconographie de l'art chrétien*, Paris, 1955–59, 3 vols.

Reymond, M., *La Sculpture Florentine: IV. Le XVIᵉ siècle . . .*, Florence, 1900.

Rezzi, S., 'Palazzo Gaddi Niccolini in Banchi', *Quaderni dell'Istitutio di storia dell'architettura*, ser. 27, fasc. 169–74, 1982, pp. 35–48.

Ricci, C., *Guida di Bologna*, Bologna, 1893.

———, 'Girolama da Treviso a Bologna', *Arte nostra*, I, 1910, pp. 5–7.

Ricci, S. de', 'L'Art du Moyen Âge et de la Renaissance à l'Hôtel de Sagan', *Gazette des beaux-arts*, LV, 1913, pp. 68–76.

Riccio, A. del, *Istoria delle pietre* (Cod. 230 Riccardiana), ed. P. Barocchi, Florence, 1979.

Richa, G., *Notizie istoriche delle chiese fiorentine . . .*, Florence, 1754–62, 10 vols.

Richardson, E. F., 'A River God by Jacopo Sansovino', *Bulletin of the Detroit Institute of Arts*, XXV, no. 1, 1946, pp. 7–8.

———, 'Two Bronze Figures by Jacopo Sansovino', *Bulletin of the Detroit Institute of Arts*, XXIX, no. 2, 1949–50, pp. 58–62.

Richardson, F., *Andrea Schiavone*, Oxford, 1980.

Richter, G. M. A., *The Portraits of the Greeks*, London, 1965–72, 4 vols.

Richter, J. P., *The Literary Works of Leonardo da Vinci*, London, 1970, 2 vols.

Ridolfi, C., *Le maraviglie dell'arte*, ed. D. V. Hadeln, Berlin, 1914–24, 2 vols.

Riess, J. B., 'The Civic View of Sculpture in Alberti's *De re aedificatoria*', *Renaissance Quarterly*, XXXII, 1979, pp. 1–17.

Rigoni, E., *L'arte rinascimentale in Padova: studi e documenti*, Padua, 1970.

Ringbom, S., *From Icon to Narrative*, Doornspijk, 1984.

Rizzo, V., 'Documenti su Solimena, Sanfelice, Sanmartino e i maestri cartapistari', *Napoli nobilissima*, XX, fasc. v–vi, 1981, pp. 222–40.

Robey, D., and Law, J., 'The Venetian Myth and the "De Republica Veneta" of Pier Paolo Vergerio', *Rinascimento*, XV, 1975, pp. 3–59.

Romanin, S., *Storia documentata di Venezia*, Venice, 1853–61, 10 vols.

Ronchi, O., 'La casa di Pietro Bembo a Padova', *Atti e memorie della R. Accademia di scienze, lettere, ed arti in Padova*, XI, 1933–34, pp. 285–329.

Rosand, D., *Painting in Cinquecento Venice*, New Haven and London, 1982.

Rosand, E., 'Music and the Myth of Venice', *Renaissance Quarterly*, XXX, 1977, pp. 511–37.

Rosci, M., *Il trattato di architettura di Sebastiano Serlio*, Milan, 1966.

Rosenthal, E., 'Michelangelo's *Moses*, dal di sotto in su', *Art Bulletin*, XLVI, 1964, pp. 544–50.

Roskill, M. W., *Dolce's 'Aretino' and Venetian Art Theory of the Cinquecento*, New York, 1968.

Rossetti, G. B., *Descrizione delle pitture ed architetture di Padova*, Padua, 1765.

———, *Il forestiere illuminato per le pitture, sculture, ed architettura della citta di Padova*, Padua, 1786.

Rossi, F., 'Un'opera giovanile di Jacopo Sansovino', *Dedalo*, XII, 1932, pp. 702–07.

———, *Il Museo Horne*, Florence, 1967.

Rossi, G., *Guida di Verona*, Verona, 1854.

Rossi, P., *Jacopo Tintoretto: i ritratti*, Venice, 1974.

———, *I disegni di Jacopo Tintoretto*, Florence, 1975.

Rosso, P. M. del, 'Curiosità artistiche', *Archivio storico italiano*, 4th ser., III, 1879, pp. 475–82.

Rotondi Briasco, P., *Filippo Parodi*, Genoa, 1962.

Rubinstein, N., 'Politics and Constitution in Florence at the End of the Fifteenth Century', *Italian Renaissance Studies*, ed. E. F. Jacob, London, 1960, pp. 148–83.

———, 'Vasari's Painting of *The Foundation of Florence* in the Palazzo Vecchio', in *Essays . . . presented to Rudolf Wittkower*, ed. D. Fraser, et al., London, 1967, pp. 64–73.

Ruesch, A., ed., *Guida illustrata del Museo Nazionale di Napoli, parte prima: Antichità*, Naples, 1911.

Russoli, F., *Scultura italiana: il rinascimento*, Milan, 1967.

Rupprecht, B., 'Die Villa Garzoni des Jacopo Sansovino', *Mitteilungen des Kunsthistorischen Institutes in Florenz*, XI, 1963–65, pp. 1–32.

Sagredo, A., *Sulle consorterie delle arti edificative in Venezia*, Venice, 1856.

Sainsbury, W. N., *Original Unpublished Papers illustrating the Life of Sir Peter Paul Rubens*, London, 1859.

Sambin, P., 'Altre testimonianze di Angelo Beolco', *Italia medioevale e umanistica*, VII, 1964, pp. 221–47.

———, 'I Testamenti di Alvise Cornaro', *Italia medioevale e umanistica*, IX, 1966, pp. 295–385.

Sandi, L., et al., *Scrittura di Antonio Corradini e decreto del Magistrato al Sal nella rifabbrica della scala dei giganti* (Nozze Piamonte-Sianchini), Venice, 1882.

Sanpaolesi, P., 'La vita vasariana del Sansovino e l'Ammannati', *Studi vasariani* (Atti del Convegno internazionale per il IV centenario della prima edizione delle *Vite* del Vasari), Florence, 1950, pp. 134–39.

Sansovino, F., *Stanze . . . di nuovo corrette*, Venice, 1538.

———, *Lettere . . . sopra le dieci giornate del Decamerone di M. Giovanni Boccaccio*, Venice, 1542.

———, *Dell'arte oratoria . . .*, Venice, 1546.

———, *L'edificio del corpo humano*, Venice, 1550.

———, *Delle cose notabili che sono in Venetia*, Venice, 1561.

———, *Del secretario . . . libri iiii*, Venice, 1564 (=1564-I).

———, ed., *Dante con l'espositione di Christoforo Landino . . .*, Venice, 1564 (=1564-II).

———, *Del secretario . . . libri vii*, Venice, 1580.

———, *Venetia città nobilissima et singolare . . .*, Venice, 1581.

Santangelo, A., *Museo di Palazzo Venezia: catalogo delle sculture*, Rome, 1954.

Santarelli, E., *Catalogo della raccolta de' disegni autografi . . . donati dal Professore Emilio Santarelli alla Reale Galleria di Firenze*, Florence, 1870.

Sanudo, M., *I diarii . . .*, ed. R. Fulin, et al., Venice, 1879–1902, 58 vols.

Sapori, F., *Jacopo Tatti detto il Sansovino*, Rome, 1928.

Sardo, F., *Su l'Argoa Voluptas di Pietro Contarini, poeta veneziano*, Teramo, 1908.

Sartori, A., *L'Arciconfraternità del Santo*, Padua, 1955.

———, *S. M. Gloriosa dei Frari*, Padua, 1956.

———, 'Di nuovo sulle opere donatelliane al Santo', *Il Santo*, n.s., III, 1963, pp. 347–58.

———, *Documenti per la storia dell'arte a Padova*, ed. C. Fillarini, Vicenza, 1976.

Scaglione, A., 'Dante and the Rhetorical Theory of Sentence Structure', in *Medieval Eloquence: Studies in the Theory and Practice of Medieval Rhetoric*, ed. J. J. Murphy, Berkeley, 1978, pp. 252–69.

Scarpellini, P., *Perugino*, Milan, 1984.

Schiavo, A., 'La Badia di San Michele arcangelo a Passignano in Val di Pesa', *Benedictina*, VIII, 1954, pp. 257–87.

_____, 'Notizie riguardanti la Badia di Passignano', *Benedictina*, IX, 1955, pp. 31–92.

_____, 'L'opera di Luigi Vanvitelli nel convento e nella chiesa di S. Agostino in Roma', *Studi Romani*, XXII, 1974, pp. 316–24.

Schiller, G., *Iconography of Christian Art*, London, 1971–72, 2 vols.

Schlosser, J. v., *Werke der Kleinplastik in der Skulpturensammlung des Allerhöchsten Kaiserhauses*, Vienna, 1910.

_____, 'Aus der Bildnerwerkstatt der Renaissance: IV. Zur Rolle des Kleinmodells im Studio des Künstlers und des Amateurs', *Jahrbuch der kunsthistorischen Sammlungen in Wien*, XXXI, no. 2, 1913, pp. 100–18.

Schnellbach, R., 'Badisches Landesmuseum: Erwerbungsbericht 1952–1962', *Jahrbuch der Staatlichen Kunstsammlungen in Baden-Würtemberg*, I, 1964, pp. 43–70.

Schottmüller, F., ed., *Königliche Museen zu Berlin: Die italienischen und spanischen Bildwerke der Renaissance und des Barocks . . .*, Berlin, 1913.

_____, *Bildwerke des Kaiser-Friedrich-Museums: Die italienischen und spanischen Bildwerke der Renaissance und des Barock: I. Die Bildwerke in Stein, Holz, Ton, und Wachs*, Berlin and Leipzig, 1933.

Schubring, P., *Die Plastik Sienas im Quattrocento*, Berlin, 1907.

_____, 'Italienische Renaissanceplastik in Budapest', *Zeitschrift für bildende Kunst*, XXV, 1914, pp. 91–104.

_____, *Die Kunst der Hochrenaissance in Italien*, Berlin, 1926.

Schütz-Rautenberg, G., *Künstlergrabmäler des 15. und 16. Jahrhunderts in Italien . . .*, Cologne and Vienna, 1978.

Schulz, A. M., 'The Sculpture of Giovanni and Bartolomeo Bon and their Workshop', *Transactions of the American Philosophical Society*, LXVIII, part 3, 1978, pp. 7–81.

_____, 'Pietro Lombardo's Barbarigo Tomb', in *Art the Ape of Nature: Studies in Honour of H.W. Janson*, ed. L. F. Sadler, et al., New York, 1981, pp. 171–92.

_____, *Antonio Rizzo: Sculptor and Architect*, Princeton, 1983.

_____, 'Paolo Stella milanese', *Mitteilungen des Kunsthistorischen Institutes in Florenz*, XXIX, 1985, pp. 79–110.

Schulz, J., 'Vasari at Venice', *Burlington Magazine*, CIII, 1961, pp. 500–11.

_____, *Venetian Painted Ceilings of the Renaissance*, Berkeley, 1968.

_____, 'The Houses of Titian, Aretino, and Sansovino', *Titian: His World and his Legacy*, ed. D. Rosand, New York, 1982, pp. 73–118.

Schwager, K., 'Zur Bautätigkeit Sixtus' V. an S. Maria Maggiore in Rom', *Miscellanea Bibliothecae Hertzianae*, Vienna, 1961, pp. 324–54.

Scott-Elliott, A. H., 'The Statues from Mantua in the Collection of King Charles I', *Burlington Magazine*, CI, 1959, pp. 218–27.

Scrase, D., 'Drawings', in *The Genius of Venice* (exh. cat.), ed. J. Martineau and C. Hope, London, 1983, pp. 246–302.

Scrinzi, A., 'Una Madonna di Jacopo Sansovino', *Venezia: Studi di arte e storia a cura della direzione del Museo Civico Correr*, I, 1920, pp. 255–57.

Secchi, S., 'Giovanni Matteo Bembo', in *DBI*, VIII, pp. 124–45.

Selvatico, P., *Sull'architettura e sulla scultura in Venezia . . .*, Venice, 1847.

Semenzato, C., *La scultura veneta del Seicento e del Settecento*, Venice, 1966.

Serlio, S., *Regole generali di architettura sopra le cinque maniere de gli edifici . . .*, Venice, 1537.

_____, *Tutte l'opere d'architettura . . .*, Venice, 1619.

Settesoldi, E., 'Gli apostoli dell'Ammannati nel Battistero di Firenze', *Antichità viva*, XIV, no. 4, 1975, p. 55.

Seymour, C., *Masterpieces of Sculpture from the National Gallery of Art*, New York, 1949.

_____, *Sculpture in Italy, 1400–1500*, Harmondsworth, 1966.

Seznec, J., *The Survival of the Pagan Gods*, New York, 1961.

Sgarbi, V., 'Una Madonna di Jacopo Sansovino', *Ricerche di storia dell'arte*, VIII, 1979, pp. 127–33.

Sheard, W. S., 'The Tomb of Doge Andrea Vendramin in Venice by Tullio Lombardo', Ph.D., Yale Univ., 1971, 2 vols. (Univ. Microfilms).

_____, '"Asa Adorna": The Prehistory of the Vendramin Tomb', *Jahrbuch der Berliner Museen*, n.s., XX, 1978, pp. 117–56 (=1978-I).

_____, *Antiquity in the Renaissance* (exh. cat.), Northampton, Mass., 1978 (=1978-II).

_____, 'The Birth of Monumental Classicizing Reliefs in Venice on the Façade of the Scuola di San Marco', in *Interpretazioni Veneziane*, ed. D. Rosand, Venice, 1984, pp. 149–74.

Shearman, J., 'A Lost Altar-Piece by Andrea del Sarto "The Madonna of S. Ambrogio"', *Burlington Magazine*, CIII, 1961, pp. 225–30 (=1961-I).

_____, 'The Chigi Chapel in S. Maria del Popolo', *Journal of the Warburg and Courtauld Institutes*, XXIV, 1961, pp. 129–60 (=1961-II).

_____, *Andrea del Sarto*, Oxford, 1965, 2 vols (=1965-I).

_____, 'Raphael's Unexecuted Projects for the Stanze', in *Walter Friedländer zum 90. Geburtstag*, Berlin, 1965, pp. 158–84 (=1965-II).

_____, 'The "Dead Christ" by Rosso Fiorentino', *Bulletin of the Museum of Fine Arts, Boston*, LXIV, 1966, pp. 148–72.

_____, *Mannerism*, Harmondsworth, 1967 (=1967-I).

_____, 'Giulio Romano: tradizione, licenze, artefici', *Bollettino del Centre internazionale di studi di architettura Andrea Palladio*, IX, 1967, pp. 354–68 (=1967-II).

_____, *Pontormo's Altarpiece in S. Felicità* (Charlton Lecture), Newcastle upon Tyne, 1971.

_____, *The Raphael Cartoons in the Collection of Her Majesty the Queen . . .*, London, 1972.

_____, 'The Florentine Entrata of Leo X, 1515', *Journal of the Warburg and Courtauld Institutes*, XXXVIII, 1975, pp. 136–54.

_____, 'Raphael, Rome and the Codex Escurialensis', *Master Drawings*, XV, 1977, pp. 107–46.

Siebenhuner, H., *Das Kapitol in Rom: Idee und Gestalt*, Munich, 1954.

Simeoni, L., *Verona*, Verona, 1909.

Sinding-Larsen, S., 'Christ in the Council Hall: Studies in the Religious Iconography of the Venetian Republic', *Acta ad archaeologiam et artium historiam pertinentia*, V, 1974.

Skubiszewska, M., 'Franciabigio's Two Tondi with Annunciation', *Bulletin du Musée National de Varsovie*, XVI, 1975, no. 3, pp. 84–96.

Söding, U., 'Jacopo Sansovinos florentiner Domfassade-Dekoration von 1515', *Kunstgeschichtliche Studien zur florentiner Renaissance*, Stockholm, 1980, I, pp. 156–64.

Sohm, P., 'The Staircases of the Venetian Scuole Grandi and Mauro Codussi', *Architectura*, VIII, 1978, pp. 125–49.

Soranzo, G., *Bibliografia veneziana . . .*, Venice, 1885.

Soravia, G. B., *Le chiese di Venezia*, Venice, 1822–24, 3 vols.

Spagnesi, G., ed., *Antonio da Sangallo il Giovane: la vita e l'opera* (Atti del XXII Congresso di storia dell'architettura), Rome, 1986.

Spalding, J., *Santi di Tito* (Outstanding Dissertations in the Fine Arts), New York and London, 1982.

Spitzer, L., *Classical and Christian Ideas of World Harmony*, Baltimore, Md., 1963.

Springer, A., *Die Kunst des Altertums*, Leipzig, 1923.

Sricchia Santoro, F., 'Per il Franciabigio', *Paragone Arte*, XIV, no. 163, 1963, pp. 3–23.

Stegmann, K., and Geymüller, H. v., *Die Architektur der Renaissance in Toscana . . .*, Munich, 1885–1909, 11 vols.

Stella, A., 'Bindo Altoviti', in *DBI*, II, 1960, pp. 574–75.

Stepan, P., 'Die Reliefs der Capella del Santo in Padua: Quellenstudien und Untersuchungen zu ihren Ikonographie', Ph.D., Univ. of Munich, 1982.

Stephens, J. N., *The Fall of the Florentine Republic, 1512–1530*, Oxford, 1983.

Stix, A., and Fröhlich-Bum, L., *Beschreibender Katalog der Handzeichnungen in der graphischen Sammlung Albertina, III, Die Zeichnungen der toskanischen, umbrischen, und römischen Schulen*, Vienna, 1932.

Stock, J., ed., *Disegni veneti di collezioni inglesi* (exh. cat.), Vicenza, 1980.

Stockbauer, J., *Kunstbestrebungen am bayerischen Höfe unter Herzog Albert V. und seinem Nachfolger Wilhelm V.*, Vienna, 1847.

Stone, R. E., 'Antico and the Development of Bronze Casting . . .', *Metropolitan Museum Journal*, XVI, 1981, pp. 87–116.

Stott, D., 'Fatte a sembianza di pittura: Jacopo Sansovini's Bronze Reliefs in S. Marco', *Art Bulletin*, LXIV, 1982, pp. 370–88.

Stringa, G., ed., *Officia propria festi Sancti Marci Apostoli . . . recitanda ex antiqua consuetudine in ducali eius Ecclesiae*, Venice, 1602.

——, *Venetia città nobilissima et singolare . . .*, Venice, 1604.

——, *La chiesa di S. Marco descritta brevemente*, Venice, 1610 (=1610-I).

——, *Vita di S. Marco Evangelista*, Venice, 1610 (=1610-II).

Strom, D., 'A New Chronology for Donatello's Wooden Sculpture', *Pantheon*, XXXVIII, 1980, pp. 239–48.

——, 'Desiderio and the Madonna Relief in Quattrocento Florence', *Pantheon*, XL, 1982, pp. 130–35.

Suida, W., 'The Samuel H. Kress Collection', *Philadelphia Museum Bulletin*, XLVI, no. 227, 1950, pp. 5–22.

Summers, D., 'Maniera and Movement: The Figura Serpentinata', *Art Quarterly*, XXXV, 1972, pp. 269–301.

——, 'Contrapposto: Style and Meaning in Renaissance Art', *Art Bulletin*, LIX, 1977, pp. 336–61.

——, *The Sculpture of Vincenzo Danti . . .* (Outstanding Dissertations in the Fine Arts), New York and London, 1979.

Supino, I., 'I Pittori e gli scultori del rinascimento nella primaziale di Pisa', *Archivio storico dell'arte*, VI, 1893, pp. 419–57.

——, *Catalogo del R. Museo Nazionale di Firenze*, Rome, 1898.

——, *La scultura delle porte di S. Petronio in Bologna*, Florence, 1914.

——, *L'arte nelle chiese di Bologna, secoli XV–XVI*, Bologna, 1938.

Swarzenski, G., 'Some Aspects of Italian Renaissance Sculpture in the National Gallery', *Gazette des beaux-arts*, 6th ser., XXIV, 1943, pp. 149–56.

Tafuri, M., *Jacopo Sansovino e l'architettura del'500 a Venezia*, Venice, 1969; Padua, 1972 (2nd ed.).

Tafuri, M., 'San Giovanni dei Fiorentini', in *Via Giulia: una utopia urbanistica del'500*, ed. L. Salerno, et al., Rome, 1973, pp. 201–30.

——, 'Progetti per San Giovanni dei Fiorentini', in *Raffaello architetto*, ed. C. L. Frommel, et al., Milan, 1984, pp. 217–24.

——, '"Renovatio urbis Venetiarum": il problema storiografico', in *'Renovatio Urbis': Venezia nell'eta di Andrea Gritti (1523–1538)*, Rome, 1984, pp. 9–55.

Tassini, G., *Iscrizioni della chiesa e convento di S. Salvatore*, Venice, 1895.

Temanza, T., *Vite dei più celebri architetti, e scultori veneziani . . .*, Venice, 1778 (reprinted Milan, 1966).

Thode, H., *Michelangelo und das Ende der Renaissance*, Berlin, 1902–13, 3 vols.

Thomas, A., 'Workshop Procedure of Fifteenth-Century Florentine Artists', Ph.D., Univ. of London, 1976.

Tietze, H., *Tizian: Leben und Werk*, Vienna, 1936, 2 vols.

——, 'Master and Workshop in the Venetian Renaissance', *Parnassus*, XI, 1939, pp. 34–35, 45.

Timofiewitsch, W., 'Die Arsenal Madonna: Anmerkungen zur künstlerichen Entwicklung des Jacopo Sansovino', in *Festschrift Luitpold Dussler . . .*, ed. J. Schmoll gen. Eisenwerth et al., Munich, 1972, pp. 223–26 (=1972-I).

——, *Girolamo Campagna . . .*, Munich, 1972 (=1972-II).

——, 'Girolamo Campagna', *DBI*, XVII, 1974, pp. 300–06.

——, 'Marginalien zur Grabmalskulptur des Danese Cattaneo', *Arte Veneta*, XXXII, 1978, pp. 230–27.

Tiraboschi, G., *Storia della letteratura italiana*, Modena, 1778, 8 vols.

Tolnay, C., *The Youth of Michelangelo*, Princeton, 1943.

——, *The Sistine Ceiling*, Princeton, 1945.

——, *The Medici Chapel*, Princeton, 1948.

——, *The Tomb of Julius II*, Princeton, 1954.

——, *Corpus dei disegni di Michelangelo*, Novara, 1975–80, 4 vols.

Tonini, P., *Il Santuario della Santissima Annunziata di Firenze*, Florence, 1876.

Tormo, E., *Os Desenhos das Antiqualhos que vio Francisco d'Ollanda pintor portugues (. . . 1539–1540 . . .)*, Madrid, 1940.

Tosi, F. M., *Raccolta di monumenti sacri e sepolcrali scolpiti in Roma nei secoli XV e XVI*, Rome, 1856, 5 vols.

Tramontin, S., *S. Maria Mater Domini, storia e arte* (Studium Cattolico Veneziano), Venice, 1962.

——, ed., *Culto dei santi a Venezia*, Venice, 1965.

Traversari, G., *Museo Archeologico di Venezia: i ritratti*, Rome, 1968.

Treccani degli Alfieri, G., ed., *Storia di Brescia*, Brescia, 1963–64, 5 vols.

Tschudi, H. v., 'Italienische Plastik des XV. und XVI. Jahrhunderts: grössere Bildwerke in Stein, Ton, und Stuck', in *Ausstellung von Kunstwerken des Mittelalters und der Renaissance aus Berliner Privatbesitz* (exh. cat.), Berlin, 1899, pp. 81–88.

Urbani de Gheltof, G. M., *Degli Arazzi in Venezia . . .*, Venice, 1878.

——, 'Tarsie ed intaglio in legno', *La Basilica di San Marco a Venezia*, Venice, 1888, pp. 411–12.

Utz, H., 'Giuliano da Sangallo und Andrea Sansovino', *Storia dell'arte*, XIX, 1973 (1975), pp. 209–16.

Valcanover, F., 'San Giovanni Battista', *Da Tiziano a El Greco . . .* (exh. cat.), ed. R. Pallucchini, Venice, 1981, pp. 100–01, no. 15.

Valentiner, W. R., 'A Neglected Sculptor in the Mannerist Exhibition at Amsterdam', *Art Quarterly*, XIX, 1956, pp. 41–49.

Vasari, G., *Le Vite de' piu eccellenti pittori, scultori, et architettori dal 1550 insino al 1567*, Florence, 1568, 3 vols.

Vendrasco, L., 'Il crollo del campanile di San Marco', *Rassegna d'arte*, II, 1902, pp. 152–53.

Venturi, A., 'Il "Cupido" di Michelangelo', *Archivio storico dell'arte*, I, 1888, pp. 1–13.

————, 'Le Cardinal de Ferrare en France', *Annales de la Société historique et archeologique du Gatinais* (extract), Fontainebleau, 1903.

————, 'Fonte dimenticata di storia artistica: il catalogo di Tommasino Lancilotto', *L'Arte*, XXV, 1922, pp. 27–33.

Vere, G. de, trs., *Lives of the Most Eminent Painters . . . by Giorgio Vasari*, London, 1912–15, 10 vols.

Verheyen, E., *The Palazzo del Te in Mantua . . .*, Baltimore, 1977.

Viale Ferrero, M., *Arazzi italiani del Cinquecento*, Milan, 1961.

Vitry, P., ed. *Musée National du Louvre: Catalogue des sculptures du Moyen Age, de la Renaissance et des Temps Modernes, I. Moyen Age et Renaissance*, Paris, 1922.

Voltelini, H. v., 'Urkunden und Regesten aus dem k. und k. Haus-Hof-, und Staats-Archiv in Wien', *Jahrbuch der Kunsthistorischen Sammlungen . . . in Wien*, XIII, 1892, pt 2, pp. xxvi–clxxiv.

Waagen, G. F., *Works of Art and Artists in England*, London, 1838, 3 vols.

Wackernagel, M., *The World of the Florentine Renaissance Artist*, ed. A. Luchs, Princeton, 1981.

Walker, J., *Paintings and Sculpture from the Widener Collection, National Gallery of Art*, Washington, D.C., 1948.

Wallace, W. E., 'Michelangelo at Work . . .', *I Tatti Studies*, III, 1989, pp. 253–77.

Ward, R., 'Some Late Drawings by Baccio Bandinelli', *Master Drawings*, XIX, no. 1, 1981, pp. 3–17.

Warner, M., *Alone of All Her Sex: The Myth and the Cult of the Virgin Mary*, London, 1976.

Webb, M. I., *Michael Rysbrack Sculptor*, London, 1954.

Weber, I., *Deutsche, Niederländische, und Französische Renaissanceplaketten, 1500–1650*, Munich, 1975.

Weddigen, E., 'Thomas Philologus Ravennae . . .', *Saggi e memorie di storia dell'arte*, IX, 1974, pp. 7–76.

Weihrauch, H. R., *Studien zum bildnerischen Werke des Jacopo Sansovino*, Strasburg, 1935.

————, 'Eine unbekannte Kleinbronze des Jacopo Sansovino in Frankfurt am Main', *Städel Jahrbuch*, IX, 1935–36, pp. 153–55.

————, 'Jacopo Tatti . . . genannt Jacopo Sansovino', in Thieme-Becker, XXXII, 1938, pp. 465–70.

————, 'Italienische Bronzen als Vorbilder deutscher Goldschmiedkunst', *Studien zur Geschichte der europäischen Plastik: Festschrift Theodor Müller*, Munich, 1965, pp. 263–80.

————, *Europäische Bronzestatuetten*, Braunschweig, 1967.

Weil, M. S., *The History and Decoration of the Ponte S. Angelo*, London, 1974.

Weil, P. D., 'Bozetto-Modello: Form and Function', *Orfeo Boselli: osservazioni della scoltura antica*, Florence, 1978, pp. 113–34.

Weil-Garris, K., *The Santa Casa di Loreto: Problems in Italian Sixteenth Century Sculpture* (Outstanding Dissertations in the Fine Arts), New York, 1977.

————, 'Bandinelli and Michelangelo: A Problem of Artistic Identity', in *Art the Ape of Nature: Studies in Honour of H. W. Janson*, ed. L. F. Sadler, et al., New York, 1981, pp. 223–51.

Weinberger, M., 'The Youth of Michelangelo by Charles de Tolnay', *Art Bulletin*, XXVII, 1945, pp. 69–74.

————, 'A Bronze Statuette in the Frick Collection and its Connection with Michelangelo', *Gazette des beaux-arts*, 6th ser., XXXIX, 1952, pp. 103–14.

————, *Michelangelo the Sculptor*, London, 1967, 2 vols.

———— and Middeldorf, U., 'Unbeachtete Werke der Brüder Rossellino', *Münchner Jahrbuch für bildenden Kunst*, V, 1928, pp. 85–100.

Wethey, H. E., *The Paintings of Titian: I. The Religious Paintings*, London, 1969.

————, *The Paintings of Titian: II. The Portraits*, London, 1971.

White, J., 'The Reliefs on the Façade of the Duomo at Oriveto', *Journal of the Warburg and Courtauld Institutes*, XXII, 1959, pp. 254–302.

————, *Art and Architecture in Italy, 1250–1400*, Harmondsworth, 1966.

————, 'Painting and Sculpture', in *Art, Science and History in the Renaissance*, ed. C. S. Singleton, Baltimore, 1967, pp. 43–110 (=1967-I).

————, *The Birth and Rebirth of Pictorial Space*, London, 1967 (=1967-II).

Wickhoff, F., 'Der Saal des grossen Rathes zu Venedig in seinem alten Schmuck', *Repertorium für Kunstwissenschaft*, VI, 1883, pp. 1–37.

Wilde, J., 'Eine Studie Michelangelos nach der Antike', *Mitteilungen des Kunsthistorischen Institutes in Florenz*, IV, 1932–34, pp. 41–64.

————, 'The Hall of the Great Council of Florence', *Journal of the Warburg and Courtauld Institutes*, VII, 1944, pp. 65–81.

————, *Italian Drawings in the Department of Prints and Drawings in the British Museum: Michelangelo and his Studio*, London, 1953.

————, *Venetian Art from Bellini to Titian*, Oxford, 1974.

————, *Michelangelo: Six Lectures*, Oxford, 1978.

Wiles, B., *The Fountains of Florentine Sculptors and their Followers . . .*, Cambridge, Mass., 1933.

Wilk, S., *The Sculpture of Tullio Lombardo: Studies in Sources and Meaning* (Outstanding Dissertations in the Fine Arts), New York and London, 1978.

————, 'La Decorazione cinquecentesca della Cappella dell'Arca di S. Antonio', in *Le sculture del Santo di Padova*, ed. G. Lorenzoni, Vicenza, 1984, pp. 109–71.

Wilkinson, E. M., and Willoughby, L. A., eds., *Friedrich Schiller: On the Aesthetic Education of Man*, Oxford, 1967.

Wilson, C. C., *Renaissance Small Bronze Sculpture . . . at the National Gallery of Art*, Washington, D.C., 1983.

Winner, M., 'Zum Nachleben des Laokoön in der Renaissance', *Jahrbuch der Berliner Museen*, n.s., XVI, 1974, pp. 83–121.

Wittkower, R., 'Transformations of Minerva in Renaissance Imagery', *Journal of the Warburg Institute*, II, 1938–39, pp. 194–205.

————, *Architectural Principles in the Age of Humanism*, London, 1962.

————, *Art and Architecture in Italy, 1600–1750*, Harmondsworth, 1973.

————, *The Sculptor's Workshop* (W. A. Cargill Memorial Lecture in Fine Art), Glasgow, 1974.

————, *Gian Lorenzo Bernini . . .*, rev. ed. by H. Hibbard, et al., Oxford, 1981.

Wixom, W. R., *Renaissance Bronzes from Ohio Collections* (exh. cat.), Cleveland, Ohio, 1975.

Wolff-Metternich, F., *Die Erbauung der Peterskirche zu Rom im 16. Jahrhundert*, Vienna and Munich, 1972.

Wolters, W., 'Tiziano Minio als Stukator in Odeo Cornaro zu Padua', *Pantheon*, XXI, 1963, pp. 20–28, 222–30.

———, 'Über die Wandteppiche von San Marco . . .', *Pantheon*, XXIII, 1965, pp. 75–83.

———, 'Der Programmenentwurf zur Dekoration des Dogenpalastes nach dem Brand vom 20. Dezember 1577', *Mitteilungen des Kunsthistorischen Institutes in Florenz*, XII, 1965–66, pp. 271–318.

———, *Plastische Deckendekorationen des Cinquecento in Venedig und im Veneto*, Berlin, 1968.

———, 'Freilegung der Signatur an Donatellos Johannesstatue in S. Maria dei Frari', *Kunstchronik*, XXVII, 1974, p. 83.

———, *La scultura gotica veneziana*, Venice, 1976, 2 vols.

———, *Der Bilderschmuck des Dogenpalastes . . .*, Wiesbaden, 1983.

Woodner Collection: I. A Selection of Old Master Drawings before 1700 (exh. cat.), New York, 1971.

Ybl, E., 'Tommaso Lombardis Altarstatuen in Bissone', *Zeitschrift für schweizerische Archäologie und Kunstgeschichte*, VIII, 1946, pp. 53–56.

Zampetti, P., ed., *Lorenzo Lotto* (exh. cat.), Venice, 1953.

———, *Jacopo Bassano* (exh. cat.), Venice, 1957.

———, ed., *Il libro di spese diverse di Lorenzo Lotto*, Venice and Rome, 1969.

———, *Guida alle opere d'arte della Scuola di S. Fantin* (Ateneo Veneto), Venice, 1973.

———, 'La Scuola del Santo', in *Le pitture del Santo di Padova*, ed. C. Semenzato, Vicenza, 1984, pp. 75–118.

Zanotto, F., *Il Palazzo Ducale di Venezia*, Venice, 1853–61, 4 vols.

Zatta, A., ed., *L'Augusta ducale Basilica dell'Evangelista San Marco*, Venice, 1761.

Zava Boccazzi, F., *La Basilica dei Santi Giovanni e Paolo in Venezia*, Venice, 1965.

Zilczer, J., 'The Theory of Direct Carving in Modern Sculpture', *Oxford Art Journal*, IV, no. 2, 1981, pp. 44–49.

Zimmermann, H., 'Franz von Stamparts und Anton von Prenners Prodromus zum Theatrum Artis Pictoriae . . .', *Jahrbuch der Kunsthistorischen Sammlungen des Allerhöchsten Kaiserhauses*, VII, pt 2, 1888, pp. vii–xiv.

Zindel, C., 'Madonna mit dem Pardelfell: Jacopo Sansovino, Cartapesta auf Holz', Diplomarbeit, Schule für Gestaltung, Bern, 1990.

Zorzi, A., *Venezia scomparsa*, Milan, 1972, 2 vols.

Zorzi, G., *Disegni delle antichità di Andrea Palladio*, Vicenza, 1959.

———, *Le opere pubbliche e i palazzi privati di Andrea Palladio*, Venice, 1965.

———, *Le ville e i teatri di Andrea Palladio*, Vicenza, 1968.

Zorzi, M., *La Libreria di San Marco: libri, lettori, societa nella Venezia dei Dogi*, Milan, 1987.

Zucchini, G., *Guida della Basilica di S. Petronio*, Bologna, 1953.

Zucker, M. J., *The Illustrated Bartsch: XXV. Early Italian Masters*, New York, 1984.

Zweite, A., *Marten de Vos als Maler*, Berlin, 1980.

MANUSCRIPTS CONSULTED*

*Exclusive of notarial acts and of documents cited only in the corpus of documents

Barbaro, M., 'Arbori de' patritii veneti', ASV, Mis. Cod.

Capellari-Vivaro, G. A., 'Il Campidoglio veneto', BNM, MSS It. Cl. VII, Nos. 15–18 (=8304–07), 4 vols.

'Liber III Visitationum Ioannis Matthei Giberti', Biblioteca Capitolare, Verona.

'Memorie Venete per la biblioteca di Monsig. Ill. mo e R. mo Gasparo Negri', CMC, Cod. Cicogna 1629.

'Mariegola della Scuola dei tagliapietra', CMC, MS 150.

Torresani, A., 'Elogiarum historicarum: 1656, sectio secunda, viventi', ASVer, Fondo Lando, No. 26.

'Visite pastorali del 1527 al 1593', ASB, Busta 15, Fasc. visite 1573–1782.

Index

Works are indexed under the artist and, where appropriate, under location and subject. Figure numbers, including colour plates, are in bold.